Alaska

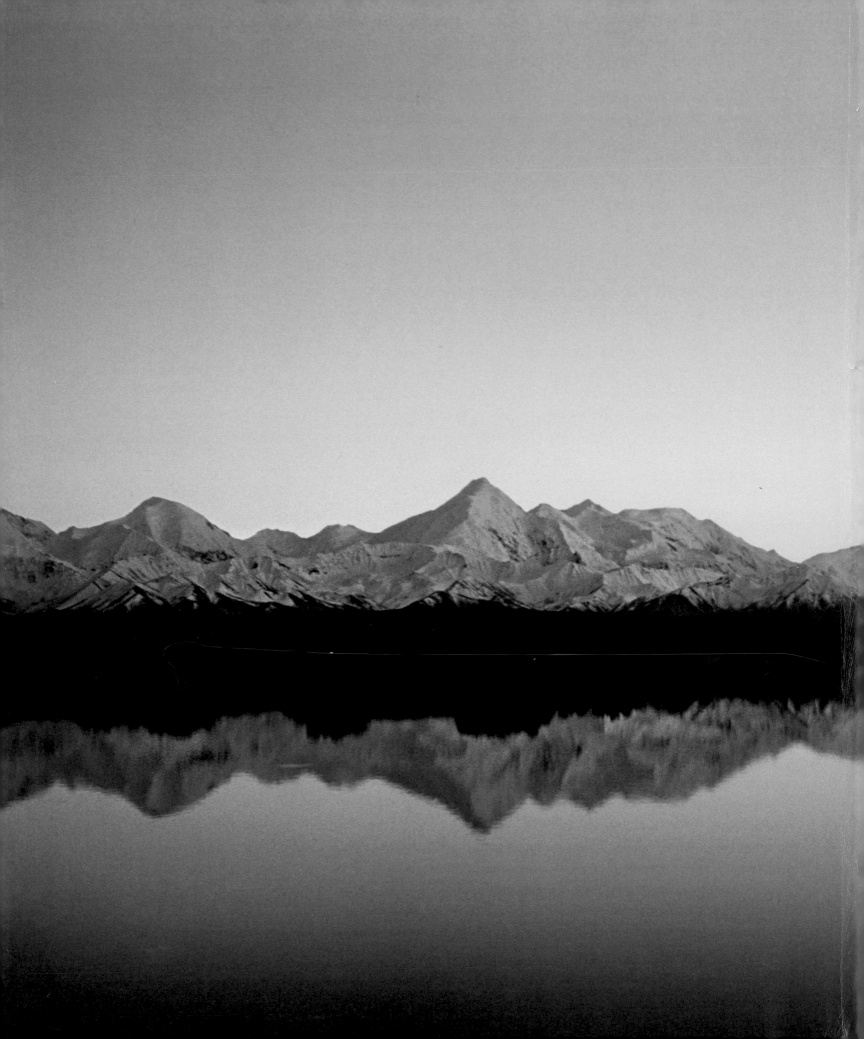

Alaska

A VISUAL TOUR OF AMERICA'S GREAT LAND

BOB DEVINE

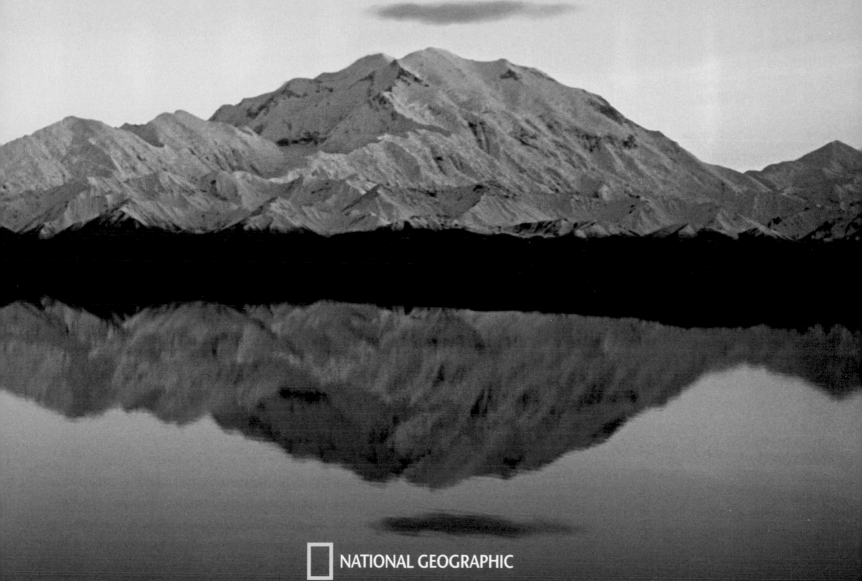

NATIONAL GEOGRAPHIC

WASHINGTON, D.C.

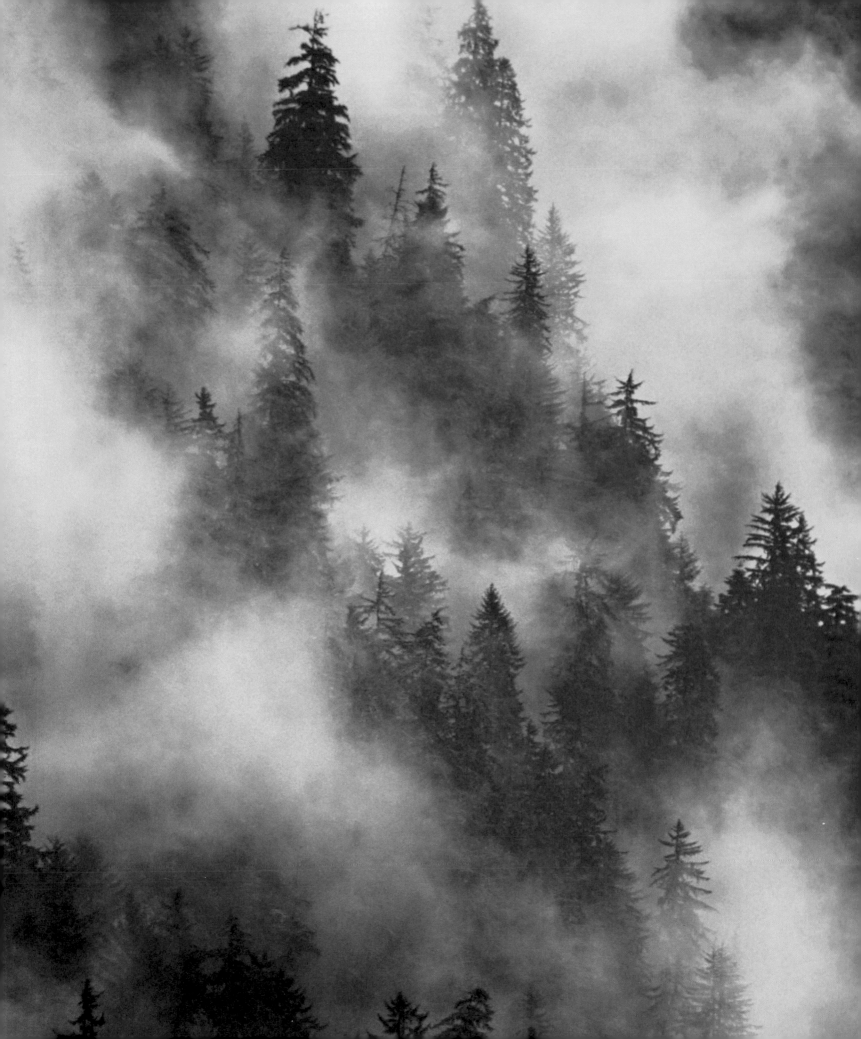

Contents

Pages 2–3: Mount McKinley hulking above lowlands of Denali National Park and Preserve; *page 4:* Temperate rain forest in the Tongass National Forest; *pages 6–7:* Anchorage skyline viewed from across Knik Arm; *pages 8–9:* Carving encountered along a trail atop Mount Roberts, in Juneau; *pages 10–11:* Chikuminuk Lake in the wilds of Wood-Tikchik State Park; *pages 12–13:* Commercial fishers hauling in sockeye salmon.

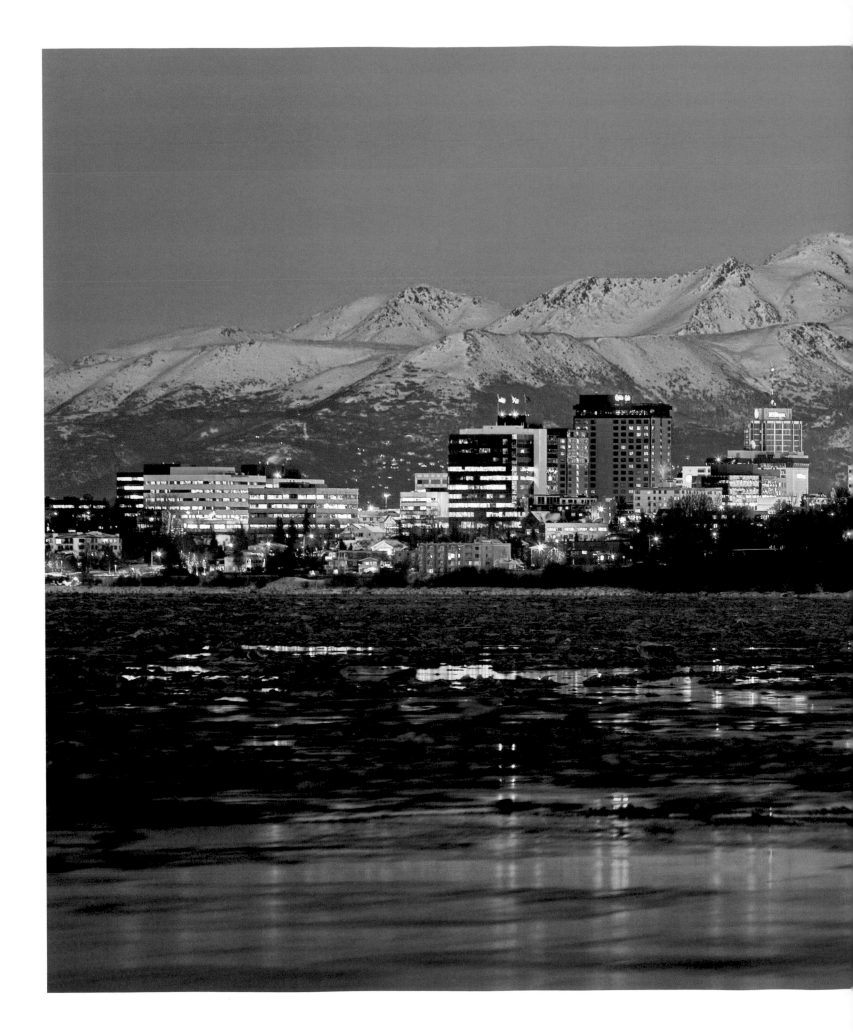

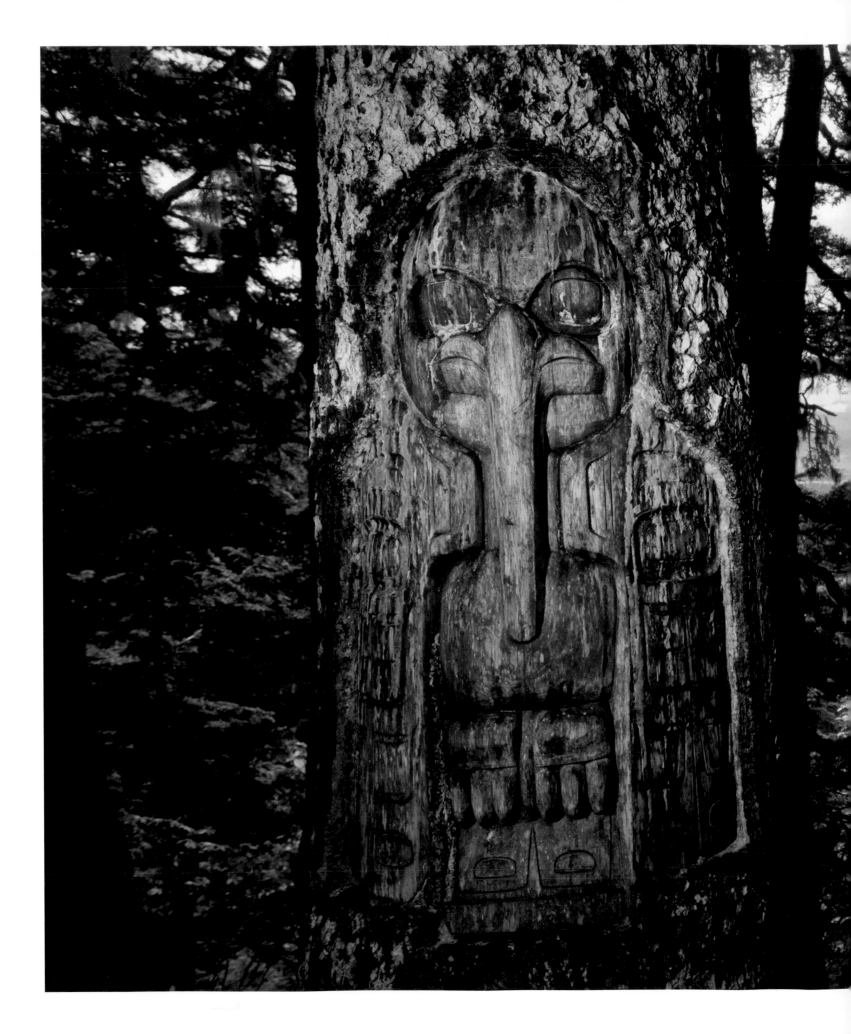

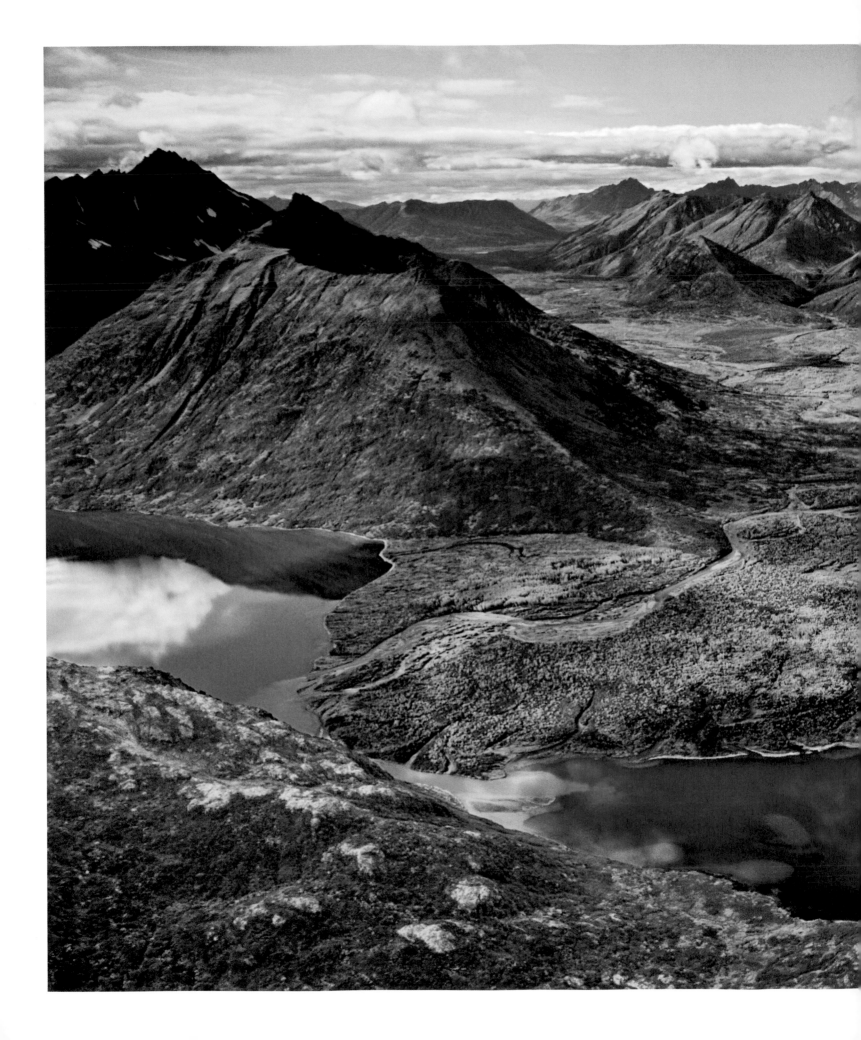

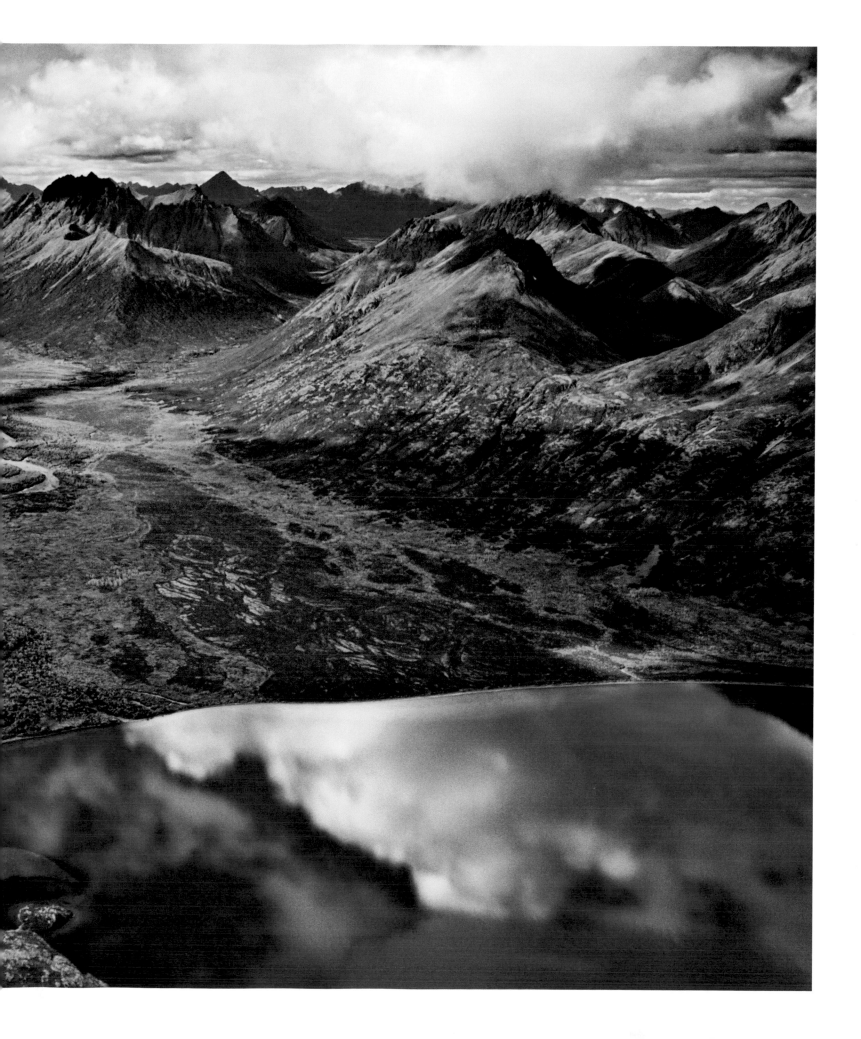

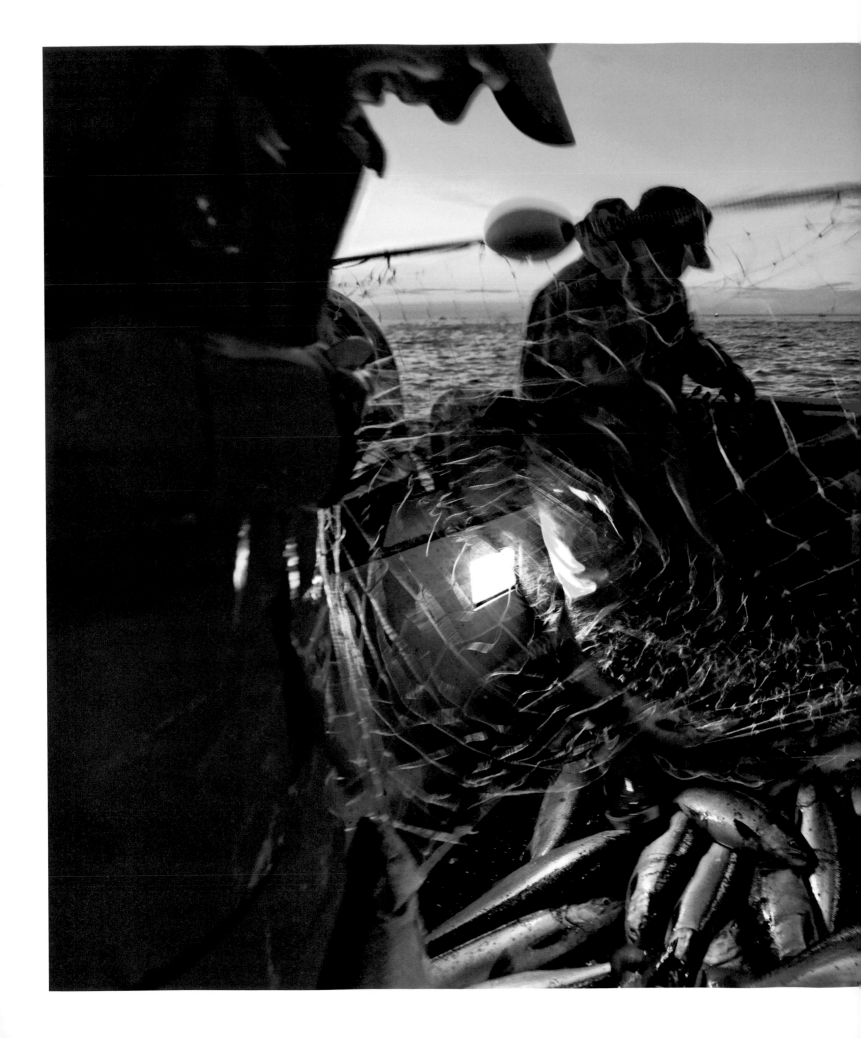

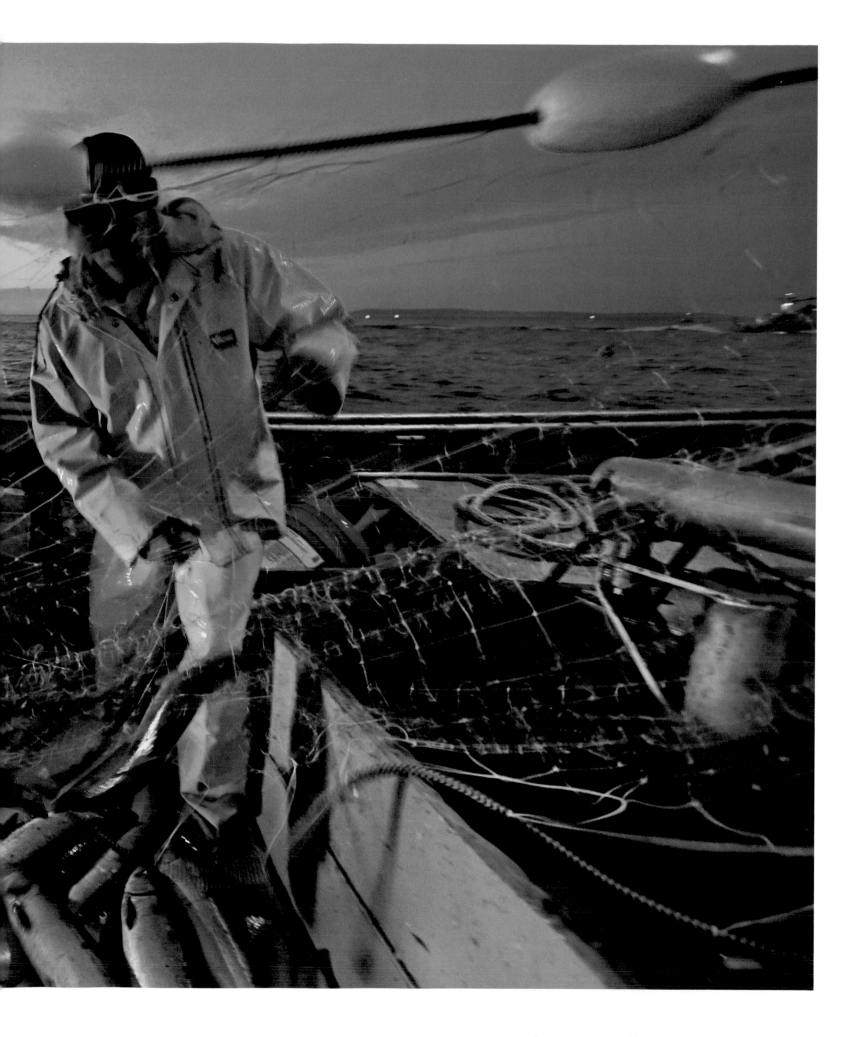

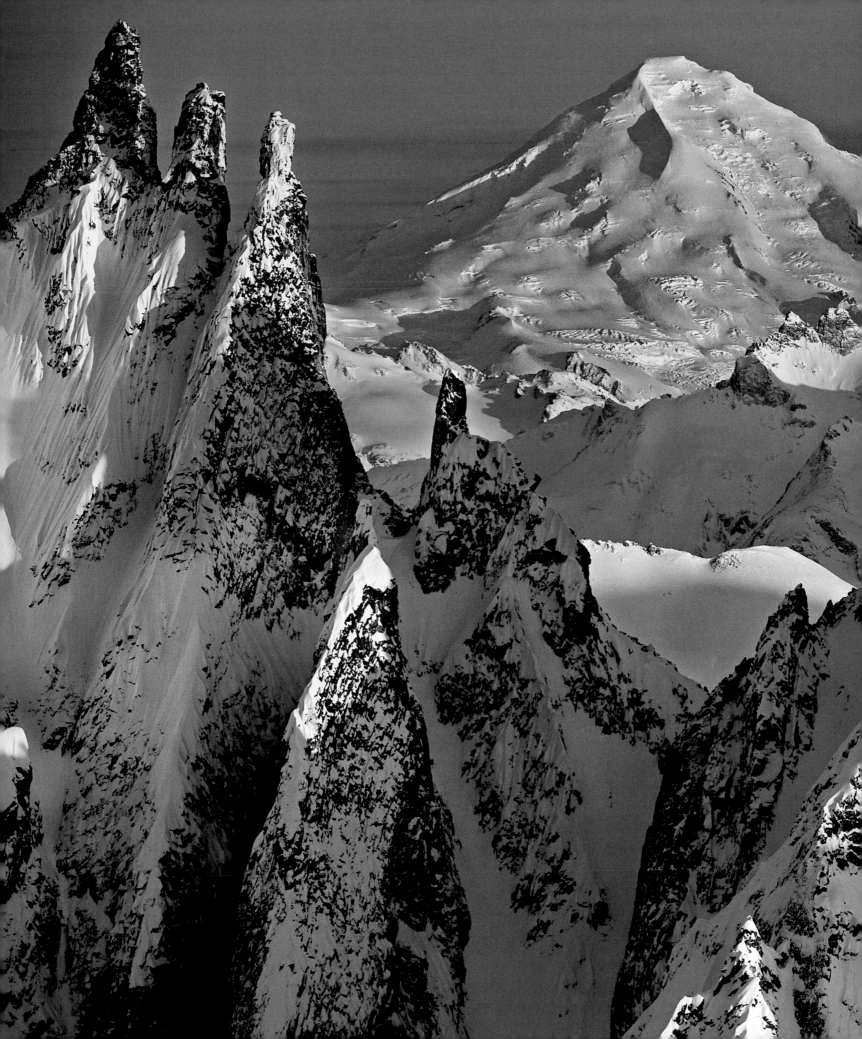

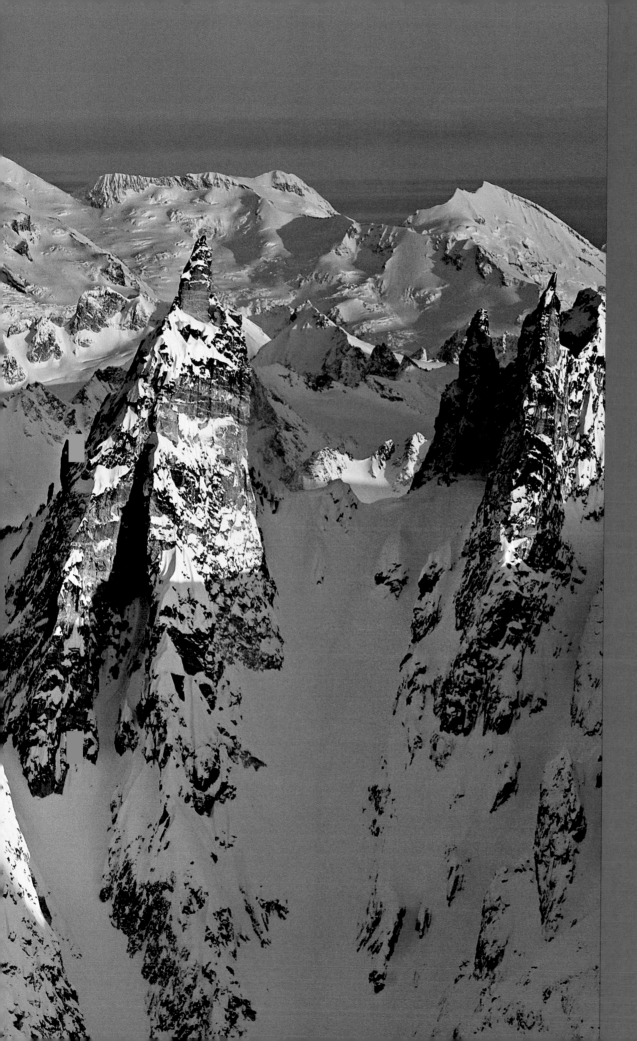

Wild at Heart

The setting sun illuminates
the Aleutian Range and Chigmit
Mountains in immense Lake Clark
National Park and Preserve—more
than four million acres in size.

Alaska

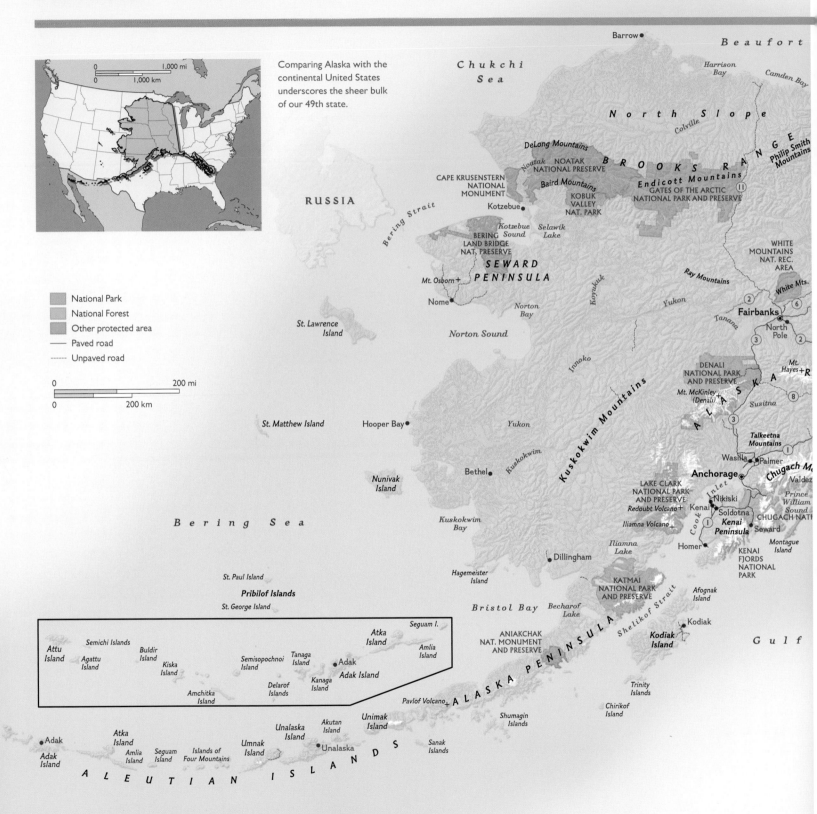

Comparing Alaska with the continental United States underscores the sheer bulk of our 49th state.

0 1,000 mi
0 1,000 km

RUSSIA

National Park
National Forest
Other protected area
Paved road
Unpaved road

0 200 mi
0 200 km

Barrow

Beaufort

Chukchi Sea

Harrison Bay

Camden Bay

North Slope

Colville

DeLong Mountains

Noatak

NOATAK NATIONAL PRESERVE

BROOKS RANGE

Philip Smith Mountains

CAPE KRUSENSTERN NATIONAL MONUMENT

Baird Mountains

Endicott Mountains

GATES OF THE ARCTIC NATIONAL PARK AND PRESERVE

KOBUK VALLEY NAT. PARK

11

Kotzebue

Bering Strait

Kotzebue Sound

Selawik Lake

BERING LAND BRIDGE NAT. PRESERVE

WHITE MOUNTAINS NAT. REC. AREA

SEWARD PENINSULA

Korukuk

Ray Mountains

White Mts.

Mt. Osborn +

Yukon

Fairbanks

2

6

Nome

Norton Bay

Tanana

North Pole

3

Norton Sound

Innoko

DENALI NATIONAL PARK AND PRESERVE

Mt. Hayes + R

St. Lawrence Island

8

Mt. McKinley + (Denali)

A L A S K A

Susitna

St. Matthew Island

Hooper Bay

Yukon

Talkeetna Mountains

1

Kuskokwim

Wasilla

Palmer

Chugach M

Kuskokwim Mountains

Bethel

Anchorage

Valdez

Nunivak Island

LAKE CLARK NATIONAL PARK AND PRESERVE

Cook Inlet

Nikiski

Prince William Sound

Redoubt Volcano +

Kenai

Soldotna

CHUGACH NAT.

Bering Sea

Kuskokwim Bay

Iliamna Volcano +

Kenai Peninsula

Seward

Homer

Dillingham

Iliamna Lake

KENAI FJORDS NATIONAL PARK

Montague Island

St. Paul Island

Hagemeister Island

KATMAI NATIONAL PARK AND PRESERVE

Afognak Island

Shelikof Strait

Pribilof Islands

Bristol Bay

Becharof Lake

St. George Island

Kodiak Island

Kodiak

Seguam I.

Atka Island

ANIAKCHAK NAT. MONUMENT AND PRESERVE

Gulf

Attu Island

Semichi Islands

Buldir Island

Semisopochnoi Island

Tanaga Island

Adak

Amlia Island

ALASKA PENINSULA

Agattu Island

Kiska Island

Adak Island

Kanaga Island

Trinity Islands

Amchitka Island

Delarof Islands

Pavlof Volcano +

Chirikof Island

Unimak Island

Shumagin Islands

Adak

Atka Island

Umnak Island

Unalaska Island

Akutan Island

Sanak Islands

Adak Island

Amlia Island

Seguam Island

Islands of Four Mountains

Unalaska

A L E U T I A N I S L A N D S

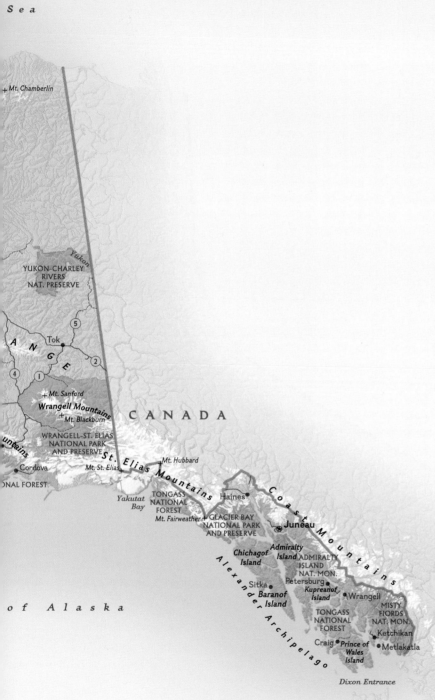

Sea

+Mt. Chamberlin

YUKON-CHARLEY
RIVERS
NAT. PRESERVE

Yukon

(5)

Tok

(2)

A

N

G

E

(4) (1)

+Mt. Sanford

Wrangell Mountains

+Mt. Blackburn

CANADA

WRANGELL-ST. ELIAS
NATIONAL PARK
AND PRESERVE

Cordova

St. Elias Mountains

Mt. St. Elias

Mt. Hubbard

NAL FOREST

Yakutat
Bay

TONGASS
NATIONAL
FOREST

Haines

Coast Mountains

Mt. Fairweather+ GLACIER BAY
NATIONAL PARK
AND PRESERVE

Juneau

Admiralty
Island ADMIRALTY
ISLAND
NAT. MON.

Chichagof
Island

Sitka Petersburg

Baranof
Island

Kupreanof
Island Wrangell

of Alaska

Alexander Archipelago

TONGASS
NATIONAL
FOREST

MISTY
FIORDS
NAT. MON.

Craig Prince of
Wales
Island

Ketchikan

Metlakatla

Dixon Entrance

W hat time do they feed the whales?" This would have been a reasonable question had it been asked by a visitor to SeaWorld. However, this question came from a woman aboard one of the Alaska Marine Highway ferries cruising up the Inside Passage in Southeast Alaska. The query was directed to the U.S. Forest Service employee who had been assigned to the ship to give short presentations about the natural world passing by the windows, including whales, which are often seen from the ferries. The gracious young man took the question in stride and did not make the woman feel foolish as he gently explained that, being wild, these whales forage for themselves.

And, truly, the woman was not being foolish, just ignorant, and she is not alone. Many park interpreters and outdoor guides report that they often field inquiries that reveal a deep lack of familiarity with nature's ways. These questions show that, in this age of urbanization and digitized life, many people live in a bubble of civilization.

Well, there's no better place to burst that bubble than Alaska.

Towering mountains that never have been named, ice fields the size of Delaware, wolves howling in the night, vast river deltas thronged with millions of migrating birds, thousand-pound grizzlies snatching 50-pound salmon out of the air as they leap upstream, supermarket-size hunks of ice splitting off tidewater glaciers and plunging into the sea, hundreds of thousands of caribou sweeping across the tundra—Alaska is one of the wildest expanses of land and water on the planet. Travelers may come from far away, from Boston, Berlin, or Beijing, but even then the geographical distance is not as great as the distance between their civilized lives and the uncivilized nature of Alaska.

Not that Alaska doesn't have pockets of development and culture; residents rightly bristle when their state is portrayed as unadulterated backcountry. They note their rich human history, dating all the way back to the first specimens of *Homo sapiens* to

Alaska Basics

1 **Highest Mountain** Mount McKinley, in the Alaska Range, Denali National Park and Preserve. At 20,320 feet, it's the tallest peak in North America.

2 **Longest River** The Yukon, 1,980 miles long. It originates over the Canadian border in Yukon and flows across Alaska to the Bering Sea.

3 **Coldest Temperature** Alaska's all-time low occurred on January 23, 1971, when the thermometer plunged to minus 80°F at Prospect Creek Camp, 20 miles north of the Arctic Circle in the Endicott Mountains.

4 **Largest Glacier** The Bering Glacier, which, combined with the ice field that feeds it, covers about 2,000 square miles, an area about the size of Delaware.

5 **Northernmost Point** Point Barrow juts into the Arctic Ocean about 9 miles northeast of the town of Barrow. Point Barrow is about 350 miles north of the Arctic Circle and about 1,300 miles south of the North Pole.

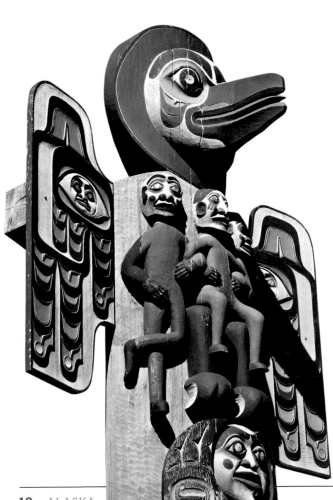

set foot on North America. They point out that they have art galleries, suburbs, tony restaurants, Air Force bases, Internet cafés, basketball tournaments, symphonies, universities, espresso stands, and many other features of modern life. Still, such oases of civilization are few; Alaska's population density is about a thousand times less than that of New Jersey.

The fact that very few people live in a very big state is the basic reason Alaska is so wild. How few people? Slightly more than 700,000—about 300,000 of whom live in Anchorage, the only city in Alaska that most Americans would call a city. To calculate the approximate populations of the state's second and third largest

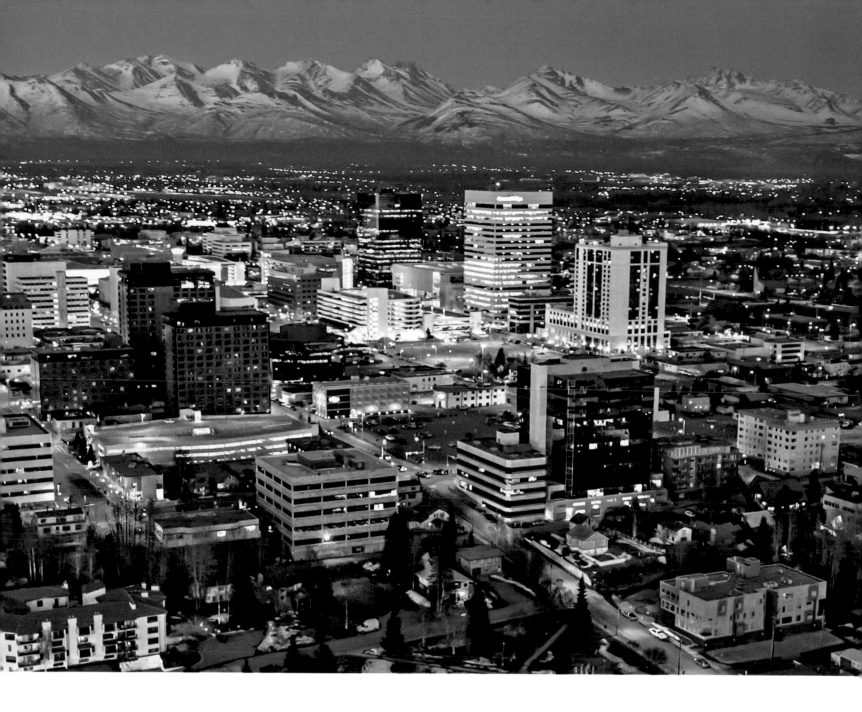

communities, Fairbanks and Juneau, knock a zero off the figure for Anchorage. Ask someone in California or Ohio about a municipality of 30,000 and that person will likely refer to it as a "town," not a city. Sitka, Alaska's fourth largest population center, if such a term is even appropriate, definitely would be referred to as a "town," given that it comes in under 9,000. According to the 2010 census, 176,846 more people live in metro Albuquerque than live in all of Alaska.

The wildlands of Alaska come in many shapes and sizes, as one would expect in a state that's larger than France, Germany, and Italy combined. The Alaska Department of Fish and Game divides this diversity into 32 "eco-regions." However, travelers can simplify this mass of scientific detail by lumping these divisions into three broad categories: coastal rain forest, boreal forest, and tundra.

With a population of some 300,000, Anchorage is home to nearly half the state's population and nearly all its skyscrapers. *Opposite:* Totem poles evoke the myths and traditional stories of Alaska natives, particularly those who live in Southeast Alaska.

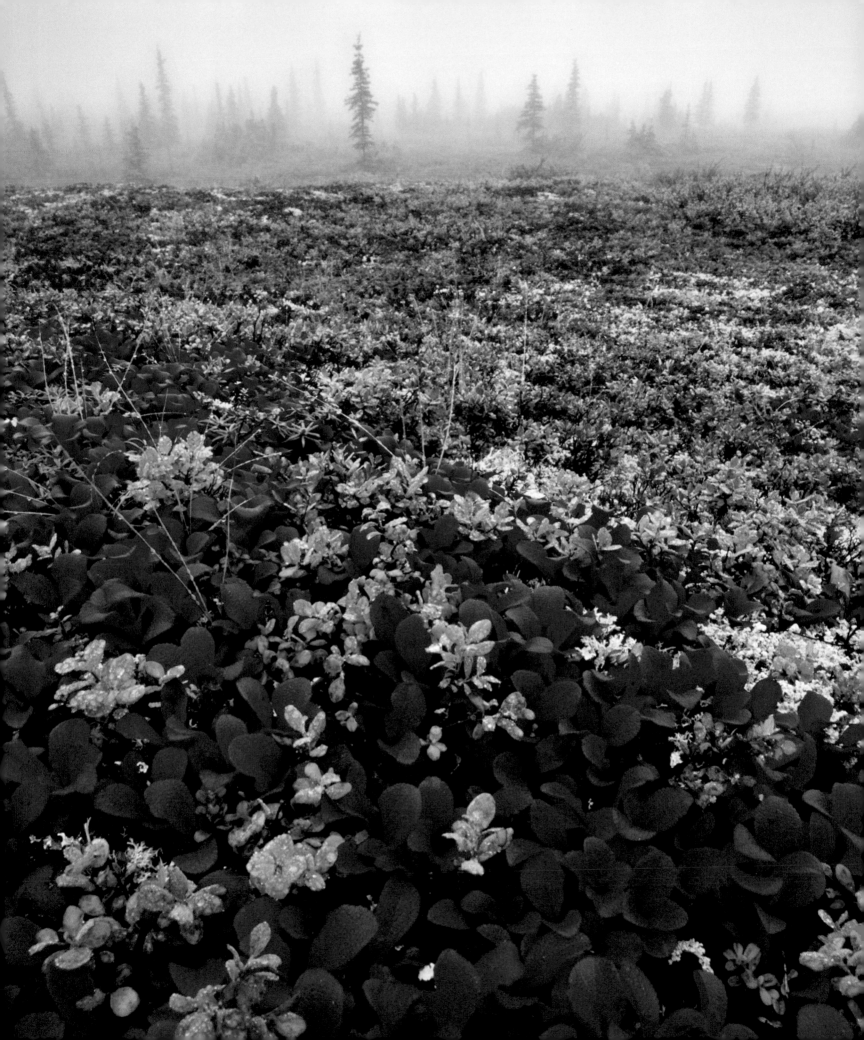

Coastal rain forest blankets Southeast Alaska, a narrow band of the south-central coast, and a small slice of the southwest coast. As its name makes plain, this region gets a lot of rain, well over 100 inches a year in many places. These downpours slake the thirst of a forest of hulking Sitka spruce and hemlock and a thick understory of salmonberry, devil's club, ferns, and hordes of other moisture-loving plants.

North of the coastal mountains and across the bulk of the interior, boreal forest dominates, as it does at these latitudes around the globe, notably in Canada and Russia. Worldwide, most people call this region the taiga, a term that, unlike "coastal rain forest," does not make plain the nature of the landscape—not unless one speaks Siberian. "Taiga" is a Siberian word meaning something like "marshy forest." But Alaskans prefer the more straightforward "boreal forest," so this book will follow their lead. The swathes of 80- and 100-foot spruce, birch, aspen, and balsam poplar in the southern parts of the boreal forest fit typical images of a conifer forest, though these are hardly the 250-foot Sitka spruce of the coastal rain forest. But as one heads north, the trees grow shorter until, finally, at the boreal forest's northern boundary, the forest has shrunk to a motley crew of spindly black spruce, as if a Christmas tree farm had been sprayed with herbicide.

North of those scraggly spruce lies tundra—the vast, mostly treeless, mostly flat expanse that runs to the shores of the Arctic Ocean. This is tough country. Ferociously cold in the winter, underlain by thin soils, and often scoured by high winds, the tundra forces plants to stay close to the ground, hanging on for dear life. In the harshest areas, they only grow a few inches high. Yet observant travelers who take the time to look closely at the tundra will discover a rich if diminutive plant community that makes the most of its demanding environment.

People, too, live in this demanding environment. They live in all the eco-regions. Not in great numbers, but they're out there in scattered villages like Eek (pop. 296), Chickaloon (pop. 272), Hope (pop. 192), and Ekwok (pop. 115). And those aren't the really little outposts. Consider Red Devil (pop. 23), Elfin Cove (pop. 20), Livengood (pop. 13), Coldfoot (pop. 10), and Hobart Bay, the smallest Alaska town counted in the 2010 census, with its roster of one, which means Hobart Bay is at least tied for the honor of being the smallest town in the world.

Opposite: In much of Alaska, the harsh climate makes it tough on trees, so ground-hugging tundra plants take over. *Right:* Caribou roam the boreal forest and tundra.

Largest National Parks

1 **Wrangell-St. Elias National Park and Preserve** Renowned for its lofty mountains and glaciers, this is the largest national park in the United States, at 13.2 million acres.

2 **Gates of the Arctic National Park and Preserve** All 8.5 million acres of the nation's northernmost national park lie north of the Arctic Circle.

3 **Denali National Park and Preserve** Alaska's most famous national park encompasses 6.1 million acres of diverse interior wildlands, ranging from low-lying braided rivers to the summit of the continent, Mount McKinley.

4 **Katmai National Park and Preserve** Known for its large contingent of hulking brown bears, Katmai's 4.1 million acres also feature mountains, glaciers, salmon runs, and 15 volcanoes, some of them active.

5 **Lake Clark National Park and Preserve** The fifth largest Alaska national park at four million acres, Lake Clark covers more ground than any other park in the United States outside of Alaska, which means that the country's five largest parks are all in the 49th state.

Most of these villages abide in the wilderness. Usually these are not designated wildernesses like a traveler would find in the other 49 states, though Alaska does contain more official wilderness than any other state. But most of Alaska is so undeveloped that even though a few people live in an area, it's still essentially wild, while most places not declared wilderness areas by Congress in the rest of the United States are farmed, mined, logged, dammed, grazed, subdivided, or otherwise developed to a degree that renders them less than wild.

The residents of these remote communities don't just live *in* the wilderness; they live *with* the wilderness. Sure, some buy canned corn and frozen pizza, but to a significant degree most of them also live off the land. They shoot moose, collect shellfish, catch salmon, trap hares, hunt walruses, and gather berries. However, unlike, say, the commercial hunters who nearly wiped out the sea otters, Alaska's subsistence hunters, fishers, and gatherers work at a much smaller scale.

Their impact usually is so light that they are even allowed to operate in portions of many public lands, including headliner places such as Denali National Park. Its full name, after all, is Denali National Park and Preserve—the phrase "and Preserve" shows up in the names of most of Alaska's national parks. The "preserve" sections of these parks are open to varying subsistence uses, as are some parts of the parks proper.

People who live off the land come to understand it well. They do this in part by slowing down, staying alert, and observing carefully. Visitors to Alaska, even those who aren't planning to hunt or fish, should take a cue from subsistence users. Travelers will never fully appreciate the wilderness if they barge around in a hurry, flitting from one site to another. They need to be patient, keeping a lookout from the railing of that ferry even if killer whales don't appear in the first ten minutes.

Once someone spots an animal, he should keep watching, see what it does, how it behaves. Don't follow the lead of "listers," for example—bird-watchers who only want to spot a species to mark it off their list. A lister might spy an arctic tern fluttering above a lake, add it to his life list of birds sighted, and then walk away. But if he had tarried, he might have noticed the tern's slender wings and aerodynamic body, which enable it to make the world's longest migration, basically Pole to Pole. He might have seen a male tern snatch a minnow from the lake, alight on the bordering sand, walk down to the shallows to rinse the fish, tote it back up the shore to his mate in their nest in the grass, and take over sitting on

Get Your Moose

"Getting your moose" is a fall ritual for many Alaskans who value this creature for its tasty meat and enormous palmate antlers. Hunters bag some 7,000 moose a year (which provide about 3.5 million pounds of usable meat), making moose the most popular big game animal in the state. The Alaska Department of Fish and Game website reminds inexperienced hunters that moose are huge; it's not uncommon for bulls to tip (more like crush) the scales at 1,500 pounds. Hence, an old saying: "Never kill a moose more than a mile from a vehicle," because successful hunters will have to pack out 400 to 700 pounds of meat.

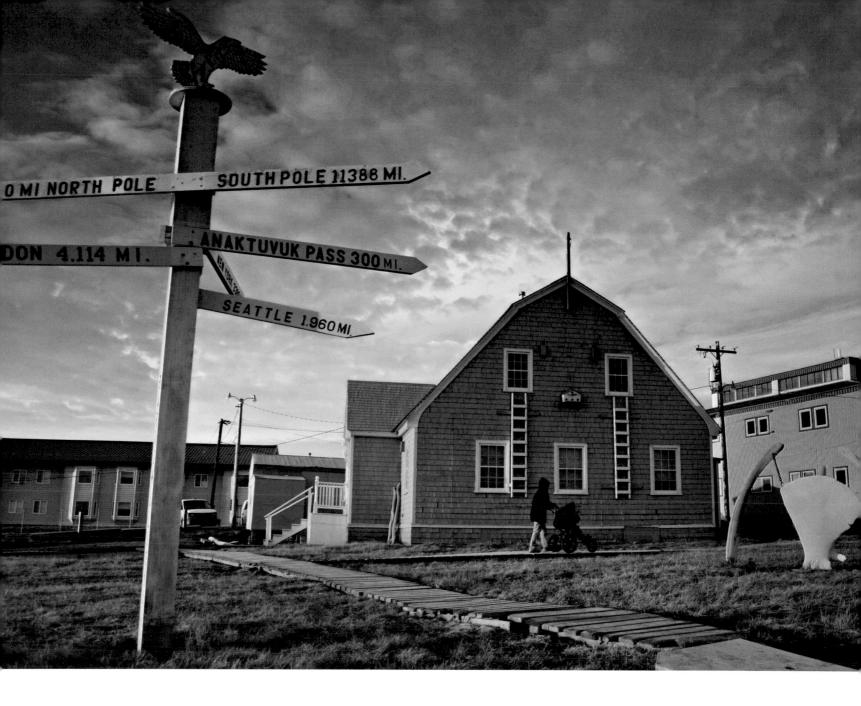

their eggs as his mate flew off to take her turn hunting. Would she return the favor? Only time—and patient observation—would tell.

In the age of virtual reality and Second Life, the value of being intimate with nature is incalculable. It always has been, though until the rise of industrial civilization, people were immersed in wildness and therefore unaware of it, like fish in the sea that don't think about the value of the water in which they're always swimming. But in recent years, more and more people have come to realize how vital wilderness is. As John Muir presciently wrote back in 1901, "Thousands of tired, nerve-shaken, over-civilized people are beginning to find out that going to the mountains is going home; that wildness is a necessity . . ." Muir also wrote, after traveling through Alaska, "To the lover of wilderness, Alaska is one of the most wonderful countries in the world." ■

Barrow is the northernmost town in the United States and, as the sign indicates, it's a long way from anywhere—except the North Pole.

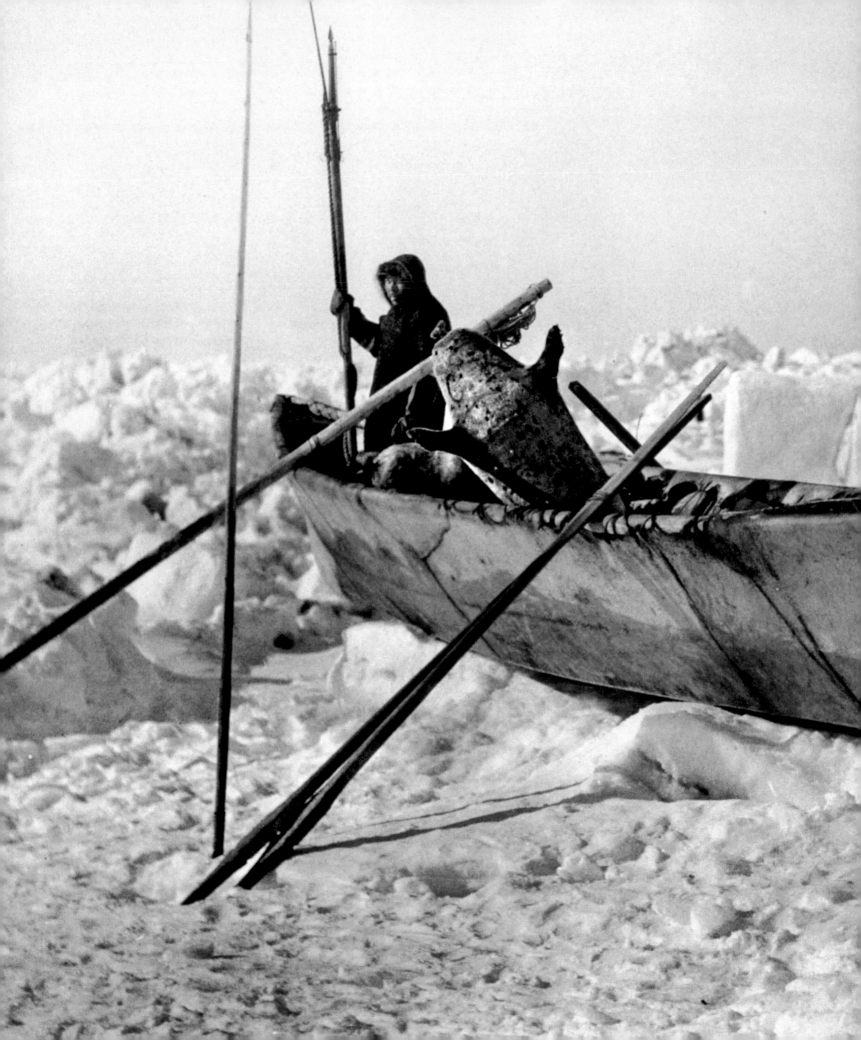

1] The Land & Its People

The Inupiat once regularly used gear such as this *umiak*—an animal skin–covered, wooden-framed boat—and sealskin float to hunt bowhead whales. Many still do on those hunts that are conducted in a traditional style.

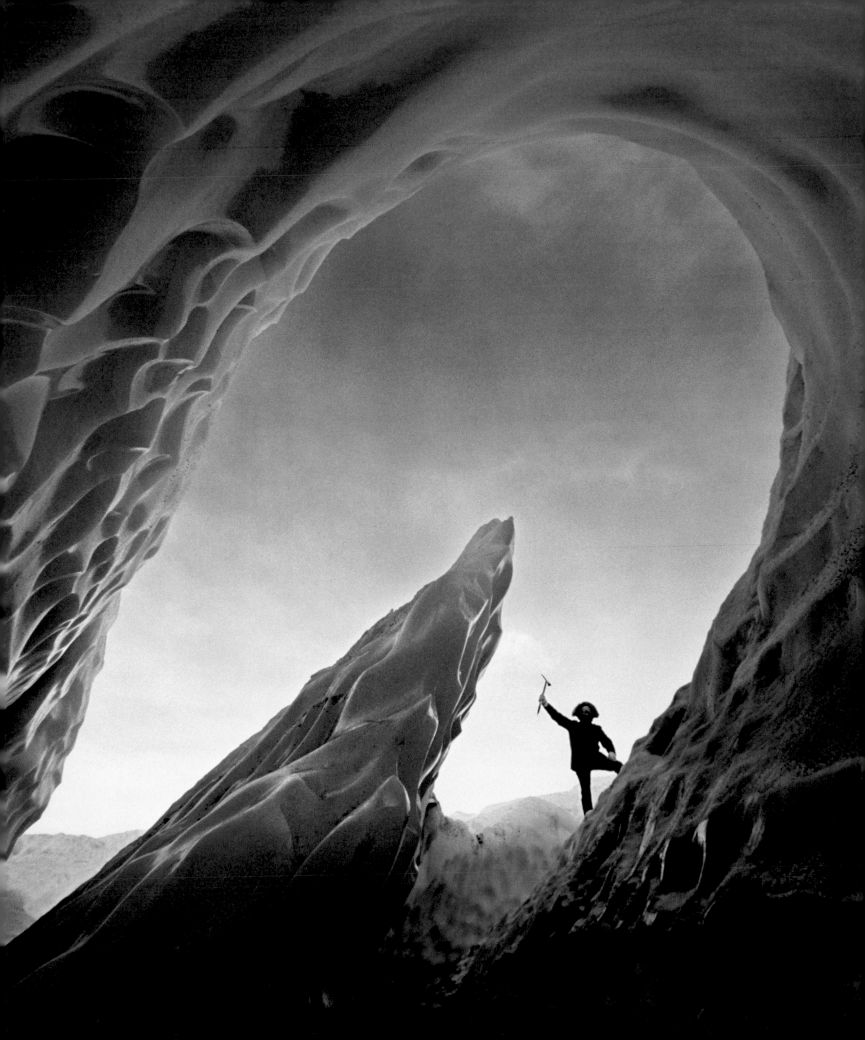

Mention Alaska to people who don't live there and most will respond with comments about bears, glaciers, cold weather, moose, mountains, the midnight sun, sea otters, forests, or some other aspect of nature. This is perfectly understandable. Alaska is by far the wildest state in the union and one of the wildest places on Earth. To people more accustomed to the blare of sirens than to the howls of wolves, the wild things are exotic and memorable. But Alaska has its human side, too. People arrived in Alaska before they went anywhere else in the Western Hemisphere. They have a long, rich history in the Great Land that deserves ample attention.

This chapter contains two sections, one on Alaska's natural history and one on its human history—a clear way in which to organize these features. However, as readers journey through the rest of the book, they will notice that there is no such separation between natural and human history in real life, that they mingle in fascinating ways, and that the vibrant interaction between people and the wild constitutes the essence of Alaska.

Natural History

By geological standards, Alaska is an adolescent. A husky adolescent, to be sure, but a mere youth all the same, with an active metabolism and more growth in its future. Far below the forests, rivers, and towns, floating on the semisolid mantle of the Earth, 60-mile-thick tectonic plates are on the move; the Pacific plate is drifting northeast into the North American plate. Because the Pacific plate is the denser of the two, it is sliding under the North American plate, causing the uplift that created many of Alaska's abundant mountains. And in places, that uplift is still going. As if it weren't already lofty enough, even Mount McKinley, the continent's highest summit at 20,320 feet, continues to slowly rise.

The motion of those subterranean plates is not always slow. Sometimes they slip suddenly and trigger earthquakes. Alaska has had more than its share of seismic activity over the years, but when residents of the state hear the word "earthquake," they immediately think of one particular event: the 1964 Good Friday quake. A magnitude 9.2 giant, it was the second most powerful earthquake in history. All over south-central Alaska, buildings crumpled, islands shifted position, streets folded up like drawbridges, docks collapsed into the sea, and tsunamis smashed into towns and villages.

A Central Yup'ik artist crafted this seal mask (above) out of wood, feathers, and wool. *Opposite:* A climber raises his ax in triumph near the opening of an ice cave in Matanuska Glacier in the Chugach Mountains.

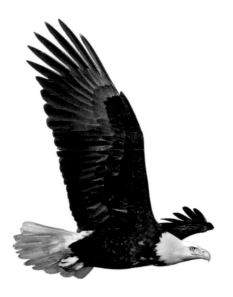

The subduction of the Pacific plate under the North American plate also has helped create an arc of volcanoes, called the Ring of Fire, that extends along almost the entire perimeter of the Pacific Ocean. This emphatically includes the Aleutian Islands and Alaska Peninsula, which feature scores of volcanoes, many of them active. It is not uncommon for some of them to blow off steam, maybe rumble a bit. Nor does one need to dig deep into the annals of history to encounter a major eruption; just over a century ago, the Novarupta volcano blew with an explosion that people heard from 1,000 miles away and that flung more ash and rock into the sky than any previous eruption in recorded history except perhaps for the Minoan eruption on the Greek island of Santorini some 3,600 years ago.

Highest Mountains

1 Mount Blackburn Situated in the midst of Wrangell-St. Elias National Park and Preserve, in south-central Alaska, Mount Blackburn stretches 16,390 feet into the sky. This makes it the fifth highest summit in Alaska, and thus the fifth highest in the United States, given that the 16 tallest peaks in the nation are all in the 49th state.

2 Mount Bona Number four on the tallest mountain chart, at 16,550 feet, Mount Bona presents onlookers with the sharp cone of a classic volcano; it is the highest volcano in the United States. Located in Wrangell-St. Elias National Park and Preserve, Mount Bona is covered with ice and is the main source for the 40-mile-long Klutlan Glacier.

3 Mount Foraker At 17,400 feet, Mount Foraker is the third highest mountain in the United States, which ought to earn it some serious respect. Alas, it lives in the shadow of Mount McKinley, almost literally—both lie in Denali National Park and Preserve, a mere 14 miles apart.

4 Mount St. Elias Topping out at 18,008 feet, Mount St. Elias is the second highest peak in the United States—and the second highest in Canada. It straddles the international boundary, partly in Wrangell-St. Elias National Park and Preserve and partly in Canada's Kluane National Park. Mount St. Elias rises very sharply behind Icy Bay and was spotted from the sea by Vitus Bering when he cruised by in 1741.

5 Mount McKinley Denali, the Athabaskan name for this mountain translates to "the Great One," and that is fitting for this broad-shouldered bruiser. Not only is Mount McKinley 20,320 high, making it by far the tallest mountain in the United States, but also its base-to-peak rise—how high it looms above the surrounding landscape—is the greatest of any mountain in the world, 6,000 feet greater than Mount Everest.

Though a lot more leisurely than earthquakes or volcanic eruptions, glaciation is another force of nature that shaped Alaska in the distant past and continues to shape it today. Glaciers and ice fields currently cover about 5 percent of the state, though that percentage is shrinking due to climate change. During the ice ages, glaciation extended to a much larger chunk of the state, but, counterintuitive to our thinking, the southern regions bore the brunt of the ice sheets while much of the interior and far north escaped the ice altogether.

Likewise, most contemporary glaciers exist in the south. There are two reasons: One, glaciers need enough moisture to continue to build up, which is no problem because this region gets huge amounts of precipitation as water-sodden storms blow in from the Gulf of Alaska. Two, glaciers thrive in sites that are below freezing most of the year, which means they usually originate in mountains because temperatures drop about 3.5°F for every 1,000-foot gain in elevation. That means the weather could be an almost balmy 60° at sea level on the southern Alaska shore and it would be 25° at 10,000 feet up in the high mountains characteristic of southern Alaska.

Some of these glaciers snake all the way down from the mountaintops to the sea, but they are icy interlopers in the lower, warmer elevations close to the coast, which are dominated by the deep green of temperate rain forest. Tropical rain forest gets most of the headlines, probably because it occupies about 75 times more of the planet than does its temperate cousin. But temperate rain forest, though it lacks the mind-boggling species diversity

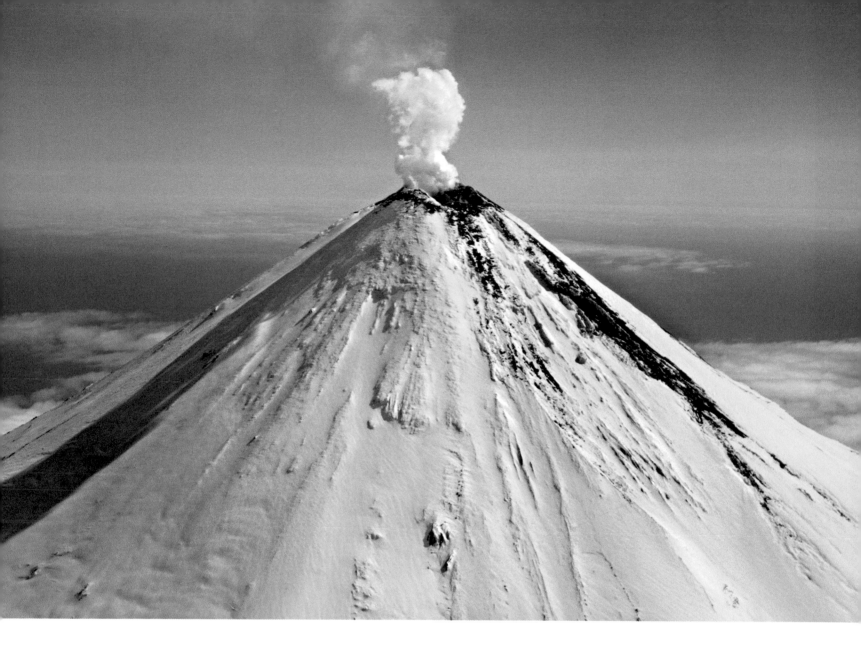

of its tropical counterpart, does rank as the most fertile ecosystem on Earth in terms of biomass.

Some of that mass takes the form of burly, 200-foot-tall trees, mostly spruce, hemlock, and cedar. In other places, the trees are smaller or absent, perhaps the result of a landslide or a major windstorm that knocked down the older trees. Beneath the canopy, plants seem to grow everywhere, starting with the limbs of the trees themselves, which sprout dense mats of mosses and a variety of small seedlings. Down on the ground sprawl fallen limbs and whole trees, their woody skeletons serving as nurse logs from which new trees and other vegetation grow, thriving on the stored nutrients and water. Bunchberries, devil's club, blueberries, and other shrubby plants further thicken the understory, while ferns, fungi, and mosses carpet the forest floor. All this adds up to huge amounts of organic matter, several times more than tropical rain forests can claim.

Though the temperate rain forest cannot match the biodiversity of the tropical rain forest—no ecosystem can—the rain forests of Alaska are no slouch in that department.

Rising 9,372 feet from the middle of the Aleutians' Unimak Island, Shishaldin Volcano presents viewers with one of the most perfect volcanic cones in the world. However, it's active, and that perfection may be blown to smithereens one of these days. *Opposite:* Bald eagles soar over much of Alaska, especially its southern coasts.

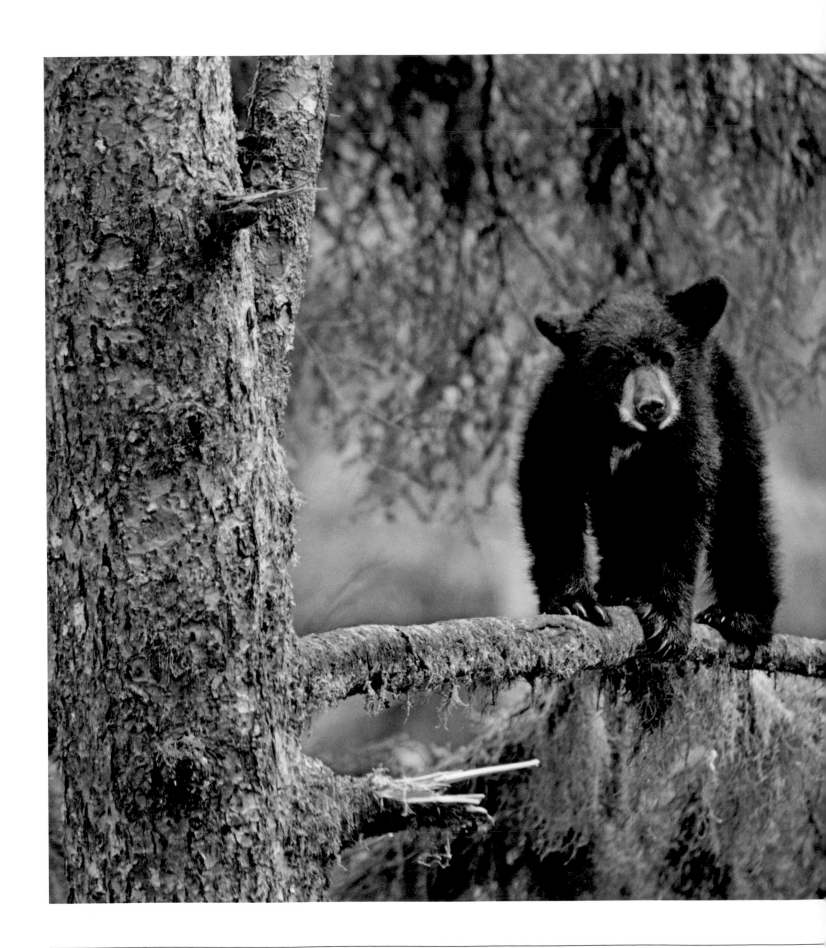

For example, when it comes to fungi, lichen, invertebrates, and soil organisms, temperate rain forests may equal or even surpass their tropical rivals. Granted, these species lack the charisma of a jaguar or scarlet macaw, but they're vital threads in the ecological tapestry. Besides, Alaska's temperate rain forest possesses its own impressive roster of A-list animals, such as wolves, bald eagles, Sitka black-tailed deer, black bears, goshawks, and

> **66 The beauty, wildness, and biological richness of Alaska are a gift not just to those of us who live here, but to all of humankind. 99**
>
> **[Richard Nelson, cultural anthropologist]**

beavers. And brown bears. Aka grizzlies, these furry behemoths are the Brad Pitts of the rain forest's A-list critters. Some 1,700 of them roam Admiralty Island in Southeast Alaska—the highest concentration of brown bears on the continent. Considering that a single beefy brown bear can weigh 1,000 pounds, that's a lot of biomass.

The abundance of brown bears on Admiralty Island and throughout Southeast Alaska's forests stems largely from the abundance of salmon. All five of the major Pacific salmon species spawn in the region. The Tongass National Forest, which encompasses most of Southeast Alaska's temperate rain forest, counts 17,000 miles of salmon habitat within its West Virginia–size boundaries. It may seem odd to place a species that spends most of its life in the ocean on the temperate rain forest's fauna chart, but in this neck of the woods, the relationship between the sea and the land is tight.

Salmon nourish the forest when they swim upstream to spawn. Along the way or after they spawn and die, their carcasses feed dozens of species of animals and untold numbers of the "little things that run the world," as renowned biologist and author E. O. Wilson once called the ants, insects, worms, and other invertebrates that contemporary society takes for

This black bear cub is one of the few bruins hanging out in the trees at Anan Creek. Most of the bears head for the creek to fish for salmon.

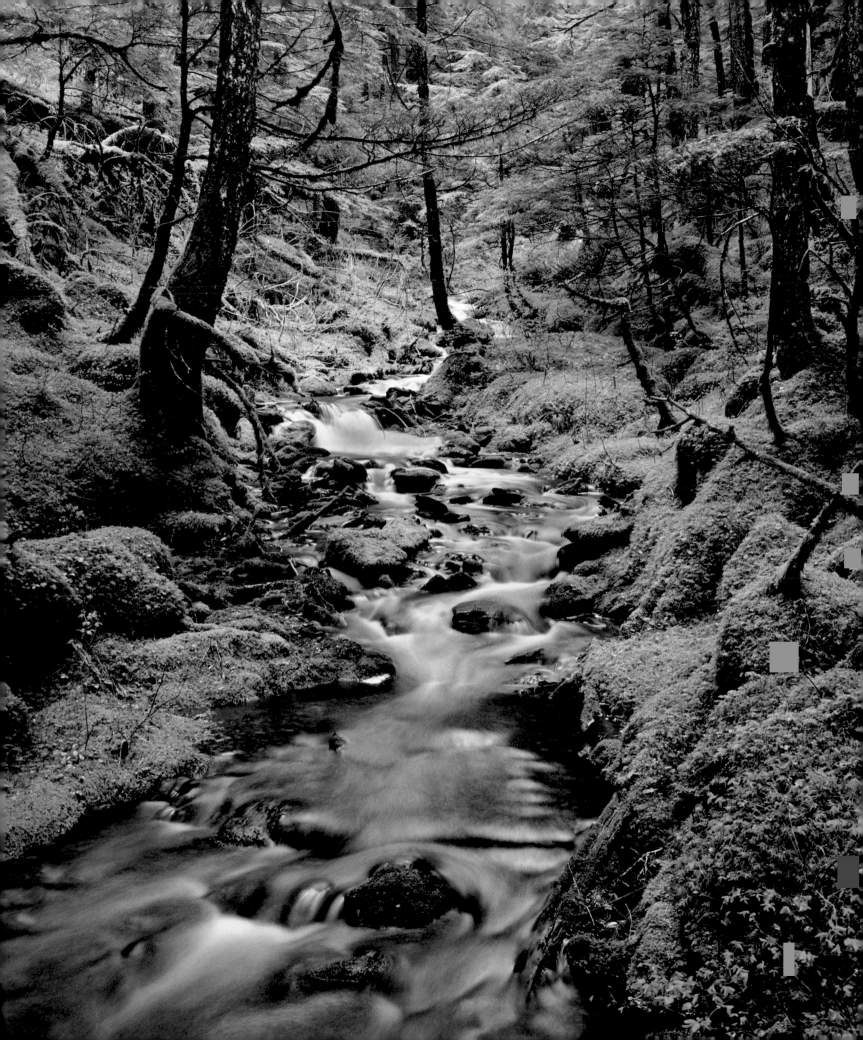

granted but shouldn't. Even plants get to enjoy a nice meal of salmon when bears and other predators carry the fish back into the forest to eat or when bears . . . well, when they do what bears famously do in the woods.

The forest returns the favor by nourishing the salmon, as well as other fish species, shellfish, migrating birds, and the countless invertebrates that use the streams, tidal flats, salt marshes, and estuaries of the rain forest. When trees fall into watercourses, the wood breaks down into dissolved nutrients and particulate organic matter, which add greatly to the productivity of these systems, which in turn helps these systems nurture young salmon and all those other creatures. Downed logs in the water also provide young salmon and other fish with shelter from osprey, eagles, and herons.

On a broader scale, that tight relationship between the sea and the forest is even more basic because the temperate rain forest wouldn't exist without the close presence of the ocean and its moisture. All those heavy gray clouds coming off the Gulf of Alaska start rising as they encounter the coastal mountains, and as they rise, they release all that rain, which, by definition, creates a rain forest. Just how much precipitation must fall annually for a place to qualify as a temperate rain forest is a matter of dispute, but 80 inches as a minimum constitutes a nice middle ground. Do the coastal forests of southeast and south-central Alaska reach this mark? One may as well ask if Usain Bolt can run the 100-meter race in less than 20 seconds. More than double that qualifying amount of rainfall drenches many sites in this part of Alaska; more than 200 inches a year is not unheard of. This harmonious blend of ocean, mountains, and rainfall is uncommon, which is why temperate rain forest is uncommon. However, the coasts of British Columbia and the Pacific Northwest enjoy similar conditions and temperate rain forest, making this verdant stretch from south-central Alaska to Oregon the largest contiguous temperate rain forest in the world.

Because Alaska's coastal ranges milk most of the precipitation from the incoming storms, a landscape quite different from the temperate rain forest lies north of the mountains. This is the boreal forest. Unlike temperate rain forest, the boreal forest is anything but uncommon. In fact, it is the most extensive terrestrial eco-region on Earth, extending across vast stretches of Alaska, Canada, and Russia. The boreal forest constitutes about 30 percent of the world's forestlands and covers about 20 percent of North America. In Alaska, the boreal forest spreads across most of the state's midsection—about 56 percent of Alaska's entire area. However, not all of this forest is forest; mountains are numerous, so one can add alpine tundra, bare rock, and ice to the mix.

One of the few amphibians in Alaska, wood frogs *(below)* manage to survive even in the Arctic because they can live for extended periods without breathing, with their hearts stopped, and with most of the body fluids frozen. *Opposite:* A creek meanders through the temperate rain forest along Eyak Lake, near Cordova.

Worthy Alaska Books

1 ***Call of the Wild*** This iconic 1903 novel by Jack London graces most every reading list about Alaska—despite the fact that it's not set in Alaska but in the Yukon during the Klondike gold rush. But the book belongs on such lists because that gold rush is so integral to Alaska history, and the sled dog story at the heart of the novel reflects the Alaska experience, too.

2 ***Coming Into the Country*** The classic nonfiction work by celebrated author and New Yorker staff writer John McPhee describes his travels in Alaska during the 1970s. It features his trademark detailed reportage and unassumingly insightful observations of the people and nature of the Great Land.

3 ***Makes Prayers to the Raven*** The subtitle of this 1986 literary nonfiction book, *A Koyukon View of the Northern Forest,* is apt. Rather than presenting his own views, cultural anthropologist Richard Nelson respectfully and meticulously conveys the perspectives of the Athabaskan villagers with whom he lived for a year. The book was made into a PBS series.

4 ***Ordinary Wolves*** This 2004 novel examines the tensions between the old ways of Alaska and modern America. Author Seth Kantner knows whereof he speaks. He was born and raised in the wilds of northwest Alaska, where he still lives a semisubsistence lifestyle, yet he is also well traveled and familiar with the outside world.

5 ***Raven Speaks*** This short book of poetry by Alaska native John Elvis Smelcer explores the raven myth. Allen Ginsberg wrote, "John Smelcer is among the most brilliant poets in recent American history." Smelcer has written dozens of books, ranging from novels to dictionaries of the Alutiiq and Ahtna languages; Smelcer himself, a member of the native village of Tazlina, is one of only a handful of native Ahtna speakers left.

Given the extent of Alaska's boreal forest, it's no surprise that even the forested landscapes within it vary considerably, from lush riparian bottomlands thick with willow, balsam poplar, and quaking aspen to higher and drier sites that are home to stands of both white and black spruce—some of them 60, 80, even 100 feet tall. That said, boreal forests share some basic characteristics. For example, they are cold in the winter. That may be stating the obvious, but those long, frigid winters probably do more to shape life in the boreal forest than any other single factor, largely because this is not bring-a-jacket cold but bring-a-spacesuit cold. Lows of 30°, 40°, and 50° below zero F are not rare. Unexpectedly, the summers are mild, even bring-shorts-and-sandals warm at times, though they are brief. Still, short as they are, the moderate summers exert considerable influence, enabling an outburst of plant and animal life that is unexpected in such a harsh climate.

Such cold winters evoke images of snow piled above the rooftops, but the boreal forest gets only modest precipitation, whether snow or rain—around 15 to 20 inches annually in most places, as little as 7 inches in some others. However, the snow does hang around for a long time—the boreal forest enjoys only about 50 to 130 frost-free days a year—so plants and animals have been forced to adapt to it. Such scant rainfall evokes images of near-desert landscapes, but, again, the reality runs contrary to expectations. Remember, "taiga," a synonym for boreal forest, is a Russian word describing a forest that is marshy, which strongly suggests the presence of water and, indeed, much of the boreal forest is sloppy wet. The topsoil is thin, and it is underlain by either continuous or patchy permafrost—permanently frozen soil—which drains poorly and leads to a lot of standing water. Such tough soil conditions evoke images of tough growing conditions, and in this case, those images do reflect reality. In much of the Alaska boreal forest, especially in the more northern areas, plants must fight to survive and they're typically much punier than their southern brethren. The black spruce that dominate these more challenging sites sometimes grow to heights of only 10 or 15 feet. Or maybe they reach 30 or 40 feet, but they're a scrawny 6 inches in diameter.

Then there's the "drunken forest"—the actual term used to describe this phenomenon. Boreal forest travelers will encounter many such clusters of trees, usually black spruce,

that no longer stand straight like soldiers at attention but instead tilt at all sorts of crazy angles like inebriated revelers reeling home from a party. Some of the trees lean so severely that they appear to have collapsed—revelers who didn't make it home—but usually they're still rooted and alive and may have been slanting that way for decades.

Drunken forests occur where permafrost has thawed. When the ice in the soil turns to water, the ground sinks and trees in the vicinity lean in toward the depression. The reasons for the thawing vary, but it doesn't take much, because in a lot of the boreal forest, a rise in ground temperature of just one or two degrees can make the permafrost start thawing. Even a disturbance as minor as a snowshoe hare trail can cause thawing because the hares' use of the path wears away the insulating surface vegetation.

Unfortunately, such natural disturbances are being overshadowed by the far greater unnatural disturbances of climate change. During the last 50 years, average temperatures in Alaska have risen about three degrees—much more than in the rest of the United States. Winter temperatures in Alaska have been climbing even more rapidly,

In parts of Alaska's interior, the boreal forest shrinks down to what locals call "drunken forest." Intense cold, poor soils, boggy conditions, and melting permafrost contribute to these landscapes populated by skinny spruce growing all askew.

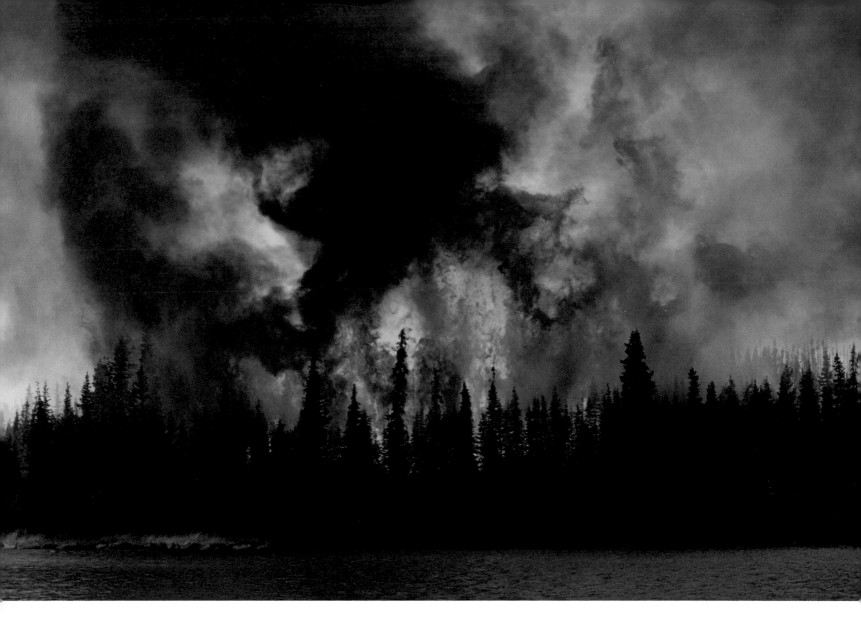

Wildfires, such as this one near Skilak Lake in the Kenai National Wildlife Refuge, are common in Alaska's boreal forest, especially as the state's temperatures rise due to climate change.

increasing almost six degrees in the last 50 years. This has caused widespread thawing of permafrost with consequences much more serious than drunken forests. In some places, buildings are sinking, roads are cracking, and shorelines are eroding more quickly as the formerly frozen ground softens. Most worrying, as permafrost thaws, it releases greenhouse gases. This creates a vicious circle in which the warming climate causes the permafrost to thaw and the thawing permafrost causes more warming.

A great deal of the boreal forest's carbon is stored in peat, aka peat moss, which is abundant in the bogs that cover a whopping 110 million acres of the Alaska boreal forest, an area some 50 times the size of Yellowstone. Peat is mostly dead sphagnum moss, mixed with other decaying vegetation. More than any other plant, sphagnum moss thrives in the acidic water of bogs, and it further consolidates its dominance by sopping up more nutrients than it can use, seemingly just so other plants cannot have them. Accordingly, huge mats of dead moss—peat—build up through the years, sometimes over thousands of years. Peat is quite flammable, so the wildfires that are becoming increasingly common in the forest burn the peat and release huge amounts

of carbon. Sometimes fires smolder deep in the peat all winter and erupt into flames again when summer comes around.

Inhospitable acidic waters and domineering sphagnum moss notwithstanding, other plants and animals—moose, for example—do manage to survive in the boreal forest's bogs. Other animals associated with bogs include olive-sided flycatchers, wood frogs, solitary sandpipers, dragonflies, and damselflies. Few plants can handle bogs, but travelers will see shrubs like bog blueberry and crowberry growing in loose mats, and numerous species of sedges, including the wonderfully named livid sedge. Carnivorous plants do well in bogs also, solving the problem of low-nutrient water by feeding on insects, of which there are famously plenty in the Alaska interior. One striking species is the northern pitcher plant, a bruiser that beckons prey with a gaping yellowish red leaf-mouth lined with downward-pointing hairs that trap flies and other insects foolish enough to enter. These pitcher plants even consume frogs and birds on occasion.

Climate change aside, the Alaska boreal forest remains largely pristine. It is among the increasingly few places on Earth that provides vast expanses of undeveloped habitat that can support a full suite of animals, including top predators, like wolves. The gray wolf is one of North America's iconic animals, but wolves in the lower 48 have been extirpated from most of their natural range. Alaska suffers no such shortage. Between 7,000 and 11,000 wolves roam the state, many of them in the boreal forest. Even with so many wolves on the prowl, travelers don't often see them because they're spread out over such a vast area and because they're stealthy. Visitors are more likely to hear their howls, which carry for miles.

The wolf population is robust largely because all that undeveloped boreal forest habitat supports an equally robust population of wolves' favored prey animals, such as caribou. Hundreds of thousands of Alaska's 750,000 caribou spend all or part of their time in the boreal forest. The state's caribou are divided into 32 herds, with herds being defined as groups that use distinct calving areas—herds often mingle on winter grazing grounds. The Beaver Mountains herd is the state's smallest, with some 70 individuals, and the Western Arctic herd is the largest, with about 325,000 members. Both call the boreal forest home, though the Western Arctic herd also uses the tundra in northwest Alaska.

Large herds need big, wild territories because they migrate as far as 400 miles between their summer and winter ranges; some people informally call them "wandering deer" due to their peripatetic ways. They're well equipped for long migrations,

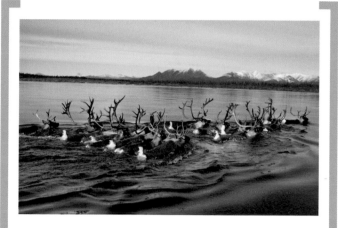

NATURAL WONDER

Cool Caribou

Caribou have many adaptations that allow them to weather the Arctic cold, such as hollow, insulating hairs, but these adaptations can make them overheat during the summer. To cool down—and to escape pesky biting insects—caribou often head for higher ground or remnant snowbanks.

possessing a special tendon that helps propel their feet forward, and big, concave hooves that spread out widely, enabling them to tramp through the snow almost as if wearing snowshoes. In addition, caribou have two large, crescent-shaped toes whose fleshy pads expand during the winter to create a hard, hornlike edge, giving them traction as they walk across ice and enabling them to better dig through crusty snow to find their staple food, a lichen known as reindeer moss. Caribou have adapted to the cold that comes with that snow and ice, too. For example, they have hollow guard hairs (the outer hairs) that give them extra insulation for those days of 40° below zero.

> " I hope the United States of America is not so rich that she can afford to let these wildernesses pass by, or so poor she cannot afford to keep them. "
>
> **[Margaret Murie, conservationist]**

Heading north in Alaska's interior, it is hard to tell just where the boreal forest ends and the tundra begins. It's not as if eco-regions are delineated by fences and customs checkpoints. One scientist uses an ingeniously simple standard: If the forest is dense enough that red squirrels can jump from treetop to treetop, it's boreal forest. If the squirrels must go down to the ground to scamper to the next tree, it's tundra. Another broad if less idiosyncratic standard is that the Brooks Range is the dividing line, with everything north of it being tundra.

Most of the tundra has no trees at all; a red squirrel set loose in the heart of the tundra might have to travel many miles to find a tree to climb. In hard-core tundra, the brutal cold, meager soil, ferocious winds, and short growing season make life impossible for trees—or, for that matter, impossible for any plant much higher than a caribou's knees. And even those ground-hugging species require special adaptations to survive.

The searching gaze of a gray wolf in Denali National Park will send caribou, moose, snowshoe hare, and other animals fleeing.

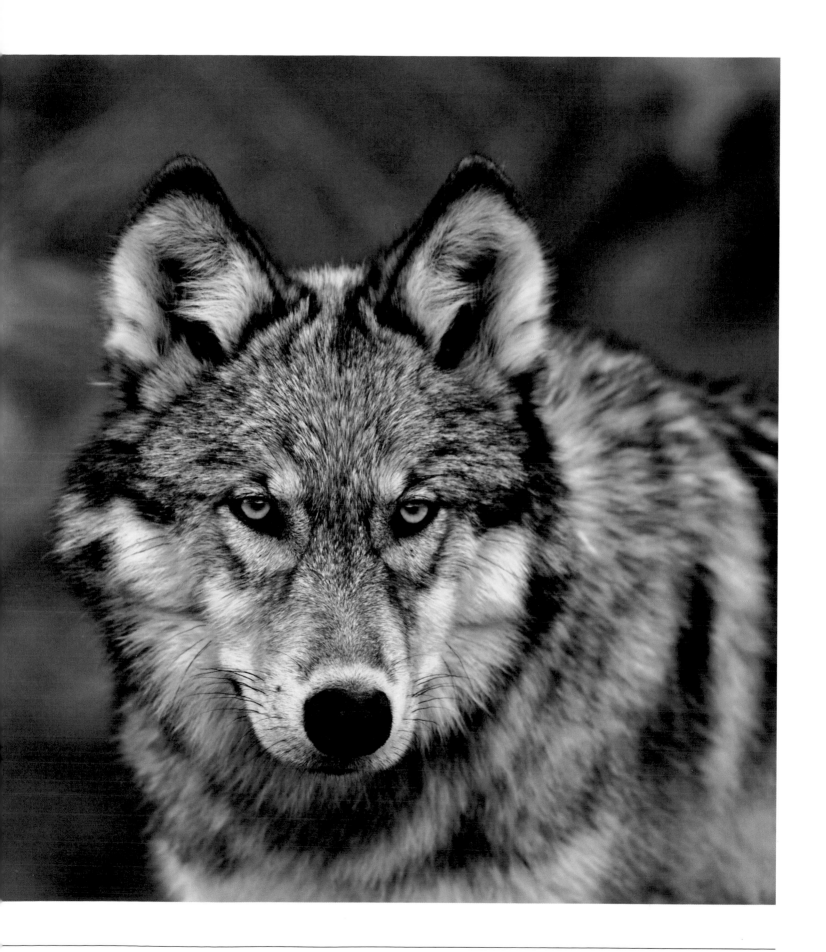

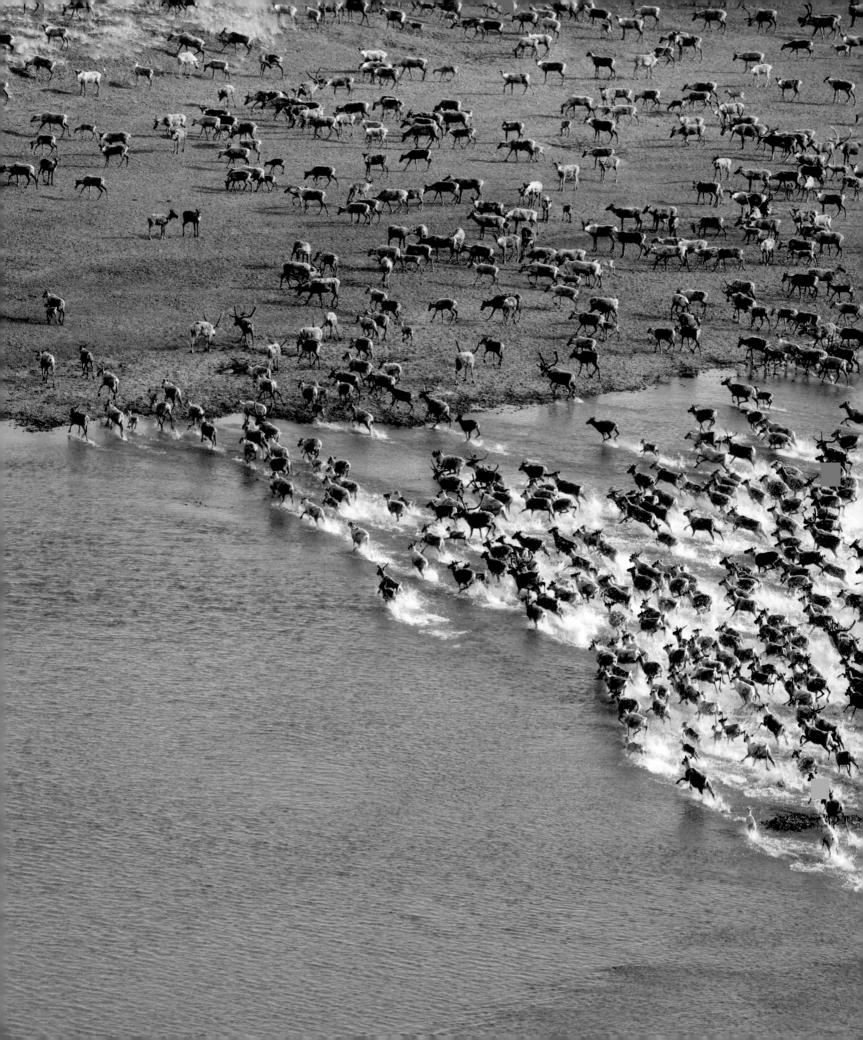

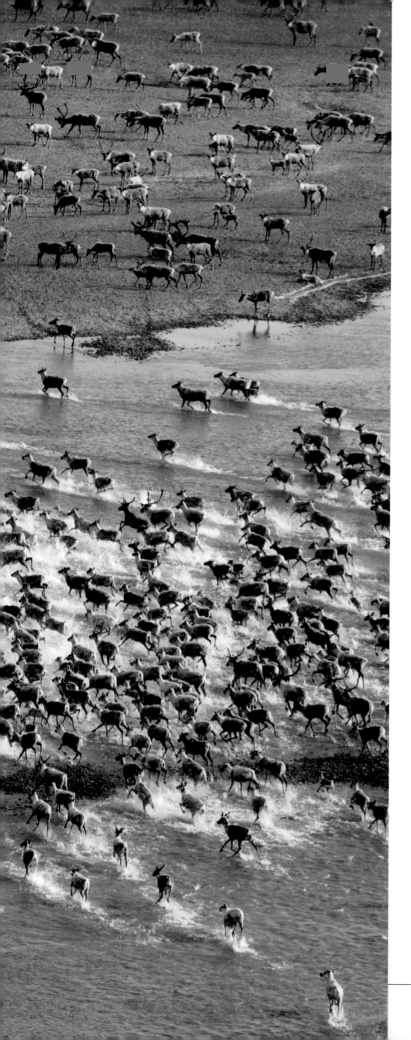

Some people call tundra "the land above the trees," but the word "above" can be misleading because it has two meanings in this context: higher altitude or higher latitude. At the lower latitudes of southern Alaska, tree line occurs between 2,000 and 3,000 feet above sea level. Beyond that elevation, the landscape grades into alpine tundra. (Just to underscore the influence of latitude, tree line in the Colorado Rockies is at about 11,000 feet.) But 500 miles to the north, tundra occurs at sea level, which means that tens of thousands of square miles of flat, low-elevation terrain in northern Alaska is tundra.

> **I looked up at the icebergs.**
> **They so embodied the land.**
> **Austere. Implacable.**
> **Harsh but not antagonistic.**
> **Creatures of pale light.** 99
>
> **[Barry Lopez, author]**

Considering that this expanse of non-alpine tundra lies north of the Arctic Circle, it comes as no shock that the climate is harsh and the winters very, very long and very, very cold. But it is surprising that summers, although brief, actually get fairly warm, nudging the thermometer up to 50 and 60 degrees. This unexpected balmy respite occurs largely because the sun doesn't set for a couple of months. Perhaps the tundra's most unexpected climatic feature is that it only receives a desertlike six to ten inches of precipitation annually.

One would think such scant precipitation would create a parched landscape, but ask anyone who has hiked across lowland tundra in the summer and he will tell you otherwise in no uncertain terms—or in certain terms that cannot be repeated in a family publication. In most places, lowland tundra is underlain by more than a thousand feet of permafrost, but in many areas, a sliver of the permafrost nearest the surface—perhaps between a couple of inches and a couple of feet—thaws during

Tens of thousands of caribou migrate through the Arctic National Wildlife Refuge. Strong swimmers, they cross many rivers during their journey.

the summer. Add this water to the snowmelt that doesn't drain due to the permafrost, and the result is a soggy world of bogs and shallow lakes. To add insult to injury—and "injury" is not metaphorical—much of the ground is mined with ankle-spraining hummocks of grasses and sedges. Whenever possible, hikers seek paths along the drier and less lumpy slopes of any hills in the vicinity. Or they give up and hire a helicopter to take them home.

Insects, on the other hand, love this wet summer muck. Not a wide diversity of insects, to be sure, but the select few that can survive the tundra winter reproduce with gusto in the warmer months and swarm across the tundra. Yet another reason for hikers to head for the hills, given that mosquitoes and blackflies are a prominent part of the insect mix. Migratory birds, however, are drawn to the insects and flock to the tundra by the millions to nest. The multitudes of flies, moths, butterflies, and mozzies, plus the summer explosion of new vegetation (even birds need their greens), provide a ready feast for dozens of species, mostly shorebirds and waterfowl, which have flown thousands of miles to reach this momentarily rich region. Between the two overflowing food sources, the migrants are able to gorge themselves and feed their young.

Bugs and birds are not the only animals that inhabit the Arctic tundra. Brown bears roam this spartan land. Huge caribou herds migrate through the region, munching on lichen. Slinky ermine glide through the brush in search of lemmings and voles. Small bands of musk oxen forage for roots, moss, and, in the summer, grasses and flowers. If threatened by, say, a pack of wolves, the musk oxen will circle the wagons, arranging themselves in a tight ring with their formidable horns facing out and their young sheltered in the middle of the circle.

One of the tundra's most popular denizens is the arctic fox, which looks more like a plush toy than a predator. Smaller than most fox species, it weighs a mere 6 to 12 pounds—about the size of a house cat. They appear larger, however, because they sport a luxurious, long-haired coat that protects them against the winter chill. The color of their coat changes from white to gray-blue, depending on the season, so they're always well camouflaged. Not that they always need camouflage to sneak up on their prey, for in addition to hunting rodents, they also eat berries, seaweed, insect larvae, and other menu items that won't run when they see a fox coming. The camo also serves to hide arctic foxes from bigger predators with a taste for plush toys, such as wolves and golden eagles.

The arctic fox roams the far north and far west of Alaska. The northern foxes tend to have brilliant white coats in winter, and the western ones sometimes have a bluish tinge. Some 4,000 are trapped each year; the sale of their pelts is an important source of income in many Alaska native villages.

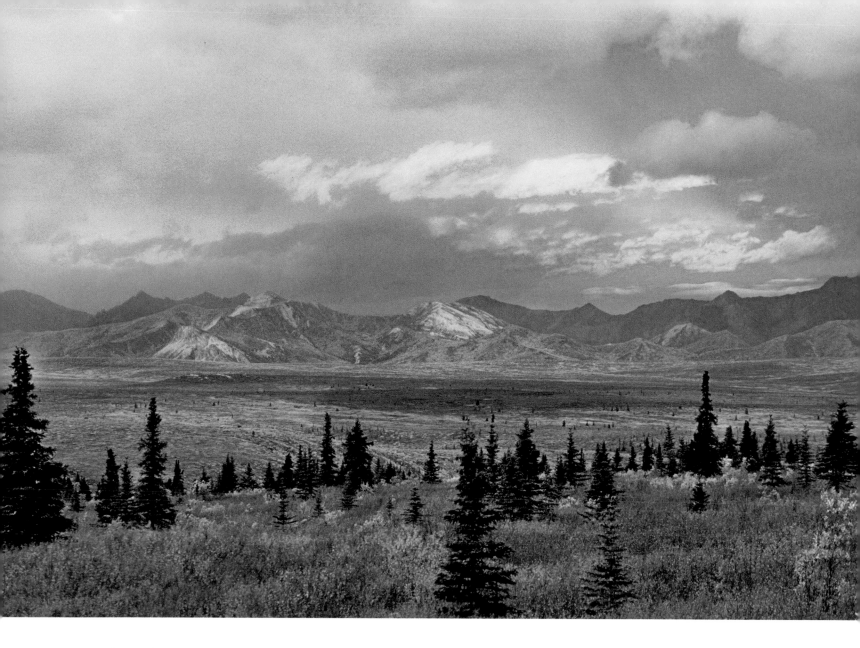

Wolves and eagles are not the only threats to arctic foxes. Climate change is warming the Arctic, making it possible for animal species that lack special cold-weather adaptations to expand northward. One such species is the red fox, which has moved up from the boreal forest into some of the southern portions of the tundra. Red foxes are now competing for food and territory with arctic foxes; how that will play out remains to be seen, but red foxes are larger and able to dominate their smaller kin, so the competition doesn't bode well for the arctic fox.

Climate change may harm arctic foxes in other ways, too. For example, the ongoing loss of sea ice in the Arctic Ocean causes problems. Usually arctic foxes mostly eat lemmings, but in times when lemming populations crash, the foxes used to spend lots of time foraging out on the ocean's pack ice. Often, they would follow polar bears and scavenge their kills. But now the pack ice is melting and it's not always there as a backup feeding ground for the foxes. Of course, those polar bears are the most famous victims of vanishing sea ice; it's their primary habitat.

In many sections of Denali National Park, this is the kind of landscape that greets hikers and backpackers: wide-open tundra, mountains in the background, and no trails to guide—or confine—one's rambles.

Human History

The west coast of Alaska is the first place in North America to feel the footstep of a human being. At least, that's the prevailing theory, though there is some scientific debate on the matter. But researchers are quite sure that somewhere between 10,000 and 30,000 years ago—give or take a few millennia—people from Siberia walked across what is now the Bering Sea to Alaska, a distance of only 56 miles at its shortest point. And they did not walk on water. Ice age glaciers and ice sheets bound up so much water that sea level fell hundreds of feet, exposing much of what had been the ocean floor and creating the Bering land bridge.

> **❝ Kids in Alaska don't know they're growing up on the Last Frontier. It's just what they see on the license plates. ❞**
>
> **[Tom Bodett, humorist & author]**

But the word "bridge" evokes the wrong image, because this was hardly a single span leading from one place across to another. When the shallow sea dried up, it uncovered tens of thousands of square miles of former seafloor; the land connection between Siberia and Alaska was a thousand miles wide at times. Sea level probably rose and fell more than once during that 20,000-year stretch, altering the extent of the connection, but a significant amount of the land bridge was likely exposed for thousands of years.

Because the land was exposed for so long, the word "migration," which is often used to describe this prehistoric movement of people across the land bridge, also evokes the wrong image. "Migration" implies that those ancient Siberians headed out to what is now North America with the intent of moving there, but it's not like they had a map and had chosen a destination. Over time, the new terra firma of the Bering land bridge became a grassy plain. Mammoths, musk oxen, bison, and other animals hunted by the prehistoric Siberians spread onto

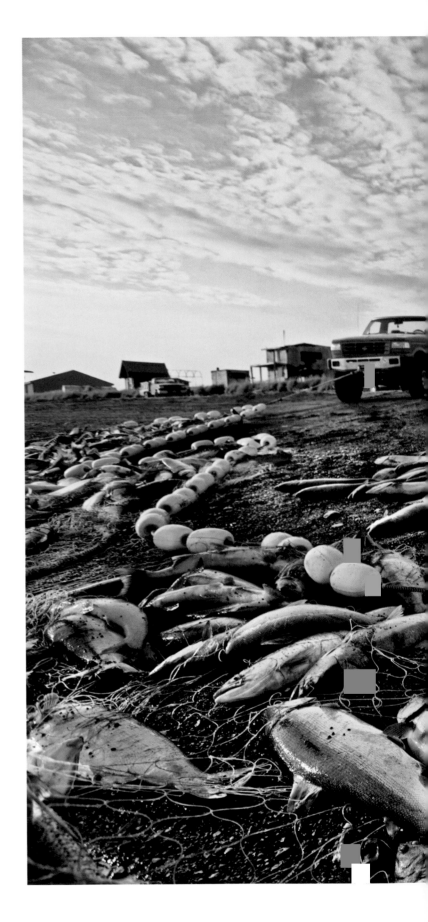

A fisherwoman expresses her gratitude and respect for the sockeye salmon she has netted in Bristol Bay, the world's most prolific sockeye fishery.

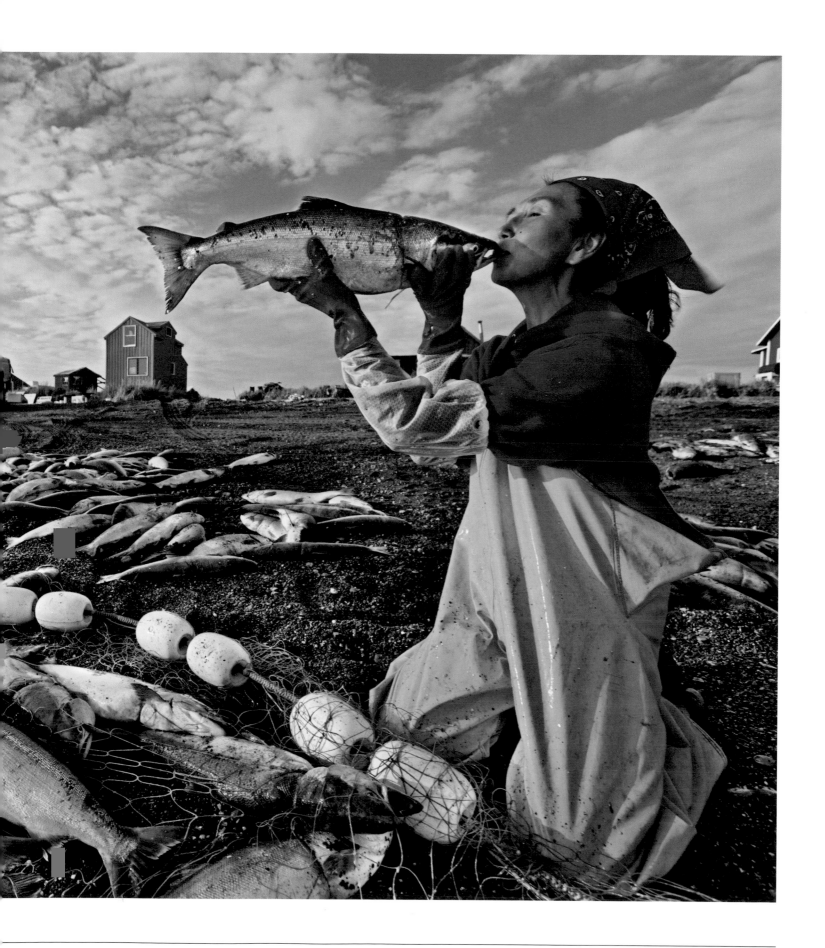

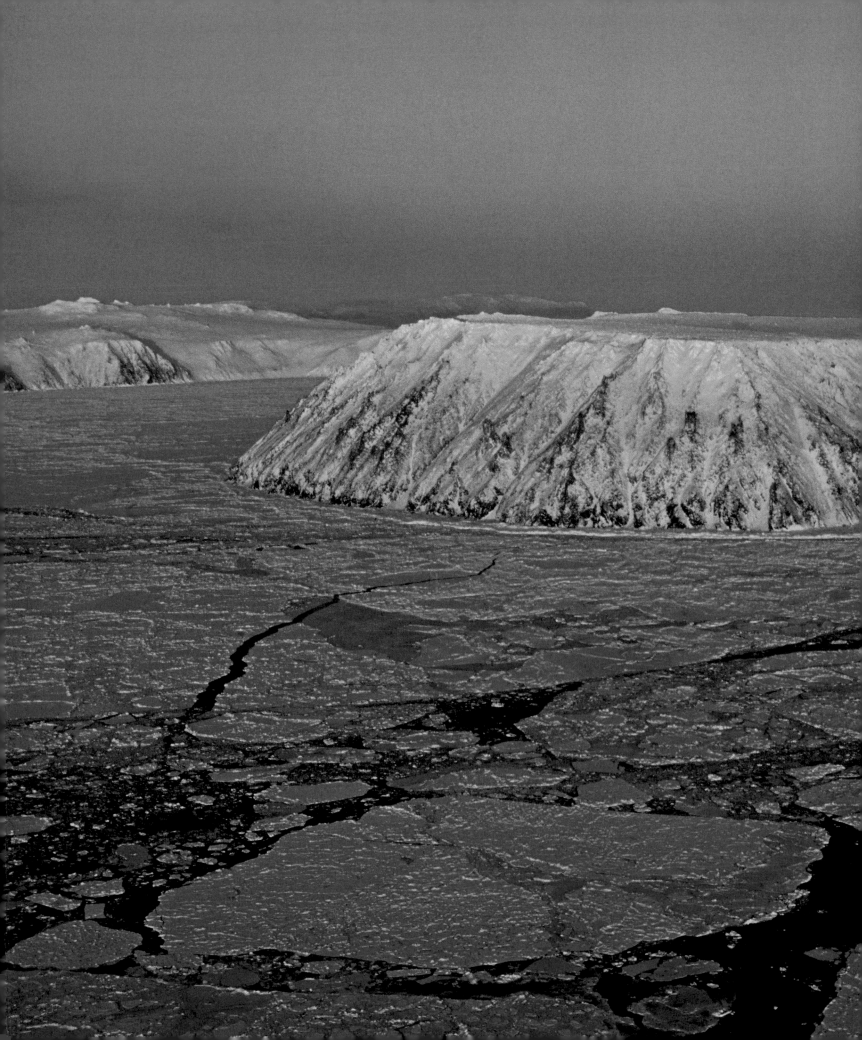

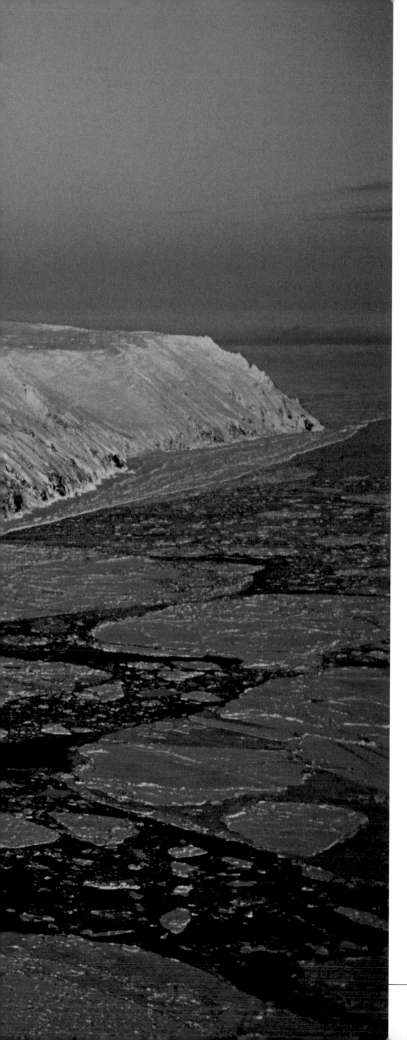

that plain—to them, it was just another place to graze. And to those Siberians, it was just another place to hunt, and to live, and over time their nomadic existence led some of them to what is now Alaska. These ancient Siberians would have felt at home in Alaska because the environment and climates of the two regions shared and still share many traits—so many that some scholars refer to Alaska, a slice of far western Canada, a one-thousand-mile-wide chunk of far eastern Siberia, and the seas between them as a unified region called Beringia.

When the ice sheets and glaciers melted, and sea level rose and the Bering Sea became a sea once more, various bands of Siberians (well, former Siberians) were living on the North American side of the water and had unwittingly become the first Alaskans and North Americans. The final reappearance of the Bering Sea did not entirely break the bonds between the people separated by the water, however. They shared genes, languages, and traditions that remained similar in some ways down through the ages. The ties between the two continents became even closer in recent centuries as these peoples with common ancestors, particularly the Yupik, regularly visited and traded with each other, interactions that sometimes even led to marriages between residents of the different continents.

The unrestrained travel back and forth came to an end during the Cold War. In the early years of the Soviet Union, the backwater border between Alaska and Siberia was largely ignored and intercontinental visiting went on as usual. However, in

Little Diomede Island, in the foreground, lies in the United States, and Big Diomede, in the background, lies in Russia. Only a couple of miles separate them.

the 1930s, U.S.–Soviet relations in the area started getting frosty, particularly when a Jesuit missionary, Father Tom Cunningham, made a habit of sneaking across from Little Diomede Island (on the U.S. side) three miles to Big Diomede Island (Soviet Union) to do a little proselytizing. However, it wasn't until 1948 that the so-called "Ice Curtain" came down with a resounding thud. On the American side, J. Edgar Hoover and other purveyors of the Red Scare called for the border to be closed. On the Soviet side, the Stalin regime likewise decided that the open boundary made them vulnerable and said nyet to unregulated travel. The locals discovered just how serious the Soviets were when, in 1948, a group of Alaska Yupik from Little Diomede jumped into their umiaks (traditional boats made of wood and animal skin) and headed over to Big Diomede only to be greeted by Soviet soldiers instead of their Siberian Yupik relatives. The Alaskans were held captive for almost two months and then sent back with a stern warning never to return.

For four decades, the border remained closed except for a handful of exceptions. Once the Soviets allowed a French windsurfer to sail 65 miles from the village of Wales, on the Alaska mainland, to East Cape, Siberia. Another time, they let a woman from Los Angeles swim from Little Diomede to Big Diomede; they even ceremoniously greeted her with a waiter in a tuxedo, a table set with china and silver, and a very welcome hot beverage. But aside from such anomalies, the border remained largely impervious until the Soviet Union broke up in the late 1980s and the Ice Curtain began thawing.

During the thousands of years after they strolled over from Asia, the earliest North Americans dispersed through Alaska and on across the hemisphere. Researchers continue to debate whether these people spread overland via ice-free corridors or along the coast in boats or both, but spread they did. Scholars also debate whether some of this first wave of arrivals remained in Alaska or whether they all went south to other parts of the Americas and lived there for millennia while developing into various cultural groups, some of which later traveled north to repopulate Alaska. Scientists do know that ancestors of today's Alaska natives have inhabited the state for at least thousands of years, and perhaps tens of thousands.

By the 18th century, these original Alaskans had separated into a rich diversity of cultural and linguistic groups, some settling into permanent communities, some sticking to nomadic lifestyles. Over time, they developed sophisticated methods of making a living from the land by catching salmon, gathering plants, and hunting caribou, seals, moose, whales, and many other animals. Their cultures likewise grew more sophisticated and the arts flourished, including intricate basket weaving, ivory and stone sculpting, dancing, totem pole carving, elaborate mask fashioning, and storytelling. This was the society the Europeans encountered when they first made contact.

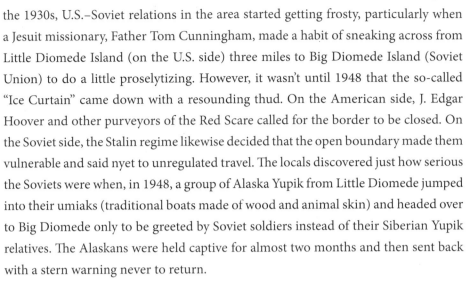

These traditional Alaska native men's boots feature sealskin bottoms and reindeer-skin uppers. They're decorated with seal intestine, dyed dog hair, and wolverine fur. Not surprisingly, they were reserved for special occasions.

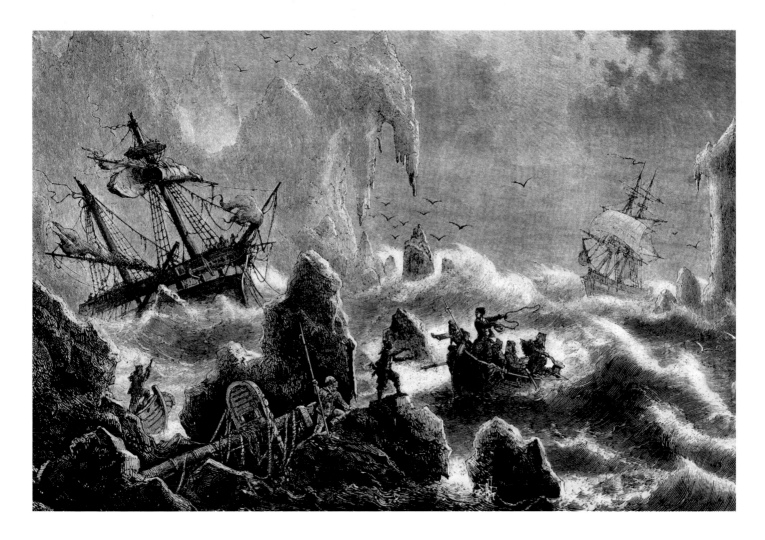

Great Britain, France, Spain, Germany, Portugal, Belgium, the Netherlands—these and other European powers had carved up most of the world into colonies by the 18th century, including nearly all of North America. But they missed a spot, if one can call the enormous northwest corner of the continent, including what is now Alaska, a spot. The Europeans also were constantly warring with one another, which may have distracted them from filling in that big blank spot on their maps.

But Peter the Great, the tsar of Russia in the early 18th century, noticed that blank spot at the edge of North America and wanted to determine if there was a land connection between it and Siberia. (Not a crazy idea, but about 10,000 years too late.) In 1724, the year before he died, Peter the Great commissioned a Danish-born officer of the Russian navy, Vitus Bering, to sail east from Siberia to explore the area. Wretched weather hobbled the voyage and it failed to accomplish much, but the seed had been planted, and in the ensuing years, Bering lobbied the Russian government to mount another expedition, which it finally did in 1741.

On June 4, 1741, two Russian ships sailed east from Siberia, one commanded by Bering. Once again, foul weather struck and the ships got separated, but Bering pressed

This fanciful painting depicts the tumultuous seas Vitus Bering and his crew encountered as they explored the Aleutian Islands in 1741. But the painting is only somewhat fanciful. What is now named the Bering Sea is indeed a dangerous place; Bering himself died on an island there in 1741, after being shipwrecked.

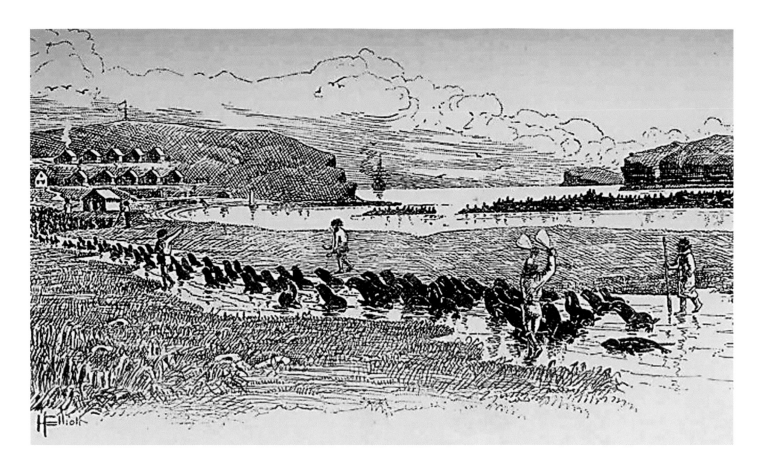

A 19th-century drawing *(top)* shows the inhabitants of St. Paul, one of the Pribilof Islands, driving northern fur seals to the killing grounds. Today's locals still harvest some of the nearly one million fur seals that flock to St. Paul. *Above:* The "Aleutian Islands" patch is a World War II U.S. Army insignia. *Opposite:* The Inupiat woman who won the Miss Arctic Circle title in 1955

on and eventually ran into the southern coast of Alaska and the Aleutians. Suffering from scurvy and worried about his ship, Bering and his crew set sail back to Russia in the fall but didn't make it; they shipwrecked on an island near the Kamchatka Peninsula. Bering and much of the crew died on the island, but a few straggled back to Siberia, where they told their compatriots of opportunities in Alaska to score some nice pelts. At first blush, this hardly ranks with explorers' tales of El Dorado or the fountain of youth, but first impressions can be misleading. For one thing, those stories about pelts were true. For another, primary among the animals whose pelts were being sought were sea otters, which wealthy customers, especially among the Chinese, prized above all others due to the unmatched warmth of the fur. A workingman would have had to save all his pay for three years to buy a single sea otter pelt.

That kind of payoff sometimes brings out the worst in people, and so it was with some of the first Russians who headed to Alaska to load up on sea otter pelts in the early 1740s. Known as the *promyshlenniki*, these trappers, traders, and sailors swept into the Aleutian Islands and other parts of Alaska like a plague. Their modus operandi was to use their guns and sheer brutality to take over native villages and then hold the women and children hostage to force the men to go out and hunt sea otters for the traders. The Unangan (aka "Aleuts") and others fought back but, with the exception of the Tlingit in Southeast Alaska, they were outgunned and often outnumbered,

and they were unable to repel the cruel invaders. For decades, some natives lived like slaves and were murdered, raped, and starved by these fortune hunters. Fortunately, a few years after the arrival of the promyshlenniki, other, less barbarous Russians also journeyed to Alaska and set up fur-trading operations.

In the 1770s, non-Russian European explorers came onto the scene, sailing into Alaska waters looking for pelts and for the Northwest Passage (a navigable waterway connecting the Atlantic and Pacific Oceans). The storied English seafarer Captain James Cook and his crew joined the long list of expeditions that tried and failed to find the fabled Northwest Passage. (They failed because no such passage existed at the time. Now, however, due to climate change, the Northwest Passage is navigable in some years for ships strengthened to withstand ice, and in a few decades, it will probably be open for a while every year to ordinary ships.) This futile quest is what brought Cook and company to the west coast of Alaska in 1778. Accounts of Cook's meanderings are somewhat unclear, as he sailed hither and yon, probing all sorts of inlets and bays to see if they led to the Atlantic. But historians know that he ranged widely, probably from Southeast Alaska all the way past Icy Cape, well into the Arctic Ocean. At that extreme northerly point, the expedition apparently encountered pack ice moving south at the rate of a mile and a half an hour, so Cook decided to move south even faster. He did pause briefly the following day, however, when he came across a herd of walruses on an iceberg. Some were killed for food, but the crew thought the "disgustful" walrus meat tasted like train oil and refused to eat it.

Sailors from the newly minted nation of the United States of America also joined in the quest to make a profit in Alaska. During the late 1840s, many of them set their sights on a non-furbearing species: the whale. In particular, they targeted the abundant bowhead whales that swam the Bering Sea and Arctic Ocean. Bowheads are big, slow, and contain plenty of the whale oil and baleen. (Baleen is the comblike structure through which bowheads and some other whale species filter food out of seawater. It is made of keratin, just like human fingernails, and is strong, light, and flexible.) Consumers wanted the oil for their lamps and as a lubricant, and the baleen for such products as hoop skirts and buggy whips.

The Parka

The parkas fashioned by the natives of western and northern Alaska are among the most practical and beautiful garments ever made. These days, most natives wear contemporary clothing, but some still wear traditional parkas, especially on ceremonial occasions. For cool weather, people might wear parkas consisting of marmot, squirrel, or fox fur. In serious cold, they prefer caribou or reindeer. Another surprisingly warm choice is a parka of bird pelts, with the insulating feathers worn on the outside.

Sailing in Arctic waters was extremely dangerous, especially during those first few decades when whalers still went to sea in wooden sailing ships. In 1871 alone, ice crushed 34 vessels. These losses declined around 1880, when whalers began switching to steel-plated steamships, but whaling in the Arctic remained hazardous. It was hazardous for the whales, too; between 1848 and 1913, commercial whalers killed approximately 20,000 bowheads, decimating the population. With bowheads scarce and the market for whale oil and baleen fading fast, the last whaling steamer left the Alaska Arctic in 1914.

HISTORY & CULTURE

New Name for Rat Island

In 1780, a Japanese whaling ship ran aground on a small island in the Aleutians. Rats escaped the vessel and populated the land, so it got burdened with the unfortunate name of Rat Island. However, after a vigorous effort to remove these non-native invaders, which had done grievous harm to seabird populations, rats were finally eliminated in 2008. With the island free of these unwanted rodents, locals felt it also deserved to be free from that ignominious name, so indigenous groups did some lobbying, and in 2012, had it renamed "Hawadax," the original Unangan name from pre-rat days.

Despite the Yankee whalers and the fact that non-Russian Europeans made some 200 voyages to Alaska during the latter part of the 18th century and the early part of the 19th, the Russians consolidated and even extended their rule of Alaska. It was only when sea otters and other desirable furbearers grew scarce in the 1820s and 1830s, due to the decades-long slaughter, that the Russians gradually lost interest in Alaska. By the 1850s, they were motivated sellers. (No one with any power ever questioned the right of the Russians to sell Alaska, this being prime time for colonialism.) However,

This rendition of the ships in Captain James Cook's voyage to Alaska was drawn by John Webber, the famed expedition artist who accompanied Cook on his 1776–1779 journey.

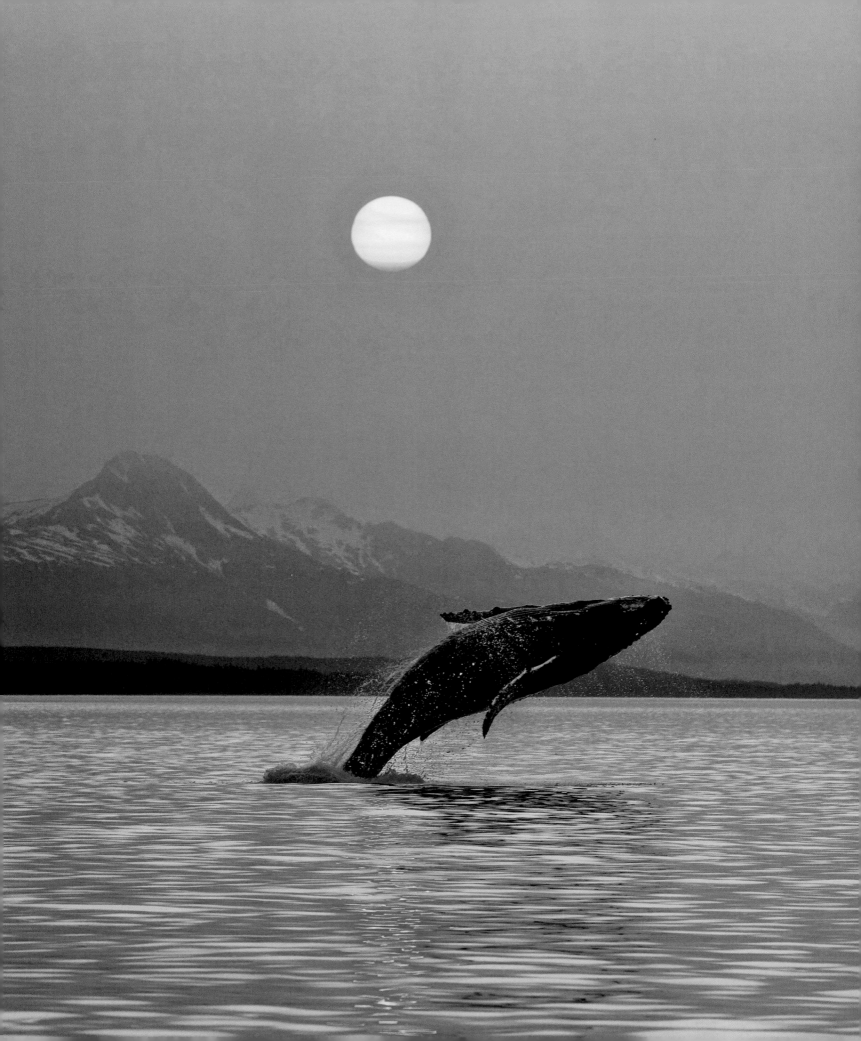

the Russians didn't want any of their European rivals to acquire the region, so they waited until the U.S. Civil War ended, in 1865, and approached the Americans.

"Walrussia." "Seward's Icebox." "Icebergia." These are some of the derisive names for Alaska that critics hurled at U.S. Secretary of State William Seward when he advocated for buying Alaska. But Seward was a zealous believer that it was America's "Manifest Destiny" to gobble up all of North America, including not only Alaska but all of Canada. In 1867, he sealed the deal with the Russians, handing over $7.2 million. Appalled that the United States would pay such a price for a harsh, remote, undeveloped land, the critics settled on "Seward's Folly" as their permanent derogatory label for the secretary's agreement.

Not surprisingly, Seward didn't think that label was a fitting name for the nation's latest acquisition. He chose "Alaska," the Unangan word for "great land," though they applied it only to the Alaska Peninsula. The American government, however, applied the name to the entire . . . well, the entire what?

Truth was, the Americans didn't know much about the place they'd bought. None of the non-native explorers had seen much beyond the coast, and the initial focus was on natural resources, such as sea otters, fur seals, and whales, that existed along the shoreline and in the ocean. This vaguely defined land wasn't even recognized by the federal government as a territory, as had previously been the case with regions acquired by international treaty, such as the Louisiana Purchase. Besides, declaring it a territory would have put Alaska on track to become a state, and Congress didn't see Alaska as statehood material. Additionally, territorial status would have granted citizenship to the residents, and Congress didn't think Alaskans deserved that, either. In fact, Russians and Alaska natives were specifically denied citizenship.

Among the first Americans to explore the country's new purchase was someone whose character and motives were utterly different from the fur traders and whalers who'd gone before. John Muir, the legendary naturalist and champion of wilderness, set out for Alaska in 1879, the first of his numerous trips to the Great Land. It seemed, well, natural that he would be drawn to this grand and wild landscape on general principle, and no doubt he was. But Muir also had a specific passion that further boosted his desire to visit Alaska; he wanted to see and study glaciers. This passion stemmed from his abiding love for the Sierra Nevada Mountains of California and particularly Yosemite National Park. He posited that his beloved Yosemite Valley had been sculpted by a glacier,

DID YOU KNOW?

Floating Factories

When 19th-century whalers killed whales, they couldn't exactly toss them in the hold whole like cod and haul them back home. So they sliced off the oil-laden blubber and boiled it in enormous pots on the deck. The heat separated the flesh from the oil, which sailors then skimmed off and stored in casks in the hold.

Opposite: Despite being 45 feet long and weighing 35 tons, humpback whales often launch themselves out of the waters of Alaska's Inside Passage.

and he sought evidence to verify or disprove his idea. His enthusiasm for the subject came out in some of his writing, such as a passage that goes, "The grandeur of these forces and their glorious results overpower me and inhabit my whole being. Waking or sleeping, I have no rest. In dreams I read blurred sheets of glacial writing, or follow lines of cleavage, or struggle with the difficulties of some extraordinary rock-form."

A hardy outdoorsman who embraced rugged travel, Muir set out in a canoe from Wrangell, in the Alaska Panhandle, with a missionary and several Tlingit, who served as guides and fellow paddlers. Where others might have spent a week poking into a few coves, Muir, always pressing farther, forged on for months, covering about 800 miles and much of the Inside Passage. Appropriately, he got all the way north to what is now Glacier Bay National Park and Preserve.

Despite some horrendous weather, he and his companions pushed into the deepest reaches of Glacier Bay's fjords, and when the weather finally lifted, they discovered that they were in the heart of glacier country. This sent Muir into such ecstasy that, in describing the scene, he seemed to have forgotten to use period marks, as in this breathless excerpt that gallops along with nary a stop: "Climbing higher for a still broader outlook, I made notes and sketched, improving the precious time while sunshine streamed through the luminous fringes of the clouds and fell on the green waters of the fiord, the glittering bergs, the crystal bluffs of the vast glacier, the intensely white, far-spreading fields of ice, and the ineffably chaste and spiritual heights of the Fairweather Range, which were now hidden, now partly revealed, the whole making a picture of icy wildness unspeakably pure and sublime." How fitting that one of the pure and sublime rivers of ice deep in the park was later named Muir Glacier.

Muir's writings about this epic voyage and his later travels to Alaska helped bring tourists to the area in the last decades of the 19th century—not that they replicated his 800-mile canoe trip. They were joined by traders, missionaries, trappers, military men, and others as Americans gradually probed Seward's Folly and began to realize that if anyone had made a mistake, it was Russia. And if anyone still doubted the wisdom of Seward's decision, the discovery of gold in Alaska likely erased those doubts for good.

People often refer to the Alaska gold rush, but "gold rushes" is a more accurate phrase; gold fever struck Alaska many times in many places. For example, what was arguably the first significant rush occurred in 1880 near Juneau, where some prospectors hit pay dirt on unimaginatively but accurately named Gold Creek.

HISTORY & CULTURE

Civil War Conflict in Alaska

During the years of the Civil War (1861 to 1865), Alaska had not yet been purchased by the United States, but that didn't entirely shield the region from the conflict. In June 1865, the *Shenandoah*, a 1,160-ton Confederate steam cruiser, entered Alaska waters to hunt Yankee merchant ships, particularly whalers. People who paid attention in history class will realize that by June 1865, the war had been over for two months, but word spread slowly in those days and the officers and crew of the *Shenandoah* rampaged through the Bering Sea unaware that the war was over. The warship captured some two dozen ships and sank most of them. The officers then turned the ship south with the intention of shelling San Francisco, but, thankfully, they found out that the war had ended before they reached the city by the bay.

Opposite: Fabled environmentalist and author John Muir spent many months exploring the wilds of Alaska.

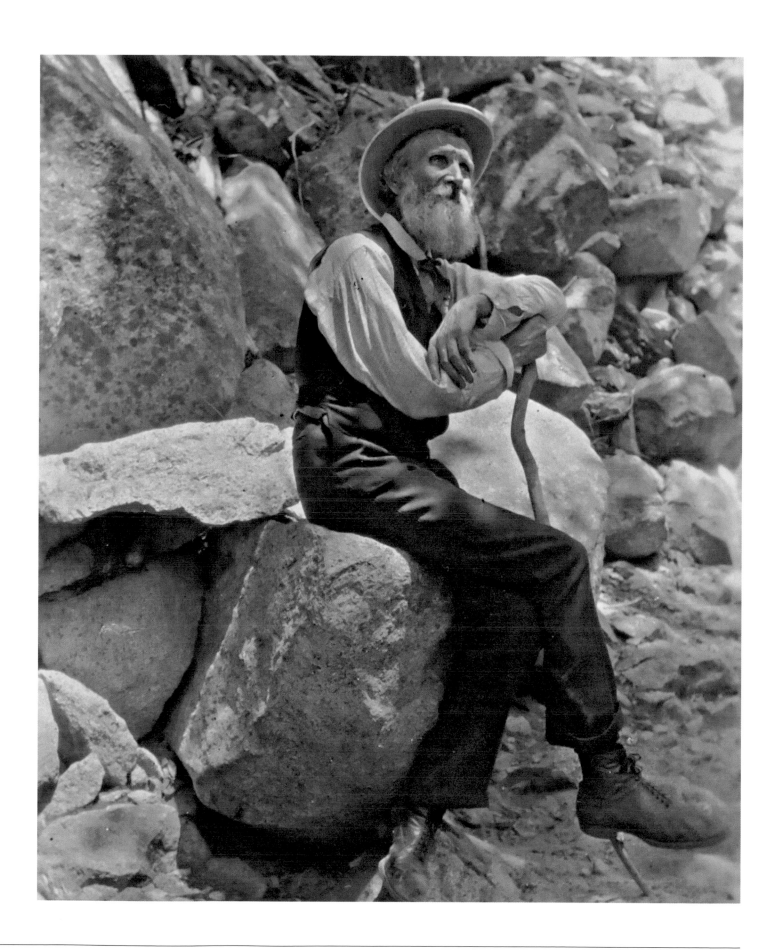

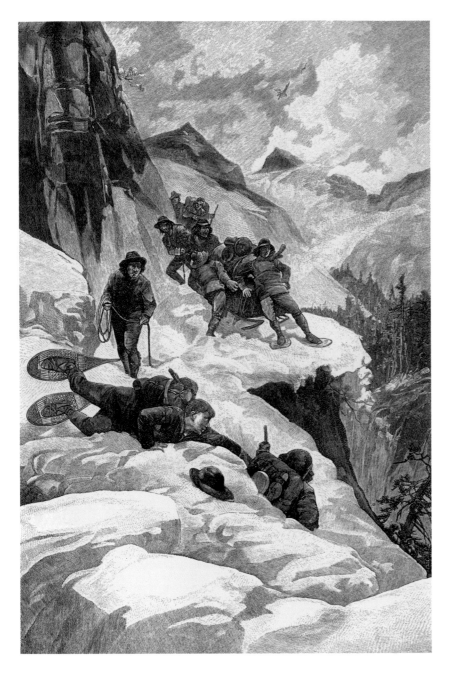

This depiction of an expedition to Alaska in the 19th century captures the trepidation with which many outsiders viewed the Great Land.

But that strike didn't draw hordes of adventurers because it mostly required hard-rock mining, which means big companies with big equipment.

The granddaddy of them all was the massive Klondike rush, which was touched off by the discovery of gold on Rabbit Creek (soon christened Bonanza Creek) in the summer of 1896. Word of the Bonanza Creek strike quickly spread among the 2,000 or 3,000 prospectors already in that part of the interior of Alaska and the Yukon, and within a few months, they'd snapped up most of the promising claims. During this same time, personal letters, government reports, and a few newspaper articles spread the gold fever wider, and more hopefuls lit out for Alaska even with winter coming; most of these rash folks got stuck somewhere well short of the Klondike and had to wait until spring to try to strike it rich. But gold fever didn't reach epidemic proportions until the summer of 1897, when successful Klondike miners walked off two ships—one in Seattle and another in San Francisco—lugging sacks of gold. Newspaper headlines screamed "Gold!" and tens of thousands of people responded by grabbing their coats and heading north. Most never made it to the Klondike, most who did went home empty-handed, and all too many didn't survive to make it home at all. In addition, a fair number stayed in Alaska—some chasing subsequent gold strikes, others settling down and helping usher Alaska into the next century.

In 1912, Alaska finally achieved official territorial status. This transferred some power to its citizens, but the federal government reserved numerous rights for itself, too, notably the right to control the management of most natural resources. Many Alaskans felt this latter power was a favor to the big fishing and mining companies based outside of the territory, and it was a point of fervent contention.

One of the thorniest problems for the first territorial legislature was simply getting there. Their first 60-day session was scheduled to begin March 3, 1913. Early March in Alaska means winter, and in 1913, there were no planes, no trains to speak of, and few roads. Consider the four legislators from Nome. Three of them mushed some 800

miles to Fairbanks by dogsled while the fourth walked to Fairbanks, going from road-house to roadhouse along the winter trail. From Fairbanks, they took a horse-drawn sleigh 350 miles to Valdez. From Valdez, they sailed aboard a steamship to Juneau. They made it the day before the legislature convened; they'd left Nome in early January.

Neither before nor after becoming a territory did Alaska ever have a traditional pioneer period. Certainly individuals and families with a pioneering spirit came to Alaska in the late 19th and early 20th centuries and settled on the land, building cabins, hunting, fishing, trapping, and generally living by the sweat of their brow. But they rarely were able to do what classic American pioneers did: establish farms and ranches. Alaska's rough climate and poor soils made farming and ranching almost impossible. When the Homestead Act was extended to include Alaska, in 1898, it had little effect. Despite the act's offer of 160 free acres to people willing to work the land for at least five years, by 1914 fewer than 200 homestead applications had been filed in the state.

However, one place in Alaska did experience a somewhat classic pioneering experience, and that's because the state does have one sizeable area with decent soil and a relatively moderate climate: the Matanuska-Susitna Valley. Locally known as the Mat-Su, the 20-by-40-mile heart of this valley lies about 30 miles north of Anchorage. Its flat terrain and fertile soils, as well as its name, come courtesy of the Matanuska and Susitna Rivers.

Even here, agriculture got off to a slow start. The Athabaskans and Dena'ina had occupied parts of the valley for hundreds of years, but they weren't farmers and ranchers. The early Euro-American arrivals came for the usual reasons, such as gold mining and trapping. Not until the 1930s did the pioneering really begin, thanks to a plan the federal government conceived.

The nation was in the throes of the Great Depression, and farms in the lower 48 were failing by the bushel. The Roosevelt administration was enacting all sorts of relief programs, and one such idea was to recruit families whose farms had gone under and to transplant them to the Mat-Su. Eventually, some 200 families volunteered, and in 1935, the government moved them to what was still a wilderness. Predictably, they struggled at first—farming in Alaska, even in the Mat-Su, is far different than farming in Iowa. But some of them prevailed, and today, the Mat-Su puts a fair bit of produce on the tables of Alaskans, including those renowned giant vegetables nurtured by the midnight sun, such as cabbages the size of a washing machine and Swiss chard taller than Shaquille O'Neal.

Gold Rushes

1 **Fairbanks** Felix Pedro's discovery of gold in 1902 kicked off one of the last sizeable Alaska gold rushes. Though Pedro's strike was real and some of the precious yellow metal was indeed dug out of the area, much of the rush was revved up by a scalawag named E. T. Barnette in order to boost his trading business.

2 **Juneau** In 1880, a pair of prospectors found gold in the area of Alaska's future state capital and touched off the first significant rush. One of that pair was Joe Juneau, for whom the city was named only because he bribed citizens into bestowing that honor upon him.

3 **Klondike** The big one. Tens of thousands of hopeful people surged into Alaska in 1897 and 1898. Though the actual gold fields lay in the Yukon, most fortune hunters traveled through Alaska to reach the Klondike, creating Alaska boomtowns like Skagway and Dyea.

4 **Nome** Just as the great Klondike rush was slowing, word spread of a significant strike in Nome. In 1899, thousands of prospectors crowded into the remote western Alaska town, transforming it overnight into Alaska's most populous city.

Skagway

Gold fever infected the tens of thousands of stampeders who headed north to the Skagway area in the late 1890s. Remnants of this feverish past can be seen in Skagway's many historic buildings and at Klondike Gold Rush National Historical Park.

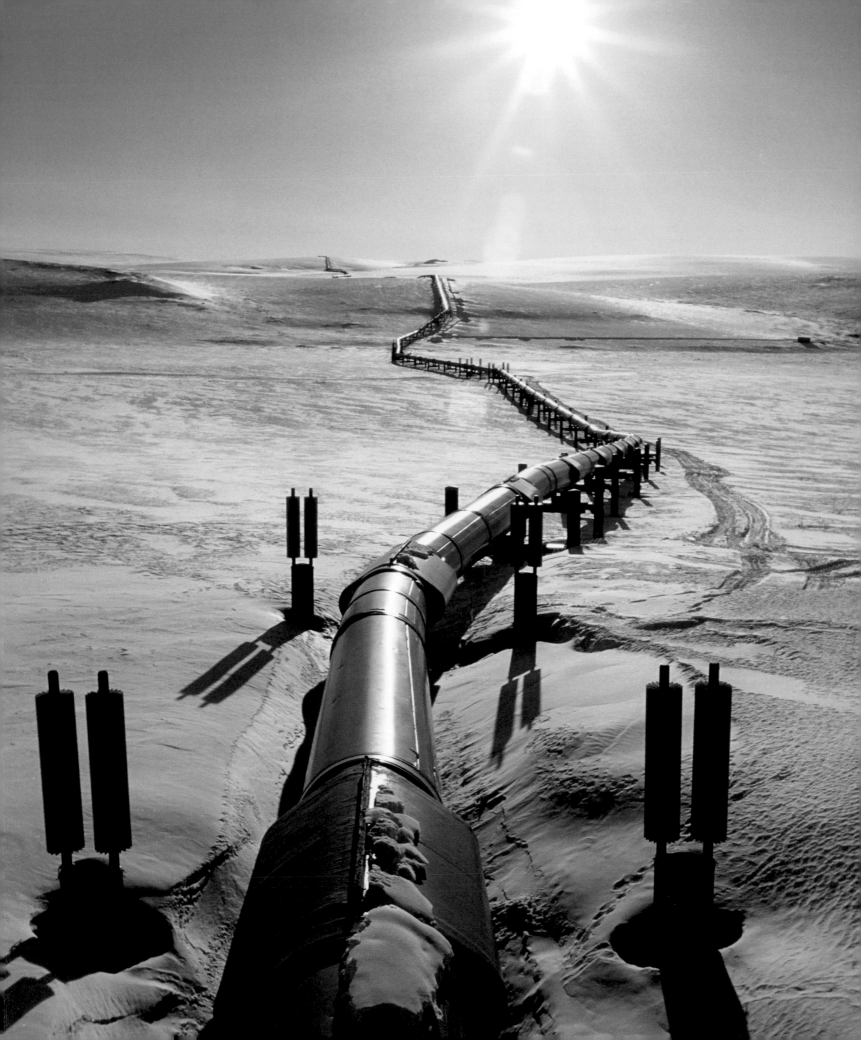

The next influx of people sent to Alaska by the federal government came in 1942. It was a far larger influx and for a far more dire reason—the threat of a Japanese invasion of the United States during World War II, a threat Japan soon carried out. Few people realize that enemy troops set foot on American soil during the war, but they did, and that soil was in Alaska. The Alaska theater heated up on June 3, 1942, when the Japanese bombed the Aleutian Islands community of Unalaska/Dutch Harbor, perhaps hoping to draw American naval forces away from the impending battle of Midway, 1,500 miles to the south. If this was meant as a diversion, it failed. So did the Japanese navy, which suffered a major defeat at Midway.

A few days after the bombing, the actual invasion started when thousands of Japanese soldiers landed on Attu and Kiska, two of the Aleutians Islands closest to Japan—in fact, they're closer to Japan than they are to Anchorage, let alone to the continental United States. It took the United States more than a year to take the islands back, largely due to their remoteness and the terrible weather than typifies the Aleutians. But after a series of naval engagements and aerial bombings by the Air Force, some 12,500 Allied troops landed on Attu and recaptured the island in a brutal battle, with thousands of casualties on each side. Happily, Kiska fell without a fight; the Japanese soldiers withdrew in the fog, and when American and Canadian troops stormed ashore, they didn't find anyone to attack.

Combat in Alaska ended with the battle for Attu, but global geography made the territory vital to the military; famed U.S. General Billy Mitchell said, "I believe that in the future, whoever holds Alaska will hold the world. I think it is the most important strategic place in the world." War-related development took place rapidly, including the construction of the Alaska Highway and numerous airfields. Perhaps the most long-lasting effect resulted from the stationing of tens of thousands of American troops in the territory. Many found the Great Land irresistible and settled there after the war. The military buildup continued as the Cold War followed on the heels of WWII, and by 1950, one in six residents of Alaska was serving in the military. The strategic importance of Alaska and its rapid growth and modernization accounted in part for its achieving statehood in 1959.

Opposite: About 17 billion barrels of oil have flowed through the Trans-Alaska Pipeline, which runs 800 miles from the Arctic Ocean to the port of Valdez.

Another boom occurred shortly after statehood. During the 1960s, Richfield Oil had probed Alaska's North Slope, up in the Arctic tundra, but its exploratory wells had come up dry. The company, by then

> **DID YOU KNOW?**
>
> ### Nuking Amchitka
>
> The Aleutian island of Amchitka was the site of three underground nuclear tests, in 1965, 1969, and 1971. The 1971 bomb had a yield of nearly five megatons—the most powerful nuclear bomb ever tested underground by the United States, with an explosive force nearly 400 times that of the Hiroshima explosion. In the two years leading up to the 1971 blast, a campaign to halt the test arose, first in Canada and then in the United States. High school students boycotted classes, labor unions stopped work, dozens of U.S. senators objected, Japan and Sweden urged President Richard Nixon to cancel the test, and hundreds of thousands of people protested and signed petitions. Eventually, the case went to the U.S. Supreme Court, where a 4–3 majority decided in favor of allowing the test to occur. President Nixon immediately ordered the military to proceed with the test, which they did. A couple of months later, the Atomic Energy Commission declared that they were going to stop any further nuclear testing on Amchitka due to "political and other reasons."

called Atlantic Richfield Company or ARCO, was losing interest in the area when, in 1967, it received a belated Christmas present. On December 26, a crew opened a rig in the Prudhoe Bay area and natural gas gushed out. This promising discovery prompted further exploration in the area, and by the summer of 1968, the oil industry reckoned it had discovered a behemoth.

Behemoth, indeed. The Prudhoe Bay field turned out to be the largest in North America, holding about 25 billion barrels (slightly more than 1 trillion gallons) of oil, about half of it recoverable using current technology. With the completion of an 800-mile pipeline from Prudhoe Bay to Valdez in 1977, the oil began flowing, reaching a peak of 1.6 million barrels a day in 1987. For decades, the oil business has been the single most important economic driver in Alaska, and it still is, even though Prudhoe Bay production has dwindled to about 240,000 barrels a day.

The burning desire of the state and the oil companies to build that pipeline helped resolve an issue that had been haunting Alaska since its purchase by the United States: Alaska native land claims. The planned 800-mile pipeline would have to cross all sorts of traditional native lands, but legal ownership by natives had never been clarified, and the oil companies couldn't buy the necessary right-of-ways until they knew from whom they had to buy the land.

On June 3, 1942, Japanese bombers dropped their payload on Dutch Harbor, a major port in the Aleutian Islands. Soon after, they invaded two of the westernmost islands, the only ground invasion of the United States during World War II. After a ferocious battle, the Allies regained the islands in 1943.

Most Alaska natives felt that it was about time this long-festering issue was settled. As one Athabaskan woman put it, "We were like foreigners in our own country." Living conditions for the majority of natives ranged from poor to appalling. On average, they only lived to the age of 35. Tuberculosis, a disease that disproportionately preys on the poor, affected natives 20 times more often than it did non-natives. Unemployment among natives was above 50 percent, and the annual per capita income was less than $1,000, well below the poverty level in the United States at the time.

From 1968 to 1971, Alaska native leaders, the state, and other interested parties debated and negotiated and, in 1971, they agreed upon the Alaska Native Claims Settlement Act (ANCSA), which President Richard Nixon signed into law in December of that year. Though ANCSA had its critics and certainly didn't immediately solve all the problems cited previously, most observers, Alaska native and non-native, felt that the act did achieve considerable progress. It provided nearly $1 billion as compensation for various claims Alaska natives surrendered, it set up 12

(and eventually 13) influential regional economic development corporations (with each Alaska native owning some stock) that gave Alaska natives a strong position in the market economy from which they'd largely been excluded, and it established more than 200 village corporations. Perhaps most significant, ANCSA allowed Alaska natives to choose 44 million acres that they would henceforth legally own.

Unlike in the lower 48, where native Americans typically were given the least desirable lands (if they were given anything at all), Alaska natives got some prime, resource-rich lands. They also picked some lands of traditional importance, sacred lands or lands where they and their ancestors had hunted for generations. Alaska natives hoped this would help them keep their cultures robust. In taking a meaningful step toward embracing the state's original peoples, ANCSA makes a fitting milestone to mark Alaska's arrival in the modern era. ■

The arts, including dance, are vital elements of traditional Alaska native life. Here, the Chilkat troupe performs at its theater in Port Chilkoot, near Haines.

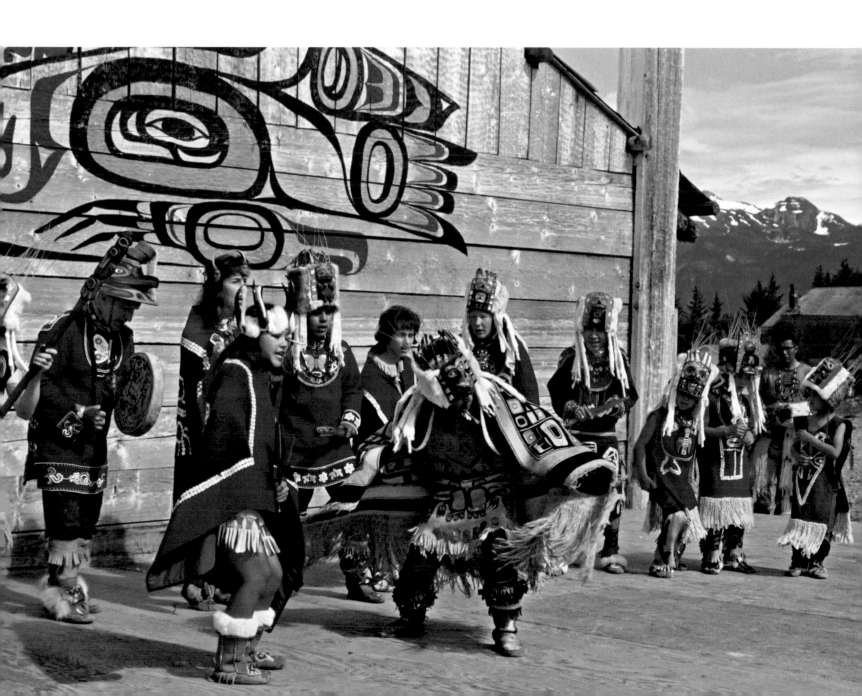

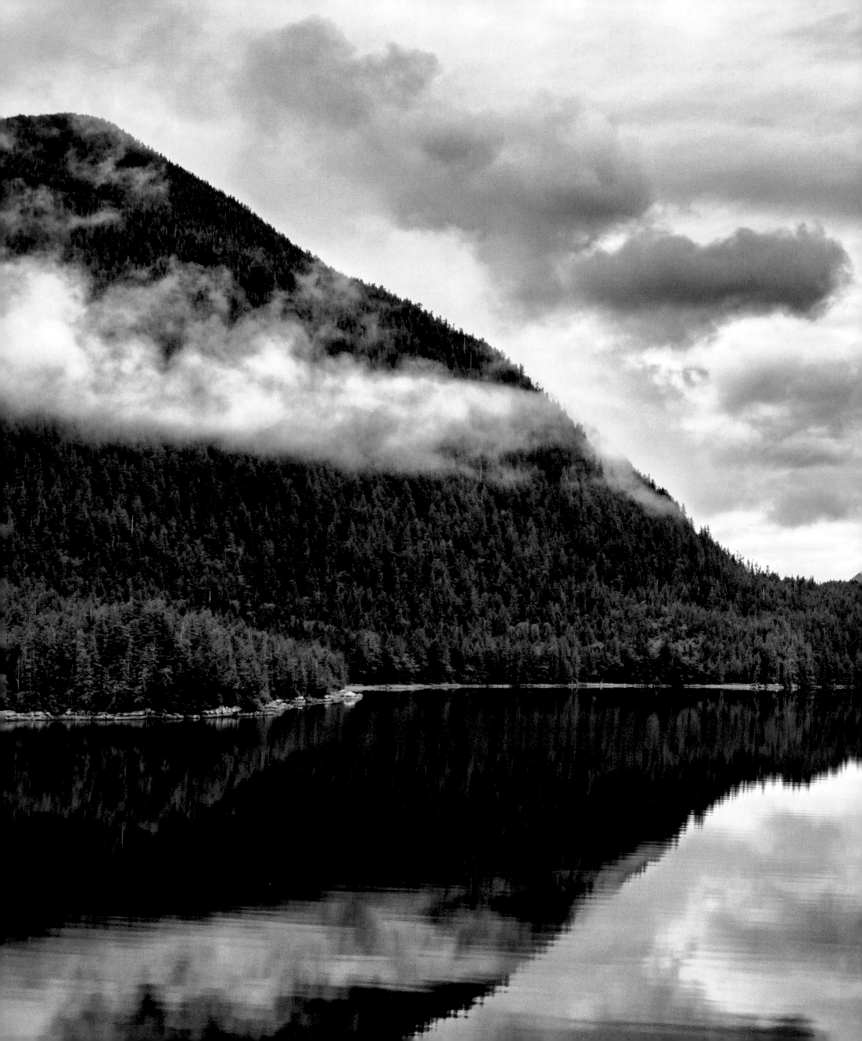

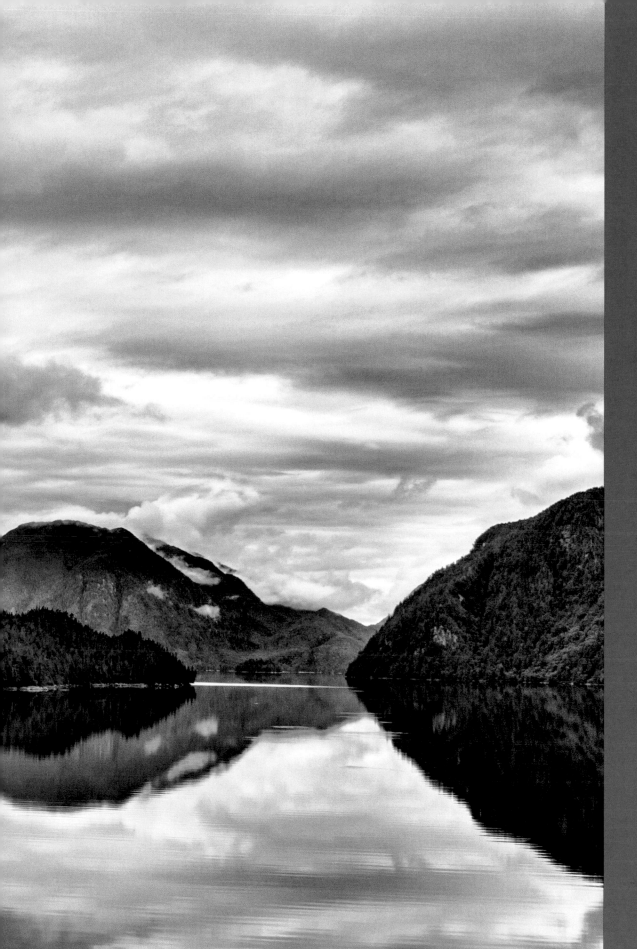

[2] Southeast

Whether plying the Inside Passage on a cruise ship or in a kayak, travelers encounter the intriguing tangle of land and water that characterizes Southeast Alaska at every turn.

Southeast

National Park
National Forest
Other protected area
Paved road
Unpaved road
Ferry

0 100 mi
0 100 km

Y U K O N

⊛ **Whitehorse**

U.S.
CANADA

St. Elias Mountains

WRANGELL-

Mt. St. Elias +
ST. ELIAS
Mt. Cook +
+ Mt. Hubbard

N.P. & PRESERVE

Cape
Yakataga

Yakutat
Bay

TONGASS
NATIONAL
FOREST

Yakutat

Chilkat Bald
Eagle Preserve
Skagway
Klukwan

Haines

C O A S T

Mt. Fairweather

CANADA
U.S.

GLACIER BAY N.P.
& PRESERVE

Glacier
Bay

Lynn Canal

B R I T I S H
C O L U M B I A

G U L F O F A L A S K A

Gustavus

⊛ **Juneau**

Telegraph Creek

TONGASS

Elfin Cove

Pelican

Hoonah

Chichagof Island

ADMIRALTY

Tenakee Springs

Admiralty
ISLAND
N.M.
Angoon

M O U N T A I N S

P A C I F I C O C E A N

A l e x a n d e r A r c h i p e l a g o

Baranof Island

Chatham Strait

Kruzof
Island
Sitka
Mt. Edgecumbe +
Sitka
Sound
Baranof
Castle
S.H.S.

Frederick Sound

Kake

NATIONAL

Kupreanof
Kupreanof
Island
Petersburg

Stikine

CANADA
U.S.

Kuiu
Island

Petroglyph Beach S.H.P.
Wrangell

37

MISTY

FIORDS

Revillagigedo
Island NATIONAL

Prince of Wales Island

Klawock

Hollis

Totem Bight S.H.P.
FOREST Ketchikan
MONUMENT
Gravina Saxman
Island Annette
Island
Metlakatla

Hyder

Craig

The Southeast is a maze of islands
and deeply carved coastline swathed
in lush temperate rain forest and
bounded by mountains on one side
and the sea on the other.

ARCTIC CIRCLE

Area
Enlarged

D i x o n

E n t r a n c e

⊛ **Prince Rupert**

As their plane descends to the Ketchikan airport, passengers looking out the windows will see a microcosm of Southeast Alaska, the half-water/half-land panhandle of the state, which stretches from Ketchikan north to Haines. Below them is a maze of islands, fjords, coves, channels, reefs, and inlets, with deep green forest covering most of the terrestrial surface. To the east rise the coastal mountains, whose summits run from about 5,000 to 10,000 feet; this north–south range roughly marks the boundary between the United States and Canada. To the west lie more islands and another maze of waterways and, out of sight beyond the islands, the open Pacific. And amid all that wildness sits Ketchikan, an isolated island town that can only be reached by plane or boat.

As a matter of fact, travelers landing at the airport will have to reach Ketchikan by plane and boat. The airport is on neighboring Gravina Island, and arriving passengers must take a short ferry ride across a narrow channel to reach town. For years, Alaska politicians had pushed for federal funding to build a bridge across this channel, and in 2005, it appeared they had succeeded, garnering a $223 million congressional appropriation toward the estimated eventual cost of about $400 million. But then word got out that only about 50 people lived on Gravina Island and that the airport only handles about as many passengers in a year as Atlanta's airport handles in a day. Suddenly, the proposed project got dubbed the "Bridge to Nowhere," and was widely criticized as an example of wasteful, pork barrel spending. The federal funding was redirected, and the bridge didn't get built. The ill-fated bridge project even became an issue in the 2008 presidential campaign when Alaska governor and vice presidential candidate Sarah Palin made the claim that she had opposed the "Bridge to Nowhere," yet a few years earlier she had publicly expressed support for the bridge.

More often than not, when visitors exit the ferry, they'll be greeted by a cool drizzle, if not a cold, hard downpour. This, too, makes Ketchikan a microcosm of this very wet region, though the town's 160 inches of precipitation a year make it soggy even by Southeast Alaska standards. The town does see a modest amount of sun during the summer, but many of the residents still plod around in brown rubber boots, popularly known as Ketchikan sneakers; folks apparently are just so accustomed to rain that they pull on their boots without even glancing outside at the weather. A bit north of Ketchikan in Little Port Walter, residents probably sleep in their rubber boots; its 225 inches of annual precipitation make it the wettest spot in the United States

Not only are Tlingit carvings colorful and wildly imaginative, the figures also are evocative of traditional stories and myths. This work features Raven and the Box of Daylight.

outside Hawaii. Luckily, the only residents are the handful of researchers at the biological research station.

Given all the water and forest that envelop Ketchikan, it was almost inevitable that commercial fishing and logging would provide the economic foundation for the town, which started up around the turn of the 19th century. Ketchikan dubbed itself the "salmon capital of the world" and so it seemed in the early decades of the 20th century, when local canneries were knocking out 1.5 million cases of canned salmon a year. The commercial catch has declined since, but it's still significant. Meanwhile, sportfishing for salmon and numerous other species has boomed and become a mainstay of the local economy. A steady stream of charter boats heads out of the harbor in the mornings, carrying out-of-town fishers who have visions of airfreighting a crate of ice-packed king salmon back home.

People who prefer terra firma can find plenty of interest by strolling around Ketchikan's central area. Like most of the other Southeast Alaska ports of call that the big cruise ships frequent, Ketchikan has lost a lot of harborside storefronts to businesses that cater to the thousands of day-trippers who come off those floating cities. Often owned by outside companies, these shops generally lack character and sell made-in-China souvenirs, generic jewelry, and other goods that have little connection to Ketchikan or Alaska. But travelers who seek out the local, independent stores will find some treasures.

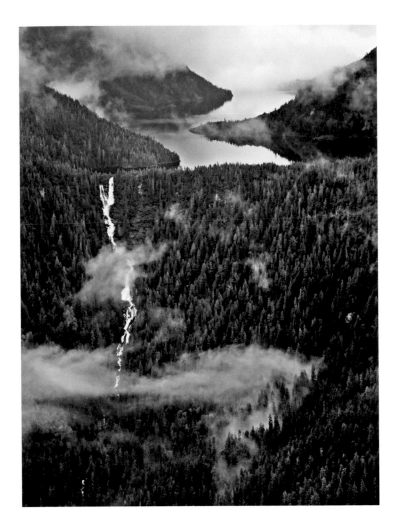

Misty Fiords National Monument came by its name honestly; if it's not misty, it's probably raining in this soggy neck of the woods. Many visitors fly over the monument in floatplanes, which serve up breathtaking aerial views.

Soho Coho epitomizes the breed. This gallery and gift shop radiates the full-throated eccentricity and creativity of its artist/owner, Ray Troll, who is, quite frankly, obsessed with fish and dubious humor in equal measures—("Specializing in the slightly inappropriate since 1985," as the man himself puts it). That is why Troll produces what he labels "fin art," though the quality of his drawing and composition makes clear that he could legitimately add an "e" to the first word of that label if he so desired.

But what would be the fun in that? And Troll's work shouts that he is a guy who has fun doing his job. Visitors never know what they're going to find as they browse Soho Coho. A "Fish Worship" cap? A "Life's a Fish and Then You Fry" apron? Maybe an "If You Must Smoke, Smoke Salmon" T-shirt? Or a "Mad Cow—Happy Salmon" refrigerator magnet? One of his classics was a T-shirt depicting a fierce, bearded salmon sporting a turban with the caption "Wanted Dead or Alive, O Salmon Bin Laden."

And then there's something like his art poster "Dream of *Didymoceras*," which shows a pair of sea creatures in weirdly spiraling shells floating dreamlike above a

sleeping couple in their bedroom. Didy what? It turns out that Troll has a scientific bent. It still involves fish, of course, or at least marine creatures of some sort, but often those from distant epochs. *Didymoceras,* for example, is an extinct genus of ammonite cephalopod that lived between about 70 and 80 million years ago. His representations of these bygone ocean denizens are painstakingly researched and accurately presented . . . well, accurately aside from the floating above the bed kind of thing.

This science/humor/fish combination has led to some monumental exhibits, such as his "Dancing to the Fossil Record" show, which included Troll's drawings, its own sound track, giant fossils, a dance floor with an interactive computer installation, murals, fish tanks, and the "Evolvo" art car. The show opened at the California Academy of Sciences in San Francisco and traveled for four years to major scientific institutions around the country; by the end, it occupied some 14,000 square feet. Knowing this, it's not as surprising to learn that Troll has lectured at Harvard and Yale, and exhibited at the Smithsonian. But perhaps his most cherished accolade is having a ratfish named after him *(Hydrolagus trolli).*

Like all the towns and villages scattered around Southeast Alaska, Ketchikan is intimately tied to the sea. Its harbor bustles with commercial fishing vessels, cruise ships, charter boats packed with sportfishers, tour boats, and ferries.

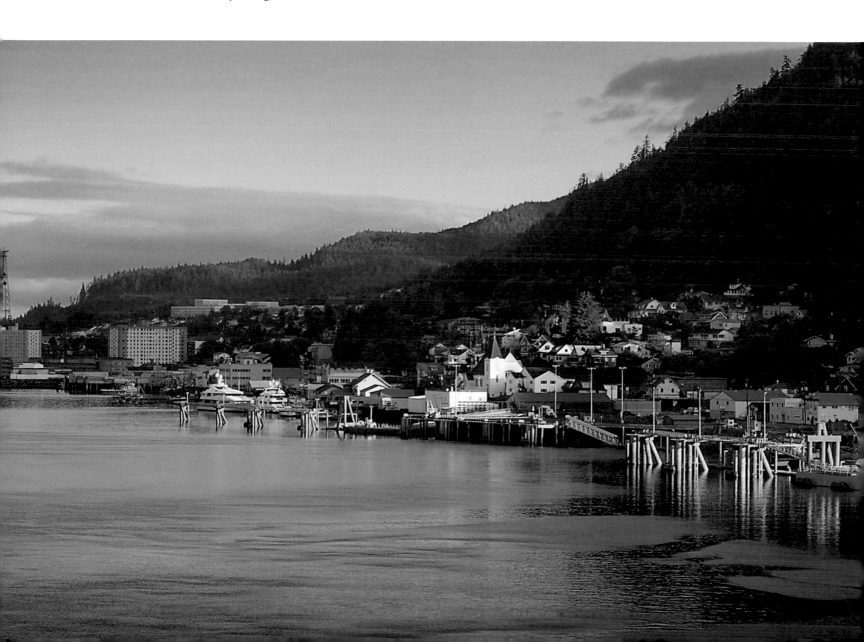

Soho Coho resides in an early-1900s building—a former bordello—on Creek Street, the old red-light district of Ketchikan. The historic area does indeed run along a creek, whose cold, clean water provides a spawning ground for salmon during the summer. The salmon/red-light district pairing led to a time-honored Ketchikan joke that referred to Creek Street as the only place where both men and salmon head upstream to spawn.

A little farther up the creek, visitors will encounter more wholesome history at the Totem Heritage Center. The City of Ketchikan established the center in 1976, to house and preserve 19th-century totem poles from abandoned Tlingit and Haida

> **66 My wife can tell you that every totem pole I've ever created becomes my mistress, and that's all I think about. 99**
>
> **[Israel Shotridge, Tlingit master carver]**

sites in the region. The center has since expanded to include other native artifacts and programs to promote the traditional arts and crafts of the Tlingit, Haida, and Tsimshian peoples.

The venerable poles in the heritage center convey much about the rich history and culture of these native peoples, as do the poles gracing many sites around Ketchikan, such as the Southeast Alaska Discovery Center, Saxman Totem Park, and Totem Bight State Historical Park. To the uninitiated, totem poles appear to be nothing but wood carvings of odd faces and distorted animals. Early missionaries mistakenly thought the poles were religious symbols. In fact, totem poles serve all sorts of functions, such as proclaiming family genealogy, honoring the dead, shaming the living, displaying wealth, recording ancient stories, or depicting important events.

The highly stylized elements that appear on totem poles developed over centuries, though the individual carvers had some room to artistically roam within the conventions of the form. Stylized as these elements are, by looking carefully, casual

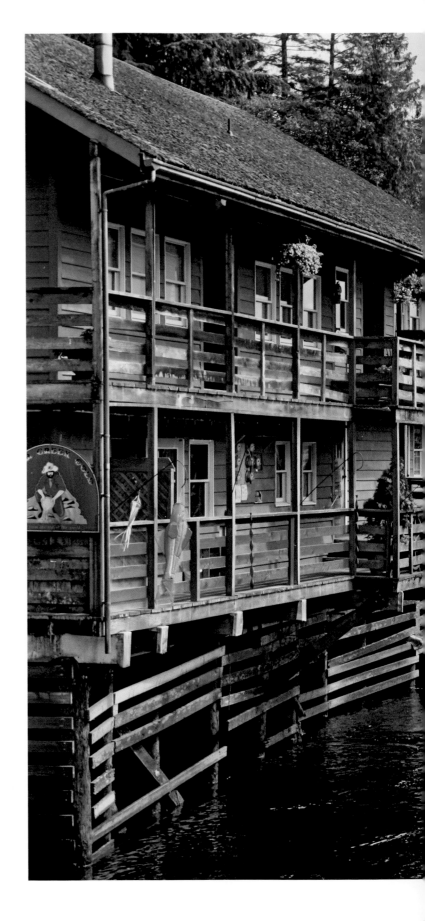

Ketchikan's Creek Street historical district can be reached on foot, but many people approach it from the water in kayaks and canoes.

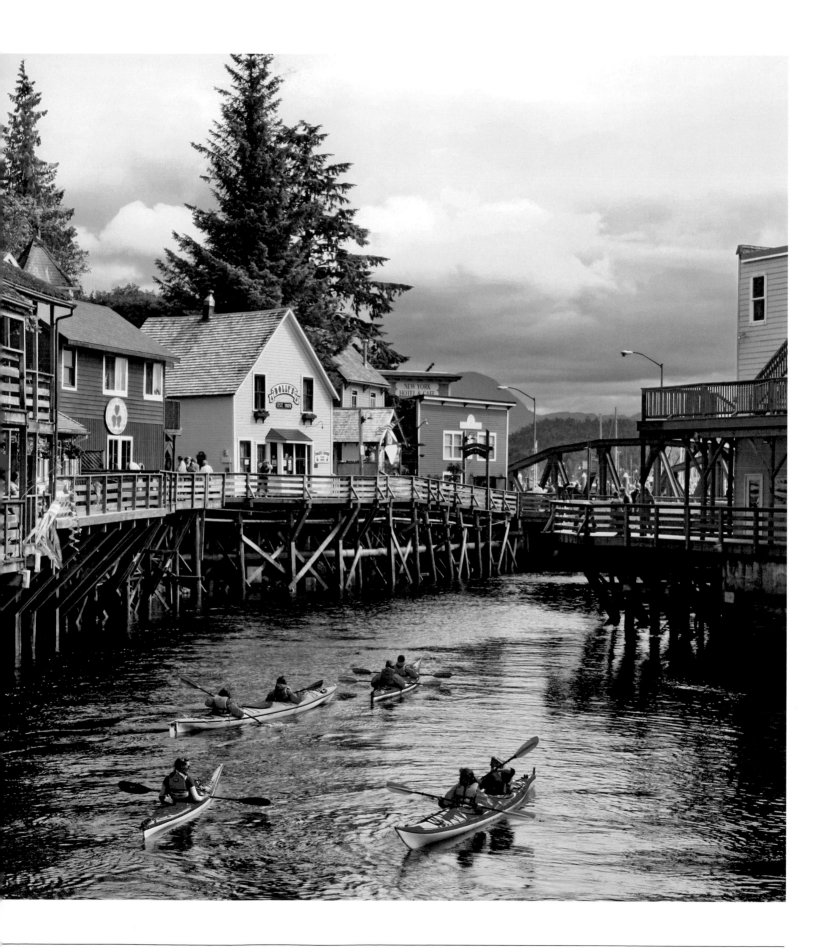

Ketchikan's Totem Poles

1 **Saxman Totem Park** Dozens of fine totem poles, some new and some old, grace this park in the village of Saxman, on the edge of Ketchikan. But the most distinctive feature of the park is the carving shed, where visitors can watch highly skilled artists shaping new poles. Often over the years, Nathan Jackson—arguably the finest totem pole carver alive—has worked his magic in this shed, and lucky travelers may get to see him in action.

2 **Totem Bight State Historical Park** Set on a beautiful wooded shoreline a little north of Ketchikan, this park is home to 14 totem poles and a traditional clan house. Many of the poles are replicas of 19th-century poles from surrounding villages that were deteriorating. Wandering along the welcoming pathways, visitors can learn much about classic Tlingit and Haida totems by studying poles such as the Thunderbird and Whale pole, the Blackfish pole, the Sea Monster pole, and the Halibut pole.

3 **Totem Heritage Center** On this wooded property in central Ketchikan, visitors can see many of the original poles that have been replicated at Totem Bight State Historical Park; the center houses the largest collection of 19th-century poles in the world. Having been rescued from abandoned villages, some are significantly degraded, but a decision was made to preserve the poles rather than try to restore them. The center is also a place where older carvers can pass along their skills and knowledge to younger carvers to keep the art of totem pole carving robust.

visitors often can discern familiar figures, such as ravens, wolves, bears, and killer whales. For example, an observer may see a face with huge eyes, thick eyebrows, and a wide mouth and have no idea what he's looking at until he notices the two big buckteeth that reveal the figure as a beaver. Such images are not randomly chosen by traditional carvers. Each image represents a clan or moiety (a "moiety" is a kind of social division). Clans are sub-groups of extended families descended from a common ancestor and overseen by a chief. The bonds among clan members are not as close as they used to be, but they still play a significant role in many people's daily lives.

People often say that some totem poles tell a story, but that's not quite correct. Rather, they display figures that evoke stories that clan members know well. For example, at Saxman Totem Park, the Sun Raven pole includes the figures of Sun Raven, his children, Fog Woman, Raven, Frog, and some salmon. Someone well versed in Tlingit legends will be reminded of three stories, including the one about Raven getting angry at Fog Woman for being a superior fisher, so she left and took her salmon with her, which is why salmon swim upstream.

Standing amid the dozens of poles at Saxman Totem Park is the Seward Pole, a fine example of what's called a "shaming" or "ridicule" pole. The derision can be aimed at a group, such as a rival clan, or at an individual, as in this case. William Seward, Secretary of State under President Lincoln, is the person most responsible for convincing the U.S. government to buy Alaska, in 1867. In 1869, when he journeyed to Alaska, he visited Fort Tongass, located in the area where Ketchikan sits today. Seward was treated like royalty. An important Tlingit personage, Chief Ebbits, entertained him and gave him many presents. In the Tlingit culture, such generosity should be reciprocated, but Seward gave no gifts in return. So after he left, the Tlingit erected a totem pole with a face representing Seward; they painted its ears and nostrils red, signifying that he was a tightwad.

Totem poles were not just knocked out willy-nilly. For one thing, they're often dozens of feet tall—sometimes more than 100 feet—and require a major effort. More to the point, they're a public statement and therefore were typically commissioned by

At Saxman Totem Park, in Ketchikan *(above)*, visitors can watch master carvers at work. *Opposite:* Elaborate totem poles stand out all over Ketchikan.

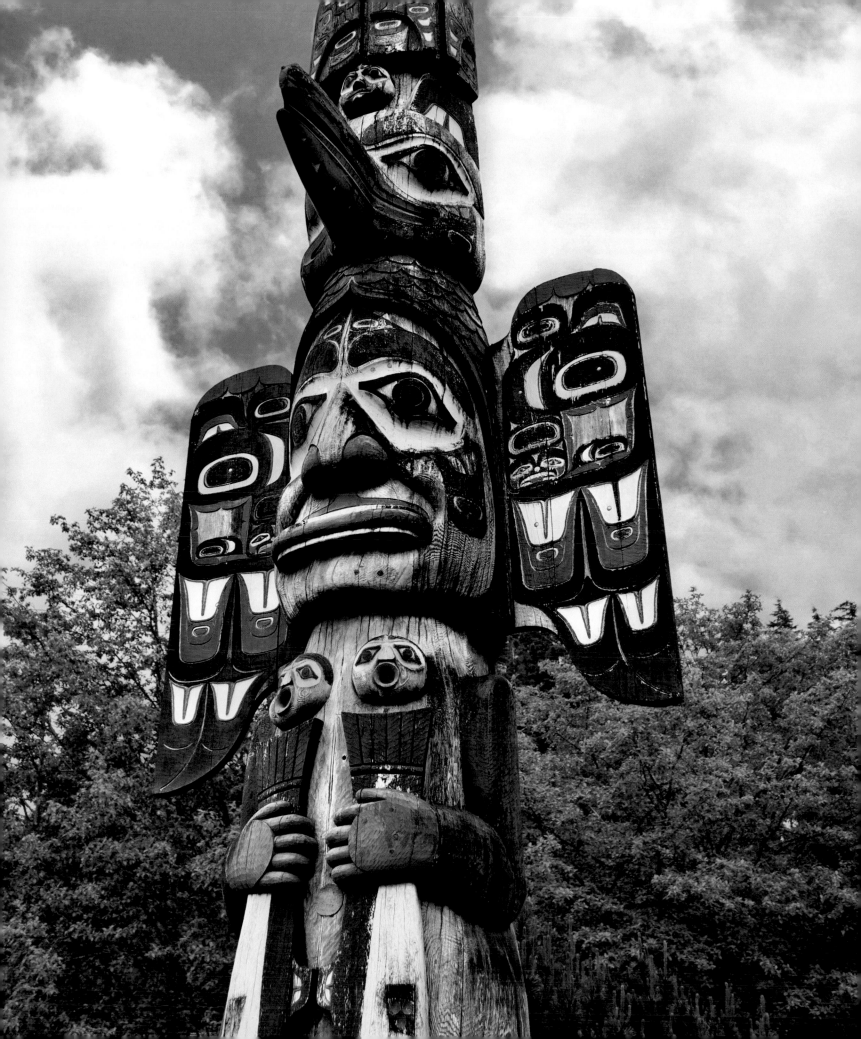

the chief or another high-ranking person. The chief would enlist the services of a master carver and describe in some detail the type of pole he had in mind. The artist would then map out the pole, procure a suitable tree (usually a western red cedar), and set to work with an adze and chisel. Once he had a rough design chipped out, the carver would switch to curved knives and other small, sharp tools to etch the fine features.

Nathan Jackson still uses many of these same tools to create totem poles. A Ketchikan resident, Jackson is arguably the most famous and most accomplished carver of poles alive. Born in 1938 in the Sockeye Clan on the Raven side of the Chilkoot Tlingit, Jackson didn't start life as an artist. Early on, he learned fishing from his clan uncle and grandfather, and became a commercial fisher. But while convalescing from a bout of pneumonia in his early 20s, Jackson passed the time carving miniature totem poles, and discovered he had both a knack and a love for them. He attended the Institute of American Indian Arts, in Santa Fe, New Mexico, and subsequently embarked on a career as an artist.

Jackson has carved masks, canoes, doors, and other objects. He is an acclaimed metalworker who has fashioned some wondrous pieces from gold and silver. He is highly regarded as a traditional Tlingit dancer. He is widely admired as a mentor to aspiring artists. But it is his traditional totem poles that have made him an icon. Before putting his adze to wood, he learned the stories and protocols and symbols so he could carry on and spread the traditional ways with authenticity. He has gone on to carve more than 50 poles—and counting. His poles and other works are on display in museums, universities, and public spaces throughout Alaska, not to mention the National Museum of the American Indian, the Field Museum in Chicago, Harvard's Peabody Museum, and museums in Europe and Japan. Notably, his totem poles and other creations also beautify Ketchikan; he has not outgrown his Southeast Alaska roots. He often has worked on some of his totem poles in public, at the carving shed adjacent to Saxman Totem Park, and likely will continue to do so as long as he can. When he passes on, one can only hope that another accomplished Tlingit artist carves a memorial totem pole in his honor.

One of the few other Alaska tribes that carve totem poles is based about 15 miles south of Ketchikan on Annette Island. Most Tsimshian people live in Canada, but a bit more than 1,000 live on the island, mostly in the town of Metlakatla. Their ancestors arrived here en masse in the late 19th century, led by Tsimshian leaders and a Church of England missionary named William Duncan. More precisely, a former missionary, as Duncan had by that time been expelled from the missionary service.

Duncan harbored visions of creating a utopian Christian community, and he convinced several dozen Tsimshian in British Columbia to join him in this quest.

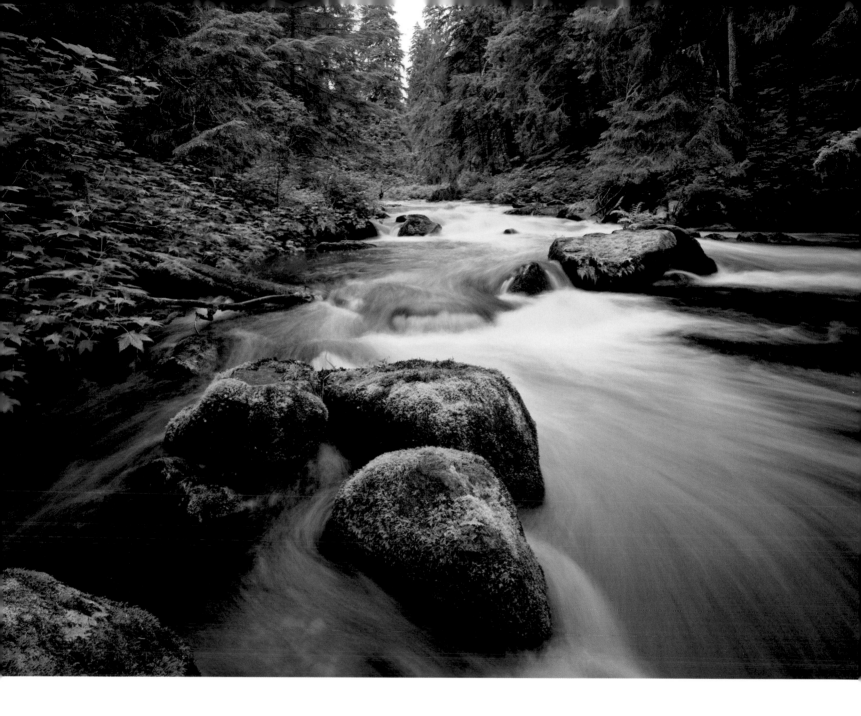

Over the next few years, hundreds of others joined, some prompted by how well the community fared during a smallpox outbreak that killed many people in surrounding places, a discrepancy that Duncan played up as divine approval of his efforts. In 1881, his doctrinal conflicts with the Church of England plus his attempts to rigidly micromanage the lives of the Tsimshian finally compelled the church to expel him.

Undeterred, Duncan decided to take his utopian vision to Annette Island. He eventually persuaded the U.S. government to make the island an Indian reservation, and in 1887, he and some 800 Tsimshian paddled by canoe to their new home. To this day, it is the only federal Indian reservation in Alaska. Duncan helped Metlakatla prosper by establishing schools, businesses, and health care, yet his good works are somewhat darkened by his dictatorial tendencies, which often took the form of

The temperate rain forest harbors countless rushing streams, such as Lower Checats Creek in Misty Fiords National Monument. When 80, 120, or even 150 inches of rain falls every year, all that water has to go somewhere.

WORTH A VISIT

Saxman Totem Park

Ketchikan is the center of Alaska's totem pole universe. Many poles are displayed in buildings around town, while scores of others, such as this one in Saxman Totem Park, brave the elements. Local artists continue to carve new poles, ever freshening the collection.

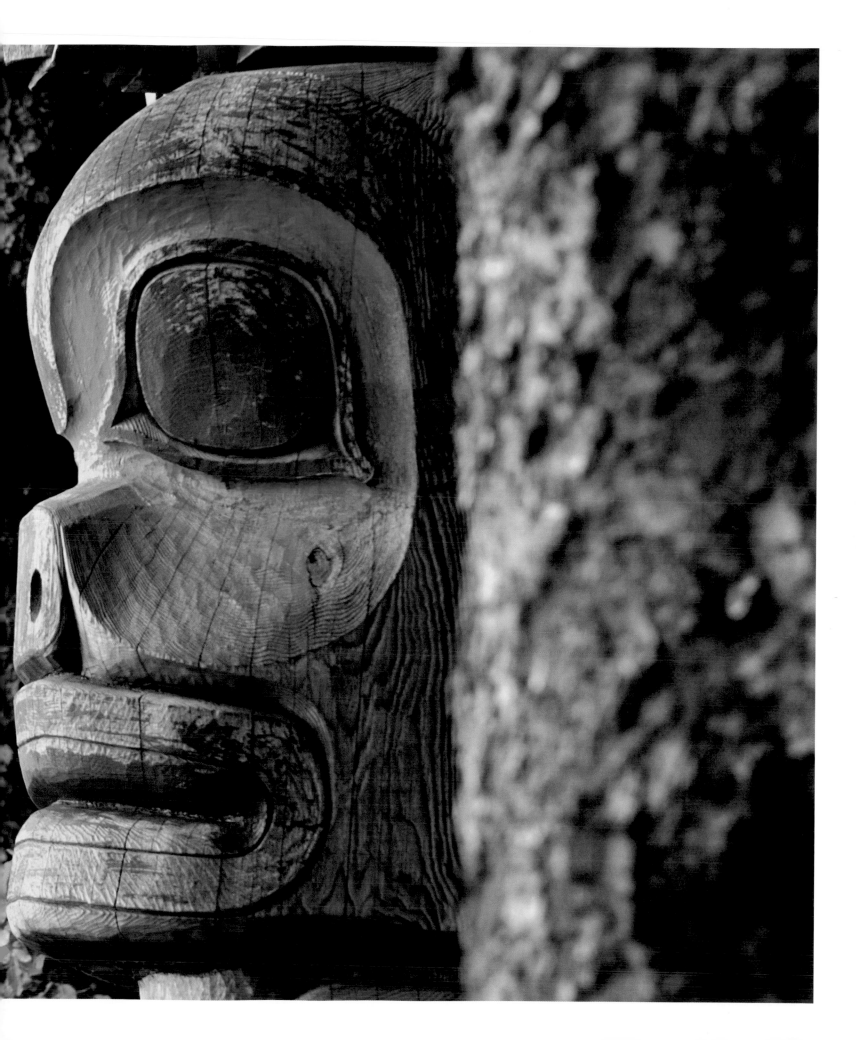

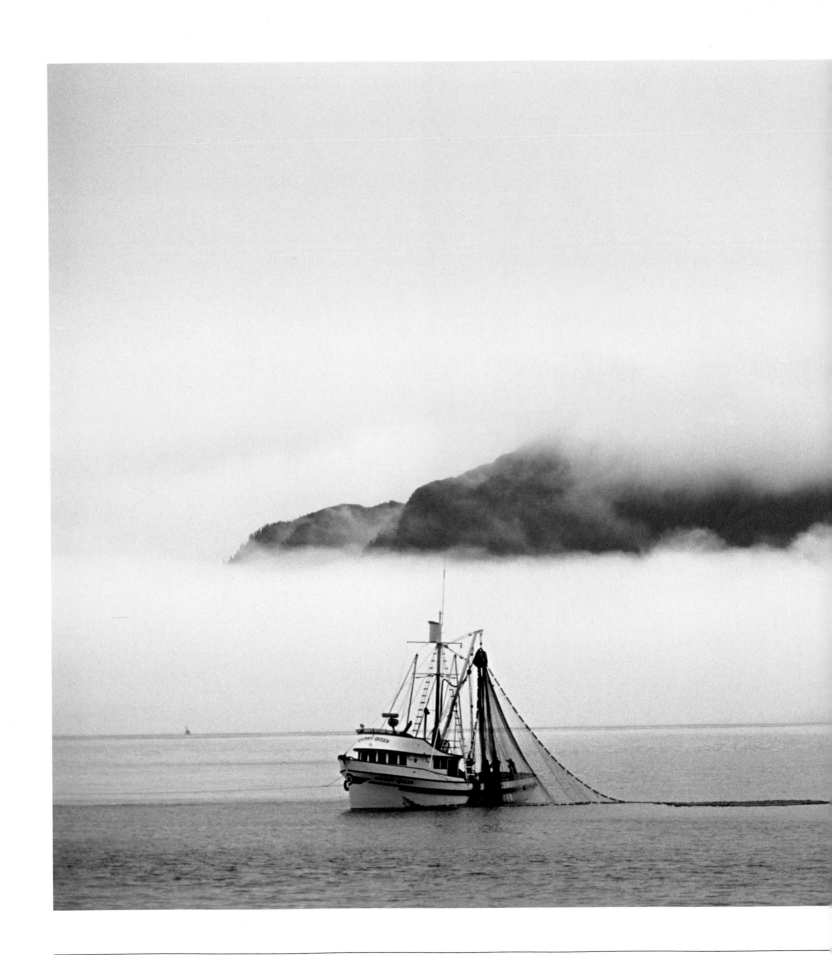

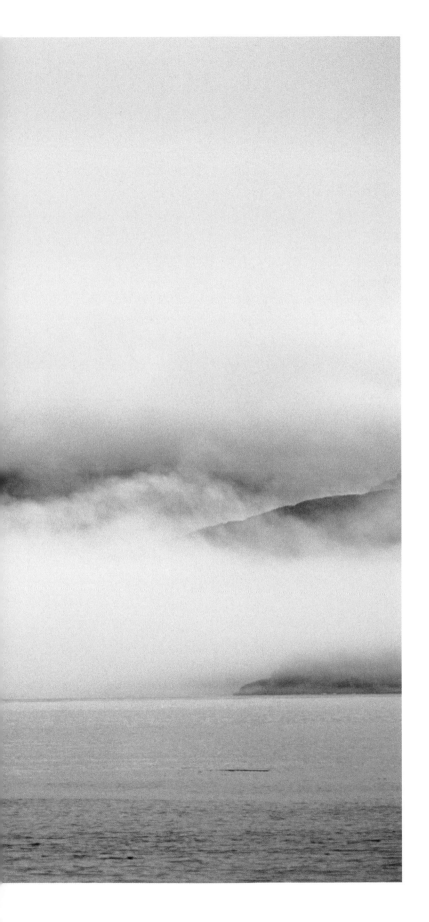

Travelers aboard ferries and cruise ships share the fertile waters of Southeast Alaska with the region's hardworking residents, such as this commercial fisher in Icy Strait.

suppressing traditional Tsimshian culture. His infamous list of rules included many practices that he insisted the natives forsake, such as painting their faces, gambling, seeking help from "conjurors" when ill, and, in general, ceasing their "Indian devilry." Quietly, some Tsimshian kept their old ways alive while also embracing aspects of the new ways, and in the 20th century, long after Duncan's death in 1918, the traditional culture experienced something of a renaissance, which continues today.

> **"There are strange things done in the midnight sun / By the men who moil for gold / The Arctic trails have their secret tales / That would make your blood run cold . . ."**
>
> **[Robert Service, poet]**

Travelers eager to taste the wilds of Southeast Alaska can find plenty of trails to hike, wildlife to watch, and backcountry lakes in which to fish, but people who want to skip that little taste and take a big gulp may want to head east 30 or 40 miles to Misty Fiords National Monument. Misty Fiords' 2.2 million acres, most of it designated wilderness, range from the Behm Canal (a natural channel that marks the eastern boundary of the island where Ketchikan is located) to the Canadian border. It's a realm of tumbling waterfalls, glaciers, salmon-snagging grizzlies, mountains, humpback whales, and icy-cold creeks and rivers. And, as its name promises, the monument is often misty (this is prime rain forest, after all), and it is riven with very long and very narrow fjords that invite exploration. Fortunately, several outfits in Ketchikan run Misty Fiords tours by boat or plane or a combination of both.

Instead of taking a boat out of the Ketchikan harbor and heading southeast through Tongass Narrows toward Misty

Fiords, most boat traffic heads northwest toward . . . well, toward almost everything else in Southeast Alaska. This is the start of the Alaska section of the fabled Inside Passage: about 300 miles as the raven flies, much farther as the boat sails. This protected route weaves among the islands, out of reach of the gut-wrenching turmoil of the open Pacific (such an inaptly named ocean, at least way up here in its tempestuous northern reaches). Not that the Inside Passage lacks navigational challenges—sandbars, tidal rips, suckholes, icebergs, summer fog, strong currents, and even occasional whirlpools lurk out there—but an experienced skipper can easily handle them, and they sure beat pounding through 20-foot seas.

Most Inside Passage voyagers don't have to worry about navigation because they travel on ships that take care of such matters. The scenic beauty of this route draws hundreds of thousands of passengers on cruise ships every year. The vast majority are massive ships, some of which carry more than 2,500 passengers plus crew. They feature wine tastings, casinos, art galleries, pools, spas, rock-climbing walls, cabarets, computer workshops, boutiques, Vegas-style musical shows, and, of course, those legendary buffets that offer food in such quantities that it would sink a smaller ship. These cruises tend to be more about the experience on the ship and less about the world outside, but they do offer brief shore excursions, and there's certainly nothing stopping passengers from just sitting on the deck and inhaling the grandeur of the Inside Passage.

Travelers who want to take a cruise but who also want to get up close and personal with Southeast Alaska can choose among a number of companies whose ships carry anywhere from a few people to a few hundred. Being smaller and having a shallower draft, they can worm into tight spaces and poke into shallow waters, which gets passengers closer to wildlife, glaciers, waterfalls, and other sights. Most important, they focus on the land outside the ship, not the entertainment inside. Many of these small ships bring along expert naturalists or knowledgeable Alaska natives who give talks and lead excursions. And those shore excursions usually are longer than those offered by the big ships and often visit more out-of-the-way places.

And then there's the Blue Canoe. This is an Alaska nickname for the state ferries, more formally known as the Alaska Marine Highway System. Ferries ply the waters all around southern Alaska, but they're especially vital to the southeast, what with its paucity of roads and many island communities. Out-of-state travelers certainly use the Blue Canoe, but most of the passengers are locals, which actually makes the

Cold-Water Diving

A tropical paradise it is not, but Southeast Alaska draws a number of hardy scuba divers who want to explore these biologically rich waters. Sea stars, jellies, corals, eels, giant Pacific octopuses, anemones, and even sea lions and whales are among the underwater sights. Yes, the water is cold—about 45°F—but that's why people wear dry suits instead of wet suits. And some divers venture near tidewater glaciers and go home with stories of sitting on icebergs while resting.

ferries all the more interesting for out-of-state travelers because they are privy to a revealing slice of Alaska life.

The ferries have been described as floating towns, which is an apt description, given how little most Alaska communities are. The smallest of the 11 ferries is designed to tote a maximum of 149 passengers, and the largest, the *Columbia,* can handle 932, plus 68 crew; that's an even 1,000, which would make the *Columbia,* when fully loaded, the 28th largest city in Alaska. Travelers aboard the ferries will see local schoolchildren going on field trips; inhabitants of towns with populations of a few dozen going to shop in towns with populations of a few thousand; grandparents going to visit grandchildren; people who are riding the ferry for the sole purpose of doing their taxes away from the distractions of home; high school basketball teams heading for away games; and salespeople on their way to call on customers. More unusual events also take place on board now and then, such as weddings and childbirths. Several kids are named "Malaspina," for example, because they had the misfortune to be born to impressionable parents on the ferry of that name.

The ferries of the Alaska Marine Highway System become temporary communities as they haul residents and visitors throughout Southeast Alaska. Often, passengers without staterooms will pitch tents (freestanding, no stakes) on the decks.

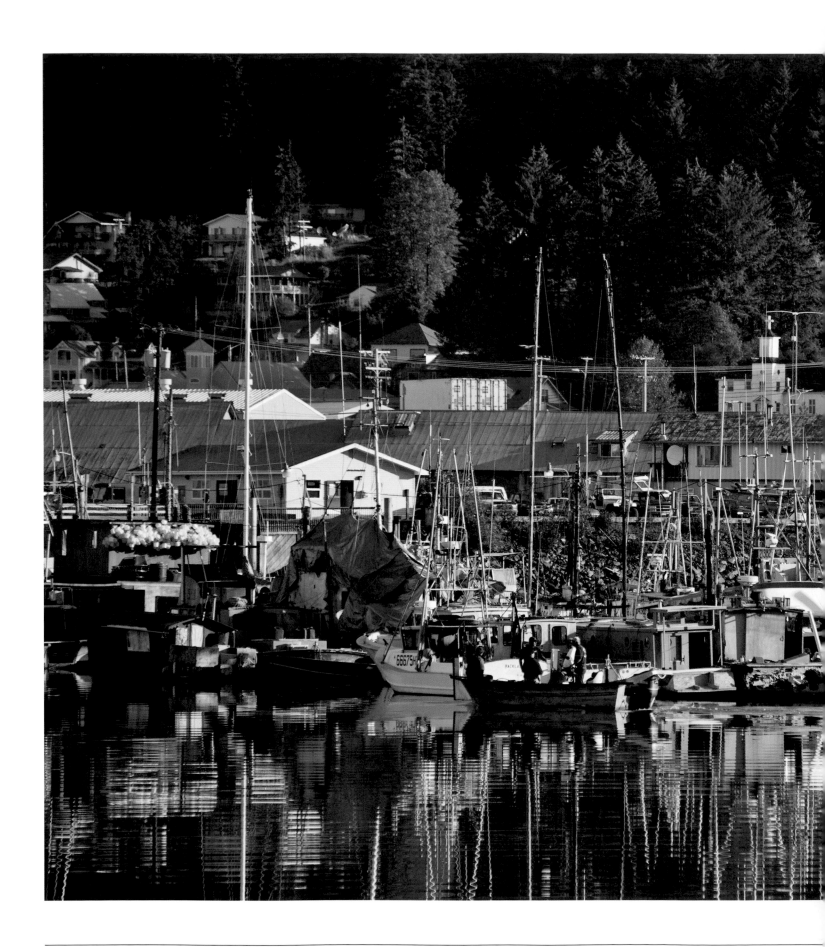

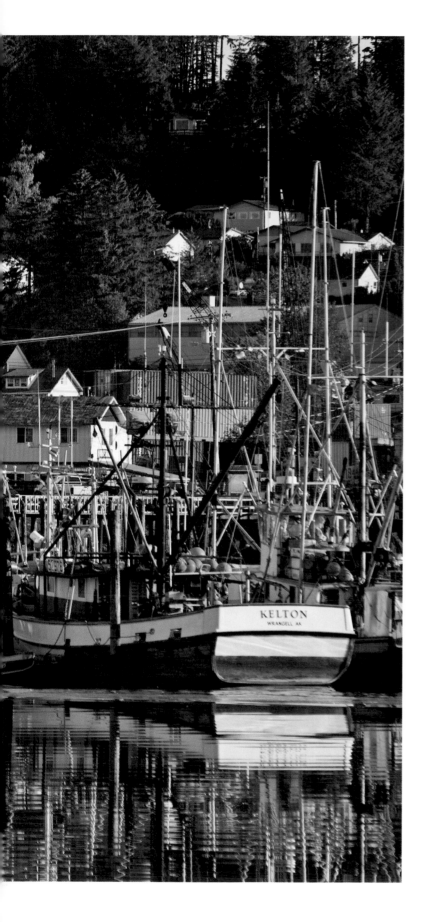

Like many of the little towns and villages in Southeast Alaska, Wrangell almost seems to have more boats than people.

Because the marine highway serves locals, it goes to lots of smaller communities, not just the half dozen major ports of call that the big cruise ships frequent. For instance, travelers could take a ferry to Kake, a largely Tlingit settlement of about 550 people on the northwest shore of Kupreanof Island. It's an untouristy place with an economy based on commercial fishing, logging, and a subsistence lifestyle—and it is home to Alaska's tallest totem pole, which thrusts more than 130 feet into the mist. Or if Kake seems too big, perhaps a ferry ride to Pelican, a fishing village of fewer than 100 full-time residents on Chichagof Island. Most of the town is built on pilings above the tidelands, and the main drag is a raised boardwalk.

Marine highway travelers looking for a town with more amenities than Pelican or Kake but less bustle and large cruise ship traffic than Ketchikan or Skagway should try Wrangell, the next main ferry port north of Ketchikan. This community of about 2,400 receives 10 or 12 cruise ship visits a month during the summer, but almost all of them are small vessels with perhaps 60 or 70 passengers; only now and then does a ship in the 500-passenger range drop anchor there, and rarely if ever does a 2,500-passenger leviathan come calling.

Ambling through Wrangell's tidy waterfront and downtown—and it's the kind of place that induces one to amble—visitors will come across such locals-oriented businesses as a grocery store, some down-home cafés, a hardware store, the iconic Grandma's Barber Shop, a marine repair shop, the Elks lodge, the Marine Bar, and the office of the *Wrangell Sentinel*,

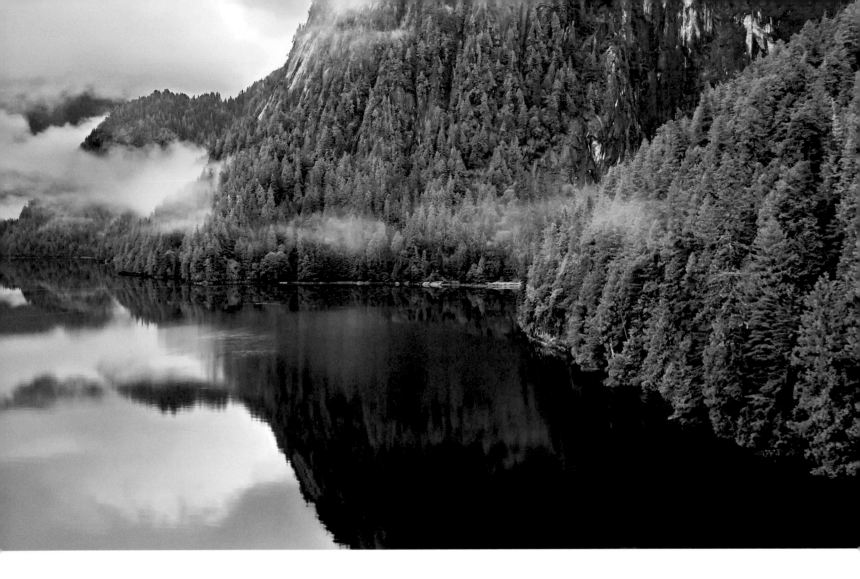

The terrain on the islands and mainland of Southeast Alaska can be imposingly rugged, which is one reason that most travel is done by boat and plane. Only Haines and Skagway, in the far north of the region, are connected to the rest of Alaska by road.

a weekly newspaper that bills itself as the oldest continuously published paper in Alaska. A gallery, charter fishing outfits, bed-and-breakfasts, a hotel, and other establishments aimed at outsiders are also part of the mix, but they seem secondary. A resident once characterized Wrangell as the kind of place where 90 percent of the citizens turn out for the Fourth of July parade.

Connected to downtown by a short footbridge, diminutive Chief Shakes Island beckons to amblers with its totem pole and a replica of a 19th-century Tlingit tribal house, lovingly restored in 2013. Just how long the Tlingit have inhabited the area remains a mystery, but it may have been for thousands of years. Clues to this mystery can be seen about a mile north of the ferry dock at Petroglyph Beach State Historic Park. Clustered below an observation deck are several dozen rock carvings. The age, origin, and meaning of these highly stylized impressions of birds, humans, and killer whales remain unknown, but experts think it likely that the artists are ancestors of the Tlingit. In keeping with Wrangell's informality, the petroglyphs are not fenced off; visitors can walk among them and look point-blank at the carvings.

Travelers who want to learn more about the area's native and Euro-American history should make a beeline for the Wrangell Museum, a spacious facility opened in 2004 that

houses collections of such number and quality that they would seem at home in a city ten times Wrangell's size. Four carved wooden house posts grace the entrance, Tlingit artifacts from the 18th century that are believed to be the oldest of their kind in Alaska. The gold rush displays also merit close attention. Three times, Wrangell served as a jump-off point for gold rushers heading up the nearby Stikine River into Canada—for the Stikine rush in 1861, the Cassair rush in 1872, and the Klondike in the late 1890s.

For a mere ten days during the Klondike mania, until he found out his wife was pregnant and they returned to San Francisco, famed lawman Wyatt Earp filled in as deputy marshal in Wrangell. His short stint was largely uneventful, but one time he took a pistol away from a disorderly man only to recognize him as a guy Earp had arrested 20 years earlier in Dodge City. By leaving, Earp missed some wild times, arguably as wild as those rowdy Dodge City days. Reporting on Wrangell in the January 1899 issue of *National Geographic,* a writer described that "a score of saloons ran wide open," and that "the most barefaced gambling games and swindling schemes were conducted on every side without concealment." Summing up, the author concluded that "this 'boomtown' of 6,000 inhabitants displayed all the worst features of such lapses in civilization."

The gold rush days are long past, but the Stikine, the river up which prospectors traveled to the Canadian gold fields, still flows from 330 miles deep in British Columbia, cutting through the coastal mountains to pour into the waters of the Inside Passage just a couple miles north of Wrangell. Like an all-pro linebacker, the Stikine is big but it's also fast—the fastest-flowing navigable river in North America. It hauls a huge amount of sediment and dumps it into the waters near its broad mouth, forming an extensive delta. The mudflats and sandbars in this delta teem with juicy invertebrates that attract millions of migrating shorebirds every spring. Hundreds of thousands of gulls and about 2,000 bald eagles (the largest springtime concentration of baldies on the continent) also show up around the same time to feed on a big run of hooligan (a small, oily fish). All this avian action is the focus of Wrangell's Stikine River Birding Festival, held every April.

Small guiding outfits based in Wrangell will take visitors into the delta and, if they want, farther up the Stikine into the Tongass National Forest. A few people go on an overnight adventure 130 miles upriver to the tiny town of Telegraph Creek, in British Columbia, but the vast majority are content with a half-day or day trip that motors 10 or 15 miles into

DID YOU KNOW?

Muskeg Meadows

Local golf enthusiasts carved a regulation nine-hole course out of the muskeg (bog) and forest on the edge of Wrangell. It's rated moderate/difficult by the U.S. Golf Association due to the narrow fairways bounded by dense forest. The fact that golfers must watch for roaming bears and moose may also nudge that rating toward the difficult end of the spectrum. And Muskeg Meadows likely is the only course with "the Raven Rule": If a raven steals a player's ball, he may replace it without penalty, provided there is a witness.

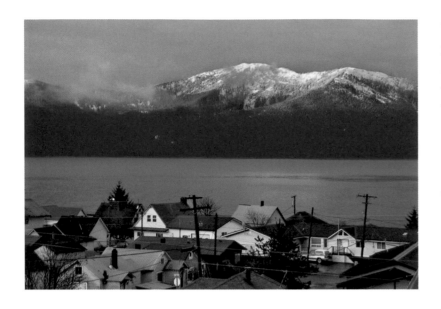

The little town of Wrangell is comfy and unpretentious, but its location at the tip of Wrangell Island surrounded by the Tongass National Forest is grand indeed.

the interior. As they leave the delta behind, boaters pass verdant islands and riverside flats backed by steeply rising forested mountains. Alert passengers will often see moose munching in the wetlands and bears rambling along the banks. Sometimes guides stray from the main stem and ease up narrow side channels, some of which measure just 20 or 30 feet across and are almost turned into tunnels by arches of willows and cottonwoods. The group may take a short side trip up Andrew Creek, leaving the silty-brown rush of the Stikine and entering the clear waters of the creek, which wriggle with spawning king salmon in midsummer. Some guides bring fishing gear for guests who want to try to hook a savory dinner.

About five miles upriver from Andrew Creek bubbles Chief Shakes Hot Springs. The Forest Service pipes its toasty waters into a couple of hot tubs, one indoors and one out in a meadow at the edge of the forest. To reach Chief Shakes Hot Springs, visitors put in at the head of Shakes Hot Springs Trail near the entrance to Shakes Slough, which leads to Shakes Lake bordered at the end by Shakes Glacier. No doubt one of the peaks in the vicinity would have been named "Mount Shakes" had that name not already been bestowed upon a summit south of Wrangell. The reason so many sites bear the name "Shakes" is that there was not just one Chief Shakes but a bunch of them; this hereditary title has been passed from one chief to another in the Wrangell area from the 18th century to the 21st century.

Some guides make the Shakes Glacier their turnaround point. They steer up the five-mile-long finger of Shakes Lake, flanked by hulking mountains thick with trees. Binoculars reveal scrape marks on the dark stone of the cliffs—ancient scars left by the grinding of the glacier back when the frozen river, raspy with silt and rocks it had picked up along the way, had slowly pushed across the land where the lake rests today. Mountain goats climb about on the upper reaches of the slopes and often are sighted by passengers, as are black bears that forage in the meadows and along the shore. If it is spring and the ice hasn't entirely melted from the lake, the guide will stop short of the glacier when he encounters the icy veneer near its face, perhaps cutting the engine and letting the boat drift. In the profound quiet, passengers can hear the thin ice at the edge of the frozen surface breaking up as the backwash from the boat gently swells beneath it. It makes a resonant, musical sound, like wind chimes tinkling in a soft breeze.

Ships continuing north from Wrangell often expand their itineraries by adding a westward detour to Sitka. The marine highway route to Alaska's fourth largest

Opposite: Dozens of mysterious petroglyphs, perhaps thousands of years old, decorate rocks on a beach just north of Wrangell. Even native elders don't know their origins.

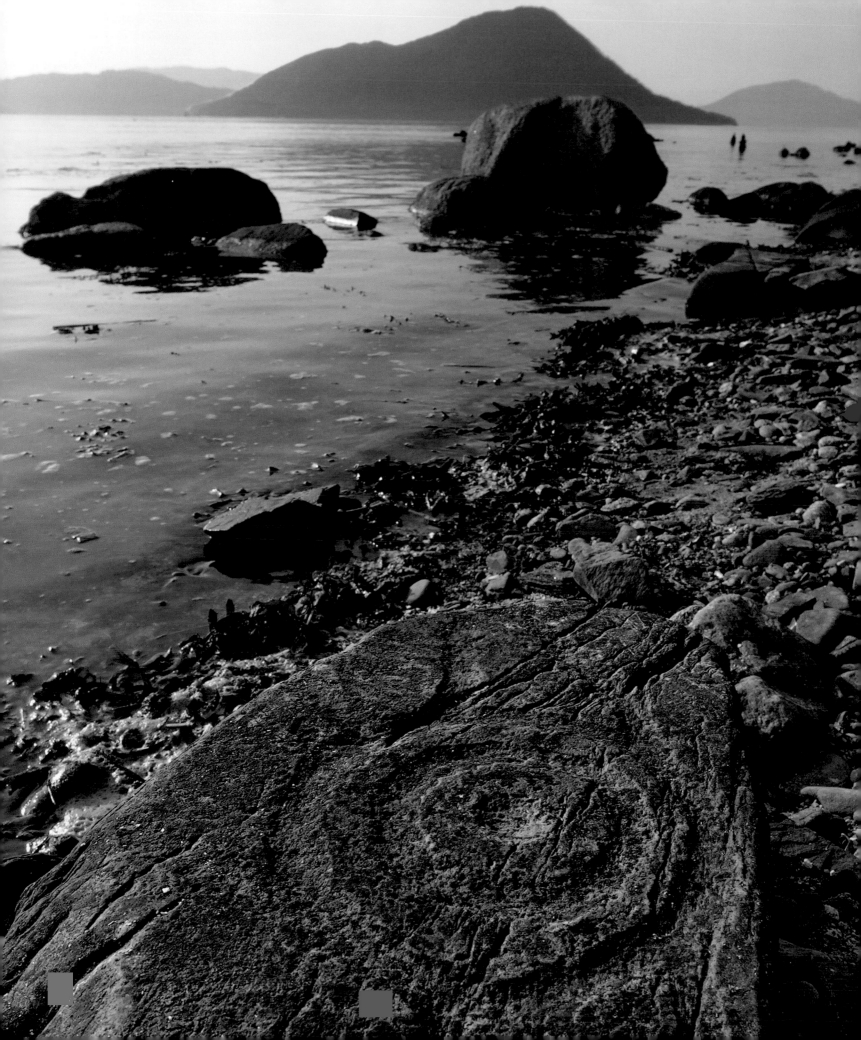

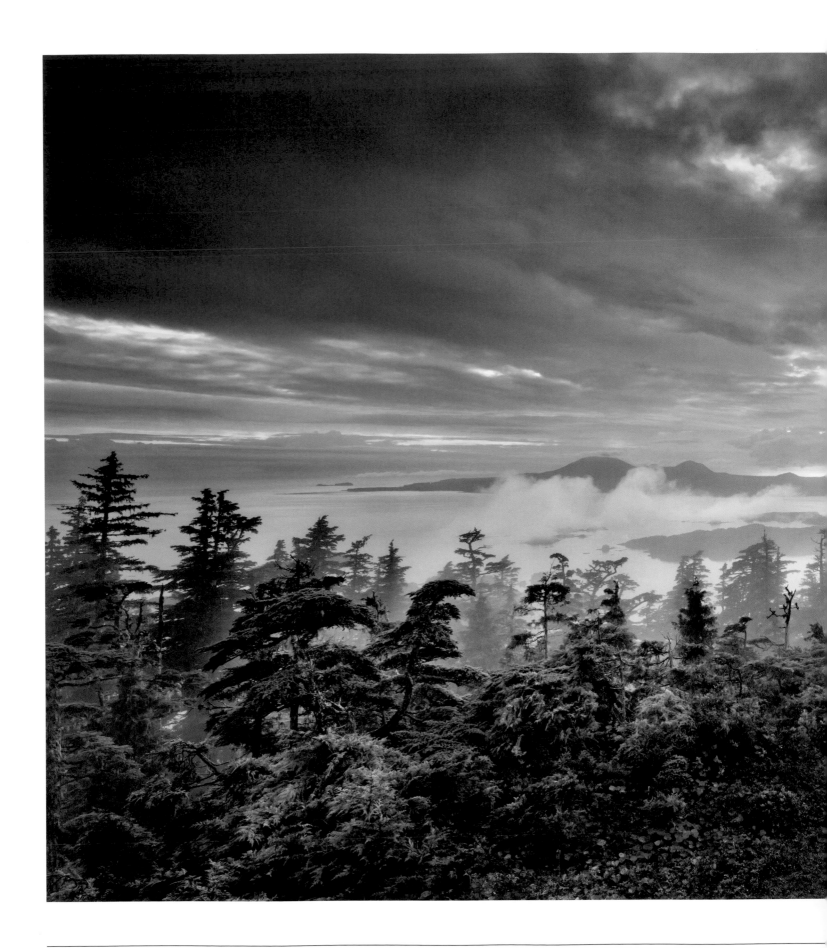

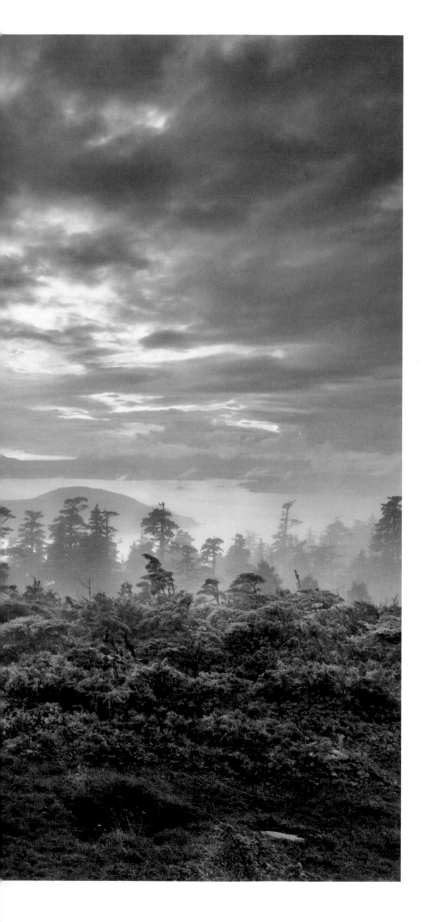

Hikers who reach the top of Harbor View Mountain are rewarded with panoramic views of Sitka Sound.

town is classic Inside Passage, twisting and turning among the islands and squeezing through slender channels with names like Sergius Narrows and Peril Strait. Yet, just a few miles before the ferry reaches Sitka, it comes out of hiding and sails into Sitka Sound—basically the open Pacific except for a little protection provided by Kruzof Island. So the town is more of an honorary member of the Inside Passage than a geographical resident.

Despite existing on Baranof Island on the outer edge of Southeast Alaska—in fact, to some degree because of it—Sitka played a key role in the early Euro-American history of the

> 66 I saw . . . the imposing fronts of five huge glaciers . . . This was my first general view of Glacier Bay, a solitude of ice and snow and newborn rocks, dim, dreary, mysterious. 99
>
> **[John Muir, conservationist & author]**

state. Due to its location, the original Tlingit settlement at what is now Sitka was recorded by Vitus Bering on his 1741 voyage of exploration for the Russian government. He noted the area's potential, and the Russians didn't forget. In 1799, when they were looking to expand their fur trade in Alaska, they headed for Sitka and set up shop there.

However, the local Tlingit had serious misgivings about the Russian presence. They knew that the Russians had put their boots on the necks of the Unangan, and worried that they might suffer the same fate. For a few years, the Tlingit tolerated the Russians but their smoldering distrust burst into flames in 1802, and they attacked Redoubt St. Michael, an outpost several miles northwest of Sitka. They killed nearly all the post's occupants, perhaps as many as 80 people.

The Russians backed off briefly, but in 1804, they returned along with an army of several hundred Unangan hunters. Having anticipated the

return of the Russians, the Tlingit had built a formidable fort just east of Sitka, to which they withdrew when the Russian force approached. Russian gunboats shelled the fortress, but to little effect. Then the Russians and Unangan stormed it, but suffered many casualties and failed to breach its walls. For the next six days, they laid siege to the fort; then, on the seventh day, they attacked once again and met no resistance. The Tlingit had slipped out of the fort overnight and retreated into the mountains.

The fur traders proceeded to build a substantial settlement on the site of the former Tlingit village. Named New Archangel, it became the capital of Russian Alaska in 1808. In 1821, the Russians invited the Tlingit to return to Sitka, not as oppressed losers of a war but as free people. The Russians apparently hoped to put a stop to Tlingit raids as well as to profit from the natives' knowledge of the region and their hunting skills. The Tlingit accepted the invitation and built a village just outside the stockade walls of the core Russian town. They sold a lot of food to the Russians, which made life for the Russians easier because obtaining provisions locally was far easier than shipping them in from Siberia. The Russians also taught the Tlingit how to grow potatoes, which the Tlingit did quite successfully, and then in turn used the potatoes to trade with the Russians. The fact that vodka can be made from potatoes surely had nothing to do with the Russians' interest in this particular vegetable.

The Russians and Tlingit coexisted peacefully enough for the next few decades. In addition to their business dealings, their cultures mingled, and some Tlingit converted to the Russian Orthodox Church. Meanwhile, New Archangel grew into a surprisingly sophisticated town by the mid-1830s, dubbed by one admittedly overheated visitor as the "Paris of the Pacific," though its refinements were mainly reserved for the Russian elite. And the suspicions born of the 1802 and 1804 battles never entirely dissipated; the Russians always kept some of the cannons in their stockade aimed at the Tlingit village.

Several notable remnants of the Russian era remain in contemporary Sitka—an appealing town of about 9,000 residents which, though it may not be the Paris of the Pacific, comes much closer to deserving that title now than it did in the 1830s. A tour of Russian times might start at the Russian Bishop's House, a part of Sitka National Historical Park. Built in 1842, this is one of the oldest Russian structures left in Alaska. The bishops who lived there were people of great power, overseeing an Orthodox diocese that ranged from California to Siberia. The elaborate

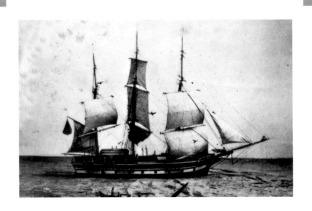

HISTORY & CULTURE

The Bombardment of Angoon

In 1882, a harpoon gun aboard an American whaling ship exploded and killed a Tlingit sailor. His people in the community of Angoon asked for a payment of 200 blankets as compensation. The captain of a naval vessel stationed in the area somehow took this as a sign of insurrection, so he sailed to Angoon and demanded that the villagers pay him 400 blankets by noon the next day or he would shell the village. They couldn't, and he did. Tlingit sailors aboard the naval vessel shouted warnings and most of the villagers escaped, but six children were killed and most of Angoon was leveled. An American officer on the naval ship wrote: "Most of the officers including myself consider it [the bombardment] a brutal and cowardly thing and entirely uncalled for." In 1973, a court awarded Angoon a $90,000 settlement.

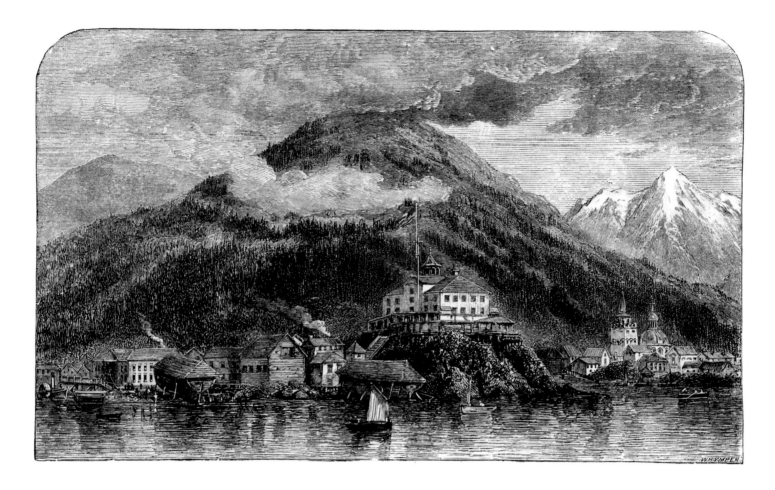

robes and other clerical garments on display in the house hint at the bishops' prestige. Other items shown in the house include old hymnals, a monumental brass samovar, muskets, old Russian coins, a sea otter pelt, and an 1862 Russian Orthodox bible.

The main part of the historical park occupies more than 100 prime acres on Sitka Sound, not far from the Bishop's House. The park was established as a national monument in 1910 to commemorate the 1804 battle between the Russians and the Tlingit, but its focus extends well beyond the Battle of Sitka to cover many aspects of Tlingit and Russian-Alaska history and culture. One of the highlights is the Southeast Alaska Indian Cultural Center, where visitors can watch Alaska native artists at work, perhaps carving a totem pole or weaving a cape.

Baranof Castle State Historic Site provides another glimpse of Sitka's Tlingit-Russian past. Called "Castle Hill" by the locals, the national historic landmark was the site of a Tlingit fort before the Russians took over, and the site of a Russian fort after the Russians took over following the Battle of Sitka. The Russians remained on the site until they sold Alaska to the United States in 1867. In fact, that deal was signed in a ceremony atop Castle Hill.

The Russians' decision to peddle Alaska was no whim, but rather a considered judgment based on economic realities and international politics. Regarding the former, for

With a population of nearly 9,000, Sitka looks very different today than it did in 1867, when the United States bought Alaska from the Russians. Even the name has changed; when it served as the capital of Russian Alaska, it was known as New Archangel.

Passing through Southeast Alaska's temperate rain forest, this hiker is on his way from Sitka to Baranof Warm Springs. This wet forest is one of the most biologically productive places on Earth.

many years, the Russians' pursuit of sea otter pelts and fur seal hides became increasingly unrewarding as the animals' populations declined. Their efforts to find a significant new source of furbearers failed, even when they pushed hundreds of miles up the Yukon River, deep into Alaska's interior. Coal-mining enterprises in Alaska flopped, Russian gold seekers returned empty-handed, and attempts at whaling produced little. The tsar and his advisers began to think that Alaska was losing its ability to make them rich (well, richer).

Furthermore, in the realm of international politics, Alaska was beginning to look like risky business. Russia had lost a war to Great Britain and allies in Crimea in the 1850s. The Russian government worried that they wouldn't be able to defend Alaska against the British, who already maintained a strong presence on the west coast of North America. Perhaps the final factor was the realization that the virgin territory of the Amur River Basin in China was much closer to home and probably far richer in unexploited resources, suggesting the wisdom of redirecting their focus to that part of Asia rather than Alaska.

By the time 1860 rolled around, the Russians were ready to sell, and the Americans, with visions of their "Manifest Destiny" to control the entire continent dancing in their heads, were interested in buying. Emissaries of the two nations talked a bit, but before they had a chance to work out a deal, the U.S. Civil War broke out, in 1861, and the United States was preoccupied for the next few years. But after the war negotiations resumed and in March 1867, U.S. Secretary of State William Seward and Russian envoy to the United States Eduard de Stoeckl signed the treaty. The official ceremony transferring ownership took place atop Castle Hill in October of that year.

When travelers soaking up the history on Castle Hill look up from the park's interpretive panels, they may notice another striking quality of Sitka's—its setting is drop-dead gorgeous. Though less than 100 feet high, the summit offers a 360-degree view of the rain forest and mountains to the north and east, and Sitka Sound and the open Pacific to the south and west.

Unlike most of Alaska, the Sitka area has some trail systems, making it relatively easy for visitors to explore a little bit of those forests and mountains. Perhaps the most appealing combination of good trails and diverse landscapes can be found at Starrigavan Recreation Area, a part of the Tongass National Forest just north of town. The estuary created by the entry of Starrigavan Creek into Starrigavan Bay forms the heart of this property. Bird-watchers favor early morning walks on the boardwalk that meanders through the estuary's marshes. During the late spring and early summer, the meadows brighten with the blooms of wild geranium, buttercup, yellow paintbrush, and the lovely but smelly chocolate lily. Midsummer brings a run of pink salmon to Starrigavan Creek; sometimes they're so abundant in the gravelly shallows of the spawning beds that it seems a person could walk across the creek on the backs of the fish. Sitka black-tailed deer and brown bears also roam the estuary. Baranof Island is the "B" of the so-called "ABC islands" (Admiralty, Baranof, and Chichagof), home to the highest concentration of brown bears in the world, so visitors need to stay alert and follow bear safety basics.

Around the estuary lies full-fledged rain forest: moss-bound, 100-foot western hemlock and Sitka spruce forming a canopy above a riot of understory vegetation that includes red huckleberries, ferns, blueberries, and ground-covering mosses and liverworts. Deer ferns, beech ferns, maidenhair ferns, and fir club moss cling to damp rock faces. In places, the forest opens up and the trails cross "muskegs"—a word many Alaskans use to refer to bogs. Boardwalks lift hikers above the spongy sphagnum moss-and-sedge mat and the ground-hugging evergreen shrubs, such as bog laurel, Labrador

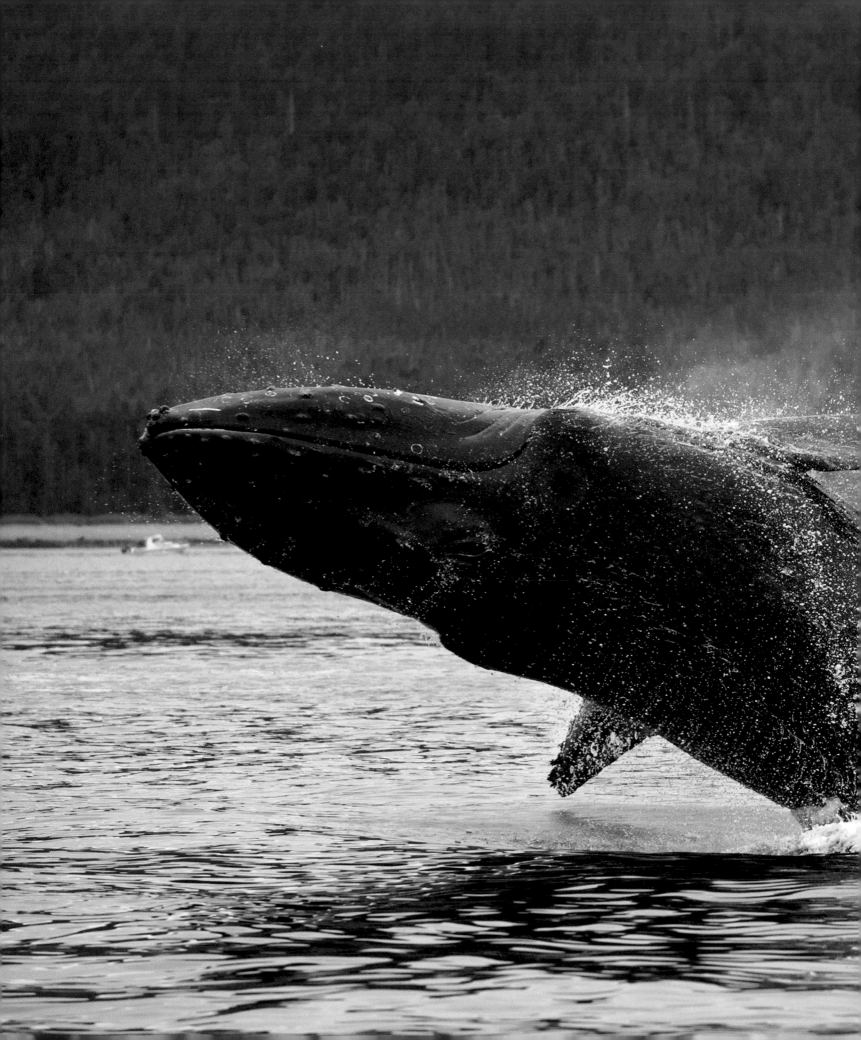

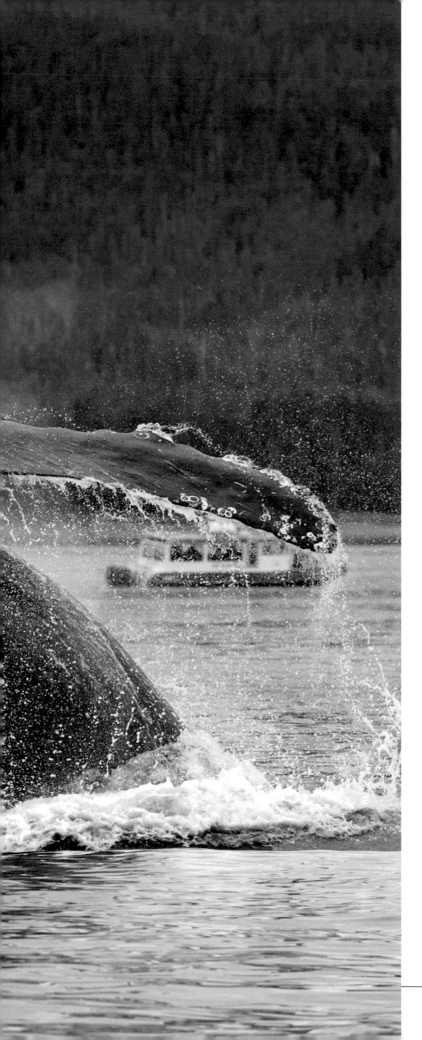

Hundreds of humpback whales feed in the rich waters of Southeast Alaska during the summer. When not eating, they sometimes breach, launching their 45-foot bodies almost entirely out of the water.

tea, crowberry, bog rosemary, and cloudberry. Wildflowers are part of the mix during the warm seasons and include swamp gentian, pond lily, and bog orchids. A less benevolent bog-loving species also inhabits these muskegs—the yellow-and-red sundew, a carnivorous plant that lures insects to their deaths.

Travelers could get mesmerized by the rain forest and spend all their time in its shady bosom, but they would do well to

remember the other half of those panoramic views from the top of Castle Hill. Sitka is a seaside city, a port whose various harbors and anchorages brim with commercial fishing boats, ferries, cruise ships, personal vessels from yachts to dinghies, water taxis, and a wide variety of charter boats.

Most of these charter boats cater to anglers, but some offer tours of comely Sitka Sound. Just as looking down on the sound from Castle Hill is wonderfully scenic, so is looking up from the sound at the surrounding landscape, ranging from the fringing forest to the backdrop of snowy mountains to the lopped-off volcanic cone of Mount Edgecumbe rising 3,201 feet from the southern tip of Kruzof Island, at the entrance to the sound. However, handsome as the vistas are, the wildlife arguably outshines them.

Before the tour boat even leaves the harbor, passengers will see bald eagles hanging about on pilings, hoping for scraps from fishing boats. Once into the sound, but close to shore where the kelp beds are, the boat likely will encounter sea otters, often a raft of maybe 10 or 15. Typically, the guide will kill the engine and

drift about 100 feet from the otters so people can really watch them and not just see them; watching implies activity, and unless they're snoozing, sea otters tend to be energetic critters. Most of their efforts revolve around food: diving to grab crabs and shellfish; cracking them open with a rock; floating on their backs and using their torsos for tables as they eat; rolling over several times to wash off the scraps. There's rarely a dull moment when otters are dining.

As tour boats move farther out into the sound, guides tell passengers to be on the lookout for the steamy spouts of whales. Humpbacks frequent Sitka Sound during the summer, migrating here from Hawaii to fatten up in these highly productive waters. Some make the 3,000-mile journey from the 50th state in just over a month. In fair weather, some tour boats go as far as St. Lazaria Island, just off the southern tip of Kruzof Island. Part of the Alaska Maritime National Wildlife Refuge, the island is basically a huge rock, some of which is covered by forest or grassy meadows. The surface of St. Lazaria only amounts to 65 acres, yet more than half a million seabirds nest here in the summer—that's more than 7,000 birds per acre. Of course, many of the birds are off the island at any given time, often close by diving into the water for food or swirling overhead like wind-driven autumn leaves. Among the 11 species that nest on St. Lazaria are pelagic cormorants, thick-billed murres, and those perennial favorites, tufted puffins. The most abundant species is the storm petrel, which nests by burrowing into the ground. The rhinoceros auklets and ancient murrelets likewise nest underground; one reason no one is allowed to land on the island is that walking on top of these burrows might cause cave-ins.

Travelers on the ferry or cruise ships depart Sitka and plunge back into the protective embrace of the Inside Passage, eventually popping out into the major north–south corridor of Chatham Strait. Those who turn north soon come to the end of the strait and a fork in the marine road—continue north up the Lynn Canal to Juneau, Haines, and Skagway, or bear west to Glacier Bay National Park.

Those who bear west should also bear in mind the adage "the journey is half the fun" because the 40-mile channel leading from the fork in the road to the entrance to Glacier Bay is a wondrous place in its own right that goes by the name of Icy Strait. The cold, fertile waters of the strait draw all sorts of marine life, including a who's who of ocean megafauna, such as gray whales, sea lions, killer whales, harbor seals,

Whale-Watching Hot Spots

1 **Frederick Sound** Abundant krill, zooplankton, and herring—what's not to like? Clearly, humpback whales favor these qualities of Frederick Sound because some 500 of these hefty marine mammals gather here to feed. A few reside in the sound year-round, but the vast majority swims these waters in July and August.

2 **Icy Strait** Most people traveling by ship through Icy Strait are on their way to Glacier Bay National Park, but if they want to see whales—orca, minke, gray, and, especially, humpback—passengers should be on the lookout for the last 30 or 40 miles before the ship reaches the mouth of Glacier Bay. Humpbacks are often easy to spot because they're the 40-ton beasts launching out of the water or smacking the surface with their 15-foot pectoral fins.

3 **Sitka Sound** After feeding in the Inside Passage at places like Frederick Sound and Icy Strait, some migrating humpback whales make a final fuel stop in Sitka Sound, at the edge of the open Pacific, before they begin the long haul back to their winter homes in Hawaii. Some linger all the way until December, which is why Sitka's WhaleFest can be held so late in the year, usually in early November. This multiday celebration of whales includes presentations by renowned whale experts, a whale art show, and whale-watching cruises led by experts.

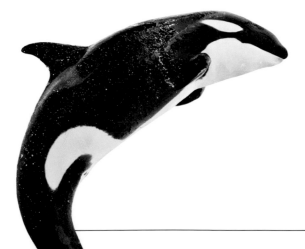

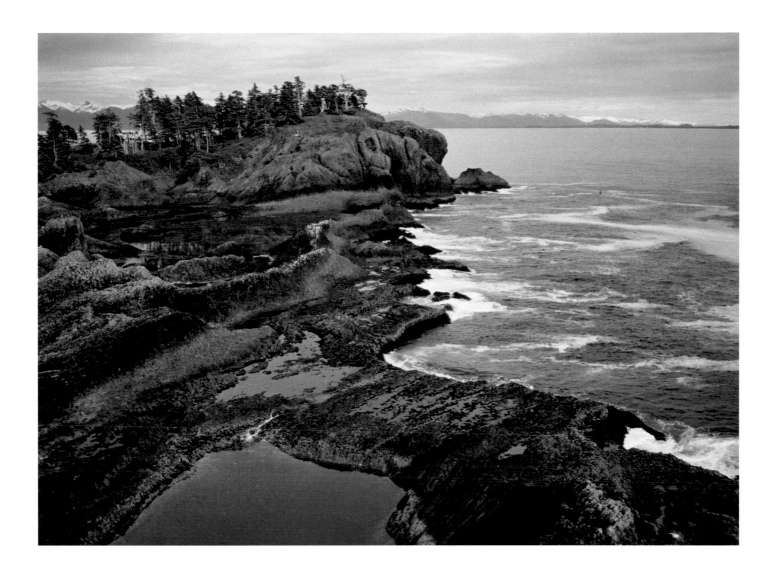

porpoises, sea otters, minke whales, and seabirds. Not to mention Icy Strait's most renowned resident, the humpback whale.

Like sea otters, humpbacks tend to be active. They will slap the water with their 15-foot-long pectoral fins, their muscular flukes (tails), or even their heads. Often, they will launch their 50- or 60-foot-long bodies partly or entirely out of the water and reenter with a splash befitting a 40-ton animal. Much of their activity involves eating. Gulping down krill, plankton, and small fish, humpbacks consume up to 3,000 pounds of food per day.

Humpbacks feed in various ways—it's not easy to capture 3,000 pounds of food in a day—but one of their methods is unique. It's called "bubble netting" and is a form of cooperative feeding. A group of humpbacks gather well below the surface of the water and start blowing bubbles while rising into a school of small fish. Different whales assume different roles; some blow bubbles to distract the fish, some to scare the fish, and some to herd the fish into a tight circle. As whales and prey reach the surface,

These tide pools on St. Lazaria Island brim with marine creatures, but this 65-acre unit of the Alaska Maritime National Wildlife Refuge is better known for its birdlife. Some half a million puffins, murres, cormorants, and other seabirds nest here during the summer.

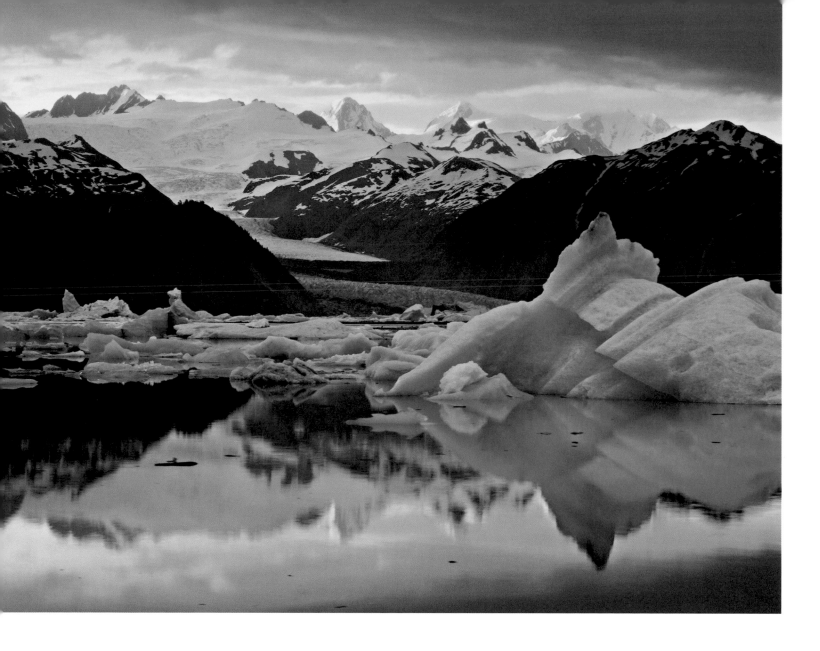

Near the end of a journey that usually begins in the high country of Canada, river rafters coming down the Alsek River enter Alsek Lake. This corner of Glacier Bay National Park and Preserve is framed by the towering St. Elias Mountains.

the humpbacks open their mouths wide and lunge upward into the massed fish. And when these big fellas open wide, it's akin to opening the business end of a monster steam shovel; they take in a huge volume of water filled with a lot of tiny fish, which the whales proceed to strain out using their baleen.

Humpbacks sometimes swim into Glacier Bay, too, but they're just a bonus for most visitors to this national park. The main attraction is the general scenery and, more specifically, the glaciers. Cruise ships large and small and the park's authorized tour boat take visitors into the 65-mile-deep bay.

Two hundred and fifty years ago, visitors couldn't go 65 miles into the bay, or even 65 yards into the bay, because there was no bay. The ice sheets of the Little Ice Age covered the area. When Captain Cook sailed along this coastline in 1778, he encountered an enormous wall of glacial ice where the bay is today. But just 16 years later, when Captain George Vancouver ventured that way, Glacier Bay had appeared and was already about five miles deep—evidence of how rapidly the Little Ice Age was fading.

Though the glaciers have retreated, plenty of them are still around, calving hunks of ice into the bay with a resounding crack followed by a whopping splash. That fallen ice becomes icebergs. Sometimes passengers will spot seals or sea otters atop the icebergs as they float past. People who are warmly dressed can stand on the deck as the boat slowly weaves among the bergs, and listen to their air pockets burst and their melting surfaces drip. Not everything is encased in ice, however; far from it—much of the shore is forested, including some dense old growth near the mouth of the bay where the trees have been growing for 250 years, since the ice began to recede. Tour boats also skirt some rocky islands that are colonized by puffins, cormorants, and murres. No wonder naturalist and author John Muir raved about Glacier Bay when he canoed its enchanting waters back in the 19th century.

Back at that fork in the marine road, northbound ships usually go about 30 miles up the Lynn Canal and then wheel sharply around the tip of Admiralty Island and sail southeast for an hour or so to Juneau. Those ships could have kept going up the Lynn Canal to Haines and Skagway, but Juneau exerts a strong gravitational pull on most travelers, whether they're traveling for pleasure, business, or government affairs. After all, it is the capital of Alaska, the state's third largest city (at 31,275 in the 2010 census, a mere 260 people fewer than number two Fairbanks), and the urban hub of Southeast Alaska. But numbers and facts hardly capture what makes Juneau so enticing. More pertinent are its rich history, its vibrant contemporary culture, and its scenic beauty. Backed by heavily forested mountains that elevate precipitously to heights of thousands of feet, its setting seems more like that of a Swiss resort than of a state capital. But Juneau isn't just a pretty face; it also boasts a vibrant contemporary culture and a rich history.

Travelers in Southeast Alaska will often spot Steller sea lions hauled out on shoreline rocks. This scene is typical; while some of the sea lions snooze, some get in each other's faces and bicker loudly, roaring and moaning.

The city's Euro-American history is closely tied to Joe Juneau—which is unfortunate. Old Joe arguably ranks at the top of the list of people for whom a state capital should never have been named. Most any other name would have been more appropriate, but perhaps the best choice would have been something like Koweeville or Koweeburg. Chief Kowee was a Tlingit of the Auk tribe who lived on Admiralty Island, not far from present-day Juneau. Looking to bring prosperity to his people, he took some gold ore to Sitka to a mining engineer named George Pilz who had offered to compensate any natives who could direct his miners to gold deposits. Pilz thought the ore showed promise, so he outfitted a couple of prospectors, Joe Juneau and Richard Harris, and sent them with Kowee to see if there was more gold where that ore had come from. Being highly diligent and trustworthy, Juneau and Harris quickly traded their rations for some moonshine, and

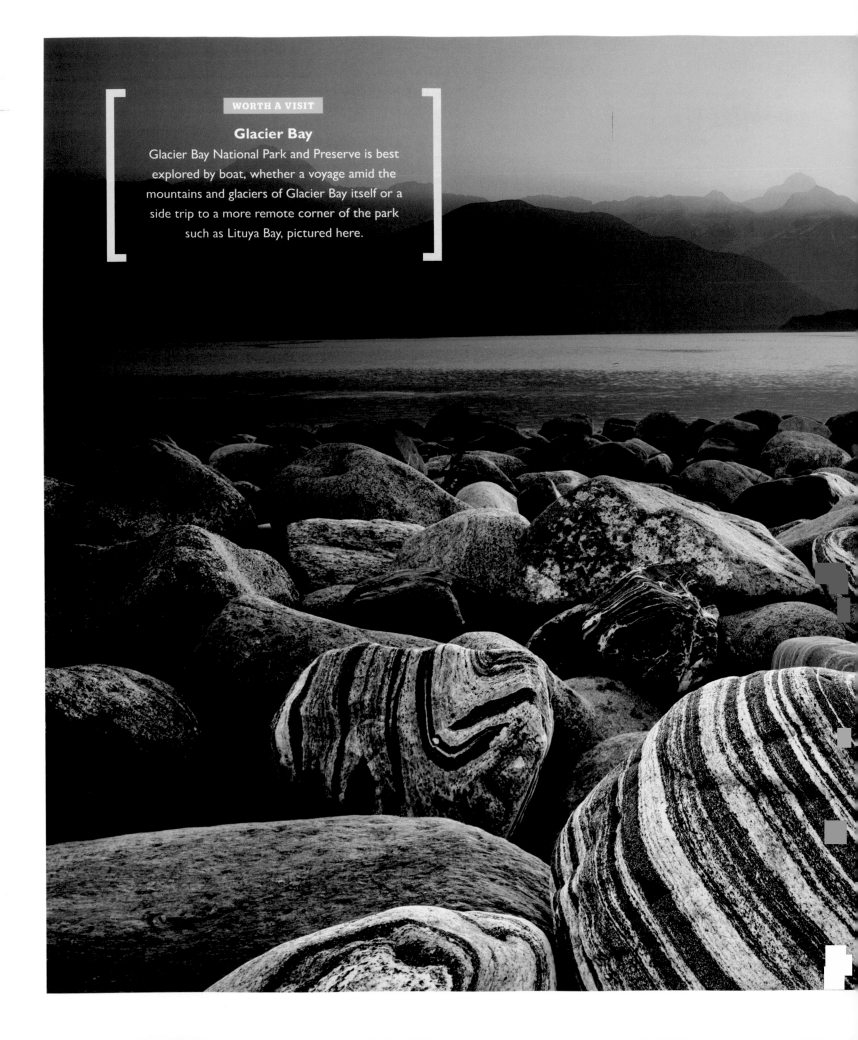

Glacier Bay

Glacier Bay National Park and Preserve is best explored by boat, whether a voyage amid the mountains and glaciers of Glacier Bay itself or a side trip to a more remote corner of the park such as Lituya Bay, pictured here.

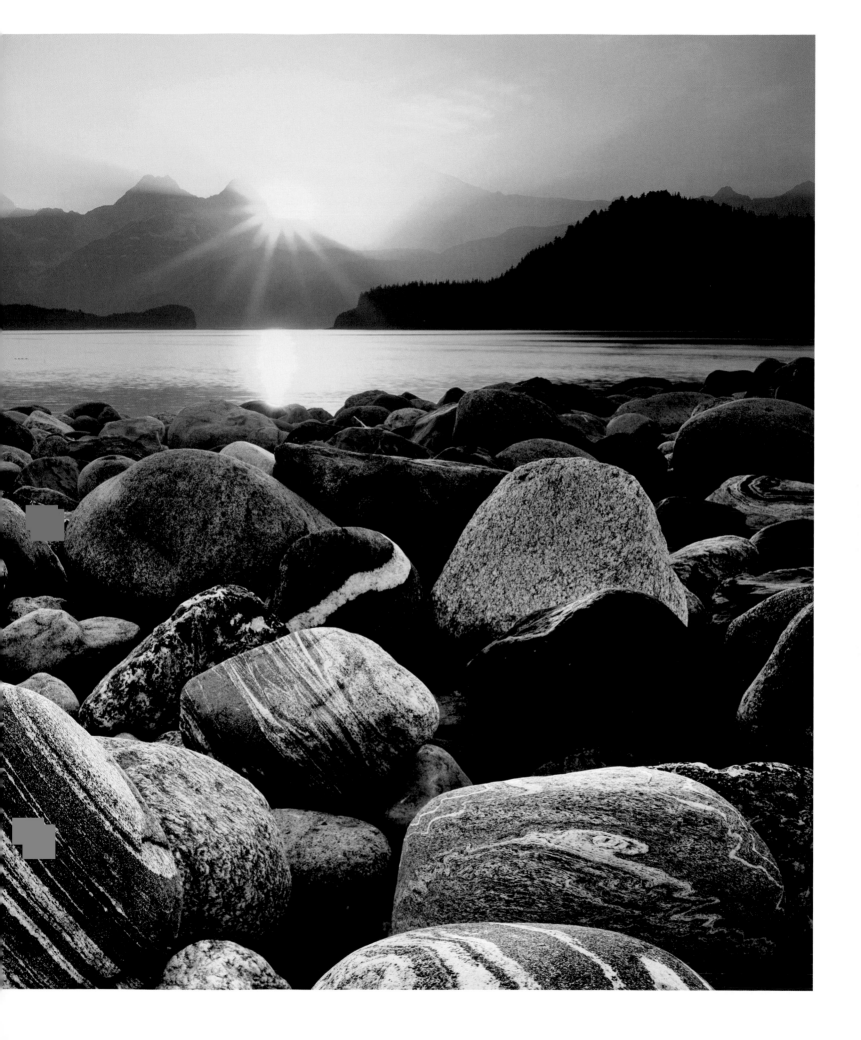

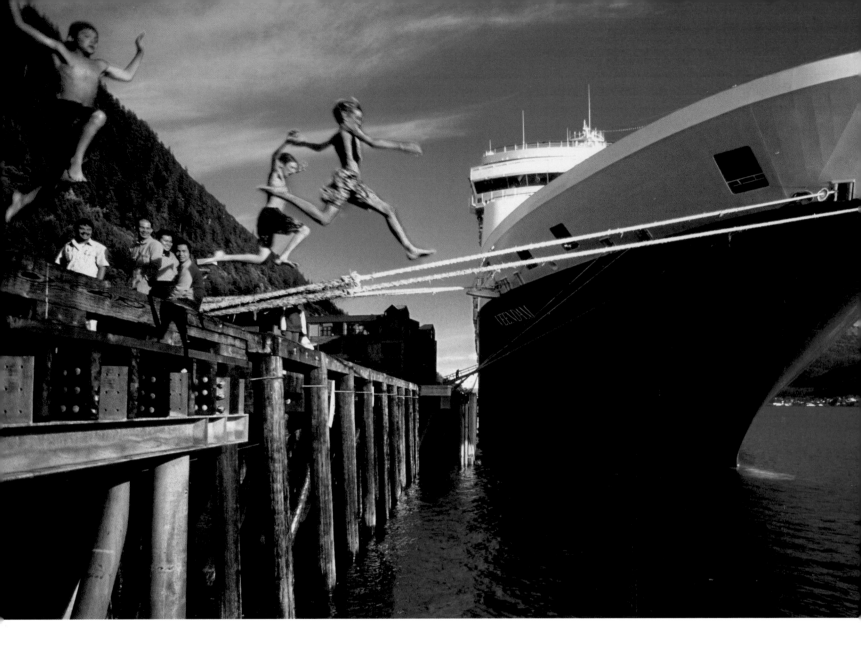

Even on a sunny summer day in Juneau, jumping off the cruise ship dock into the chilly waters of Gastineau Channel takes more enthusiasm than sense.

instead of getting going, they got drunk. Predictably, they soon slouched back to Sitka with nothing to show.

A determined Chief Kowee also returned to Sitka, toting some more gold ore. This prompted Pilz to try again, and once more, he sent out Juneau and Harris with Kowee. Only this time, Kowee spurred them on up Gold Creek and into the Silver Bow Basin, where they struck gold. What happened next is uncertain, but the majority opinion among historians is that Juneau and Harris acted according to character and loaded half a ton of gold ore in their canoe and hightailed it for Canada rather than bringing the treasure back to Pilz. But justice prevailed when the two scoundrels bumped into another, more upstanding member of Pilz's widespread prospecting team, who convinced them to take the ore to Pilz—convinced them apparently by keeping a gun on them. When the gold got to Sitka, in 1880, it ignited Alaska's first big gold rush.

But wait, there's more. Joe still had some unsavory behavior left in him. At first, the new town was called Harrisburg, perhaps because Harris acted as recorder. But there already were several communities of that name in the United States, so folks in the gold camp decided to change it to Rockwell, in honor of the navy commander who had arrived with the first load of gold seekers. But that didn't stick, either, when Joe complained that he was being neglected by history and he lobbied to have the place named after him. And it didn't hurt his cause when he bought a lot of drinks for his fellow citizens. So Juneau it was, and still is.

The Juneau gold rush soon petered out, as there wasn't much gold where individuals could easily get at it. But there was a lot of gold deeper in the ground. With the right equipment and plenty of capital, three major gold-mining operations began digging out very productive lodes near Juneau and across the Gastineau Channel on Douglas Island. The biggest of the three was the Treadwell Gold Mine; by the late 1890s, it was running the largest gold mill in the world, crushing some 5,000 tons of ore a day. Altogether, the three mines produced $158 million worth of gold in their several decades of operation, and that was back when gold sold for $20 to $35 an ounce. Using a middle-of-the-road 2013 price per ounce, those three mines put out about $8 billion worth of the yellow metal.

Gold may have played an important role in the early days of Juneau, but gold was everything to the development of Skagway, and in a way, it still is. Today, Skagway thrives on the history of the quest for gold, which brings hundreds of thousands of tourists to town every summer.

In 1895, Skagway didn't exist. Its future site, at the end of Taiya Inlet at the end of the Inside Passage, was basically a wilderness inhabited by a few Tlingit and Euro-American settlers, and used by others as a seasonal hunting and fishing camp. But the area had one crucial distinction: It lay at the Inside Passage end of trade routes over two passes through the Coast Mountains to the Yukon Territory, in Canada. When gold was discovered near the Klondike River in the Yukon, in 1896, most of the tens of thousands of gold seekers heading for the Klondike shipped up the Inside Passage to try to make the trek over these passes. Gold rushers poured into the

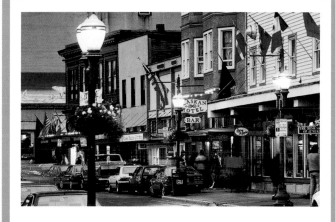

DID YOU KNOW?

Still Standing

Unlike most Alaska towns, Juneau has never experienced a major fire, so in the old downtown area, more than 140 buildings dating from before 1914 are still standing.

area and, in 1897, a surveyor named Frank Reid named the boomtown "Skaguay" (a variation of the Tlingit name, Skagua), which the newly established post office changed to the current spelling in 1898.

As happens with most gold rushes, Klondike fever cooled off in just a couple of years, and the population dropped precipitously from a high of perhaps 10,000 in 1898 (making it the largest city in Alaska at the time) to just over 3,000 in 1900 and less than 1,000 by 1910. But unlike so many gold rush boomtowns, Skagway didn't vanish. Not only did the municipality survive, but some 100 gold rush–era structures survived, and many are still in use today, albeit after considerable restoration.

Klondike Gold Rush National Historical Park has absorbed more than a dozen of these venerable buildings, starting with the old train depot, which houses the park's visitor center. The park even features a saloon. The Mascot was built in 1898—one of the 70 or 80 drinking establishments that enlivened Skagway at that time. The Park Service has preserved it and set it up to look like it did in 1898, complete with mannequins posed as bartenders and customers.

In a nearby historic building, travelers will find another saloon, the Red Onion, only this one is alive and kicking and populated by real bartenders and customers. Constructed in 1897, the Red Onion began life as a bordello—reputed to be the most exclusive in town. The first floor served as the bar, and the upstairs contained ten rooms where prospectors satisfied their other appetites. Each room was connected to the bar's cash register by a copper tube so the ladies could quickly deposit their earnings, usually in gold, and signal their readiness for the next customer.

After visiting the wide-open boomtown in 1898, Samuel Steele, superintendent of the North-West Mounted Police, said "Skagway was little better than a hell on earth." The saloons and brothels may have had something to do with his harsh judgment, but it's likely that the man most responsible was Jefferson Randolph Smith, better known as Soapy Smith.

It was not exceptional cleanliness that earned Smith his nickname of "Soapy." That moniker came from a scam he ran for years in which he would sell bars of soap on the street for exorbitant prices by making a big show of hiding paper money under the wrappers of some of them, including

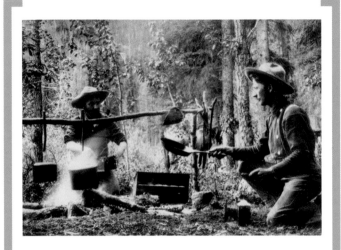

The Sourdough

Gold rushes produced some of Alaska's most colorful history, and at the center of these gold rushes were the rugged, resourceful prospectors. We're not talking about the greenhorns wearing dress shoes and toting suitcases—they generally went back home after a few weeks, if they even survived. The men (and they were almost exclusively men) referred to as "sourdoughs" were the prospectors who knew what they were doing in the wilderness and stayed around for a while, often remaining in Alaska once the gold rush was over. They were called "sourdoughs" because many of them kept sourdough bread starter in a pouch close to their bodies in the winter so it wouldn't freeze.

Opposite: An old pump station connected to the once massive Treadwell Mine attests to Juneau's gold-mining past.

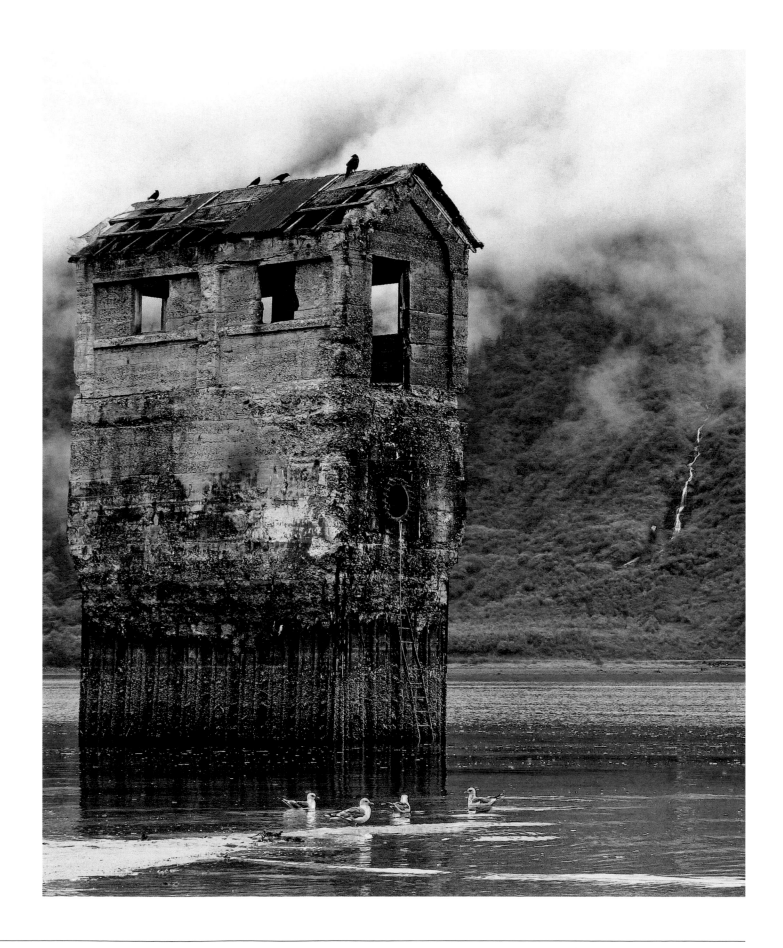

Exploring the White Pass & Yukon Route

During the Klondike gold rush, the narrow-gauge rail route was blasted and chiseled 110 miles through the mountains to connect Skagway to Whitehorse, Yukon.

1 The trip starts at the Skagway **depot.**

2 The train passes the **Gold Rush Cemetery** at railroad Mile 2.5.

3 Continuing above the Skagway River, the train chugs up to **Denver** at Mile 5.8.

4 The train crosses the Skagway East Fork River and reaches **Rocky Point,** which yields tremendous views of Skagway and beyond.

5 A profusion of waterfalls decorates the route as the train proceeds, topped at Mile 11.5 by the spectacular **Bridal Veil Falls.**

6 At Mile 16, just before entering **Tunnel Mountain,** the train crawls across a bridge 1,000 feet above Glacier Gorge.

7 Shortly after the long tunnel, at Mile 17, one of the finest vistas of the route appears—**Inspiration Point.**

8 Finally, the railcars reach their destination, **White Pass Summit**—2,865 vertical feet higher than sea level, where the train started.

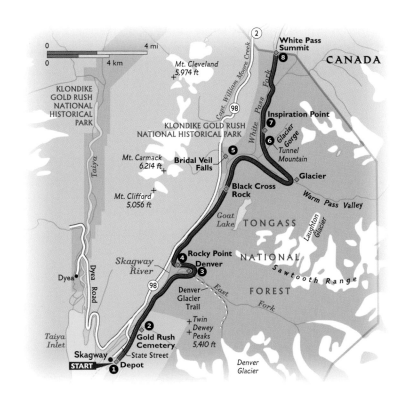

one with a $100 bill. Using sleight of hand, he pocketed the ones with the money, but he had accomplices in the crowd who would unwrap a bar of soap and shout with delight while holding up the cash they'd supposedly found. This usually started a run on the remaining bars of soap, and Smith and his crew made out like the bandits they were.

Smith operated for many years in Colorado, but a nearly lawless boomtown like Skagway was catnip to him, and he went there in 1897. By 1898, he had a gang of about 100 thugs and con men working for him, and he more or less ruled Skagway. His illicit enterprises included dishonest gambling halls, freight companies that didn't really haul freight, and telegraph companies whose wires didn't connect to anything. One of his most outrageous gambits was an army enlistment con in which his henchmen would pose as military doctors and tell would-be enlistees that they needed to disrobe for a physical. While the fake doctor pretended to administer the examination, other henchmen would steal the unfortunates' possessions.

Needless to say, Smith made more than his share of enemies, including a successful prospector that Smith's minions fleeced to the tune of nearly $3,000 in gold. In July 1898, that victim stirred up a group of long-suffering citizens, who in turn formed a vigilante committee led by Frank Reid, the surveyor who had named Skagway. One evening, the vigilantes got together on one of the wharves to talk about ridding the town of Smith, but Smith got wind of the meeting; he and some of his gang trooped down to the wharf to confront the group. Reid and Smith got into a heated argument and suddenly exchanged gunfire; another of the vigilantes may also have shot Smith. Hit three times, including once through the heart, Smith died on the spot. Reid was badly wounded and died 12 days later, but at least his death was not in vain, for Smith's gang fell apart—some of them were jailed—and Skagway, though still wild, became a more law-abiding town.

Skagway's focus on its gold rush history, which in turn focuses on those mountain passes and the Klondike gold fields that lay beyond, signals that visitors to this town have reached the end of the Inside Passage. There's even a highway connecting Skagway to Whitehorse, Yukon, and to the world outside the maze of islands, fjords, coves, channels, reefs, and inlets that define Southeast Alaska. Then again, travelers can hop a southbound ferry and plunge right back into that captivating maze. ■

Opposite: A tourist train takes visitors from Skagway up through the coastal mountains to the Canadian border.

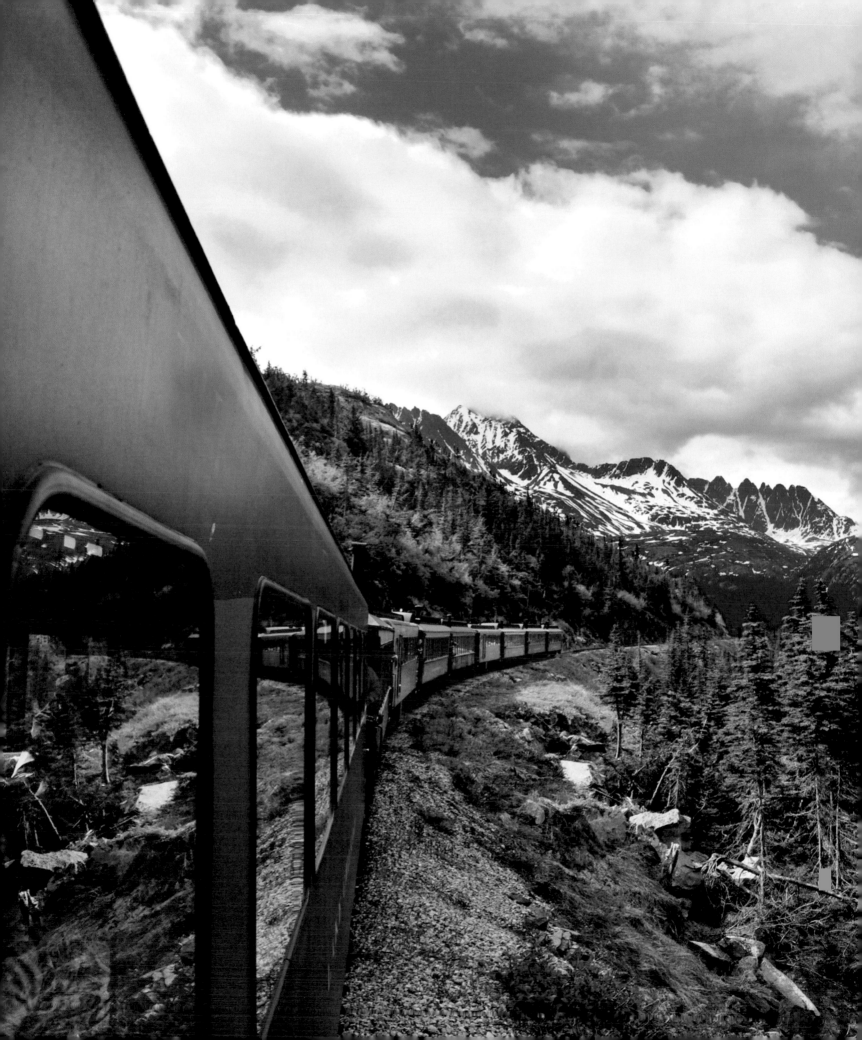

Sites and Sights in Southeast

For a good introduction to both the natural history and human history of Southeast Alaska, visitors can go to the **Southeast Alaska Discovery Center** in Ketchikan. The rain forest exhibit comes complete with the sounds of birdcalls and running water. Curious minds should take the time to listen to some of the recordings of native elders discussing traditional ways of life. *alaskacenters.gov/ketchikan.cfm*

The world's largest collection of 19th-century totem poles can be found in Ketchikan at the **Totem Heritage Center.** Deteriorating in abandoned villages, the totems were rescued and brought here to preserve these definitive pieces of Tlingit, Haida, and Tsimshian culture. The center also displays fine beadwork, woven baskets, and other native arts. *visit-ketchikan.com*

Totem poles new and old tower among the trees and lawns of **Saxman Totem Park,** in Saxman Native Village just outside Ketchikan. Travelers can wander among the poles on their own or take a tour, which also includes a traditional dance performance, a chance to watch carvers at work, and an opportunity to hear some of the stories behind the totems. *visit-ketchikan.com*

For another chance to commune with totem poles, visitors can head ten miles north of Ketchikan to **Totem Bight State Historical Park.** In a pleasant shoreline setting, visitors stroll along paths through the forest and encounter the totem poles scattered about the property. *dnr.alaska.gov/parks/units/totembgh.htm*

The waters and the lands of 2.2-million-acre **Misty Fiords National Monument** compete to be the more spectacular. The waters include soaring falls, intimate fjords, clear creeks thronged by salmon, and broad channels where humpback whales and sea otters roam. The land offers a six-million-year-old volcanic plug, the deep and eponymously misty rain forest, a sheer 3,000-foot cliff, and a full complement of Alaska wildlife—such as wolves, grizzly and black bears, mountain goats, and deer. *visit-ketchikan.com*

Given that Wrangell is a remote town with a population of only about 2,400, one would expect the local museum to be a dinky affair with maybe a bear trap and an old rifle or such. However, the **Wrangell Museum** is much larger and finer than one would expect, starting with the four exquisite carved house posts at the entrance that date from the 18th century—some of the oldest such Tlingit artifacts in the state. Perhaps the museum's developers figured it had to be substantial considering that Wrangell has a lot of history to cover, being the only Alaska town that was governed by four sovereigns—Tlingit, Russians, British, and Americans. *wrangell.com/museum*

Tour boats based in Wrangell take passengers a few miles north to view the wonders of the big, swift **Stikine River.** Its sprawling delta and a run of small fish called hooligan draw a crowd in the spring: millions of shorebirds, hundreds of thousands of gulls, and a couple thousand bald eagles. Travelers who head a few miles upriver are treated to moose, rain forest, glaciers, mountains, bears, and an inviting hot springs. *wrangell.com*

One of the most prolific runs of pink salmon in Southeast Alaska surges up **Anan Creek,** about 35 miles southeast of Wrangell. This did not escape the notice of the local bears, as both grizzlies and black bears flock to the creek to feast on the pinks. People can safely watch this spectacle from the **Anan Bear**

A bald eagle in the rain forest

and Wildlife Observatory. *wrangell.com/visitorservices/anan-bear-and-wildlife-observatory*

Situated around a series of three harbors on Frederick Sound, **Petersburg** is a pleasant town that bills itself as Alaska's "Little Norway," due to its early settlement by Norwegians. Evidence of this heritage abounds, from the reproduction of a Viking ship that sits downtown to the Sons of Norway Hall to the Little Norway Festival to the many building exteriors that feature rosemaling—the flowing floral painting that developed as a folk art in Norway in the mid-18th century. *petersburg.org*

Visitors can explore the southeast end of **Mitkof Island** by driving south out of Petersburg on the 34-mile **Mitkof Highway,** most of which is paved. At Mile 14, people can venture into the muskeg (bog) on the **Blind River Rapids Boardwalk.** Around Mile 16, motorists come to the **Blind Slough Swan Observatory,** where migrating trumpeter swans gather in late fall; several dozen stay through the winter. From the end of the highway, travelers can gaze upon the **Stikine River Delta.** *petersburg.org*

Travelers who want to see an active tidewater glacier can board a tour boat in Petersburg and motor about 25 miles east up **LeConte Bay** to **LeConte Glacier.** There's also a seal nursery in the area. *petersburg.org*

The best way to make the acquaintance of Sitka is to ascend 100-foot-high **Castle Hill,** which provides a panoramic view of the town and its scenic environs. This is also the location of **Baranof Castle Hill State Historic Site,** where, in 1867, the Russians lowered their flag and the Americans raised theirs, signaling Alaska's change of ownership. *dnr.alaska.gov/parks/aspunits/southeast/baranofcastle.htm*

Though its central purpose is to commemorate the Battle of Sitka—the 1804 conflict between the Tlingit and the Russians—**Sitka National Historic Park** covers a lot more Tlingit and

Russian history and culture. At the park's **Southeast Alaska Indian Cultural Center,** visitors can watch Alaska native artists at work and even talk with them about their art. *www.nps.gov/sitk*

In the late 19th century, the teacher and missionary Reverend Sheldon Jackson accumulated a huge collection of native artifacts from all over Alaska, which are now on display in Sitka's **Sheldon Jackson Museum.** The museum's variety is impressive—mukluks made from fish skins, frightening shaman's masks, armor fashioned from walrus ivory. Don't neglect to look into the scores of drawers, which contain smaller objects. *museums.alaska.gov/sheldon_jackson/sjhome.html*

Visitors who are curious about what's happening in the waters of Sitka Sound should stop by the **Sitka Sound Science Center.** Not only is the name wonderfully alliterative, but also there's poetry in the swaying, slithering, slimy sea creatures in its aquaria and touch tanks. Aside from the aquaria, most of the center is devoted to scientific research, but the public can enjoy a few other displays, such as whale bones, preserved marine specimens, and a killer whale skeleton. *sitkascience.org*

To check out the terrestrial portion of Sitka's surroundings, travelers can go seven miles north of town to **Starrigavan Recreation Area.** This small but diverse property offers an estuary, marshes, bogs, shoreline, and rain forest. Such varied habitats foster varied plants and animals, which include grizzlies, many bird species, some sizable conifers, Sitka black-tailed deer, and abundant wildflowers. *sitkatrailworks.org*

The fact that **Admiralty Island** has the highest concentration of grizzlies in the world may not strike some travelers as a big selling point, but others visit the island for that very reason. In particular, many go to **Pack Creek,** in **Admiralty Island National Monument,** where a multitude of bears gathers in the summer to feed on salmon. *www.fs.usda.gov/tongass*

Downtown Skagway

The **Alaska State Museum,** in Juneau, houses tens of thousands of objects ranging from natural history to native artifacts to fine art to Euro-American history. Where else could one find an antique Russian samovar the size of a potbellied stove or a belt fashioned from some 200 caribou mandibles? *museums.alaska.gov*

Looming above the cruise ship docks in Juneau is 3,819-foot **Mount Roberts.** Hikers can tackle the long haul up its flanks, but most visitors choose to travel to the 1,800-foot level via the **Mount Roberts Tramway.** Here they find a restaurant, a theater with shows about Tlingit culture, a gift shop/museum, a nature center, and some fine views. Travelers who want to escalate to amazing views can walk the easy to moderate trails from the tram up above tree line to the subalpine meadows. *goldbelttours.com/mount-roberts-tramway*

About 15 miles north of Juneau, travelers come face-to-face with the **Mendenhall Glacier.** Its face is spectacular, given that it's about a mile wide and occasionally big parts of it fall off and thunder into the waters of the lake below. The visitor center serves as a museum and an observation point. A network of trails gives people the chance to see such sights as beavers, waterfalls, black bears catching salmon, rain forest, and mountain goats. *www.fs.usda.gov/tongass*

Many visitors to **Glacier Bay National Park and Preserve** never leave their cruise ships

or tour boats, and that's just fine. People can savor the calving glaciers, misty mountains, and humpback whales without setting foot on land. But the land is worth exploring, too, and is mostly easily accessed at **Bartlett Cove,** the location of park headquarters, a venerable lodge, a small museum, and a network of trails. *www.nps.gov/glba*

Haines is probably best known as the gateway to the **Chilkat Bald Eagle Preserve,** where several thousand bald eagles overwinter. But this little town harbors several other attractions, including the **Chilkat Center for the Arts, Alaska Indian Arts, Fort William H. Seward National Historic Landmark,** and the surprisingly fascinating **Hammer Museum,** which displays some 1,400 hammers, from an 800-year-old Tlingit warrior's hammer to a Waterford crystal hammer. *haines.ak.us*

"Gold! Gold! Gold! Gold!" So read a Seattle newspaper headline in 1897, when news of the Klondike gold rush swept the country and put Skagway on the map. To this day, the town revolves around that gold rush era. Ground zero for reliving those freewheeling times is **Klondike Gold Rush National Historical Park.** A stroll around town—sometimes on old wooden sidewalks—reveals that the rest of Skagway also boasts many historic buildings, but these are still in use as shops, galleries, residences, and saloons. *www.nps.gov/klgo*

Originally built to connect Skagway to Whitehorse, Yukon, and to the Klondike gold fields, the **White Pass & Yukon Route Railroad** still makes that 110-mile run at times, but these days most passengers only ride the narrow-gauge rails 20 miles up to White Pass and then back down. But what a 20 miles it is—with views of the Skagway River, glaciers, waterfalls, forests, gorges, and, as the train nears the 2,865-foot summit, grand vistas of the mountains and waterways of the Inside Passage. *wpyr.com*

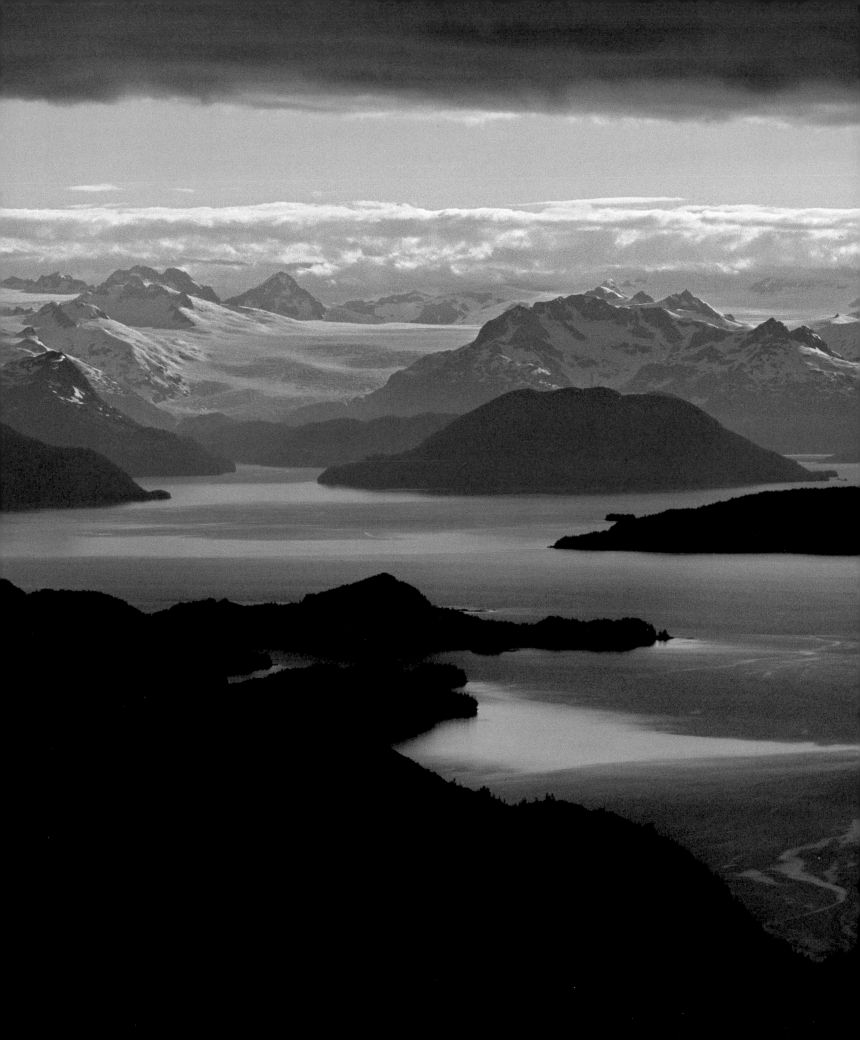

3 [South Central]

Prince William Sound is a sumptuous
blend of land and sea. Scores of
uninhabited islands pepper its waters,
and the rugged mainland coast has been
chiseled into a plethora of bays, coves,
and fjords.

South Central

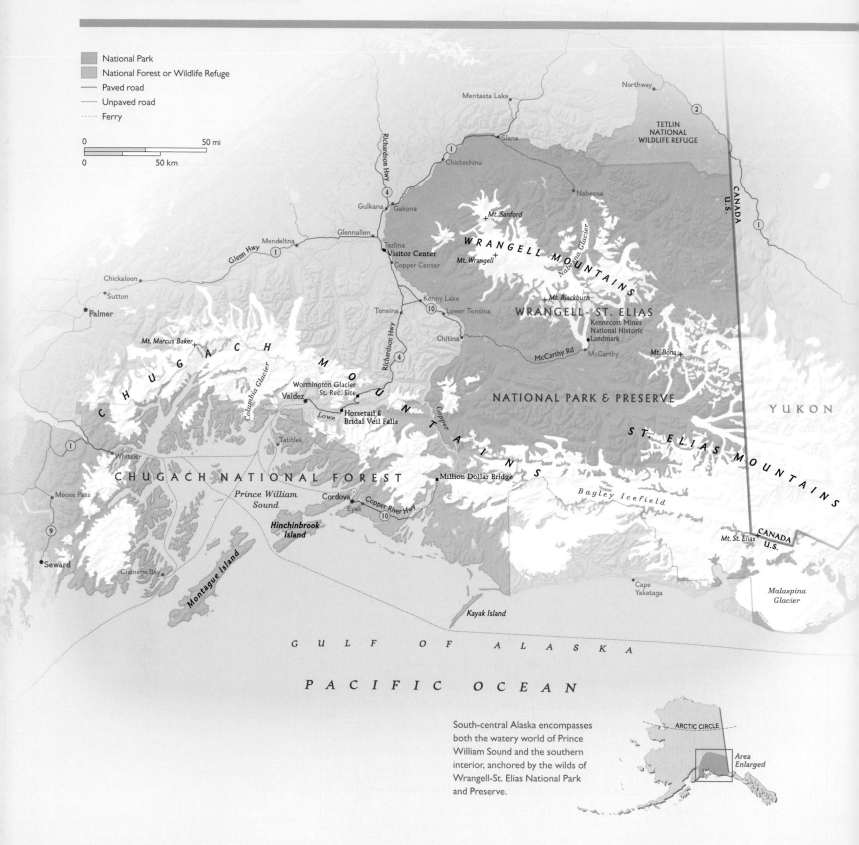

National Park
National Forest or Wildlife Refuge
Paved road
Unpaved road
Ferry

0 50 mi
0 50 km

Northway

Mentasta Lake

TETLIN
NATIONAL
WILDLIFE REFUGE

Slana

Chistochina

Richardson Hwy

Nabesna

4

Gulkana Gakona

Mt. Sanford

WRANGELL MOUNTAINS

Nabesna Glacier

CANADA
U.S.

2

Glennallen

Mendeltna

Glenn Hwy

Tazlina
Visitor Center
Copper Center

Mt. Wrangell

Chickaloon

Kenny Lake

Mt. Blackburn

WRANGELL - ST. ELIAS

Sutton

Tonsina

Lower Tonsina

Kennecott Mines
National Historic
Landmark

Palmer

Richardson Hwy

Chitina

Mt. Marcus Baker

10

McCarthy Rd

McCarthy

Mt. Bona

4

Columbia Glacier

Copper River

NATIONAL PARK & PRESERVE

YUKON

Worthington Glacier
St. Rec. Site

CHUGACH MOUNTAINS

ST. ELIAS MOUNTAINS

Valdez

Lowe

Horsetail &
Bridal Veil Falls

1

Whittier

CHUGACH NATIONAL FOREST

Tatitlek

Million Dollar Bridge

Bagley Icefield

CANADA
U.S.

Mt. St. Elias

Moose Pass

Prince William
Sound

Cordova

Copper River Hwy

9

Eyak

10

Hinchinbrook
Island

Cape
Yakataga

Malaspina
Glacier

Seward

Chenega Bay

Montague Island

Kayak Island

G U L F O F A L A S K A

P A C I F I C O C E A N

South-central Alaska encompasses
both the watery world of Prince
William Sound and the southern
interior, anchored by the wilds of
Wrangell-St. Elias National Park
and Preserve.

ARCTIC CIRCLE

Area
Enlarged

In 1778, famed English sea captain James Cook and his crew left the tumultuous waters of the Gulf of Alaska and sailed into a relatively peaceful sound protected by a picket fence of islands. Roughly 30 by 70 miles, this handsome body of water and the land embracing it featured thick forests, deep fjords, abundant fish, and massive glaciers. Captain Cook must have been impressed, for he bestowed upon this place the name of his powerful patron, the Earl of Sandwich, First Lord of the Admiralty; from that point on, it was to be known as Sandwich Sound.

However, no such place can be found in an atlas of Alaska today. The name did make it onto the maps created by Cook's onboard cartographers, but its life was brief. By the time the expedition returned to England, the Earl of Sandwich had fallen into disrepute, accused of corruption and mishandling his duties at the Admiralty. Politic men, the editors of Cook's maps, dropped Sandwich and renamed the sound in honor of the king's third son, who later ascended to the throne as King William IV. So, in today's atlases, this sumptuous jumble of land and sea bears the name Prince William Sound.

Of course, the sound no doubt already had an indigenous name when Cook showed up. For thousands of years, the region had been inhabited by the Sugpiaq, a seafaring people whose primary territory stretched from Kodiak Island to the eastern end of the sound. In their animal-skin *qayaqs* (precursors to contemporary kayaks), the Sugpiaq hunted sea lions, seals, and sea otters. Many of their prosperous villages lay near the mouths of streams and rivers, where they caught salmon heading upstream to spawn. Though the arrival of Europeans and Americans decimated the Sugpiaq, these resilient people abide. Some lead contemporary lives elsewhere in Alaska, while others still occupy small villages on the coast and islands and live a semisubsistence lifestyle based on the bounty of Prince William Sound.

Nowadays, many visitors enter beautiful Prince William Sound through the incongruously ugly portal of Whittier, a busy jump-off point because it lies on the western shore of the sound just 65 road miles from Anchorage. Most of this town of fewer than 300 is merely utilitarian—harbor, warehouses, ferry terminal, and so on—but two features drop it several points down the aesthetics scale. The first is the fact that most of Whittier's residents live in a couple of brutish concrete high-rises that would have made the Soviet architects of the 1950s proud. The second is the tunnel.

Whether going by road or railroad, travelers must brave the 2.5-mile Anton Anderson Memorial Tunnel during the final approach to Whittier. With its dim light

Masks such as this one, collected in 1872, have long played an important role in Sugpiaq culture. They tell family stories, depict spirits, and are used by dancers.

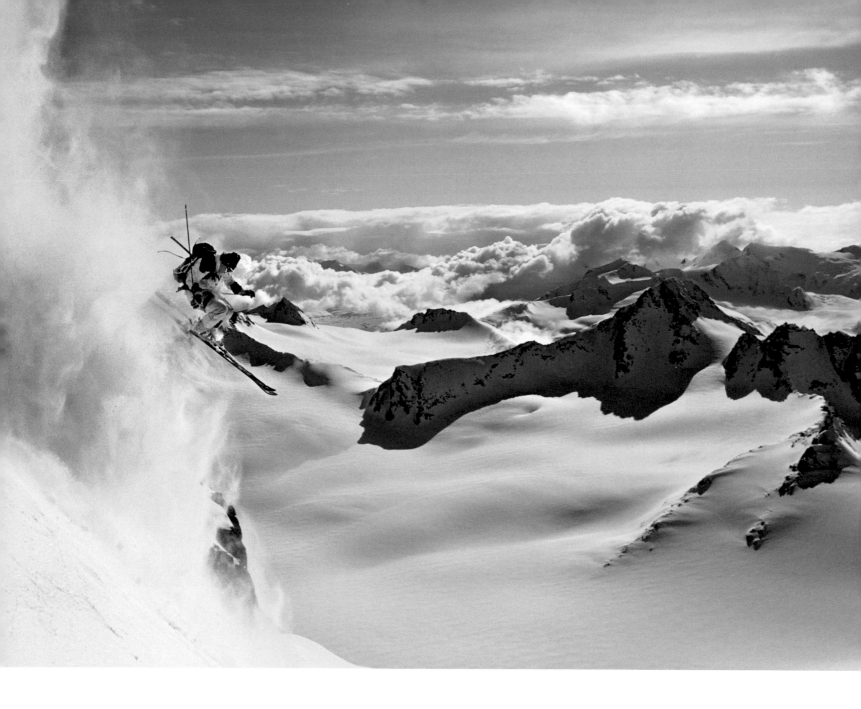

Heavy snow blankets the Chugach Mountains in the winter, turning the range's sawtooth slopes into a magnet for extreme skiers and snowboarders. Sometimes they seem to spend more time in the air than in the powder.

and dripping rock walls, this claustrophobic hole through Maynard Mountain seems more suited to bat colonies than to vehicles. The passage is so narrow that vehicles going west and vehicles going east—not to mention the occasional train—must take turns, traveling single-file in staged caravans. Best not to think about the signs in the tunnel that say "Evacuate to Safe House only when strobe light flashing."

Though it's much farther than Whittier from Alaska's population centers (such as they are), the Richardson Highway offers a much prettier route to Prince William Sound. Cutting through the Chugach Mountains from the north, the last 30 miles are a destination all their own. The downward run to the sound begins at Thompson Pass, the high point in the road at 2,678 feet. Practitioners of extreme winter sports flock to the area because it is blessed (non-daredevils might say cursed) with sawtooth slopes

and extraordinary snowfalls. The pass was once blanketed with 62 inches of snow in one day and nearly 1,000 inches during one winter. In summer, the snow melts from the lower elevations and reveals an alpine tundra garden of ground-hugging greenery speckled with wildflowers.

The near vertical slopes and prolific powder of Thompson Pass attract all sorts of extreme winter recreationists. For years the World Extreme Skiing Championships were held there. The pass is still home to the Tailgate Alaska big mountain snowboarding competition, which draws some of the world's top pros to zoom down untracked 5,000-foot runs. And for several years the area has hosted the Thompson Pass Snowkite Festival in which participants with more adrenaline than sense hook themselves to huge kites that pull them across the snow.

As the highway snakes downhill from the pass, stunted trees appear here and there until the road dips below tree line and enters the forest. In a few miles, motorists slip into Keystone Canyon, following the Lowe River. Boisterous waterfalls dive from the dark cliffs bordering the highway and plunge into the river. Some are big enough to bear names, such as Horsetail Falls and Bridal Veil Falls, and offer pullouts to travelers who want to get out of their cars and tarry, perhaps feel the mist on their faces.

As motorists continue down the last stretch of the Richardson, they may notice the old highway markers that count down the miles to Valdez, the town on the sound that waits at the end of the road. However, visitors looking for a hotel or some grilled salmon will be surprised when they reach mile zero, the location of downtown Valdez, and find . . . nothing.

The explanation for Valdez's vanishing act lies deep in the Earth in the realm of tectonic plates. At 5:36 p.m. on March 27, 1964, the North American plate suddenly surged over the subducting Pacific plate, generating the infamous Good Friday earthquake. A magnitude 9.2 monster was the second most powerful quake ever recorded. And the epicenter was in Prince William Sound, only 55 miles west of Valdez.

For almost four minutes, the ground heaved. All over southern Alaska, buildings crumbled, streets split open, bridges collapsed, and people scattered in terror. But knocking down the works of civilization was child's play compared with the havoc the quake wreaked on the natural world. Consider vertical displacement. This dry scientific term masks a fearsome phenomenon in which the planet

Keeping Eyak Language Alive

Marie Smith Jones was the last full-blooded Eyak and the last fluent speaker of the language, so when she died in 2008, it seemed that the Eyak tongue had vanished forever. Some 500 people still belong to Native Village of Eyak, near Cordova, but none has Jones's pure-blooded background or fluency. However, a linguistically gifted French boy, Guillaume Leduey, became intrigued by the Eyak language as a teenager and began learning it. Now in his mid-20s, Leduey has become a fluent speaker and is working with the planet's only other fluent speaker, Michael Krauss, a renowned linguistics professor at the University of Alaska, Fairbanks, who is in his late 70s.

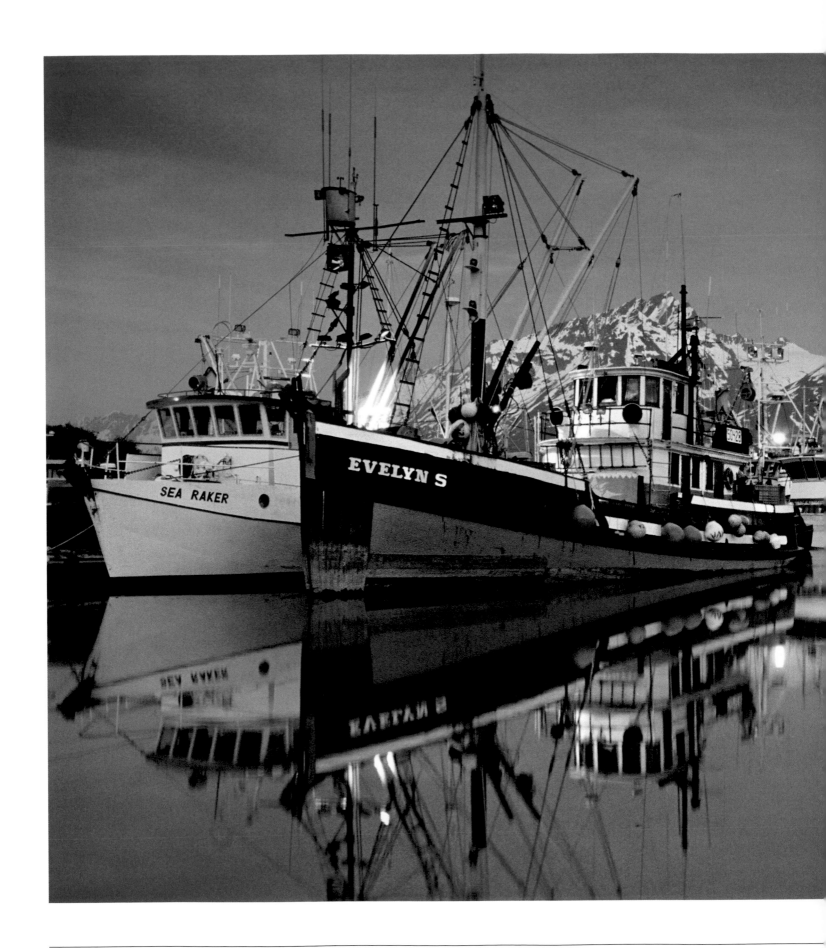

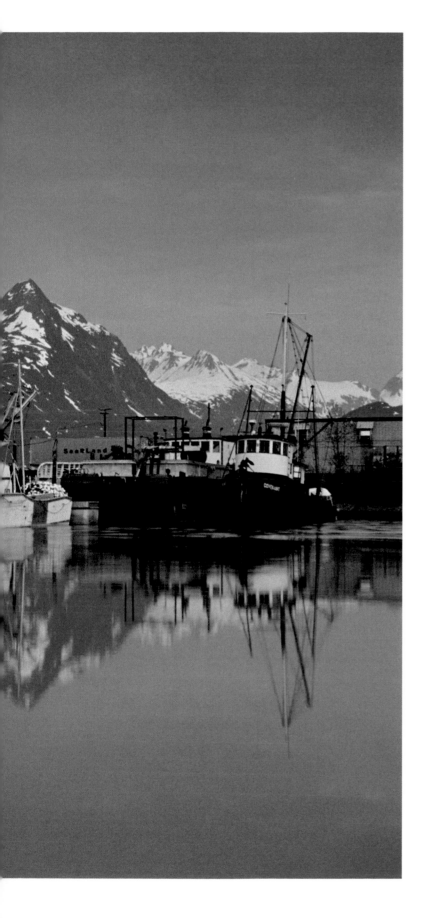

The Valdez harbor shelters commercial fishing vessels as well as tour boats that take travelers into Prince William Sound to watch wildlife, view glaciers, and go kayaking.

flexes its seismic muscles and shoves around great patches of supposedly solid ground. The southwest end of Montague Island, the largest island in the sound, abruptly elevated 10, 20, even 30 feet in some spots. Neighboring Latouche Island moved some 60 feet to the southeast. Huge landslides occurred all around the sound.

Those landslides and similar massive earthen slumps that took place underwater caused some of the most grievous destruction, particularly in Valdez. People who have a strong stomach can watch a video derived from a bit of grainy 8-mm

> **66 Flying itself is not inherently dangerous, but, like the sea, it can be terribly unforgiving. As can the Alaskan wilderness. Combined— the two can boggle the mind. 99**
>
> **[Mort Mason, bush pilot & author]**

film shot by someone who is very lucky to have survived the events he documented. The amateur moviemaker was standing aboard the *Chena,* a 400-foot freighter docked at the port that fateful day. The footage shows members of crew on the deck of the ship throwing candy and fruit to kids down on the dock when the shaking begins and a chasm opens beneath them. The dock and everyone on it slid into the chasm; none of these 30-some people would survive. The *Chena,* too, seemed bound for a watery grave, but, miraculously, it stayed afloat in that maw of mud and water and then got swept into town by a gush of water, landing upright.

The earthquake caused this tragedy when its shock waves liquefied the loose sediments on which the dock was built. The dock was not the only casualty; a 4,000-foot-long by 600-foot-deep section of the waterfront plunged into the bay. And this was far from the end of Valdez's ordeal. The slump of sediments into the depths spawned a local tsunami 30 to 40 feet high that thundered ashore, destroying

most of what little was left of the waterfront and rampaging several blocks farther into Valdez. Meanwhile, the quake's force had ruptured the fuel tanks at the Union Oil Company, igniting a fire that burned through a sizeable portion of the ill-fated town.

In one respect, Valdez was fortunate; the local tsunami that hit town could have been much larger. Most of us are familiar with the tsunamis that fan out from the source fault of an underwater earthquake; these are tectonic tsunamis. But landslides and submarine slumps, if big enough, can generate "local" tsunamis. These don't race across oceans at hundreds of miles an hour as tectonic tsunamis do, but they can reach incredible heights in the immediate vicinity. Not that the 30- to 40-foot wave that hammered Valdez was puny, but just 10 miles away, in Shoup Bay, a local tsunami caused a run-up of about 100 feet—"run-up" meaning that when it surged ashore and met the hills ringing the bay, the rushing water washed up those slopes to points some 100 vertical feet above the normal water level. Even closer to Valdez, at the Cliff Mine, the run-up from the local tsunami pushed water more than 200 vertical feet up the hillside. Local tsunamis accounted for at least 82 of the 131 deaths caused by the Good Friday earthquake.

The tectonic tsunami also wreaked havoc, and not just in Alaska. It hit Vancouver Island, in British Columbia, wiping out a native village and sending 20-foot waves into the larger towns of Port Alberni and Alberni. These two towns suffered extensive damage but no loss of life, even though the tsunami roared ashore in the middle of the night without official warning, in part because the first wave was relatively small and alerted people to the danger before the second, larger wave struck.

The lower 48 did not escape unscathed. The 1964 tsunami is the largest ever to batter America's Pacific coast. Along the Washington shore, the waves took out bridges, houses, boats, and roads, reaching heights of 15 feet as it swept inland. It inflicted similar harm along the Oregon coast, but with a twist. Instead of smashing oceanfront property, the waves did most of their damage when they surged up a number of estuaries whose underwater topography actually amplified the waves. California was the hardest hit. Not only did the tsunami cause extensive property damage but also it killed a dozen people. Most of the damage and ten of the deaths occurred in Crescent City, where the waves topped 20 feet and flooded much of the town.

In addition to tsunamis, the Good Friday earthquake generated seiches: standing waves and oscillations in lakes, reservoirs, and other bodies of water created when

The Wilderness Guide

Grizzlies, glaciers, massive mountains, iceberg-choked rivers, extreme weather, and vast expanses of trackless wilderness—Alaska abounds with challenges that lie beyond the skills of most visitors. Enter the wilderness guide. These savvy outdoorspeople enable travelers to venture—safely—into the Great Land's great backcountry. They'll teach you how to kayak, guide you through a maze of islands, show you how to use crampons, and lead you across a glacier. They are the keys that unlock some of Alaska's hidden treasures.

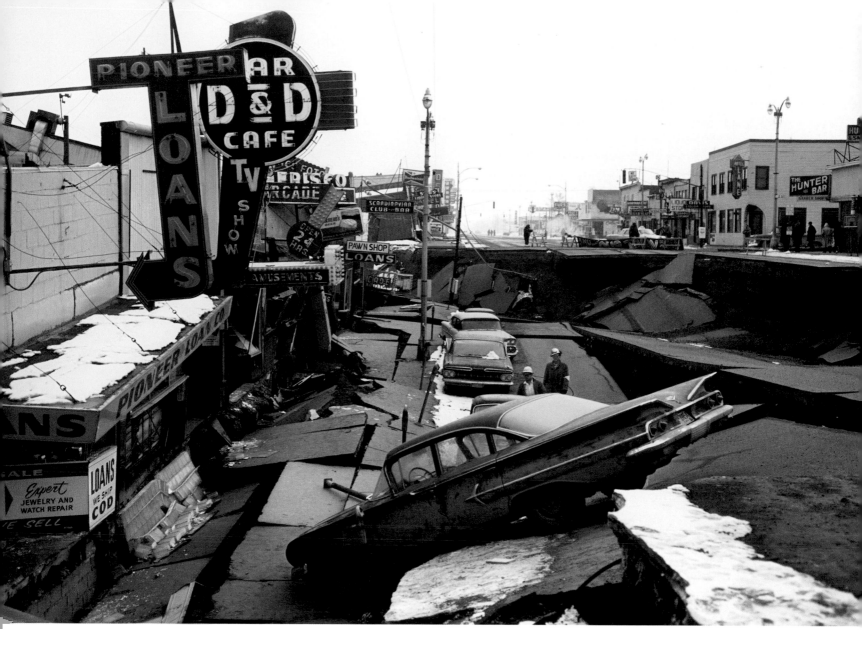

seismic waves pass through an area. The 1964 quake produced seiches from a few inches to six feet high and was so powerful that some seiches occurred as far away as Australia.

The gut-wrenching video of the waterfront slipping into the bay can be seen today in a museum in downtown Valdez—a museum and a downtown that are located four miles from where that tragedy took place. After the devastating quake, the town was condemned and the community was moved from its dangerous site to a spot four miles west along the bay on higher ground underlain by a stable geological foundation. So motorists looking for this town of 4,000 must ignore the old mileposts and continue down the Richardson Highway for a few more minutes.

Perhaps Valdez would have been built in a better location in the first place if most of its early residents hadn't been blinded by the glint of gold. Prior to the winter of 1897–98, Valdez had been little more than a camp, but this changed soon after news of the Klondike gold rush propelled tens of thousands of stampeders north. Various

In 1964, the Good Friday earthquake, the second strongest ever recorded, struck southern Alaska. Though its epicenter was in Prince William Sound, it wreaked havoc as far as distant Anchorage, as this photo shows. The quake spawned tsunamis that obliterated villages and hammered Valdez so hard that its citizens moved the whole town four miles to a safer location.

Great Sea Kayak Trips

1 **Shotgun Cove/Kittiwake Rookery** Reached from Whittier, this four-hour tour starts along forested shoreline and passes numerous waterfalls on its way to a black-legged kittiwake rookery, where some 10,000 of these striking seabirds nest in the summer. Leaving behind the raucous rookery, kayakers paddle to the more peaceful environs of Emerald Cove and other watery nooks and crannies.

2 **Blackstone Bay** Reached from Whittier, this six-hour venture starts with a water-taxi ride to the put-in site; passengers often spot sea otters, seals, and occasionally whales. After settling into their kayaks, paddlers stroke through deep blue waters glimmering with chunks of ice as they glide close (but not too close) to the faces of several tidewater glaciers.

3 **Sawmill Bay** Reached from Valdez, this eight-hour trip offers the mountains, waterfalls, forests, and other scenic treats that abound in Prince William Sound. But kayaking in this tranquil bay in the summer is special because paddlers will join thousands of salmon as they head up the streams that flow into the bay, providing the opportunity to watch the spawning drama and the bears, bald eagles, and other critters that feed on salmon.

4 **Glacier Island/Columbia Glacier** Reached from Valdez, this four-day journey is highlighted by abundant wildlife and an intimate encounter with one of Alaska's largest and most active tidewater glaciers. Floating amid luminous-blue icebergs, kayakers will witness the Columbia Glacier calving truck-size shards of ice into the sea. On other days, they'll cruise around pristine Glacier Island while watching for seals, puffins, sea lions, whales, and bald eagles.

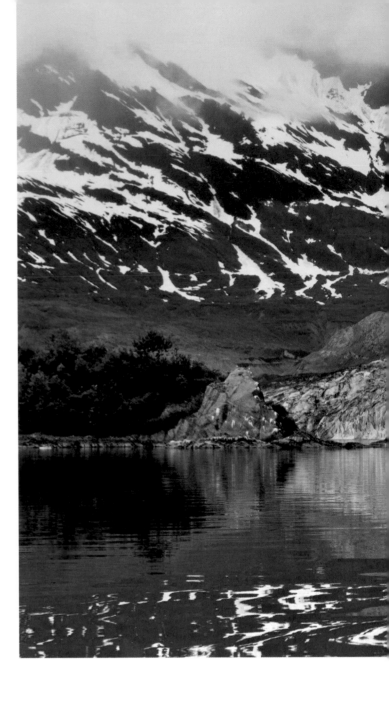

places in Alaska competed to earn the reputation as the best trailhead from which to journey to the Canadian gold fields. A large majority of would-be prospectors ended up in the Skagway area, which was, in fact, a superior jumping-off point. But promoters sold a fair number of gold seekers on the merits of starting in Valdez and heading up the All-American Route, so called because, unlike the paths out of Skagway, it mostly went through Alaska instead of Canada. By the spring of 1898, a tent city had sprouted and several thousand stampeders passed through Valdez that year.

Sadly, those unscrupulous promoters omitted a few salient facts. Though the All-American Route to the Klondike is indeed slightly shorter as the crow flies than the route from Skagway, crows don't have to trek across vast glaciers and haul supplies up steep mountains. Consider this quote from a 19th-century witness:

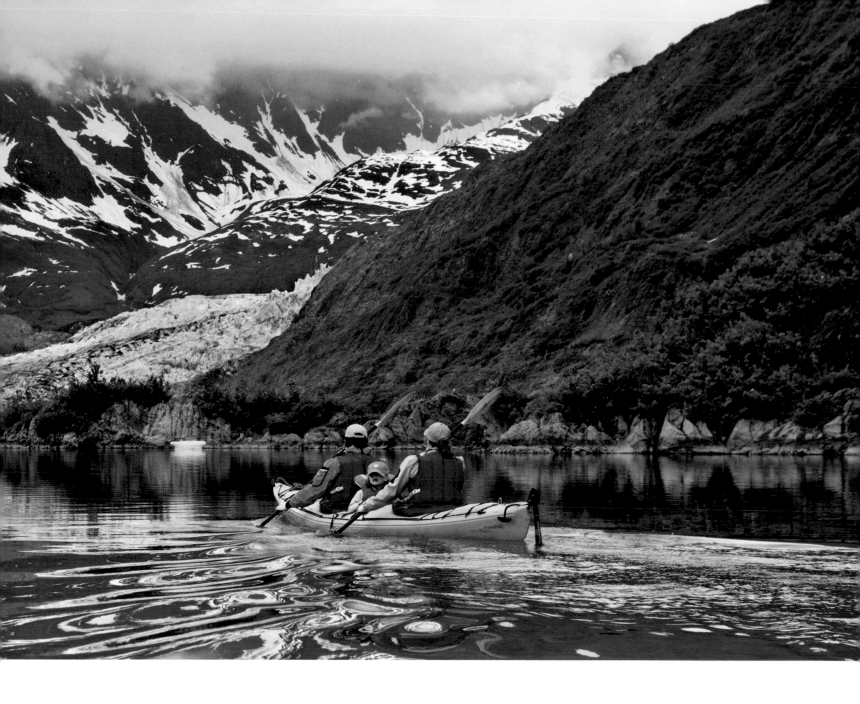

"Think of a man hitching himself to a sled, putting on 150 pounds, and pulling that load from 7:00 a.m. till 2:00 p.m., eating frozen bread and beans and drinking snow water for lunch, then walking back the distance of ten miles. If this is not turning yourself into a horse what is it?" Note the words "walking back" in this description. The writer was referring to the fact that in order to drag enough supplies across glaciers or steep stretches—far more than 150 pounds was needed for a season of gold hunting—the stampeders cum horses had to repeat this process 10, 15, even 20 times. Given the hardships, it's hardly surprising that few of the wannabe Klondike prospectors who headed out of Valdez ever reached the Klondike to do any prospecting. Some died, and many dragged themselves back to Valdez with nothing to show for their efforts but some combination of frostbite, scurvy, snow blindness, and empty pockets.

Just ten miles from Valdez, Shoup Bay is one of many prime sea kayaking destinations in Prince William Sound. Visitors are likely to spot bald eagles, sea otters, and seabirds, and are certain to see Shoup Glacier.

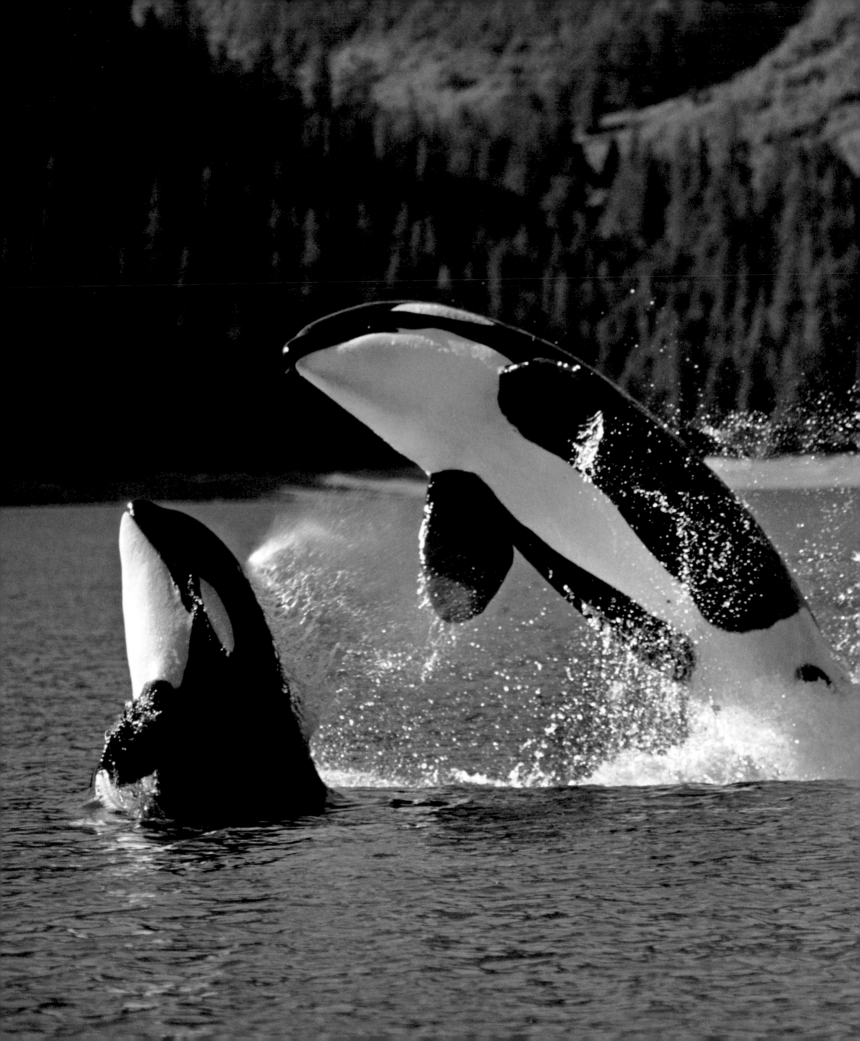

Today, Valdez revolves around the oil industry (it's the terminus of the trans-Alaska pipeline), commercial fishing, and the tourism that stems from the town's splendid surroundings. Though many visitors head up the Richardson Highway into the mountains, the majority turn their eyes to Prince William Sound. The main body of the sound lies about a dozen miles southwest of Valdez; the town sits near the end of a long, deep fjord that narrows to less than a mile wide at one point. Framed by steep slopes, the fjord is a beautiful setting in which to kayak or fish.

Travelers seeking a more extensive tour of this northeastern section of the sound can venture out aboard one of the tour boats that operate out of Valdez. Throughout the fjord, passengers will be served views of the shore-hugging forest and waterfalls that sluice down the cliffs. The falls are so abundant that, in some places, the boat will pass a dozen in half a mile.

Wildlife seems to be everywhere. Bald eagles always make an appearance, perched in treetops or soaring overhead. Occasionally, black bears amble into view on the shore or in a mountainside meadow. Puffins, cormorants, murres, and other seabirds frequently wing past. Humpback whales may suddenly missile out of the water and execute their signature aerial twists before cannonballing back into the sea with a resounding splash. Boats often stop just offshore from a sea lion colony so passengers can watch as dozens of these raucous beasts grumble and growl in what seems like endless squabbling.

Sea otters are plentiful in these waters, sometimes clustering in rafts, which can include dozens, even hundreds of individuals. Tour boats often slow down or stop to allow people to watch these crowd-pleasing members of the weasel family. Passengers might see an otter surface clutching a crab or sea urchin, which it typically will eat while floating on its back, holding its catch in both forepaws and chomping on it much as a human gnaws corn on the cob. Seeing otters feeding is common, given that they consume 20 to 30 percent of their body weight each day. Otters also like to get their beauty rest. Sometimes two otters will hold paws while snoozing so they won't drift apart, a sight sure to evoke an "ahhhh" from onlookers. If a boat arouses their curiosity, otters may straighten up vertically in the water and stare at the vessel with their forepaws raised in a comical "hands-up" position.

Opposite: A pair of killer whales cavort in Bainbridge Passage in the southwest corner of Prince William Sound. Hunting fish or marine mammals, killer whales roam throughout the sound.

Exploring the Richardson Highway

This scenic highway connects Prince William Sound to points north. The road follows a dramatic river up into the coastal mountains, then follows a succession of pretty rivers to the Copper River Valley.

❶ About Mile 13 out of Valdez, the route swings and enters the narrow confines of **Keystone Canyon.** At every bend, waterfalls seem to cascade from towering cliffs.

❷ Turn out at Mile 13.4 to see **Horsetail Falls** and about half a mile later, Bridal Veil Falls.

❸ At Mile 24, a one-mile dirt road leads to **Blueberry Lake State Recreation Site,** which has a campground, picnic tables, and fine fishing.

❹ Two miles farther, the road reaches its highest point, 2,678-foot **Thompson Pass.** It's one of the snowiest places in Alaska.

❺ At Mile 28.7, stop at the **Worthington Glacier State Recreation Site.** A paved trail leads to the face of the glacier.

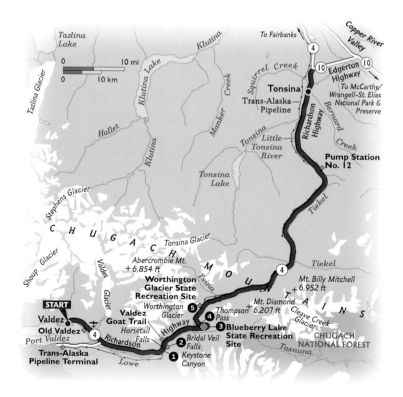

Some tour boats do all-day trips that range beyond the fjord to Prince William Sound proper. Most of these round Point Freemantle and steer north up into Columbia Bay. Sharp-eyed passengers may spy mountain goats scaling steep slopes near the snow line on the mountainsides. Easier to spot, considering that the males can reach 2,500 pounds and 11 feet in length, are Steller sea lions, which may be seen flippering through the water or hauled out on the shore. These remarkable animals can dive to depths exceeding 1,000 feet in search of favored foods.

Even before boats enter Columbia Bay, the surface of the sound begins to flash with extra sparkle, something more than light reflecting off water. Icebergs. More precisely, growlers and bergy bits—old-time sailors' names for smaller pieces of floating ice. To officially rate the term "iceberg," a chunk of ice must be at least 16 feet across. Proceeding north, boats soon encounter legitimate icebergs, sometimes vast flotillas of them. Discerning observers will notice that they come in different colors. White icebergs have large numbers of air bubbles trapped inside them; greenish black bergs have broken off from the bottom of a glacier; those famous dazzling blues indicate how dense the ice is—the bluer an iceberg is, the more compressed the ice.

On a clear day, passengers will see the source of the icebergs from well over ten miles away: the Columbia Glacier. This hulking river of ice extends south to the sound from high in the Chugach Mountains. It is a long glacier—a little more than 30 miles—but not nearly as long as it used to be. As recently as 1980, it measured about 40 miles and contained twice the volume of ice. Recently, the Columbia has been calving as much as two cubic miles of ice into the sound in a year, about five times as much freshwater as the state of Alaska uses annually. All that fallen ice creates a lot of icebergs; at times, they're so numerous that boats cannot get near the glacier. However, within the bounds of safety, tour boats try to get close, perhaps within a mile on a good day, because the Columbia is such an active glacier.

The face of the Columbia is about 10 miles wide and 100 feet tall, with another 100 to 300 feet extending vertically below the water. Calving occurs somewhere along the face almost constantly, though mostly these are smaller events. But "smaller" is a relative term, and in this context, it might mean a Hummer-size block of ice breaking off, accompanied by loud crackling and sometimes a sharp blast that sounds like a gunshot. Less frequently but often enough, pieces the size of a house split off and thunder into the water. When such large hunks fall away from the face, the sudden lifting of so

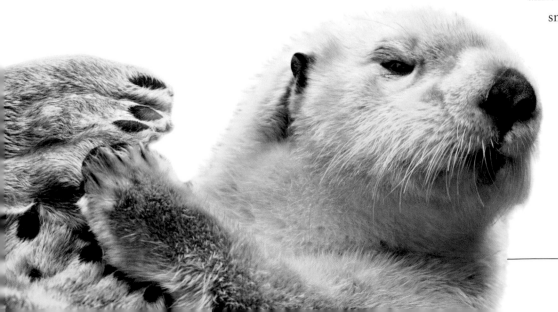

Blessed with chart-topping cuteness, sea otters abound in the near-shore waters of Prince William Sound. Tour boats often tarry to let passengers watch as otters dive for food, eat crabs and shellfish, and groom their luxurious coats.

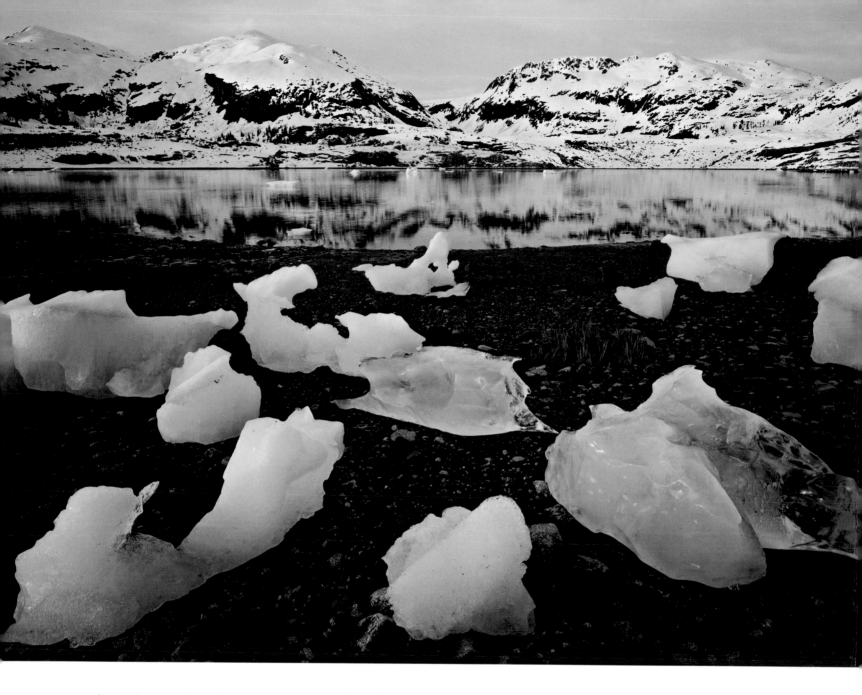

much weight sometimes releases massive pieces of ice from the underwater portion of the face and they spring to the surface like giant corks. Occasionally, these formerly submerged masses of ice celebrate their newfound freedom by rocketing into the air, sometimes as high as the top of the glacier's face, before falling back down and smacking the water with a gargantuan belly flop.

As tour boats returning from the Columbia Glacier round Point Freemantle and turn north toward Valdez, having spent the day cruising amid the natural riches of Prince William Sound, they pass within half a dozen miles of Bligh Reef, where those natural riches suffered a dire blow in 1989. For it was upon this submerged rock that the oil tanker *Exxon Valdez* ran aground just after midnight on March 24 of that year—another Good Friday disaster, 25 years after the Good Friday earthquake shook Alaska to the core.

Many glaciers flow down from the Chugach Mountains and drop chunks of ice into Prince William Sound. Some float around as icebergs and smaller "bergy bits," while other hunks of ice wash up onto beaches.

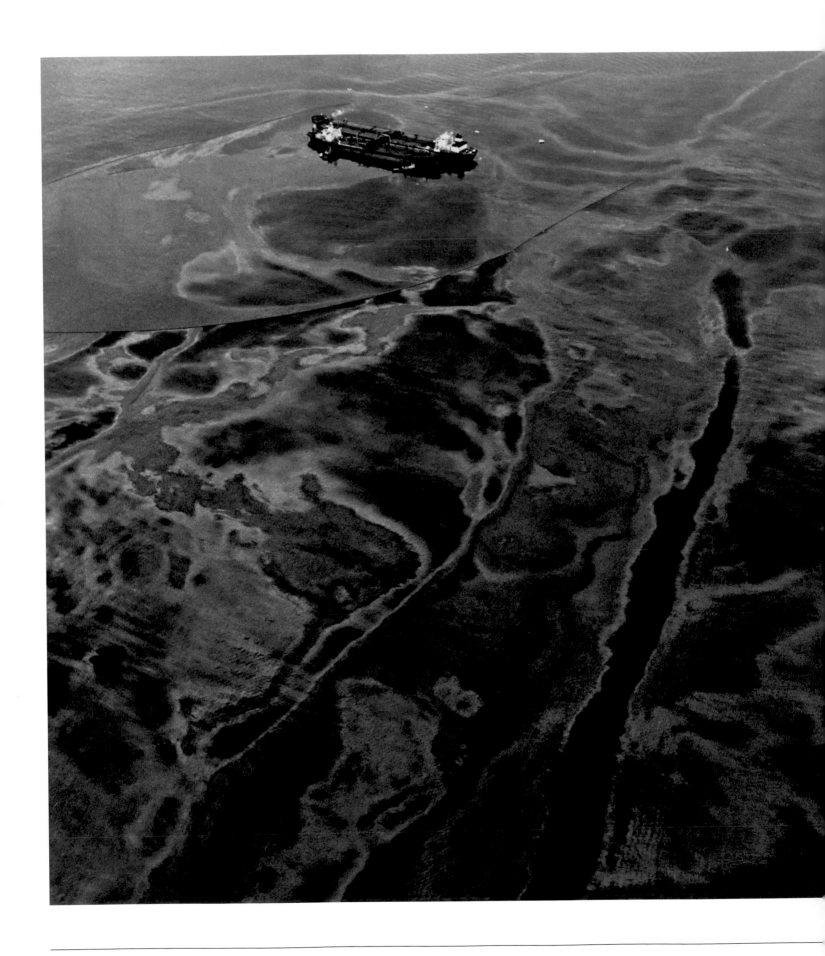

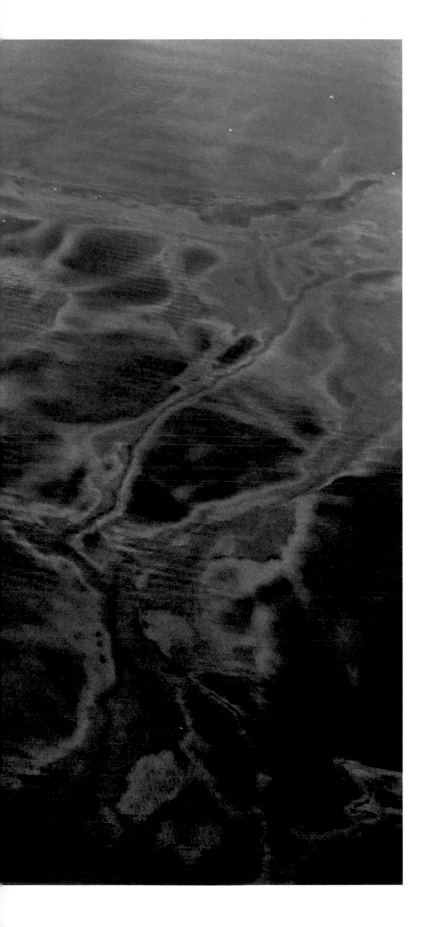

In 1989, the supertanker *Exxon Valdez* ran aground in Prince William Sound. Millions of gallons of oil leaked, killing seabirds and marine mammals, devastating fisheries, and fouling some 1,500 miles of coastline.

The 987-foot tanker—the second newest in Exxon's fleet at the time—was carrying 53 million gallons of North Slope crude from the trans-Alaska pipeline terminal in Valdez to Long Beach, California. But the ship didn't get far. Less than three hours out of Valdez, the tanker's lookout spotted the Bligh Reef navigation light off the starboard bow; it should have been off the port bow. The officer piloting the ship initiated corrective maneuvers, but it was too late—1,000-foot ships don't turn on a dime. At 12:04 a.m., the *Exxon Valdez* scraped onto the rocks and came to rest with its midsection lying across a pinnacle of the reef.

> ❝ Absolutely no drilling for oil in Bristol Bay, no drilling for oil in the Arctic National Wildlife Refuge, double-bottoms and double-hulls for all tankers sailing in U.S. waters. ❞
>
> **[Toby Sullivan, fisher, after the *Exxon Valdez* oil spill]**

The causes of the accident remain unclear, despite years of investigation and litigation—most likely some combination of fatigue, procedural mistakes, inadequate oversight, and poor judgment. But what is undisputed is the result: Eight of the ship's 11 cargo tanks ruptured, and at least 11 million gallons of crude oil spewed into the pristine waters of Prince William Sound. The toxic substance spread widely, fouling some 1,300 miles of coastline and severely damaging fisheries, tourism, and wildlife. For months, television news broadcast horrifying images of oiled sea otters and seabirds. Thousands of people rushed to help with the cleanup and to try to save the injured animals, but many died. Best estimates figure that among the dead were 250,000 seabirds, 2,800 sea otters, 300 harbor seals, 250 bald eagles, and up to 22 killer whales. Less noted but no less important,

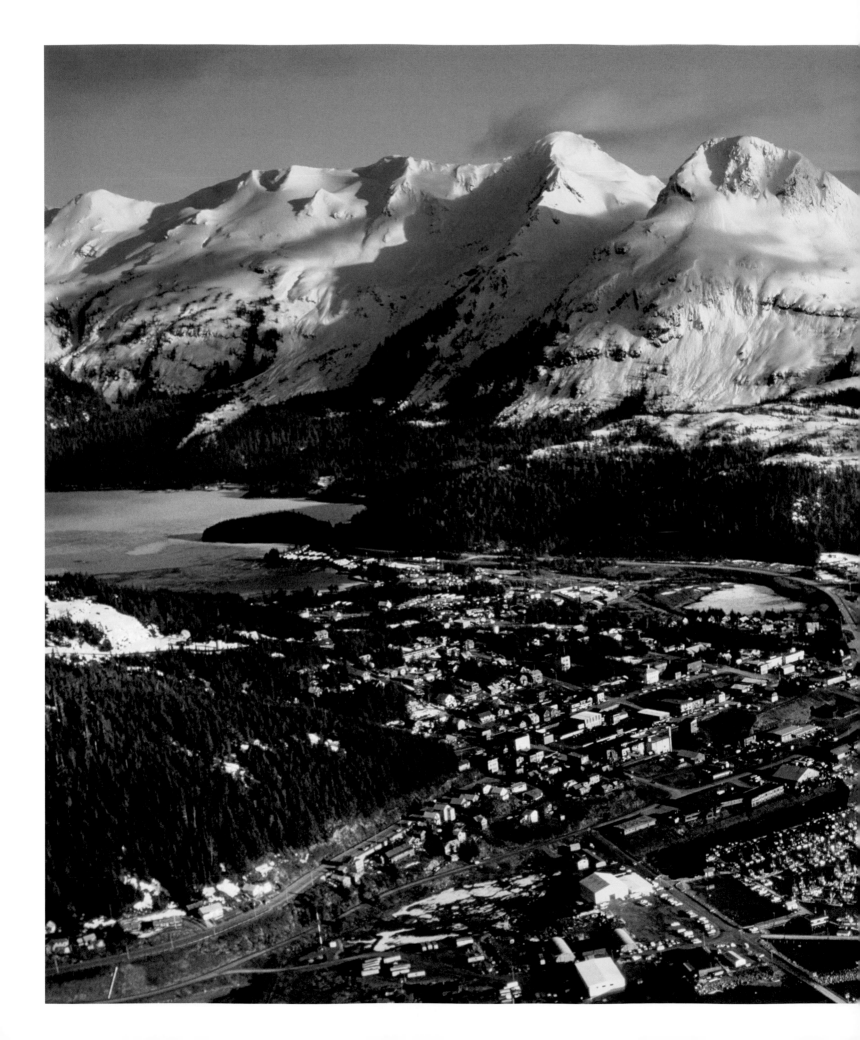

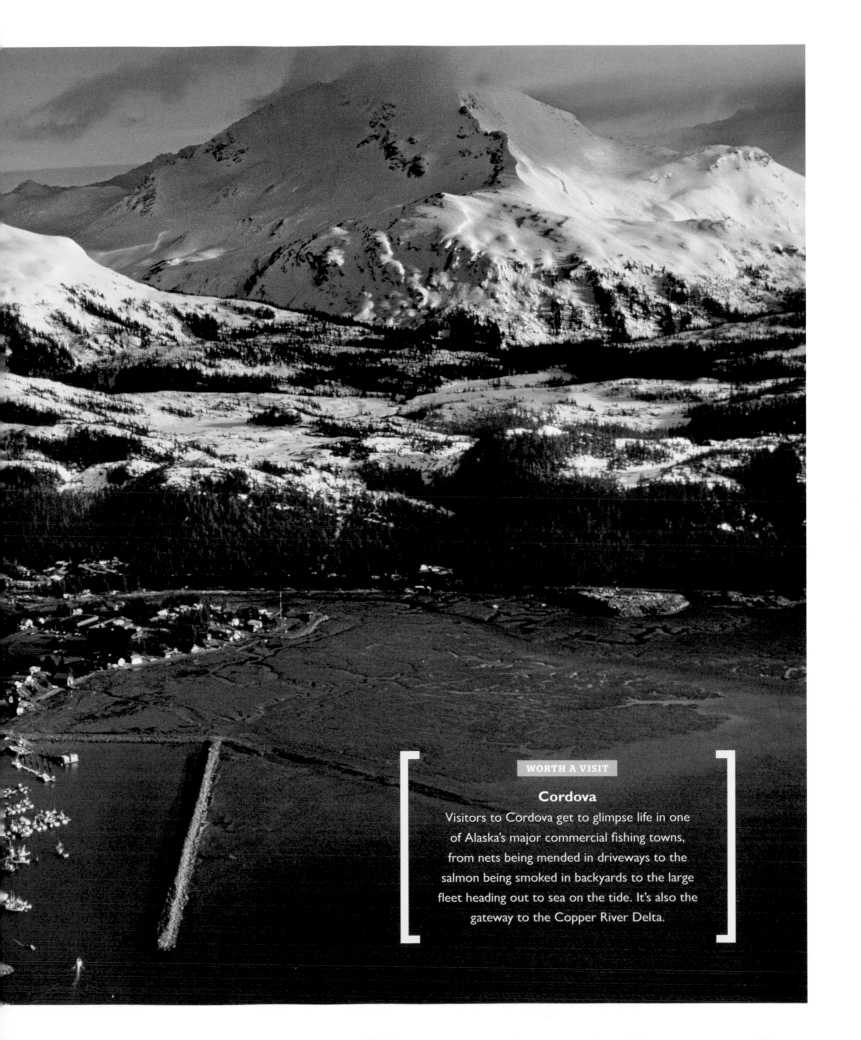

Cordova

Visitors to Cordova get to glimpse life in one of Alaska's major commercial fishing towns, from nets being mended in driveways to the salmon being smoked in backyards to the large fleet heading out to sea on the tide. It's also the gateway to the Copper River Delta.

the little creatures that form the base of the food web perished in untold numbers, diminishing the productivity of the sound for years to come.

The fate of the two killer whale pods hit hardest by the spill shows that the long-term effects of an oil spill can be subtle—and devastating. The oil killed several members of the AB and AT1 pods, but not just any members. A disproportionate number of the victims were mature females, and it so happens that mature females are the leaders in killer whale society. Some of the deceased females had young offspring, many of which died in the next few years, most likely because of the loss of their mothers. The AB pod's social order broke down, which is unusual for killer whales, and one splinter group split off from the pod and joined another, which is extremely unusual. Still, the AB pod is slowly recovering. The AT1 pod is not; no new offspring have appeared since the spill, and scientists think the pod is heading for extinction.

One of the places hurt by the oil spill was Cordova, a community of about 2,300 tucked into Orca Inlet at the far eastern edge of Prince William Sound. Life in this little town revolves around fishing. Small but mighty, Cordova ranked number five in the United States in the value of its annual seafood catch in 2010. When the spill knocked down fish production in the sound, it knocked down Cordova. However, the town got back on its feet, perhaps sooner than some because it is positioned so that some of its fishers work to the west in the sound and some to the east in the Copper River Delta, which eluded the oil slick.

The Copper River Delta fishery is Cordova's claim to fame. Typically, when supermarkets and seafood shops display salmon in their refrigerated cases, they identify it merely by species: "sockeye," for example. But in stores that buy salmon from the delta, customers will encounter signs identifying the lustrous red fillets as "Copper River Sockeye." These sockeye are prized for their taste and nutritional value, which, according to some Cordova fishers, results from the unusually large amount of savory and healthful fats that these fish must build up to make the long migration up the Copper to their spawning grounds. Fishery biologists note, too, that the Copper River carries an enormous load of nutrients into the delta, which fuels

Salmon of the Sound & Delta

1 King The largest of the five major Alaska salmon species, the king salmon (aka "chinook," "Tyee," and "blackmouth") naturally was named Alaska's state fish—a big fish for a big state. They commonly run 30 to 50 pounds, but the record king, caught in 1949, weighed in at 126 pounds.

2 Sockeye Many people consider sockeye the tastiest salmon species, though this judgment is a matter of endless debate in Alaska. But it's indisputable that chefs, seafood buyers, and ordinary consumers crave sockeye and pay top dollar for it. Both sockeye and their roe are very popular in Japan. Sockeye are also called "reds" because they turn a brilliant scarlet when they enter freshwater on their way to spawn.

3 Coho Many sportfishers come to Alaska to chase coho because they fight tenaciously and taste great. About three-quarters of all the nation's coho, which many people call "silvers," are caught in Alaska. Lots of restaurants seek coho because their fillets are the perfect size, and they retain an appetizing orange-red color.

4 Pink Commercial fishers haul in about 140 million pinks a year, making this three- to five-pound species by far the biggest salmon catch in the state. Their flesh is not as savory or firm as other species, so almost all of them are canned. Pinks are also called "humpies" because the males develop a huge hump on their backs when they hit freshwater and prepare to spawn.

5 Chum Always last on the list, chums, frankly, just don't taste that good compared with other salmon. That's why many Alaskans traditionally fed chum to their dogs, giving this species its other common name: dog salmon. Incongruously, chum are beautiful. They sport metallic, greenish blue backs speckled black, and develop black-and-red stripes on their sides when they get ready to spawn.

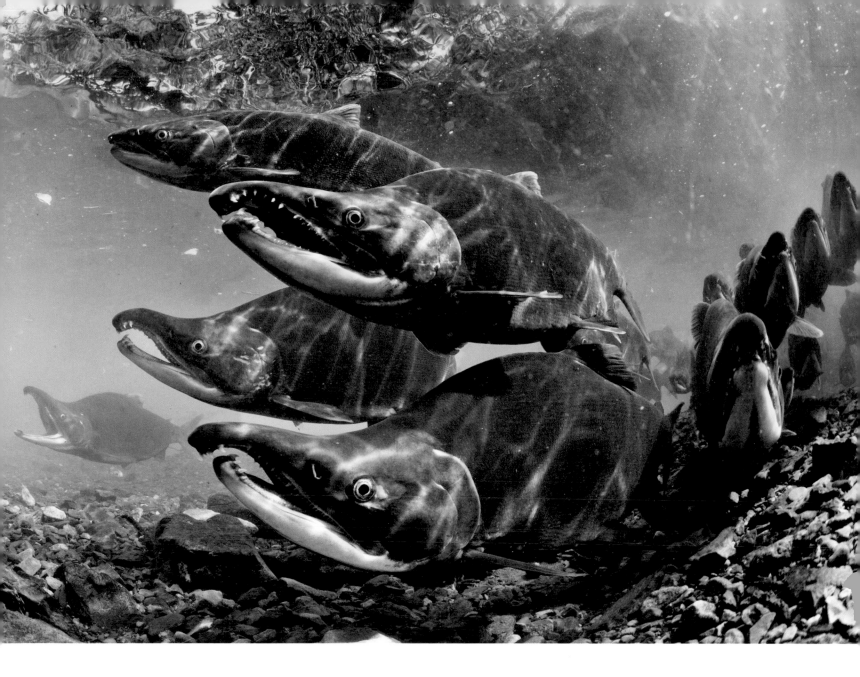

lush plankton blooms that enrich the entire food web, which in turn fattens up the salmon with those yummy and desirable omega-3 fatty acids.

The bounty of the Copper River Delta extends far beyond salmon and plankton. The 300-mile-long river and its many tributaries drain a basin the size of West Virginia. After this mighty rush of water and sediments funnels into a single channel to cut through the coastal mountains, it emerges from the confines of the high country and spreads out in a classic fan-shaped delta, a 700,000-acre tapestry of sloughs, meadows, mudflats, cottonwood forests, marshes, and sandbars all woven together by the many threads of the river. Poster-worthy wildlife abounds. Grizzly bears, black bears, sea otters, river otters, moose, sea lions, wolves, beavers, harbor seals, minks, wolverines—the list is long. But above all, the delta is a sanctuary for birds in a world where few sanctuaries remain.

Sockeye salmon spawn in creeks all over the Copper River Delta. These are the famously delicious "Copper River Reds," sought by chefs and eager consumers all over the United States.

Arctic terns, bald eagles, phalaropes, and numerous other species come to the delta to nest in the summer, including most of the world's dusky Canada geese. Perhaps the most conspicuous of the nesting species are the trumpeter swans, the world's largest swan species. It's hard to miss these regal birds as they cruise the backwaters with their bright white body weighing up to 40 pounds; black bill, legs, and feet; and wingspan as broad as eight feet. Even their nests stand out. For a couple of weeks, the

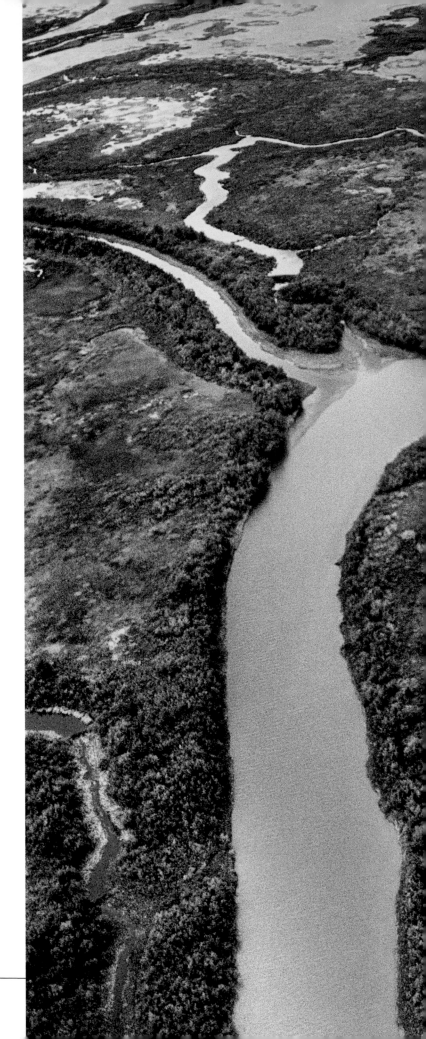

> **NATURAL WONDER**
>
> ## Down in the Delta
>
> The riches of the Copper River Delta are built from the bottom up. The burly river carries 75 million tons of sediment downriver a year, and dumps it into the delta and the Gulf of Alaska. In summer, as ice and snow in the basin's high country melts, the sediment load swells to 750,000 cubic feet a day, one of the largest such loads in the world. The layer of silt that forms the foundation of the delta is 600 feet deep and counting.

cob (a male swan) brings nesting material to the pen (a female swan), which then carefully arranges the cattails and bulrushes until she has constructed a 6- to 12-foot-diameter mansion of a nest. Trumpeter swans are conspicuous even when you cannot see them—their resonant calls prove that they come by their name honestly. From 5 to 10 percent of the world's trumpeter swans nest in the delta.

Most of the birds that use the delta don't nest there. They're migrants, and they come because it's the largest wetland ecosystem on the Pacific coast of North America and a key stopover on the migratory bird route known as the Pacific flyway. Prominent among these long-distance travelers are the several million waterfowl that tank up in the delta during the spring on their way north to nest in the tundra, and likewise stop for some food and rest in the fall on their way back south.

Renowned as a spawning grounds for salmon and a major stopover for migrating birds, the Copper River Delta is a jigsaw puzzle of snaking channels, marshes, and wooded uplands.

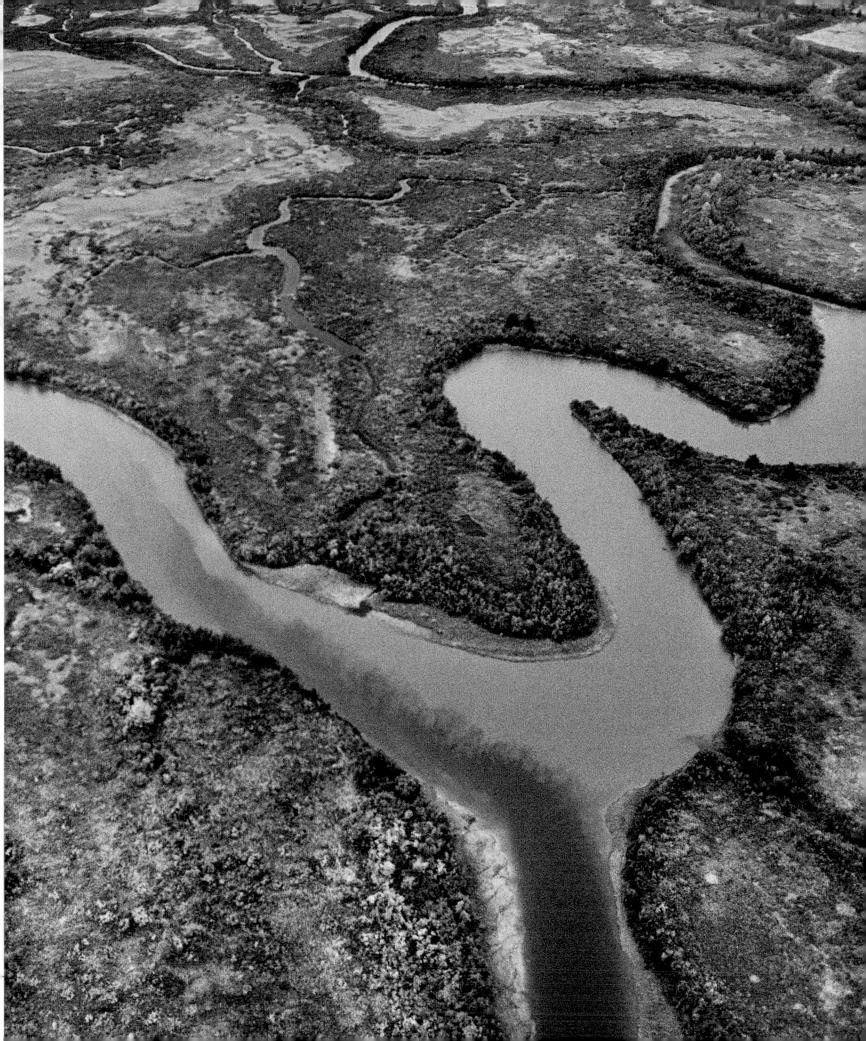

Ma Johnson's Hotel occupies a restored 1920s building in the tiny town of McCarthy. Reached via a notoriously rough, 60-mile-long dead-end road, McCarthy sits in the middle of Wrangell-St. Elias National Park and Preserve. McCarthy is the only settlement in what is by far the largest park in the United States. *Opposite:* Ermine in its winter coat

The town was named Kennicott, after the explorer Robert Kennicott. The mine was named after him, too, but the founders misspelled it "Kennecott," and unfortunately, that mistake stuck, confusing visitors to this day. Kennicott is basically a ghost town now, except for the historic Kennicott Glacier Lodge, a fine hostelry whose 180-foot-long front porch provides grand views of the Kennicott and Root Glaciers. The lodge does a brisk business during the summer, because much of the area encompassing the mine and town has been preserved as Kennecott Mines National Historic Landmark.

The historic buildings in Kennicott do not include any bars or brothels, unlike in most old mining towns. That's because the company wanted to keep its town neat and clean; perhaps they felt it would be better if workers blasting tunnels with dynamite didn't have hangovers. So the wild and woolly elements of frontier life found a home five miles down the hill from Kennicott, in a ramshackle community that grew up to be the town of McCarthy. Though the 2010 census takers didn't need to spend much

time in McCarthy—population 28—this tiny hideaway does have some appealing amenities, such as a museum, a saloon, and a few colorful restaurants and hotels, several housed in appealing historic structures. But those amenities are not the reason so many travelers come to McCarthy. Nor is the proximity of Kennecott Mines the only reason. The town's finest feature is its location, right in the middle of Wrangell-St. Elias National Park and Preserve.

Wrangell-St. Elias is big. By far the largest park in the nation, its 13.2 million acres could swallow half a dozen Yellowstones or the entire country of Switzerland. Even the elements that make up Wrangell-St. Elias are big. The Bagley Icefield is 10 miles wide in places, thousands of feet thick, and nearly 100 miles long. Led by 18,008-foot Mount St. Elias, the park contains 9 of the 16 highest peaks in the United States, not to mention the fact that there is such a multitude of formidable mountains that many have yet to be named. Combined with neighboring Glacier Bay National Park and a couple of adjacent Canadian parks, Wrangell-St. Elias forms a United Nations World Heritage site that is the largest internationally protected natural area in the world.

Wrangell-St. Elias is as wild as it is big. Its 9.7 million acres of designated wilderness are the most in the United States, and the park's other 3.5 million acres are not exactly Disneyland. McCarthy is an anomaly; no other towns lie within park boundaries. Only two roads penetrate Wrangell-St. Elias—both are gravel, both are dead ends, and both are rough, potholed, and alternately dusty, muddy, or icy. Other than around the edges, there are no formal campgrounds or trails.

Big and wild. Therein lies the beauty of Wrangell-St. Elias. That beauty starts at the top with all those brawny mountains, which dominate a sizeable portion of the park. Several major ranges come together to create this high-country extravaganza of rock and ice. Ice is most evident in the scores of glaciers that stretch down from the mountains, polishing stony slopes and grinding out valleys. They coat about a quarter of the park. Many are 10, 15, 20 miles long and a couple of miles wide; some go to much greater lengths. At about 75 miles, the Nabesna is the world's longest interior valley glacier. The Malaspina Glacier could cover Rhode Island.

The Ahtna, an Athabaskan people who have lived in the region for at least 1,500 years, have a name for Mount Wrangell that

Little Critters of Wrangell-St. Elias

1 **Northern Flying Squirrel** These smallish squirrels cannot fly. But they can glide as far as 150 feet from tree to tree by deploying a flap of skin that runs from their wrists to their ankles. Flying squirrels play a vital role in maintaining a healthy forest. They feast on the fruiting bodies of mycorrhizal fungi and spread the spores of these fungi, which enable conifers to increase their uptake of nutrients and water.

2 **Vole** Every animal is dinner for some other animal, and the lowly vole is a more popular prey item than most. The half dozen species of these chubby, mouselike creatures that inhabit the park are fodder for coyotes, owls, martens, foxes, and many other predators. And voles excel at being fodder because they are one of the most prolific breeders among mammals. Their gestation period is a mere three weeks; within a month, a newborn vole becomes sexually mature. Each female typically produces three to ten babies a litter, and each female can produce five to ten litters a year. One captive female somehow managed 17 litters in one year.

3 **Ermine** In the old days, ermine fur coats were highly prized; the creamy white winter fur often was used for trim on royal robes. Such uses have declined in modern times due to changing attitudes and abundant alternatives—and perhaps because people realized that ermine are weasels. About a foot long and weighing in at about five ounces, ermine are very slender, and for a good evolutionary reason: They mostly eat voles, and being skinny enables them to slink through the narrow tunnels voles make under the snow.

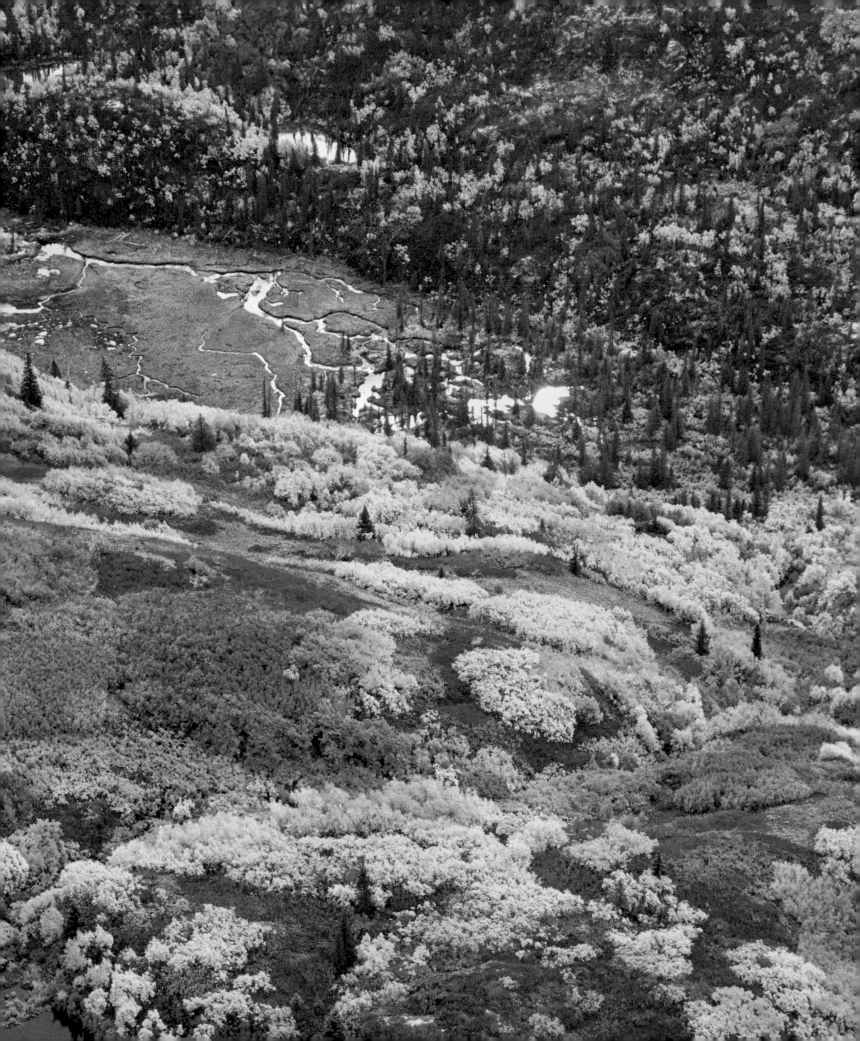

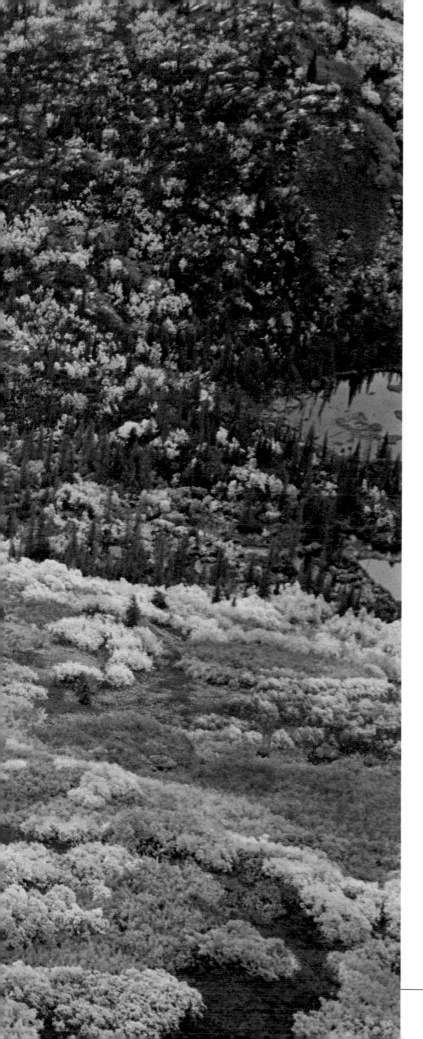

hints at the reason that so many glaciers have formed in this park. The name, "K'elt'aeni," is difficult to translate, but means something like "the one that controls the weather." Mount Wrangell and its mountainous brethren do indeed strongly influence the weather, and it is the weather plus the topography that creates glaciers.

When moisture-packed air masses from the Gulf of Alaska sweep into the park, they collide with the steep mountains and rise upward. As they gain elevation, they cool and release most of that moisture, dumping prodigious amounts of snow—dozens of feet in a heavy year. Over time, it accumulates and starts exerting pressure on the bottom layers of snow, gradually squeezing the air out of them and coarsening the powdery snow. As the weight above continues to increase, the granular snow eventually is compressed into ice. Given plenty of snow and the right terrain, that ice expands into an ice field. When that ice field grows thick enough, at certain places, it will start flowing downhill into valleys. And, voilà, a glacier is born.

Not all of Wrangell-St. Elias is rock and ice. Just below that stark realm lie carpets of alpine tundra consisting of mountain avens, dwarf birch, reindeer lichens, blueberry, buttercups, and polar willows. Sure-footed mountain goats and Dall sheep might be spotted feeding on the steeper slopes,

It may not be New Hampshire, but the forest and tundra of Wrangell-St. Elias National Park and Preserve flash a surprising amount of color in autumn.

and roly-poly marmots and diminutive pikas dwell in the rock piles. Sometimes caribou trek to those heights to escape the biting bugs. In mid-elevations, trees begin making an appearance, grading into full-fledged forests of white spruce, paper birch, and aspen as one goes lower. Black bears, lynx, and porcupines wander beneath the canopy while a golden eagle may soar in the sky above. In the lowlands, generally found in the river basins, the land seems to be half water: Lakes, willow bogs, and

> **66 Nowhere else in Alaska can you become so endlessly surrounded by high mountains, glaciers, rock, and ice. 99**
>
> **[Gary Larsen, geophysicist, referring to the Wrangell and St. Elias Mountains]**

wetlands abound, providing habitat for geese, trumpeter swans, ducks, beavers, and long-legged moose grazing on submerged vegetation. Salmon streams draw grizzlies, and in a couple of drier areas, transplanted herds of bison add a dash of the Great Plains to the scene.

Whether heading for the mountains, the low country, or in between, travelers will find Wrangell-St. Elias challenging. Veteran outdoorspeople will need all their savvy, and the less experienced should consider enlisting one of the many guide services that operate in the park. Visitors who want to drink deeply of this wilderness can arrange for a small plane to drop them off in some remote corner of the park, with or without a guide, for as long as they like. If they don't have the time, money, or inclination to be left out in the backcountry, a plane ride itself might be just the ticket. Even from a thousand feet in the air, with the shadow of the plane just a moving dot on a gleaming glacier far below, passengers can get a feel for this raw landscape and behold a big and wild world that looks much as it did thousands of years ago. ■

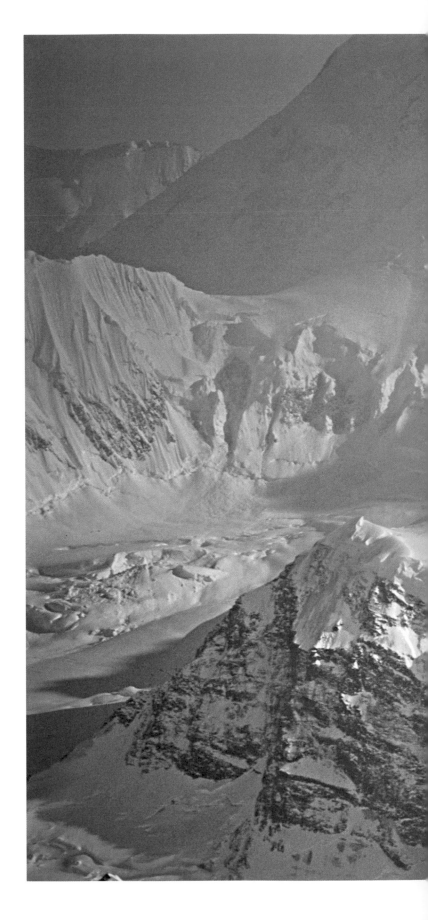

Wrangell-St. Elias National Park and Preserve is nearly roadless and tough to penetrate on foot, so many people take bush planes to explore the backcountry.

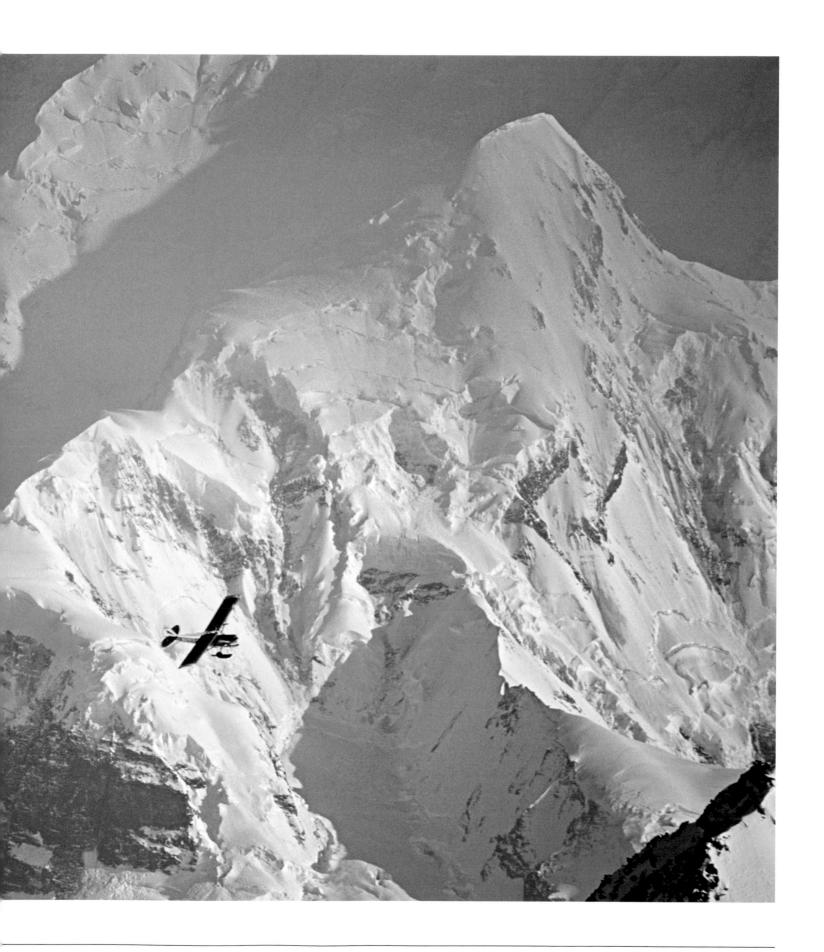

Sites and Sights in South Central

Whittier is like a battered old gate that opens onto an enchanted garden. This little town on the western border of Prince William Sound offers few amenities, but it houses a number of outfitters who will take travelers into the sound to watch whales, catch fish, sidle up to tidewater glaciers, scuba dive, and kayak alongside sea otters. *whittieralaskachamber.org*

Whittier, Valdez, and Cordova are the main ports of call for the **Alaska Marine Highway** in Prince William Sound, with whistle-stop service to the tiny villages of Chenega Bay and Tatitlek. But the cliché about the journey being half the fun rings true in this case. Travelers can take the ferry from any of these departure points to any of these destinations and savor grand scenery and wildlife sightings as the ship slaloms through islands and along the pristine coastline. *dot.state.ak.us/amhs*

Valdez is one of those towns that draws energetic travelers from around the nation and world. River rafting, skiing, sportfishing, hiking, kayaking, snowboarding—a person can run herself ragged recreating in and around this town, especially during the summer when the sun barely sets. Though Valdez mostly attracts visitors who use it as a hub to venture into the northeastern end of Prince William Sound or the southern flanks of the Chugach Mountains, the town itself deserves a little attention. The **Valdez Museum** covers all the main bases of the area's history and culture, from native peoples to gold rush era to pioneer days to the arrival of the oil industry. To glimpse what Valdez looked like before the 1964 earthquake destroyed it and the community moved to its present location, visitors should check out the incredibly detailed scale model of the town at **Remembering Old Valdez.** The harrowing video of the earthquake will vividly convey the reasons for relocating the community. The **Maxine & Jesse Whitney Museum** presents one of the most extensive private collections of native art and artifacts in Alaska. And the quality matches the quantity. The intricate walrus-ivory carvings of whales, ships, dolls, and birds are superb, as are the

traditional parkas, such as the one fashioned from the breasts of 40 murres and lined with wolverine fur. *valdezalaska.org*

A few hours in a tour boat out of Valdez brings passengers to one of the planet's natural wonders: an active tidewater glacier. And it's not just any old representative of the genre, but the mighty **Columbia Glacier**—30 miles long, 10 miles wide at the face, and exceptionally kinetic. It sheds ice like a dog sheds hair. Icebergs from the Columbia bob in the bay and the sound for miles beyond the glacier, glinting in the light with radiant shades of blue that a painter would be hard-pressed to match. When the Columbia calves an uncommonly large section of ice—something the size of a Boeing 747, let's say—the explosive sound of it breaking off from the face and the sight of it pounding into the water and sending up a hundred-foot splash seems positively primeval. *valdezalaska.org*

Cordova is not a tourist town, but it is a great place to visit. No roads connect Cordova to the rest of Alaska; visitors must come by plane or ferry. Commercial fishing provides the heartbeat for the community, so travelers might start by strolling around the docks

Horsetail Falls in Keystone Canyon

and taking in the boats and fish-processing plants. On the north side of the harbor is the **Prince William Sound Science Center,** a research facility that offers the public a few dockside displays. On the south side is the **Ilanka Cultural Center,** which serves the Native Village of Eyak and contains a small museum. In the little downtown overlooking the harbor, there are no Burger Kings, Starbucks, or Marriotts; the businesses are local and independent, just like the residents. *http://cordovachamber.com*

Just east of Cordova sprawls the 700,000-acre **Copper River Delta,** a fertile wildland of ponds, willow thickets, sloughs, cottonwood groves, and mudflats backed by uplands of forested mountains. The delta supports a diverse cast of wildlife, including moose, bears, beavers, and all manner of birds. Millions of avian migrants, especially shorebirds, spend time feeding and resting at this major stopover on the Pacific flyway. To celebrate this phenomenon, Cordova stages the **Copper River Delta Shorebird Festival** every May. Visitors can explore the area by driving out the **Copper River Highway,** a 50-mile dead-end road, most of it gravel, that bisects the delta. Partway along, drivers can take a short spur to **Alaganik Slough,** where an elevated boardwalk with interpretive signs allows people to venture into habitat that otherwise is inaccessible without a boat. During the summer, when spawning candlefish crowd into the slough, a parade of hungry animals descends on Alaganik, including bears, bald eagles, and gulls. A few miles farther along, the **Haystack Trail** branches off from the highway and winds a little less than a mile through the spruce forest to the top of a knoll that overlooks the delta and the Gulf of Alaska beyond. At the end of the road, motorists come to the **Million Dollar Bridge,** which actually cost $14 million to build back in 1910. This 1,550-foot bridge was a key link in the railroad from the Kennecott copper mines to Cordova. Near the bridge is the soaring face of the **Childs Glacier,** which frequently calves ice into the Copper River it borders. *http://cordovachamber.com*

Kayak Island lies in the Gulf of Alaska, just offshore from the eastern tip of the Copper River Delta, a quarter moon–shaped curve of land that catches all sorts of flotsam from the Pacific; commercial fishers' floats, rubber duckies, even messages in a bottle have washed up on its beaches. Kayak Island or somewhere in the vicinity is where Vitus Bering first encountered Alaska in his voyage of discovery for Russia in 1741. *http://cordovachamber.com*

The **Richardson Highway** runs north from Valdez and Prince William Sound through the Chugach Range to the interior section of south-central Alaska. The first 30 miles are a real knockout. About a dozen miles out of Valdez, the road winds through narrow **Keystone Canyon,** running a gauntlet of waterfalls. Motorists reach the high point—literally—some 25 miles from Valdez when the highway tops out at **Thompson Pass,** 2,678 feet. It's one of the snowiest places in Alaska, and that's saying some. Just a couple of miles farther along, travelers can pull over at **Worthington Glacier State Recreation Site,** which has a little visitor center, interpretive signs, and a short trail to the face of the glacier.

From the hamlet of Chitina, at the end of the Edgerton Highway and the confluence of the Copper and Chitina Rivers, the notorious **McCarthy Road** strikes out east into Wrangell-St. Elias National Park and Preserve—"notorious" because this rutted, muddy, 60-mile gravel dead end with its one-lane bridges and minefield of sharp rocks has chewed up many a vehicle. It has a particular appetite for tires. In fact, most Alaska rental car agreements specifically prohibit travel on the McCarthy Road. But for careful drivers willing to ease along at about 20 miles an hour (and carry a couple of spare tires), it's usually an adventure and not a disaster. At road's end, travelers park by the Kennicott River and walk across one of the footbridges into the 28-soul town of **McCarthy,** where they can take in the historic buildings, eat at a down-home restaurant, or stroll through the little museum. *coppervalleychamber.com*

Moose antlers, McCarthy

The **Kennecott Mines National Historic Landmark** enables visitors to imagine life in the copper mines and adjacent company town when this remote outpost was bustling. From about 1910 to 1938, Kennecott was one of the world's most productive copper mines; at its peak, some 600 people worked in the tunnels and town. Managed by the National Park Service, many of the historic buildings have been or are being rehabilitated, including the assay office, some bunkhouses, the school, the concentration mill, and the general store. Kennecott Mines is just a few miles up a dirt road from McCarthy; shuttle service is available. *nps.gov/wrst/historyculture/kennecott.htm*

For at least 50 miles in every direction from Kennecott Mines, the land lies within the boundaries of **Wrangell-St. Elias Park and Preserve.** At 13.2 million acres, Wrangell-St. Elias is the largest unit in the National Park System. It ranges from the summit of the second highest mountain in the nation to the shores of the Pacific and includes ice fields, alpine tundra, conifer forests, glaciers, broad rivers, lush riparian lowlands, and the vast array of wildlife that comes with such a diversity of habitats. Only two significant roads—both rough dead ends—penetrate this almost entirely undeveloped park. Aside from taking these roads, travelers who want to see the backcountry typically go in a small plane. Visitors can glimpse the park from the **Headquarters Visitor Center,** which is perched on a bluff above the Copper River on the western edge of this great wilderness. *nps.gov/wrst/historyculture/kennecott.htm*

The little town of **Yakutat** is tucked away on the Gulf of Alaska between the southeastern tip of Wrangell-St. Elias National Park and Preserve and the Tongass National Forest. Not surprisingly, most visitors come for the scenery, the wildlife viewing, and the sportfishing. Surprisingly, some come for the surfing, which is excellent provided one is willing to wear a serious wet suit. *yakutat.net*

Abutting Wrangell-St. Elias National Park and Preserve on the north, the **Tetlin National Wildlife Refuge** admirably does its stated job; it provides a refuge to wildlife, and lots of it. Wolves, caribou, grizzlies, moose, and hundreds of thousands of birds live in or visit these 683,000 wild acres. Most of the refuge is sopping wet—mostly lakes, ponds, rivers, marshes, and so on—so the best way to explore is via boat. However, landlubbers can get a good look by stopping at the developed **pullouts** along the 65 miles of the Alaska Highway that skirt Tetlin, or by using one of the refuge's campgrounds or trails. The **visitor center** is located at Milepost 1229 of the highway. *fws.gov/refuge/tetlin*

Trumpeter swan

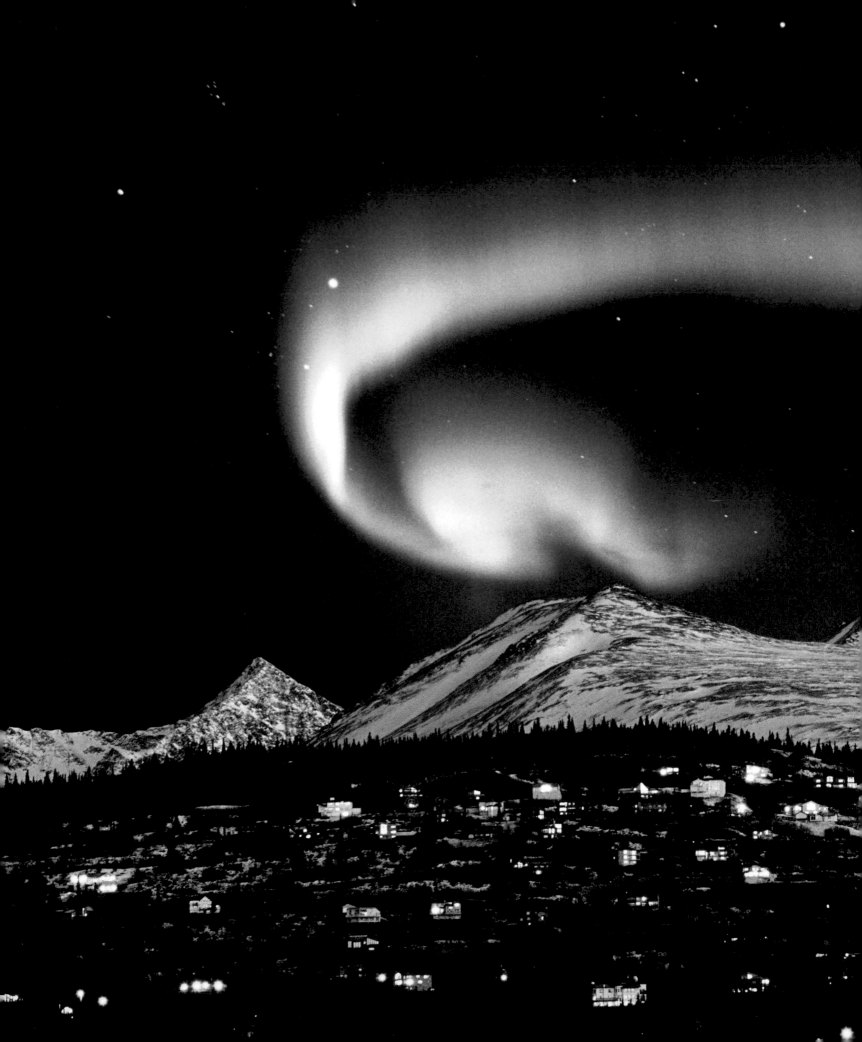

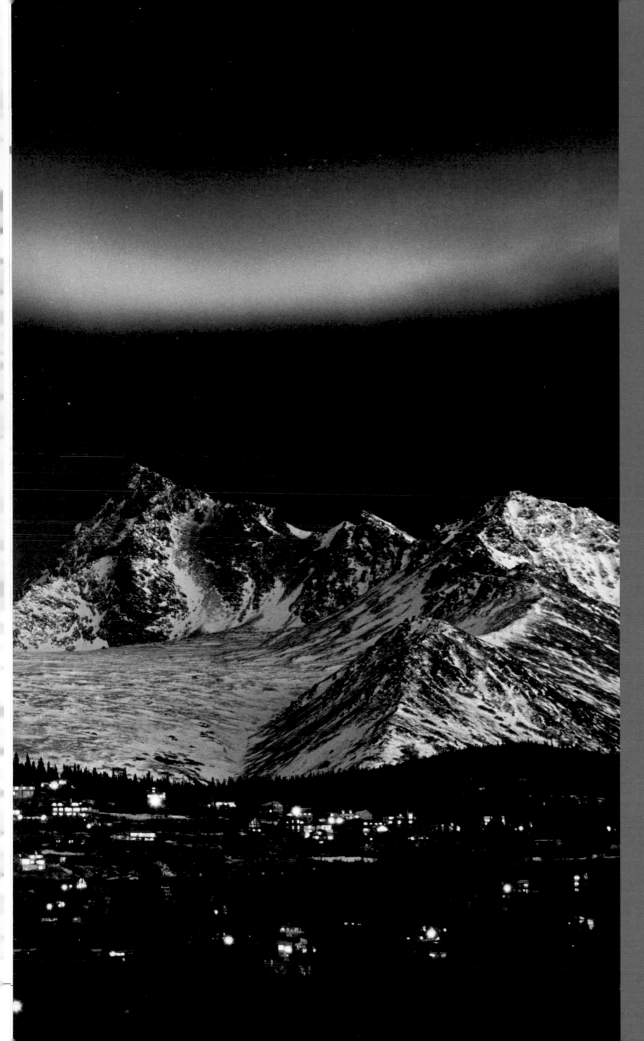

Shimmying above a hillside neighborhood in Anchorage, the aurora borealis gives new meaning to the phrase "bright lights, big city."

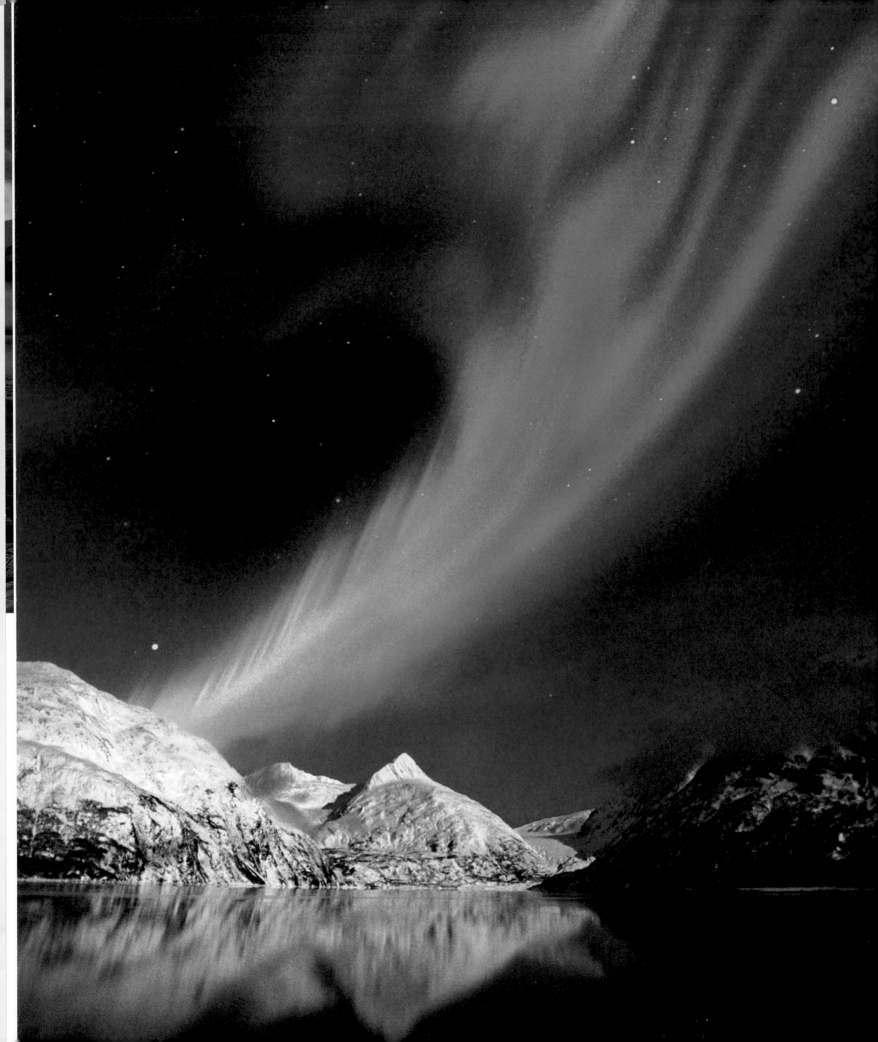

Like most everyone else in the village, Ahgupuk learned to hunt and fish and seemed destined to lead a subsistence lifestyle with some commercial fishing mixed in. But he got hurt in a hunting accident and ended up spending several months in the hospital in Kotzebue. To pass the time, he began sketching scenes from Inupiat life, at first using the only medium available: toilet paper. Eventually, a nurse noticed his drawings and provided him with some more suitable paper. Ahgupuk went on to artistic renown. He drew and painted on plenty of fine paper and canvas during his 89 years, but he retained a taste for using diverse surfaces; his art has appeared on seal skins, plywood, ceramic tiles, fish skins, tree mushrooms, and caribou hides. His work appears in the collections of the Smithsonian, the National Museum of the American Indian, the California Academy of Sciences, and many other esteemed institutions.

The museum gives an entire gallery to Sydney Laurence, Alaska's most celebrated painter. His works reflect Laurence's fascination with Alaska's natural wonders and its people. He painted glaciers, trappers, totem poles, seascapes, forests, sailing ships, Alaska natives, the northern lights, miners, serene coves, and isolated cabins, but he is best known for his hundreds of renderings of Mount McKinley.

Laurence was the first professionally trained artist to live in Alaska. Born in Brooklyn, New York, in 1865, he studied in New York City and, starting in the late 1880s, he frequently exhibited in prestigious venues in the United States and Europe. However, in the early 1900s, he took off for Alaska, leaving art behind in an attempt to strike it rich as a prospector. Alas, he was more skilled with a paintbrush than with a gold pan. Around 1911, he started painting seriously again, living in Valdez most of the time. In 1915, he went to Anchorage and settled there, becoming one of its first residents. Initially, he earned his daily bread as a photographer, but he continued painting, and within a few years, he was the most famous artist in Alaska.

Museum visitors who tire of looking at exhibits and yearn to get their hands on something have many options. They might go to the Kinetic Space for some physics fun, such as blasting the air cannon to study the effects of wind. They might head to the Bubble Space and stand on the bubble pad, where, with the tug of a cord, they can encase themselves in a giant bubble. The Tsunami Tank lets visitors play king of the sea; they can send a series of tidal waves rolling into a miniature seaside town. Sticking

Opposite: Portage Lake fills with water from the melting of Portage Glacier. Here, the northern lights lend the lake an otherworldly appearance.

> **NATURAL WONDER**
>
> ### Dall Sheep
>
> Travelers along the Seward Highway just south of Anchorage often see Dall sheep clambering about the cliffs above the road. All white with curling horns—the rams have massive horns that curl much more than the females'—they're easy to spot. Rather than using camouflage to protect themselves, they stay close to steep, rocky slopes, which they can climb with amazing agility to escape coyotes, bears, wolves, or other predators.

with the seismic theme, one can also shake a model to see how the kind of clay that underlies some of Anchorage liquefies when unsettled by tremors.

The Anchorage Museum also presents many special exhibits, such as one in 2013 on aviation in Alaska. To outsiders, this may sound obscure, but planes, particularly small planes, are integral to Alaska life as much as cars are to life in the lower 48. This is especially true outside the cities. The main reason for this is straightforward: Alaska is a big state with few roads—more than 100 times fewer miles of paved road per square mile than in the rest of the United States. People

> ❝ I will be bold to say, the Russians themselves have never been amongst [the natives]: for if that had been the case, we should hardly have found them clothed in such valuable skins as . . . those of the sea-otter. ❞
>
> **[Captain James Cook's 1770s journal, Cook Inlet entry]**

use small planes to visit relatives, to go shopping, to get to the hospital, to have a night out in the city, to go moose hunting, to catch a baseball game, and so on. Due to this matter-of-fact use of planes, hundreds of little paved, gravel, and dirt airstrips are scattered around the state. And people certainly don't confine themselves to these established facilities. When airstrips aren't available, pilots will land on paved roads, gravel roads, gravel bars in riverbeds, meadows, beaches, lakes, bays, rivers, and harbors. There is about one small plane per 1,400 residents in the United States compared with about one plane per 70 residents in Alaska.

But practicalities and statistics don't fully explain Alaskans' love affair with small planes. Part of their bond stems from the fact that Alaskans don't think of these aircraft as "small planes" but as "bush planes." And the people

Raven Glacier looms above a hiker at Crow Creek Pass in Chugach State Park.

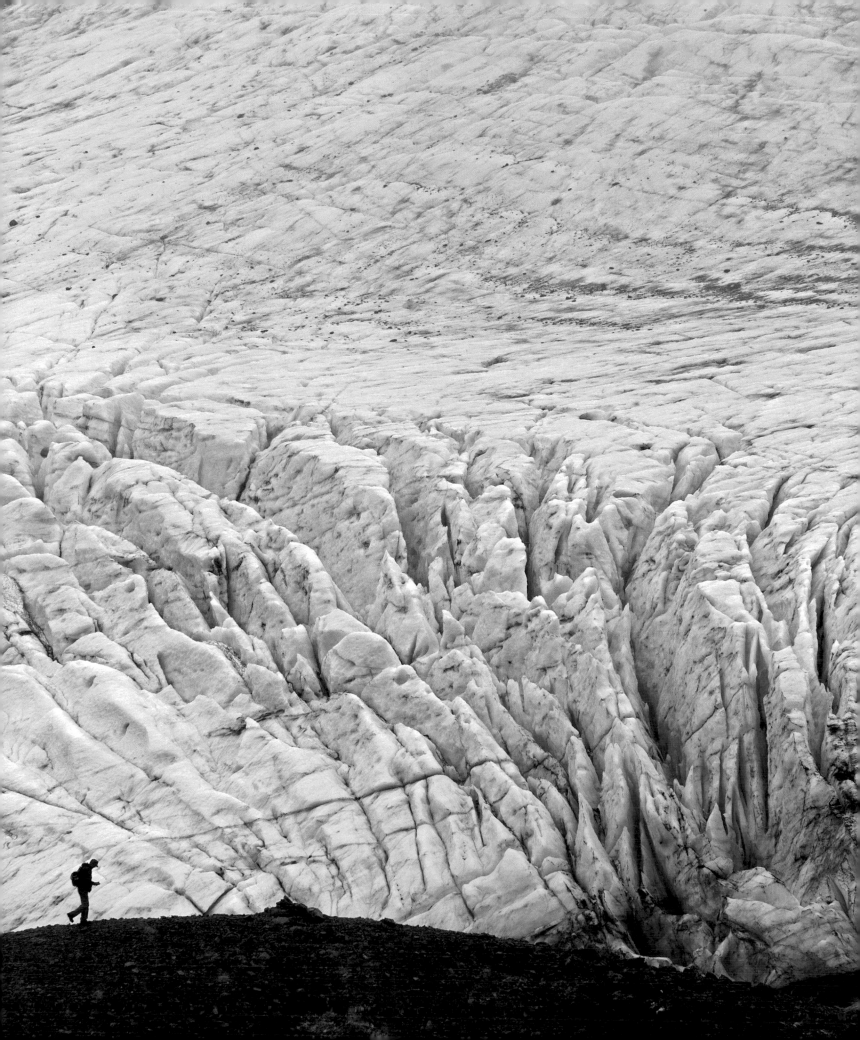

who fly them are often thought of as "bush pilots"—romantic, even heroic figures in Alaska lore.

Consider Harold Gillam. He was one of the "Wrangell Mountain Skyboys," as the aviation exhibit at the Anchorage Museum termed the cadre of daring bush pilots who first flew the high country of what is now Wrangell-St. Elias National Park, back in the 1930s. Gillam apparently possessed uncanny eyesight that enabled him to fly in fog and rain that kept other veteran bush pilots by the fireplace. People said there were three kinds of weather: "Pan American weather" (clear skies fit for commercial flights); "flying weather" (not-clear skies that might thwart Pan Am but not skilled bush pilots); and "Gillam weather" (nasty, stormy weather that only Gillam would tackle). Gillam's nickname was "Thrill 'Em, Chill 'Em, Spill 'Em, But No Kill 'Em Gillam."

Gillam made some bold rescues in his time. For example, as a young pilot with only 40 hours under his belt, he flew into dense fog over eastern Siberia to rescue a famous bush pilot and his mechanic who had gotten lost while trying to rescue sailors from a ship stuck in the ice. Another time, a man fell down a mine

Trails of Chugach State Park

1 Anchorage Overlook Trail An easy, quarter-mile loop in the Anchorage Hillside Trail System, which lies along the western boundary of Chugach State Park, where it abuts Anchorage. The trail offers good views of the city, Cook Inlet, and the Alaska Range.

2 Flattop Mountain Trail Another route in the hillside system, Flattop yields vistas of the same places as the Anchorage Overlook, only much grander because they're from much higher. This perspective must be earned via a difficult, steep 1.5-mile (one-way) trail that requires some hand-over-hand scrambling. Flattop is the most climbed peak in Alaska.

3 Historical Iditarod Trail Also known as the Crow Pass Trail, this 27-mile (one-way) path follows a beautiful and rugged section of the historic Iditarod supply route, running from the Eagle River Nature Center to the end of Crow Creek Road, above Girdwood. The terrain ranges from easy to difficult. Hikers may see moose, glaciers, mining ruins, bears, high peaks, and pristine forest.

4 Thunderbird Falls Trail This gentle trail passes through birch forest along a steep hillside overlooking Eklutna Canyon. It's a one-mile (one-way) stroll to 200-foot-high Thunderbird Falls. In winter, the falls usually freezes, creating a magnificent ice sculpture.

5 Turnagain Arm Trail True to its name, this easy route (with a dash of moderate) parallels Turnagain Arm, following the support road built in the 1910s for construction crews working on the railroad. It's 9.4 miles (one way) but can be broken into shorter sections. Watch for wildflowers and, at Windy Corner, Dall sheep.

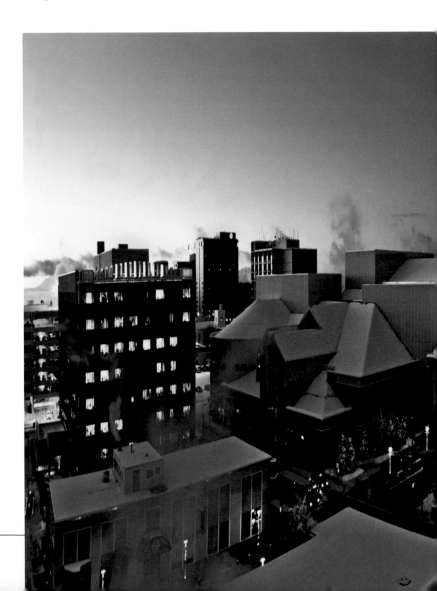

shaft in the Wrangell Mountains during a raging storm, and Gillam flew out to try to bring the injured man back to the hospital before he died. Sadly, as the local newspaper in Valdez reported, the man died despite Gillam's heroics. Happily, the newspaper was mistaken, and as the corrective story said a week later, the report of the man's death had been "very much exaggerated"—Gillam had saved his life.

Visitors to Anchorage can dive deeply into Alaskan's love of planes at the Alaska Aviation Heritage Museum. It's located on—where else?—Aircraft Drive a few blocks north of the Anchorage International Airport. Hard to miss, what with the U.S. Air Force F-15, the Northern Air Cargo DC-6, and the Alaskan Airlines 737-200 Combi parked out front. The museum building is jammed with displays and photos of planes, and outside the building, about three dozen actual planes await inspection. And to see some bush planes in action, visitors can simply look north; the museum sits on the south shore of Lake Hood, the busiest seaplane base in the world. But to truly understand the appeal of bush planes, visitors should go for a ride in one, whether a 30-minute sightseeing trip or a flight deep into the wilds to get dropped off at some back-of-beyond wilderness lake.

A flightseeing jaunt to the area just south of Anchorage would provide some fine views, but this is one stretch of Alaska that can be explored by road; the scenic Seward

With a population of about 300,000, Anchorage is Alaska's largest city. In fact, it is nearly ten times larger than any other municipality in the state. Anchorage possesses the one and only urban skyline in the Great Land.

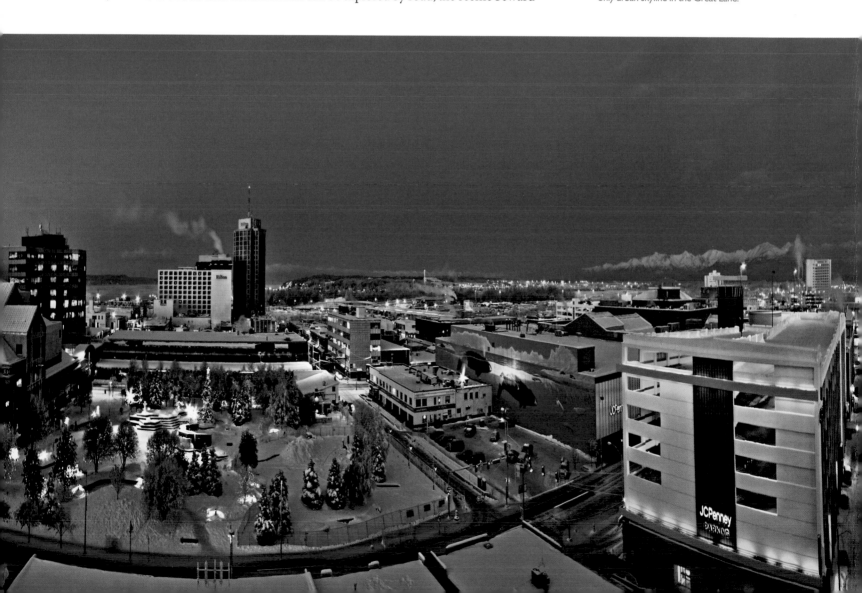

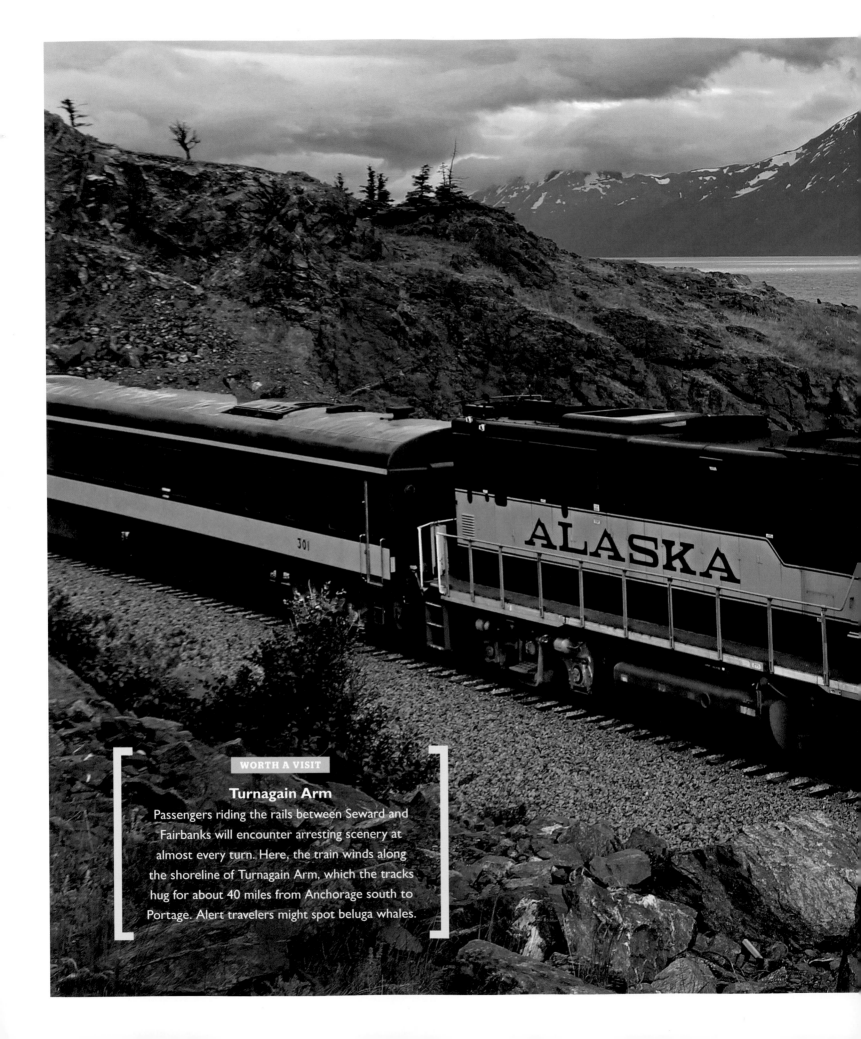

Turnagain Arm

Passengers riding the rails between Seward and Fairbanks will encounter arresting scenery at almost every turn. Here, the train winds along the shoreline of Turnagain Arm, which the tracks hug for about 40 miles from Anchorage south to Portage. Alert travelers might spot beluga whales.

This oil painting of Mount McKinley is one of many renditions of "The Mountain" created by Sydney Laurence in the early 20th century. Laurence lived in Alaska for many years, and painted a wide variety of its natural wonders.
Opposite: Yup'ik feathered dance fans

Highway hugs the northern shore of Turnagain Arm for some 40 miles. One reason the highway and railroad run right next to coastline is that cliffs rise almost vertically from the water's edge in many places, grading into the slopes of the Chugach Mountains. Carving a railroad bed out of the base of these cliffs was probably the most difficult part of building the Seward-to-Fairbanks railroad a century ago. Thick with spruce, hemlock, and aspen, and dotted with meadows painted by wildflowers, these mountains are part of 500,000-acre Chugach State Park, the popular outdoor playground of Anchorage residents.

Most of the park is utter wilderness inhabited by wolves, lynx, and grizzlies, but these species rarely are visible from the highway. Dall sheep, however, frequently show up on the cliffs at Windy Corner, about a dozen miles down the highway from Anchorage. Rams generally remain in the high country, but ewes and their adorable kids often can be seen close to the road.

Beluga Point, a few miles from Windy Corner, is another good place for wildlife watching, but would-be watchers need to turn their backs on the mountains and look to the water—and note the name of the point. This is probably the most accessible spot

in Alaska from which to see beluga whales, most of which roam in seas farther north. Not as many belugas live in Cook Inlet these days due to the pressures of development here in the state's busiest region; where once there were as many as 1,300, there are now about 300. However, this isolated population has been placed on the endangered species list, and the National Marine Fisheries Service hopes to build the number of belugas back to at least 800.

In the meantime, visitors can still see groups of these social animals cruising Turnagain Arm, especially during the summer when the salmon are running. Belugas are not hard to spot. They're about 13 feet long, weigh around 3,000 pounds, often swim near the surface in shallow water, and are all white. ("Beluga" comes from the Russian word for "white.") Well, they're white most of the time; for a brief period during the summer, their top layer of skin turns yellowish. This jaundiced look doesn't last long because, unique among whales and other cetaceans, belugas molt. They seek waters with rough gravel beds where they rub themselves against the gravel until that outer layer of yellow skin peels off, leaving them with a fresh new coat of white.

Visitors may hear a beluga before they see it. Called the "canaries of the sea," belugas chirp and whistle and squeal and click. Researchers also describe one vocalization in the belugas repertoire as a "moo"—these "canaries" are lucky they weren't dubbed the "cows of the sea."

The waters of Turnagain Arm are themselves the source of a natural phenomenon. Cook Inlet's tides are among the most powerful in the world, particularly in Turnagain Arm. Turnagain's mean tidal range of about 30 feet is the most extreme in the United States, and the fourth highest in the world.

The moon and sun create the gravitational pull that is the basic cause of the vertical rise and fall in sea level, typically twice a day, but the magnitude of the tide in a particular place stems largely from local factors, such as the configuration of the coastline, the topography of the ocean floor, and the depth of the water. When a number of such factors come together in one place, like Turnagain Arm, it produces enormous vertical fluctuations in sea level in the course of just a few hours, which in turn produce forceful horizontal movements of water.

In Turnagain Arm, those horizontal movements cause a rare phenomenon called a tidal bore, or bore tide, which occurs in only a few dozen places in the world, and seldom as dramatically as here. In Turnagain, it can be a churning wall of water, usually between two and six feet high, that rumbles

Places to Buy Alaska Native Art in Anchorage

1 **Alaska Native Heritage Center** Given the Heritage Center's mission to serve all the state's Alaska natives, it's no surprise that its gift shop offers arts and crafts from every corner of Alaska. This wide range of goods might include an ivory-handled *ulu* (curved knife) or a whalebone sculpture.

2 **Alaska Native Medical Center** Tourists seldom discover the medical center's little craft shop, but they should. Dolls, baskets, jewelry, clothing, and other authentic products can be had at bargain prices. In addition, hundreds of pieces are on permanent display throughout the medical center.

3 **Anchorage Museum** A baleen bracelet, a sealskin doll, a woman's bag trimmed with sea otter fur—scores of fine Alaska native crafts are available at the museum's gift shop. But the shop also carries Alaska native–created fine art, some traditional and some contemporary, and some of which runs into the thousands of dollars.

up the waterway with the incoming tide at 10 or even 15 miles an hour. And rumble it does, emitting a low-frequency roar that can be heard for miles. These tidal bores are so remarkable that a painting of one hangs in the Anchorage Museum, created in 1919 by none other than the aforementioned Sydney Laurence.

Travelers who want to witness this spectacle can consult tide tables to see the approximate time for an upcoming tidal bore and station themselves at observation posts a bit south of Anchorage along the highway. Arguably the best spot is the Bird Point Scenic Overlook, where a network of stone paths and platforms provides perfect views of the water, and interpretive signs provide information about the tides.

If the tidal bore is expected to be a big one, such as when the moon is at its closest point to the Earth and the wind is blowing right, onlookers may get a glimpse of a human phenomenon associated with tidal bores: surfers and paddleboarders riding the wave. This may sound dangerous—and it is. Yet there they are, wet-suited adventurers whisking past atop the wave on a long, long ride up Turnagain Arm.

Non-bore tides also are dangerous. People may be tempted to explore the mudflats exposed by an ebbing tide, but in places, the mud is like quicksand and people can get stuck in it and drown when the tide rolls back in. Even people who don't get mired sometimes die when they're caught by incoming tides. The tide tables mentioned earlier are generally reliable, but it's not for nothing that they carry warnings about the vagaries of tides, especially in a place like Turnagain Arm with its massive tidal range.

Consider the cautionary tale of Joseph Eros. In the summer of 2013, Eros, a fit, 42-year-old captain in the U.S. Army, died because of those ultimately unpredictable tides. He hiked across the mudflats to Fire Island, 3.5 miles offshore from Anchorage. Eros had made the trek to the island and back at least five times before—people do it often—and he took all the usual precautions: He started to the island when the tide was receding and started back to Anchorage well before the tide was supposed to return. But for some unknown reason—perhaps the strong winds that blasted the area that day—the tide came back early to a broad channel just a few hundred yards from the mainland shore, so Eros and a companion had to swim for it. Between the swift current and the icy water, the swim was a terrible struggle. Eros's companion, a former member of the Yale swim team, barely made it. Tragically, Eros did not.

Travelers could profitably spend many hours, even days, along the 40 miles of the Seward Highway that

Opposite: Born in 1923 in a remote Alaska town that had never even been visited by an airplane, Bill English grew to love flying and became a famed bush pilot.

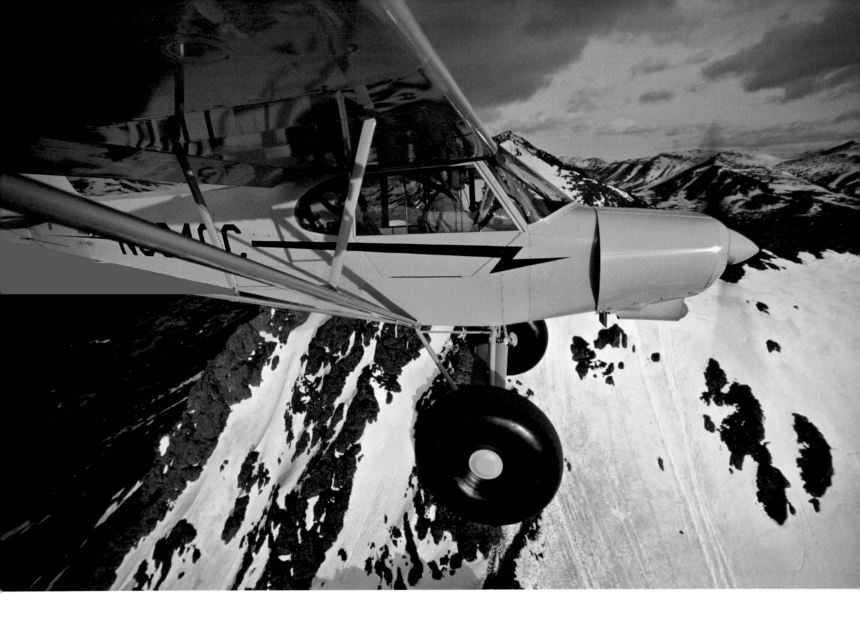

A bush plane flies over the Chugach Mountains. This rugged range starts on Anchorage's eastern doorstep and continues for some 300 miles southeast along the coast. Residents of Anchorage flock to the nearest parts of these mountains to ski, hike, watch wildlife, climb, and mountain bike.

skirt Turnagain Arm. In addition to the tides, Dall sheep, and belugas, there are forested picnic areas, trails heading into Chugach State Park, numerous pullouts with great views, and Potter Marsh, where visitors can stroll a long boardwalk and check out the birds, moose, and other wetland life in this small corner of the Anchorage Coastal Wildlife Refuge.

However, motorists should not ignore another scenic drive, the Alyeska Highway, which branches northeast off the Seward near the town of Girdwood. Prior to 1964, the highway branched off *in* Girdwood, but that year's Good Friday earthquake and the resulting tsunami so devastated the little town that the citizens moved it two miles up the road into the hills.

Just shy of the new Girdwood, a rough road angles off three miles to the Crow Creek Mine, a productive gold mine from the 1890s to the 1940s that is now a tourist attraction. It's a ramshackle affair where visitors can wander through eight original buildings and rent a gold pan and try their luck in the creek. Most travelers drive on past the Crow Creek Mine turnoff and continue a mile up the Alyeska Highway to Alyeska Resort, a

ritzy ski area of condos and vacation homes capped by the large and luxurious Alyeska Prince Hotel. This extensively developed playground for residents of Anchorage and the vicinity serves as a reminder that the big city is only a few dozen miles away.

Travelers shouldn't get so entranced by the area south of Anchorage that they neglect the area north of the city. However, as people head north out of Anchorage on the Glenn Highway, they should make one more stop, way out on the outskirts of town. Here, on a 26-acre parcel of forest, lies the Alaska Native Heritage Center, the single best place in the state at which to be introduced to the culture and history of Alaska natives. And without learning something about Alaska natives, visitors will never gain a complete understanding of the Great Land, because Alaska natives play such a prominent role in the life of the state. Also, travelers should stop here because it's fun. They can watch a vibrant dance performance, throw a spear, create native art, or listen to a storyteller.

The Heritage Center divides Alaska natives into 11 groups, some of which are small and singular, and some of which are large and encompass a number of subgroups. But as visitors journey around the state, they'll encounter many different ideas about ways to divide Alaska natives into groups. For example, the Heritage Center doesn't use the term "Eskimo," yet it is used by many other people, Alaska natives and non-natives alike, to refer to the Alaska natives of the far north and of much of the west coast. The peoples labeled as "Eskimo" usually think of themselves as belonging to smaller units: Those in the far north generally identify as "Inupiat," and those in the west as "Yupiit." Sometimes people will say "Inupiat Eskimo" or "Yup'ik Eskimo." ("Yup'ik" is the adjective form.) Just to further confuse these already confusing matters, folks also often disagree about the proper way to spell the names of many Alaska native groups. For instance, the proper spelling for the Central Yup'ik includes the apostrophe, but many people omit it. One final note: Many Alaskans prefer the term "Alaska native" for any Alaskan resident of indigenous ancestry, as opposed to "Alaskan native" or "native Alaskan," which many Alaskans would use to refer to a person of any ancestry who was born in Alaska. But, of course, many Alaskans mix these terms indiscriminately.

One reason for the prominence of Alaska natives is simple: They constitute almost 20 percent of the population, and many remote villages are inhabited almost entirely by Alaska natives. In the lower 48 states, Native Americans make up only about one percent of the population. But the prominence of Alaska natives also stems from the fact that their cultures better weathered the collision with Euro-American civilization

DID YOU KNOW?

Lake Hood Seaplane Base

The high-pitched buzz of seaplane engines is almost continuous at Lake Hood, next to Anchorage International Airport. More than 1,000 planes are housed there, and its 60,000 to 90,000 takeoffs and landings a year make Lake Hood the busiest seaplane base in the world.

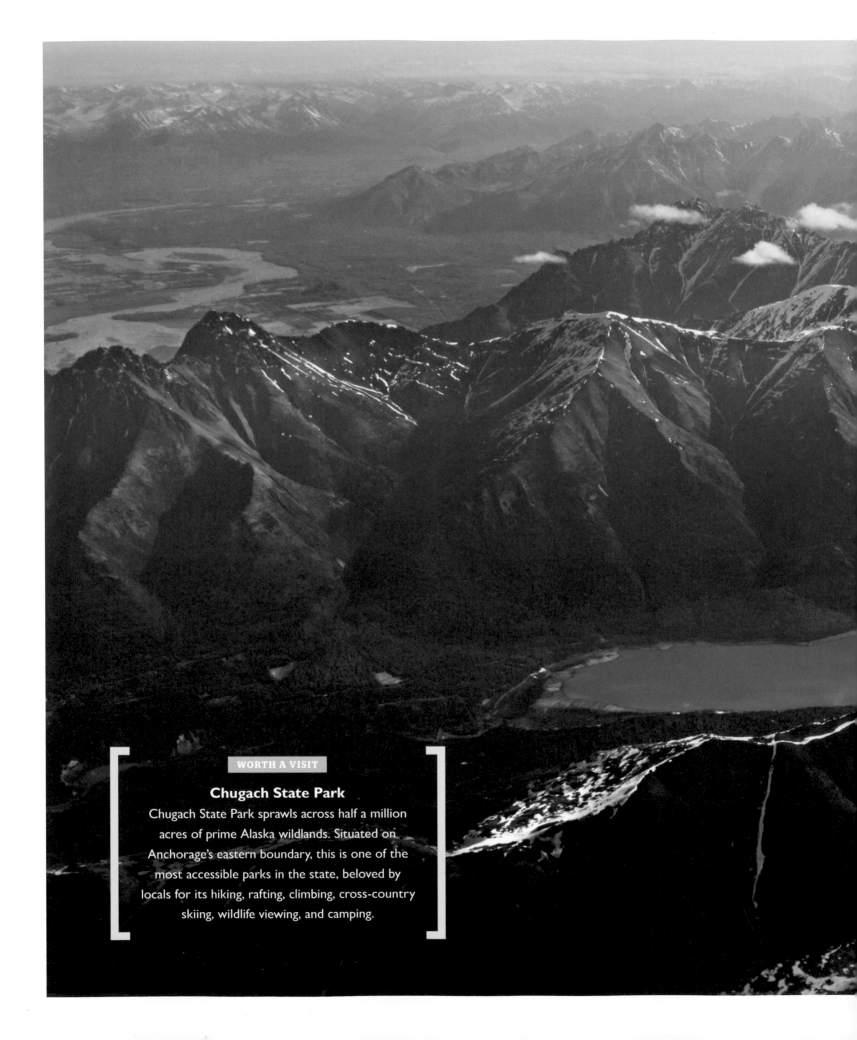

Chugach State Park

Chugach State Park sprawls across half a million acres of prime Alaska wildlands. Situated on Anchorage's eastern boundary, this is one of the most accessible parks in the state, beloved by locals for its hiking, rafting, climbing, cross-country skiing, wildlife viewing, and camping.

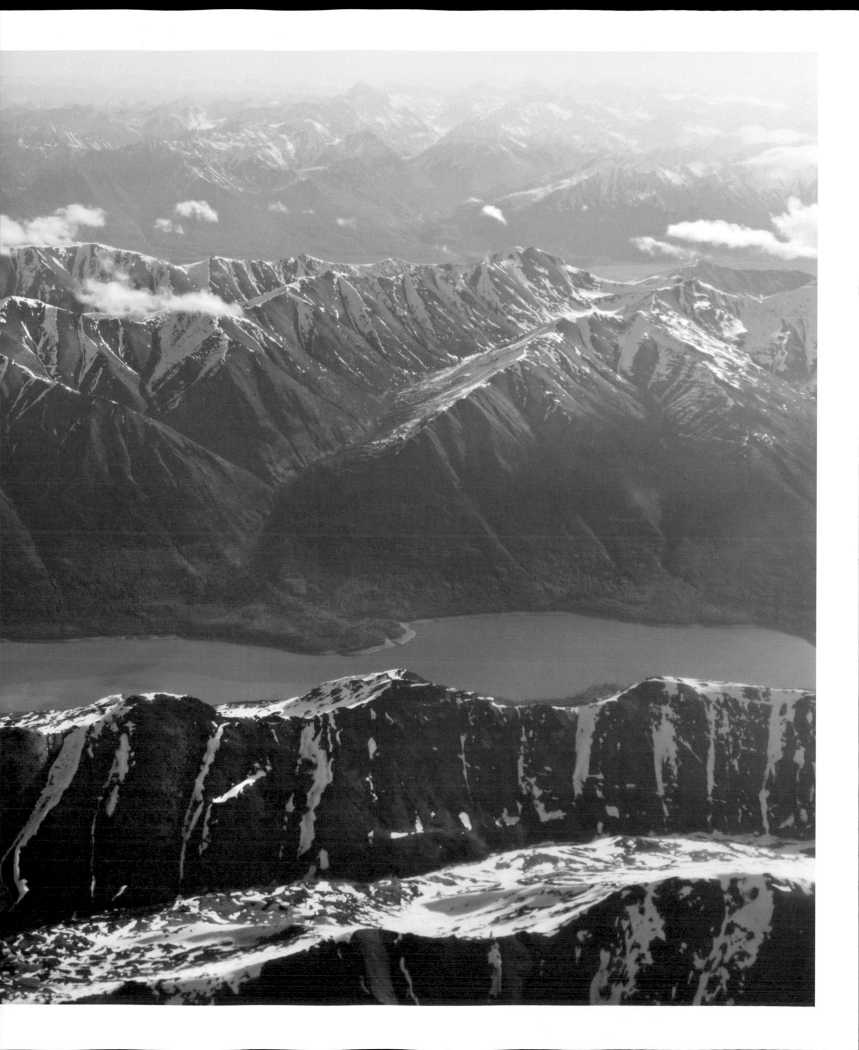

Hatcher Pass Drive

This scenic road runs from the low country by the Matanuska River to the low country by the Susitna River, along the way winding through the high country of the Talkeetna Mountains.

❶ The route begins 7.5 miles north of Palmer. At Mile 8.5, take the turnout for the **Little Susitna River,** a waterway that rushes down from Mint Glacier.

❷ The next five miles feature turnouts for savoring the river and mountains. This stretch ends at a parking area for the **Gold Mint Trail.** From here, you can hike to **Mint Glacier.**

❸ At Mile 17, visitors approach the spur to **Independence Mine State Historical Park.** Continuing to Mile 18.9, the road peaks at 3,886-foot **Hatcher Pass Summit.**

❹ Similar landscapes and views await at Mile 19.3; park at **Summit Lake State Recreation Site** and stroll around the lake or up to the bluff.

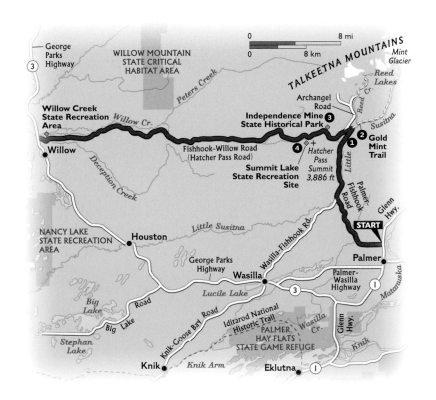

than did Native Americans in the lower 48. Not that Alaska natives didn't suffer from some of the same problems, such as being decimated by unfamiliar diseases and having their languages and religions repressed. But by and large, they came through with their cultures relatively intact. This may be partly because they've had more economic opportunity, due largely to the fact that they didn't lose almost all their prime traditional lands to outsiders, as Native Americans did.

The key to retaining ownership of valuable lands was the passage by Congress, in 1971, of the Alaska Native Claims Settlement Act (ANCSA). After long negotiations with many political and business interests, Alaska natives won extensive subsistence-use rights, almost a billion dollars in compensation for surrendering rights to some lands, and the ownership of about 44 million acres, to be managed by 12 regional native corporations and 220 village native corporations. These corporations are engaged in fishing, logging, mining, oil production, health care, and tourism, and produce thousands of jobs and billions of dollars in revenue. ANCSA certainly didn't solve all the economic issues faced by Alaska natives, but it has helped a great deal.

About 30 miles north on the Glenn Highway from the Alaska Native Heritage Center, in the valley drained by the Matanuska and Susitna Rivers, a very different land deal was implemented in the 1930s. Caught in the twin grip of the Great Depression and the Dust Bowl drought, Midwestern farmers were failing by the bushel. Among the many government programs aimed at helping them was an obscure project intended to establish agricultural colonies ("colonies" was their term) by relocating failed farmers to various sites around the country and providing these colonies with aid to get them started. They were established in Florida, Arkansas, and Georgia, but the one that especially raised eyebrows was the colony proposed for the Matanuska-Susitna Valley of Alaska. At the time, most Americans perceived Alaska as a remote, wild, and foreign place; could farmers possibly survive there?

The farmers were chosen from Minnesota, Michigan, and Wisconsin; the government figured people from these northern climes would be more accustomed to the weather they would encounter in Alaska. After screening volunteers, 203 couples, almost all with children, were chosen in 1935 and sent to their new home far away. Perhaps the screening could have been more thorough—one man landed in a mental hospital rather than Alaska, and another was later discovered to have a wooden leg—but most of the families arrived ready to get going.

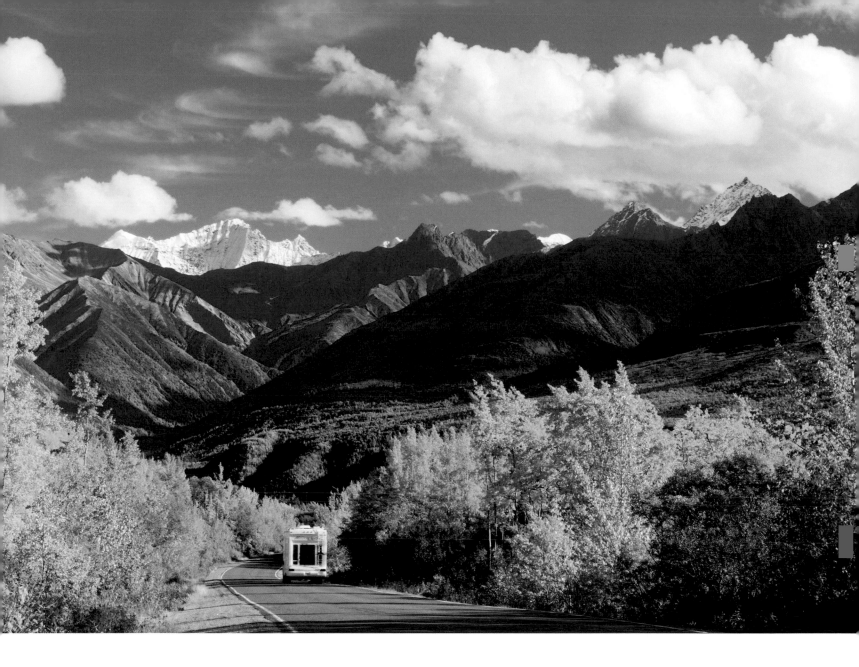

However, the going was rough at first. Some supplies arrived late. A number of the land parcels were unworkable. Much of the valley was mud. Conditions soon improved, but they hardly got easy, and within five years, half the colonists had left. But the others fared well enough and helped make the Mat-Su Valley (as locals call it) the breadbasket of Alaska—not that there's much competition for that title. Alaska imports most of its food besides fish and game.

Today, the Mat-Su is more of an Anchorage suburb and outdoor recreation destination than an agricultural powerhouse, but a fair number of farmers still work the land, in some cases even using the distinctive, government-designed houses and barns built for the colonists. Besides, even if farming in the valley is modest, it enjoys one claim to agricultural fame: giant veggies.

Vegetables love the midnight sun. The growing season may be short, but with 18 to 20 hours a day of energizing summer sunshine and some TLC, veggies can thrive in

A traveler heeds the call of the open road, driving the Glenn Highway in the upper Matanuska Valley in the Alaska autumn; the Chugach Mountains loom in the background.

A birch forest near the Knik River in the Matanuska-Susitna Valley has been painted white by frost. Birch is one of only a handful of tree species that grow in the boreal forest.

the Mat-Su, ballooning to preposterous sizes. Backs strain to lift 60-pound zucchinis. Pulling 20-pound carrots from the ground qualifies as an upper-body workout. One bunch of Swiss chard topped out at nine feet—tall enough to qualify as a small tree. The heavyweight championship bout of monster produce is the Giant Cabbage Weigh-Off at the Alaska State Fair. So popular

Mushers & Their Dogs

Snow machines have largely replaced dog sleds as the typical means of backcountry winter transportation in Alaska, but both the mushers standing on the sled and the hardy dogs pulling it remain cherished symbols of Alaska life. As mushing has faded from everyday use, it has expanded as a sport, capped by the 1,000-mile Iditarod race from Anchorage to Nome. The Matanuska-Susitna Valley is a hotbed of high-profile mushers and home to the Iditarod Trail Sled Dog Race Headquarters and the Knik Museum & Sled Dog Mushers' Hall of Fame.

is this event that it even has its own cheerleaders—a group of women called the "Cabbage Fairies," who prance about in green dresses, green jackets, green hats, and green everything else. The current record cabbage, which was entered in the 2012 fair and dubbed the "Palmer Pachyderm," tipped the scales at 138.25 pounds. And they're not just for show, as noted in a limerick that accompanied one of 2012's losing cabbages, which its owners had named "Emerald": "This Emerald's weight is not profuse. Not enough to feed a moose. A mountain of kraut is what she's about. A cabbage is put to good use."

One farm in the valley raises a crop that you will definitely not see amid the corn and soybean fields of the Midwest. This Alaska specialty is *qiviut* (KIV-ee-ute). A grain, perhaps? Some exotic fruit? Not even close. Qiviut is the fine hair combed from the woolly undercoat of

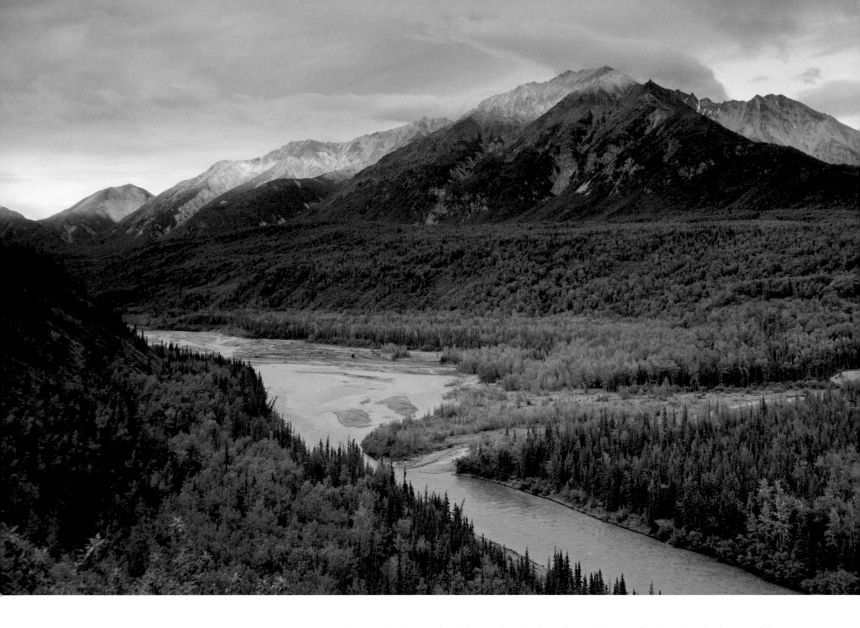

At the east end of the Matanuska-Susitna Valley, the Matanuska River cuts through boreal forest at the base of the Chugach Mountains. Some of that flowing water started as ice in the Matanuska Glacier. *Opposite:* Sled dogs at work

musk oxen at the Musk Ox Farm, located on the outskirts of Palmer in the heart of the Mat-Su Valley. This may be the far north compared with the Midwest, but for musk oxen, it is unnaturally far south; wild musk oxen originally ranged farther north in the Arctic portions of Canada, Siberia, Greenland, and Scandinavia as well as Alaska. They were hunted out of Alaska in the 19th century, but were reintroduced from Greenland in the 1930s, and were eventually placed in several locations around the state, including a couple of subarctic spots. Today, several thousand roam free in Alaska.

About 60 musk oxen live at the Musk Ox Farm, a nonprofit that was started back in the 1950s, both to protect the species and to develop a cottage industry for Alaska natives. Visitors can take a tour and get a close look at these ancient beasts, one of the few large animals from the mastodon–mammoth era that is still with us today. And large they are, weighing 600 to 800 pounds. (Or, to use Mat-Su units of measurement, a musk ox weighs about five record-size cabbages.)

The qiviut gathered from the farm's musk oxen is used by a far-flung network of Alaska native women to weave hats, scarves, baby booties, and other garments.

These are soft and light and yet incredibly warm—eight times warmer than sheep's wool by some estimates. The warm part comes as no surprise, considering that musk oxen evolved to survive Arctic winters. Visitors can buy qiviut clothing at the farm or at the Oomingmak Co-op, in Anchorage; "Oomingmak" is the Inupiaq word for musk ox, and means "the bearded one," referring to the long guard hairs that hang down from musk oxen and make them look like beefy mops.

Long before people came to the Palmer area looking for qiviut or giant veggies, they came searching for gold. In 1886, a gold strike in the vicinity of Anchorage motivated prospectors to fan out through the region, including in the Talkeetna Mountains, on the north edge of the Mat-Su Valley. They found dribs and drabs of placer gold in the streams running down the Willow Creek drainage and, in the early 1900s, prospectors followed these watercourses up to hard-rock lodes of gold embedded in quartz veins in the mountains.

Today, visitors can get a whiff of those hard-rock mining days by touring Independence Mine State Historical Park, about 25 scenic miles north of Palmer, up near Hatcher Pass. At its peak, in 1941, the mine employed about 200 people, and its dozens of structures and miles of tunnels sprawled across more than 1,350 acres of mountain tundra. Many of the buildings are still standing and open for viewing, with or without an interpretive guide. The mine might have continued to thrive for some time, but the outbreak of World War II caused the government to shut it down as nonessential to the war effort. By 1946, when the wartime ban was lifted, a number of economic and political factors had combined to render gold mining unprofitable, and the mine closed down for good in 1951.

It turned out that mining was not the region's future, but its past. The real future lay down in the low country of the fertile Matanuska-Susitna Valley and, most notably, in the blossoming urban center of Anchorage. ∎

"Fur Rondy" Events

1 **Miners and Trappers Charity Ball** People often show up in costumes at events throughout the many days of the Fur Rendezvous ("Fur Rondy" in localese), Anchorage's big winter bash, but costumes are essential at the Miners and Trappers Ball. Attendees can enter a contest if they dress up in certain categories, such as historical or nursery rhyme. Men can also enter the Mr. Fur Face Contest, at which beards and moustaches are judged.

2 **Outhouse Races** Teams build or commandeer outhouses, attach them to skis, and push them along a downtown street. Most participants wear costumes. Don't they do this in Manhattan?

3 **Rondy Snowshoe Softball** The name says it all—men and women playing softball in the snow while wearing snowshoes. Well, not quite all. Again, most participants wear costumes, so the crowd may see Mr. Potato Head pitching to a guy wearing a silver tutu.

4 **Running of the Reindeer** Pamplona, Spain, may host the running of the bulls, but Anchorage owns the running of the reindeer. It goes without saying that most of the participants wear costumes—pink wigs, *Where's Waldo* outfits, garbage bags, Roman sword-and-sandal garb—as they run alongside reindeer down Anchorage's main drag.

5 **Yukigassen Championships** Imported from Japan, this sport is a combination of capture the flag, paintball, dodgeball, and snowball fights. The Fur Rondy is the official U.S. Championship tournament, so the winner gets to go to Japan and represent the United States at the World Championships. And here's the really strange thing about this event—the participants don't wear funny costumes!

Sites and Sights in Anchorage & Mat-Su

Anchorage was born near the mouth of **Ship Creek** in the early 20th century, so it's a fitting place to begin a tour of the city. When the salmon are running, visitors will see all sorts of locals fishing from the banks, including office workers in suits and ties. There's a salmon-viewing area along Ship Creek Avenue where people can see spawning action. *anchorage.net*

The **Tony Knowles Coastal Trail** is a paved multiuse trail that meanders for 11 miles along the shore of Knik Arm and Cook Inlet from downtown Anchorage to Kincaid Park. Cyclists, runners, skaters, and people just out for a stroll flock to this scenic path. Sometimes moose and other wildlife are encountered along the way, and beluga whales occasionally make an appearance offshore. *anchorage.net*

Much of the artwork travelers find in Alaska is traditional in style and substance: a photographically accurate painting of wolves trotting through the forest or a representational rendering of a bald eagle carved out of walrus ivory. But Anchorage's **International Gallery of Contemporary Art** lives at the other end of the artistic spectrum. It has exhibits such as a video installation of a lady applying red lipstick to herself and a collection that chronicled an artist's hip-replacement surgery, making art of his blood, X-rays, bone fragments, and related paraphernalia. The latter was literally and figuratively hip. *igcaalaska.org*

Prior to 2009, the **Anchorage Museum** was already the most noteworthy attraction in the city—and then it underwent a vast expansion, both in physical space and in the breadth of its portfolio, and became even more noteworthy. In addition to its extensive and excellent exhibits on history, the arts, and culture, the museum now has all sorts of science offerings, such as a planetarium and the Arctic Studies Center. Furthermore, the **Imaginarium,** a longtime downtown attraction beloved by children for its interactive, hands-on science, moved into the museum. In the Imaginarium, kids—and adults—can trigger an earthquake, touch intertidal critters, or fire an air cannon. *anchoragemuseum.org*

Small planes are integral to Alaska life, as the exhibits at the **Alaska Aviation Heritage Museum** make clear. Besides the abundant photos and displays, this Anchorage museum has a collection of more than two dozen aircraft, many of them airworthy. Included are rarities like the 1944 Grumman Widgeon amphibious plane and the Stinson L-1 Army reconnaissance plane, the only one of its kind still fit to fly. The museum's observation deck overlooks the **Lake Hood Seaplane Base,** the busiest floatplane base in the world. *alaskaairmuseum.org*

Though visitors might spot a moose or a bear along one of the trails, the flora outshines the fauna at the **Alaska Botanical Garden,** on the east side of Anchorage. People can relish the 11 acres of cultivated garden or the 110 acres of mostly wild boreal forest. Bluebell, fool's huckleberry, and other blooms brighten the Wildflower Trail in spring and summer. Visitors who simply must get a fauna fix can troop out the Lowenfels Family Nature Trail to watch spawning king salmon. *alaskabg.org*

Because it borders Anchorage on the east, **Chugach State Park** serves as kind of

Canoeing in Portage Valley

an honorary city park. But it is hardly the kind of park a person visits to feed the pigeons or listen to the municipal band on the Fourth of July. Chugach harbors half a million acres of grade-A wilderness. Parts of it have never been explored, and some of its peaks have never been named. Grizzlies, glaciers, wolves, forest, mountain goats, and even flying squirrels live in its depths. This wild backcountry is complemented by the areas adjacent to the city and along the Seward Highway that are more developed, with amenities such as trails and picnic areas. *dnr.alaska.gov/parks/units/chugach*

Potter Marsh—officially named the Potter Point State Game Refuge—is the most scenic and accessible part of the **Anchorage Coastal Wildlife Refuge.** About ten miles south of downtown Anchorage along the Seward Highway, motorists will find the spur road that leads to the marsh; moose often feed in the willows that border the drive. Once on the boardwalk trail, it's time to pull out the binoculars and look for the many bird species that frequent Potter Marsh. *adfg.state.ak.us*

The 40-mile stretch of the **Seward Highway** heading south from Anchorage is a beauty. It is bounded on one side by the mountains and forests of Chugach State Park and on the other by the waters and tidal flats of Turnagain Arm. Motorists can tarry at numerous developed pullouts, such as the Potter Creek Viewpoint & Trail, McHugh Creek Picnic Area, Beluga Point, and the Bird Point Scenic Overlook. Several trails start from these

A female musk ox

pullouts and lead back into the state park. *dnr.alaska.gov/parks/units/chugach*

Visitors aren't likely to strike it rich, but they can rent a pan and try their luck panning for gold at **Crow Creek Mine,** a few miles back into the mountains from the Seward Highway. Folks come up with a few flakes now and then. The real attractions are the original buildings and the artifacts dating back to the mine's productive years, from the 1890s to 1940s. *crowcreekmine.com*

Portage Glacier has receded so far that it is no longer visible from the glassed-in viewing room that was built at the **Begich, Boggs Visitor Center** for the express purpose of admiring the glacier. However, the mountain-rimmed lake sprinkled with icebergs merits some admiration, the visitor center has enough displays to be considered a bit of a museum, and travelers can take a boat tour up the lake to view the glacier. The five-mile drive from the Seward Highway to the center winds through the **Portage Valley,** a destination in its own right with mountains, forest, trails, and campgrounds. *www.fs.usda.gov/chugach*

The rich traditions and contemporary interests of Alaska natives are the focus of the **Alaska Native Heritage Center,** which occupies 26 wooded acres on the northern outskirts of Anchorage. Visitors can take a tour that leads around a small lake to several "village" sites, each depicting a particular native culture or group of similar cultures. The Hall of Cultures brims with art and crafts, both historic and modern. Visitors can stop by the tables at which native artists are creating their works and have a chat. In the Gathering Place, people can watch native dancers, athletes, storytellers, and other performers. *alaskanative.net*

When travelers heading north from Anchorage on the Glenn Highway reach the 13-mile mark, they should consider taking a side trip east on Eagle River Road about a dozen miles to the **Eagle River Nature Center.** Though it offers informative displays, helpful staff, and a picnic area with terrific views, the center itself is secondary to the surrounding landscape, which can be explored via several inviting trails that fan out from the center. *ernc.org*

Over the years, Alaska native beliefs and Russian Orthodox Church teachings blended in various ways in various places. One of the spiritual offspring of this union can be found a few minutes south of the Mat-Su Valley at **Eklutna Historical Park.** On the grounds are the old St. Nicholas Russian Orthodox Church, probably built around 1870 (and perhaps as early as 1830) in Knik and moved to Eklutna around 1900; the new St. Nicholas church, built in 1962 and still used regularly; and the Athabaskan cemetery, which dates back to at least 1652, but may have been used for the last thousand years. The religious blending is clear in the cemetery, where graves of Athabaskans are marked by both the colorful spirit houses of Athabaskan tradition and Russian Orthodox crosses. *eklutnahistoricalpark.org*

Strung along a single block of East Elmwood Avenue in downtown Palmer—ground zero for the original agricultural colony that the federal government established here during the Great Depression—are three of the original colony buildings. The **Colony House Museum** was once the home of a colonist family and has been restored to look as it did between 1935 and 1945, including many of the belongings of the original occupants. Most of the guides who conduct tours are descendants of original colonists, and a few are original colonists who came here as children. Across from the museum is the **Colony Inn,** built in 1935 and used as a teachers' dormitory until the 1960s. Today, it's a cozy, small inn and restaurant. A block east is the **United Protestant Church,** aka the "Church of a Thousand Trees." Colonists built the church between 1935 and 1937, using logs for pretty much everything, even the altar. *palmerhistoricalsociety.org*

Situated in the farmland just outside Palmer, the **Musk Ox Farm** serves a dual purpose. One, it provides work to hundreds of Alaska native weavers who use the ultra-warm hair (qiviut) from the undercoat of the musk oxen to fashion exquisite hats, scarves, and other items of clothing for sale. Many of these hand-knit items display traditional patterns unique to particular villages. Given qiviut's extraordinary warmth, softness, and durability, and the knitters' superb craftsmanship, prices range high, such as caps for $180 and scarves for around $300. Two, the farm enables visitors to get a close look at these fascinating ice age beasties. A spring tour lets people see cute 20-pound calves suckling on their moms or being fed by a bottle. Later in the year, visitors may witness the ornery, 800-pound rutting bulls charge each other at 35 miles an hour and thunderously butt heads. *muskoxfarm.org*

Portage Glacier

From the 1890s to the early 1940s, the Independence Mine was a busy place. In dozens of buildings dotting hundreds of acres, a couple of hundred workers dug, processed, and shipped gold. Today, their labors are memorialized at **Independence Mine State Historical Park,** in the Talkeetna Mountains about 20 miles north of Palmer. Visitors can tour the mess hall, bunkhouses, commissary, assay office, and other buildings, and get a feel for a gold miner's life. *dnr.alaska.gov/parks/units/indmine.htm*

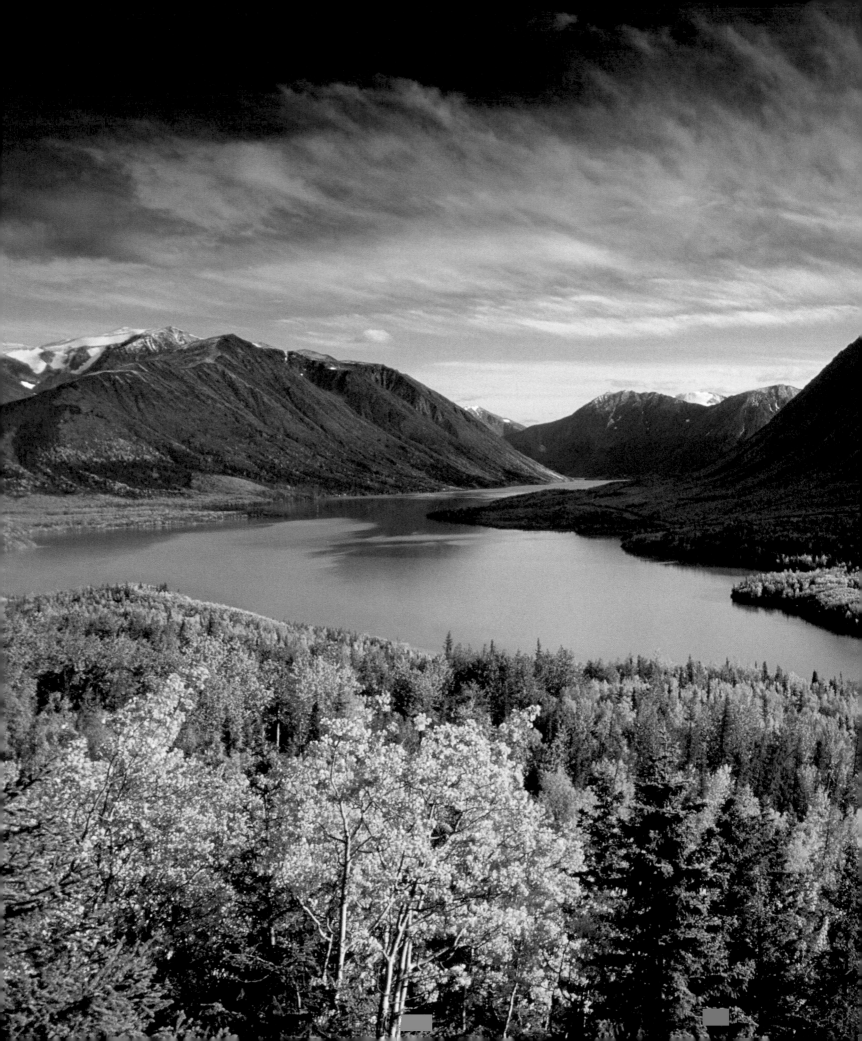

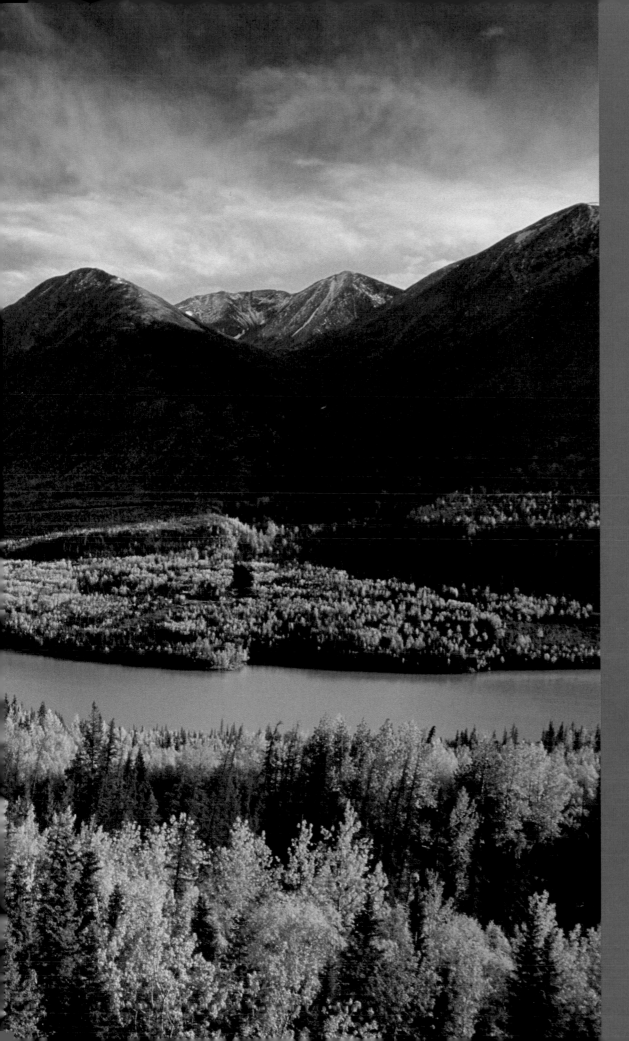

5] Kenai Peninsula

Long and slender, Kenai Lake curves for some 25 miles through the Kenai Mountains. It's a favorite destination of anglers, kayakers, campers, hikers, and lovers of the outdoors.

Kenai Peninsula

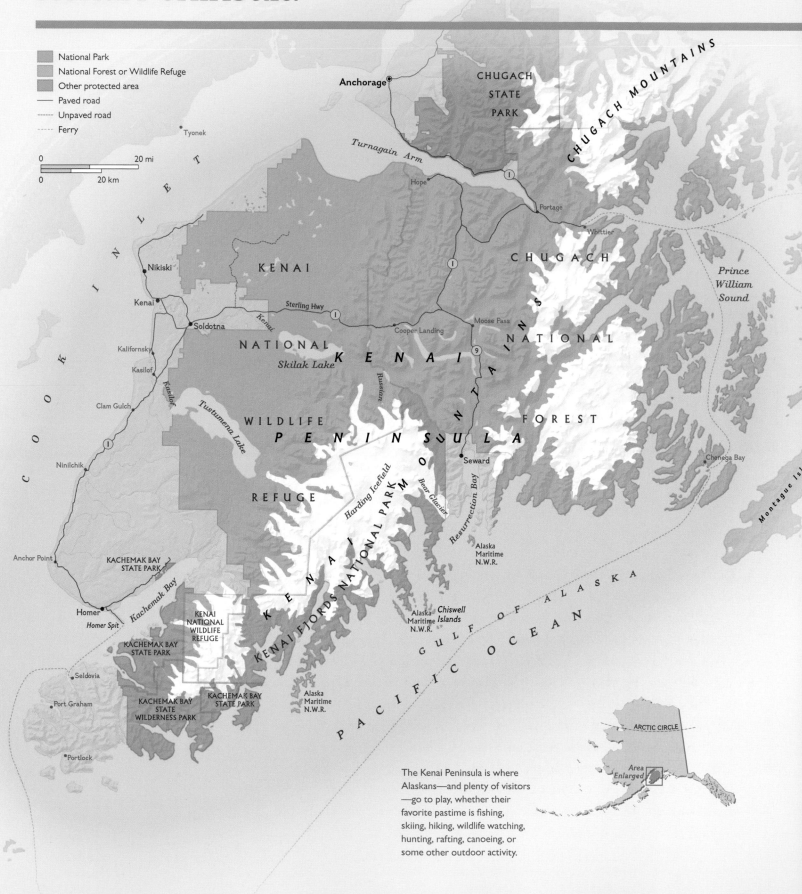

National Park
National Forest or Wildlife Refuge
Other protected area
Paved road
Unpaved road
Ferry

0 20 mi
0 20 km

CHUGACH
STATE
PARK

CHUGACH MOUNTAINS

Anchorage

Turnagain Arm

Tyonek

Hope

Portage

Whittier

Prince
William
Sound

KENAI

CHUGACH

Nikiski

Kenai

Sterling Hwy

Cooper Landing

Moose Pass

NATIONAL

Soldotna

Kenai

Kalifornsky

Skilak Lake

KENAI

MOUNTAINS

NATIONAL

FOREST

Kasilof

Kasilof

Clam Gulch

Tustumena Lake

WILDLIFE

PENINSULA

Russian

Chenega Bay

Ninilchik

REFUGE

Harding Icefield

Seward

Bear Glacier

Resurrection Bay

Alaska
Maritime
N.W.R.

Montague Island

Anchor Point

KACHEMAK BAY
STATE PARK

Kachemak Bay

KENAI
NATIONAL
WILDLIFE
REFUGE

KENAI

Chiswell
Islands

Alaska
Maritime
N.W.R.

Homer

Homer Spit

KACHEMAK BAY
STATE PARK

FJORDS NATIONAL PARK

GULF OF ALASKA

Seldovia

Port Graham

KACHEMAK BAY
STATE
WILDERNESS PARK

KACHEMAK BAY
STATE PARK

Alaska
Maritime
N.W.R.

PACIFIC OCEAN

Portlock

ARCTIC CIRCLE

Area
Enlarged

The Kenai Peninsula is where
Alaskans—and plenty of visitors
—go to play, whether their
favorite pastime is fishing,
skiing, hiking, wildlife watching,
hunting, rafting, canoeing, or
some other outdoor activity.

COOK INLET

Alaska's playground.

That's what many Alaskans call the Kenai Peninsula, the roughly 150-mile-long and 80-mile-wide thumb of land just south of Anchorage that juts southwest between Cook Inlet and the Gulf of Alaska. But the word "playground" is misleading. The Kenai is hardly a city park with slides and swing sets. It's a wild place of forests, rivers, glaciers, lakes, mountains, and marshes; a place the size of West Virginia with a population of only some 55,000; a place that mostly lies within the boundaries of the Kenai National Wildlife Refuge, Kenai Fjords National Park, and Kachemak Bay State Park and State Wilderness Park. Visitors are more likely to see a grizzly than a teeter-totter.

The "playground" label comes from the peninsula's proximity to Anchorage and most of the state's residents. Because the northern border of the Kenai is a mere 25 miles south of the city as the boat sails and 50 miles away as the car drives, many Alaskans vacation there. They, along with plenty of outsiders, come for all sorts of reasons, including a decent offering of civilized amenities, such as luxurious lodges, art galleries, historical sites, and fine restaurants. But mostly they come for the outdoors, for the canoeing, wildlife-watching, glacier trekking, berry picking, mountain climbing, cross-country skiing, hunting, sea kayaking, hiking, and clam digging. And, above all, they come for the fishing.

Sportfishers positively lust for the Kenai. Its appeal starts with geography. This peninsula is very nearly not a peninsula; dig a canal ten miles from the eastern fingertip of Cook Inlet to the western fingertip of Prince William Sound, and the Kenai Peninsula would become Kenai Island. So there is a long coastline riddled with fjords, bays, and coves, which means an abundance of saltwater fishing. Anglers bring their own boats or go out on one of the flotilla of charter boats and chase red snapper, ling cod, rockfish, sea bass, and, most notably, halibut.

It's certainly not their appearance that makes halibut wildly popular. Flatfish with both of their eyes on the side of their steamrolled body that faces up as they slide along the ocean bottom, halibut look freakish. But they are determined fighters and great eating. By almost all accounts, small and average-size halibut—maybe in the 10- to 25-pound range—taste best. But many fishers still yearn to reel in the big fellas, and "big" does not mean 40 or 50 pounds, not among halibut aficionados. They use a term that better captures what they consider big: "barn door halibut." There's no official weight that qualifies a halibut as a barn door specimen, but many people

Traditional Athabaskan baby basket, made out of birch bark and moose hide and decorated with beads. Athabaskans are renowned for their intricate beadwork, which is on display in many museums and cultural centers.

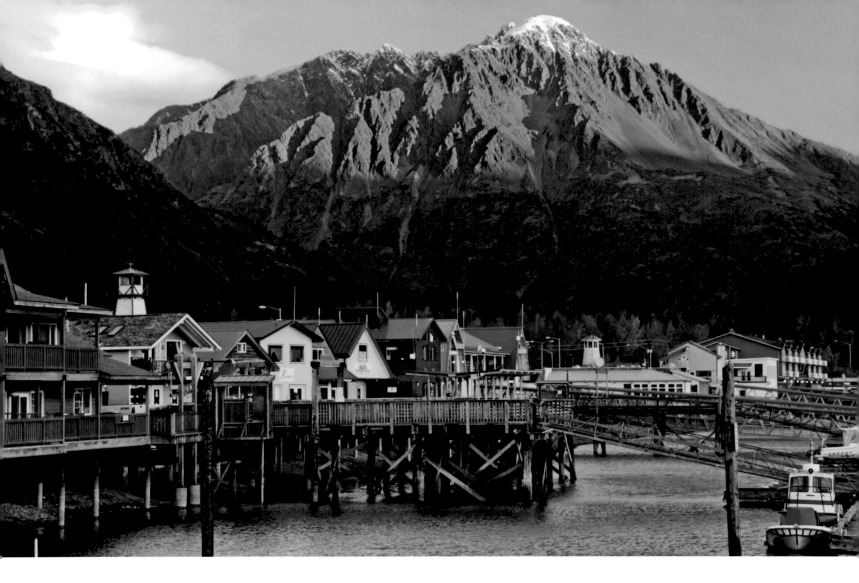

The Seward Small Boat Harbor is a fine place to get a seafood dinner or watch bald eagles scavenge, but mainly it serves as the hub for boats that take travelers to Kenai Fjords National Park, Resurrection Bay, and great fishing spots.

use 100 pounds as the minimum. Visitors walking along the Homer Spit pass by one charter fishing office after another, each wallpapered with photos of grinning anglers standing beside hanging halibut that are almost as large as the anglers—sometimes even larger. No wonder Homer—a lively, multifaceted town that could have plausibly adopted any of dozens of engaging mottoes—went with "Halibut Fishing Capital of the World." Incidentally, the world-record Pacific halibut, caught in Alaska waters, crushed the scales at 459 pounds.

But here's the thing. Saltwater fishing, halibut fever notwithstanding, is not the most popular form of angling on the Kenai. It so happens that the peninsula's geography also makes it a paradise for freshwater fishing. Lakes, rivers, creeks, and wetlands pepper the peninsula; some 40 percent of it is covered by fresh water. Some fishers favor float-tube fly-fishing for Dolly Varden on the Summit Lakes. Others opt to go ice fishing on Rainbow Trout Lake for, naturally, rainbow trout, as well as arctic char. Elsewhere, anglers chase grayling, lake trout, kokanee, and steelhead. But what really gets fishers cooking—literally and figuratively—is salmon.

All five species of Pacific salmon, including the three that make anglers weak in the knees—king (chinook), sockeye (red), and silver (coho)—flock to the peninsula.

Throughout the Kenai, salmon crowd into rivers and creeks, running the age-old gauntlet of rapids, bears, eagles, and other obstacles that lies between the fish and their spawning grounds. Nowadays, humans equipped with rod and reel must be added to that list of dangers.

Of course, salmon aren't exclusively freshwater fish. Being anadromous, they are born in fresh water, migrate to salt water for part of their lives, and then return to fresh water to spawn and die. Not content to wait for the salmon to enter the rivers and creeks, some fishers venture forth in boats to drop their hooks into near-shore waters as those swimming fillets approach the mouths of the rivers and creeks in which they were born. Nowhere is this more evident than at the Seward Silver Salmon Derby, one of several major fishing derbies that take place on the peninsula.

Since 1956, the Seward Silver Salmon Derby has been drawing fishers who like silver salmon and prizes to this town at the southern end of the Seward Highway. Thousands of people pack the hotels and camp out on the waterfront and, come daylight, motor out into Resurrection Bay in a quest of prize-winning silver salmon. Cash prizes await the anglers who land the five heaviest silvers, with $10,000 going to the person who catches the biggest of the year. Even more sought after are the silvers that have been tagged. Fishers might reel in a tagged fish worth $5,000, $10,000, and even $50,000 in cash, or perhaps one whose tag entitles the lucky angler to a brand-new Chevy Silverado 4x4 or a Hawaiian vacation.

Fishing derbies can get pretty crazy, but to experience true fishing madness on the peninsula, visitors should watch—from a safe distance—combat fishing. "Combat fishing" is the commonly used term, not just a phrase dreamed up by some headline writer. This melee occurs during major salmon runs on easily accessible rivers and creeks, most notably for a couple of months in midsummer near the mouth of

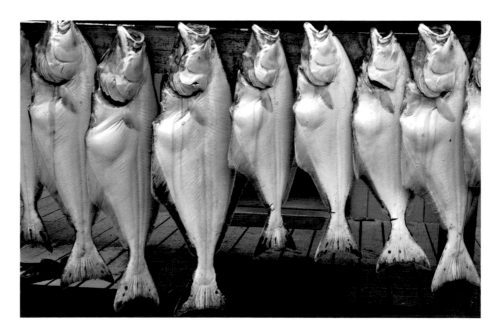

In coastal communities all over the Kenai Peninsula, charter boats head out to sea bearing anglers eager to hook a halibut. Some fishers seek tasty fillets, and some are chasing trophy halibut, which can weigh more than the person holding the fishing rod.

the Russian River, where it flows into the Kenai River. Hundreds of anglers throng the water's edge, sometimes only a couple of feet apart, casting their lines into the river in hopes of catching some of the multitudes of sockeye heading upstream.

Not surprisingly, all those sharp hooks being flicked around in such close quarters create a hazard to humans as well as to fish. One veteran Alaskan fishing guide includes the following suggestion on his advisory list for anglers planning to go combat fishing on the Russian River: "Safety should be No. 1. Protect your eyes and ears, head, and body as much as possible. Sunglasses,

safety glasses, or goggles are a must. A hat is a must, and plenty of clothing and good waders, too."

Of course, most sportfishing on the Kenai does not evoke the adjective "combat" or take place in a festival atmosphere like that of the Seward Silver Salmon Derby. More typical would be a couple of friends in a boat quietly drifting down a river with their fishing lines trailing behind them and no one else in sight. The peninsula is so rich in scenery and wildlife that, amazing as it may seem to hard-core anglers, many people don't even bring a fishing rod with them when they visit.

Seward, for example, despite its huge appeal to sportfishers, attracts plenty of visitors who don't know a reel from a creel. Some come for events besides the Silver Salmon Derby, such as the annual Polar Bear Jumpoff. Since 1986, this January celebration has given participants the opportunity to don costumes and leap into water so cold that people can almost play ice hockey on it. But this lunacy is for charity and, besides, most attendees skip the leaping-into-the-harbor part and go for the parade, carnival, seafood buffet, or the always popular turkey bowling.

Apparently the residents of Seward believe in all-season suffering, because every Fourth of July since 1915, they have held the Mount Marathon Race, in which 900 participants (the maximum allowed, for safety reasons) hustle up 3,022-foot Mount Marathon and back down again. The race has become a massive event that draws thousands of onlookers as well as top athletes, including some Olympians. The record time for the three-mile course, as of 2013, is 42 minutes and 55 seconds.

Experienced runners will recognize that 42:55 is a terribly slow record time for a three-mile run. Of course, it's a mountain race, so times will be much slower than on a flat course, but even if the road to the summit is steep, top runners should be able to complete the race in more like 25 or 30 minutes. Well, that would be true if there were a road. Instead, contestants start at sea level and head uphill over rough terrain, careening through gullies, loose shale, and sometimes ice and snow. Some slopes are so steep that runners—if you can call this running—have to haul themselves up using their hands. No wonder the times appear slow and contestants often stagger to the finish line with skinned knees and spattered with mud. But Alaskans love a challenge, and the race always signs up the maximum number of entrants.

Visitors to Seward who prefer less blood and mud might want to take in the Alaska SeaLife Center, beautifully situated on the town's downtown waterfront overlooking Resurrection Bay. One of the state's finest

Unusual Wild Berries

1 Cloudberry These modest-size berries start out red and ripen to an enticing amber. High in vitamin C, even after being frozen, they are a staple for many Alaska natives.

2 Lingonberry Lingonberries look a lot like commercial cranberries and are sometimes called low-bush cranberries. They are abundant on the Kenai Peninsula in late fall, and are best picked after the first frost.

3 Nagoonberry Known as the "berry of kings" in Russia, these deep-red treats hide in the depths of the woods and are hard to find but worth the trouble. "Nagoonberry" comes from a Tlingit word. These prized berries also go by many other names, including arctic raspberry, northern dwarf raspberry, and short-stemmed raspberry.

4 Salmonberry Salmonberries come in two flavors: tart and sweet. The red ones are tart, and the golden ones are sweet. Apparently, they got their name because they look like salmon eggs, but that doesn't make them any less tasty.

Opposite: Competitors labor up Mount Marathon in Seward's grueling annual race, which makes a road run seem like a walk in the park. *Left:* Cloudberries

museums and research institutions, the center will introduce travelers to the glories of Alaska's marine ecosystems. Underwater viewing galleries let visitors press their faces against the glass and watch harbor seals and sea lions zip past with astounding speed and grace. In the Discovery Pool, people can run their fingers over sticky sea anemone tentacles or a sea star's smooth arms. Video monitors enable patrons to observe some of the center's rehabilitation efforts; one time it may be drawing blood from an auklet, another time it may be administering anesthesia to a sea otter.

The SeaLife Center offers a variety of special tours for visitors who want to dive a little deeper into the marine realm. The behind-the-scenes tour, for example, takes people into the back rooms of the center to see what the staff does. "Encounters" are hour-long visits with a particular critter or group of critters led by center experts, such as the Marine Mammal Encounter, which involves quality time with harbor seals, and the Puffin Encounter, in which people get to hang out with puffins and other seabirds in the aviary.

Travelers who want to learn about one of Alaska's more mysterious and intriguing creatures should go on the Octopus Encounter. While handing bits of food to a giant Pacific octopus, a staff member will regale the group with details about this

A surprisingly intelligent beast, the giant Pacific octopus inhabits the coastal waters of the Kenai Peninsula and is a celebrity at Seward's Alaska SeaLife Center.

eight-armed invertebrate, the largest of all octopus species. How large? A good-size adult might measure about 15 feet across and weigh about 75 pounds; the largest ever reported is said to have been about—gulp—30 feet across and about 600 pounds. Their heft is even more remarkable considering that they have no bones. Being boneless makes them incredibly flexible—a 50-pound octopus can pass through a two-inch hole—which is handy for skulking about in underwater rock gardens while on the hunt.

Visitors may learn many other fascinating details about the giant Pacific octopus—its chameleonlike ability to camouflage itself by changing colors or the fact that it will occasionally prey on fair-size sharks—but what many people find most astonishing is its intelligence. These animals can learn to open jars, solve mazes, play with toys, and, as part of their camouflage technique, mimic the shape of other sea creatures. They have the largest brain of any invertebrate, but that's not the half of it: In fact, that's only two-fifths of it, because three-fifths of the octopus's neurons (the impulse-conducting cells critical to sensing and thinking) are found not in its brain but in its arms. These sucker-dotted appendages seem to think for themselves in some ways. Researchers have seen a severed octopus arm (an octopus can grow a new arm) crawl across the bottom of an aquarium tank, seize a piece of food, and pass the food up the arm from sucker to sucker toward where the octopus's mouth used to be.

Stranger still, the giant Pacific octopus displays emotions. Extensive anecdotal information and abundant experiments have convinced scientists of this. In one aquarium, an octopus took a dislike to one of the volunteers and squirted her with water whenever she came close to the tank, something it didn't do to other people. Eventually, the volunteer left and the squirting stopped, but when she returned for a visit months later, the octopus shot her on sight with salt water. On the other hand, an octopus will show signs of affection toward people it likes and trusts. It may greet them by raising its arms out of the water and waving them excitedly around, kind of like a happy dog wagging its tail. Other times, an octopus will lay an arm gently on a favored person's hand, and its skin will turn from reddish and a little bumpy to white and smooth—a sign of relaxation.

Their appetites whetted by the SeaLife Center, travelers wanting to see Alaska's marine life in the wild will find a variety of tour opportunities at Seward's Small Boat Harbor. Dozens of outfits with offices at the harbor offer boat trips into Resurrection

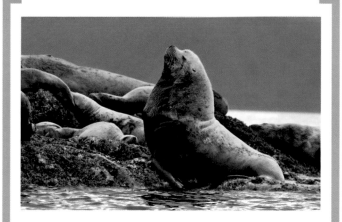

NATURAL WONDER

Studying Steller Sea Lions

Steller sea lions are fan favorites at the Alaska SeaLife Center, but outside the safety of the aquarium, they are not faring well. For more than a decade, researchers at the SeaLife Center have been trying to determine the reason for the widespread decline of these charismatic creatures. It appears there is no single, simple answer, but studies point to factors such as killer whale predation and a reduction in the availability of the most nutritious prey.

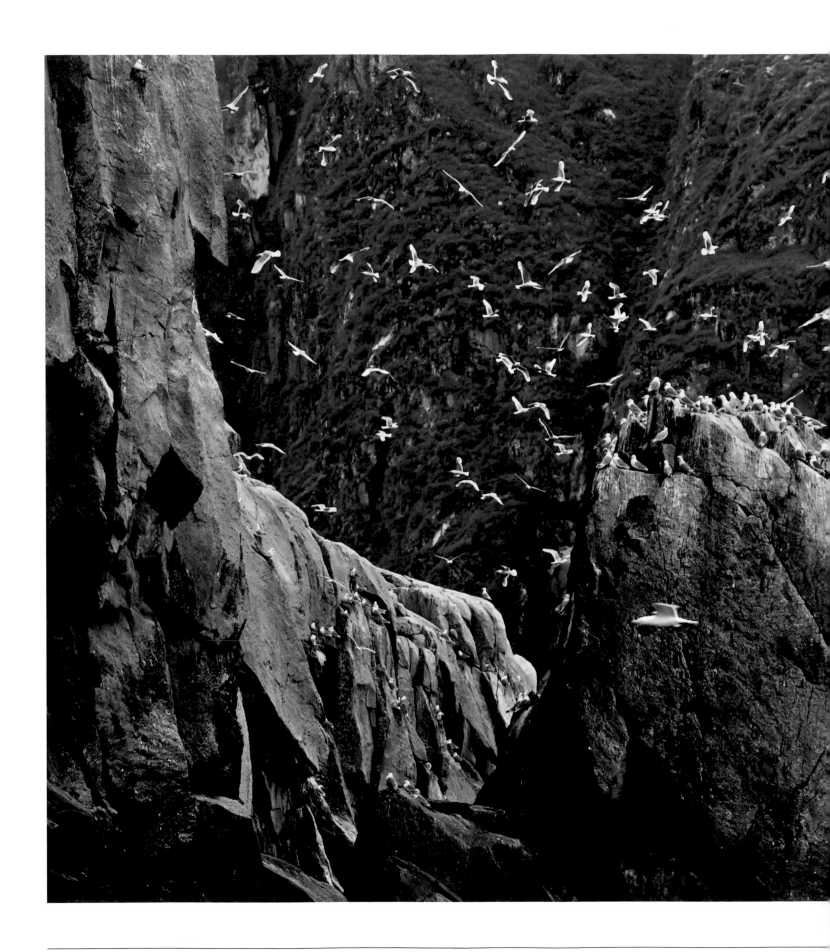

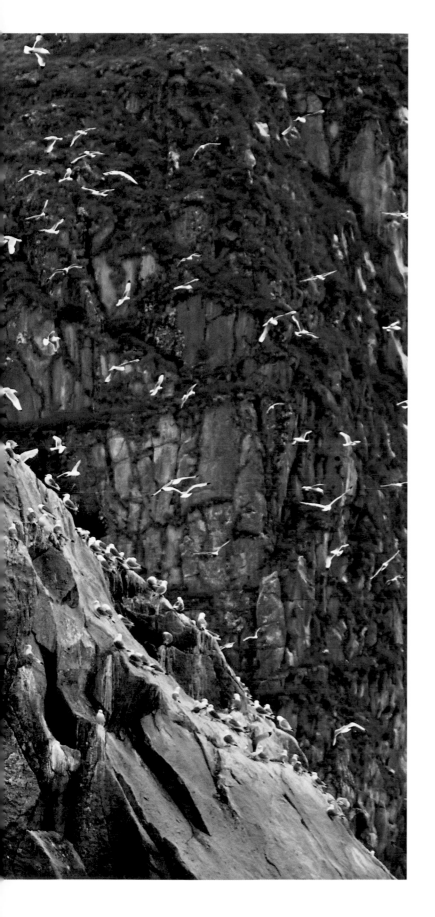

Bay and beyond. Some trips last a couple of hours, some last a week. Some use small boats that carry maybe 20 passengers while others use boats with capacities of more than 200. Some are spartan journeys that require passengers to bring their own food and water, and others serve salmon and prime rib in heated, glass-enclosed dining rooms. But they all take travelers out to sample at least a small part of the coastal waters of the Kenai Peninsula.

> **❝ Never let work get in the way of your fishing."**
> **"When you don't have skill, you gotta have luck."**
> **"There's no shortage of good days as long as you're fishing. ❞**
>
> **[Various Kenai River fishing guides]**

Marine life thrives in these cold, fertile waters. Passengers will often see bald eagles and sea otters in or near the harbor as well as throughout Resurrection Bay. Oystercatchers walk about the rocky shore, wading into tide pools to pry apart mussels. Harbor seals periscope their heads out of the water to stare at boats as they pass. Sometimes pods of porpoises appear, swimming along in the classic in-and-out-of-the-water pattern that made a verb out of the word "porpoise." Dall's porpoises—easily identified by the black-and-white markings that make them look like mini–killer whales—like to surf the bow waves of tour boats. In the spring, gray whales cruise across the mouth of Resurrection Bay, working their way up the coastline to their summer feeding grounds. Humpback whales also frequent these waters, eating voraciously, sometimes for 23 hours a day, as they fatten up for the long migration back to their breeding grounds in Hawaii.

Part of the Alaska Maritime National Wildlife Refuge, the Chiswell Islands host a sea lion rookery and multitudes of nesting kittiwakes, murres, puffins, and other seabirds.

About 30 miles south of Seward, boats arrive at the remote Chiswell Islands, part of the Alaska Maritime National Wildlife Refuge. Twisted

and chiseled by eons of crashing waves and earthquakes, the gray bedrock cliffs of the Chiswells thrust almost vertically from the sea. Sea stars, mussels, green anemones, and barnacles cling to the lower levels of stone walls exposed by the ebbing tide. Higher up, Steller sea lions lounge on narrow ledges, which they reach through a combination of high tides and their uncanny ability to climb, uncanny because they seem so blubbery and clumsy out of the water. Higher still, in crevices, on ledges, and on the tops of rocky towers are the tens of thousands of seabirds that nest on these islands. Like an extraordinarily busy airport with no control tower, the islands and the surrounding skies are a constant whirl of avian air traffic as birds head out to feed and return to bring food to their young and mates.

The ocean realm south of Seward is an endlessly fascinating place, but there is also a terrestrial attraction that pulls tour boats to this area. Only some ten miles out of Seward, while still in Resurrection Bay, passengers need only glance to the west and they'll be gazing at the stunning coastline of 608,000-acre Kenai Fjords National Park, which stretches on south for several dozen miles. You won't find many flat marshlands or sandy beaches here; along most of the shore, rocky cliffs and steep forested mountains rise precipitously from the water. During the spring and summer, once the melt has begun, waterfalls and nearly vertical streams pour off the slopes, brilliant white against dark stone.

As tour boats round Caines Head and come to the northern boundary of the park, the first feature they encounter is Bear Glacier. Often, boats will pick their way through the icebergs and treat passengers to a close-up view of the glacier's snout. However, sometimes conditions dictate staying farther back, such as in the summer of 2008, when exceptionally high water levels, strong currents, and large standing waves near the front of the glacier made it unsafe to approach for several days.

Park staff determined that Bear Glacier had experienced a glacier lake outburst flood (GLOF). Such floods occur when a glacier expands across a waterway and forms an ice dam, backing up water behind it until melting, earthquakes, volcanic action, or some other force breaks the dam and the water rushes out. The 2008 Bear Glacier GLOF was minor; the 1986 Hubbard Glacier GLOF, in Southeast Alaska, was not. In fact, the 1986 Hubbard GLOF was the largest in recorded history. The glacier blocked off Russell Fiord, and soon a lake covering dozens of square miles filled up behind it. When that glacial dam burst,

Glacier Glossary

1 Crevasse A crevasse is an open fissure in the surface of a glacier that forms when the speed of the slow-flowing ice varies, such as when it slides over the top of a rocky outcrop.

2 Erratic When a hiker comes across a granite boulder sitting in a valley bottom miles from any granite formations, it's likely an erratic: a rock carried far from its original site by a glacier and then stranded in that new home when the glacier melts.

3 Moraine Lateral moraines are created when loose rocks roll off the sides of glaciers and form long, thin ridges along a glacier's icy flanks. Terminal moraines are formed when rocks roll off a glacier's snout. When the ice melts, the moraines are left behind and they outline the historic boundaries of the glacier.

4 Nunatak A rocky protrusion in the middle of a glacier or ice field, such as a mountaintop that the glacier flowed around but didn't cover.

5 Rock Flour As glaciers roll over bedrock, they grind some of it into a fine dust known as rock flour—aka glacial flour or glacial milk. Rock flour often gets into streams, giving them that milky, light green color so common to waterways in Alaska.

6 Serac When sets of crevasses intersect, they often produce tall, jagged pinnacles of ice called seracs. Word has it that an 18th-century Swiss geologist and mountaineer bestowed the name "serac" on such pinnacles because they reminded him of the texture of the serac cheeses made in the Alps.

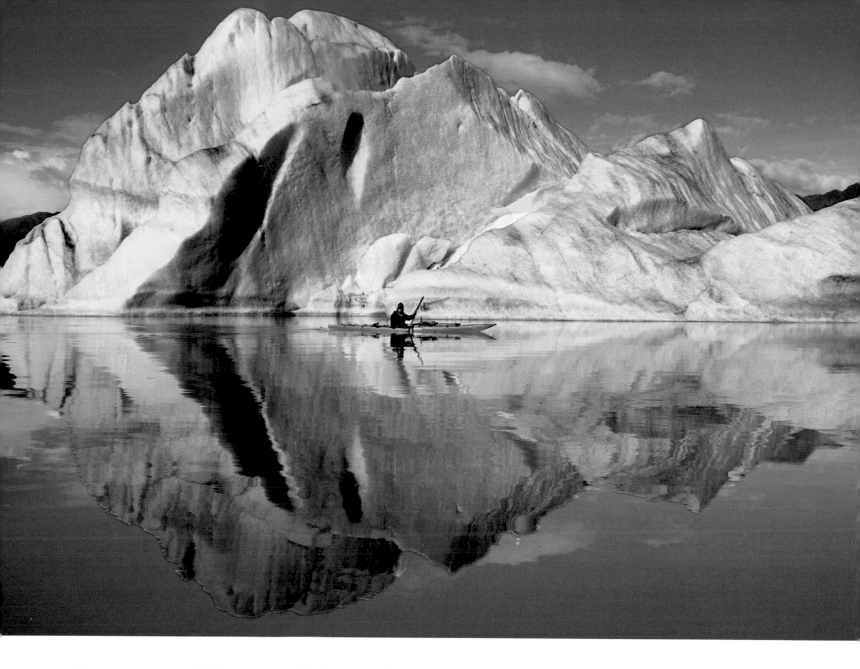

A kayaker paddles past an iceberg near the shore of Kenai Fjords National Park. Icebergs are created when chunks of ice sheer off from the park's many tidewater glaciers and drop into the sea.

the pent-up water gushed out at rates as high as 3.7 million cubic feet per second. That's about 60 times more water than the peak historic flow of the Mississippi River. Where was the second largest GLOF ever recorded? Also Hubbard Glacier, in 2002. The takeaway: Don't build a cabin on the shore of Russell Fiord below the point where the ice dam keeps forming.

Starting a tour of Kenai Fjords National Park at a glacier is fitting because fjords, after all, were created by glaciers grinding steep-walled canyons out of seaside mountains and then receding, leaving a fjord behind. Furthermore, dozens of glaciers flow down from the park's high country, many of them all the way to the sea. Ice is the raison d'être of this park, a large majority of which is cloaked by ice.

More than half of the park is buried beneath a single body of ice: the Harding Icefield, the largest ice field that lies solely in the United States. More than 30 of the park's glaciers emanate from this 700-square-mile expanse of ice, which is thousands

Fly-Fishing on the Kenai River
The Kenai Peninsula is known as "Alaska's Playground," the place where residents as well as out-of-towners come to camp, hike, canoe, hunt, ski, and otherwise enjoy the outdoors. But the favorite game on this playground is fishing.

Kilchers: The Next Generations

Longtime Homer luminary Yule Kilcher became regionally famous for his attempts, first unsuccessful and later successful, to cross the Harding Icefield, not to mention that he helped write Alaska's constitution and served in the state senate. Some of his progeny have achieved fame in various ways, too. Eldest son, Atz, and several other family members star in the Discovery Channel's reality show *Alaska: The Last Frontier,* and granddaughter Jewel Kilcher is better known simply as "Jewel," the multiplatinum singer/songwriter.

Black bear tracks lead across a beach on Nuka Island, at the southern end of Kenai Fjords National Park.

of feet thick in places. The ice field came into being some 23,000 years ago when ice covered a third of the Earth; it is one of the remnants of a vast ice sheet that enveloped much of south-central Alaska.

The first known attempt to trek across the Harding Icefield occurred in 1936. A Swiss immigrant named Yule Kilcher wanted to get to Homer from Seward and didn't want to wait for the next ship. He should have been more patient. The 27-year-old opted for the most direct route across the ice field, so he optimistically headed up Lowell Creek toward that ocean of ice. Unsurprisingly, a week later, he dragged himself back into Seward, having discovered that crossing the ice field is not a casual stroll. The first known successful effort took place four years later, when a couple of hardy and well-prepared Alaskans made it all the way. The next known successful effort wasn't until 1968, when a mountaineering party made the crossing in eight days, tossing in a first ascent of the Kenai Peninsula's highest peak along the way. Among the members of that group was none other than an older and wiser Yule Kilcher.

Fit and hardy travelers—*extremely* fit and hardy travelers—can take a three- to five-day guided tour that entails flying up to one side of the ice field and then cross-country skiing 40 miles to the other side. Somewhat less ambitious and not quite as fit and hardy travelers can opt for the 12-mile drive from Seward to Exit Glacier and a hike up the Harding Icefield Trail, which goes to the ice field but not across it. Mind you, this is no cakewalk; the roughly eight-mile round-trip path gains 3,000 vertical feet, and often involves slogging through some snow even in summer, but great views of the ice field—if there's no rain or fog—reward the effort.

Adventurers wishing to try Kilcher's original idea—hiking from Seward to Homer—would be right to focus on negotiating the Harding Icefield, but if they managed to get across it and descend the west flanks of the Kenai Mountains, they'd find one last obstacle between them and Homer: Kachemak Bay. However, they might want to linger instead of hurrying to overcome this last obstacle, because this lightly populated (even by Alaska standards) side of the bay has its own allure.

That appeal starts with the scenery. A traveler standing on the eastern shore of Kachemak Bay will see natural splendor in all directions. To the north lie the cold, clean waters of the bay itself and the western shore, five to ten miles distant. To the south and east lie the forests, lakes, glaciers, and rivers of the Kenai Mountains and Kachemak Bay State Park. To the west, the mouth of the bay blends into the waters of Cook Inlet and, on the far side of the inlet, the jagged peaks of the Aleutian Range, including a number of volcanoes, challenge the sky.

Despite the fact that the entire population of this thousand-square-mile area could fit into a high school auditorium, civilized pleasures also beckon travelers to this side of the bay—remarkably civilized in the case of several high-end lodges that bring luxury to this backcountry setting. Take the venerable Kachemak Bay Wilderness Lodge, ensconced in the forest overlooking China Poot Bay. Here's some of what guests get for around $800 a night per person: spacious and well-appointed private cabins, all with fine views; fresh flowers, fancy chocolates, fruit baskets, and wine waiting when guests arrive; a solarium with an outdoor deck; a Finnish sod-roof log sauna; an outdoor hot tub; and a dock with a cookout pavilion. And then there are the meals. A

Cormorants, murres, kittiwakes, and other seabirds nest and roost on this little island in Kachemak Bay. Islands provide a haven from terrestrial predators, such as foxes and raccoons, but avian raiders, such as bald eagles, still pose a threat.

The few dozen residents of Halibut Cove live on the water as much as on land. Like the person shown here, many use rowboats, canoes, or kayaks to travel back and forth across the cove that serves as main street.

typical dinner might include steamed king crab legs and mussels fresh out of China Poot Bay for appetizers, butternut squash soup with wild rice and roasted pumpkin seeds, an entrée of fresh silver salmon (also right out of China Poot Bay) in a lemon beurre blanc sauce, and Kahlua crème brûlée for dessert. Arguably best of all, the lodge accepts only about a dozen guests at a time and has nearly the same number of staff to attend to them, including a number of local naturalist/guides who will take guests on customized outings, including tidepooling, fishing, hiking, sea kayaking, and wildlife-watching boat tours.

A couple of bays north of the lodge—about five miles by boat—sits another oasis of civilization: Halibut Cove. Measuring the distance in terms of boat travel is appropriate because boats and floatplanes are the only way to reach this tiny community tucked away on both shores of a lagoon between Ismailof Island and the mainland. The village is built on the water as much as on land, with many of the buildings resting above the lagoon on pilings. A raised boardwalk follows both shorelines and connects most of the structures, though residents often use skiffs, canoes, kayaks, and other watercraft to shoot across the lagoon because it's faster than going on the boardwalk. Visitors

are welcome to stroll the private parts of the boardwalk between 1 p.m. and 9 p.m., provided they respect residents' privacy.

Perhaps 50 people, fewer in the winter, live in Halibut Cove. But for a couple of decades early in the 20th century, the place was a boomtown. Gold? Oil? Sea otter pelts? No, it wasn't any of the usual suspects. It was the lowly herring that drew more than 1,000 workers to the fishery, which took advantage of the multitudes of herring that spawned in the cove and returned there to spend the winter. Some residents did the fishing and others worked in the dozens of salteries that sprang up, where they processed the catch, packed the herring in brine-filled barrels, and shipped them to the East Coast. Unfortunately, in the late 1920s, the herring cratered. No one is quite sure what happened, but researchers think it's likely that some combination of overfishing and pollution of the herring's spawning grounds was the culprit. Ironically, the pollution was not the typical urban/industrial cocktail of chemicals and sewage but the fish waste from the salteries, which was dumped onto the eelgrass beds in which the herring spawned. The eelgrass beds recovered long ago, but the big runs of herring have never returned.

Following the herring crash, most of the buildings were torn down, and the materials used for development in Homer. Aside from a few reclusive holdouts, Halibut Cove turned into a ghost town. But the seeds of change were sown in 1948, when Clem Tillion, a commercial fisher, came to town, and more seeds were planted in 1952, when he married and his wife, Diana Tillion, joined him in Halibut Cove. In 1966, Clem started a small ferry service from Halibut Cove to Homer, which lessened the town's isolation. In 1968, Diana, a talented and innovative artist who often painted with octopus ink, opened the Cove Gallery, catching the eye of other artists. Soon a trickle of settlers, most of them commercial fishers or artists, moved to Halibut Cove, and the population swelled to . . . well, maybe 25 or 30.

In the ensuing years, another gallery was established (it shows only Halibut Cove artists, who number around 20), several high-end lodges were built, and one of the Tillions' daughters (a fine artist herself) and her husband opened a modest eatery they named the Saltry. The Saltry evolved into one of Alaska's finest restaurants, and now serves about 100 guests a day during the summer, most of whom ferry over from Homer for lunch or dinner. With the Saltry drawing so many visitors and the fame of the local artists spreading, Halibut Cove is no longer a secret hideaway, yet it has retained its quirky, intimate charm through the years.

Boat Tour on Kachemak Bay

Boat tours, such as this one run by the Center for Alaskan Coastal Studies, introduce day-trippers to Kachemak Bay and the lands on its south side.

❶ The journey begins in the harbor near the end of Homer Spit. You'll reach **Gull Island** in just 30 minutes. In summer, the island hosts thousands of nesting seabirds.

❷ From Gull Island, it's about a mile to the Center for Alaskan Coastal Studies' **Peterson Bay Coastal Science Field Station.** Here, you can visit touch tanks, filled with a variety of critters.

❸ Begin the **forest hike** at the center. Plant diversity along the trail is high because it marks a transition zone between coastal and interior boreal forest.

❹ The trail emerges on the cobble shore of **China Poot Bay,** where the retreating tide reveals a mysterious world of tide pools.

❺ Some tours head out to **Peterson Bay,** where you'll spot sea otters and an oyster farm that thrives in the clean, cold water.

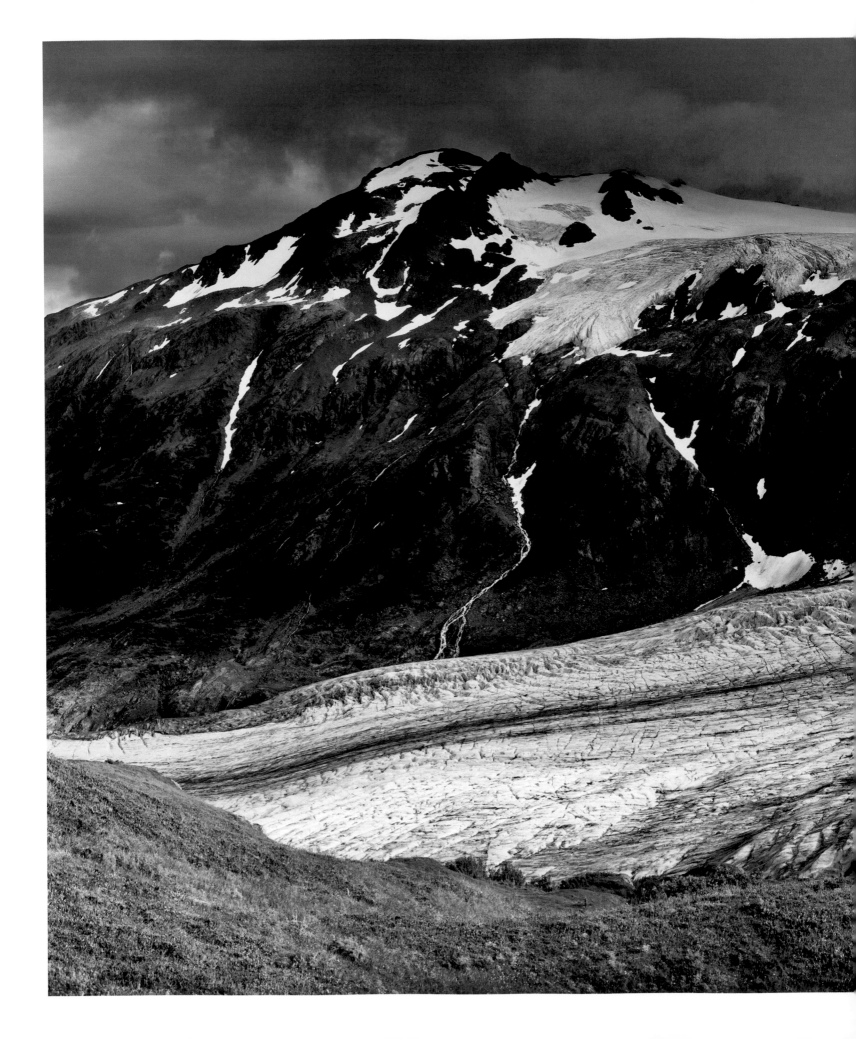

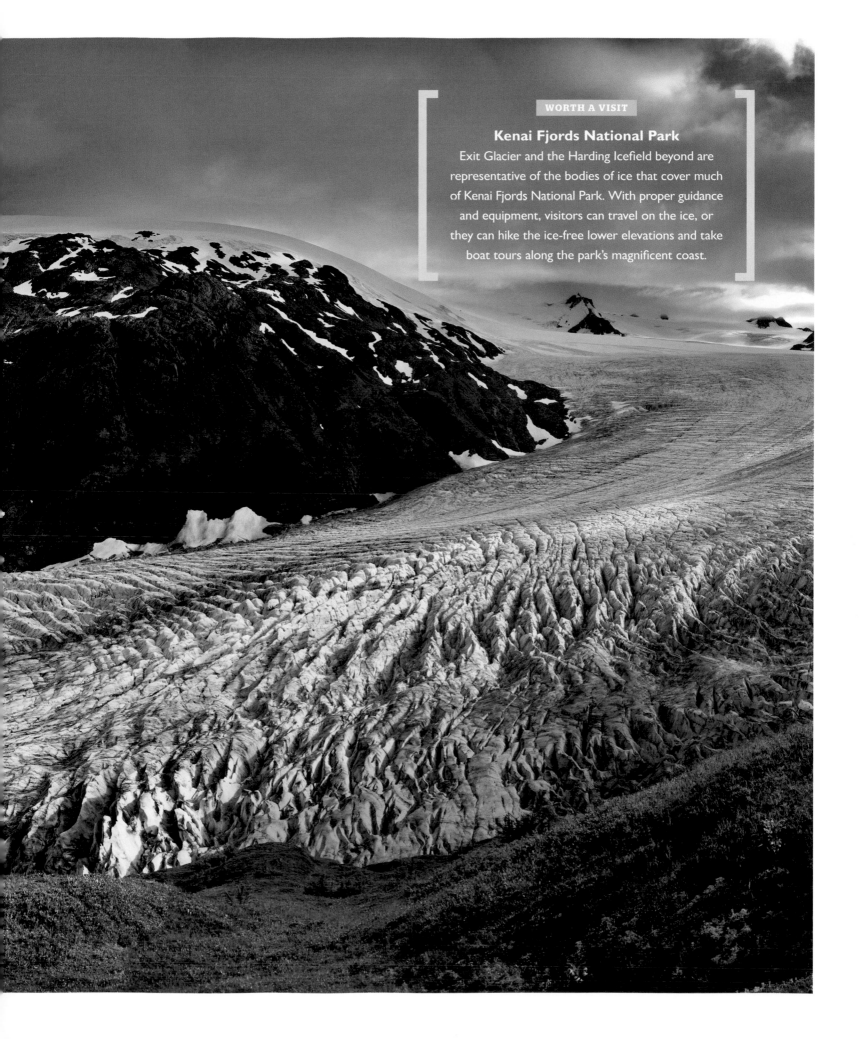

Kenai Fjords National Park

Exit Glacier and the Harding Icefield beyond are representative of the bodies of ice that cover much of Kenai Fjords National Park. With proper guidance and equipment, visitors can travel on the ice, or they can hike the ice-free lower elevations and take boat tours along the park's magnificent coast.

Sea stars are among the denizens of the mud that show up at low tide on the Homer Spit. *Opposite:* Alex Combs's "Green Blue Red" hangs in the Pratt Museum, in Homer.

Homer, the town at the other end of the ferry service from Halibut Cove, also exudes quirky charm, though not on such an intimate scale. Still, only about 5,000 folks live in Homer, so it's intimate compared with, say, Chicago. And Homer has so much quirky charm that it became grist for the popular stories told in writing and on the radio by author, humorist, and radio show host Tom Bodett, who lived in Homer from 1982 to 1999. As much as anyone, Bodett put Homer on the map.

Barely out of his teens, in 1976, Bodett moved from Michigan to Petersburg in Southeast Alaska, where he worked as a logger, deckhand, and contractor. In 1982, he moved to what was then the even smaller town of Homer, where he began writing. Soon he was contributing tales about life in small-town Alaska to National Public Radio's *All Things Considered,* which quickly led to a book on that same, endlessly fertile subject: *As Far as You Can Go Without a Passport: The View From the End of the Road.* In this first of his many books, Bodett delved into a truly eclectic selection of topics, such as trapping, soap operas, halibut fishing, and losing socks in the washing machine. This well-received book in turn led to a syndicated radio show *The End of the Road Review,* which Bodett did for a number of years.

All the references to the "end of the road" were references to Homer's location at the end of the Sterling Highway. The town is proud of its end-of-the-road ambiance and the independence and eccentricity that such a remote position fosters. Actually, for most of its existence, Homer was beyond the end of the road; the highway didn't even come to town until 1950. At the time, its population barely exceeded 300 people, most of whom were tied to commercial fishing in some way. Commercial fishing remains a mainstay of the Homer economy, but the arrival of the highway expanded the possibilities and the population.

Adding to the assortment of idiosyncratic end-of-the-road characters who inhabited the Homer area were the "barefooters" who came down the highway in the mid-1950s. More formally known as the Wisdom, Knowledge, Faith, and Love Fountain of the World, they were a weird blend of cult, community service organization, and back-to-the-land farmers. They wore robes, and the men grew long hair and beards. They got their nickname because they didn't wear shoes, even in the winter. For a few years, they farmed a bit of rural land a few miles up the bay from Homer, but for various reasons, the colony fell apart and the barefooters scattered. One who landed in Homer and lived there for decades was Asaiah Bates, who became a beloved member of the community and even served on the Homer City Council. In 2007, Homer Mayor Jim Hornaday officially declared February 14 "Brother Asaiah Bates Day." Bates figured "Halibut Fishing Capital of the World" was a bland civic brand and lobbied for "Cosmic Hamlet by the Sea."

Though Halibut Cove has more artists per square mile than does Homer, Homer does harbor more artists in absolute terms and far more than most communities its size. Galleries abound, and they lean toward sophisticated art as opposed to velvet paintings of howling wolves, though traditional Alaskan subjects and influences certainly appear in many of the works. Of particular note is the Bunnell Street Arts Center, a nonprofit institution that occupies the town's oldest commercial building, the Old Inlet Trading Post, which used to sell hardware to homesteaders. In the center's main room—an airy space featuring a grand piano—visitors can catch monthly shows, usually of a single featured artist. The emphasis is on cutting-edge contemporary art. In the back room, browsers can contemplate the works of some 60 Alaska artists. The center also offers an array of workshops, concerts, readings, and other events.

Artists in the Backcountry

Tucked away in remote hamlets and isolated cabins, many Alaskan artists like to live close to the land that inspires their art. A classic example was Alex Combs, a nationally acclaimed painter and potter and one of the founders of modern Alaskan art.

For the last three decades before his death, in 2008, Combs resided in the tiny village of Halibut Cove (population maybe 50), which can only be reached by boat or floatplane. Despite being in a position to command high prices, Combs would leave his Halibut Cove studio open for visitors even when he wasn't around; he simply put out a sign inviting them to take whichever piece they wanted and leave however much money they felt was fair.

To reach the absolute end of the road, visitors must leave central Homer and venture onto the Homer Spit. The final stretch of the Sterling Highway runs down the middle of this narrow, 4.5-mile-long sand-and-gravel finger that pokes southeast into Kachemak Bay, reaching halfway to the far shore. Experts dispute its origins. Some think that the spit is a terminal moraine left behind by a retreating glacier, and that materials from the ocean washed up against it and built the moraine into the spit over time. Other people think it's simply an exceptionally long classic spit, built up over the ages by ocean currents depositing sand and other rocky debris. One

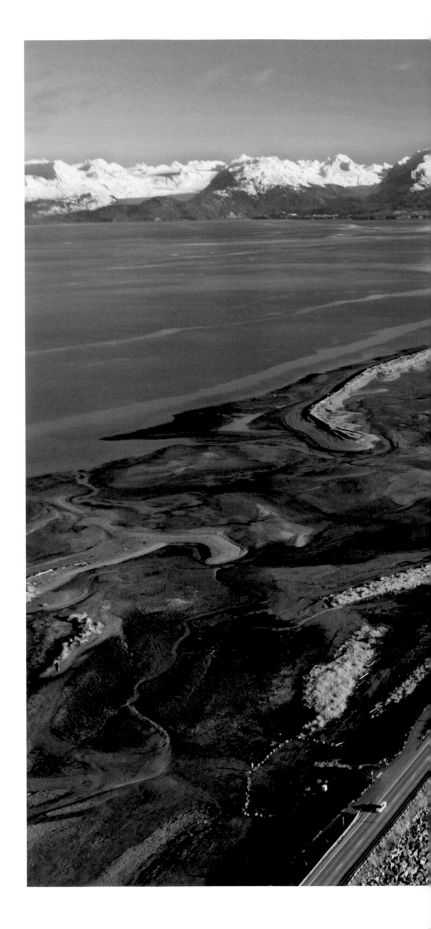

A hotbed of activity that includes Homer's harbor, the Homer Spit stretches five miles into Kachemak Bay. Visitors will find everything from bald eagles to bars.

NATURAL WONDER

Razor Clams

The 50 miles of Cook Inlet shoreline between the Anchor and Kasilof Rivers harbor an abundance of beaches that in turn harbor an abundance of razor clams; more than a million clams are dug out of these teeming sands every year. The most popular area is near the aptly named town of Clam Gulch.

thing experts agree on: The Homer Spit is considerably skinnier now than it was before the monumental 1964 earthquake caused the spit to drop about seven feet, resulting in lateral encroachment by the sea and a narrowing of the already slender extension of land.

Travelers might envision the spit as miles of untouched beach curving far into the pristine waters of Kachemak Bay. Indeed, there are miles of beaches, but most are far from untouched, particularly toward the far end of the spit. The place is a hotbed of human activity, especially during the summer, when the road is jammed with cars, trucks, RVs, cyclists, and pedestrians. Much of the route is lined with restaurants, tour operators, art galleries, candy shops, hotels, gift shops, and other businesses. People can be seen flying kites, kayaking along

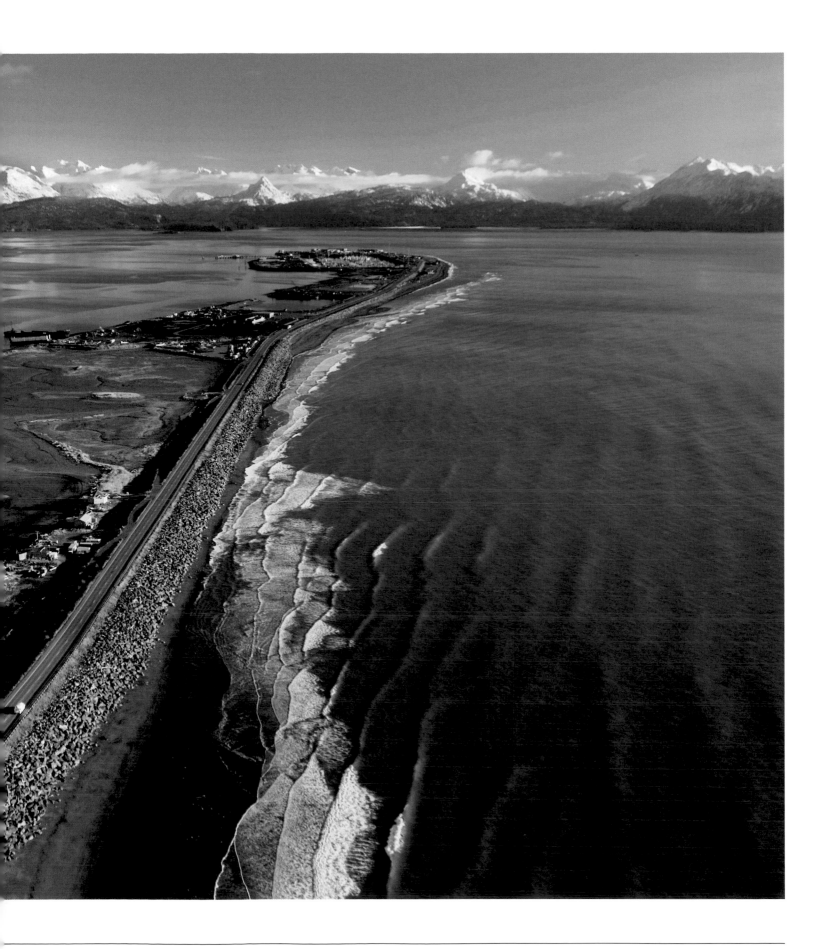

the shore, reeling in dinner at the Fishing Hole, licking ice-cream cones, watching sea otters, or grilling in the campground.

Most of all, people come for the boats, as the harbor on the spit is the jump-off point for a large commercial fishing fleet and a perhaps even larger array of sportfishing charter boats, not to mention the tour boats, water taxis, and the Alaska state ferry. Hundreds of anglers dreaming of beefy halibut and tasty salmon clamber aboard those charter boats and motor out into Kachemak Bay and Cook Inlet. Most come back smiling.

Like Homer in general, the spit attracts intriguing local characters, and many of them—along with plenty of tourists and the fishing crowd—frequent the Salty Dawg Saloon. The Salty Dawg has been up and running since 1957, but the two log cabin–style buildings date back to 1897 and 1909—and were actual log cabins. Through the years, one or the other served as a post office, railroad station, grocery store, coal mining office, and oil company office. Customers are encouraged to tack dollar bills to the ceiling and walls, which thousands of patrons do; every few months they're collected and given to charity.

Any discussion of Homer Spit characters must mention the Eagle Lady. Born in 1923 on a farm in Minnesota, Jean Keene started breaking and training horses at an early age. Her prowess with horses landed her a gig as a rodeo trick rider in 1952, but it also landed her in the hospital with terrible injuries a few years later after a stunt called the "death drag" went wrong. The accident ended her rodeo career, and for the next couple of decades, she knocked around as a cattle truck driver, the operator of a dog and cat grooming business, and the owner and manager of a truck stop. Ready for a change, in 1977, she got an old RV, drove to Alaska, and kept on driving until she came to the end of the road at the end of the Homer Spit—the area known as Land's End—where she parked in an RV campground. She lived there the rest of her life, though she moved out of the RV and into a drafty trailer.

During her first winter at Land's End, she tossed some scraps of food to a couple of bald eagles that were hanging about, the way these scavengers do, especially in the winter when food is hard to come by. Her feathered fan club had grown to maybe half a dozen birds by the end of the spring, when the eagles scattered to their summer haunts. Things escalated rapidly during the next several winters, and by the late 1980s, some 200 eagles were showing up for several hundred pounds of chow every morning. Feeding the eagles turned into a major operation. In the months leading up to winter, Keene would stockpile fish scraps and the occasional road-killed

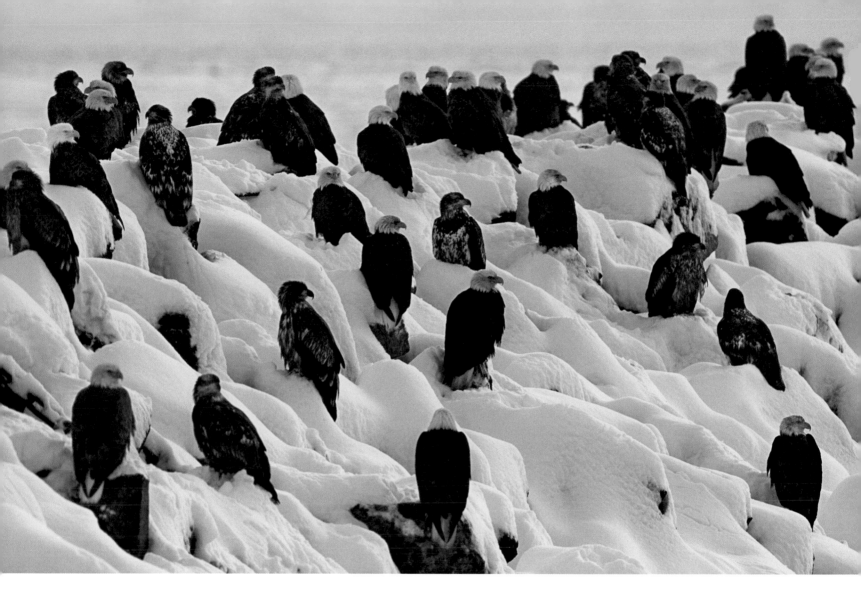

moose in freezers at the neighboring seafood plant, where she worked. Come winter, she would borrow a company forklift and haul the food over to her trailer as needed. Each morning, she would spend two or three hours serving breakfast to her flock.

Many locals and the few tourists who got to Land's End in the winter enjoyed watching the eagle mob. The national media found her irresistible; the Eagle Lady showed up in *Life, People,* the *Washington Post,* and on both *The Rush Limbaugh Show* and *The Daily Show.* But some of Keene's biggest fans were wildlife photographers. Like the eagles, they flocked to Keene's trailer, only their goal was to capture glorious images of America's national symbol riding the wind with Kachemak Bay and snow-capped mountains in the background—and with Keene's trailer and other signs of human development conveniently left out of the frame. Hundreds, maybe thousands, of photographers came over the years; God only knows how many calendars feature photos of "wild" eagles taken next to Keene's trailer.

The photographers were among Keene's many defenders when some locals and environmentalists began complaining about the eagle feeding, which a number of imitators had begun doing elsewhere in Homer. The critics were concerned that it

Bald eagles huddle on a breakwater in Homer. Hundreds of eagles used to gather near the end of Homer Spit every winter to be fed by Jean Keene—aka the Eagle Lady—who lived there from 1977 until her death in 2009.

The Russian influence on the Kenai Peninsula shows in the Transfiguration of Our Lord Russian Orthodox Church, in Ninilchik. *Opposite:* A chestnut-backed chickadee

was disrupting the eagles' natural habits and that some of the eagles were causing traffic problems and occasionally snatching pets. In 2006, the city council passed an ordinance prohibiting the feeding of eagles—unless your name was Jean Keene. With some assistance, she continued fattening her flock almost to the day she died, in 2009, at age 85. Upon her death, the Alaska Legislature issued a memoriam in her honor, but she would probably have been even more proud of the memorial plaque that her Homer friends put above her favorite booth at the Land's End Resort, a literal stone's throw from where the Eagle Lady lived.

Keene has passed on, but Land's End and the nearby harbor still brim with Homeresque characters and provide superb people watching. Early risers watching the commercial fishers prepare to go to sea may notice small groups of men who look a bit different: longer, fuller beards and maybe a woven belt or an old-fashioned embroidered shirt. These are the Old Believers. If any of the Old Believer women are present, their appearance is even more striking; they wear bright red, purple, and pink ankle-length satin dresses, and the married women add equally brilliant scarves to cover their hair.

If the Old Believers are talking when they pass by, especially if they're middle-aged or older, most likely they will be speaking in Slavonic, a fading dialect of Russian. Their ancestors did originally come to Alaska from Russia, but far from directly. Their separation from the old country began in 1666, when the head of the Russian Orthodox Church made some changes in the prayer books and traditions. Some members of the church refused to accept the changes and were persecuted for their refusal. Many went underground, but others fled to Siberia; these became the Old Believers.

For centuries, they existed in isolation in Siberia, content to largely live apart from society so they could abide by the old ways. But when the communists took over Russia in the early 20th century, the Old Believers had to flee once again. Many crossed the border and took up residence in a remote part of China, where they lived for several decades. But when the communists seized power in China in the late 1940s, the Old Believers were driven out yet again. The group that eventually moved to Homer went from China to Brazil, but stayed for only a few years. Lack of economic opportunity and a sense of being out of place in the tropics sent them packing, and most landed in a small town in Oregon. To this day, a fair number live in Oregon; young men from the Kenai Peninsula enclaves often go to Oregon to find eligible Old Believer women to marry. But some Old Believers felt that the forces of modernization were too pervasive in Oregon, so they headed to a wild part of the interior of the Kenai Peninsula about 20 miles north of Homer. Here, they founded the town of Nikolaevsk, which now numbers some 350 people, nearly all of whom are Old Believers, though some are more assimilated into American culture than others. Old Believers subsequently have established three other villages in the area.

As travelers head north up the coast from Homer, they'll encounter mainstream Russian Orthodox influences and towns with names like Ninilchik, Kasilof, and Kalifonsky. Russian fur traders built a fort at what is now the town of Kenai in 1791, making it the second permanent Russian settlement in Alaska. The Russian influence might have been even stronger except the Dena'ina defeated them in the Battle of Kenai in 1797, and the site declined to the status of a minor trading post. Visitors who want to experience a bit of Russian culture can tour the Holy Assumption of the Virgin Mary Church, a traditional Russian Orthodox

Across-the-Bay Wilderness Lodges

1 Alaska's Sadie Cove Wilderness Lodge Grandfathered in to what is now a designated wilderness area, this lodge lives up to the unspoiled nature that surrounds it. It has won numerous major awards as an eco-lodge, including making Forbes's list of the top ten green resorts and *Conde Nast*'s list of the top ten green vacations. Sustainable touches are everywhere: The lodge's energy comes from a small hydroelectric setup on the creek running through the property; the five guest cabins were hand-milled by the owner using driftwood; and old skiffs and dinghies are reused as raised beds in the garden.

2 Kachemak Bay Wilderness Lodge This is the place for travelers who want to get away from it all . . . well, all but the fine wines, chocolates on the bed, fresh flowers in the room, Finnish-style sauna, outdoor hot tub, solarium, finely appointed rooms, gourmet meals, and nearly one-to-one ratio of staff to guests. However, don't mistake this lodge for some fancy spa; it has its rustic elements, it's embraced by beautiful wilds, and it offers all sorts of outdoor activities.

3 Peterson Bay Lodge and Oyster Camp The owners and operators of this lodge welcome guests as if they were cousins coming for a summer stay. Visitors certainly spend time fishing, hiking, and sea kayaking, but most also spend considerable time hanging around the lodge with the owners and other guests. Maybe they bring their day's catch down to the main lodge and cook it on the outdoor grill or perhaps they just lounge on the big deck and chat with the owners about life in Alaska. Some guests even like to help tend to the oysters and blue mussels that are grown in the bay right below the lodge—and nearly every guest is more than willing to help eat them.

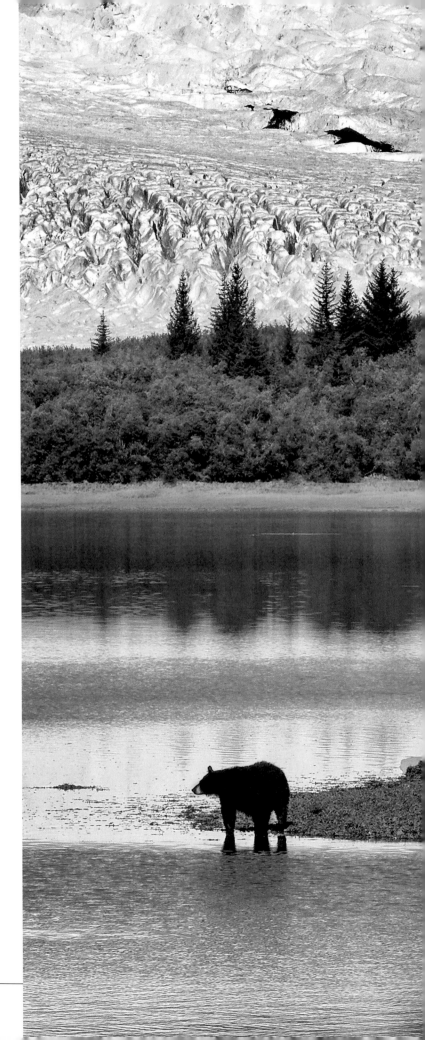

structure crowned by robin's-egg-blue onion domes. It was built in 1894, and is a national historic landmark.

Lurking on the eastern boundary of Kenai is the western boundary of the Kenai National Wildlife Refuge. No visit to the Kenai Peninsula would be complete without seeing the refuge. In fact, a visit wouldn't be anywhere near complete without seeing the refuge because it covers about half of the peninsula, and motorists can hardly drive anywhere on the Kenai without

crossing this two-million-acre natural enclave; the Sterling Highway runs right through the middle of it.

The refuge began in 1941 as the Kenai National Moose Range, and was expanded and designated a wildlife refuge in 1980. The government couldn't have picked a better place to protect moose because they absolutely love it here. And why wouldn't they? After all, moose thrive in small lakes, ponds, bogs, marshes, and other shrubby and forested wetlands, and the refuge is drenched with these moose-friendly bodies of water. It may not be the "Land of 10,000 Lakes," but in an area 27 times smaller than Minnesota, it harbors some 4,000 lakes. Travelers who want to see the heart of the Kenai Peninsula should drive one of several decent gravel roads that branch off the Sterling Highway and wander through the backcountry. Better yet, take a boat into this watery wilderness—there are a couple of canoe trail networks— and get a moose's-eye view. ■

A black bear roams the shoreline of Kenai Fjords National Park, with the crevasses of Pedersen Glacier in the background.

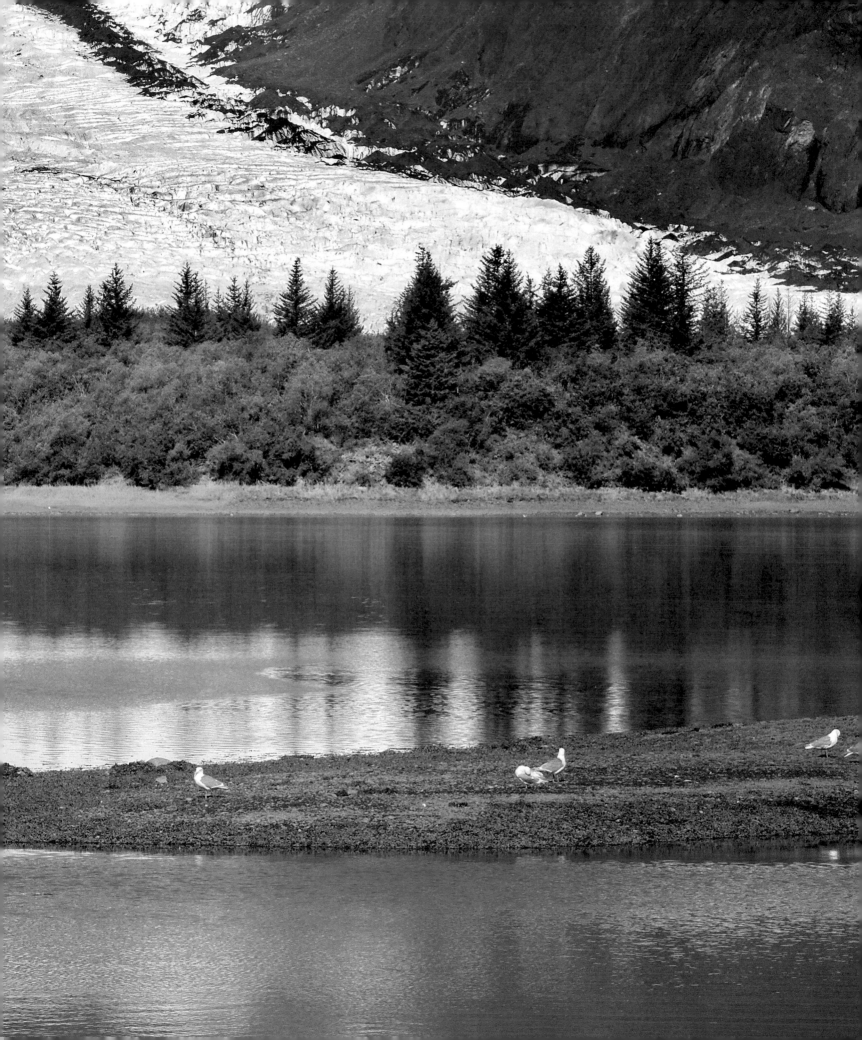

Sites and Sights in Kenai Peninsula

Appropriately set on the Seward waterfront at the head of Resurrection Bay, the **Alaska SeaLife Center** is one of the state's premier museums and research institutions. Visitors can go down to the underwater viewing galleries and watch Steller sea lions and harbor seals glide by. The Discovery Pool enables the curious to touch and feel sea stars, anemones, and other tide-pool denizens. Encounter Tours provide in-depth, guided meet-ups with octopuses, marine mammals, or seabirds. Visitors who want to see some of the center's rehabilitation efforts can watch various procedures on video monitors, such as blood being drawn from an auklet or surgery being performed on a sea lion. *www.alaskasealife.org*

Alaska SeaLife Center

Travelers may want to check out some books about the Kenai Peninsula at the **Seward Community Library & Museum,** but they shouldn't overlook the "& Museum" part of this new building. It includes paintings by leading Alaskan artists, elaborate Russian icons, the original Alaska flag (designed by a local boy in 1927), and a harrowing video of the 1964 earthquake, which hit Seward hard. *www.cityofseward.net/library*

The historic **Van Gilder Hotel** in downtown Seward not only makes a great base of operations, but it's a bit of a destination itself, not least due to the extensive collection of historic photos that line its walls. Take the time to read the often lengthy captions, such as the text beside the photo of the great downtown fire of 1941, which describes the military approach soldiers stationed in town took as they tried to extinguish the blaze. They dynamited the building in which the fire started, blowing burning debris all over town and spreading the fire rapidly. *vangilderhotel.com*

Ice and rock. That's the essence of most of the 608,000 acres of **Kenai Fjords National Park.** And some of the features that are currently free of ice were formed by ice, such as the eponymous fjords. It's a raw, elemental world. A flightseeing trip over the vast **Harding Icefield,** which blankets more than half the park, provides a quick overview. The boat tours out of Seward that explore the east coast of Kenai Fjords treat passengers to the massive churning of tidewater glaciers as well as the whales, sea otters, porpoises, sea lions, harbor seals, seabirds, and other marine life that inhabit this edge of the Gulf of Alaska. In the far north of the park, people can drive up to within half a mile of **Exit Glacier,** which can be reached via an easy trail. The much more strenuous, four-mile-one-way Harding Icefield Trail winds up to the edge of the icy heart of the park. *nps.gov/kefj*

Kachemak Bay State Park is one of the few parks in the nation in which visitors might see wolves and whales, tide pools and mountains, puffins and gyrfalcons. The 400,000 wilderness acres combine exquisite stretches of coastline and forested interior for a lively diversity of terrain, wildlife, and experience. Though it's a wilderness park, it does offer more than 80 miles of trails for people who want to penetrate its depths. *www.dnr.alaska .gov/parks/units/kbay/kbayl.htm*

Most visitors to the remote village of **Halibut Cove** on Kachemak Bay come for the art, the food, or both. Only reachable by boat or floatplane, this roadless hamlet of maybe 50 souls has long been a haven for 15 or 20 artists, some of national stature. Their works are displayed in two galleries. Food so savory that it's a work of art in its own right can be found at the Saltry, one of Alaska's best restaurants. *homeralaska.org*

As motorists enter Homer on the Sterling Highway, they encounter the **Alaska Islands & Ocean Visitor Center.** However, "visitor center" is not the proper description for this elaborate, high-tech facility, which is more like a natural history and cultural museum. The center's mission is to study the Alaska Maritime National Wildlife Refuge and teach the public about this constellation of 2,500 far-flung islands, home to multitudes of marine mammals and some 40 million seabirds—more than in the rest of North America put together. A number of interactive exhibits delve into the relationship between humans and the refuge. A full-size talking model of an Unangan trapper discusses the havoc introduced foxes wreaked on seabirds, and a talking figure of Olaus Murie, the famed naturalist, shares tales of his early explorations of the islands. Visitors who only have time to see one exhibit should go to the Seabird Theater, where realistic-looking, guano-stained rocks mimic one of the refuge's bird colony islands. More than 100 sculpted puffins, auklets, and other birds occupy the rocks. At the press of a button, the colony seems to spring to life as huge screens overhead and amid the rocks erupt in a maelstrom of seabirds, realistic enough to make a person duck. *islandsandoceans.org*

Situated at the end of the road and surrounded by natural beauty, Homer has attracted more than its share of artists. As a result, Homer also has more than its share of galleries, led by the **Bunnell Street Arts Center,** a nonprofit institution that features the work of many

Homer's Pratt Museum

locals as well as artists from other parts of Alaska. Customers in the market for paintings of soaring eagles and chainsaw sculptures of rearing grizzlies will have to look elsewhere; the center presents innovative, contemporary art. *bunnellstreetgallery.org*

A cursory description of the **Pratt Museum** might make it seem like a stereotypical small-town museum—some native artifacts here, some pioneer artifacts there, and some nature displays. But the Pratt takes these typical interests to a much higher level and adds some other elements as well. For example, in addition to native artifacts, visitors will find a compelling video of Alaska native hunters in a kayak stalking a seal. And a live feed from a camera mounted on Gull Island complements the natural history exhibits. Museum visitors can pan and zoom the camera to get a better look at this seabird colony in Kachemak Bay. *prattmuseum.org*

An easy way to have a look at the countryside around Homer is to drive a couple of miles out of town to the **Carl E. Wynn Nature Center.** This 140-acre spread includes spruce forest, wildflower meadows, and a migration corridor for black bears and moose. Visitors can hike the network of trails on their own or join a guided outing. *akcoastalstudies.org*

Though it's at the margin of Homer geographically, the **Homer Spit** is at the heart of the community in many ways. Sticking out

almost five miles into Kachemak Bay, the spit is a long, narrow finger of sand and rock split down the middle by the Sterling Highway. The first couple of miles are relatively undeveloped, but the last half pulses with activity, at least during the summer. People can stop at the Homer Ice Arena to go ice skating, speed skating, or to play or watch ice hockey. If they want to do some lazy angling, they can drop a hook at the fishing hole. If they want to do some vigorous angling, they can charter a sportfishing boat at the harbor and go after halibut and other saltwater quarry. Anglers done for the day can stroll over to the historic Salty Dawg Saloon and tell tales of the one that got away as they knock back a beer or two. Visitors who prefer to eat their seafood on the half shell can stop by the Kachemak Shellfish Growers Co-op and pick up some of the finest oysters on Earth. People looking to shop and eat can amble along several boardwalks lined with galleries, cafes, gift shops, candy stores, and many other businesses. And travelers who don't want to leave the spit come nightfall can get a room at the venerable Land's End Resort or at a number of other, smaller hostelries. *homeralaska.org*

Salty Dawg Saloon, Homer Spit

Visitors can glimpse Alaska's Russian past in Kenai, the peninsula's largest city (with a population of a whopping 7,000 or so). The **Kenai Visitors & Cultural Center** exhibits some items from the Russian era, as well as items harking back to early Alaska native times and pioneer days. The three blue onion domes atop its roof tell travelers that they have reached the **Holy Assumption of the Virgin Mary Russian Orthodox Church.** The first church on this site was built by a Russian monk in 1845, the present church in 1894. A block away is **St. Nicholas Chapel,** a traditional Russian Orthodox chapel made of logs. *visitkenai.com*

Near the mouth of the Kenai River, just south of downtown Kenai, sprawl the **Kenai River Flats,** some 3,000 acres of riparian area and wetlands. Thousands of snow geese congregate here in the spring to fatten up during their migration to Siberia. In May and early June, caribou come to calve, and visitors may spot baby caribou testing out their wobbly legs. In spring and summer when the candlefish and salmon are running, harbor seals and sometimes beluga whales swim upriver to feed just offshore from the flats. *visitkenai.com*

More than half of the peninsula, some two million acres, lies within the bounds of the **Kenai National Wildlife Refuge.** It encompasses some mountains and forest, but the bulk of the refuge is a soggy realm of lakes, rivers, ponds, bogs, and wetlands. Like any self-respecting wildlife refuge, this sanctuary brims with animals, including moose, wolves, grizzlies, black bears, Dall sheep, sandhill cranes, lynx, wolverines, trumpeter swans, and beavers. Visitors who want to sample the watery sections can take advantage of the Kenai National Wildlife Refuge Canoe Trail System. People who would like to see the drier parts might enjoy the Skilak Lake Loop Road, a 19-mile arc that curves through the Skilak Wildlife Recreation Area. *kenai.fws.gov*

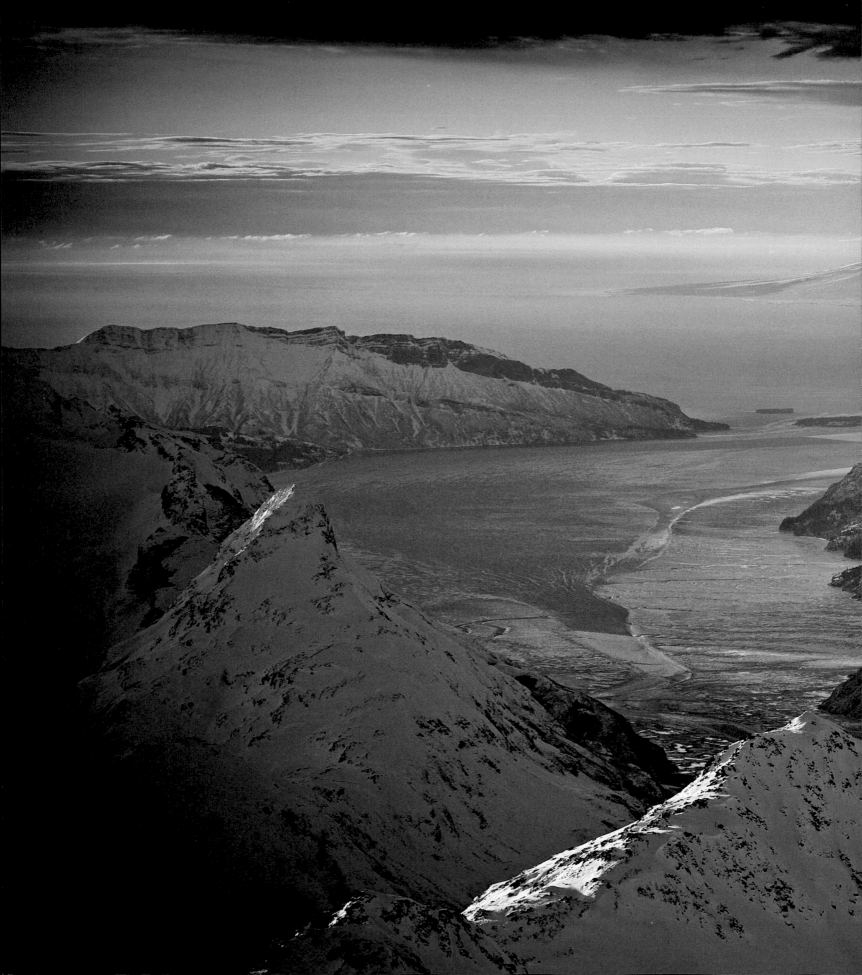

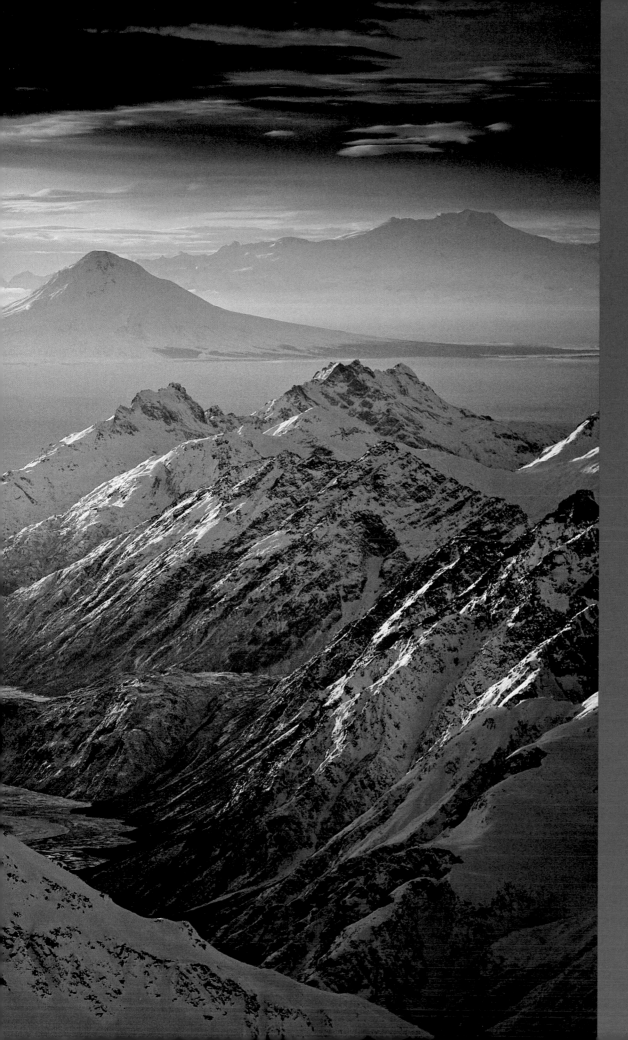

6] Alaska Peninsula & Aleutian Islands

The Chigmit Mountains run for hundreds of miles along the southeastern coast of the Alaska Peninsula. In the background, the cone of the all-too-active Augustine Volcano rises from Cook Inlet.

Alaska Peninsula & Aleutian Islands

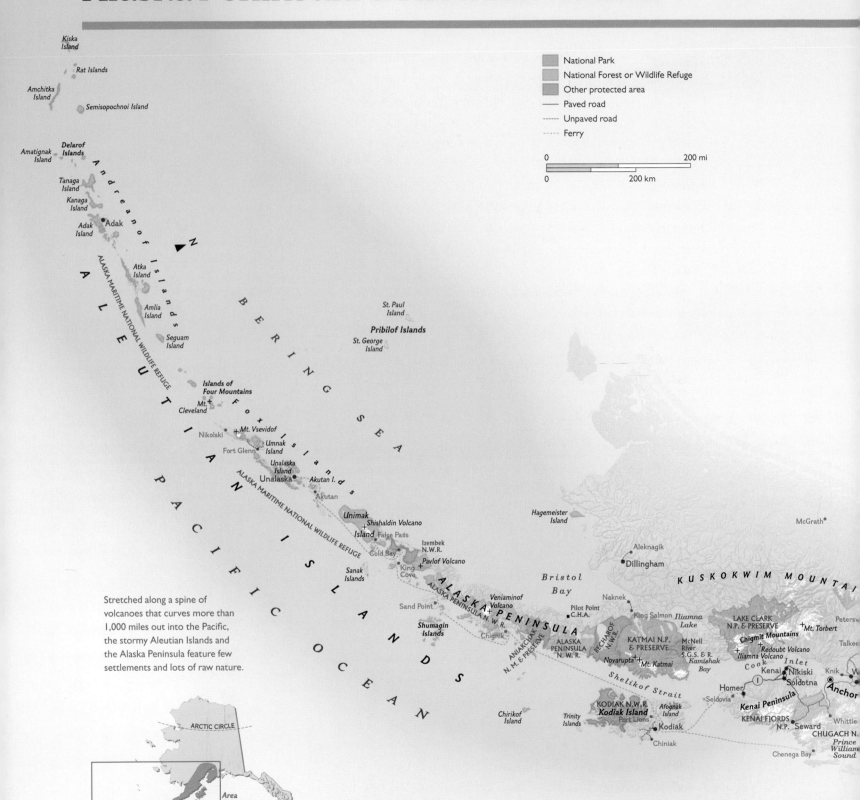

National Park
National Forest or Wildlife Refuge
Other protected area
Paved road
Unpaved road
Ferry

0		200 mi

0		200 km

Attu Island

Kiska Island

Rat Islands

Amchitka Island

Semisopochnoi Island

Delarof Islands

Amatignak Island

Tanaga Island

Kanaga Island

Adak Island

Adak

Atka Island

Amlia Island

Seguam Island

Andreanof Islands

ALASKA MARITIME NATIONAL WILDLIFE REFUGE

A L E U T I A N

Islands of Four Mountains

Mt. Cleveland

Nikolski

Mt. Vsevidof

Umnak Island

Fort Glenn

Unalaska Island

Unalaska

Akutan I.

Akutan

Fox Islands

ALASKA MARITIME NATIONAL WILDLIFE REFUGE

I S L A N D S

P A C I F I C O C E A N

B E R I N G S E A

St. Paul Island

Pribilof Islands

St. George Island

Hagemeister Island

McGrath

Unimak Island

Shishaldin Volcano

False Pass

Cold Bay

Izembek N.W.R.

King Cove

Pavlof Volcano

Sanak Islands

Sand Point

Shumagin Islands

Chignik

ALASKA PENINSULA

ANIAKCHAK N. M. & PRESERVE

ALASKA PENINSULA N.W.R.

Veniaminof Volcano

Bristol Bay

Naknek

Pilot Point
C.H.A.

King Salmon

Aleknagik

Dillingham

KUSKOKWIM MOUNTAINS

BECHAROF N.W.R.

Iliamna Lake

McNeil River S.G.S. & R.

Kamishak Bay

LAKE CLARK N.P. & PRESERVE

Chigmit Mountains

Mt. Torbert

Petersv

KATMAI N.P. & PRESERVE

Novarupta

Mt. Katmai

Redoubt Volcano

Iliamna Volcano

C o o k I n l e t

Kenai

Nikiski

Soldotna

Knik

W

Anchor

Talkee

Shelikof Strait

Chirikof Island

Trinity Islands

KODIAK N.W.R.

Kodiak Island

Afognak Island

Port Lions

Kodiak

Chiniak

Homer

Seldovia

Kenai Peninsula

KENAI FJORDS N.P.

Seward

CHUGACH N.

Prince William Sound

Chenega Bay

Whittie

Stretched along a spine of volcanoes that curves more than 1,000 miles out into the Pacific, the stormy Aleutian Islands and the Alaska Peninsula feature few settlements and lots of raw nature.

ARCTIC CIRCLE

Area Enlarged

We are waiting for death at any moment. We are covered with ashes, in some places ten feet and six feet deep. Night and day we light lamps. We cannot see the daylight . . . and we have no water. All the rivers are . . . just ashes mixed with water. Here are darkness and hell, thunder and noise. It is terrible. We are praying."

A fisherman named Ivan Orloff wrote these dire words in 1912. He was writing what he probably thought was his last message to his wife as he and his companions huddled in terror for more than two days in a camp on Kaflia Bay, on the eastern shore of the Alaska Peninsula. The downpour of ash finally relented, and Orloff and his friends survived. They were lucky to be 35 miles from Novarupta, the volcano that had erupted in what is now Katmai National Park and Preserve. Closer places got buried under as much as 700 feet of ash, pumice, and rock in what was the biggest volcanic eruption of the 20th century.

Novarupta spewed an estimated seven cubic miles of debris high into the air. People as far away as Juneau—about 650 miles—said they felt tremors from the blast. By some estimates, Novarupta was 30 times more powerful than the 1980 eruption of Mount St. Helens. In Kodiak, more than 100 miles away, the ash was so thick that ships couldn't dock in the harbor, roofs collapsed from the weight, and birds fell from the sky. In Vancouver, B.C., toxic rain ate holes in clothes hung outside to dry. Ash eventually drifted around the world, fouling waterways, stunting crops, ruining fisheries, and blocking so much sunlight that the global temperature dropped several degrees.

Alfred Naumoff, Jr., a Sugpiaq artist born and raised in a remote village on Kodiak Island, created this contemporary version of a traditional Sugpiaq mask. Naumoff is also an expert at carving traditional wooden kayaks.

Volcanic eruptions on the scale of Novarupta don't happen often—not in Alaska, not anywhere. But lesser eruptions? Well, they happen frequently on the Alaska Peninsula and in the Aleutian Islands. According to the Alaska Volcano Observatory (the fact that such an institution exists in Alaska speaks volumes), between 22 and 26 eruptions occurred in this region between 2000 and 2013. The observatory doesn't count every little burp, either. The 2009 eruption of Redoubt, a 10,197-foot stratovolcano across Cook Inlet from the Kenai Peninsula, was fairly typical. Between March and July that year, Redoubt exploded numerous times, sometimes sending lahars (debris flows of mud, water, rocks, and pyroclastic material) 25 miles down the Drift River Valley.

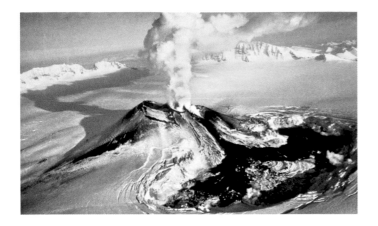

Volcanic Blowhards

1 Cleveland Between 1990 and 2013, this Chuginadak Island landmark was the most active volcano in the region, erupting nine times, most recently in 2013. There are hot springs at its base, should anyone care to take a dip next to a volcano that has erupted nine times in 23 years.

2 Veniaminof This slacker has only erupted eight times between 1990 and 2013, most recently in 2013. Rising in the midst of the Alaska Peninsula National Wildlife Refuge, this stratovolcano is a bruiser, some 20 miles wide at its base.

3 Shishaldin This classic cone has erupted four times between 1990 and 2013, most recently in 2008. At 9,372 feet, its summit is the highest point in the Aleutian Islands. It juts up from the middle of Unimak, the easternmost of the islands.

4 Pavlof Pavlof has erupted four times between 1990 and 2013, most recently in 2013. It towers 8,261 feet above the Alaska Peninsula National Wildlife Refuge and has a nearby sibling, Pavlof Sister, which is 7,028 feet high.

5 Akutan Akutan has erupted three times between 1990 and 2013, most recently in 1992. It is located on Akutan Island. In fact, it pretty much is Akutan Island. The entire island is covered by a layer of ash.

Nineteen major explosions shot clouds of ash between 17,000 and 62,000 feet into the sky; one time, the ash got so thick in Anchorage that it shut down the airport for 20 hours. This all counts as one eruption.

The Alaska Volcano Observatory lists 53 active volcanoes (a number that could change at any moment) and plenty more inactive volcanoes in the Aleutians and on the Alaska Peninsula. A large majority of the nation's volcanoes lie in this region. But volcanoes are not merely features of the islands and the peninsula; to a large degree, they are the islands and the peninsula. The Aleutian Islands and the Aleutian Range, which form the spine of the Alaska Peninsula, constitute the northern portion of the Ring of Fire, a chain of volcanoes that frames most of the Pacific Ocean. The subduction of the North Pacific plate beneath the North American plate along the 25,000-foot-deep Aleutian Trench accounts for the high level of tectonic activity. The Aleutians are almost but not entirely volcanic in origin; many of them are the tips of underwater volcanoes.

Travelers who would like to see some of the region's volcanic features should take a trip to the Valley of Ten Thousand Smokes, in Katmai National Park and Preserve. This is the site of the devastating 1912 Novarupta eruption described at the beginning of this chapter, but not to worry, this volcano has not erupted since and gives no indication that it intends to do so anytime soon.

The Valley of Ten Thousand Smokes is one of the areas that Novarupta buried beneath hundreds of feet of volcanic debris. Geologist Robert Griggs journeyed to the valley four years after the eruption and later wrote this description of the scene he observed: "The sight that flashed into view as we surmounted the hillock was one of the most amazing visions ever beheld by mortal eye. The whole valley as far as the eye could reach was full of hundreds, no thousands—literally tens of thousands—of smokes curling up from its fissured floor." For decades after the 1912 upheaval, the valley floor remained so hot that it melted the shoes of anyone who walked on it. Now, more than a century later, things have cooled down and visitors can hike around without risking their shoes, but the valley is still largely barren, an almost literal moonscape of rock and ash that Apollo astronauts have used to train for lunar missions.

Lest visitors begin to think this entire region is nothing but volcanoes and blast zones, they should leave the Valley of Ten Thousand Smokes and ramble through some

of the other four million acres of Katmai National Park and Preserve. Near the middle of the park lie several large lakes surrounded by snowbound mountains. Boreal forest greens the riparian areas along the lakes, rivers, creeks, and the coastline on Shelikof Strait, which marks Katmai's eastern boundary. Tundra covers the lower slopes of the mountains, a green carpet that sprouts bright wildflowers in the spring and summer.

Wildlife flourishes in this unspoiled land. Caribou, moose, wolves, lynx, snowshoe hares, wolverines, beavers—charismatic mammals abound. The coast offers a whole different suite of mammals to watch, including killer whales, sea lions, belugas, gray whales, and sea otters. Prolific runs of salmon, particularly sockeye, pack Katmai's rivers and creeks. Preserving habitat for the sockeye was one of the two main reasons Katmai was expanded and upgraded from national monument to national park and preserve.

The other main reason for the upgrade was to protect the park's large population of brown bears. More than 2,000 of these top predators roam Katmai. In fact, though Katmai was established in 1918 as a national monument in recognition of its volcanic

Coastal paintbrush and wild geranium brighten the tundra on some Aleutian Islands, which are largely treeless. *Opposite:* Recent lava flows darken Mount Veniaminof, a massive and exceptionally active volcano.

In 1912, the Novarupta Volcano exploded with power unmatched by any other eruption on Earth in the 20th century, leaving behind the Valley of Ten Thousand Smokes. In this 1917 photo, three explorers cook their dinner over a steaming fumarole.

features—the Novarupta eruption made a big impression—bear watching has arguably surpassed the volcanoes as the park's claim to fame.

Close to park headquarters, at Brooks Camp, the three developed sites along the Brooks River are among the best places in Alaska to see brownies in action. Managed closely by park personnel, these sites have platforms from which small groups of visitors can safely observe bears, sometimes from as close as 20 feet. Brooks Falls is the most renowned of the three sites. Every day while the sockeye are running—usually late June through July—several dozen brown bears spend part of their day fishing near the falls.

This is not Niagara. Stretching across the 50 yards or so of the river, the falls is on average only about the height of a "brownie" standing upright. Some of the bears will wade out to the top edge of the falls and take a position facing downriver, knowing that the migrating salmon will have to leap up the falls en route to their spawning beds. Wait. Wait. Wait. Suddenly, a five-pound sockeye explodes from the water below and arcs over the wall of bedrock, but this fish isn't destined to continue its journey. With unnerving speed, the bear pivots and uses its mouth to snatch the fish out of the air.

Bears don't always employ the same techniques. For example, sometimes a bear will use a single paw to guide an airborne fish dinner into its mouth. Others will go

to shallows a little above or below the falls and use their dinner plate–size paws to pin salmon to the river bottom. Many bears try different methods over the years, improving their success rate as they gain experience. Most of the brown bears that congregate at the falls are repeat customers who come summer after summer, and that can add up to a lot of years in which to hone their skills, given that brown bears typically live 20 to 25 years.

When a brownie snags a salmon, the bear usually carries the fish to a flat rock or the river's edge to eat. There they can hold the sockeye on the ground with their paws while biting into it. When the salmon run is going strong, bears often won't eat the whole fish. Instead, as their goal is to store up enough fat to see them through winter hibernation, they high-grade—take the best and leave the rest, as the old forester's saying goes. They'll eat the skin, brain, roe, and other fatty parts of the salmon and then head back into the river to grab another sockeye to high-grade.

Watching brownies at the river high-grading sockeye makes one wonder if the bears out on the park's coast need a few survival tips. Over there, 60 or 70 miles east of Brooks Falls in places like Hallo Bay and Swikshak Lagoon, visitors watching the bears cannot help but notice that they're mostly eating sedges—essentially grazing like a bunch of cows. How are they going to bulk up to 600 or 800 pounds and survive the winter if they're eating nothing but salad?

The answer can be found on the calendar. Brown bears troop over to coastal flats in the spring to gorge on sedges and sometimes clams because the salmon aren't running yet. In this region, the bears typically emerge from their winter dens sometime in May, and they come out *hungry*. They cannot wait four or six weeks to eat, so they take what's available. In late May and most of June, that means sedges and sometimes clams.

Bear watching is different on the coastal flats, more unnerving than at the Brooks River. No platforms, no ever-present rangers, no trees to climb—not that brown bears cannot climb trees, but it's not their forte. Also, places like Hallo Bay are very lightly developed and very few people visit there. Those who do visit will meet the bears on their own terms; whether or not that's desirable depends on the visitor.

Private tour operators fly groups of maybe four or six out to the wild shore, where they land on a narrow beach. They may be on a day trip or they may overnight in a camp established by the tour company. A guide will take the group on a hike to a sedge meadow where brown bears are likely to be feeding. Either before heading out

DID YOU KNOW?

Bear Fences

In recent years, portable electric fences have become increasingly popular among campers in Alaska as protection against bears. They weigh three or four pounds and enclose an area of about 25 by 25 feet. How well do they work? Apparently pretty well, but not well enough to preclude the need to use standard bear-country procedures, such as keeping a clean camp and storing food in bearproof containers away from the camp.

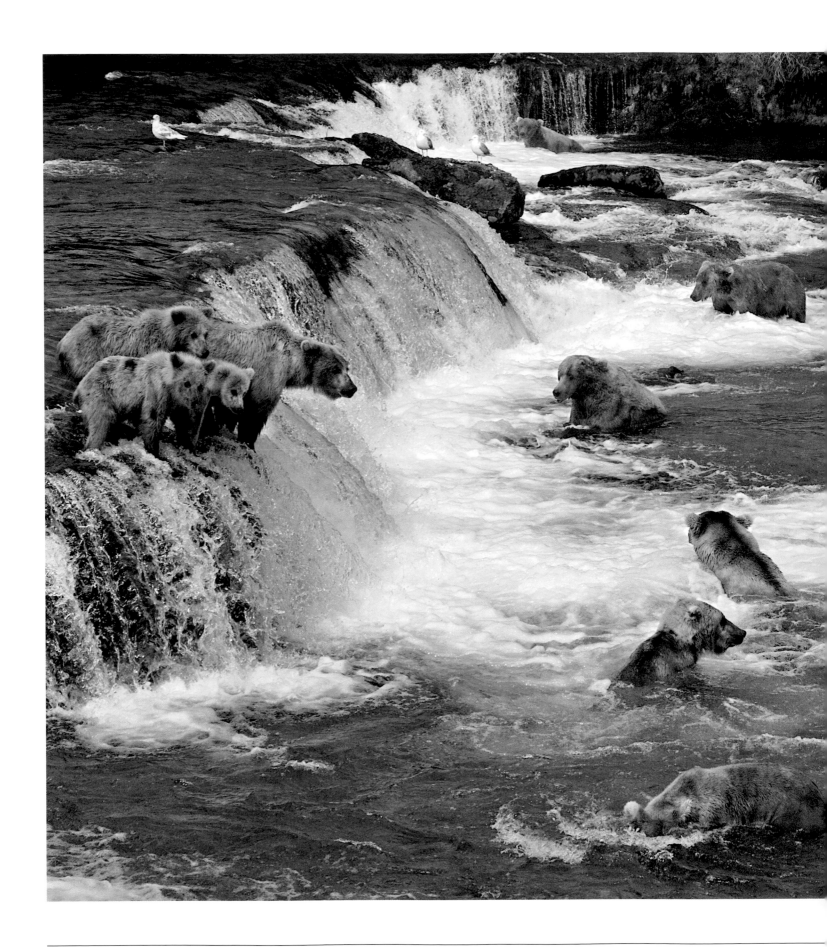

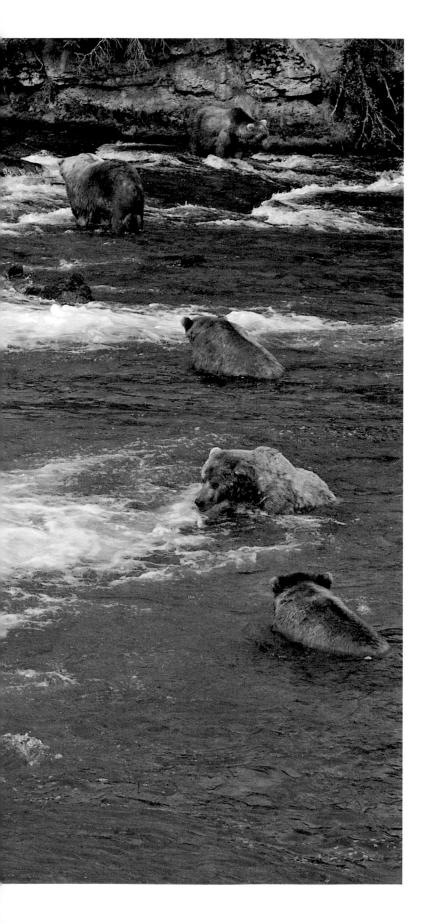

or during the walk, the guide will provide a detailed briefing on how to behave around bears. (At least, the guide should do this, if he's appropriately knowledgeable and careful.) This is when it starts to get unnerving.

Some of these operators rely largely on their grasp of bear behavior for safety. It also helps that these are utterly pristine places where bears haven't been hunted and don't see people as enemies and where bears have never gotten into garbage cans or coolers and therefore haven't developed a taste for human food.

> 66 [F]or many of us the world would be a poorer place without bears. We keep bears because they are a part of nature and because of what they do for the human mind, body, and soul. 99
>
> **[Stephen Herrero, wildlife biologist, author of *Bear Attacks*]**

Finally, guides carry some kind of defensive tool to use as a last resort, such as a flare or bear spray. (One operator whose outfit conducts tours at Hallo Bay reports that his guides have only needed to use flares four times in 12 years, and they've never experienced a mauling.) But more than anything else, they keep customers safe by knowing how bears behave and knowing how people need to behave around bears.

For example, a knowledgeable guide will tell her charges never to walk straight at a bear, because it may take that as a sign of aggression. If a bear seems to be even a little agitated by the group's presence, all the people need to avert their eyes, show their profiles or turn their backs, maybe drop to one knee, and otherwise convey submission. And if the bear still doesn't settle down, even if it's hundreds of yards away, the group needs to change course.

Observing such ursine etiquette, the guide will lead visitors over the mudflats, which are usually pocked with humungous

Brooks Falls, in Katmai National Park and Preserve, is one of the best sites in the world for getting a close—and safe—look at brown bears in the wild. Close can be a mere 20 feet.

brownie paw prints that make it all too easy to calculate the sobering length of the claws. Once the guide spots a few bears in the distance—say, a quarter to a half mile away—she will watch awhile, figure out where one or a couple of them are most likely headed, and then set the group down in a spot along the bears' projected route. The guides are good at this, and often the bears will eventually pass close by, maybe 100 yards away, maybe 50 yards, maybe 10 yards. Definitely unnerving. But also exhilarating.

The rest of the Alaska Peninsula also shelters large numbers of brown bears. And caribou. And moose. And wolves, whales, geese, sea lions, falcons, river otter, beaver, and a plethora of other wildlife. The 400 miles running southwest from Katmai National Park and Preserve to the tip of the peninsula are almost solid nature sanctuary sprinkled with maybe a half dozen tiny towns and villages around the edges. Run a finger down a map and it will pass over Becharof National Wildlife Refuge, Alaska Peninsula National Wildlife Refuge, Pilot Point State Critical Habitat Area, Izembek National Wildlife Refuge, Aniakchak National Monument and Preserve, and so forth.

These places offer none of the comforts of developed parks, such as campgrounds, guided hikes, rangers, and lodges. Generally, visitors hire a boat or bush plane, get dropped off in the middle of nowhere, and fend for themselves until their scheduled pickup—or maybe for another few days if the weather is bad. And the weather is often bad. So it comes as no surprise to learn that very, very few people visit these back-of-beyond wildlands. Take Aniakchak National Monument and Preserve. Of the more than 400 properties managed by the National Park Service, it is the least visited, and by a wide margin. Only 10 visitors were recorded in 2008. In 2010, that figure soared to 62, but in 2012, it fell back to 19. The most visited national park, Great Smokies, felt the footsteps of nearly 10 million people in 2012.

Oh, but the things the lucky few see. At the heart of Aniakchak, for instance, lies a six-mile-wide, 2,500-foot-deep caldera, the dramatic reminder of a monumental volcanic eruption 3,500 years ago. Hot springs in the area bubble with orange water, and some of the fish caught in the vicinity taste of volcanic minerals. Izembek's 150-square-mile lagoon features North America's largest eelgrass bed, which draws hundreds of thousands of migrating waterfowl. Becharof centers around a 35-by-15-mile

Bear Country Don'ts

1 Don't run from a bear. They are faster than Olympic sprinters, and you are not.

2 Don't grill salmon in your tent unless you want uninvited dinner guests who may make you the entrée.

3 Don't approach a bear to have your photo taken next to it. (Yes, people have actually tried this and it generally hasn't turned out well.)

4 Don't carry your bear spray in your pack. That's about as useful as installing your car horn in your trunk.

5 Especially don't run from a bear if you're with your wife. A few years ago a husband and wife and their guide were walking down a beach in Katmai National Park and Preserve when a big brown bear surprised them. His eyes on the bear, the guide reminded the couple to stay calm and stay put, but when he turned to see how the husband was doing—he'd been trailing slightly—the guide saw that he was sprinting away down the beach. Fortunately, the bear didn't give chase and soon wandered off. The guide and the wife went to find the husband and finally discovered him crouching in some willows a full mile down the beach. The guy may have escaped the bear, but he didn't escape without any consequences; that night the whole camp could hear his wife reading him the riot act.

lake—second largest in Alaska—that serves as a nursery to millions of sockeye salmon. About five miles south of Becharof Lake towers 4,800-foot Mount Peulik, an active volcano that occasionally gushes lava into the lake. Nearby stand the otherworldly Ukinrek Maars—rounded craters created in 1977 during a series of eruptions.

All the volcanic activity on the Alaska Peninsula may strike travelers as dangerous—and it can be—yet, amazingly, only one person in Alaska is known to have died in an eruption. That unfortunate was Fred Purchase, a soldier who was stationed far out in the Aleutians on Chuginadak Island during World War II as part of an Army Air Force weather unit. In June 1944, he was hunting on Mount Cleveland, an impossibly perfect cone-shaped stratovolcano, when it underwent a violent eruption. It blew steam and ash 20,000 feet high, poured lava across miles of the landscape, and hurled boulders the size of cars across the island. Purchase was never found.

Though there is no record of anyone else having died due to an eruption in Alaska, a number of people have thought they were going to. The ash that Alaska volcanoes so often exhale creates serious dangers for airplanes, not only in terms of visibility but because it can get sucked into jet engines and choke them until they fail. And there are lots of airliners in the skies above Alaska because they fly polar routes, often stopping

Moose range through the forests and wetlands of much of the Alaska Peninsula. Though they're herbivores and despite cartoons featuring friendly Bullwinkle the Moose, these hulking animals—some reach 1,500 pounds—are dangerous and should be treated with the same respect given to bears.

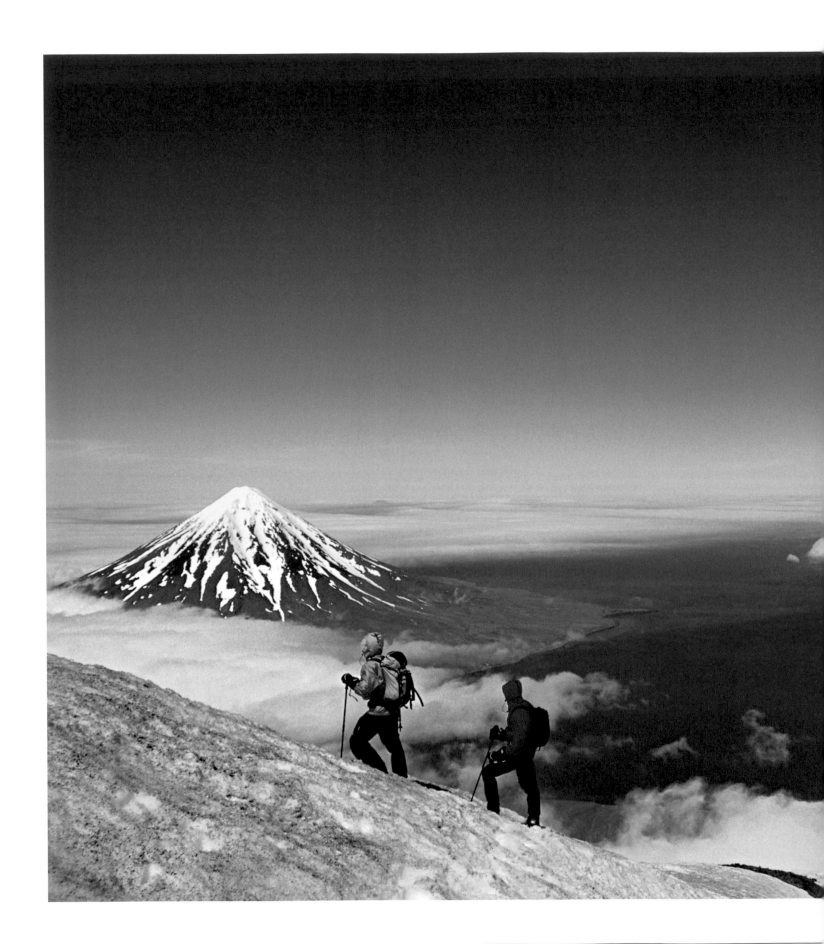

Climbers ascending the volcano on Carlisle Island get a clear view of Mount Cleveland, one of the most active volcanoes in the Aleutian Islands.

in Anchorage to refuel. The authorities issue warnings when ash presents a danger, and when conditions warrant caution, flights are grounded. Once in a rare while, however, someone makes a mistake and a plane blunders into a cloud of ash.

A classic example of the chaos that can ensue took place in 1989, when a KLM airliner taking 231 passengers from Amsterdam to Tokyo was approaching Anchorage. As it was crossing the Talkeetna Mountains, about 70 miles north of the airport, day suddenly turned to night as the Boeing 747 flew into an ash cloud from an eruption of Mount Redoubt. (Yes, *that* Mount Redoubt, the same one that erupted and shut down the Anchorage airport in 2009.) The pilots tried to

> 66 The name Alaska is probably an abbreviation of Unalaska, derived from the original Aleut word *agunalaksh,* which means 'the shores where the sea breaks its back.' The war between water and land is never-ending. 99
>
> [Corey Ford, author]

power up and out of the cloud, but the engines began failing before the plane could make it. Soon, all four engines cut out and the plane plunged toward the ground. As the pilots fought to restart the engines, smoke filled the cockpit, the fire alarm sounded, and much of the control panel went black. Inside the dark cabin, passengers were screaming as the jet continued its precipitous dive toward the rugged mountains below. The pilots kept running through the restart procedure, maybe eight times altogether, but the engines remained dead. Finally, when the plane had dropped some 12,000 vertical feet and was only a few thousand feet above the mountains, two of the engines fired up and the plane was able to pull out of the dive and make it to Anchorage.

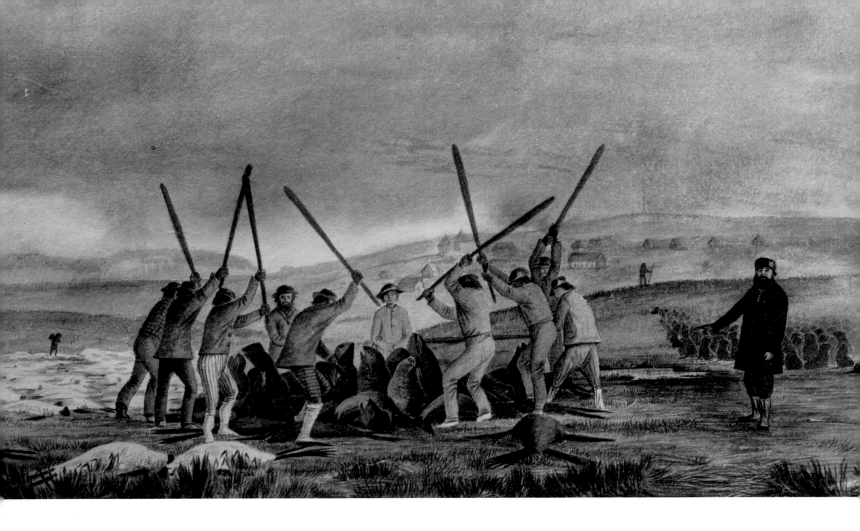

In the late 1700s, Russian traders moved some Unangan from their homes in the Aleutian Islands to previously uninhabited Saint Paul Island, some 250 miles to the north, where they were forced to capture and kill fur seals for the traders. *Opposite:* A sea otter

Near the tail end of the Izembek refuge, mainland Alaska ends and the Aleutian Islands begin, making their westward march of more than a thousand miles, reaching most of the way to Russia. No one can say just how many islands there are because it all depends on how one defines an island. Does a rock that pokes out of the water just high enough for a gull to stand on count? Roughly speaking, there are about a dozen big islands (say, 100 to 800 square miles each), maybe a few dozen more that are best measured in square miles instead of square feet, and hundreds of small ones that may not even have names.

This was the realm of the Unangan, called the Aleuts by the Russians and by many others today. These seafaring people journeyed among the islands in distinctive, cleverly designed kayaks often called "baidarkas," which handled wonderfully but only in the hands of a highly skilled paddler. No large mammals—and very few of any size—lived on the treeless Aleutians, so the Unangan largely subsisted by hunting marine mammals and by fishing, sometimes ranging far out to sea. But there were plenty of seals, whales, sea lions, and other quarry, and the Unangan were marvelous hunters, so they fared well. Researchers estimate that between 12,000 and 25,000 people inhabited the Aleutians before the arrival of the Russians. No one knows just how long the Unangan have lived in the Aleutians, but it has been a very long time; for example, Nikolski, a village on Umnak Island in the central Aleutians, has been continuously occupied for some 4,000 years.

In a terrible twist of fate, the Unangans' prowess at hunting the Aleutians' marine mammals contributed to the subjugation of these Alaska natives by some of the Russian fur traders who sailed into the islands in the mid-18th century. In particular, these traders wanted sea otter pelts, which were fetching high prices at the time, and the islands were brimming with sea otters. However, the Russian trappers couldn't handle the baidarkas and therefore couldn't catch sea otters as well as the Unangan.

Of course, the Russian traders could have traded for sea otter pelts, as traders have been known to do, but that wouldn't have been as lucrative. Instead, they used their superior armaments to subdue the Unangan—who had welcomed them initially—and then they forced Unangan hunters to venture out to get sea otters while the Russians held the rest of the village hostage. Russians had used this technique to exploit indigenous peoples in Siberia, too, but by the mid-1700s, it was increasingly frowned upon, and in 1762, Catherine the Great officially banned it. Tsarina Catherine even singled out the situation of the Unangan and decreed that they be treated decently. However, the Aleutians were an extremely far-flung outpost of the Russian Empire, the kind of place where decrees go to die. No one enforced the tsarina's orders, and the traders continued to hold Unangan hostage, sometimes starving them, and on occasion even raping and murdering them.

Though outgunned, the desperate Unangan rebelled in 1763. On the island of Unalaska, they destroyed several Russian ships and killed the crews. The Russians retaliated by leveling several Unangan villages and massacring the occupants. Uprisings on other islands were put down just as brutally, and soon the rebellion faded out. The exploitation of the Unangan continued for some decades, but the situation improved over time. Many of the Russian traders and crews settled down with Unangan women, had children, and even adopted native ways. Perhaps most important, more Russians came to the Aleutians, and by and large, they behaved more decently than the first wave of traders had.

The paragon of this new breed was Ivan Veniaminov, a young Russian Orthodox priest who volunteered for the unpopular posting to Unalaska. He learned the local Unangan dialect, created a written alphabet for it, and then taught classes of Unangan children in their own language. This

HISTORY & CULTURE

Vilifying the Unangan

Readers of the famous novel *Island of the Blue Dolphins* may recall that Aleuts (that is, Unangan) under the command of a Russian sea captain played the role of villains. It is historically accurate that Unangan ranged as far south as the Channel Islands in southern California, where the novel is set, as sea otter populations in Alaska were being overhunted. But it hardly seems fair to portray the Unangan as villains, given that they were often forced into service by unscrupulous Russian traders who held their families hostage.

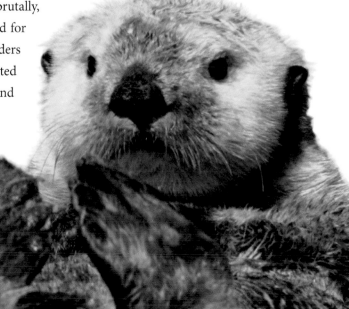

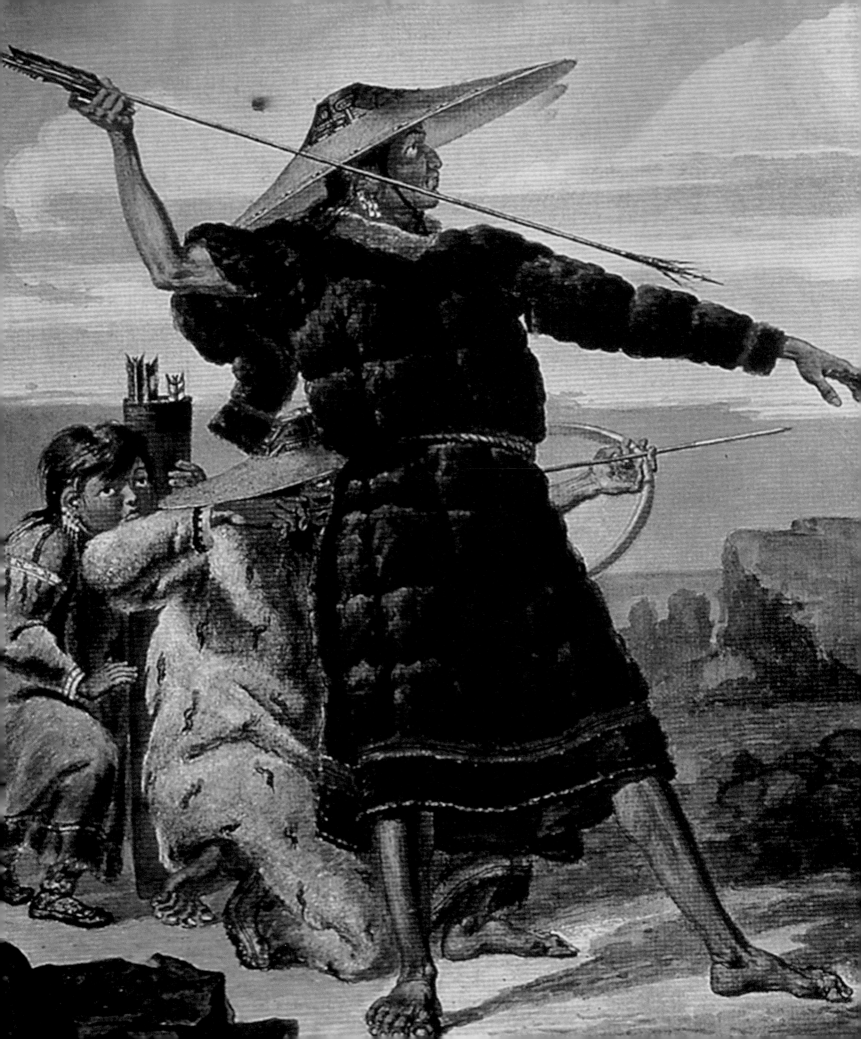

was not standard operating procedure. He also immersed himself in Unangan culture, covering thousands of miles in a kayak every year and spending time in villages throughout the Aleutians. Though he was there primarily to convert the locals to the Russian Orthodox Church, he respected their beliefs and traditions. He wrote, "You must win your converts by kindness, consideration, and the power of the Word, and under no circumstances by force or by bribery or by false promise." Veniaminov came to be known as "the Good Father" among the Unangan.

By the mid-1850s, the Unangan and Russian cultures had become deeply intertwined. The Unangan developed a fondness for bread, tea, pancakes, and other Russian foods. They learned to play and build Russian musical instruments. Renowned for their basket weaving, Unangan women were willing to try new things, and they incorporated silk from the Russians into some of their baskets. In turn, the Russians followed many of the ways of the Unangan in adapting to life in the harsh environment of the Aleutians, such as their hunting and conservation strategies. The Russians also adopted some aspects of Unangan culture, such as their music, arts, and dancing.

This blend of Unangan and Russian is still apparent in the Aleutians today, particularly in the town of Unalaska. Both Unangan and Russian-Alaska history and culture are covered at the 9,250-square-foot Museum of the Aleutians, though the Unangan occupy center stage. The museum houses hundreds of thousands of Unangan artifacts, with more coming in all the time. Twenty-five known Unangan prehistoric sites are within three miles of the museum. The oldest, Unalaska Bar, dates back some 9,000 years, making it one of the oldest archaeological sites in Alaska. The Russian influence is most apparent downtown at the Russian Orthodox Church of the Holy Ascension, a national historic landmark. The current wooden church topped by two blue cupolas was completed in 1895, but the first church on this site dates to 1825. Inside is a superb collection of hundreds of icons, works of art, and artifacts.

Many people refer to Unalaska as "Dutch Harbor," but Dutch Harbor is actually only the name of the harbor. The town straddles two islands: the main island, Unalaska, and a small island named Amaknak. They're connected by a 500-foot span officially called the Bridge to the Other Side. Far and away the most populous town in the island chain, Unalaska is home to a little more than half of the 8,000 residents of the Aleutians, and that's during the off-season.

Opposite: Mikhail T. Tikhanov's 1818 watercolor depicts an Unangan man in his festival finery. His headgear is typical of the elaborately painted wooden ceremonial hats for which the Unangan were famous.

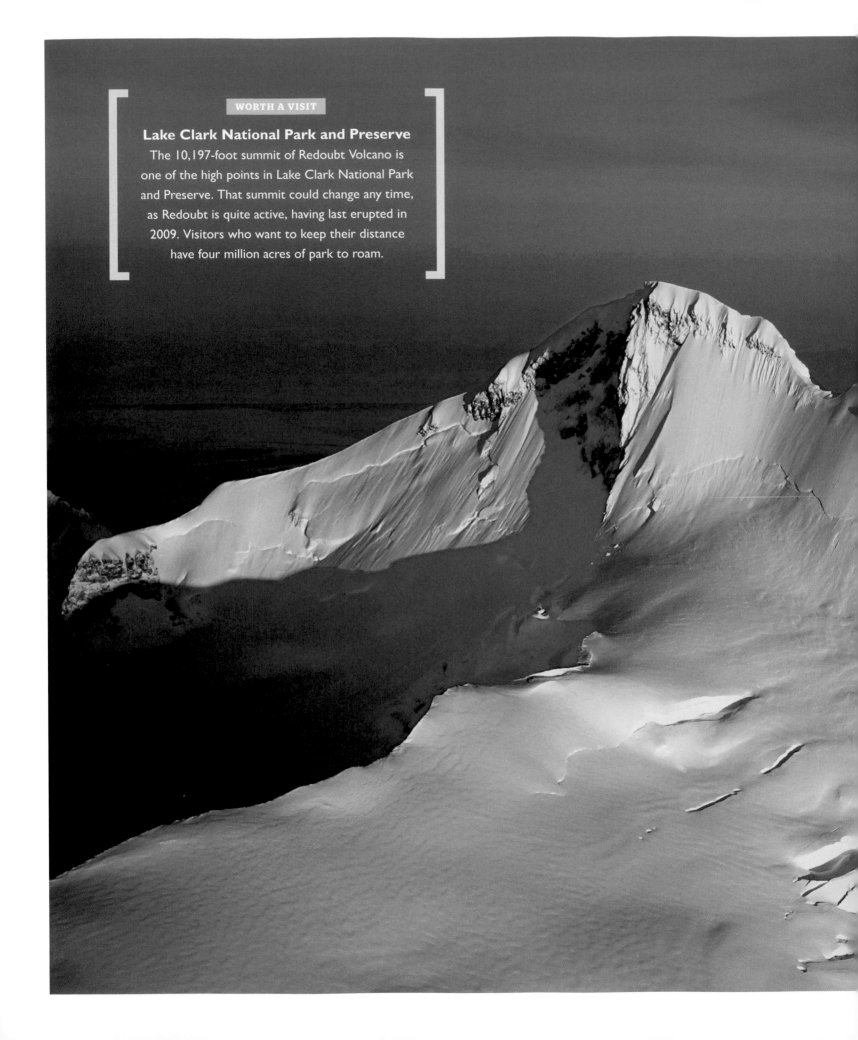

Lake Clark National Park and Preserve
The 10,197-foot summit of Redoubt Volcano is
one of the high points in Lake Clark National Park
and Preserve. That summit could change any time,
as Redoubt is quite active, having last erupted in
2009. Visitors who want to keep their distance
have four million acres of park to roam.

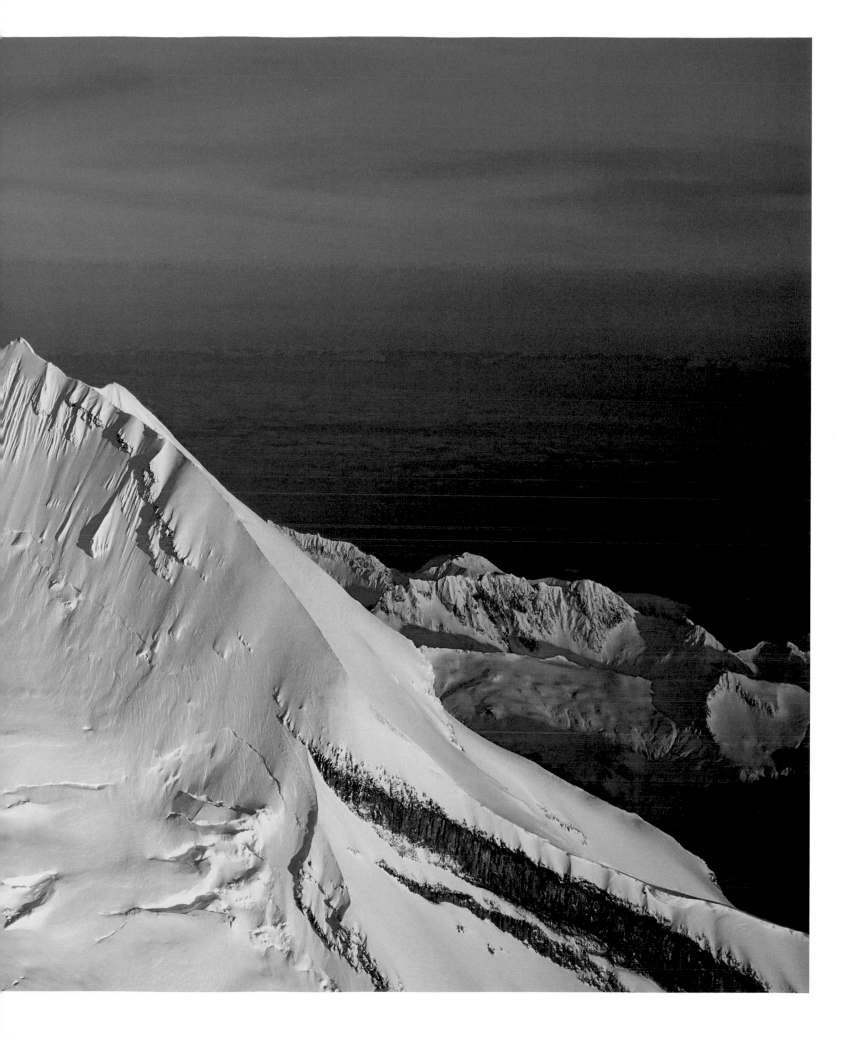

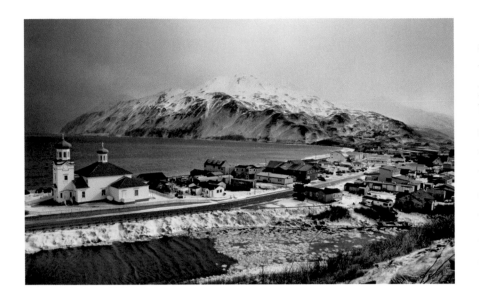

Rising amid the utilitarian buildings in the remote Aleutian island town of Unalaska, the Russian Orthodox Church of the Holy Ascension lends grace to this commercial fishing center. Though Russia occupied the Aleutians long ago, from the mid-1700s to the mid-1800s, their influence is still evident.

During the main commercial fishing season, in the fall and winter, Unalaska swells to twice its normal size. Thousands of temporary workers flock to town to work on the boats and in the canneries, not to mention at the hotels, marine supply stores, bars, and other businesses that get crazy busy. By volume, Dutch Harbor has been the number one fishing port in the United States for more than 20 years, and by value, it comes in at number two (second behind New Bedford, Massachusetts, where they land about one-sixth as many pounds of seafood, but much of the catch is pricy scallops). Fishing boats annually bring in about 700 million pounds of seafood to Dutch Harbor, where it is processed and shipped around the world.

The pollock fishery is huge and well known in fishery circles for being well managed. Dutch Harbor outfits also haul in mackerel, salmon, rock sole, sablefish, yellowfin, and other species. But to the general public, Dutch Harbor fishers are famous for just one thing: crabs. Thirty years ago, this would have been easy to understand because, back then, they were landing about 200 million pounds of crab a year—an enormous catch. But the size of the catch has dwindled to about one-tenth that amount. Now the fame of the crab fishers stems from another source: reality TV.

In 2005, *Deadliest Catch* debuted on the Discovery Channel, and the popular series is still going. It follows the lives of the crews of several crab boats based in Dutch Harbor. The name of the show conveys the reason the producers chose this particular place and this particular profession: It's dangerous. Commercial fishing in general usually ranks as America's first or second most dangerous job (logging sometimes gets the dubious honor); commercial fishing is especially dangerous in the tumultuous and lethally cold Bering Sea; and crab fishing is more dangerous than other fisheries because it takes place in the fall and winter, it involves swinging 700-pound steel traps around the deck, and it is done at a breakneck pace.

At least, it used to be done at a breakneck pace, under the original quota system. In an effort to avoid overfishing, quotas were set for the fleet as a whole (some 250 boats at that time), and the crab fishery would be shut down as soon as the quota was reached. This resulted in a frantic—and dangerous—race in which each crew was trying to catch as many crabs as possible as quickly as possible. Often, quotas were reached in just a few days, so crews would work with little or no sleep, some would cut safety corners to speed things up, boats would go out when the starting gun sounded regardless of the weather, and some boats would head out overloaded with those heavy crab traps,

which sometimes caused them to capsize in heavy seas—capsized vessels accounted for almost two-thirds of the 73 deaths among crab fishers in the 1990s.

Ironically, just one year after the debut of *Deadliest Catch,* the deadly quota system was changed to a much less deadly quota system. Boats got individual quotas for the three-month crab season, which eliminated the dangerous race. Now crews can stay in port if there's a bad storm, they can get adequate sleep while they're at sea, they aren't tempted to overload their boats with traps, and there's no reason to cut safety corners. In the 1990s, an average of more than seven crab fishers a year were getting killed; in the first six years after the adoption of the new quota system, there has been only one fatality.

It is also safer to be on land in Unalaska than it used to be. Back in the day, this was a notoriously wild and woolly port, epitomized by the Elbow Room. In the 1960s, when only about 400 people lived in Unalaska and the Elbow Room was the only bar in town, it was the place to go for getting drunk, having a brawl, taking drugs, or betting on a dogfight in the street outside. For a couple of decades, this dingy little bar remained the infamous pit that *Playboy* anointed as the nation's "roughest bar." But as Unalaska grew bigger and more mellow—though it's hardly turned into Carmel— the Elbow Room likewise smoothed off a few of its rougher edges. This symbol of

These large fishing vessels are part of the pollock fleet that operates out of Dutch Harbor, next door to Unalaska. Dutch Harbor also is home base for commercial fishers who go after crabs, salmon, mackerel, and other species, but most of all, the huge pollock fishery makes this the number one seafood port by volume in the United States.

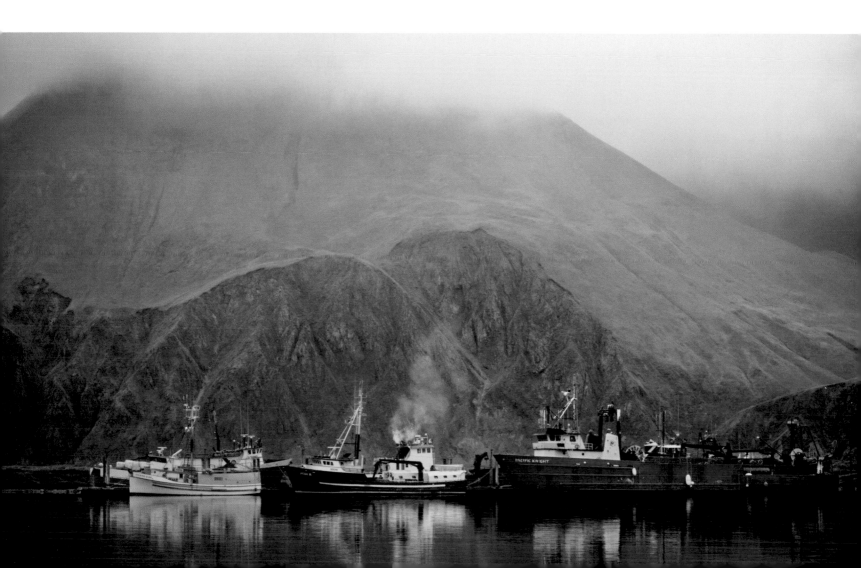

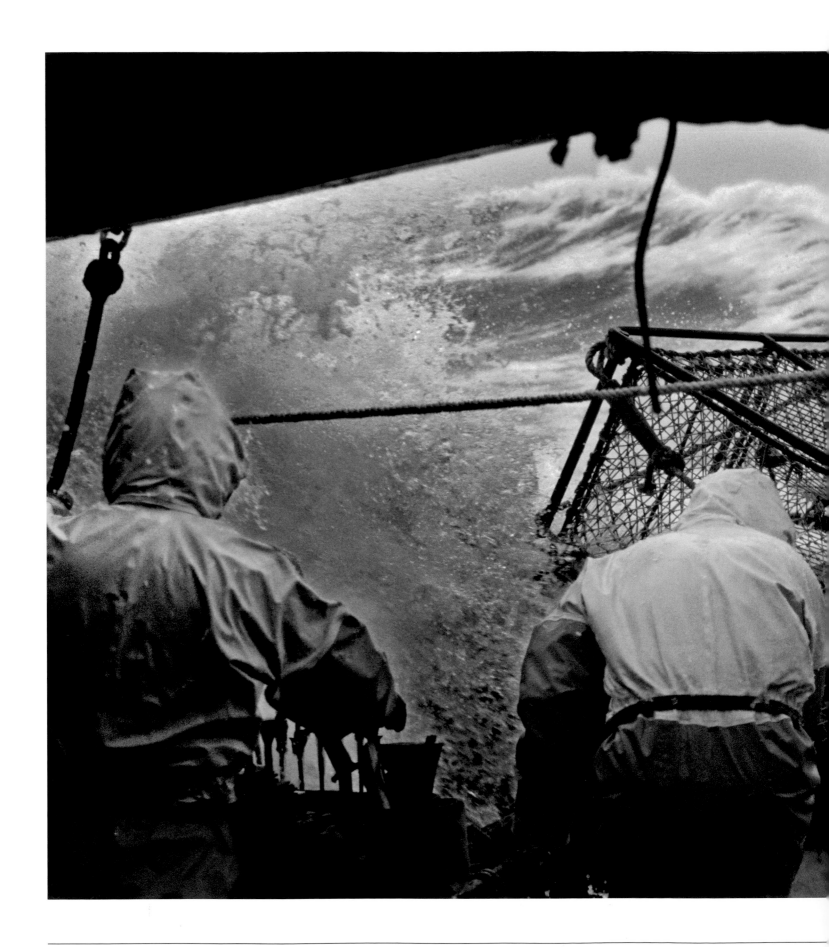

The crew of this Bering Sea crab boat battles heavy seas and 50-knot winds to bring in the catch. Fishing for crabs in this area is notoriously dangerous. No wonder crab legs are expensive.

Unalaska's frontier days finally closed in 2005. Some residents waxed nostalgic; some said good riddance.

Invading hordes of rowdy fishing crews are not the worst threat ever faced by the citizens of Unalaska and the Aleutians. Back in 1942, near the start of World War II, the islands endured an actual invasion by the Japanese military. It began on the evening of June 3, with an air raid on Dutch Harbor. The Japanese were expecting to surprise the Allies and bomb a carrier fleet, but the Allies had intercepted a message and

The Commercial Fisher

The wind is blowing 25 to 30 knots out of the northwest. Twenty-foot swells are lifting and dropping the boat in a nauseating rhythm. Wind-driven raindrops bullet off the rain gear of the men and women on the heaving deck as they fight to keep their balance while they haul in a net full of fish and dump them into cold storage below decks. This is the commercial fisher, a fixture in Alaska life and lore.

knew an attack was imminent. The Japanese pilots ran into antiaircraft fire instead of a carrier fleet, but they still dropped their payload on secondary targets and killed 25 servicemen at the Margaret Bay Cantonment Barracks.

A few days later, thousands of Japanese soldiers invaded Attu and Kiska, the two westernmost of the larger Aleutian Islands. No Allied troops were stationed on Attu, but there was an Unangan village. The Japanese destroyed the village, took the 40 surviving villagers hostage, and later sent them to Japan as prisoners of war, where 16 died due to the horrible conditions of their imprisonment. A dozen men in a U.S. Navy weather unit were stationed on Kiska, along with their faithful dog, Explosion. They took to the hills when the Japanese came ashore, but most were captured after a few days.

One, however, held out for 50 days, eating worms and plants. Finally, weighing only 80 pounds, he surrendered rather than starve.

On May 11, 1943, the Allied forces moved to retake Attu, landing 12,500 troops on the roughly 15-by-30-mile island. The 18-day battle that ensued was the second deadliest in the Pacific theater, after Iwo Jima, in terms of casualties relative to the number of troops engaged. Small-scale fights took place all over the rugged terrain, often ending up in savage hand-to-hand combat. Nearly all the Japanese fought to the death. Only 28 of 2,379 surrendered.

Both sides had to battle not only each other but also Attu's abysmal weather. Dashiell Hammett, the famous author, was stationed in the Aleutians and wrote, "Modern armies had never before fought on any field that was like the Aleutians . . . We would have to learn as we went along, how to live and fight and win in this new land, the least-known part of our America." Heavy rain, dense fog, and sometimes hurricane-force winds made the 18-day battle even more horrific, particularly for the Allies because their clothing was inadequate. Many suffered from hypothermia, frostbite, and trench foot. Often the fog got too thick or wind too strong, and supply planes couldn't drop food to the Allied soldiers, some of whom went days without eating. While nearly 1,700 Allied troops were killed or wounded in battle, some 2,100 were taken out of action by severe cold injuries or disease, and much of the disease stemmed from exposure.

After recapturing Attu, the Allies turned their eyes to Kiska. To pave the way for their invasion, the Allied planes dropped seven million pounds of bombs on this small island during the next couple of months. Then, on August 15, a huge contingent of almost 35,000 troops landed on Kiska expecting an even greater bloodbath than on Attu, given that the Japanese force on Kiska was more than twice the size of the force that had dug in on Attu. But instead of being met with bullets and bayonets, the Allied troops were greeted by half a dozen dogs that had somehow survived the intense bombardment. Improbably, one of them was Explosion, the dog that had belonged to the U.S. Navy weather unit.

For eight days, the Allied troops searched the island. In the rain and fog, they sometimes accidentally shot at each other—24 men were killed by friendly fire—but no one was shot by the Japanese because there were no Japanese. It turned out that they had secretly evacuated their entire force a couple of weeks earlier, escaping through the cordon of Allied warships by cleverly diverting some of them

Kodiak's Chiniak Highway

This route traces the scenic northeastern shore of Kodiak Island, slaloming around three deep bays before swinging east to end at Cape Chiniak and Cape Greville.

1 The drive begins at the corner of Marine Way and Rezanof Drive in **Kodiak.** At Mile 2.4, enjoy the panoramic view that opens up at **Deadman's Curve.**

2 Turn left at Mile 4.4 into **Buskin River State Recreation Site**—the most popular fishing site on Kodiak's road system. Half a mile farther is the turnoff for **Anton Larsen Bay,** a spur that leads to the pretty fjord **Anton Larsen Bay.**

3 Just past Mile 6.6, the highway comes to **Womens Bay,** so named because Sugpiaq women went there to hunt.

4 The route's major junction occurs at Mile 30.6, where **Pasagshak Bay Road** cuts due south for 16.5 miles. This road leads to **Fossil Beach,** where rocks contain fossilized seashells.

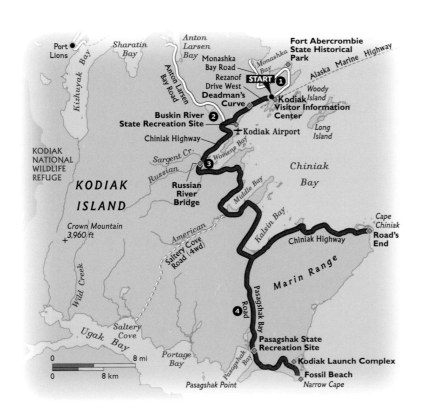

so eight Japanese ships could quickly slip in, snatch up the 5,000-plus soldiers, and slip out undetected.

Despite the ferocity and importance of the Aleutian campaign, few Americans have ever heard about it. Some military historians call it the "forgotten war." But the inhabitants of the islands have not forgotten. For one thing, they're reminded by WWII debris, such as rusting jeeps, abandoned barracks, and overgrown gun emplacements. They are also are reminded when they visit sites like the Aleutian World War II National Historic Area, a museum near the Unalaska airport that details the story of the campaign. But most of all, the people of the Aleutians, especially the Unangan, remember the campaign because of the internment and its lasting impact on their lives.

Most Americans have heard about the internment of Americans of Japanese descent during World War II, but few have heard about the similarly reprehensible treatment of the Unangan during the war. In the former case, the government's motives were simple, though racist; the government thought that, due to their ancestry, the Japanese Americans might collaborate with the Japanese in their war with the United States.

Unangan arriving at the Ward Lake Evacuation Camp, on Admiralty Island in Southeast Alaska in 1942. Nearly 900 Unangan were forcibly interned in such camps during World War II. Conditions were so bad that some 100 of them died.

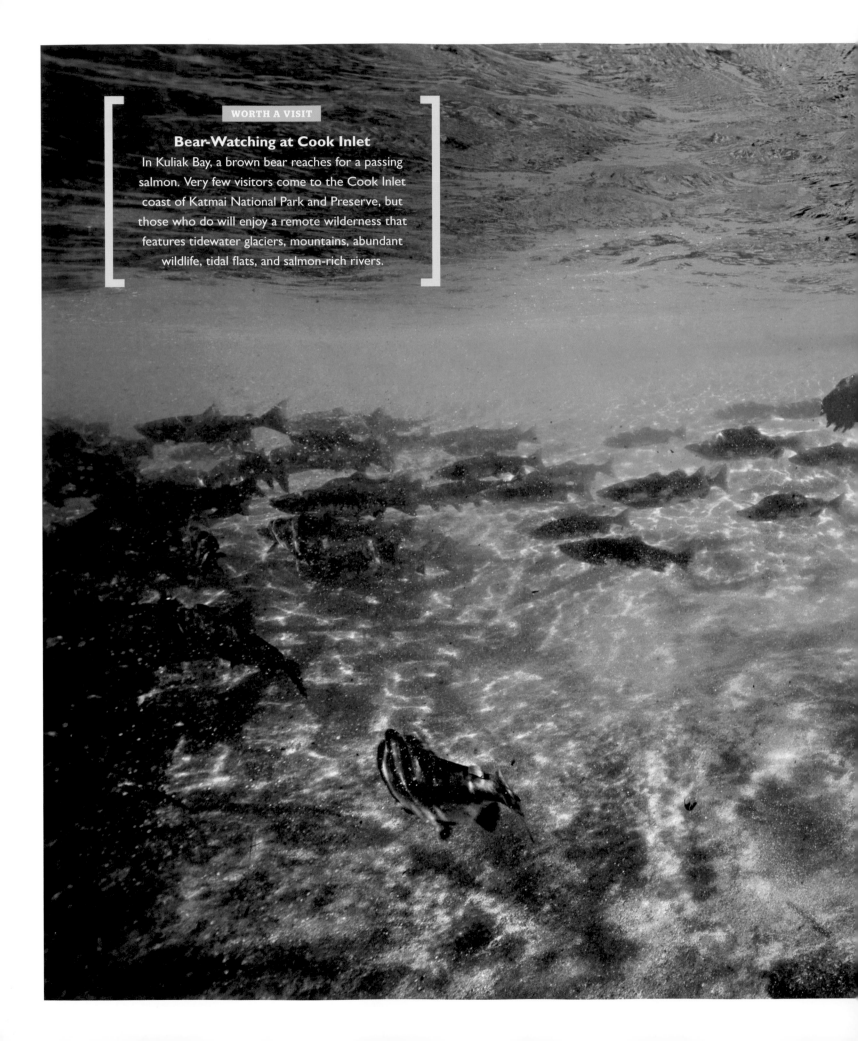

Bear-Watching at Cook Inlet

In Kuliak Bay, a brown bear reaches for a passing salmon. Very few visitors come to the Cook Inlet coast of Katmai National Park and Preserve, but those who do will enjoy a remote wilderness that features tidewater glaciers, mountains, abundant wildlife, tidal flats, and salmon-rich rivers.

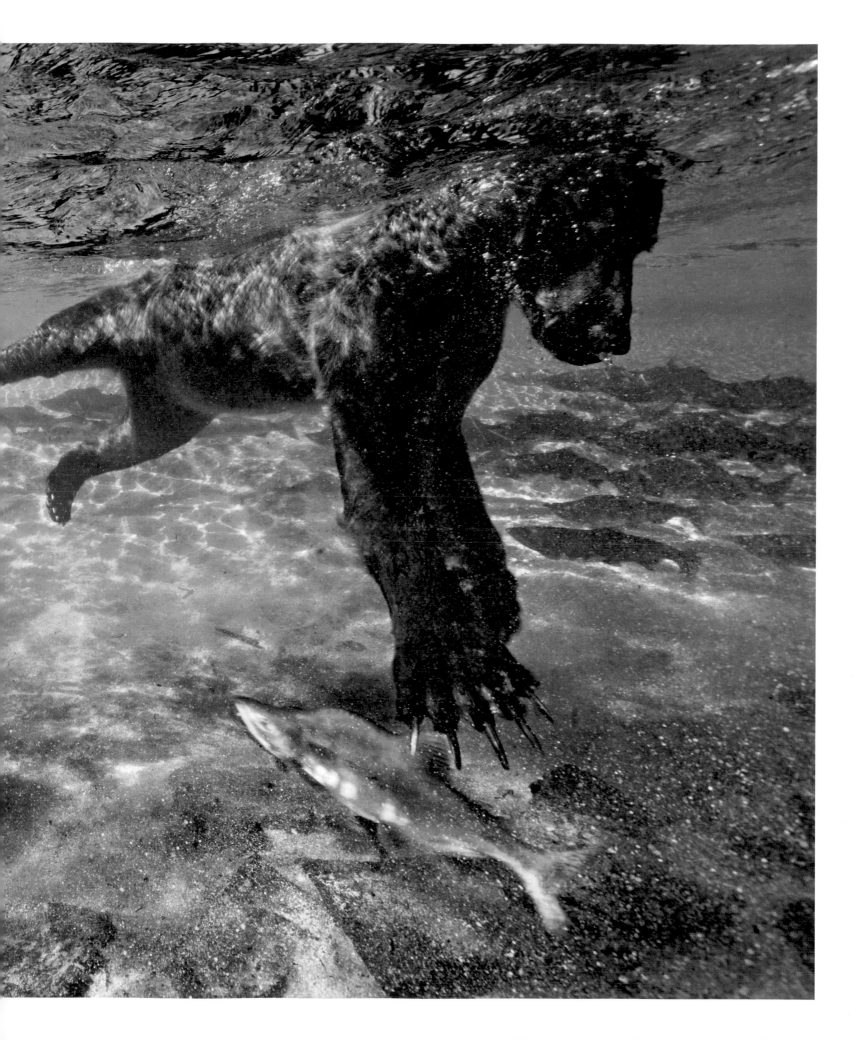

The government's motives in the case of the Unangan were less clear, though also tinged with racism.

After the Japanese invaded Attu and Kiska, the government began evacuating non-natives from the islands, but the government officials couldn't decide what to do with the Unangan. Some officials felt the Unangan should be moved because they would get in the way of the military; one official wrote of the Unangan: "Their immoral nature makes them a menace to soldiers and other workers at the base . . ." Other government administrators wanted to evacuate the Unangan to protect them, but these paternalistic officials thought the Unangan wouldn't be able to take care of themselves, as evident from official correspondence that contained comments about the Unangan such as "These people could never adjust themselves to life outside . . ." and "We try to teach them safety but they have primitive tendencies . . ."

In the end, the officials ordered that nine villages be evacuated. They loaded the 881 Unangan residents onto ships and transported them to Southeast Alaska. Note that

This narcissus flycatcher is a native of Asia that occasionally strays to the Aleutians. Such surprise sightings make the hearts of avid North American birders go pitter-patter. *Opposite:* Horned puffins on the Cook Inlet side of Katmai National Park and Preserve

they took *only* Alaska natives, which the government defined as anyone who had one-eighth native blood or greater. In cases of mixed marriages between Unangan and non-natives, the non-native spouse was left behind, and sometimes, the couples never were able to reunite. After the Unangan had been cleared out, in some places, the government killed their animals and burned their villages so they would not fall into Japanese hands. In other places, they looted the villages or took them over for military use, or both. Even the churches were vandalized and sometimes razed.

In Southeast Alaska, the dispossessed Unangan were jammed into so-called "duration villages," meaning places where they would be kept for the duration of the war. Most of the duration villages consisted of miserable, rotting buildings, like abandoned canneries or an old gold mining camp. People were packed in; one group of 28 was stuffed into a 15-by-20-foot house. Many structures lacked basic amenities, such as toilets, heat, running water, and electricity. Some didn't even have doors or windows. Having been yanked out of their homes with little warning and forced to bring only one bag, lots of the Unangan lacked adequate clothing to stay warm during the winters. The food they received was generally substandard, and the water they drank was often tainted. Many got sick, but the medical care also was poor. In their two to three years of internment, about 100 of the 881 died.

In 1944 and 1945, the Unangan were allowed to return to the islands, but many never went back because their villages and homes had been destroyed. These former settlements became known as the "lost villages." Because a large number of elders had died due to the miserable conditions in the duration villages, the Unangan suffered a great loss of culture. It has taken several decades and a vigorous, conscious effort for them to regain some of their traditional knowledge.

Among the lost villages is the one that used to be on Attu, though it was obliterated by the Japanese, not the U.S. government. Some of the scars of the ferocious battle that raged across the island in 1943 remain; for the most part, however, time, weather, and tundra have erased those terrible 18 days. Though no one lives on Attu anymore, people still occasionally visit. These hardy visitors spend thousands of dollars and risk being tossed about in stormy seas to reach Attu aboard chartered vessels, but they are willing to pay the price because of the . . . birds.

DID YOU KNOW?

The Rat Pack

Over the centuries, rats from ships that landed on Aleutian Islands have wreaked havoc with seabirds. These isolated islands lack any native mammalian predators, so the birds evolved as ground nesters, making their young and their eggs easy prey for these invasive rats. In an effort to protect as yet uninfested islands, the U.S. Fish and Wildlife Service, which manages the Alaska Maritime National Wildlife Refuge, has set up a "rat spill" response program. Among other measures, they have stashed rat spill supply kits on Adak and Unalaska Islands. When it appears that a ship in distress might run aground on one of the bird islands, a rat spill response team is mobilized and, if necessary, dispatched to repel the invading rodents.

Yes, birds. Attu is hallowed ground for North American birders. Closer to Asia than to the North American mainland, this westernmost Aleutian island is one of the best places to spot birds that can be added to a North American life list. For a bird to be placed on the list, it must be seen in North America, and according to the boundaries drawn by the American Birding Association, Attu is in North America. So, if a Eurasian siskin, a Siberian blue robin, or an Oriental turtledove is seen in Asia, it cannot go on the list. But if seen east of the maritime boundary between Russia and the United States—the boundary between Asia and North America and the boundary that happens to be

about 100 miles west of Attu—it can indeed go on the list. For hard-core listers who have seen pretty much every native North American bird there is to see, such intercontinental vagrants are about all that's left for them to add. So off they go to Attu. Between the storms that blow Asian species off course and migration routes that lead Asian species over the island, 30 to 35 Asian species can often be sighted on Attu over the course of a few weeks.

Insane? Indulgent? Journeying to Attu to add birds to a life list may be any or all of these things, depending on one's point of view, and yet it captures the essence of the Aleutians and the Alaskan Peninsula—remote, difficult, even dangerous, but at the same time, wonderfully challenging and rewarding. ■

Amaknak Island hosts busy Dutch Harbor and abuts Unalaska, the largest town in the Aleutians. Even so, in this sparsely settled island chain, its most populated area still features wildlands.

Sites and Sights in the Alaska Peninsula & Aleutian Islands

Spread across the northern end of the Alaska Peninsula, **Lake Clark National Park and Preserve** dazzles with its diversity, from 10,000-foot volcanoes to the sea-level shores of Cook Inlet. Glaciers? Check. Boreal forest? Check. Big-shouldered mountains? Check. Rivers and creeks thick with spawning salmon? Check. Long, narrow lakes that make kayakers salivate? Check. Wetlands beloved by moose, beavers, ducks, and all manner of water-loving wildlife? Check. Tundra-carpeted plateau favored by herds of caribou? Check. Campgrounds, guided nature walks, scenic drives, park lodge, extensive trail network, hot showers? No check. This is a roadless and almost entirely undeveloped park that most visitors fly into on floatplanes. But for those who come prepared or who hire guides, the park will rate an emphatic checkmark for excellence. *nps.gov/lacl*

Bears. Sure, there are moose, forest, salmon, harbor seals, mountains, foxes, and other attractions, but people come to **McNeil River State Game Sanctuary** for the bears. Tucked into Kamishak Bay and bounded on the south and west by Katmai National Park and Preserve, McNeil is one of the best places in Alaska—and therefore in the world—in which to observe brown bears up close but safely. Due to its immense popularity, access to the bear-watching area is strictly controlled by a lottery that allocates only about 250 permits a year. The lucky few fly to the sanctuary, hike out to a small viewing pad on the McNeil River with ten other lottery winners and an armed Alaska Department of Fish and Game guide, and stay there for six to eight hours. On a typical day, onlookers

will see maybe two or three dozen bears fishing for salmon (the record is 74), most within 200 feet, some only a spine-tingling 10 feet away. *adfg.alaska.gov*

Like its neighbor, McNeil River State Game Sanctuary, **Katmai National Park and Preserve** is renowned for its opportunities to view brown bears. More than 2,000 roam the park, and while the salmon are running, the bears predictably cluster in certain stretches of rivers and creeks where the fishing is good. The park service has developed three viewing sites along one of these bear-magnet stretches of the **Brooks River,** which is close to **Brooks Camp,** the park's hub and site of park headquarters, a campground, a lodge, guide services, and other amenities. Visitors who want to observe brown bears in an established (that is, safe and with guides) but utterly undeveloped setting should fly to the park's Cook Inlet shore. Before the salmon runs start, bears gather on the coast's tidal flats and meadows in places like **Hallo Bay** and **Swikshak Lagoon** to feed on sedges and clams. Of course, given that Katmai encompasses more than four million acres, bears are far from its only attribute. It is blessed with abundant wildlife and stunning scenery—and 15 volcanoes, some of them still active. In fact, the park was established to protect its volcanic features following the monster 1912 eruption of Novarupta, the world's most powerful eruption in the 20th century. The devastation wrought by this outburst can still be seen in the park's **Valley of Ten Thousand Smokes.** *nps.gov/katm*

Compared with the scattering of tiny towns and villages on the Alaska Peninsula, **Kodiak** is huge, with a population of more than 6,000. It's a commercial fishing hub set on the northeast shore of **Kodiak Island,** the second largest island in the United States, after the Big Island of Hawaii.

While wandering the waterfront and watching the boat traffic, visitors should check out the *Star of Kodiak,* the last Liberty ship built during World War II; it's now the home of a seafood outfit. To see another slice of WWII history, travelers can drive north four miles to **Fort Abercrombie State Historical Park** (yes, drive; Kodiak is the one place on the Alaska Peninsula or in the Aleutian Islands with a real road system, though L.A., it's not). The fort's old artillery emplacements now serve as an excellent viewpoint from which to spot sea otters, puffins, and whales. *kodiak.org*

Kodiak Island was one of the first places Russian fur traders settled once they began expanding out of the Aleutian Islands. To learn more about this rich and often tragic history, travelers in Kodiak can go to the **Baranov Museum.** Note the two-story building itself, a national historic landmark known as the Russian American *Magazin.* This log structure, beautifully restored, dates back to 1808, and is not only the oldest Russian building in Alaska but the oldest *building* in Alaska. It originally served as the warehouse for sea otter and seal pelts. Inside, the collections include a wide range of Russian artifacts, as one would expect, but also many Alaska native pieces and some works by famed Alaskan artists, such as Sydney Laurence and Eustace Ziegler. *baranovmuseum.org*

The Russians established their first settlement on Kodiak in 1784. That seems like a long time ago until it's contrasted with the fact that the Sugpiat (aka Alutiiq) first inhabited the island at least 7,500 years ago. All those years of Sugpiat life make for a lot of history, and that is what visitors can explore at the **Alutiiq Museum and Archaeological Repository,** in Kodiak. This handsome museum displays some of the finest of its 250,000 artifacts, photographs, ethnographic items, videos, and audio recordings. The museum also exhibits carvings, traditional skin sewing, paintings, basketry, and other arts and crafts created by contemporary Sugpiat artists. *alutiiqmuseum.org*

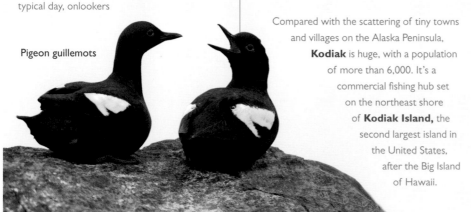

Pigeon guillemots

Lake Clark National Park

Considering that Kodiak Island possesses the only significant road system in the region, a drive on the **Chiniak Highway** might be in order. It's about 40 miles one way from downtown Kodiak to Road's End, on Cape Chiniak; the first dozen miles are paved, and the rest is decent gravel. The highway clings to the northeastern shore of the island, passing through rain forest, tundra, and meadows enlivened by flowers in the summer. Sights range from spawning salmon to the largest Coast Guard station in the United States. Motorists can also take the **Pasagshak Bay Road,** a 17-mile spur off the highway that passes the Kodiak Launch Complex (a private aerospace facility that launches commercial and military rockets and is definitely not open to the public), and ends at aptly named Fossil Beach, where some of the rocks do indeed shelter fossilized seashells. *kodiak.org*

When people hear the word "Kodiak," the first thing that comes to mind for many of them is the Kodiak bear. This celebrated subspecies of brown bear—said to be the largest in the world—is the stuff of legend among hunters and wildlife watchers. A number of guides and air taxis based in and around Kodiak will take visitors to various bear-watching sites, many of which are in the **Kodiak National Wildlife Refuge,** a 1.9-million-acre roadless

area that covers two-thirds of Kodiak Island, all of Uganik and Ban Islands, and a chunk of Afognak Island. In addition to the bears, the refuge harbors lush temperate rain forest, alpine tundra, deep fjords, and loads of non-bear wildlife. *fws.gov/refuge/kodiak*

"Tusty." That's what many locals call the **M.V. Tustumena,** the state ferry based in Homer that serves Kodiak Island and the Aleutians. Occasionally, people call it "Rusty Tusty" because it is one of the oldest ferries in service in Alaska, dating back to 1964, but it's a term of endearment (usually). Tusty is the only ferry in this region and constitutes a lifeline for many of the residents, especially in the small communities. Most of the time, Tusty shuttles back and forth between Homer and Kodiak, but twice a month, the old sea dog heads down the Alaska Peninsula to the Aleutians, all the way to Unalaska. It's a four-day (give or take) trip one way. Once in Unalaska, passengers can spend a few hours in town and then get back on board and do the return trip to Homer, or they can fly back from Unalaska. Coming and going, Tusty stops at a number of isolated villages that travelers rarely see, and passes incredibly scenic wild coastlines. Passengers can even enter a lottery to win a seat on a bus that takes the lucky winners on a two-hour tour to see the birds and other wildlife in Izembek Lagoon while the ferry is docked in Cold Bay. *dot.state.ak.us/amhs*

Unalaska is by far the biggest and busiest town in the Aleutians. In terms of the amount of seafood caught and shipped out, it has the number one port in the United States, **Dutch Harbor.** At the vast **Museum of the Aleutians,** visitors can get an overview of the islands: the history and culture of the Unangan, details of the Russian era, and information about the battles fought in the Aleutians during World War II. The WWII campaign is also presented at the **Aleutian World War II National Historic Area.** *unalaska.info*

The 2,500 islands, reefs, islets, spires, and coastal areas of the **Alaska Maritime National Wildlife Refuge** are scattered all over Alaska,

ranging from Forrester Island in the south near the Canadian border to Cape Lisburne in the north on the Arctic Ocean. Traveling between the most distant units is the equivalent of going from California to Georgia, though the majority of the refuge can be found on and around the Alaska Peninsula and the Aleutians. Most of these sites are exceedingly remote, but that's part of what makes them havens for sea otters, seals, sea lions, and about 40 million seabirds—some 80 percent of all the seabirds of North America. *alaskamaritime.fws.gov*

Administered as a single unit, the **Alaska Peninsula** and **Becharof National Wildlife Refuges** together embrace 5.5 million acres. Those acres feature volcanoes, rugged coastline, the state's second largest

Fireweed on Kodiak Island

lake, tundra, and rivers, but most of all, that acreage provides a refuge for wildlife—wolves, brown bears, sea otters, falcons, caribou, and many other species—just like the name says. *alaskapeninsula.fws.gov* or *becharof.fws.gov*

As distant and undeveloped wild places go, **Izembek National Wildlife Refuge** is fairly accessible; both the Alaska Marine Highway and scheduled flights go to Cold Bay, even though its population barely exceeds 100. Visitors can even rent a vehicle and bounce around 40 miles of gravel roads that fan out into the 418,000 acres of the refuge. The animals that take refuge in Izembek range from gray whales to caribou, but it is famous for the clouds of migrating waterfowl and other birds that come to feed in Izembek Lagoon. *izembek.fws.gov*

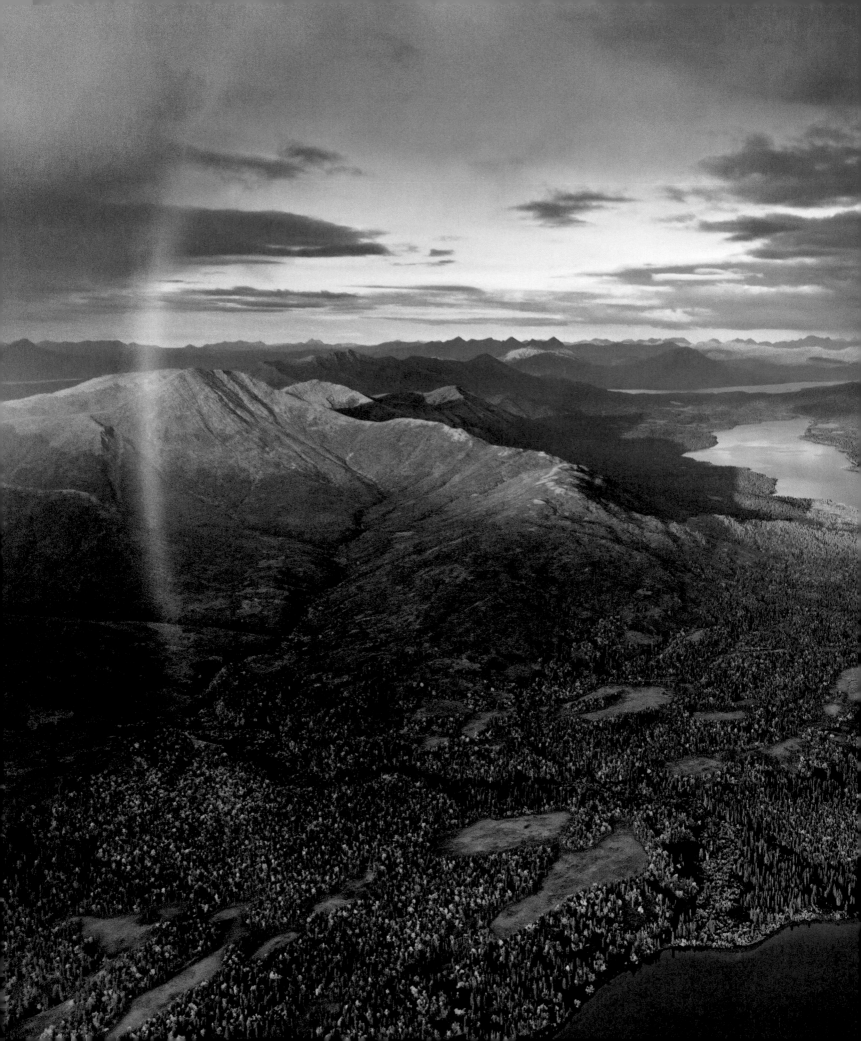

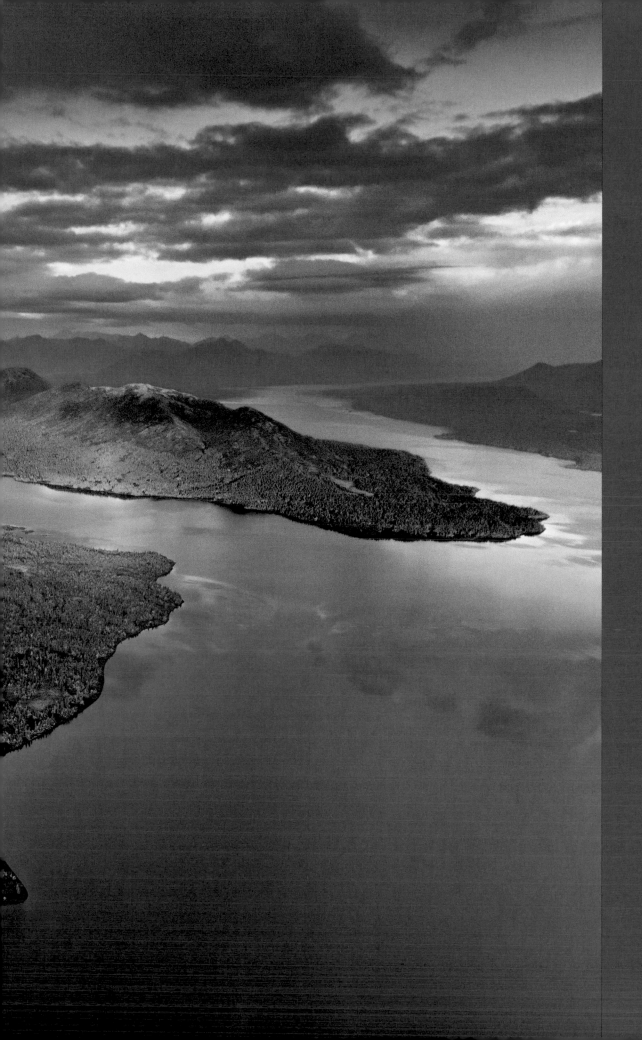

The largest state park in the United States, Wood-Tikchik is built around a series of long, narrow, interconnected lakes that offer great fishing and wildlife-watching.

Western Alaska

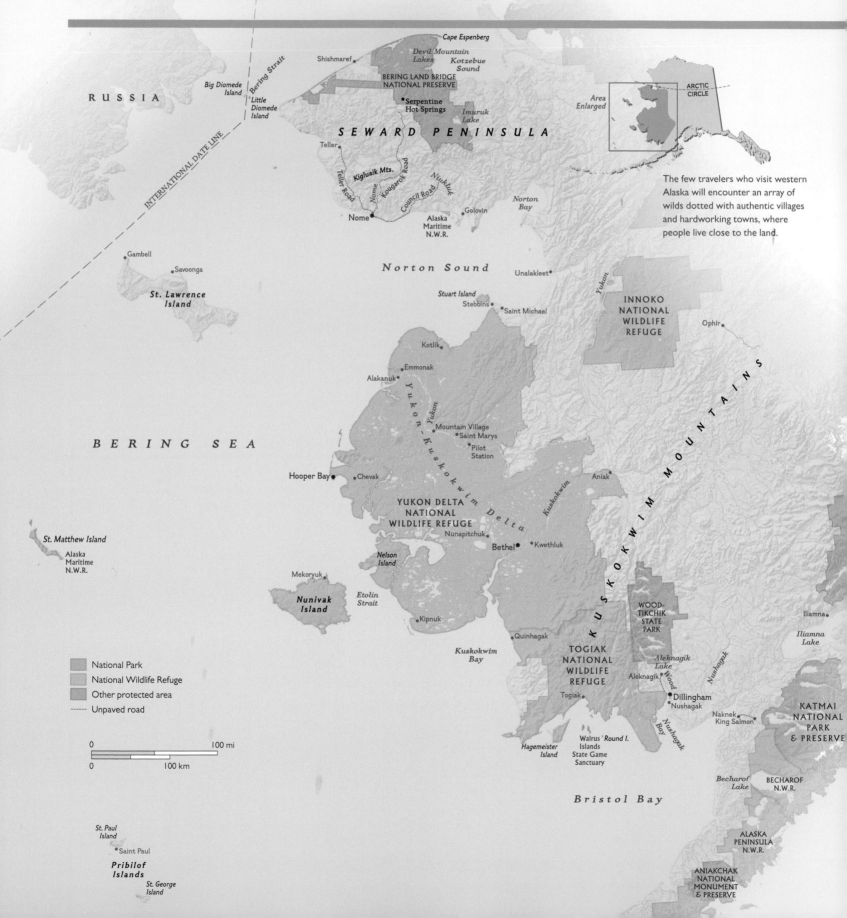

The few travelers who visit western Alaska will encounter an array of wilds dotted with authentic villages and hardworking towns, where people live close to the land.

ARCTIC CIRCLE

Area Enlarged

RUSSIA

Big Diomede Island

Bering Strait

Little Diomede Island

INTERNATIONAL DATE LINE

Cape Espenberg

Shishmaref

Devil Mountain Lakes

Kotzebue Sound

BERING LAND BRIDGE NATIONAL PRESERVE

Serpentine Hot Springs

Imuruk Lake

SEWARD PENINSULA

Teller

Teller Road

Kigluaik Mts.

Nome

Kougarok Road

Niukluk

Council Road

Norton Bay

Golovin

Nome

Alaska Maritime N.W.R.

Gambell

Savoonga

St. Lawrence Island

Norton Sound

Unalakleet

Yukon

INNOKO NATIONAL WILDLIFE REFUGE

Ophir

Stuart Island

Stebbins

Saint Michael

BERING SEA

Kotlik

Emmonak

Alakanuk

Yukon

Yukon

Mountain Village

Saint Marys

Pilot Station

Yukon-Kuskokwim Delta

Kuskokwim

Aniak

KUSKOKWIM MOUNTAINS

Hooper Bay

Chevak

YUKON DELTA NATIONAL WILDLIFE REFUGE

Nunapitchuk

Bethel

Kwethluk

St. Matthew Island

Alaska Maritime N.W.R.

Nelson Island

Mekoryuk

Nunivak Island

Etolin Strait

Kipnuk

Kuskokwim Bay

Quinhagak

TOGIAK NATIONAL WILDLIFE REFUGE

WOOD-TIKCHIK STATE PARK

Iliamna

Iliamna Lake

Aleknagik Lake

Aleknagik

Wood

Nushagak

KATMAI NATIONAL PARK & PRESERVE

Togiak

Dillingham

Nushagak

Hagemeister Island

Walrus Islands State Game Sanctuary

Round I.

Nushagak Bay

Naknek

King Salmon

Becharof Lake

BECHAROF N.W.R.

Bristol Bay

St. Paul Island

Saint Paul

Pribilof Islands

St. George Island

ALASKA PENINSULA N.W.R.

ANIAKCHAK NATIONAL MONUMENT & PRESERVE

National Park

National Wildlife Refuge

Other protected area

Unpaved road

0 100 mi

0 100 km

Most of Alaska is off the beaten track, but from a traveler's perspective, western Alaska is so far out of the way that it's off the unbeaten track. Even a more remote region, like the far north, garners more attention because it has certain celebrated features: It's north of the Arctic Circle, it has polar bears, it borders the Arctic Ocean, and it hosts the nation's northernmost town. Western Alaska enjoys no such claims to fame. Other than some hardy hunters and fishers, few outsiders make it to the long coastline, the immense river delta, the lakes, the isolated islands, the forest, the marshes, or the tundra that characterize this realm.

But that's not to say there's no one there. In fact, western Alaska is more populated than many parts of the state, especially in terms of the number of towns if not the number of people in those towns. This is where most of Alaska's Eskimos live, though the term "Eskimo" bears explaining.

Using language and culture as markers, the first people that seem to qualify as Eskimos made their presence known about 5,000 years ago, apparently having evolved from earlier cultural forms already present in western Alaska. About 4,000 years ago, the ancestors of the people now known as Unangan and Sugpiat branched off from western Alaska, moving south onto the Alaska Peninsula and Aleutian Islands, and eventually developing distinct languages and cultures.

Much later, perhaps 1,500 to 2,000 years ago, some Eskimos from western Alaska migrated to the northwest corner of Alaska, from which they spread eastward. Today, these people are called (in Alaska) the Inupiat or, as a whole from Alaska to Greenland, the Inuit. They have their own languages and cultures, and their linguistic and cultural ties to the earliest Eskimos remain strong enough that they remain an Eskimo people. Finally, there are the Eskimos whose ancestors never left western Alaska, the people known nowadays as the Yupiit. ("Yupiit" is the collective term; "Yup'ik" is the singular and adjective form and the name of the language.) Not only was western Alaska the birthplace of the Eskimo peoples, but through prehistory, history, and still today, it is also the stronghold of Eskimo life, alongside the region of the Inupiat in the far north.

In Alaska, the term "Eskimo" is still widely used, by Alaska natives and non-natives alike, to refer to the Yupiit, Inupiat, and Sugpiat together, as well as to natives of Eskimo origin who inhabit northern Canada and parts of Greenland. However, the "Eskimo" peoples of Canada and Greenland generally find the word offensive. In Canada, they

Created by a Yup'ik artist around 1950, this beluga whale mask is made from wood, wool, and feathers.

prefer to be called "Inuit," and in Greenland "Kalaallit" or, simply, "Greenlanders." The Inuit, including the Kalaallit, consider "Eskimo" derogatory because it is a foreign word they did not choose, and it was long thought to mean "eater of raw meat." However, later linguistic work determined that "Eskimo" likely is an Ojibwa word meaning something like "to net snowshoes."

Little is known about the humans who preceded the Eskimos in western Alaska. These mystery people came over the Bering land bridge from Siberia 10,000 to 30,000 years ago. Though the land "bridge" was hundreds of miles wide at various times when sea levels dropped, western Alaska's Seward Peninsula is the closest point to Russia (55 miles) and a natural place for people heading east from Siberia to end up.

Indeed, recent archaeological digs on the peninsula, in Bering Land Bridge National Preserve, have turned up evidence of humans dating back as far as 12,000 years. Scientists on the preserve have also unearthed the remains of mammoths, mastodons, steppe bison, and some of the other ice age animals that people in Siberia are thought to have followed across the land bridge in a slow-motion migration. Those creatures are long extinct, having been replaced by caribou, bears, moose, and other large mammals—though not ice age large. There's still an ancient feel to this 2.7-million-acre national preserve, a spare landscape of tundra, eerie rock formations, hot springs, rounded mountains, and vast flatlands peppered with ponds.

Some of the preserve's most spectacular features are its maar lakes. Such lakes form when hot magma from deep in the Earth rises up and comes into contact with groundwater, which produces steam, which causes water to expand in volume about 1,000 times, which results in a drawn-out explosion. Such explosions blow wide, shallow craters in the ground, which later fill with water to create a maar lake. Ordinary maar lakes—maybe 1,000 feet across—can be found throughout the world, but the Bering land bridge is home to the four largest maar lakes in the world. All exceed three miles across, and the Devil Mountain Lakes maar stretches the measuring tape to five miles.

The preserve's maars are enormous because the magma interacted with groundwater in the form

Western Alaska Pinnipeds

1 Walruses Walruses are the largest of Alaska's pinnipeds—pinnipeds being carnivorous aquatic mammals with flippers. These blubbery behemoths run about eight feet and 2,500 pounds for the delicate females and ten feet and 3,500 pounds for males. Males employ special air sacs to make a sound like ringing a bell. Both sexes sport two- to three-foot-long ivory tusks, prized by Alaska native artists for carving.

2 Steller Sea Lions These summer residents of the Bering Sea go about seven feet and 600 pounds for the females and nine feet and 1,500 pounds for the males. Gregarious to a fault, Steller sea lions congregate in raucous groups on rocks and beaches and make a racket that can be heard for miles. They grumble, snort, roar, and growl, but they do not bark; they leave that to seals.

3 Northern Fur Seals No other pinnipeds in Alaska have such a huge discrepancy in size between females and males; females are about five feet and a slight 120 pounds, while males are around seven feet and 600 pounds. Likewise, their life expectancies diverge radically: on average, 10 years for males and 27 for females. (Maybe it's all that weight the males are lugging around.) Relentless hunters, northern fur seals spend about 300 days a year on the prowl in the ocean.

4 Ribbon Seals Ribbon seals are small—about five feet and 150 pounds for either sex—but distinctive. They got their name from the light-colored bands that form rings around their dark-furred bodies. Ribbon seals rarely go ashore, spending almost their entire lives in the water or on sea ice, which makes them vulnerable to climate change.

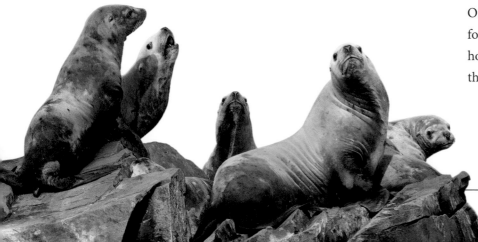

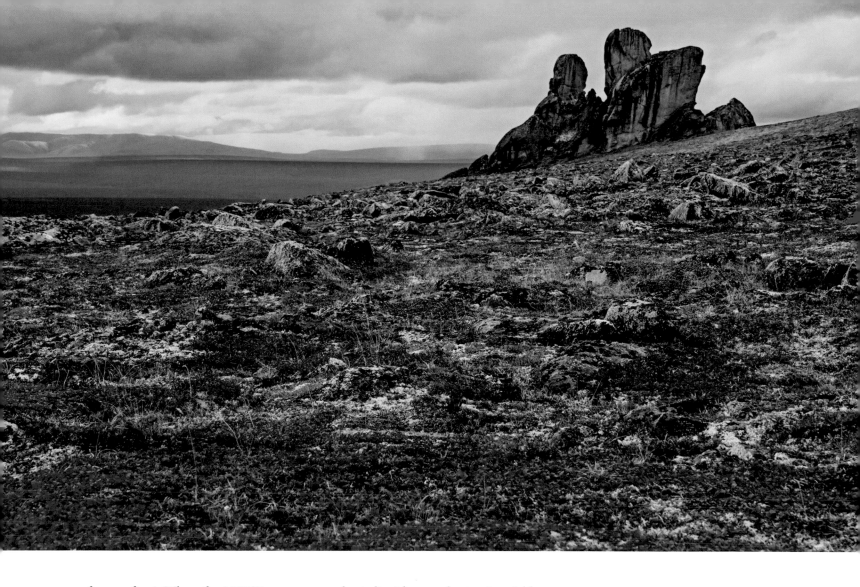

of permafrost. When the 1800°F magma superheats liquid groundwater, it quickly boils off and the explosive reaction quickly shuts down. But when magma encounters permafrost, it takes longer to melt through it and boil it off, so the explosive reaction persists for much longer. During the ice ages when these maar lakes formed, the permafrost was hundreds of feet thick, so the ongoing explosions continued for some time and left huge craters behind.

It would be logical to assume that Bering Land Bridge National Preserve was established to protect this unusual landscape of maar lakes, volcanoes, hot springs, and prehistoric human sites—logical but only partly true. The designation "preserve" means that this National Park Service property is also intended to preserve subsistence resources. Subsistence lifestyles are practiced in many parts of the state, but nowhere more than in western Alaska, especially among the Yupiit.

Around 20,000 Yupiit live in scores of villages scattered across western Alaska, but they're clustered most densely in the Yukon-Kuskokwim Delta, particularly along the coast and the lower reaches of the major rivers. They constitute the most populous Alaska native group that has largely maintained its cultural identity. For example, nearly all of them speak Yup'ik, about half as their first language.

Travelers to Bering Land Bridge National Preserve are following in the footsteps of the first humans to set foot on North America. The best hiking is found in the uplands, like the tundra around Serpentine Hot Springs pictured here, with alpine bearberry wearing its autumnal red and a granite tor jutting up in the background. *Opposite:* Steller sea lions

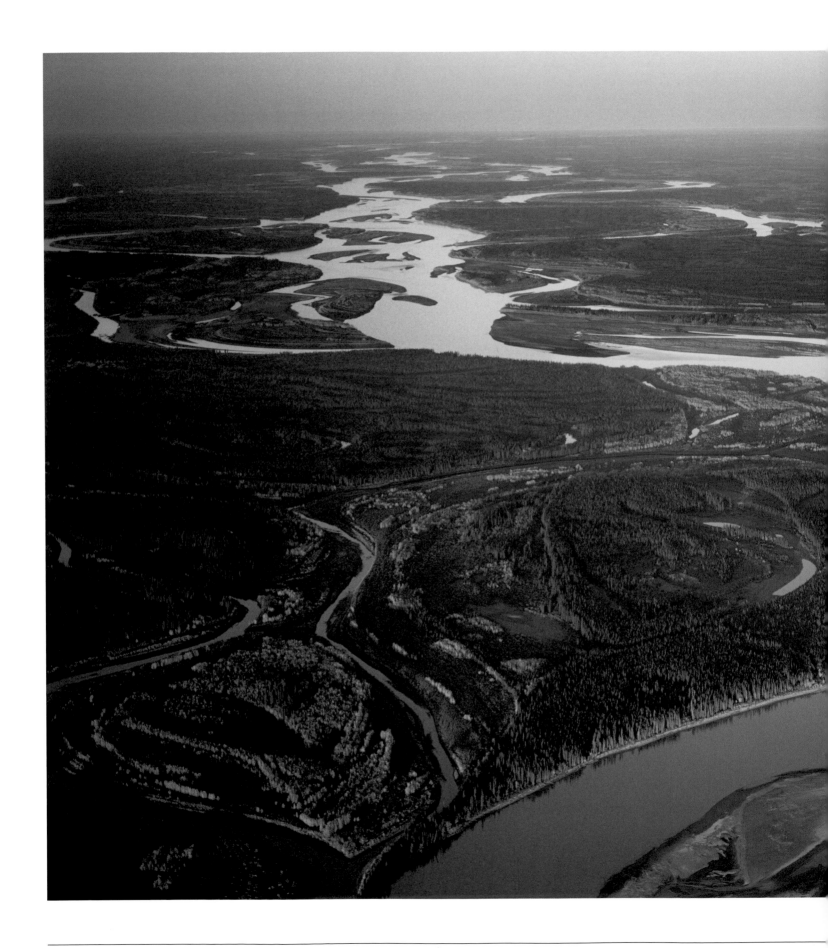

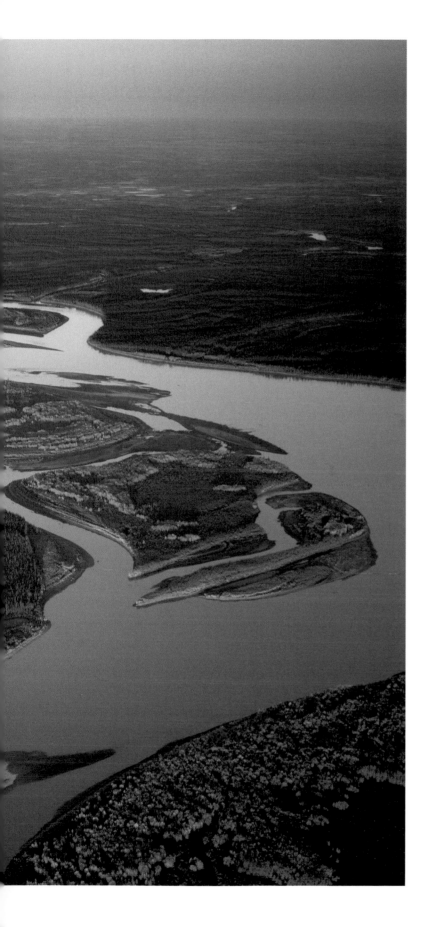

Roughly the size of Oregon, the Y-K Delta, as it's commonly called, is the second largest delta in the United States, after the one formed by the Mississippi. It is anchored by Alaska's two largest rivers, the Yukon and Kuskokwim, which drain vast inland regions. The Yukon alone winds northeast almost 2,000 miles, all the way across Alaska and well into Canada, and boasts a drainage considerably larger than Texas. As the Yukon, Kuskokwim, and many other rivers flow down from interior mountains and spread out on the flatlands of the delta, they create a mosaic of streams, ponds, sloughs, and lakes interspersed with tundra, a few hills, and some scrubby woodlands along a

> ❝ Even before statehood, the effort to change Native Alaskans into proper 'Americans' was starting up, a joint project of the Christian missionaries and the U.S. government. ❞
>
> **[William L. Iggiagruk Hensley, state legislator, activist, & author]**

few of the rivers. In addition, there are the bays, inlets, coves, beaches, and tidal flats on the Bering Sea coast of the delta.

Flat, almost treeless, and with little geographical diversity, the Y-K Delta does not look like a land of plenty, but it is actually an excellent place in which to lead a subsistence lifestyle. Firm numbers are hard to come by, but one study estimates that the Yupiit in the delta make about 75 percent of their living off the land. In the dry uplands, Yup'ik hunters can bag moose, caribou, and other big game. Families gather cow parsnip, wild celery, marsh marigold, and other edible greens on the tundra. In the late summer and early fall, the tundra also yields blueberries, salmonberries, and crowberries, which can be eaten immediately, frozen for winter use, or mixed with sugar and lard to make *akutaq,* aka "Eskimo ice cream." (Traditionally, akutaq can be a mix of other foods, too, such as fish, caribou, or seal oil.)

As it approaches the Bering Sea, the Yukon River splits into many channels, forming an enormous and fertile delta that extends for miles.

An emperor goose guards its eggs in the Yukon-Kuskokwim Delta. Much of the world population of these geese nest in the delta, along with multitudes of other waterfowl.

At certain times of the year, millions of geese and other waterfowl descend on the delta, providing an abundant source of meat and eggs. Hunters from coastal villages put out to sea to catch bearded seals, ringed seals, and beluga whales. Sometimes the coastal dwellers trade marine mammal products for big game products from inland inhabitants.

Above all, salmon fuel the Yupiit. Dozens of freshwater and saltwater fish species call the delta and its near-shore waters home, and the locals catch many of them, but salmon are the Yupiit's mainstay. During the summer, salmon by the millions head up from the ocean into the delta's rivers and creeks. When the salmon are running in their area, many Yupiit stream out of their villages and head to fish camps, where they catch and preserve salmon. Smoking, drying, and freezing salmon has long been the key to surviving the winter, and it remains important today, even though the Yupiit have integrated somewhat with the broader economy.

Sometimes the meeting between the Yupiit's ways and the broader economy is more like a collision than an integration. The state's fishing regulations, for instance, occasionally conflict with the Yup'ik's subsistence rhythm. A research paper by Colin Thor West and Connor Ross cites a representative case involving people from Nunapitchuk, a delta village that is not located on a salmon-bearing stream. To get their salmon, they must travel 20 miles by boat to the Kuskokwim River, which takes about two hours one way and burns about $100 worth of gas (which can run maybe eight dollars a gallon out here), which is a big bite for subsistence folks who may only make a few thousand dollars a year in the cash economy. They also must time their trip just right to take advantage of a pulse of salmon moving up the stretch of the Kuskokwim where they fish. But some Nunapitchuk residents reported that one time they went to all the trouble and expense of making the trip only to discover that the Alaska Department of Fish and Game had just closed the area to salmon fishing. Of course, Fish and Game is simply trying to protect the resource, but the Yup'ik fishers nonetheless went home empty-handed. One hopes that ongoing discussions can help prevent such mishaps in the future.

The tension between Yup'ik ways and the larger society goes beyond practicalities such as fishing regulations, because subsistence living is much more than an economic issue for the Yupiit. Yup'ik radio broadcaster and writer John Active writes, "Our subsistence lifestyle is our culture. Without subsistence, we will not survive as a people. If our culture, our subsistence lifestyle should disappear, we will be no more."

In another passage, Active elaborates on some of the Yup'ik attitudes toward nature and each other that he hopes his people can retain. "I thank my grandmother who . . . taught me these things, who taught me to appreciate our subsistence lifestyle, to not

waste, but share; to not steal, but provide for myself; to remember my elders, those living and dead and share with them; to be watchful at all times that I do not offend the spirits of the fish and animals; to give the beaver or seal that I caught a drink of water so its spirit would not be thirsty; to take from the land only what I can use; and to give to the needy if I have enough to share."

Most Yup'ik villages are remote, small (maybe a couple of hundred people), and not set up for casual visitors, but intrepid travelers can find a guide service here and a basic hotel there. Most outsiders who want to glimpse the realm of the Yupiit go to Bethel, though it's hardly a major tourist destination. The transportation and supply hub for the Y-K Delta, this ramshackle bush town features one of the busiest airports in Alaska, with daily flights from Anchorage and dozens of small planes coming and going from delta settlements.

Depending on the season, between 6,000 and 8,000 people live in Bethel, about two-thirds of them Yupiit. Some even dress in traditional clothing, such as caribou-skin parkas and sealskin mukluks, but that doesn't mean they won't be texting on a

This resident sports the kind of warm clothing that's usually needed to walk about Nunivak Island. She's one of only a couple of hundred people who live on this large island, along with large herds of musk oxen and reindeer.

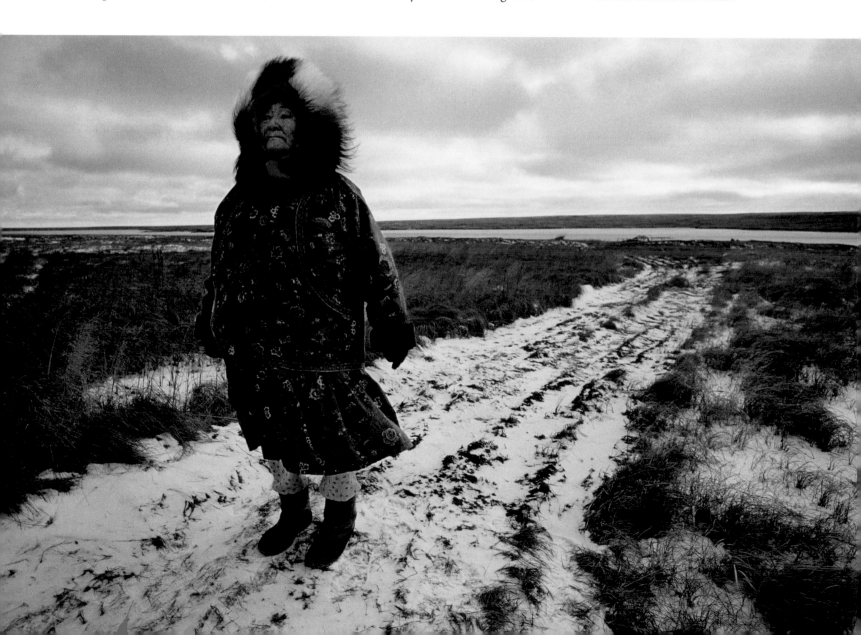

smartphone or drinking a latte. Bethel is surprisingly cosmopolitan, notably when it comes to cab drivers, many of whom are South Korean and Albanian. The fact that nearly 100 cabbies operate in Bethel is striking, considering that the town only has a couple of dozen miles of roads. They do everything from taking someone to the store to taking someone fishing—the fish ride in the trunk. Forget it, New York; Bethel has by far the most cabs per capita in the United States. For an introduction to Yup'ik culture and history, take a cab to the Yupiit Piciryarait Cultural Center and Museum. One of its three galleries houses a permanent collection of art and artifacts, and the other galleries offer changing exhibits, often of contemporary Yup'ik artists.

Bethel also is the gateway to the Y-K Delta, much of which lies within the Yukon Delta National Wildlife Refuge. Naturally, the refuge is open to subsistence hunting, fishing, and gathering, given that dozens of Yup'ik villages lie inside its boundaries. The presence of these settlements hardly makes the refuge crowded with people; at more than 19 million acres, about the size of South Carolina, the refuge swallows up those villages like the ocean swallows some pebbles. Guides based in Bethel and in a few of the villages will take visitors by boat or plane to have a look at the delta, especially its wildlife.

Some classic Alaska charismatic megafauna, such as bear, moose, and caribou, can be seen around the edges of the delta, in the northern hills and eastern mountains. The coast has its own suite of watchable animals, including seals, whales, walruses, and, on rare occasions, even a polar bear or two. However, it is the birds that rate the spotlight. During the spring and fall, millions of migrating geese, ducks, swans, shorebirds, cranes, and other species swarm the delta, eating relentlessly to load up for the long flights ahead.

Seabirds add to the avian action, notably the huge colony of about a million that inhabits the cliffs on the southwest side of Nunivak Island, about 20 miles off the delta coast. But they are not the island's claim to fame—that would be the musk oxen. Standing four or five feet at the shoulder, weighing maybe 500 to 700 pounds, covered in a thick, shaggy coat topped with guard hairs that dangle almost to the ground, musk oxen look like ice age holdovers. And they are. Musk oxen and caribou are the only remaining Arctic ungulate

Traditional Alaska Native Artists

Alaska natives have been making fine traditional art for millennia. They often work in remote villages with just a few tools, fashioning totem poles, baskets, ceremonial masks, and all sorts of other pieces that are not only beautiful but also rich with cultural significance. In western Alaska, for example, Yup'ik, Siberian Yupik, and Inupiat artists are renowned for their sublime ivory sculptures—not elephant ivory but walrus tusk ivory. Following the ethic of avoiding waste, they even produce appealing sculptures from walrus teeth.

Opposite: Mare's tail grows in the shallow wetlands of the Yukon Delta National Wildlife Refuge. This kind of sodden tundra covers much of the Yukon-Kuskokwim Delta.

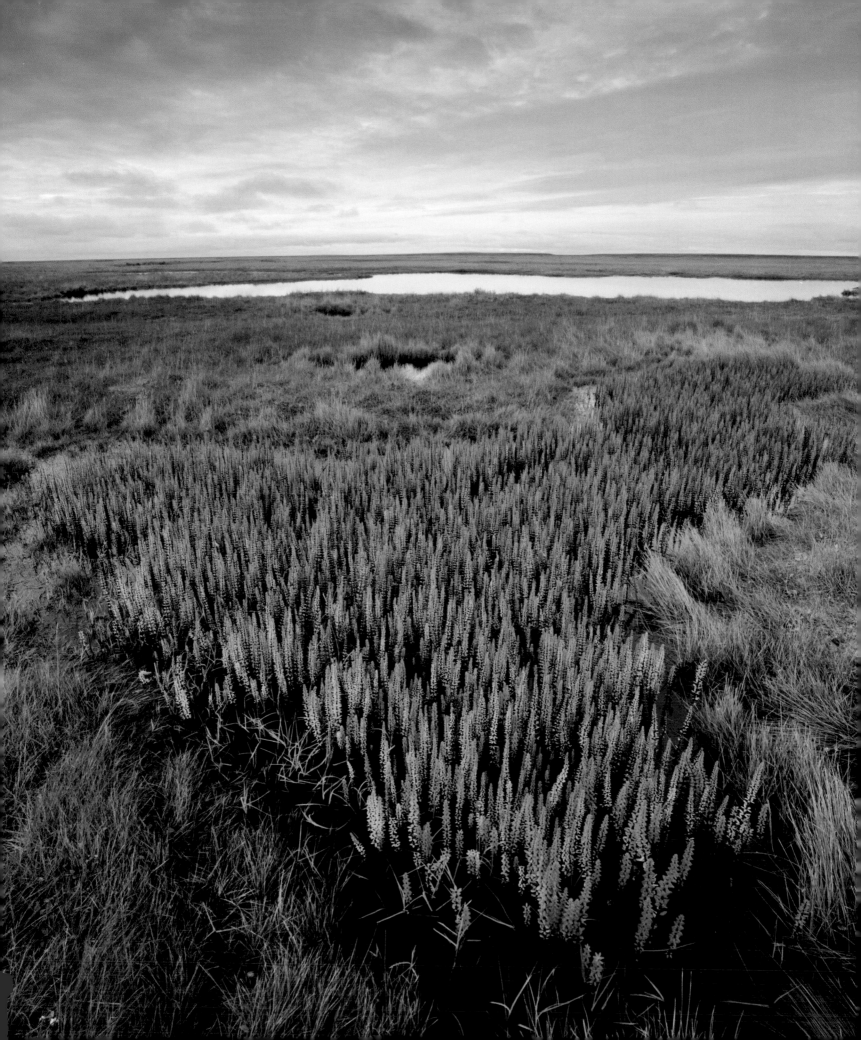

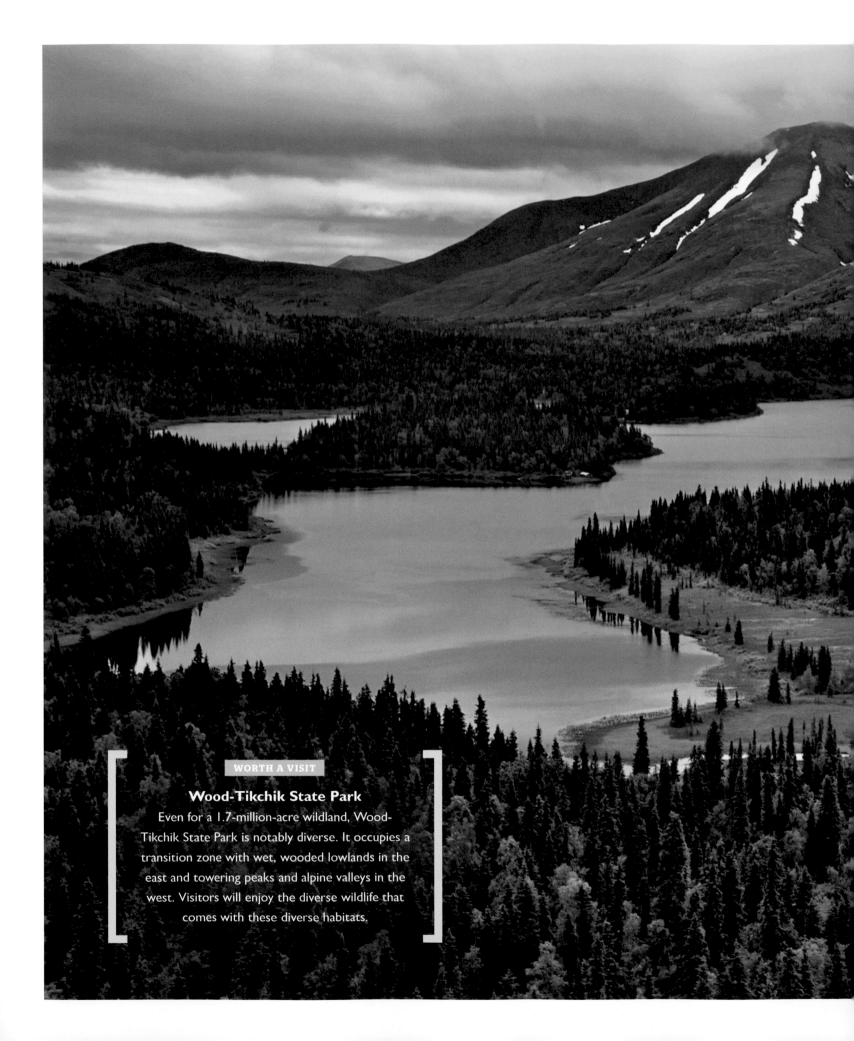

Wood-Tikchik State Park

Even for a 1.7-million-acre wildland, Wood-Tikchik State Park is notably diverse. It occupies a transition zone with wet, wooded lowlands in the east and towering peaks and alpine valleys in the west. Visitors will enjoy the diverse wildlife that comes with these diverse habitats.

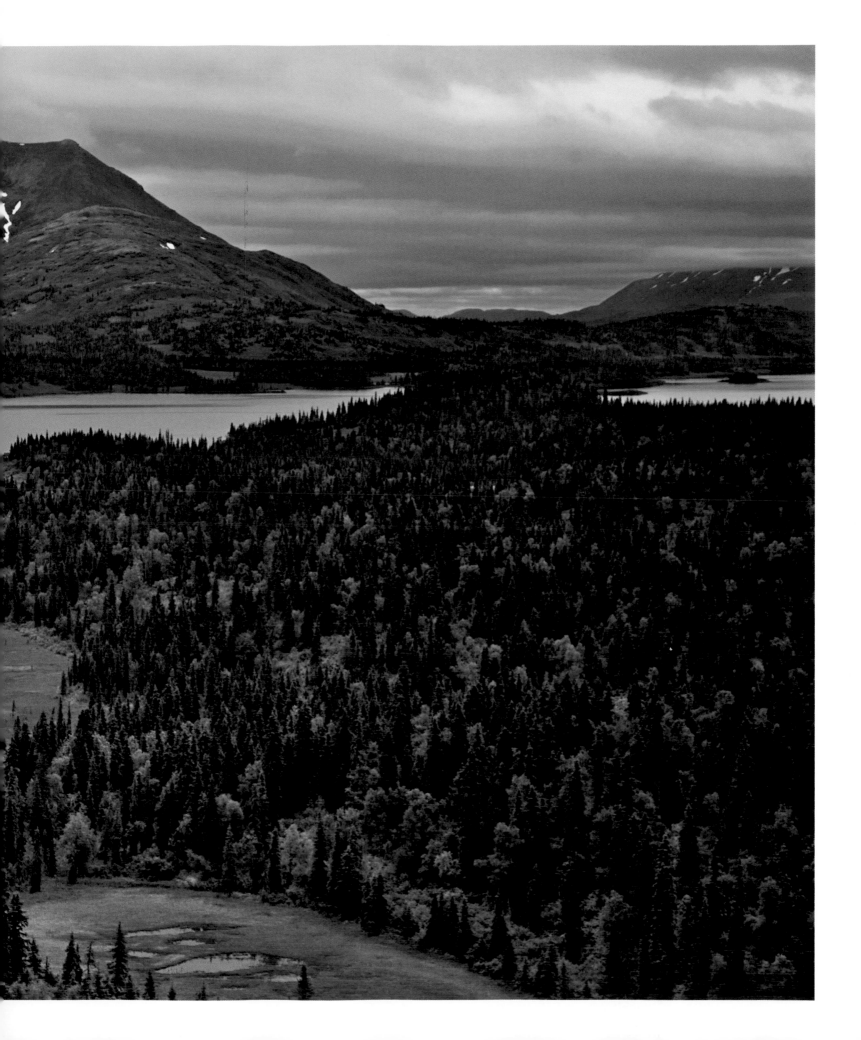

species that existed during the ice ages. The coats of the musk oxen and other adaptations make them superbly fit to survive harsh winters.

Unfortunately, those coats aren't thick enough to stop bullets. In the late 1800s, hunters wiped out the musk ox populations in Alaska. Fortunately, in 1935 and 1936, a few musk oxen were brought from Greenland to Nunivak Island to repopulate Alaska with these remarkable beasts. After a slow start, they thrived on the island, and by the 1960s, some musk oxen were being taken off Nunivak and transplanted to other parts of Alaska. Today, some 4,000 live in the wild in the state, about 500 of them on Nunivak Island.

Interaction between the Yupiit and Europeans began in the early 19th century, with the arrival of Russian fur traders. Having taken most of the sea otters in the Aleutians and in more southern parts of Alaska, the Russians turned their gaze northward toward western Alaska, where they hoped to harvest not only sea otters but also inland fur-bearers, particularly beavers and river otters. Following a few earlier probes, in 1818, a party of Russians made its way to Bristol Bay, in the far south of western Alaska. They established Fort Alexandrovski near the head of Nushagak Bay, which branches off of Bristol Bay, just a few miles from what is now Dillingham, the central town in

About 500 musk oxen inhabit Nunivak Island, part of the Yukon Delta National Wildlife Refuge. The island was the first site in Alaska to which these ice age beasts were reintroduced, after being eliminated from the state by hunters. *Opposite:* A parakeet auklet, one of the many seabird species that nest on western Alaska's islands

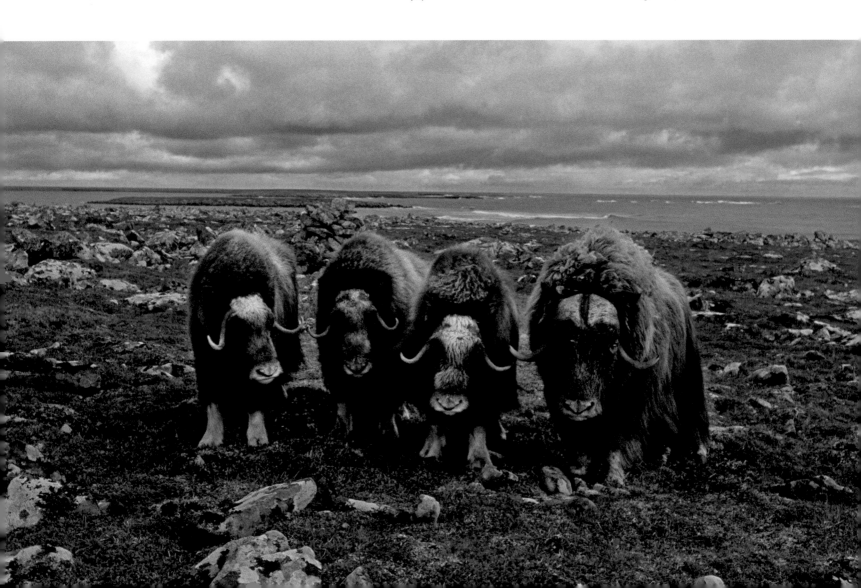

the area today. Soon the Russians had expanded, building small outposts and Russian Orthodox missions at several sites in the Y-K Delta and as far as several hundred miles inland up the Yukon and Kuskokwim Rivers.

In western Alaska, the Russians generally treated the locals decently, unlike the Russian traders who brutalized the Unangan in the Aleutians. Relations did turn dangerous at one point in the late 1830s, when the Russians inadvertently introduced smallpox to the locals; hundreds of Yupiit died. Some of the Yupiit thought the Russians had purposely inflicted smallpox upon them, so in 1839, they killed Russian American Company employees at a mission on the Yukon River. Fortunately, cooler heads on both sides prevailed, and relations were once again friendly within a couple of years.

The Russian Orthodox missionaries enjoyed amicable relations with the Yupiit, too. In fact, in some places, the Yupiit enthusiastically embraced the church. A missionary stationed at Fort Alexandrovski in the 1840s reported Yupiit adopting Christianity with such fervor that they burned their ceremonial masks or threw them into the river. By 1846, the parish counted some 700 locals among its members.

Soon the Russian Orthodox missionaries were about the only Russians left in western Alaska and throughout the state. The Russian government and trading companies weren't making much money in Alaska by the 1840s and 1850s. Combined with geopolitical factors, declining profits eventually sent the Russians packing. By 1860, they were looking to sell, and in 1867, they closed the deal with the United States. However, little happened after the American flag was raised over Sitka. The United States soon pulled out most of what few officials and troops they had in Alaska. American commercial interests maintained a presence in a few areas, such as harvesting seals in the Pribilof Islands and catching fish in the Kodiak Archipelago, but there was no surge of Yankee activity following the acquisition of Alaska.

Not until 1884 did Americans show any significant interest in western Alaska. That year, they came for souls and for salmon. Sheldon Jackson, Alaska's general agent for education, asked various Protestant denominations to consider missionary work in the Great Land, with a particular invitation to the Moravian Church to go to the Bristol Bay and Kuskokwim River areas, where Russian Orthodox missionaries were still operating. The Moravians accepted the invite and, in 1884, sent two missionaries to scope out the region. In 1885, three Moravian missionaries

Islands of Western Alaska

1 **St. Lawrence** This 100-mile-long island juts from the Bering Sea far from the Alaska mainland, just 36 miles off the coast of Russia. About 1,500 Siberian Yupik lead a largely subsistence lifestyle on this storm-lashed slice of tundra and rock, which is also home to reindeer, walruses, seals, and seabirds.

2 **Pribilofs** The two main Pribilof islands, St. Paul and St. George, are 100-square-mile specks poking out of the Bering Sea 200 miles north of the Aleutians and even farther from everywhere else. About 700 people, nearly all of them Unangan, share these volcanic islands with a wealth of wildlife, notably the birds (248 species have been sighted here) and the roughly one million fur seals, more than half of the world's population. (The Pribilofs were once known as the "Northern Fur Seal Islands.")

3 **Nunivak** The eighth largest island in the United States, Nunivak's 1,600 square miles are home to about 500 musk oxen, between 1,000 and 1,500 reindeer, hundreds of thousands of seabirds and waterfowl—and a scant 200 or so people.

4 **Round Island** One of seven islands in the Walrus Islands State Game Sanctuary in Bristol Bay, Round Island is a mere three miles long, but as many as 14,000 male walruses haul out on its beaches, making it one of the largest walrus haul-outs in North America.

motored up the Kuskokwim in a boat loaded with supplies and lumber until they came to a likely spot, whereupon they built a church. They named the settlement Bethel, and it's now the major town in the Y-K Delta. To this day, there are several Moravian churches in Bethel as well as in a few other towns and villages in western Alaska. However, the Russian Orthodox Church was entrenched among many Yupiit; they did not flock to the Moravian faith, and the Russian Orthodox influence is still much stronger.

> **❝ As long as I have the land and nobody tries to stop me from using it, then I'm a rich man. Everything I need—my food, clothes, house, heat—it's all out there. ❞**
>
> **[An Inupiat resident of Ambler, Alaska]**

Also in 1884, the Arctic Packing Company built the first cannery in Bristol Bay, close to the Russian Orthodox mission in Nushagak. The bay's prolific salmon runs soon attracted other American companies, and a number of canneries were established around the northern reaches of Bristol Bay. Still, western Alaska largely stayed off America's radar until something that trumped both souls and salmon hit the headlines: gold.

It all started with the "three lucky Swedes." Not a singing group and not all Swedes (one was Norwegian), these three prospectors met in 1898, while sniffing around for gold on the Seward Peninsula. One of them had previously seen some enticing color while panning in a creek near the mouth of the Snake River (later renamed the Nome River). So the trio slapped together a little sailboat in Golovin and headed some 100 miles along the coast to the mouth of the river, near the present-day site of Nome. Within days, they knew they had struck it rich. They returned to Golovin, did the legal work to set up the Cape Nome Mining District, and proceeded to file nearly 100 claims for themselves, their relatives,

The shallows of Bristol Bay reflect the sky as the bay narrows near Dillingham—at the head of the bay. Its deeper waters host one of the world's great salmon fisheries.

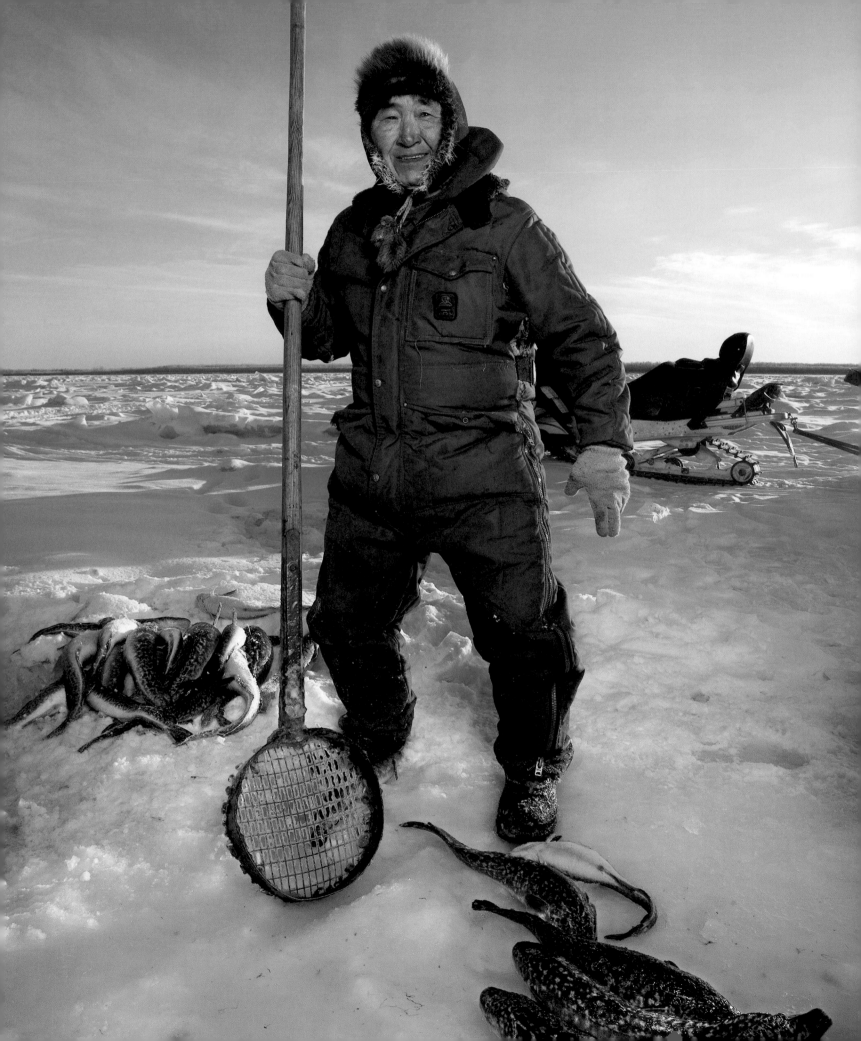

and friends. Over the next couple of decades, their mining company unearthed about $20 million worth of gold—a fortune by today's standards, a megafortune in the early 20th century.

The three lucky Swedes did not have the area to themselves for long. Word of their strike traveled up the Yukon to Dawson, in Canada, which was jammed with gold seekers lured by the Klondike gold rush. But the Klondike rush was fading, especially for the late arrivals who hadn't staked claims early, so in the spring of 1899, thousands of them headed for Nome—one report says 8,000 left Dawson in a single week. That summer, thousands more stampeders left from San Francisco and Seattle to try their luck in Nome. However, just as in the Klondike—and in nearly every gold rush that has ever been— early birds had staked out most of the good claims, and the latecomers arrived for dinner after the table had been cleared.

But Nome gave the tardy a second chance. Walking on the Nome beach that summer in 1899, one of the soldiers who'd been sent to keep the peace discovered a trace of gold in the sand on the beach. This prompted a prospector to drag his rocker box down to the beach, and in less than three weeks, he separated more than $1,000 worth of gold from the sand. The land office ruled that claims could not be staked in the tidal zone, so the beach became a free-for-all. A couple of thousand people bearing rocker boxes, shovels, and buckets descended on the beach, many setting up tents right there on the sand. The beach and the adjacent tundra were covered with furniture, suitcases, barrels of whiskey, pumps, sacks of beans and flour, piles of lumber, and bedding. All told, people dug about two million dollars in gold out of the beach. Naturally, this touched off another rush—gold nuggets just lying on the beach!—and thousands more people poured into Nome.

Chaos often attracts crooks, and Nome was no exception. Gangs, thieves, claim jumpers, looters, and all sorts of other shady characters showed up in this boomtown. And the biggest crook of all was a federal judge, one Alfred Noyes. A political heavyweight and friend of Noyes's, Alexander McKenzie had persuaded President William McKinley to appoint Noyes judge of the newly created judicial district that included Nome. In 1900, Noyes and McKenzie arrived in Nome with their luggage and a clever scheme: When prospectors brought claim disputes to the judge, he put them into receivership while he pretended to be considering the cases. While Noyes kept the disputes in limbo, McKenzie would hire men to mine the contested sites.

When they were finally caught and a federal judge in San Francisco ordered them to stop, the greedy duo brazenly continued their fraud, perhaps figuring that the Seward Peninsula was so remote that it lay beyond

Opposite: A Yup'ik man gathers a nice winter catch of burbot from his fish trap on the Kuskokwim River, near the village of Akiak.

Little Diomede

About 25 miles west of the western tip of the Seward Peninsula, in the middle of the Bering Strait between Alaska and Russia, lies the tiny (3 square miles!) island of Little Diomede, population about 140. Two miles farther west and a nation away sits Big Diomede (a whopping 11 square miles), Russia's easternmost point. During the winter, an ice bridge usually forms between the two islands, so someone could walk from the United States to Russia, though it's illegal and the fact that the Russians have a military base on Big Diomede ought to discourage such a venture. The international date line runs between the islands, which means that Big Diomede is 23 hours ahead of Little Diomede, thus their nicknames: "Tomorrow Island" for Big Diomede and "Yesterday Isle" for Little Diomede.

the reach of the law. It didn't. U.S. marshals arrested Noyes, McKenzie, and their court clerk. However, then as ever, the wealthy and powerful often did lie beyond the reach of the law: Noyes and McKenzie used their political connections to avoid prison, and only the clerk spent time behind bars.

Among those who came to the Nome area from far away in the 1890s were a number of Sami (sometimes called Lapps), the indigenous people of the northern regions of Norway, Sweden, Finland, and the extreme northwest of Russia. The Sami did not come after gold, however. They came for the reindeer. The Sami's story is wonderfully told by Faith Fjeld, an American author, lecturer, and historian of Sami descent, in a long article that provided most of the following information about the Sami.

Sheldon Jackson recruited Sami to come to Alaska to help teach reindeer-herding techniques to some of the Inupiat on the Seward Peninsula and elsewhere; reindeer herding has been the anchor of Sami culture since the 17th century. Reindeer are the same species as caribou, though after 10,000 years of separation—reindeer in Europe and caribou in North America—they've evolved slight differences. But the salient distinction is that most reindeer are domesticated, which is why Jackson also brought hundreds of reindeer to Alaska, to start the herds.

Some observers have questioned Jackson's motives. On the one hand, many Inupiat on the Seward Peninsula and elsewhere were in dire straits at the end of the 19th century, having been recently decimated by introduced diseases, particularly a tuberculosis epidemic they called "The Great Death." Jackson's Reindeer Project was seen as a way to help the impoverished and sometimes starving Inupiat make a living. On the other hand, Jackson seemed to see the Reindeer Project as a way to control the Inupiat, to blend them into the American economy and culture so they would become "friends and auxiliaries of the White Man," as Jackson once wrote.

Whatever Jackson's reasons and despite some early travails, the Reindeer Project turned out to be a success—for a while. Sami herders and reindeer trickled into western Alaska during the 1890s, then a large group arrived in 1898, the same year the Nome gold rush was igniting. In fact, a few Sami abandoned the Reindeer Project in favor of prospecting for gold, but most stayed on and taught about 600 Inupiaq and Yup'ik apprentices the ways of reindeer. For example, they showed the students how to rope and harness reindeer, how to milk them and make cheese, how to produce glue from

their hooves, and how to fashion Sami-style ski boots from reindeer heads. Soon, Alaska natives were using the reindeer for food and selling extra meat to the miners in Nome. By 1910, the herds in Alaska numbered about 27,000, a number that would balloon to 600,000 in a decade. Live reindeer also proved useful, especially in delivering mail. Pulling traditional sleds that the Sami had brought from home, reindeer could outpace dog teams; many Alaska natives and Sami got jobs as mail carriers.

Sadly, the Reindeer Project became a victim of its own success. As herds grew and profits grew with them, a couple of American businessmen bought up many of the reindeer, reducing the Inupiat and Sami to hired hands. Conditions on the reindeer lands deteriorated, and conflicts erupted among herders as their stock mingled. In 1929, the Great Depression struck, and the market for reindeer meat collapsed. As part of a broader effort to bring order to the reindeer industry, in 1937, Congress passed the Reindeer Act, which decreed that only Alaska natives, not whites, could be owners of Alaska's reindeer. Sadly, the Sami, who are a light-skinned and often blue-eyed and blond-haired people, were classified as white. The authorities gave them just two weeks to sell their herds, which they usually had to do at a loss. This shattered the lives they had built in Alaska. Some stayed on, some returned to their ancestral homeland, and others just scattered. The reindeer business lay in tatters for decades, but in recent years, a demand for reindeer meat has returned, stirring efforts to revive the industry.

Two mushers pose with their reindeer-powered sled. In the early 1900s, the Inupiat and Yup'ik started raising reindeer for food. By 1920, it had become a big industry, with western Alaska herds numbering some 600,000. Reindeer also excelled at pulling sleds and were sometimes used to haul the mail.

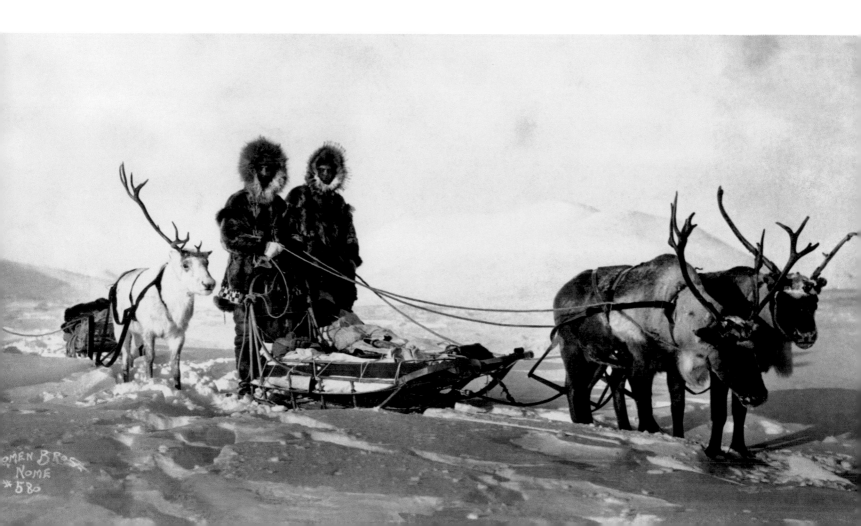

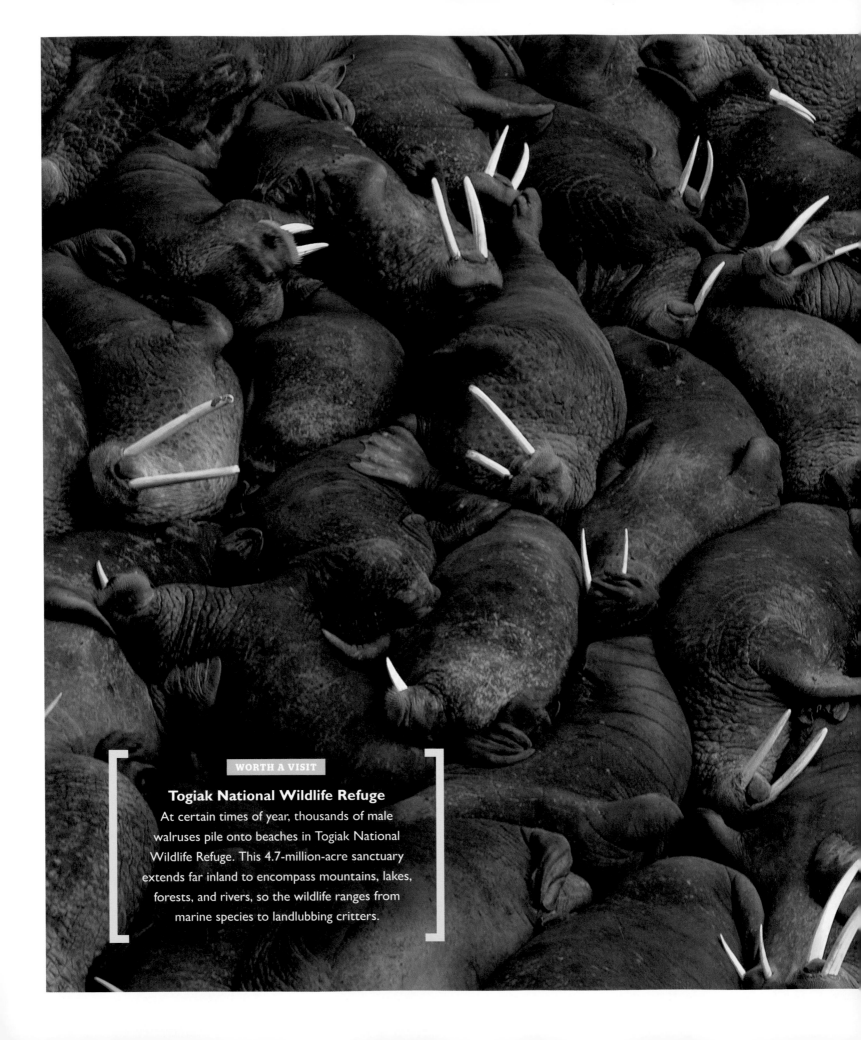

Togiak National Wildlife Refuge
At certain times of year, thousands of male
walruses pile onto beaches in Togiak National
Wildlife Refuge. This 4.7-million-acre sanctuary
extends far inland to encompass mountains, lakes,
forests, and rivers, so the wildlife ranges from
marine species to landlubbing critters.

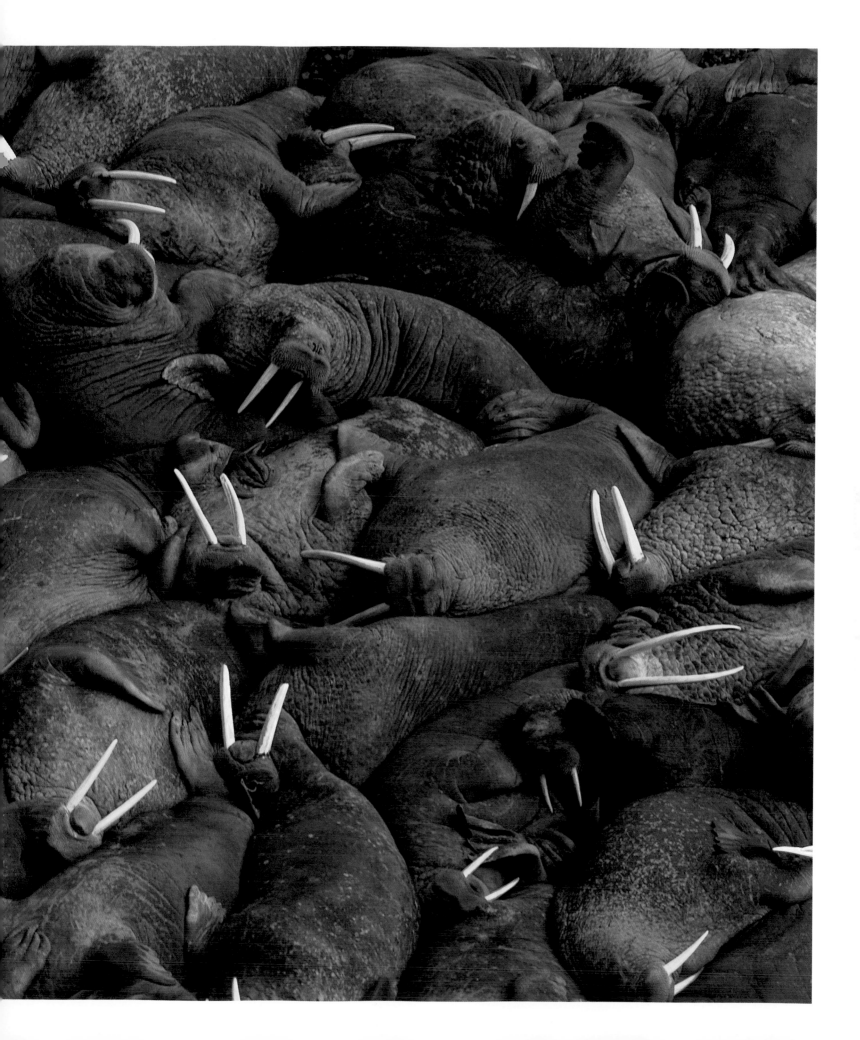

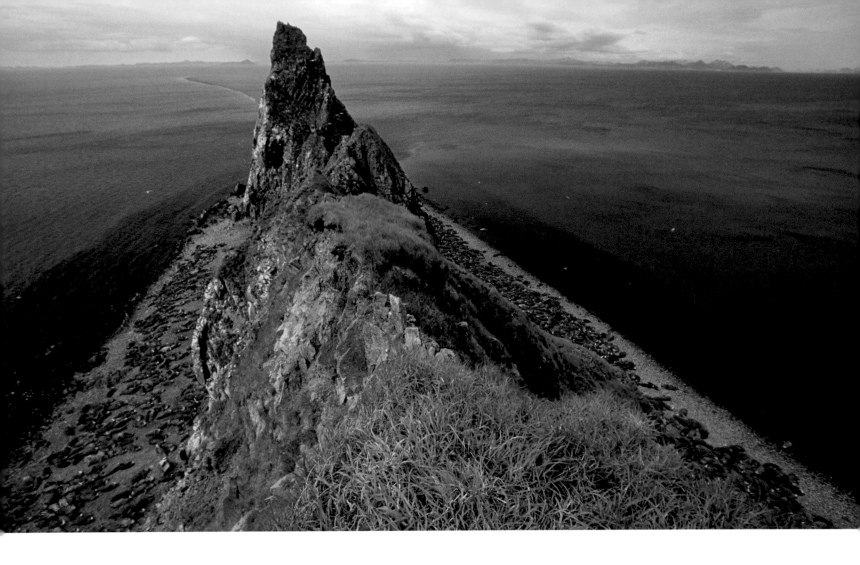

As many as 14,000 walruses at a time crowd onto Round Island, part of the Walrus Islands State Game Sanctuary, in Bristol Bay. Human access to the island is strictly controlled, but with proper permits, people can hike or even camp on this walrus haven. *Opposite:* Red fox kits

One of today's reindeer herds roams the tundra about 200 miles west of Nome. That's right, west, not east. This herd of 2,000 to 3,000 munches moss in the middle of the Bering Sea on St. Lawrence Island. St. Lawrence is a narrow, 100-mile-long island that lies a mere 36 miles off the mainland Russia coast. This stormy, windswept land is inhabited by about 1,500 people, nearly all of them Siberian Yupik. (They don't use the apostrophe, unlike the Central Yup'ik on the western Alaska mainland.) More than half live in the town of Savoonga, which owns the reindeer herd.

The reindeer are one of several efforts the people of St. Lawrence are making to lift their troubled economy. Living in such an extraordinarily remote place makes it tough to prosper in the market. St. Lawrence is more suited to a subsistence lifestyle, which is what the people here have relied upon for some 2,000 years, but it has gotten more difficult since the arrival of the Europeans and Americans. When American whalers nearly wiped out the whale population in the 19th century, it dealt a severe blow to the islanders, causing widespread famine.

Mother Nature can be harsh as well, such as in 2013, when adverse weather caused the walrus harvest to plunge. The islanders eat walrus meat, get oil from the blubber, use the hide for their skin boats, and even make drums out of the stomach membranes. St. Lawrence artists also have a long tradition of carving beautiful ivory sculptures

from walrus tusks, many of which they sell; it's a significant source of cash for some families. But during the spring hunt of 2013, the islanders took only 87 walruses, not even a tenth of their usual take. The Savoonga Council declared an economic disaster.

Walruses don't inhabit places that are easy to reach, but the Walrus Islands State Game Sanctuary, about 65 miles southwest of Dillingham as the bush plane flies, is relatively accessible. Of the seven islands in the sanctuary, Round Island is the only one even slightly set up for visitors. This three-mile-long isle serves as one of the largest haul-out sites for walruses in North America. Walruses are tough to count because they divide their time between swimming the sea in search of prey and staying on land, but as many as 14,000 have been tallied in a single day on Round Island. To set foot on the island, stay in the island's campground, or approach within three miles of it by boat, visitors must get permits.

Most travelers who want to see the walrus sanctuary charter a floatplane in Dillingham, but it is most certainly not walrus watching that brings most people to this town of 2,300 near the northern end of Bristol Bay. Fish are the magnet, both for residents and for visitors. Most of the residents, plus thousands of seasonal workers, do jobs that are in some way tied to commercial salmon fishing, whether the job involves going to sea on one of the hundreds of fishing boats that crowd the harbor, packing the catch in one of the processing plants, or serving beer to fishers when they come off the boats. Dillingham is the nerve center for the legendary Bristol Bay sockeye fishery, the largest in the world. Between 20 million and 40 million sockeye salmon enter the bay each year on the way to their spawning grounds, and the commercial fishers catch perhaps 15 to 30 million of them, depending on the limits imposed that year to ensure that enough sockeye make it through to spawn.

Many visitors to Dillingham also come to fish. These sportfishers chase sockeye, too, but their menu is more varied and includes other salmon species, arctic grayling, rainbow trout, Dolly Varden, arctic char, and northern pike. Anglers can hook king salmon in the river right in town, but most use Dillingham as a gateway to backcountry fishing in the millions of wild acres in nearby Wood-Tikchik State Park (the nation's largest state park) and Togiak National Wildlife Refuge (more than double the size of Wood-Tikchik). Non-anglers also head into these unspoiled lands for wildlife watching, kayaking, rafting, or just to hang out at a campsite or remote lodge and savor the essence of western Alaska. ■

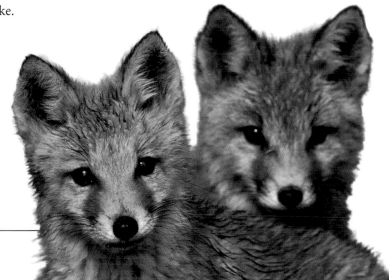

Sites and Sights in Western Alaska

Nushagak River king salmon

It is hard to get away from fish in **Dillingham,** but, then, most people don't want to; it is the fishing that brings them here. Located at the confluence of the Wood and Nushagak Rivers at the head of Bristol Bay, this town is perfectly positioned for both saltwater and freshwater fishing. For more than a century, it has served as the main port for the Bristol Bay sockeye fishery, the largest sockeye fishery in the world. The commercial fleet catches from 15 to 30 million of these succulent beauties in a year, with plenty left over to spawn and keep the cycle of life going. Visitors can go down to the harbor and watch the hundreds of boats coming and going. They can also charter one of the sportfishing boats and head into the bay or up the rivers to do some angling of their own. To continue with the fish theme, travelers can get the visitor center to help set up a tour of one of the salmon canneries. People wanting to get away from fish can enjoy the **Sam Fox Museum,** which shares a building with the visitor center and library. Renovated in 2011, this modest museum focuses on local history, particularly that of the Central Yup'ik. Exhibits of carved ivory, baskets, and skin sewing display some fine Yup'ik arts and crafts. *dillinghamchamberofcommerce.org*

Visitors to Dillingham who want to explore the great outdoors don't have to go far; the eastern boundary of **Togiak National Wildlife Refuge** lies just three miles west of town. This wilderness of lakes, rivers, mountains, and coastline sprawls across 4.7 million acres—more than twice the size of Yellowstone National Park. To navigate this expanse, almost all travelers enlist the help of guides. Rafting tours often start on headwater lakes and drift the waterways for several days. Most trips are geared to fishers or hunters, though sightseers and wildlife watchers will also enjoy themselves, assuming they don't mind roughing it. The refuge shelters moose, wolves, river otters, bears, caribou, and, on its extensive coastline, sea lions, whales, seabirds, and walruses. *togiak.fws.gov*

One of western Alaska's few roads leads 25 miles north out of Dillingham through the backcountry up to Aleknagik, a village on the southern tip of a lake of the same name. But the town is not the destination for most of the outside travelers who drive up from Dillingham; they're headed for **Wood-Tikchik State Park,** whose southern boundary lies at the northern end of Aleknagik Lake. Whether they take a boat up to the park from Aleknagik or fly in on a floatplane, they'll have entered the system of interconnected, 15- to 45-mile-long lakes that constitutes the heart of Wood-Tikchik—and a big heart it is, given that this 1.7-million-acre wildland is the biggest state park in the United States. Most visitors come to fish and hunt, but the lovers of wildlife and scenery also will find much to admire in this diverse park. Its west side features brawny mountains and alpine valleys, while the east side is characterized by wet and wooded lowlands. *dnr.state.ak.us/parks/units/woodtik.htm*

For something completely different, travelers in Dillingham can go look at walruses. However, they're not exactly at the town beach. Travelers must journey southwest about 65 miles by floatplane or a bit farther by charter boat to **Round Island** in the **Walrus Islands State Game Sanctuary.** In the course of one day, as many as 14,000 male walruses haul their 3,500-pound bodies onto this three-mile-long island, creating quite a scene of snoozing, swimming, and squabbling. The island also hosts many red foxes, hundreds of Steller sea lions, and hundreds of thousands of seabirds. To protect the wildlife, access to the island is strictly controlled, but with the proper permits, visitors can cruise close to shore in certain places, land and hike in certain places, and camp in the designated campground. *adfg.alaska.gov*

Bethel serves as the hub of the Central Yup'ik people and of the Yukon-Kuskokwim Delta, the Yup'ik heartland. Almost two-thirds of its approximately 6,400 residents are Yup'ik, but the other third is a pretty diverse lot. Most notably, an unusually large number of South Koreans and Albanians live in Bethel, many of whom work as cab drivers. Despite having only about 25 miles of roads, most of them unpaved, Bethel hosts almost 100 cabbies; it has more per capita than any other city or town in the United States. Visitors might want to take a cab to the **Yupiit Piciryarait Cultural Center and Museum** to see the collection of Yup'ik art and artifacts. *bethelculturalcenter.com*

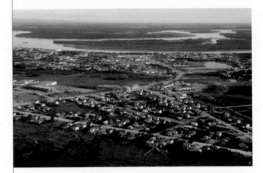

Bethel, in the Yukon Delta

Bethel is the gateway to the Yukon-Kuskokwim Delta, the Oregon-size lowland formed over the millennia as the Yukon and Kuskokwim Rivers deposited their loads of sediment on their way to the Bering Sea. Much of the delta falls inside the borders of the **Yukon Delta National Wildlife Refuge,** a 19-million-acre realm of tundra riddled with so many lakes, ponds, rivers, sloughs, and creeks that it often seems more water than land. Some mountains rise at the eastern edge of the refuge and some hills mound up here and there, but most of the delta is flat and just a few feet above sea level. Guides will take visitors to hunt, fish, or just

gaze at the wildlife. During migration, seemingly endless clouds of shorebirds, ducks, swans, cranes, geese, and other birds throng the delta, tanking up for the long days of flying yet to come. People go to the coast to see seals, walruses, whales, and, every now and then, a polar bear. *yukondelta.fws.gov*

About 20 miles out to sea from the Yukon-Kuskokwim Delta is **Nunivak Island,** most of which is part of the Yukon Delta National Wildlife Refuge. It's a sizeable chunk of real estate; at more than 1,600 square miles, it's the eighth largest island in the United States. A good thing, too, because that means its herd of some 500 musk oxen and herd of more than 1,000 reindeer have plenty of room to roam. About half the size of bison but even hairier, with long, drooping guard hairs that make them look like ambulatory mops, musk oxen are one of only two ice age Arctic ungulate species that have survived to the present day. *yukondelta.fws.gov*

The **Pribilof Islands** are the most remote places in Alaska in terms of being both far from any other inhabited sites and far from any land. Yet about 700 Unangan—whose ancestors were brought here from the Aleutian Islands by Russian fur traders a couple of centuries ago—live on St. Paul and St. George, the two main islands. "Main" is a relative term, given that even the larger island, St. Paul, is only about 100 square miles, but that's big enough for wildlife lovers. Nearly a million northern fur seals haul out on these islands, and 248 bird species—including numerous vagrants from Asia—have been sighted here. Not to mention that many ultra-cute arctic foxes prowl the islands. Each island has a small, clean, basic hotel—the St. George Hotel is a national historic landmark—and each island is served several times a week by direct flights from Anchorage, often bearing package tours of birding and wildlife-watching enthusiasts. *stpaultour.com* and *stgeorgetanaq.com*

Of all western Alaska communities, **Nome** is the one most geared to travelers who aren't

fishing or hunting. A walking tour of this town of 3,500 takes in some historic sites, though most of the gold rush–era buildings have burned down or been obliterated by storms. Visitors can see the source of those storms by strolling down Front Street, which skirts the edge of the Bering Sea. Every March, Nome

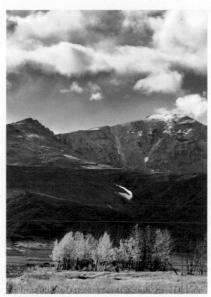

Kigluaik Mountains, Seward Peninsula

hosts the Bering Sea Ice Golf Classic, held on a makeshift, six-hole course atop the frozen ocean. Traditionally, golfers use bright orange balls and spent shotgun shells for tees. To learn more about Nome's flamboyant past, check out the **Carrie M. McLain Memorial Museum,** which covers early Seward Peninsula Alaska native life, the gold rush, and the 1925 diphtheria epidemic. A couple of shops in Nome carry Alaska native arts and crafts, ranging from souvenirs to fine art. Especially fine are some of the walrus ivory sculptures, an age-old specialty of Inupiat, Yup'ik, and Siberian Yupik carvers in this region. *visitnomealaska.com*

Nome is the only town in western Alaska that has a sizeable road system. About 300 miles of decent gravel roads fan out along the coast and up into the tundra-covered mountains. Visitors can rent a car and tour around on their own, though they should first make sure

they're properly informed and prepared. The 72-mile **Council Road** paces the Bering Sea for about 30 miles and then veers inland to the **Niukluk River.** In early summer, as the ice starts to melt, ringed seals, eiders, harlequin ducks, and other marine mammals and birds congregate in the gaps in the ice. The 86-mile **Kougarok Road** runs north into the rugged **Kigluaik Mountains,** which invite hiking on the wide-open tundra. Scan the roadside cliffs for gyrfalcons, nesting eagles, and peregrine falcons—and keep an eye out for grizzlies. Wending its way northwest to the village of **Teller,** the 72-mile **Teller Road** is another fine birding route and may yield encounters with musk oxen and reindeer. *visitnomealaska.com*

The first travelers to arrive in **Bering Land Bridge National Preserve** most likely came here from Siberia between 10,000 and 30,000 years ago. These days, the visitors—not that there are very many—generally come from Nome, a 100-mile bush plane flight to the south. Most of the 2.8-million-acre preserve is wet, bug-infested, lowland tundra, but the rolling hills of the interior beckon to hikers. Try the old lava flows around **Imuruk Lake** and the four big maar (crater) lakes in the **Devil Mountains–Cape Espenberg area.** The most popular destination is **Serpentine Hot Springs,** which offers people a place to soak in steamy hot water. Between soaks, travelers can wander amid the granite tors on the nearby ridges. *nps.gov/bela*

St. Matthew Island is far away from places that are themselves far away from civilization, making it arguably the most remote place in Alaska. This roughly 30-by-4-mile, tundra-coated isle lies in the Bering Sea some 200 miles from outposts like the Pribilof Islands or St. Lawrence Island. Not surprisingly, no humans live on the island, though it is home to a fair number of animals, including "singing" voles—a species found only here—and the McKay's bunting—a bird species that breeds only on St. Matthew's. And the rare human visitors who find their way here will not find any mosquitoes—proof of the island's extreme isolation.

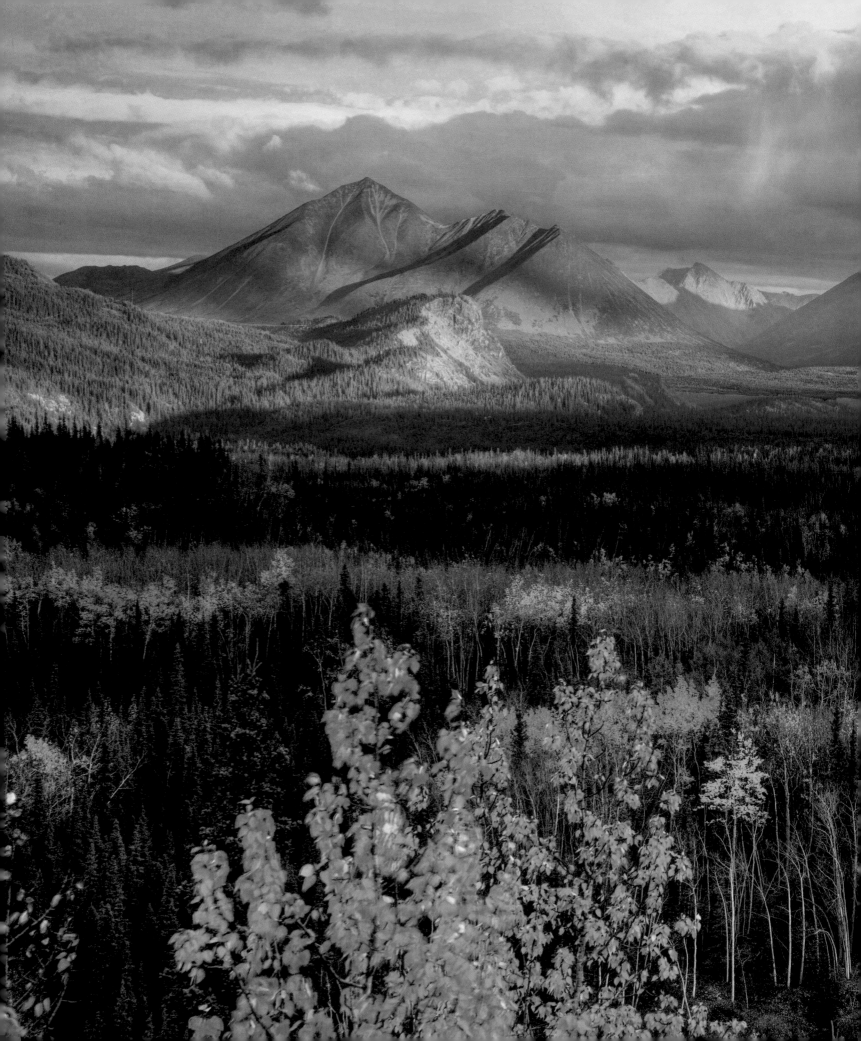

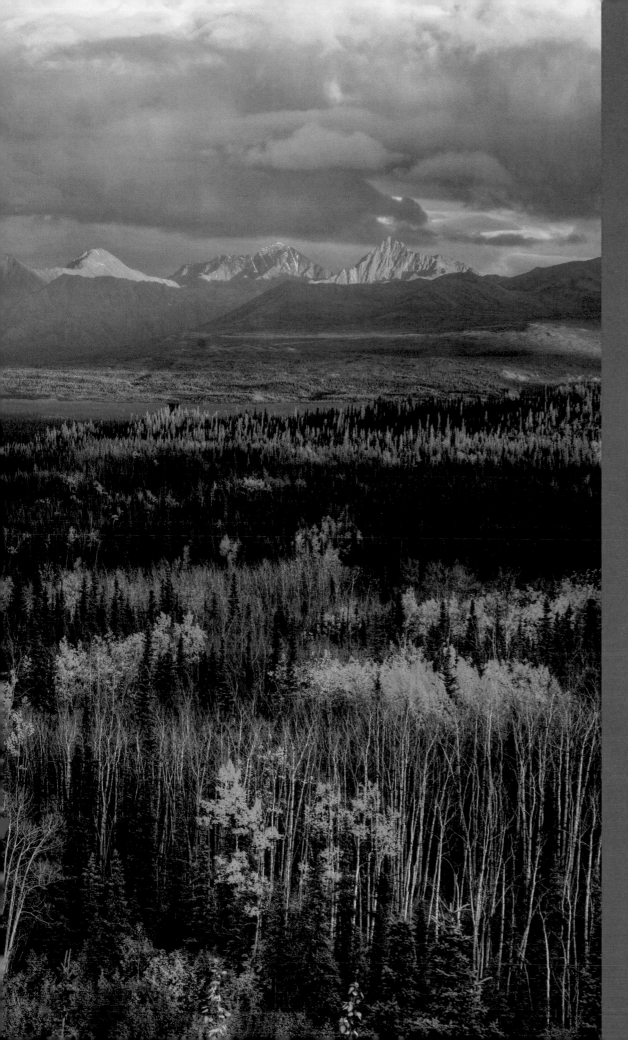

8] Interior Alaska

A fall scene in Denali National Park and Preserve. This big-sky expanse of boreal forest and mountains is representative of much of interior Alaska.

Interior Alaska

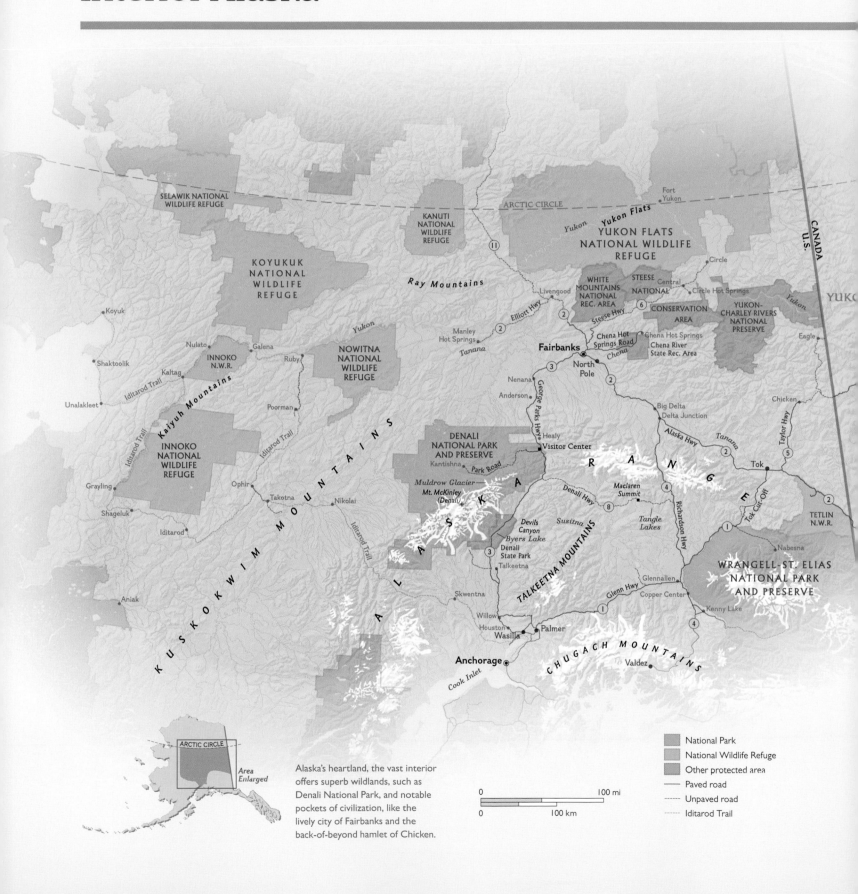

SELAWIK NATIONAL WILDLIFE REFUGE

KANUTI NATIONAL WILDLIFE REFUGE

KOYUKUK NATIONAL WILDLIFE REFUGE

ARCTIC CIRCLE

Yukon Yukon Flats

YUKON FLATS NATIONAL WILDLIFE REFUGE

Fort Yukon

Ray Mountains

Circle

WHITE MOUNTAINS NATIONAL REC. AREA

STEESE NATIONAL

Central

Circle Hot Springs

Koyuk

Livengood

Elliott Hwy

CONSERVATION AREA

YUKON-CHARLEY RIVERS NATIONAL PRESERVE

YUKON

Manley Hot Springs

Tanana

Chena Hot Springs

Chena Hot Springs Road

Chena River State Rec. Area

Eagle

Nulato

INNOKO N.W.R.

Galena

Ruby

NOWITNA NATIONAL WILDLIFE REFUGE

Fairbanks

Chena

Shaktoolik

Kaltag

Poorman

Kaiyuh Mountains

North Pole

Nenana

Anderson

Big Delta

Delta Junction

Chicken

Unalakleet

Iditarod Trail

Yukon

Iditarod Trail

George Parks Hwy

Alaska Hwy

Tanana

Taylor Hwy

Grayling

INNOKO NATIONAL WILDLIFE REFUGE

Ophir

Takotna

Nikolai

DENALI NATIONAL PARK AND PRESERVE

Kantishna

Park Road

Healy

Visitor Center

R A N G E

Tok

Shageluk

Muldrow Glacier

Mt. McKinley (Denali)

Denali Hwy

Maclaren Summit

Richardson Hwy

Tok Cut-Off

Iditarod

K U S K O K W I M M O U N T A I N S

A L A S K A

Devils Canyon

Byers Lake

Denali State Park

Susitna

Tangle Lakes

TETLIN N.W.R.

Nabesna

Aniak

Iditarod Trail

TALKEETNA MOUNTAINS

Talkeetna

WRANGELL-ST. ELIAS NATIONAL PARK AND PRESERVE

Skwentna

Glennallen

Kenny Lake

Willow

Houston

Glenn Hwy

Copper Center

Wasilla

Palmer

Anchorage

CHUGACH MOUNTAINS

Valdez

Cook Inlet

ARCTIC CIRCLE

Area Enlarged

Alaska's heartland, the vast interior offers superb wildlands, such as Denali National Park, and notable pockets of civilization, like the lively city of Fairbanks and the back-of-beyond hamlet of Chicken.

0 100 mi
0 100 km

National Park
National Wildlife Refuge
Other protected area
Paved road
Unpaved road
Iditarod Trail

CANADA
U.S.

Mount McKinley rises like a citadel in the midst of Alaska's vast interior. Not only is it the tallest mountain in North America, in a sense, it is the world's highest peak; it towers some 18,000 feet above the land at its base, far more than does Mount Everest and more than any peak other than Mauna Kea, in Hawaii, which is mostly submerged. From McKinley's summit, you can see more than 200 miles across Alaska's heartland—a blend of boreal forest, lakes, swift rivers, tundra, glaciers, and other mountains. In the words of Robert Tatum, one of the climbing party that first reached McKinley's summit, "The view from the top of Mount McKinley is like looking out the windows of Heaven."

Tatum and his fellow mountaineers tackled McKinley in 1913. Another group preceded them in 1910, and would have gone down in history as the first to reach the highest point on the continent if only they hadn't climbed the wrong peak. This sounds utterly moronic—like trying to be the first person to swim from Cuba north to Florida but accidentally stroking south to Jamaica instead—but it was actually an understandable mistake. Mount McKinley boasts two pinnacles, the South Peak and the North Peak. The South Peak is the true summit, at 20,320 feet, but the North Peak is close behind at 19,470 feet, and was long thought to be the higher of the two.

An Athabaskan mask, "Father of the Silver Salmon." In addition to paint, the unknown artist used wood for the chin, feathers stuck in what are called "spirit rings," and carved wood for the protruding fish heads.

Despite the mix-up, the 1910 climb is considered one of the most amazing mountaineering feats of all time. A great account of this venture can be found in Bill Sherwonit's classic book, *To the Top of Denali,* which provided much of the following information. The guys who did it were anything but mountaineers. It essentially started as a dare, made in a bar in Fairbanks in the fall of 1909; reports don't make clear how many drinks may have been involved. The man who accepted the dare, Tom Lloyd, was a 50-year-old, overweight prospector. He rounded up some prospector buddies and, in December—yes, December, when it's 20 below and there are about four hours of daylight—the group of seven headed for the mountain, about 170 miles away.

It took the better part of two months for the group to reach the Mount McKinley area. By that time, some of them had been at each other's throats and three men had quit the expedition. The four remaining men spent March casting about for a route to the top, crossing the dangerous Muldrow Glacier, and hauling supplies higher and

Charlie McGonagall (left) and Tom Lloyd, two members of the renowned Sourdough Expedition, photographed at their high-elevation camp on Mount McKinley in 1910. This ragtag group of prospectors set out to be the first people to ascend the continent's highest mountain, but they climbed the North Peak, unaware it is slightly lower than the South Peak.

higher—at one point, they spent several days lugging firewood and, seriously, a wood-burning stove up to one of their camps on the glacier. And they did all this with no real mountaineering equipment; picture guys in bib overalls, long johns, parkas, and moccasins wielding homemade ice axes and crampons.

On April 1—how appropriate—the foursome made their first summit attempt from their camp at about 11,000 feet, but a storm drove them back. A couple of days later, three of them tried again; Lloyd stayed behind for reasons unknown, but likely due to altitude sickness. The trio was traveling light, with just some hot chocolate and a bag of doughnuts. Oh, and the 14-foot spruce pole they'd been dragging along for some time, plus a 6-by-12-foot American flag to fly from it. They figured that their pals back at their mining camp in Kantishna would be able to see it flapping in the wind, thus proving that they had made it to the summit. This was a tad optimistic, given that Kantishna is some 35 miles from Mount McKinley and spotting the flag from there would be akin to spotting an ant from an airplane.

Flagpole and doughnuts in hand, the three pushed rapidly up the mountain. Just a few hundred feet from the top, one of the climbers called it a day. He later explained that he'd just finished his turn carrying the pole and figured he'd done his bit, though some suspect he, too, fell to altitude sickness. But the other two made it, planted the pole, and returned to the high camp. They'd endured a climb of more than 8,000 vertical feet up and 8,000 feet back down in 18 hours; highly trained and elaborately equipped climbers today usually only do 3,000 or 4,000 vertical feet when they summit the mountain. Those wild men of 1910 came to be known as the Sourdough Expedition.

For a few years, many people doubted that the Sourdoughs had really made the climb, and not just because no one could see the flag from 35 miles away. More likely, the doubts resulted from Lloyd's fanciful telling of the story; for example, he claimed that they'd ascended both the North and South Peaks. But the Sourdoughs were vindicated when members of the 1913 expedition were on their way to the South Peak and actually spotted the flagpole.

The peak those men in the 1913 expedition climbed has long been listed as 20,320 feet high, but in 2013, that hallowed figure was threatened by a U.S. Geological Survey (USGS) report that came up with the figure 20,237. However, despite Alaska's lieutenant governor announcing that Mount McKinley's height had been recalculated downward, the South Peak's elevation, in fact, had not been officially changed. The USGS later explained that the radar technique they used is not meant to measure peaks and serves a different purpose, so the number 20,237 cannot be taken at face

value. Regardless, even at 20,237 feet, McKinley would still be the tallest mountain in North America by a wide margin.

Although more than a thousand climbers attempt to reach the summit of Mount McKinley in a typical year (about half to two-thirds succeed), the vast majority of travelers prefer to gaze at the mountain from a lower, and safer, vantage point. However, there are a number of visitors who don't know a crampon from a coupon but still get summit-elevation views of the mountain by taking high-altitude flightseeing trips. Passengers on these flights must be physically fit and wear oxygen masks in unpressurized cabins, but that's considerably easier than, say, carrying a 14-foot spruce pole up to the top. Most flightseeing trips stay several thousand feet lower, below oxygen-mask levels, but they still provide spine-tingling perspectives of McKinley and other mountains in the mighty Alaska Range. Some of the trips include landings on high-elevation glaciers, allowing passengers to set foot in this exotic alpine world.

One final high-elevation viewing option exists, but only a handful of people have ever used it, probably because it makes toting a 14-foot pole up the mountain seem reasonable by comparison. This is the hang-gliding option. Yes, a few people have packed hang gliders up to the top of Mount McKinley and then soared off to landing points far, far, far below. They all lived to report that it is, indeed, exhilarating; yet there has not been a crowd rushing to duplicate their feat.

Even climbers who reach the 20,320-foot summit of Mount McKinley don't get this wondrous aerial view of what locals simply call "the Mountain." To enjoy this perspective, travelers must go up in a bush plane, some of which come with oxygen masks for high-altitude flying.

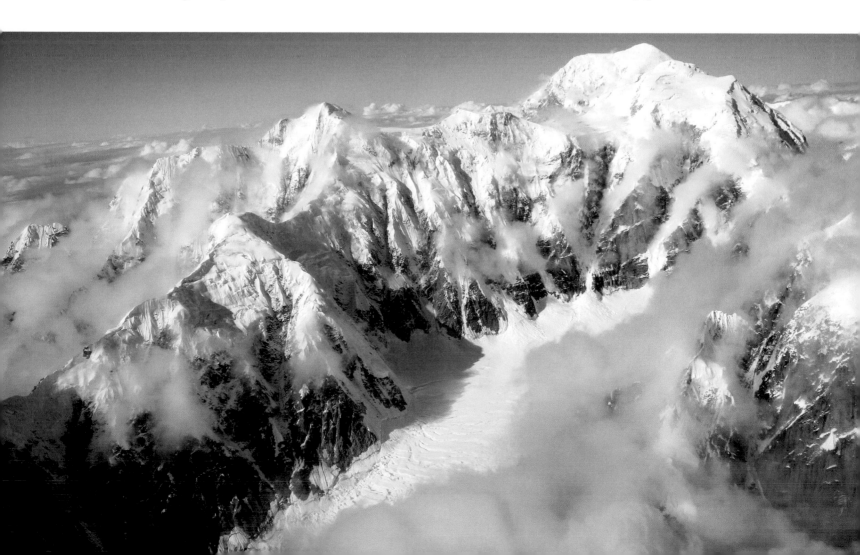

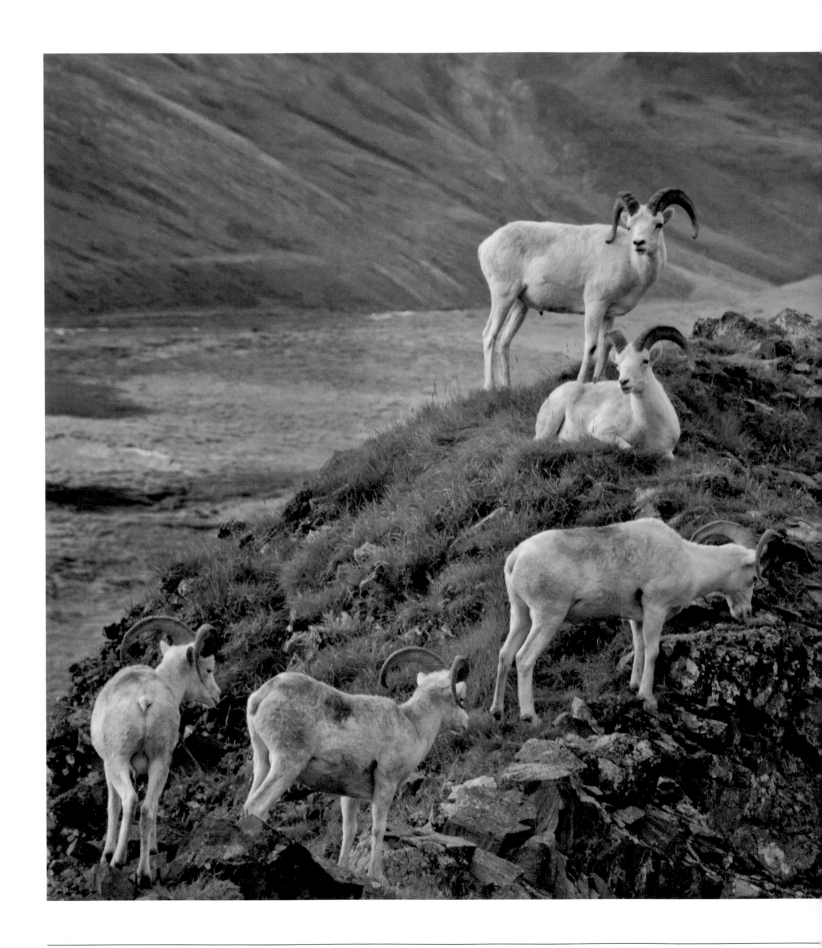

DID YOU KNOW?

Bug-Free Cars

Sometimes in the interior, the mosquitoes will swarm around travelers in such numbers that a person cannot get into her car without bringing dozens of six-legged hitchhikers in with her. Here's how to prevent this invasion: Unlock the car door, walk about 20 feet away, jump around like a demented person to shake off the beasties, sprint to the car, open the door quickly, jump in, and slam the door shut. Sure, it looks ridiculous, but it's worth it.

Most people choose to look at McKinley from the lowlands. Lists of good viewpoints range from the lobby of the Museum of the North, in Fairbanks, to well-placed pullouts along the George Parks Highway between Anchorage and Fairbanks, to the top of the J.C. Penney parking garage in Anchorage. (Explorer George Vancouver and crew even saw the summit from their ship in Cook Inlet in 1794.) But the best easily accessible viewpoints are strung out along the Park Road, which is the 92-mile, dead-end byway that runs west from the George Parks Highway through Denali National Park and Preserve.

It is fitting to behold the mountain from inside the park. After all, the mountain is located in Denali, a park that was born in 1917 as Mount McKinley National Park; it was rechristened Denali National Park and Preserve in 1980. People have

Dall sheep generally stick to the rocky heights to avoid close encounters with wolves, bears, and other predators.

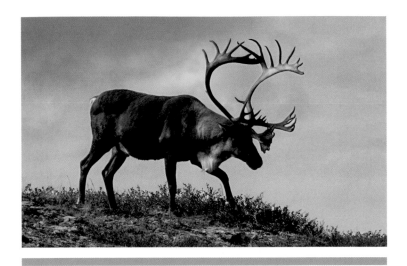

Denali Field Seminars

1 **Big Five** Though the field seminars available to visitors to Denali National Park vary some from year to year, this three-day course on the park's five most charismatic large mammals is a common offering. Participants explore the backcountry with experts while learning about the park's bears, wolves, Dall sheep, moose, and caribou.

2 **Glaciology** During the five days of this seminar, the small group will hike out with a park glaciologist to a glacier and learn about these rivers of ice. Participants will also help conduct scientific research, such as using high-precision GPS to map the glacier's terminus position and ice surface elevations.

3 **High-Country Wildflowers** Flower lovers will spend three days with a naturalist in the forest and up in the tundra looking at the spring burst of wildflowers (which occurs in June in Denali). Participants will learn to identify flowers and find out how they've adapted to the harsh conditions.

4 **Edible & Medicinal Plants** An authority will take participants into the field to teach them how to identify and collect edible and medicinal plants. People also will get to prepare meals, herbal remedies, and body care products using the plants they've gathered.

been dueling for decades about whether to use "Denali" or "McKinley" as the name for the mountain and the park. "Denali," meaning "the great one" or "the high one," was the original name for the mountain, bestowed by the Koyukon Athabaskans. Of course, it's a big mountain, and other Alaska native peoples also noticed it and had names for it, such as "Dghelaay Ce'e," the Ahtna name, and "Diineezi," the Middle Tanana name. When the Russians came along, they dubbed it "Bolshaya Gora," but they didn't have much traction in this part of Alaska, and that name didn't stick.

The first non-native American to get into the act was a prospector named Frank Densmore, who, in 1889, modestly named it "Densmore's Mountain." But Frank was pretty much the only person taken with that name. Seven years later, someone called it "Mount McKinley" and that became the official name, which it still is—except in Alaska. For a long time, many Alaskans lobbied to change the names of both the mountain and the park to "Denali." In 1980, when the federal government agreed to call the park "Denali" but not the mountain, Alaska officially changed the mountain's name to "Denali" in all state records. These days, most Alaskans call it "Mount Denali," but many locals have their own, uncontroversial name for it—simply, "The Mountain."

The Mountain is so imposing that travelers often spend an inordinate amount of time staring at it, but there are plenty of other things to do in the park. Which is good, given that The Mountain is partly or entirely obscured by clouds or fog or rain more often than not during the summer—skies are actually clearer in winter and spring.

Second only to The Mountain, Denali's wildlife is the most celebrated feature of the park, and rightly so. Bigger than Vermont, Denali encompasses diverse habitats, including boreal forests, braided river valleys, ponds, lakes, and rolling hills swathed in tundra. With such a variety of landscape types, it comes as no surprise that the park also shelters a wide variety of animals. Without backpacking into the hinterlands, the best way to see the wildlife—and the scenery and The Mountain—is to take one of the shuttle buses out the Park Road. With rare exceptions, these are the only vehicles allowed beyond the first 15 miles.

Opposite: Lucky visitors to Denali National Park will get a clear view of Mount McKinley. *Above:* Both female and male caribou sport antlers.

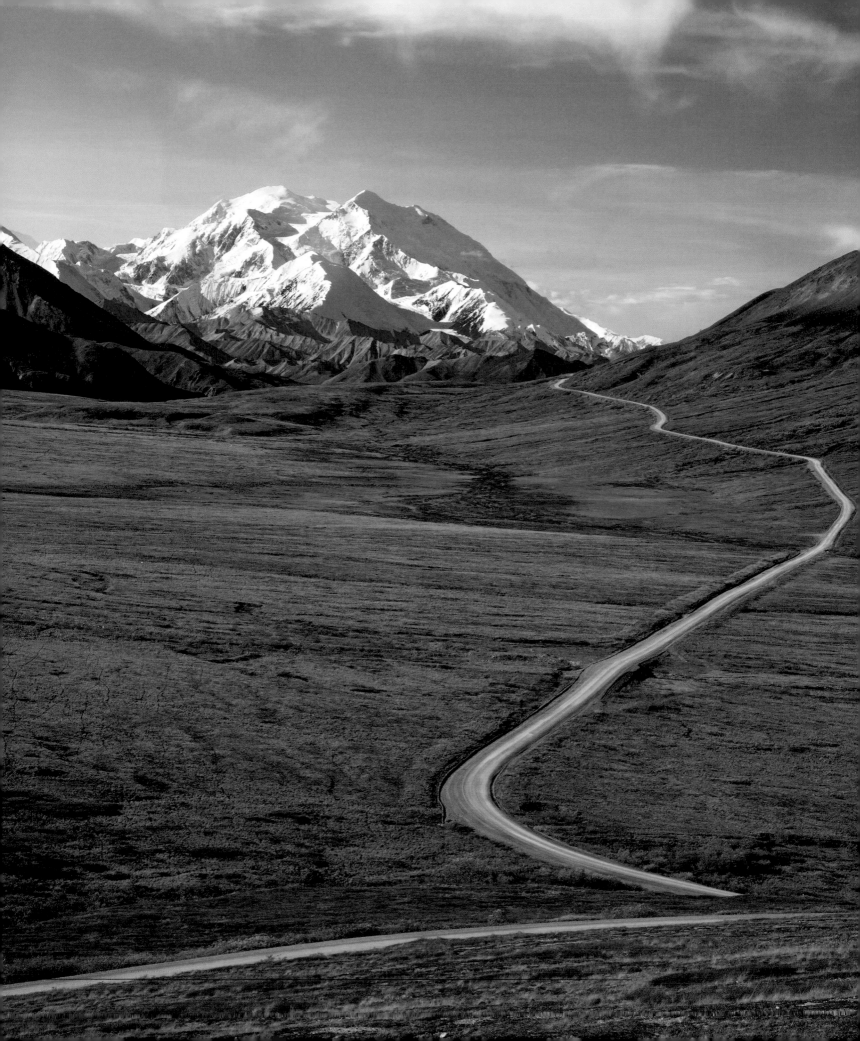

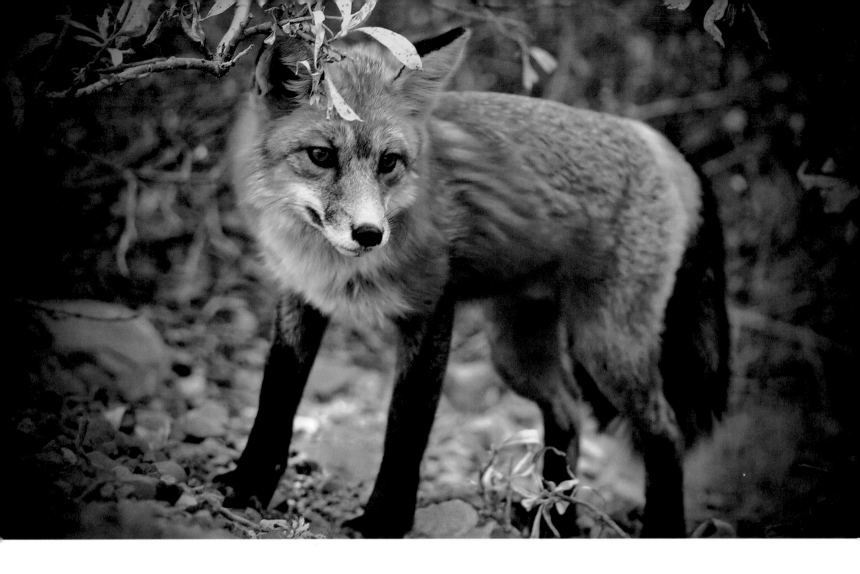

Red foxes, which can also be colored black or silver, range throughout Denali National Park and are often spotted by visitors. These crafty hunters mainly prey on mice, voles, lemmings, and snowshoe hares, but they also have a taste for blueberries and crowberries.

Aside from mosquitoes, moose are often the first critter bus passengers spot. They're fairly numerous, they're huge, and they're usually standing in the open in the shallows of a pond chewing on slimy vegetation they've just ripped off the bottom. Snowshoe hares are not huge and don't tend to stand around in the open, but sometimes they're incredibly numerous. They undergo about a ten-year boom-and-bust cycle, and if they're in a boom period, visitors will likely see some of them as the bus motors through the forest. They reach population densities as high as 600 per square mile. Their furry, outsized paws (their snowshoes) make them easy to identify.

Lynx largely depend on snowshoe hares for survival; when times are good (from the lynx's point of view), a lynx will eat one hare every day or two. Lynx populations rise and fall in relation to the snowshoe hares, but with a bit of a lag. When hare numbers are peaking, more lynx start surviving and producing more young, so their numbers rise in a year or two. But with more lynx around to prey on the hares, perhaps combined with the hares overgrazing available food resources, the snowshoe population declines, which in turn causes the lynx population to decline in a year or two. However, even when lynx numbers are high, visitors seldom see one of these stealthy cats.

As the bus continues west, the landscape gradually grades from forest to tundra. The absence of any vegetation higher than a grizzly's belly greatly increases the odds of sighting a sow and her cubs ambling along a distant hillside, or perhaps a burly boar (a male grizzly) searching for carrion beside a river. Sometimes grizzlies show up right next to the road, perhaps digging after an arctic ground squirrel. It's amazing how fast a grizzly can shovel big chunks of tundra using its weightlifter shoulders and Frisbee-size paws. It's also amazing that a 500-pound creature would put so much effort into trying to catch an animal that weighs about as much as one of the bear's claws, but apparently grizzlies think of arctic ground squirrels the way a five-year-old child thinks of ice cream.

Except for its last few miles, the 92-mile Park Road is surrounded by the wilderness section of the park. Those last few miles lead into one of the preserve sections, the millions of acres of Denali in which, within limits, a regulated number of people can engage in subsistence hunting, fishing, and trapping. Many of the folks who can legally pursue subsistence activities in the preserve are Athabaskans, whose ancestors hunted, fished, and trapped across most of interior Alaska for more than a thousand years.

Travelers can get an introduction to Athabaskan history and culture at the Morris Thompson Cultural and Visitors Center, a grand complex on the Chena River in downtown Fairbanks. They'll learn that the Athabaskans aren't a clear-cut social/cultural entity, such as the Unangan or the Tlingit. Athabaskan is a language family that includes 11 distinct linguistic groups in Alaska and many others in Canada and the lower 48 states. Though all the Athabaskans in Alaska share some traditions and practices, they tend to identify at a more local level; this was especially true in the past when they thought of themselves as belonging to a seminomadic band of maybe a few dozen nuclear families. The center offers a museum, an artisan's workshop and demonstration area, gorgeous sidewalk mosaics inspired by the famous beadwork of the Athabaskans, classes in traditional arts and crafts, and even a "Taste of Alaska" program for small groups that want to sample traditional foods.

Fairbanks also hosts the World Eskimo-Indian Olympics every summer, going back to 1961. This event draws indigenous people from all over Alaska and even a few from other parts of the circumpolar Arctic, such as Greenland. But don't expect to see competitors running the mile or tossing the shot put. Instead, onlookers might see the one-foot high kick, in which an athlete leaps into the air, kicks one foot up as high as possible at a suspended target,

A Drive Through Denali National Park

The 92-mile Park Road extends into Denali's wild heart—stepping through spruce and aspen forests, along mountainsides above river valleys, across vast expanses of alpine tundra, and providing ample opportunities to view the resident wildlife.

❶ Head to the **Wilderness Access Center,** a half mile from the park entrance. Most excursions begin here. Park buses only travel beyond Mile 15—no private vehicles.

❷ The park's dramatic landscape takes center stage as the road rises from the East Fork Toklat River to **Polychrome Pass,** at Mile 46. Savor the vista from the rest stop here.

❸ The **Eielson Visitor Center,** at Mile 66, is all about location, location, location. From this perch, visitors get a top-to-bottom view of Mount McKinley, if skies are clear.

❹ From Eielson, the road descends to **Wonder Lake.** At Mile 84.6, most buses take the short spur to **Wonder Lake Campground,** a beautiful spot to picnic or hike.

❺ A few buses continue to **Kantishna,** a mile from the road's end. Several preexisting, privately owned lodges remain here, and are available to rent.

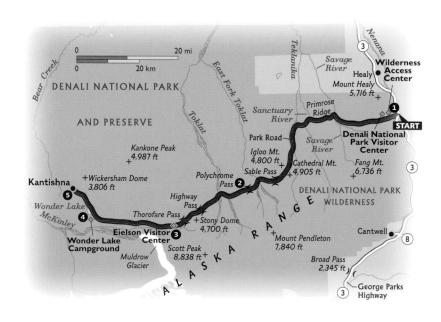

then returns to the gym floor and lands on the same foot with which he kicked. The record for men is an astounding 9 feet 9 inches (Alaskan style; there's also a Canadian style). Then there's the contest with ear weights, in which a participant must walk as far as he can with 16 pounds of lead ingots hanging by a length of twine wrapped around the base of his ear. The world record holder staggered 2,887 feet before the pain overwhelmed him.

An event like the ear weight may strike outsiders as harsh, but, then, so was the environment that the people who established these games had to endure. Coping with discomfort, even pain, was sometimes vital, perhaps a matter of life and death.

> **❝ People like the Koyukon recognize that their community is not limited to the human sphere, but includes their entire surrounding environment. ❞**
>
> **[Richard Nelson, cultural anthropologist]**

Some of the games helped people specifically train for situations they would likely encounter. For example, the kneel jump entails leaping forward from a kneeling position and landing with perfect balance, a crucial skill when traveling over moving ice. Instead of athletics, a few events involve traditional skills, such as the fish-cutting contest and the seal-skinning contest. By the way, the record for skinning a seal is 57 seconds, faster than most people can slice up an apple.

The Athabaskans had long hunted and fished in the area where Fairbanks now exists, but being seminomadic, they had never settled there. Besides, it's not a site knowledgeable people would have chosen. In fact, Fairbanks was founded by accident. In 1901, a shifty character named Captain E. T. Barnette hired a sternwheeler to take him and 130 tons of cargo up the Tanana River so he could establish a trading post where a busy trail and a proposed railroad line would

An archival photo depicts an Athabaskan family preparing for a caribou hunt. Caribou were (and often still are) a vital resource to many people living in Alaska's interior.

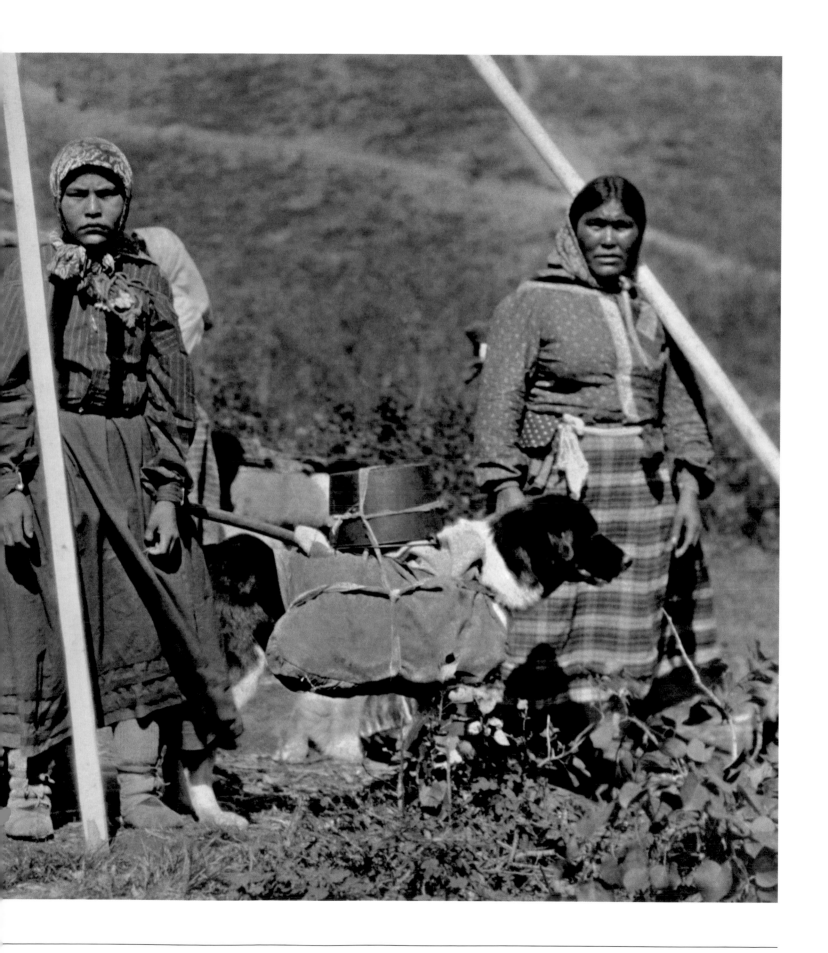

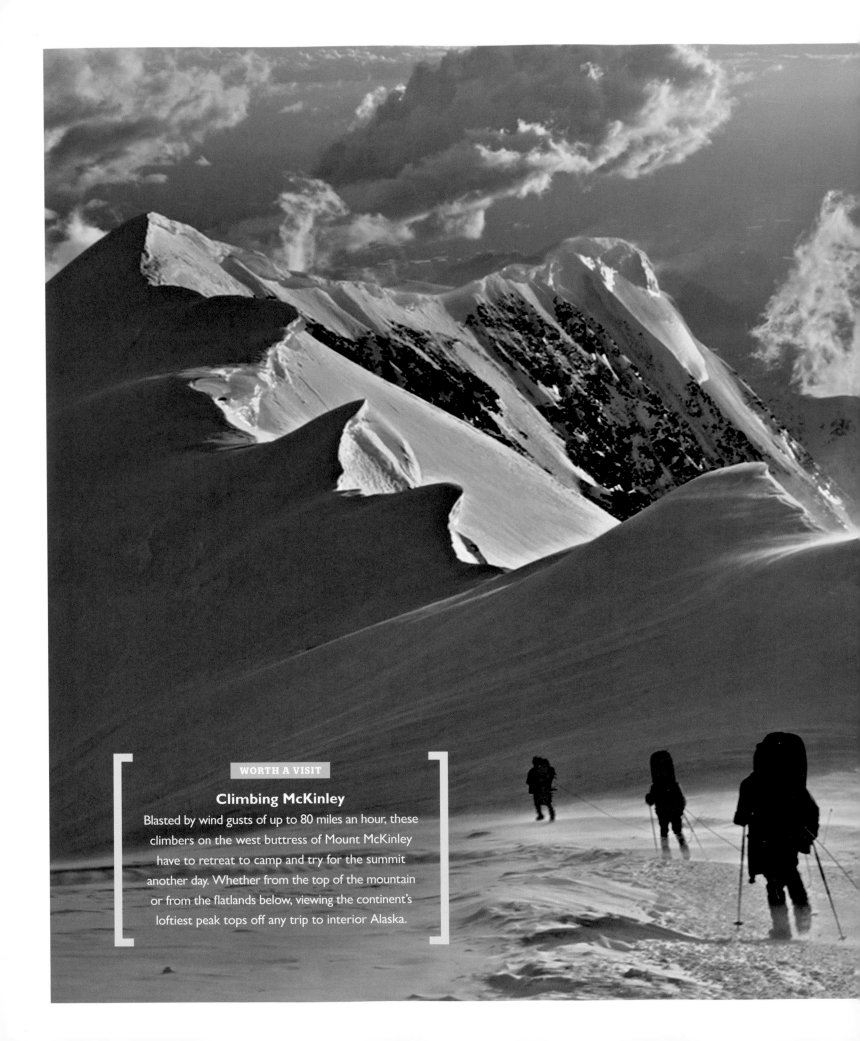

Climbing McKinley

Blasted by wind gusts of up to 80 miles an hour, these climbers on the west buttress of Mount McKinley have to retreat to camp and try for the summit another day. Whether from the top of the mountain or from the flatlands below, viewing the continent's loftiest peak tops off any trip to interior Alaska.

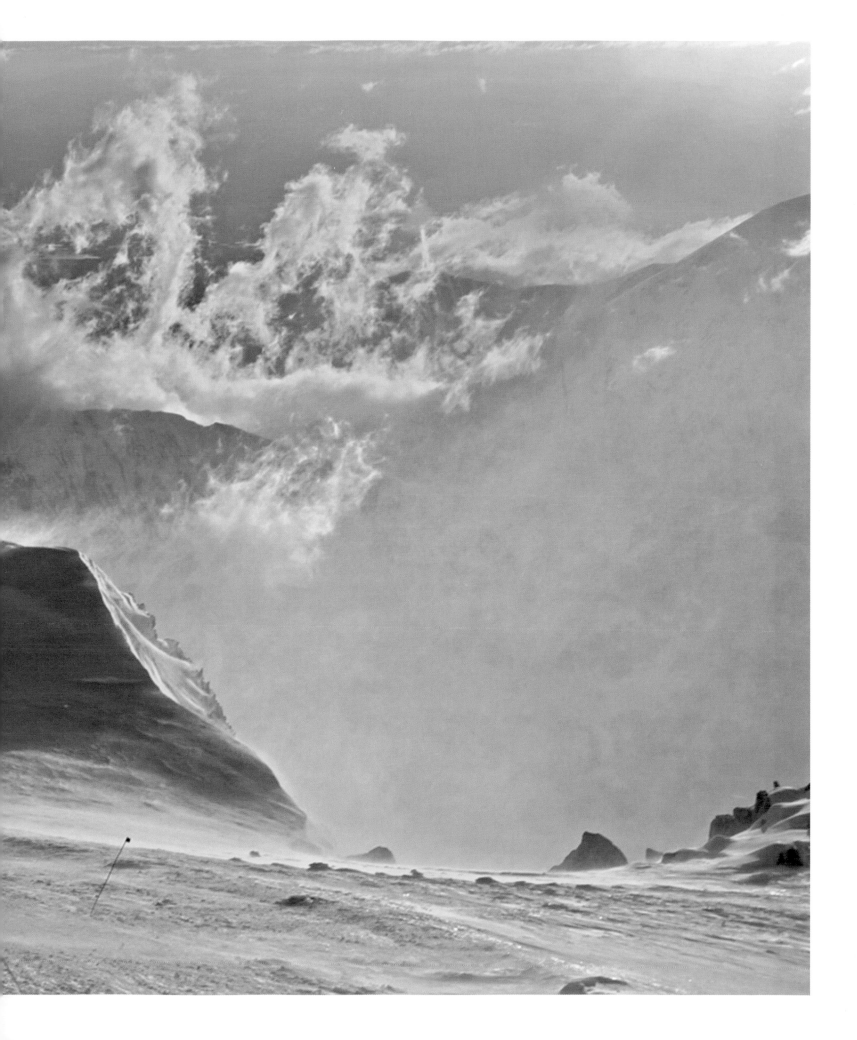

cross. However, some rapids prevented the overloaded riverboat from reaching the crossing, so Barnette directed the captain to try an alternate route up the Chena River. That failed, too, and to safely make it back down the river, the sternwheeler captain had to dump Barnette, his wife, his workers, and his cargo at an unprepossessing spot on the south bank of the Chena. And thus was Fairbanks founded.

But Barnette was lucky. The following year, gold was discovered near Fairbanks. Apparently, Barnette wanted to make sure that this discovery turned into a gold rush, so late that year, he asked a musher who had been among those dumped off the sternwheeler with him to take a sled dog team to Dawson City and spread the word. The massive Klondike gold rush had taken place just a few years earlier near Dawson City, and a fair number of gold-hungry folks were still around the area. Sure enough, they came stampeding to Fairbanks after the Dawson City paper interviewed the musher and ran a headline saying, "Rich Strike Made in the Tanana," and other papers around the country picked up the story. Barnette became a rich man, the mayor of Fairbanks, and a notorious swindler. But the most intriguing part of this tale is that musher, Jujiro Wada.

Born in a small town in Japan in 1875, Wada was—according to some reports—the son of a lower-class samurai warrior who died when Wada was young. When he was 16, he stowed away on a freighter to San Francisco, where he stayed only a few weeks. Not that he chose to leave; he was apparently shanghaied and tossed aboard a whaling

Two men slog through the snow near Fairbanks in the early 1900s, using a dogsled and snowshoes. For many years, this is what winter travel looked like in Alaska. *Opposite:* Bush pilot Don Sheldon flies above Alaska mountains in 1964.

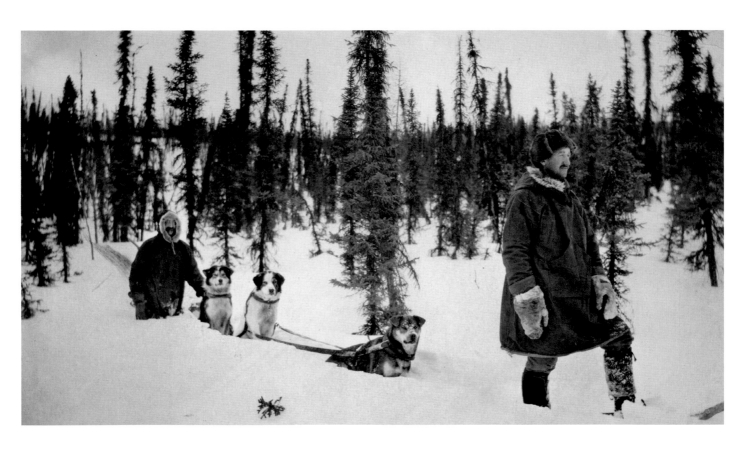

ship heading for the Arctic Ocean off the north coast of Alaska. However, the voyage turned out well for Wada. During his three years as a cabin boy, he learned to read, write, and speak English, and he became an accomplished navigator. Afterward, he spent some years in and around Barrow and picked up skills as a hunter, trapper, and musher. In 1901, a Japanese prospector—almost certainly Wada, as there were very few Japanese in Alaska—showed up in Nome during that town's gold rush and applied for U.S. citizenship so he could stake a claim, but he was denied. Shortly thereafter came Wada's time with Barnette, after which he spent several years mushing around Alaska and northern Canada, hunting and trapping for a living.

In 1906, a group of Inupiat showed up in Nome to do some fur trading, with their chief doing the negotiating—and that chief was none other than Wada. Soon dubbed "King of the Eskimos" by local papers, Wada had in fact earned the trust and respect of some Inupiat by dealing with them fairly, unlike many of the white traders, so a group of them had made him a chief. Wada spent a couple of years in and around Nome doing chiefly things and adding to his already astonishing repertoire of accomplishments by becoming a celebrated long-distance runner. He won two 50-mile races and one 35-miler, for which he was paid $2,800.

His running exploits notwithstanding, Wada was still known mainly for his mushing prowess, and in 1909, the Seward Chamber of Commerce hired him and several other mushers to blaze a trail from Seward to the newly booming goldfields of Iditarod, about 500 miles to the northwest. Yes, that Iditarod, the one that has given its name to the world's most famous sled dog race. Wada and his companions established the trail that would later become the route for the first half of the Iditarod. The remaining years of Wada's life are less known, but he reportedly mushed tens of thousands of miles more and made a fair amount of money prospecting for gold. He died in 1937.

The trail from Seward to Iditarod combined with the mail trail from Iditarod to Nome would become the basic route for the Iditarod race, though the race starts in Anchorage, omitting the Seward to Anchorage stretch. The inspiration for the race took place in 1925. In December 1924, a diphtheria outbreak started in Nome and environs, home to some 10,000 people at the time. This highly contagious disease has now been all but

The Bush Pilot

Landing on mountain glaciers to pick up a climbing party or feeling their way through fog to deliver freight and mail to a remote village—the daily work of bush pilots deserves respect. But what makes them legendary are their daring efforts in dire circumstances. Consider what storied bush pilot Don Sheldon did when a boat capsized in a dangerous Devil's Canyon rapids of the Susitna River, leaving seven battered and freezing passengers stuck on a narrow ledge at the base of one of the canyon walls. Sheldon couldn't land in the thrashing rapids, so he set his pontoons down on a sliver of quiet water a quarter mile upstream and drifted down through the raging whitewater.

As the lurching plane came alongside the men, Sheldon hit the throttle and somehow managed to maneuver the plane close enough to the ledge for one of them to jump onto a pontoon and climb into the cab. Sheldon had to drift wildly for a mile and a half through the rapids until he reached a quiet stretch of water, where he dropped off the man. Then he took off and repeated the entire sequence three more times, picking up two men on each pass, until all were safe.

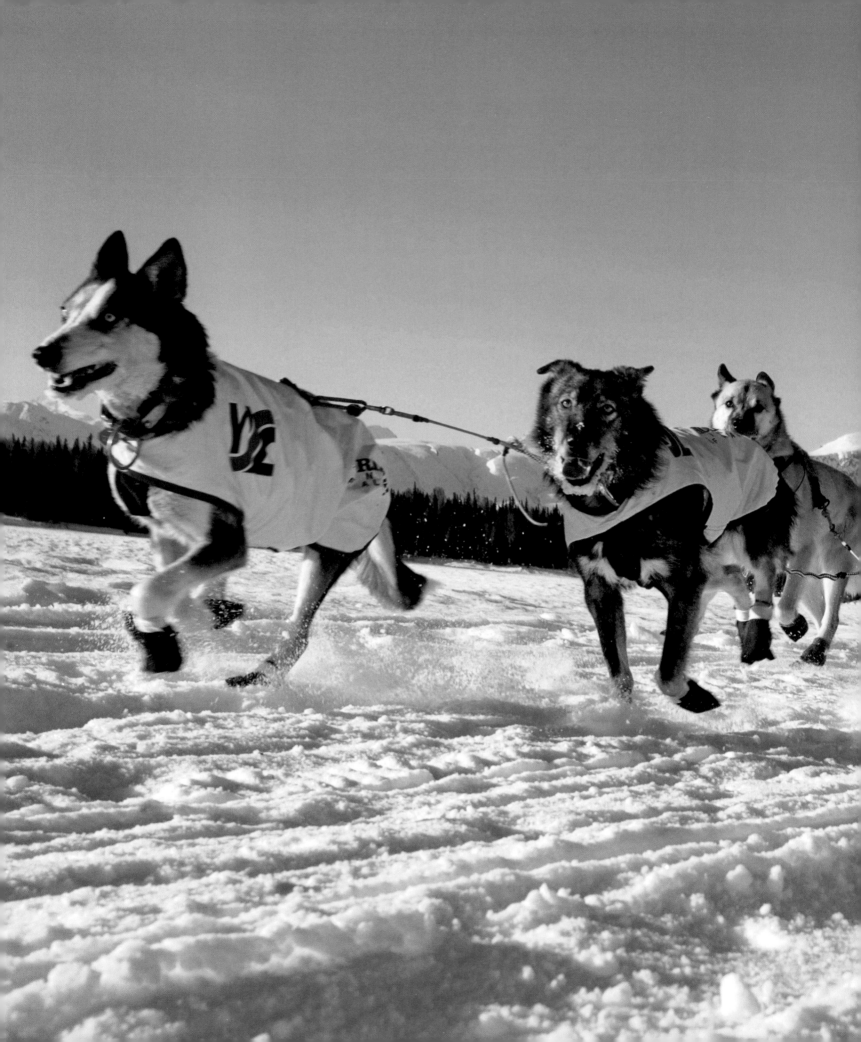

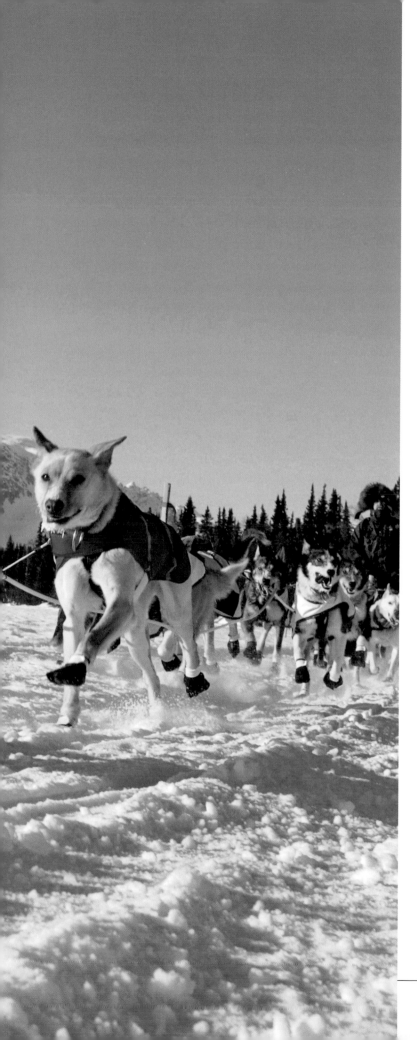

eradicated from the United States, but in the 1920s, it still killed 13,000 to 15,000 Americans a year, usually through slow suffocation. The young are especially susceptible—diphtheria was known as "the strangling angel of children."

When two children died in January 1925, Nome's lone doctor knew a full-blown epidemic was imminent and that hundreds, even thousands, of people could die. He didn't have enough usable serum, so he sent urgent telegraphs all over the country

to locate a supply of the diphtheria antitoxin. It turned out that there was an adequate stock of serum in Anchorage, but that didn't solve the second problem: how to get it to Nome. Aviation was in its infancy in Alaska and there was no plane available; no roads led to Nome (they still don't), so driving wasn't an option; ships couldn't reach Nome because the Bering Sea was choked with sea ice; and no railroad lines ran to Nome. The authorities finally decided that they had no choice but to deliver the serum the old-fashioned way: via dog sled.

To speed up delivery, the serum was shipped by rail from Anchorage to Nenana, at which point the mushers took over. The plan was to pass the serum along from one sled dog team to the next, relay style. The mushers would use a mail trail from Nenana to the northern part of what is today's Iditarod Trail and then follow that on into Nome. But nearly 700 rough miles lay between the antitoxin in Nenana and the patients in

Eager sled dogs haul musher Allen Moore down the trail near the Finger Lake checkpoint during the 2007 Iditarod sled dog race. The 1,000-mile race passes through some two dozen checkpoints, many more than 50 miles apart.

Mushing Terms

1 **Dog in Basket** A tired or injured dog being carried in the sled. The main body of the sled, where cargo can be carried, is called the basket.

2 **Dropped Dog** A dog that the musher has dropped from his team at a checkpoint. These dogs are cared for at the checkpoint and then flown back to Anchorage.

3 **Line Out!** A command given by a musher to the lead dog to pull the team out straight from the sled

4 **Pedaling** Pushing the sled with one foot while keeping the other one on the runner. This gives the team a little extra momentum; remember that one Iditarod was decided by one second.

5 **Swing Dogs** Dogs that run directly behind the leader whose job is to help swing the team in turns or curves

6 **Wheelers** Dogs placed directly in front of the sled whose job is to pull the sled out and around corners or trees. Often the strongest dogs are chosen to do this tough work.

Nome who desperately needed it. Every day counted at this stage of the epidemic, so the 20 mushers and 150 sled dogs chosen to make the run pushed themselves to the limit. They forged ahead day and night, braving blizzards and temperatures of minus 50°. And they persevered; on February 2, the last dog team pulled into Nome with the serum. A trek that usually took 15 to 20 days had been made in just over 5 days. In the end, at least five children died, but many hundreds and perhaps thousands were saved by the courageous efforts of the mushers and their dogs.

Moved by this feat, New York City commissioned a famous sculptor to create a bronze statue of Balto, the lead dog on the last leg of the journey. Among the honored guests at the unveiling of the statue in Central Park in December 1925 was Balto himself. To this day, the bronze Balto stands next to the children's zoo, burnished by decades of kids sitting astride his back. On the plaque by the statue are the words "Endurance, Fidelity, Intelligence."

Those three qualities are still needed by the dogs—and the mushers—who compete in today's Iditarod. This ultimate sled dog race more or less follows the historic trail from Anchorage through the interior to Nome, a distance of about a thousand miles. (The route varies slightly year to year.) The race was conceived in the 1960s, and was first run as a long-distance event that went all the way to Nome in 1973. Its founders had two goals, both of which were achieved: to preserve the historic Iditarod Trail and to preserve mushing culture.

Alaskans used dog teams for all sorts of practical purposes right up into the 1960s, but then snow machines (snowmobiles) came along and replaced both dogs and mushers. The Iditarod revived mushing not as a practical mode of winter transportation but as a sport and a valued link to a proud past. These days, many rural Alaskans have kennels full of frisky sled dogs. Some mushers operate tours of their facilities and even take travelers out for rides, whether a half hour's jaunt through the nearby woods or a weeklong expedition into the backcountry. A few operators even put their sleds on wheels and offer rides to tourists during the summer. As for the sport, a dozen major races now take place in Alaska every year, attracting entrants from all over the state and the lower 48, Canada, Russia, and Europe, but the Iditarod is still the Super Bowl of mushing.

When people envision a sled dog, they usually picture a beautiful Siberian husky or a brawny Alaskan malamute, but serious racers have largely replaced these proud purebreds with the "Alaskan husky." The quotation marks are needed because Alaskan huskies are mutts, not a genuine breed. But the term "mutt" implies a random lineage, and that's far from the case. Each racer and kennel owner meticulously breeds Alaskan huskies to produce the combination of traits that enable a dog to help haul a sled and musher 1,000 miles in nine or ten days.

Mushers obviously want dogs that have speed, strength, and endurance, but some of the characteristics that make a great sled dog are not so obvious. For example, they need to have good feet. (Mushers generally say "feet," not "paws.") There's a saying among mushers: "As go their feet, so go the dogs." Even less obvious but no less vital are traits such as good attitude, a passion for pulling in a harness, and the ability to work in a team.

The results of breeding for all these qualities is an Alaskan husky that isn't, well, husky. Instead of some heavily muscled, 90-pound, noble-looking Alaskan malamute, most Alaskan huskies run maybe 50 pounds and look much scrawnier. Many of them even sport floppy ears instead of the classic pointed ears of the purebreds. However, Alaskan huskies are scrawny the way a marathon runner is scrawny—they're lean and

Volunteers wait at one of the 2013 Iditarod checkpoints, in the village of Nikolai. As exhausted competitors arrive after a long day on the trail, the volunteers tend to both mushers and dogs.

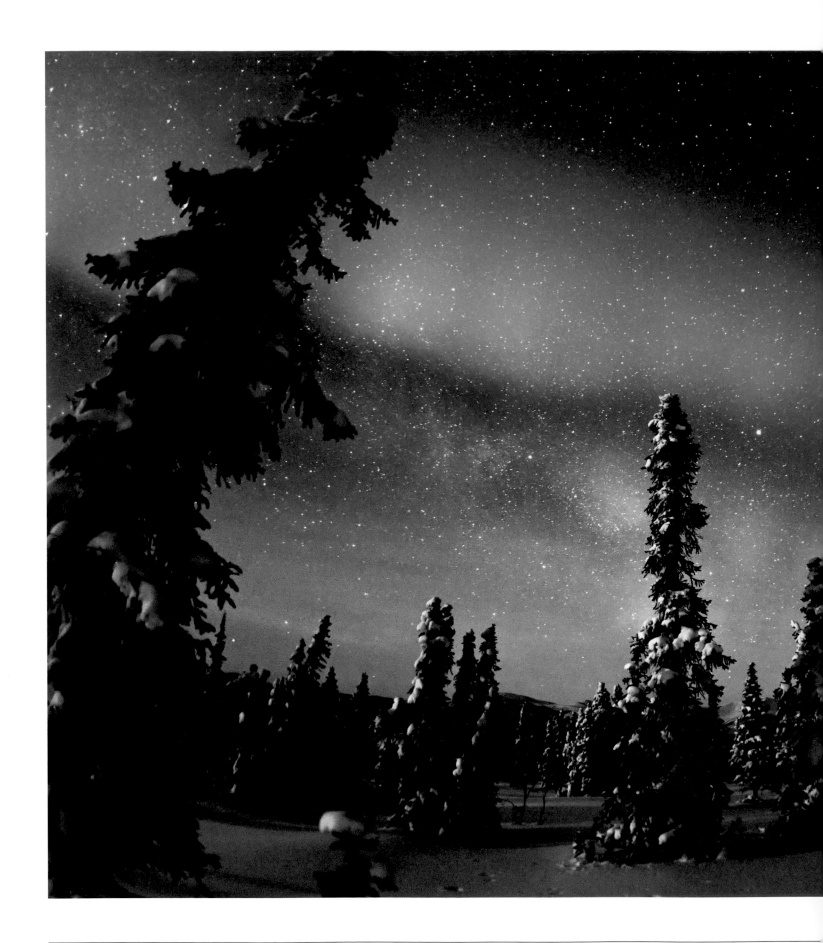

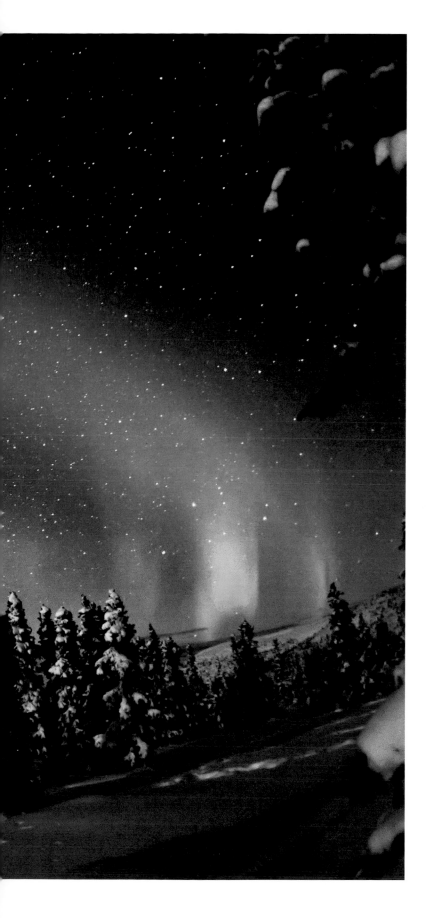

The aurora borealis shines its mystical light on the forest near Chena Hot Springs. Green is the most common color, but the northern lights also display shades of pink, blue, purple, yellow, and red.

whipcord strong, and in a long-distance race, they can leave those purebreds in the dust (well, in the snow).

As the breeding and training of the dogs have progressed over the years, along with the training and savvy of the mushers (mushers must also be in top physical shape), the Iditarod race times have fallen dramatically. Dick Wilmarth won the first championship, in 1973, in a time of 20 days, 49 minutes, and 41 seconds. Within a decade, the winners were finishing more than a week faster than Wilmarth. As of 2013, John Baker held the record time, having finished in 2011 in a time of 8 days, 18 hours, 46 minutes, and 39 seconds.

> **66 [The northern lights] draw a viewer emotionally up and out of himself, because they throw the sky into a third dimension, on such a vast scale, in such a beautiful way, that they make the emotion of self-pity impossible. 99**
>
> **[Barry Lopez, author]**

And 39 seconds? Isn't it kind of ridiculous to measure the times to the second in a race that takes more than a week to complete? Well, Dick Mackey and Rick Swenson don't think it's ridiculous. In the 1978 Iditarod, after more than two weeks on the trail, Mackey and Swenson were the first mushers to reach Front Street in Nome, where the race ends. Improbably, their teams were running neck and neck. With dogs sprinting, mushers mushing, the crowd screaming, the two exhausted teams charged toward the burled arch that marks the finish line. At the last moment, Mackey's team edged ever so slightly ahead and won the race—by one second.

The Iditarod winners mentioned so far are all men, but women mushers also have excelled in this grueling race, most notably Susan Butcher, who won in 1986,

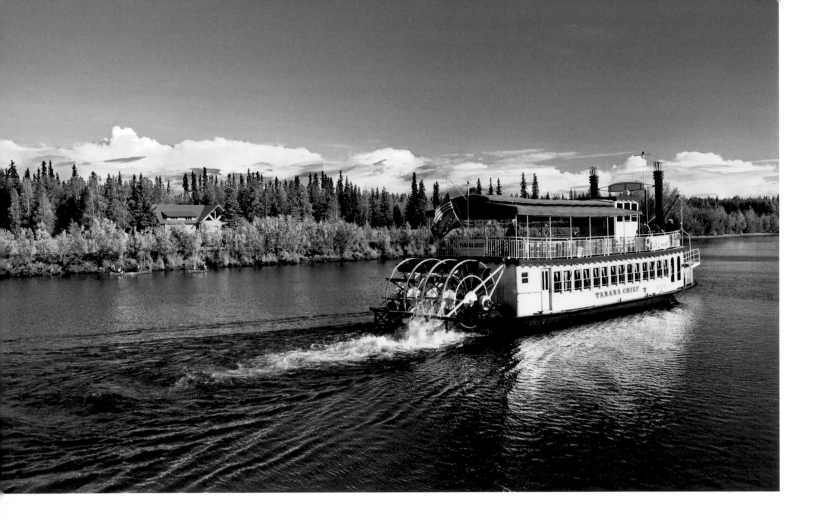

The stern-wheeler *Tanana Chief* takes travelers on a tour of the Chena River, near Fairbanks. This replica of the 1898 vessel of the same name does tourist cruises, but during much of the 20th century, stern-wheelers were the workhorses of interior rivers.

1987, 1988, and 1990. She set a new record in 1986, broke her own record in 1987, and broke her own record again in 1990. Only one person—the aforementioned Rick Swenson—has won more times (five—and oh so close to a sixth time in that wild 1978 race). The first woman to finish the Iditarod was Mary Shields, who passed under the burled arch in Nome in 1974, the second year the race was held. These days, Shields lives on 20 acres of forest close to Fairbanks and personally conducts intimate tours of her kennels—she has been raising sled dogs for nearly 50 years. A sign above one of her gates reads, "May I be the person my dogs think I am." Visitors might want to ask her about her 1,200-mile dog sledding expedition across Siberia.

Tales of mushing through blizzards and occasional temperatures of 50° below notwithstanding, winter in the interior is not as unbearable as many travelers think. Consider winter in Fairbanks, the hub of the interior. Sure, a former mayor of Fairbanks reported that on a minus-60° day, he saw a tire fall off the back of a truck and shatter when it hit the street. But minus 50° or 60° is unusual; the average low for Fairbanks in January is only about 20° below. And, yes, snow may cover the ground for the entire winter, but not all that much snow; only five or six feet falls in an average winter. Besides, a fair amount of snow is needed for mushing.

Not that dogsledding is all that people do in the interior during the winter. Quite a few travelers come to Fairbanks and vicinity to gape awestruck at the aurora borealis,

aka the northern lights. The northern lights shimmy across the night sky in colossal, ever shifting bands of light. Auroras occur when solar flares send streams of charged particles into the Earth's magnetic field, where they react with atmospheric gases to create those radiant colors. Undulating yellow-green streamers may suddenly swell to drape the whole sky. Sometimes blues, purples, and pinks dance into the picture. On rare occasions, the aurora is wholly red. Many lodges and tour operators cater to aurora watchers with such amenities as heated, glassed-in rooms or hot tubs from which to marvel at the lights.

Below-freezing weather may not be conducive to picnics in the park, but it's perfect for the World Ice Art Championships, held in Fairbanks every March. Sculptors from around the world fashion both realistic and abstract pieces, some more than 20 feet in length or height. Past creations include a swan flapping its wings, a semitruck, mountain goats jumping over a crevasse, and two knights jousting (including the horses). The abstract works defy written description, but one in 2013 was titled "Rending Age Fading, Vile Brooding Within, Progressive Rebirth." Hmmm. Perhaps the artist of that abstract piece was in need of spring and some sunshine.

The longing of interior residents for spring to appear and sweep away the long winter is evident in the Nenana Ice Classic. Since 1917, Alaskans have wagered on the exact time the icebound Tanana River at the town of Nenana will break up, signaling the start of spring. Each winter, Nenana residents erect a large tripod on the frozen river and run a line from the tripod to a clock in a building on shore. When the ice breaks up—usually in late April or early May—the tripod falls and stops the clock, determining the winning time. Typically, about 300,000 people buy tickets, at $2.50 a pop. Half the money goes to the winner, and half to local nonprofits.

With the advent of spring, travelers can more easily take to the handful of highways that wind through the interior. One of the most popular is the Chena Hot Springs Road, which runs east out of Fairbanks for 57 miles. The first part of the route is a pleasant mix of woods, campgrounds, picnic areas, and stretches of the Chena River that invite canoeing or kayaking. About midway, the road enters the Chena River State Recreation Area,

Midnight Sun Baseball

A tradition since 1906, the Fairbanks Goldpanners play a team from the outside on the summer solstice. Using only natural light, the game goes from about 10:30 p.m. to 1:30 a.m. Though the Goldpanners are amateurs, the level of play is high, and many Goldpanners have gone on to the majors, including stars like Tom Seaver and Dave Winfield.

After a busy day of hiking, canoeing, or fishing along the Chena Hot Springs Road, many travelers mellow out in the steamy waters at Chena Hot Springs Resort, at the end of the road.

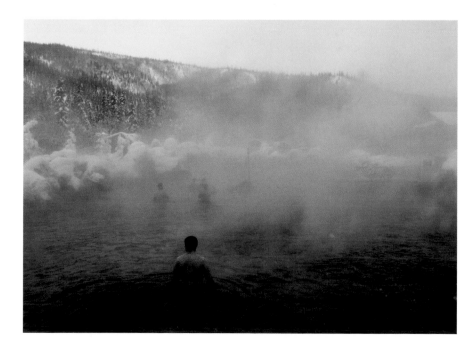

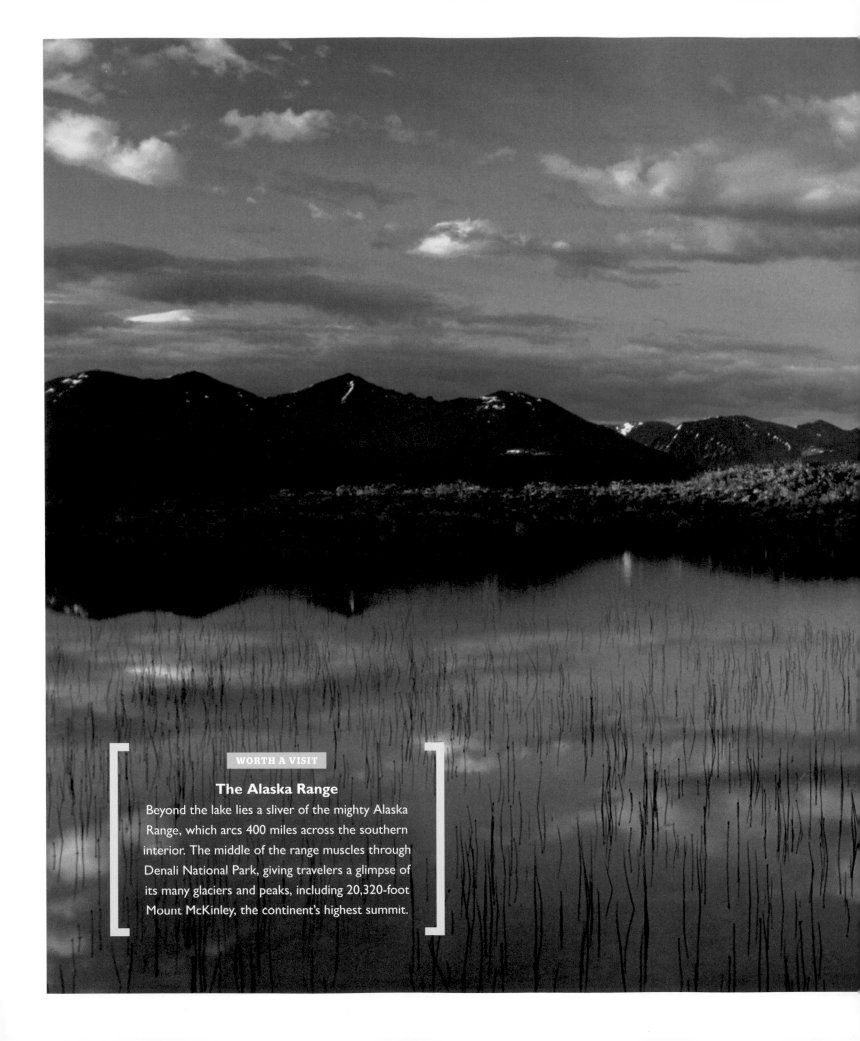

The Alaska Range

Beyond the lake lies a sliver of the mighty Alaska Range, which arcs 400 miles across the southern interior. The middle of the range muscles through Denali National Park, giving travelers a glimpse of its many glaciers and peaks, including 20,320-foot Mount McKinley, the continent's highest summit.

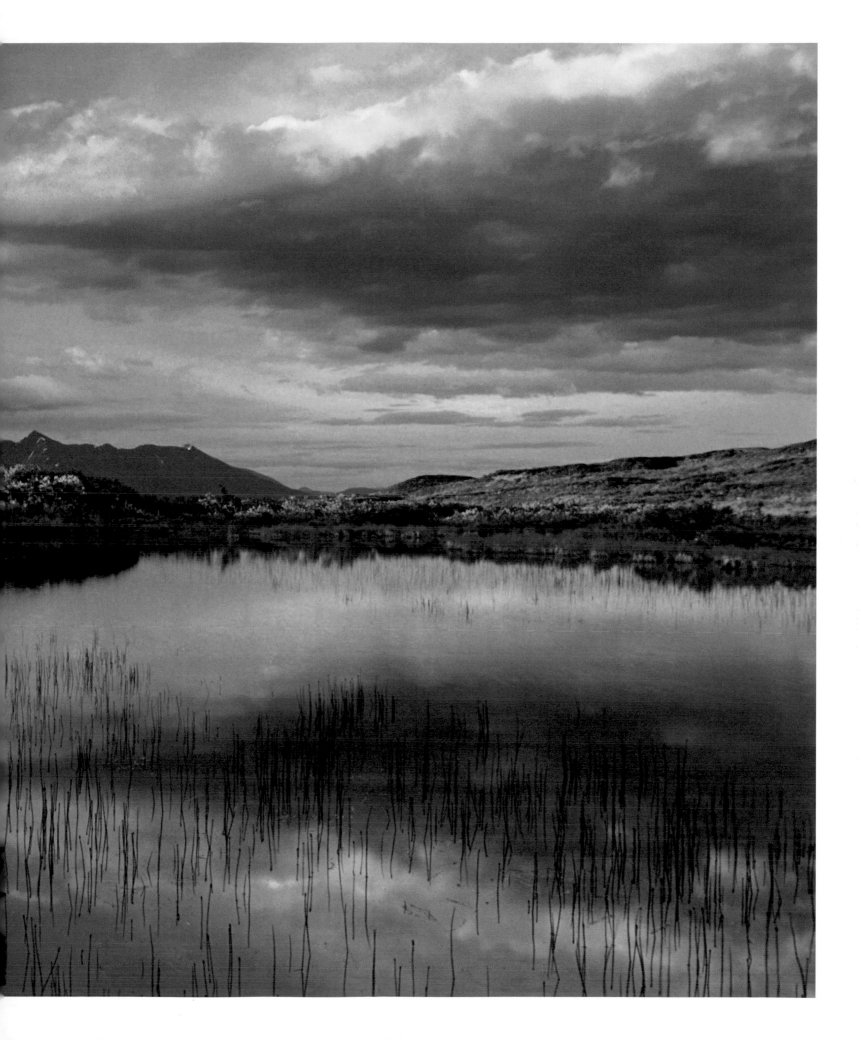

The Taylor Highway threads through the high country of the extreme eastern section of the interior. Branching off the Alaska Highway, the Taylor, most of which is gravel, runs for 160 miles before it dead-ends on the Yukon River in the little town of Eagle.

and travelers have the opportunity to hike into some superb backcountry, notably on the Granite Tors Trail. This 15-mile loop takes in boreal forest, alpine tundra, and challenging mountains. About halfway through the hike, the trail crosses the Plain of Monuments, an expanse of tundra pierced by tors—granite outcrops that range from a few feet to 100 feet high. At the end of the road lies Chena Hot Springs Resort, where hikers can soothe their tired muscles.

Travelers with an urge to roam farther afield should enjoy the Taylor Highway, which is not only more enjoyable in the spring but enjoyable *only* after spring arrives; snow renders it impassable during the winter. Starting in Fairbanks, motorists drive 218 miles southeast deep into the interior on the Alaska Highway and then turn onto the Taylor and head north even deeper into the interior. The road is paved for the first 65 miles or so (plans are in the works to pave more) and then turns into gravel for the last 95 miles, at which point it dead-ends on the Yukon River. Some of the gravel portion is pretty good, and some is washboarded and potholed, and most of it is winding and steep, but people who stick it out are rewarded with top-of-the-world views.

Though travelers on the Taylor cannot see Chicken from the road—it's tucked away just off the highway near Milepost 66—they shouldn't overlook this famously eccentric hamlet. The town harbors about 25 residents—more like 100 in the summer when the seasonal miners are present—and a handful of ramshackle commercial buildings.

Established in 1903, Chicken is said to have originally been called Ptarmigan, owing to the prevalence of that bird species in the area, but townsfolk changed the name because they couldn't spell ptarmigan. Chicken has no phone service, no Internet service, no central plumbing (travelers are welcome to use the outhouse), and no electricity except what generators can provide, but residents do have a great sense of humor about their happily backward burg. A glance at their goofy website (which is maintained by someone outside Chicken, as Chicken lacks Internet service) conveys the townspeople's relaxed attitude. Don't miss the NSFAQs (Not So Frequently Asked Questions). A typical exchange starts with a visitor's question—"Does everyone in Chicken wear the same red flannel shirt?"—and ends with the answer—"Not at the same time."

The Taylor Highway ends at Eagle, on the south bank of the Yukon River, population somewhere between 86 and 146, depending on who's counting. Compared with Chicken, Eagle is a metropolis, with a courthouse, school, some streets, a church, a

library, and a couple of museums. However, the town lost some of its buildings on May 6, 2009, when a historic flood assaulted Eagle. That spring, when the ice on the Yukon broke up, it jammed together a few miles downstream from Eagle, forming a dam and causing the water to back up. Not only did the water rise and pour into town but chunks of ice, some the size of a car, rode the flood into town and smashed into buildings, destroying some and knocking others off their foundations.

However, people in remote parts of the interior are accustomed to nature's unpredictable power. So, on May 7, the day after the flood, the citizens of Eagle immediately began the hard work of recovery, aided by a generous outpouring of relief from folks in Fairbanks and the emergency efforts of the state and federal governments. On May 8, they even held the long-planned ceremony for the Eagle Community School's graduation class of 2009, which consisted of one student. And that student, along with most everyone else in Eagle, spent the rest of the day helping with the recovery.

The citizens of Eagle displayed the resilience that people need in the interior. Likewise, the interior's animals and plants must be tough and adaptable to persevere, given the challenges that this region presents. Even visitors must show some fortitude and flexibility if they're going to make the most of a journey through Alaska's vast heartland, but if they do adopt a rough-and-ready attitude, the rewards can be great. ■

This photo shows pretty much all of downtown Chicken, a tiny and famously eccentric town tucked just off the road 66 miles up the Taylor Highway. Maybe 25 people live here year-round, which has its challenges, given that snow closes the Taylor for the long winter.

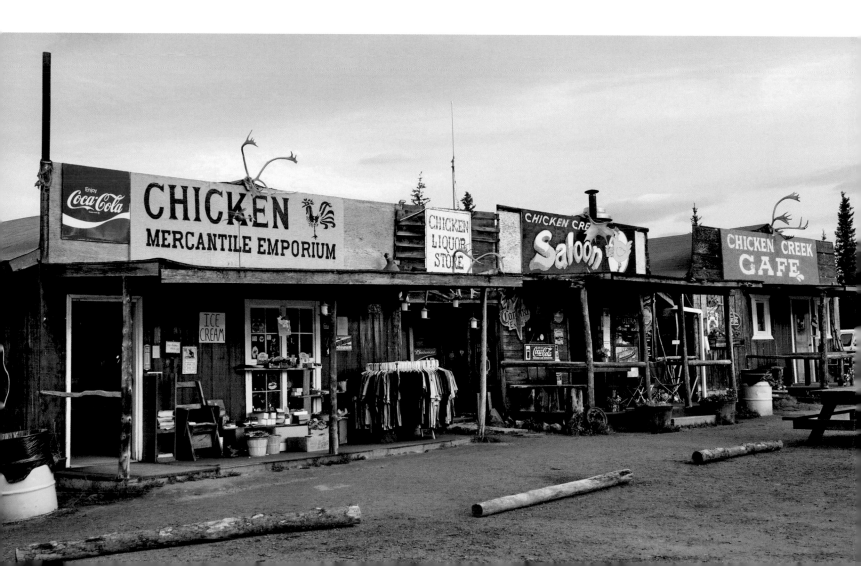

Sites and Sights in Interior Alaska

At the end of a 14-mile spur road off the Parks Highway lies **Talkeetna,** a town of about 900 people that does indeed feel like an end-of-the-road hideaway. It features log houses, an airstrip that calls to mind an unkempt gravel road, and cafés that serve musk ox burgers. Get a taste of the town's vivid past by grabbing a bite at the historic **Talkeetna Roadhouse,** browsing the **Talkeetna Historical Society Museum,** or following the society's walking-tour map of the **Talkeetna Historic District.** Talkeetna is a hotbed of bush pilots and flightseeing outfits, especially flights that deliver climbers to the base of Mount McKinley or take people on aerial tours of The Mountain and other parts of Denali National Park and Preserve. *talkeetnachamber.org*

Most of its 134 miles are unpaved, dusty or muddy depending on the weather, impassable in winter, and empty of towns and service stations, but the scenic **Denali Highway** appeals to some travelers precisely because of these back-road qualities. Besides, in a pinch, motorists can get gas or fix a flat at one of the handful of colorful roadhouses or lodges that line the route. Scan for grizzlies and caribou from the pullout atop 3,835-foot **Maclaren Summit,** the second highest road pass in Alaska. Motorists who want to get out of their cars for a while can take a side trip into the **Tangle Lakes** to do some canoeing, fishing, bird-watching, or to take a jet-boat tour. *blm.gov/ak/st/en/fo/gdo/denali_hwy.html*

Talkeetna welcome sign

The few dozen square miles near the entrance to **Denali National Park and Preserve** brim with things to do. The **Visitor Center** is the logical place to start. It doubles as a natural history museum and screens visually sumptuous films in the spacious theater. A shuttle bus takes people from the center to the **park kennel,** but this is no temporary home for Fido; the park's sled dogs live here. The rangers use them to patrol during the winter, and during the summer, the dogs are the stars of a mushing demonstration staged several times a day. The visitor center also houses the **Murie Science and Learning Center,** where travelers looking for an in-depth exploration of Denali can sign up for multiday field seminars (though space in these classes typically needs to be reserved well ahead). Visitors can hike several established trails on their own or in groups guided by park staff. And then there's the **backcountry,** other 99 percent of the park. Fit, savvy, and properly equipped travelers can get permits (best to reserve them months ahead) to venture into the millions of wild, trailless acres sprawling north, south, and especially west of the park entrance. Less-prepared visitors can take a park shuttle bus up to 90 miles west on the park road (private vehicles generally not allowed), the one road that goes deep into the wilderness. The shuttle drivers double as guides, providing some running commentary and stopping along the way to let people view The Mountain, bears, caribou, or whatever else merits some lingering. At the end of the road lie several privately owned **lodges** that were grandfathered into this otherwise lodge-less park. These provide a cozy alternative for visitors who long to experience the backcountry but prefer not to camp. *nps.gov/dena*

Zooming between Denali National Park and Fairbanks, most motorists on the George Parks Highway don't notice little **Nenana** and its 400 or so residents, but the town has a rich past. It was here in 1923 that President Warren G. Harding drove the golden spike to symbolize the completion of the Alaska Railroad. Visitors can glimpse this railroading past at the **Alaska**

Denali National Park

State Railroad Museum, a small affair in the 1922 train depot. Nenana has long served as a port for tugs and barges that ply the Tanana and Yukon Rivers, bringing supplies and people to remote towns and villages. Visitors can watch river traffic from the deck at the **Alfred Starr Cultural Center,** built to showcase local Alaska native history and culture. *nenana.org*

If a visitor could only go to one place for an introduction to the interior of Alaska, the best choice would probably be the **Morris Thompson Cultural and Visitors Center.** Opened in 2009, this facility contains the Tanana Chiefs Conference (which represents 42 interior tribes and villages), the Fairbanks Convention and Visitors Bureau (and the main visitor center), and the Fairbanks branch of the Alaska Public Lands Information Center. Also in the building and around the grounds are an artisans' workshop and demonstration area, a museum, a theater, and a restored pioneer cabin. *morristhompsoncenter.org*

The coolest spot in downtown Fairbanks in the summer is the **Fairbanks Ice Museum.** Its heart is a 20°-below-zero exhibition space filled with creative ice sculptures. Visitors can venture into the cold or admire the pieces from a heated viewing room. Some of the works are

fashioned by the same artists who compete in the annual **World Ice Art Championships,** which takes place in Fairbanks every March. A big-screen slide presentation shows the artists at work. *icemuseum.com*

Just west of downtown Fairbanks are the 44 acres of **Pioneer Park,** a combination historical museum, theme park, community center, tourist trap, and city park. Highlights include the Alaska Native Village and Museum, Pioneer Hall, the Pioneer Air Museum, and the sternwheeler *Nenana,* a massive, meticulously restored riverboat that steamed the Yukon River from the 1930s to the 1950s. *co.fairbanks .ak.us/parksandrecreation/pioneerpark*

In the midst of Fairbanks, flanked by subdivisions and malls, sprawls a 1,600-acre oasis called **Creamer's Field Migratory Waterfowl Refuge.** As the name promises, ducks, geese, and swans flock to the refuge's fields and ponds during the spring and fall migrations. Various trails and observation platforms provide excellent views of the waterfowl and other wildlife. Several trails lead deep into the boreal forest, where visitors might see anything from a moose to a calypso orchid. *adfg.alaska.gov/index.cfm? adfg=creamersfield.main*

Travelers should set aside several hours to wander through the acclaimed **Museum of the North,** an architecturally stunning complex located on the campus of the University of Alaska, Fairbanks. It perches on a hill, and on clear days, visitors can see the Alaska Range and Mount McKinley. Still, the real treasures await inside, where people can tour all the regions of the state by roaming the Gallery of Alaska, provided they get past Otto, the nine-foot, 1,250-pound brown bear that guards the gallery entrance. The museum also houses the Rose Berry Alaska Art Gallery, the Western and Arctic Coasts Gallery, the world's largest collection of high-latitude dinosaurs, and the Arnold Espe Auditorium, which presents multimedia programs. *uaf.edu/museum*

Also on the university campus is the **Georgeson Botanical Garden.** The expected floral fireworks certainly draw people to the garden, but more intriguing is its position as the hemisphere's northernmost botanical garden. Visitors can learn how Alaska's native plants adapt to the land of the midnight sun and frigid winters. Starting around mid-July, people can marvel at 30-pound beets, cukes the size of third graders, and other monster veggies that 20 hours of sunlight a day fosters. *georgesonbg.org*

Forget horses and cows. At the **Large Animal Research Station** on the university campus, visitors will see caribou, reindeer, and musk oxen. Learn why the legs of caribou and reindeer click when they walk and why 800-pound musk ox bulls don't get concussions when they ram into each other during rutting contests. *uaf.edu/lars*

Bar in Fairbanks Ice Museum

The **Chena Hot Springs Road** runs east out of Fairbanks for 57 scenic miles. Opportunities to hike, canoe, picnic, camp, and kayak can be found along the way, especially in the **Chena River State Recreation Area.** At the end of the road, visitors can drop in or stay overnight at the **Chena Hot Springs Resort,** which offers not only the soothing hot springs but also a restaurant, dogsledding, fishing, gold panning, tours of the **Aurora Ice Museum,** and many other activities. *dnr.alaska. gov/parks/units/chena and chenahotsprings.com*

Angling 161 miles northeast out of Fairbanks, the **Steese Highway** leads all the way to

Circle, a small town on the Yukon River, less than 60 miles south of the Arctic Circle. Partly paved, partly gravel, this back road offers mountains, wildlife, bush towns, hot springs, camping, alpine wildflowers, hiking, riverboats, canoeing, and the chance to tour a couple of historic gold dredges, including the 250-foot-long, five-story **Gold Dredge No. 8,** which the National Park Service declared a national historic mechanical engineering landmark. *explorefairbanks.com*

Running north–south in the extreme eastern portion of the interior, the **Taylor Highway** branches off the Alaska Highway and winds— tightly winds—160 miles (less than half paved) to **Eagle,** on the Yukon River. On the way to this historic river port, the road passes through deep forest, runs along high ridges, crosses rivers and streams, and goes by the famously idiosyncratic tiny town of **Chicken.** *chickenalaska.com*

Overshadowed by its celebrated national park neighbor just to the north, 325,000-acre **Denali State Park** also warrants attention. Pierced by more than 30 miles of the George Parks Highway, the pullouts in the park provide grand views of Mount McKinley and its Alaska Range entourage. A number of established trails penetrate the park, taking advantage of lakes and ridges. Many are backpacking routes, but day hikers can enjoy them by simply walking a few miles up and back. There's a campground at Byers Lake. *dnr.alaska.gov/parks/ units/denali1.htm*

The **White Mountains National Recreation Area** offers a million acres of mountains, river, trails, and wildlife. Visitors come here in winter as well as summer. In the warm months, they hike, raft, fish, and pan for gold. In winter, they go snowshoeing, cross-country skiing, dogsledding, and run about on snow machines. In fact, much of the recreation area is more accessible in winter than in summer because the snowy trails are groomed, whereas they can be boggy and difficult to hike in summer. *blm.gov/ak/st/en/prog/sa/white_mtns.html*

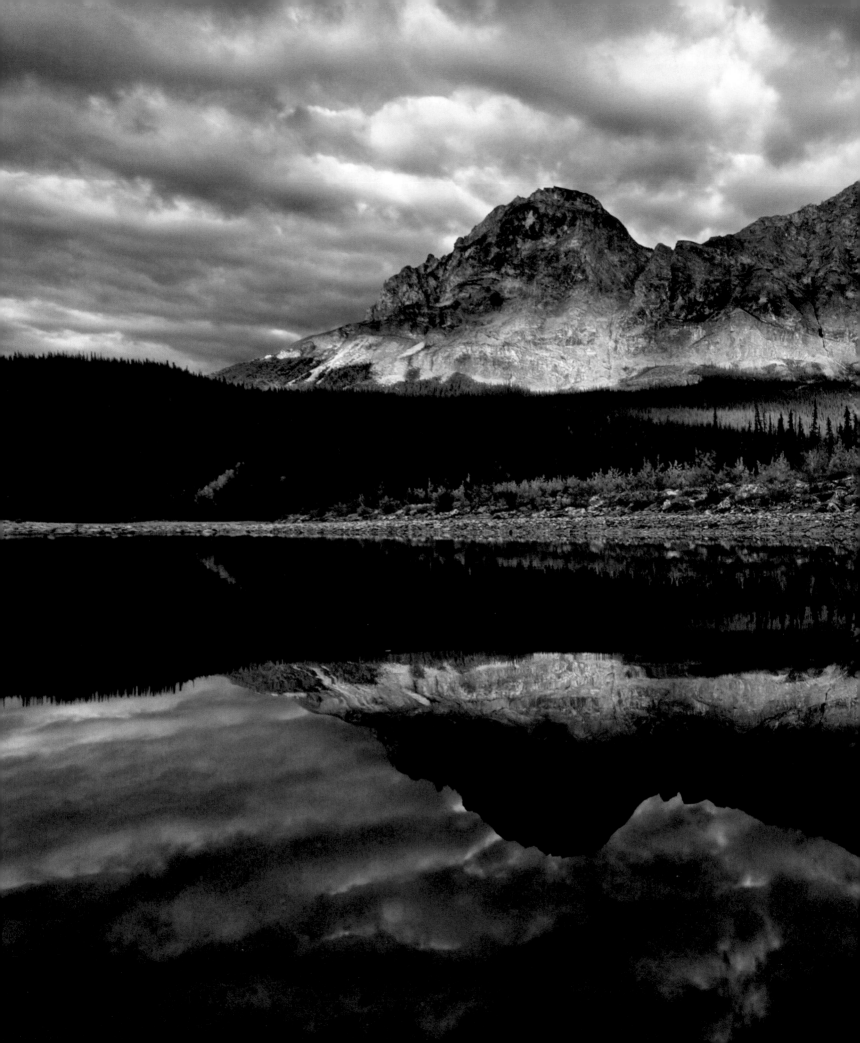

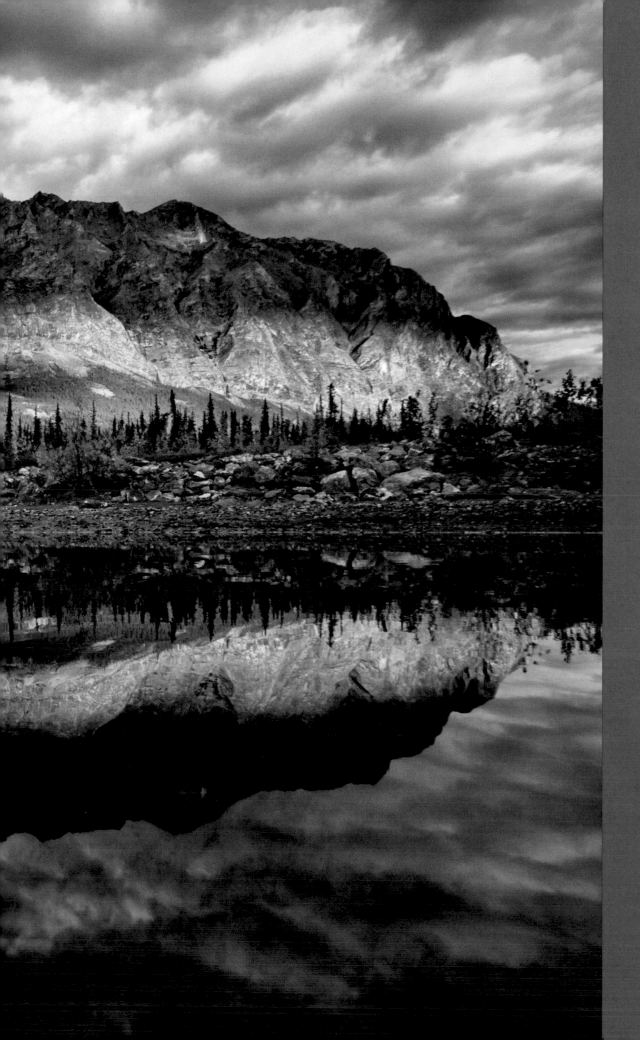

Late afternoon sunlight paints a stripe across Sukakpak Mountain, which rises near the Dalton Highway as it cuts through the Brooks Range.

The Far North

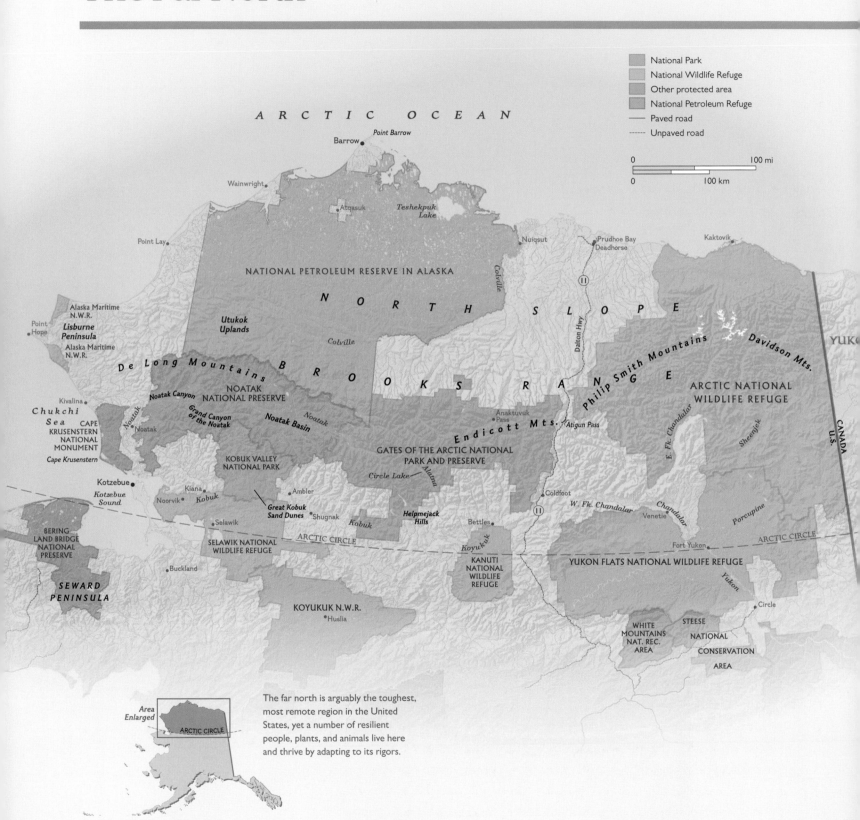

National Park
National Wildlife Refuge
Other protected area
National Petroleum Refuge
Paved road
Unpaved road

0 100 mi
0 100 km

ARCTIC OCEAN

Point Barrow
Barrow

Wainwright

Atqasuk Teshekpuk Lake

Nuiqsut Prudhoe Bay / Deadhorse Kaktovik

Point Lay

NATIONAL PETROLEUM RESERVE IN ALASKA

NORTH SLOPE

Colville

Dalton Hwy

YUKON

Alaska Maritime N.W.R.
Point Hope
Lisburne Peninsula
Alaska Maritime N.W.R.

Utukok Uplands

Colville

De Long Mountains B R O O K S R A N G E

Philip Smith Mountains Davidson Mts.

ARCTIC NATIONAL WILDLIFE REFUGE

Kivalina

Chukchi Sea

CAPE KRUSENSTERN NATIONAL MONUMENT
Cape Krusenstern

Noatak Canyon
Grand Canyon of the Noatak
NOATAK NATIONAL PRESERVE
Noatak
Noatak

Noatak Basin

Noatak

Anaktuvuk Pass
Atigun Pass
Endicott Mts.

CANADA
U.S.

Sheenjek

E. Fk. Chandalar

Kotzebue
Kotzebue Sound

KOBUK VALLEY NATIONAL PARK

Kiana
Noorvik Kobuk

Circle Lake Alatna

GATES OF THE ARCTIC NATIONAL PARK AND PRESERVE

Coldfoot

W. Fk. Chandalar Chandalar
Venetie

Porcupine

ARCTIC CIRCLE

Great Kobuk Sand Dunes
Ambler
Shugnak Kobuk

Helpmejack Hills

Bettles

Koyukuk

BERING LAND BRIDGE NATIONAL PRESERVE

SELAWIK NATIONAL WILDLIFE REFUGE

Selawik

ARCTIC CIRCLE

Fort Yukon

YUKON FLATS NATIONAL WILDLIFE REFUGE

SEWARD PENINSULA

Buckland

KANUTI NATIONAL WILDLIFE REFUGE

Yukon

Circle

KOYUKUK N.W.R.

Huslia

WHITE MOUNTAINS NAT. REC. AREA

STEESE NATIONAL CONSERVATION AREA

Area Enlarged
ARCTIC CIRCLE

The far north is arguably the toughest, most remote region in the United States, yet a number of resilient people, plants, and animals live here and thrive by adapting to its rigors.

atitude 66° 33' N. At this point, the sun never sets on the day of the summer solstice and never rises on the day of the winter solstice. This is the Arctic Circle, an imaginary line, yet a boundary that intrigues the imagination. Beyond this line lies the far north region of Alaska.

To understate the obvious, the climate north of the Arctic Circle is demanding. It plays a pivotal role in shaping the lives of the plants, animals, and people who call the far north home. Depending on where one goes in this 300-by-600-mile region, a typical midwinter day would hit a high of about 10° below zero and a low of about 25° below zero. Note, too, that those are just the averages; thermometers all too often plummet to fearsome lows of 40° and 50° and 60° below zero, never mind the windchill. Plants, animals, and people must be prepared to deal with these extremes, not just the averages. Most of the far north receives a desertlike 5 to 15 inches of rain a year, but that's largely because it's often too cold to rain. Snow and ice cover the ground the majority of the year, though it does melt off during the brief summer, when high temperatures run in the 50s and 60s.

Brutal as the climate is, people have lived in this region for millennia. On the northwest coast, in Cape Krusenstern National Monument, researchers have unearthed evidence of human occupation dating back some 5,000 years. The monument contains an archaeological district consisting of scores of limestone ridges that run from the shore back into the interior like a series of giant earthen waves. The ridges formed during different periods, so digs in various ridges have yielded stone tools, harpoons, pottery, and other artifacts stretching from thousands of years ago to historical times. The earlier sites were simple hunting camps, and the later sites were more sophisticated settlements characterized by such features as pit houses and storage structures.

Because Cape Krusenstern is undeveloped, hardy travelers who wander its 650,000 acres see much the same world that the monument's early inhabitants saw, though the effects of climate change have produced a few visible changes, such as more willows in a realm that used to be almost treeless. Still, much of the landscape is covered by tundra vegetation, either ankle-spraining cotton grass tussocks or, in drier areas, a blend of blueberry, dwarf willow, Labrador tea, and other low-growing plants. Musk oxen, brown bears, wolves, moose, and caribou range across the monument. Along the coast, several fertile lagoons attract vast flocks of migrating waterfowl and other birds. Cape Krusenstern is a bit more accessible than most of the northwest coast because it's only about a dozen miles away from Kotzebue, the

The animal figures on this Inupiat mask suggest the close relationship that Alaska natives of the far north have with the natural world.

northwest's main town, where travelers can hire bush planes or boats to take them to this gateway to the past.

The waters offshore from Cape Krusenstern National Monument harbor a different but equally rich assortment of wildlife. This is the Chukchi Sea, which extends from the Bering Strait in the south to the Lisburne Peninsula, about 50 miles north of the monument, at which point the Chukchi Sea grades into the Arctic Ocean. The Chukchi is shallow and brimming with phytoplankton, which makes for robust populations of fish and a highly productive sea floor thick with mollusks, crustaceans, and other organisms. This seafood buffet feeds a variety of marine mammal species, such as gray whales, humpback whales, several species of seals, fin whales, diving seabirds, and beluga whales—as many as 3,500 belugas use a single lagoon for bearing their young and feeding. The Chukchi Sea also shelters polar bears, a species that is half marine mammal and half terrestrial—though it's increasingly terrestrial as Arctic ice melts due to climate change. About half of America's polar bears, perhaps 2,000 animals, live in this sea and on the adjacent coastline.

In the summer, the Chukchi Sea also hosts much of the Pacific walrus population. Walruses are notoriously hard to count, but estimates range from tens of thousands to hundreds of thousands. They thrive in these waters because walruses are bottom-feeders and the Chukchi's bottom is so fertile. Those walrus "mustaches" are in fact hundreds of very sensitive whiskers, which walruses use to search for clams, sea cucumbers, worms, and other soft invertebrates in the mud and silt. Walruses eat by yanking their piston-like tongues back suddenly, creating a vacuum-cleaner effect that sucks prey into their mouths. If they catch any snails or clams, walruses suck out the soft parts and spit out the shells.

The Inupiat in coastal communities on the Chukchi Sea and the western shore of the Arctic Ocean consider walruses a key resource. Under the state's subsistence-use laws, only Alaska natives can legally harvest walruses. They eat the meat, organs, blubber, and skin; use the hides to make rope or cover wooden-framed boats; and fashion the long ivory tusks into works of art, jewelry, and other handicrafts that are important culturally and commercially.

To help conserve walruses, Alaska natives formed the Eskimo Walrus Commission in 1978; 19 walrus-hunting communities now belong. As a director of the commission once said, "We rely on the walrus. It is a big part of our diet and our tradition.

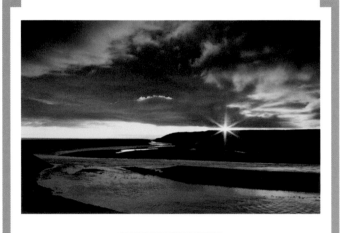

DID YOU KNOW?

Sleep & the Midnight Sun

Trying to take advantage of the far north's long, sometimes endless summer daylight can turn travelers into sleep-deprived zombies. Self-restraint can prevent visitors from overextending themselves, but the midnight sun also causes a physiological issue. Darkness signals the human body to turn on melatonin, a hormone that affects sleep, so travelers may need to take extra measures, such as taping aluminum foil over windows and wearing sunglasses at night before settling in to sleep.

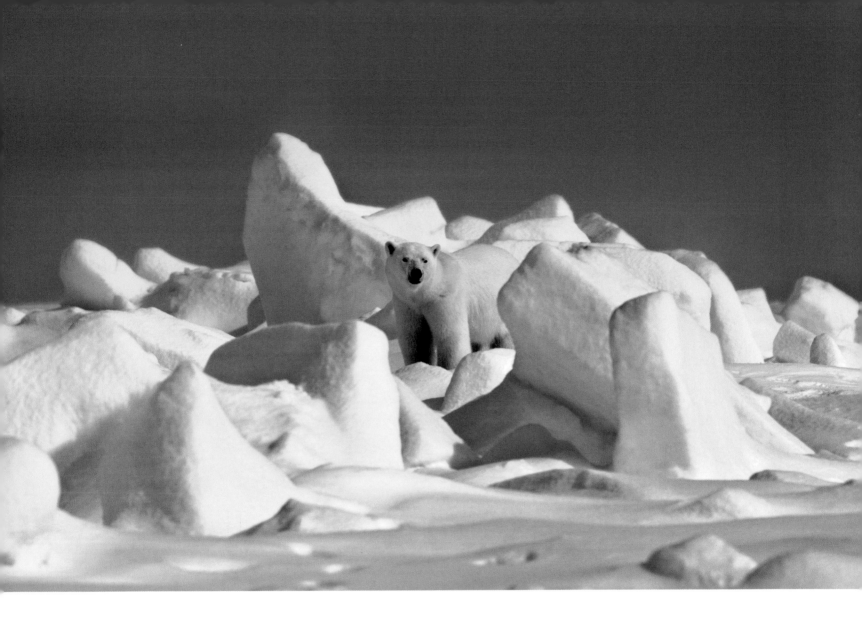

Without it, I think we would be somewhat lost." The commission dealt with issues like "headhunters," who took walruses solely for their tusks, which violates both the spirit and the law of subsistence use. However, now the walruses face a threat that is beyond the control of the commission and local communities: global climate change.

Unlike seals, walruses cannot swim for days on end, so when they're out to sea feeding and grow weary, they hoist their two-ton bodies onto ice floes to rest. But as average temperatures in Alaska have risen three degrees in the last 50 years—winter temperatures have climbed six degrees—those vital floes have been melting and the ice pack that produces them has been receding north beyond the shallow waters where the walruses feed. More and more often, walruses are forced to leave their feeding areas out in the ocean and haul out on the coast. This poses a terrible choice for walruses; either they don't get enough to eat or get exhausted in the quest for food. The lack of sea ice presents walrus mothers with a particular problem. Normally, they park their calves on an ice floe, dive to the sea floor below to feed for a while, then return to the floe to nurse their calves, then repeat. But without ice floes, the mothers must put their calves

A polar bear on the ice-crusted Chukchi Sea, off the northwest coast of Alaska. Such ice provides vital hunting grounds for the bears as they stalk seals, their favorite prey, but increasingly, the ice is thinner and shorter lived due to the effects of climate change.

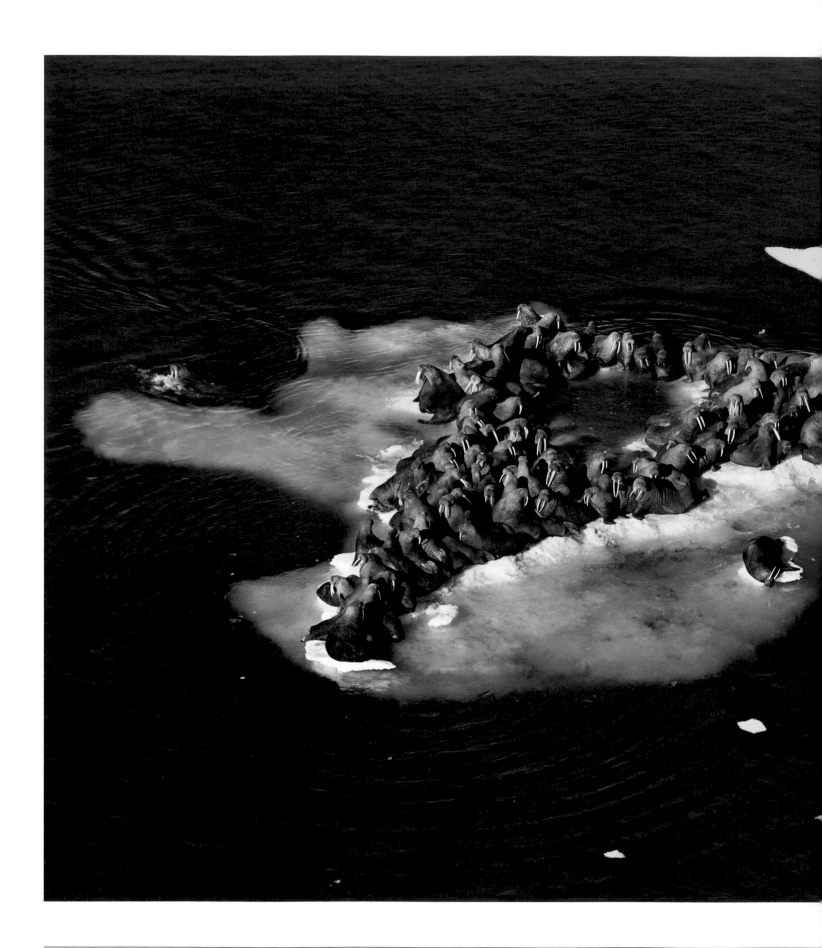

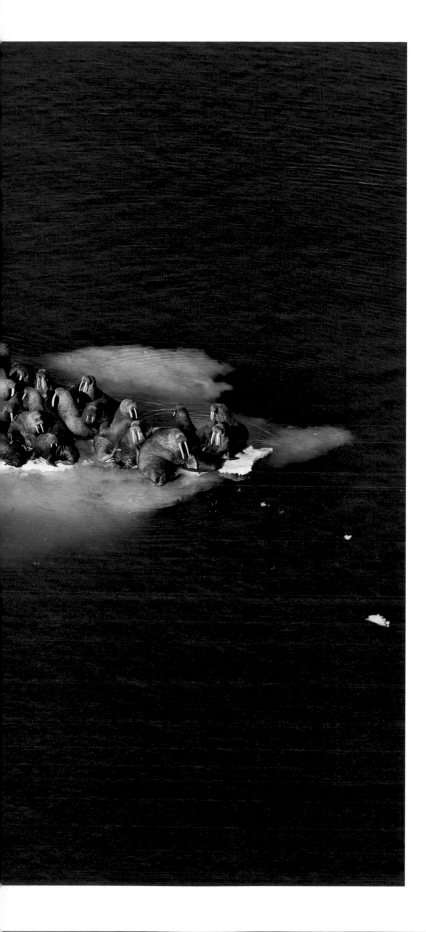

Walruses in the Arctic Ocean use pack ice as a platform on which to rest between deep dives in search of food.

on land, often many miles from the feeding grounds, which means they have to abandon their offspring for long periods during which the mothers cannot nurse or protect their young.

Caribou Antlers

Unique among members of the deer family, both male and female caribou grow antlers. However, bulls and cows grow them at different times and for different purposes. Bulls' antlers grow through spring and summer so they're ready for the fall rut, when bulls use their antlers to spar with each other over females. After the rut, bulls shed their antlers. Cows grow their antlers through the summer and fall and keep them all winter, using them to defend their winter feeding areas (large holes they've dug in the snow) against the larger but antlerless bulls. Females don't shed their antlers until spring.

Crowding thousands, even tens of thousands of walruses onto a narrow beach also creates a more immediate danger than hunger and neglect of the young: stampedes. Sometimes when a hunter or polar bear approaches, or even when a plane flies overhead, overcrowded walruses will panic. And when thousands of animals weighing as much as two tons each start blindly rushing about, some of the walruses get trampled, particularly the young. In 2007, some 500 walruses died in a stampede. In 2009, 130 were similarly crushed to death. Who knows how many stampedes occur on a smaller scale or out of sight? In 2013, when some 10,000 walruses jammed onto a barrier island near Point Lay in northwest Alaska, the U.S. Fish and Wildlife Service worked to keep people and planes away in an effort to prevent another such tragedy.

Kotzebue is one of the 19 communities that belong to the Eskimo Walrus Commission, but it doesn't rely on walruses

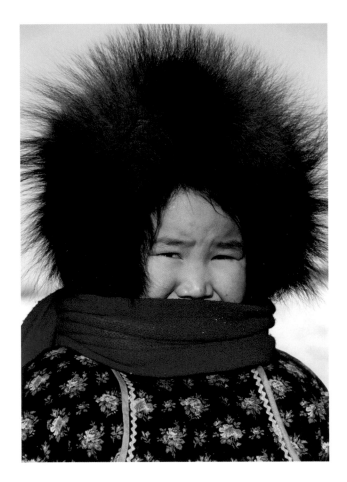

An Alaska native girl wears a fur ruff and kuspuk parka to ward off the cold in Kotzebue. Designed for women, the traditional kuspuk is cut loose in the back so an infant can be tucked in and carried piggyback style. Cold-weather kuspuks have fur on the inside.

and other marine mammals as much as the little villages do. With a population of about 3,300, it serves as the central city of the northwest and has a more diversified economy. Still, most of the residents, a majority of whom are Inupiat, lead at least a partly subsistence lifestyle, and the town remains closely tied to the natural world; its very structure conforms to the demands of its setting. Situated on the tip of a narrow, three-mile-long spit that juts into a sound on the Chukchi Sea, Kotzebue takes serious hits from the weather. Accordingly, its buildings tend to be low-lying and utilitarian.

One structure that manages some style while still being solid enough to withstand Arctic storms is the Northwest Arctic Heritage Center. Opened in 2010, this spacious complex serves both as a museum covering natural history and Inupiat culture and as National Park Service headquarters for four park service units within a 100-mile radius: Kobuk Valley National Park, Noatak National Preserve, Bering Land Bridge National Preserve, and the aforementioned Cape Krusenstern National Monument. As fewer than 4,000 people visit these four units combined in a typical year, the heritage center is the closest most folks will get. At least the polar bear here is stuffed and won't try to eat anyone, as would its wild cousins.

Assuming a traveler is not in Kotzebue during a winter blizzard of wind-driven snow or a summer blizzard of biting bugs, a stroll around town is in order. Even a brief outing will let visitors glimpse a no-frills, hardworking, far-north town. A short walk from the heritage center is the airport, inviting travelers to fly back to easier places or fly out to even more difficult ones. Occasionally, flights are delayed by moose ambling across the runway. Mounted caribou and moose antlers appear on houses, stores, sheds, garages—pretty much any structure the size of a doghouse on up. Linger on Shore Avenue, the town's main drag. This skinny gravel road runs tight along the beach that faces Kotzebue Sound. Visitors will see small fishing boats hauled out on the sand for repairs, and long, red strips of salmon drying on racks. Travelers who are in town during the six midsummer weeks when sunset never comes can sit on the beach in the middle of the never dark night and watch the sun crouch on the horizon, bathing the sea in a rich amber glow.

Travelers who aren't willing or able to reach the far north can get a feel for the region by reading the works of Kotzebue resident and author, Seth Kantner. A child of the Arctic, Kantner writes fiction and nonfiction about his exotic stomping grounds and the people and critters that inhabit them. He grew up hunting, trapping, and working as a commercial fisher. Now he still does those things but has added writing, photography, and even a stint as an adjunct professor

Opposite: Antlers lying on the autumnal tundra in Kobuk Valley National Park provide an echo of the caribou herds that migrate through the region.

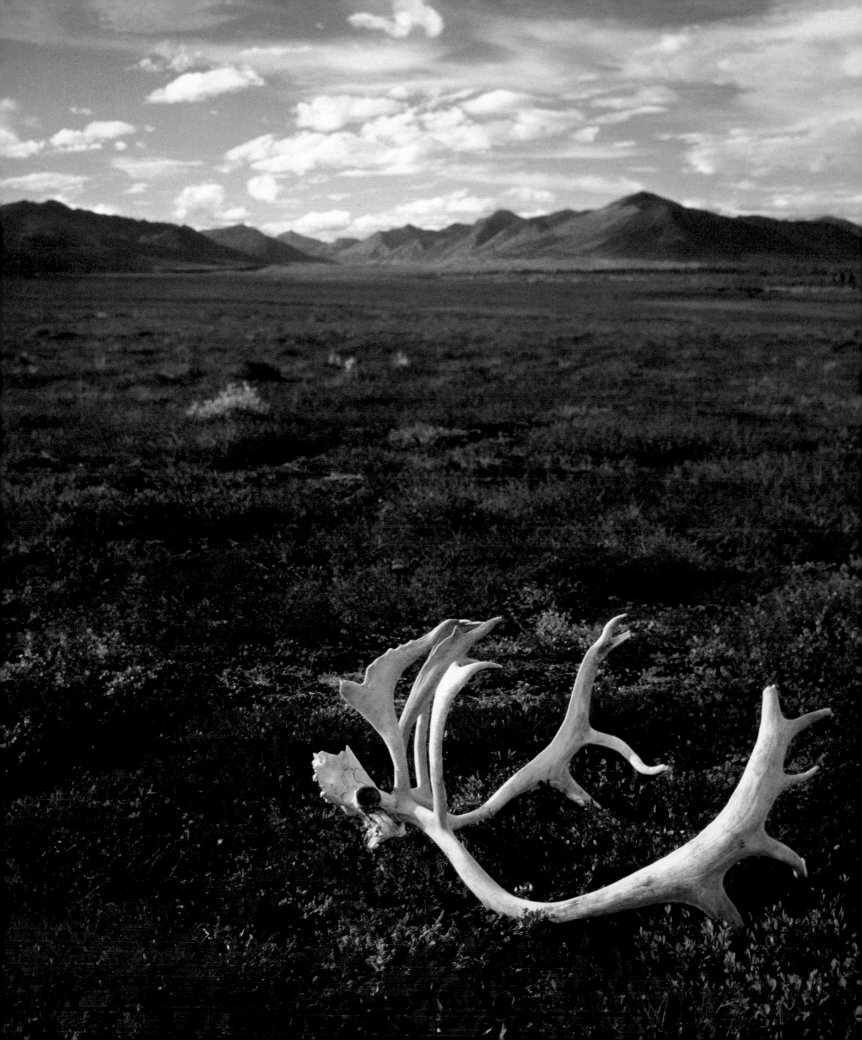

to his resume. His first novel, *Ordinary Wolves,* made the best-seller list and got enthusiastic reviews—the *New York Times Book Review* said *"Ordinary Wolves* has scope and style to match its subjects, the wide open spaces of Alaska and youth . . ."* and the *L.A. Times Book Review* proclaimed the novel "A rare thing of beauty, a novel alive with detail about a life most of us would never experience."

Kantner has also written many columns for *Orion* magazine. Here's a brief taste of one of them:

"The house is shaking again, sheets of snow howling past, the way it is supposed to be here in the Arctic on the second-shortest day of the year. Out there in the dark my dog is barking. Whatever it is that's got him hollering must be important—if he spends more than a minute out of his doghouse it will be drifted with snow.

"China [Kantner's daughter] is out, too, playing. I bundle up and head out to check on her. The door is buried, the air full of moving snow. Worf, my third-hand dog, is curled up beside his house, his face and body crusted white. He springs to his feet, overjoyed. I pound his frozen snap with a moose bone until he is free."

If Kantner's account makes life in Kotzebue seems too posh, travelers can join the fewer than 4,000 people a year who visit those remote park units whose headquarters

Sand dunes bring a touch of the Sahara to Kobuk Valley National Park. Travelers rafting down the Kobuk River can take a short hike to see this landscape, one that few visitors expect to encounter in Alaska.

are in the heritage center. A number of guides take people on float trips through Kobuk Valley National Park and Noatak National Preserve. Adrenaline junkies will enjoy the upper portions of the Kobuk River, but most visitors might prefer to stick to the lower stretches, which allow rafters to drift serenely through tundra and patches of boreal forest, watching for grizzlies, caribou, and golden eagles. Most trips also involve a short hike from the river to the park's most famous feature: the Great Kobuk Sand Dunes, a 25-square-mile mini Sahara whose golden dunes rise as high as 500 feet, though the more accessible dunes are more in the 100-foot range.

The Noatak, a designated Wild and Scenic River, takes visitors on an even more ambitious adventure. From its headwaters deep in the Brooks Range, the Noatak snakes almost 400 miles east to west until it empties into Kotzebue Sound, about 15 miles across from Kotzebue. Numerous put-in points allow rafters, kayakers, and canoeists to carve those 400 miles into shorter segments. Almost the entire watershed of this pristine river is protected as wilderness, either in the 6.6-million-acre Noatak National Preserve or in the Gates of the Arctic National Park and Preserve. The river begins in forested mountains but soon descends into the broad, gently sloping Noatak Basin, characterized by abundant wildlife and rolling hills. As it flows on toward the sea, the river passes through the 65-mile-long Grand Canyon of the Noatak—beautiful in its own right, but visitors shouldn't expect the red-rock drama of Arizona's Grand Canyon. Soon, the Noatak winds into the seven miles of the much steeper Noatak Canyon. The landscape eventually grades from forest into tundra, and the river finally braids and runs through the flat delta into the sea. Most river runners take out before reaching the delta.

Flying from Kotzebue into the Brooks Range and floating back out on the Noatak River will give travelers a look at the far north's heart, but there's an easier way. Not easy, but easier. Drive the Dalton Highway. This is the only road in Alaska that crosses the Arctic Circle, and it keeps going 300 more miles all the way to the Arctic Ocean. (Technically, the road ends a few miles short of the ocean when it encounters oil company property; the general public can continue to the ocean only by going on an organized tour.) But it's not exactly an interstate. It isn't called the "Haul Road" for nothing.

Wild & Scenic Rivers

1 Alatna The Alatna descends the south slopes of the Brooks Range inside Gates of the Arctic National Park and Preserve and runs about 180 miles to the confluence with the Koyukuk River. The upper 40 miles are rocky, shallow, and sprinkled with rapids, so most people put in around Circle Lake and float the mellow lower portion of the river, savoring the wildlife (especially bears), the boreal forest, the great fishing, and the wonderfully named Helpmejack Hills.

2 Kobuk The wild and scenic portion of this 300-mile river lies up in the Brooks Range and, like some femme fatale in a 1940s film, it is both beautiful and dangerous; only very experienced river runners or travelers on guided trips should tackle this stretch. The lower portion of the Kobuk is much gentler, but it's not designated a Wild and Scenic River because it is a major travel corridor for people from several local villages and is heavily used during fishing and hunting seasons. The lower river passes through Kobuk Valley National Park.

3 Noatak From it headwaters in the middle of the Brooks Range, the Noatak flows nearly 400 miles west to Kotzebue Sound. Its first 330 miles are designated as Wild and Scenic River, and they live up to that billing, passing through mountains, canyons, and tundra-covered hills. It is mostly a gentle float, but like all wilderness rivers, the Noatak has its hazards and should not be taken lightly.

4 Sheenjek A river made famous by conservationists Olaus and Mardy Murie, the Sheenjek starts as a trickle in the eastern part of the Brooks Range and runs south for about 250 miles before it merges into the Porcupine River. It begins in southern reaches of the Arctic National Wildlife Refuge and ends in the northern reaches of the Yukon Flats National Wildlife Refuge, which suggests, rightly, that voyagers are likely to see a lot of wildlife. No monster rapids, but the river has some moderate rapids and other dangers that paddlers need to respect.

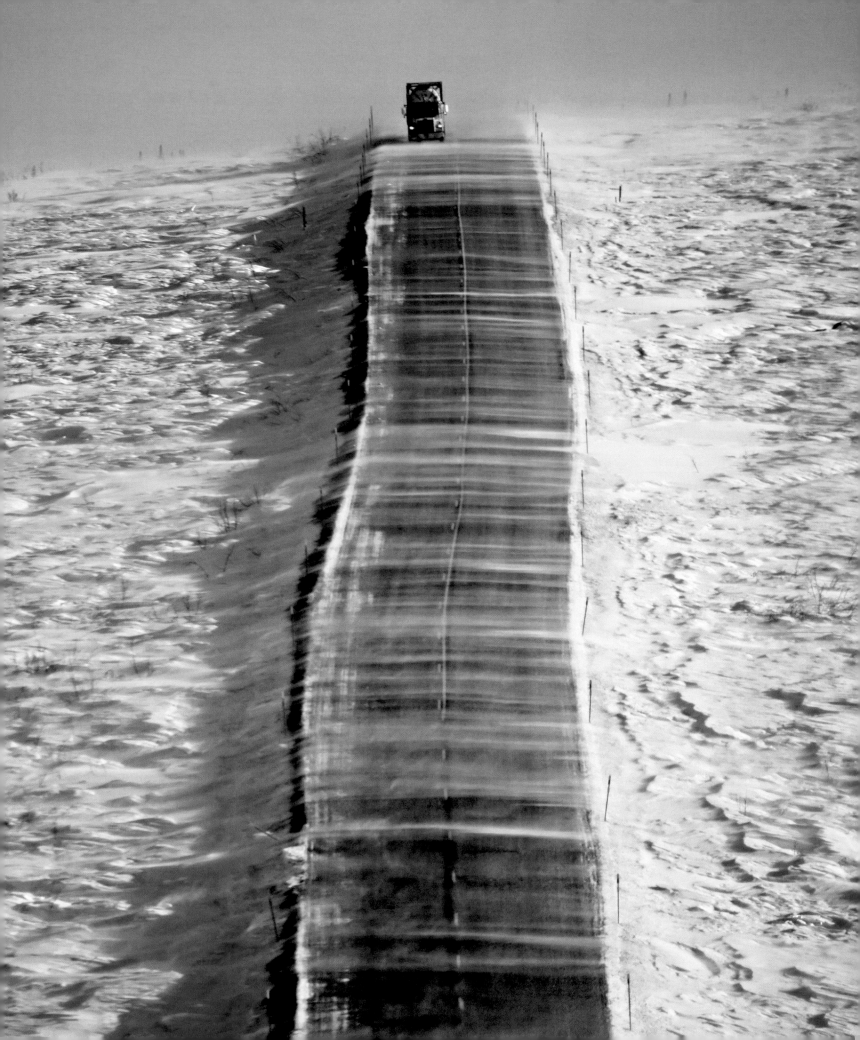

The Dalton Highway was built in 1974 to provide construction access to the northern stretch of the trans-Alaska pipeline, which runs from the oil fields in Prudhoe Bay, at the northern end of the Dalton, to the port in Valdez, in south-central Alaska. Today, its primary function is to connect the outside world to the oil fields and the company town of Deadhorse. Most of this so-called highway is gravel, it offers very few services, there are potholes, it is subject to avalanches, there is scant cell phone coverage, some sections are washboarded, vehicles must deal with steep grades, sometimes it snows in the high passes even in July, and it's a workhorse thoroughfare that's ruled by 18-wheelers, not Toyota Corollas. But many travelers feel the hardships of the highway are small price to pay for this quintessential Alaska journey.

The Dalton starts 84 miles northwest of Fairbanks and then runs northwest 115 miles through interior Alaska before it hits the Arctic Circle and enters the far north. At this point, boreal forest and rolling hills border the highway, but soon it begins climbing toward the Brooks Range. By the time motorists reach Coldfoot, at Mile 175, the surrounding area is dotted with 5,000- and 6,000-foot peaks, and there's no doubt travelers are in the mountains.

Coldfoot—could there be a better name for an Arctic town?—is a miniscule settlement; if a resident goes to Fairbanks for the day, the population drops about 10 percent. But Coldfoot does have a gas station and basic lodging, which is no small thing when the next services lie at the end of the road, 240 miles to the north—this is reportedly the longest stretch of road in the United States without services. Still, Coldfoot's most important role is as a gateway to the exquisite wildlands that sandwich the remainder of the highway. Staff at the Arctic Interagency Visitor Center provides information and advice about National Park Service, Bureau of Land Management, and U.S. Fish and Wildlife lands in the area; listen carefully to their advice because this landscape can be unforgiving. Rangers refer to it as a "black-belt wilderness," meaning visitors should have a black belt in outdoors skills or go with someone who does. From the Coldfoot Airport, bush pilots will fly travelers into the backcountry, either for a flightseeing trip or to be dropped off for a longer communion with nature. Many travelers also fly from Fairbanks to Bettles, a village about 30 miles west of the Dalton, and then take an even smaller plane into the wilds from there.

Opposite: A truck rumbles up the Dalton Highway in winter, the road like a bridge above a frothing sea as it crosses the snowy tundra.

Dalton Highway

This road is wild and beautiful, and long and rough—passing through boreal forest, across tundra, and beyond the Arctic Circle to the North Slope and the Arctic Ocean.

❶ The route begins near Livengood. At Mile 55.5, it crosses the 2,290-foot **Yukon River Bridge;** to learn about the pipeline, stop by the **Yukon Crossing Visitor Contact Station.**

❷ At Mile 98, pause at the **Finger Mountain BLM Wayside** to stroll the short interpretive nature trail.

❸ The Dalton crosses the **Arctic Circle** at Mile 115; interpretive signs enhance the **Arctic Circle BLM Wayside.**

❹ At Mile 175, **Coldfoot** (pop. 11) provides gas, lodging, tours, and flightseeing.

❺ Above the tree line at Mile 244.7, the road crests 4,739-foot **Atigun Pass.**

❻ Watch for Dall sheep and grizzlies as you descend to the tundra-covered **North Slope.** Millions of birds nest and breed here.

❼ The highway ends at Mile 414 in the oil town of **Deadhorse.**

The most popular destination—though it's hardly overrun with visitors—is Gates of the Arctic National Park and Preserve. Its eastern border lies just west of the Dalton, and from there, this enormous park sprawls west all the way to Noatak National Preserve, about 200 miles; it's nearly four times larger than Yellowstone. When famed explorer and conservationist Bob Marshall saw the area in the 1930s, he wrote, "It seemed as if time had dropped away a million years and we were back in a primordial world." Today, travelers will find the same sawtooth mountains, the same pure rivers, and the same array of wolves, grizzlies, beavers, caribou, eagles, and other wildlife.

> **66 Some of the hardiest people in the society were drawn to bush Alaska in search of a sense of release—of a life that remembered the past. 99**
>
> **[John McPhee, author]**

The riches of Gates of the Arctic reach well beyond just the flashy mountains and celebrity animals. For example, a visitor who slows down and observes closely may spot a frog the size of his thumb hopping along the forest floor. It's a wood frog. One can state this with certainty because this species of wood frog is the only amphibian that lives north of the Arctic Circle. And the way it survives the Arctic winter is just short of a miracle.

When snow and ice bury the park and the landscape goes into the deep freeze, so do the wood frogs. Special chemicals enable up to 65 percent of the water in their bodies to gradually crystalize into ice as their body temperature drops as low as minus 12°C (10°F.) Their hearts stop beating, they stop breathing for weeks at a time, and their metabolic processes almost completely shut down. Solutes known as cryoprotectants prevent the frogs' tissues from being damaged at those extremely low temperatures. Wood frogs in Alaska have far higher concentrations of these solutes than do wood frogs in the lower 48.

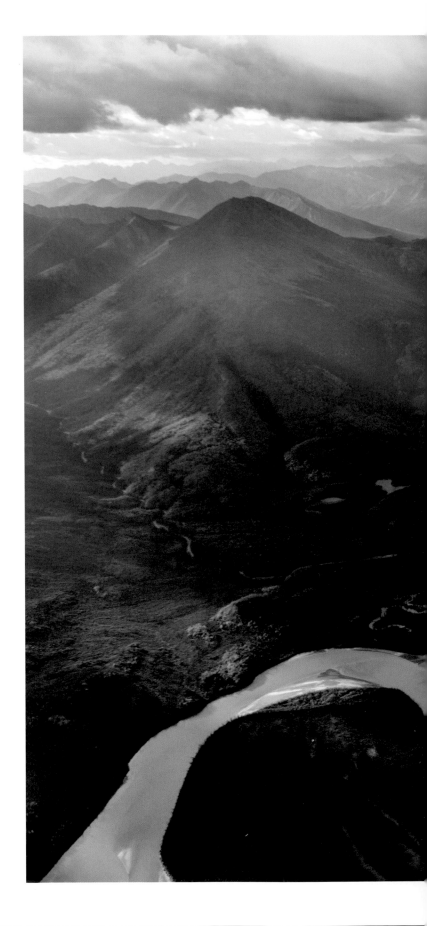

This image of the Alatna River meandering through the Brooks Range makes clear why it is a designated wild and scenic river.

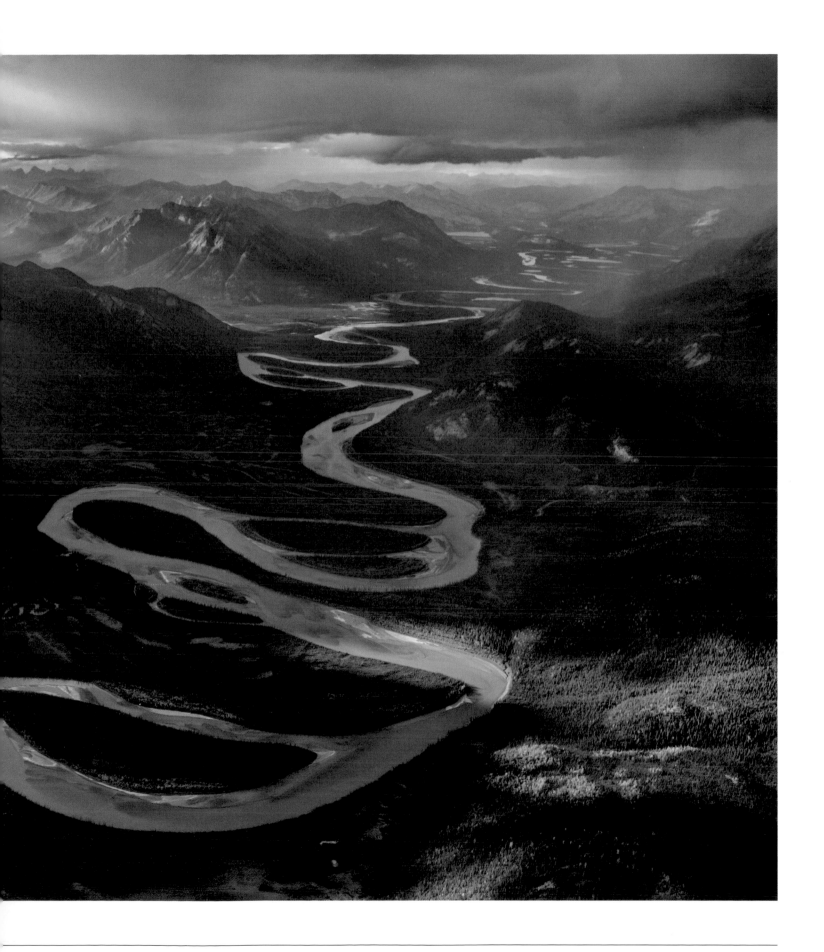

Scientists are studying wood frogs from Alaska in hopes of developing a way to safely freeze human tissue, enabling donor organs to be much more easily stored and shipped to patients in need of a transplant.

Travelers continuing north another 75 miles up the Dalton from Coldfoot will arrive at the top of Atigun Pass, elevation 4,739 feet, the highest point in Alaska's road system. The pass also marks the Continental Divide; water flowing south ends up in the Bering Sea, and water flowing north goes into the Arctic Ocean. The pass enjoys a reputation as a likely place to spot Dall sheep, those nimble beasts with the curling horns.

Atigun Pass also has a reputation—not one that it enjoys as much—as a likely place for avalanches, which seem to be getting more frequent. In the space of one week in late May 2013, more than half a dozen avalanches rumbled across the Dalton between Miles 240 and 245—the pass is located at Mile 244. Two of the avalanches hit moving trucks; fortunately, no one was injured in either incident. One tractor-trailer was knocked sideways and shoved on top of the guardrail. The other was swept off the highway and carried all the way across the frozen West Fork of the Chandalar River before it came to rest on the far bank. The first motorist on the scene said that the debris on the highway was a mixture of ice and slush: "a cross between a tsunami and an avalanche." A Department of Transportation spokesperson noted that the area is prone to typical snow avalanches in the winter, but these "slush avalanches" in the spring are unusual. The best way to avoid avalanches is to drive the Dalton in mid-summer or late summer.

As motorists who don't get detoured by an avalanche descend the north side of Atigun Pass, they soon start along a stretch of about 25 miles that skirts within a few miles of the western boundary of the Arctic National Wildlife Refuge (ANWR)—and nowhere near the eastern boundary. This refuge is huge, the largest in the nation; the eastern border is more than 200 miles from the Dalton, and the refuge is just as long north to south as it is east to west. It's about the size of Massachusetts, Vermont, and New Hampshire combined.

Due to the long-running controversy over whether to drill for oil in the refuge, many people have heard of this back-of-beyond refuge. But if it hadn't been for the efforts of two of America's most renowned early conservationists, Olaus and Margaret "Mardy" Murie, these 19 million acres of northeast Alaska may never have become a refuge, and oil development may have proceeded unnoticed.

Mardy landed in Alaska with her family in 1911, at age nine. Frontier Alaska was a good match for this lover of the

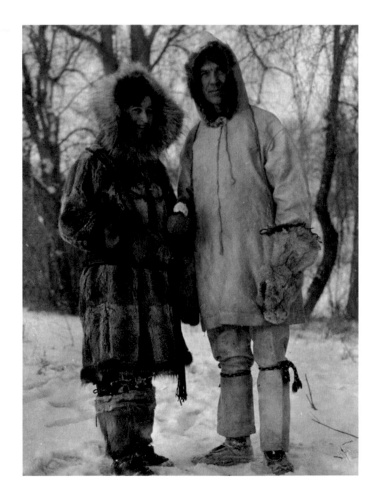

Renowned conservationists Margaret and Olaus Murie on their honeymoon in the Brooks Range, 1924—a honeymoon during which they conducted a caribou study and traveled by dogsled. The Muries spent many years in Alaska doing research and championing conservation.

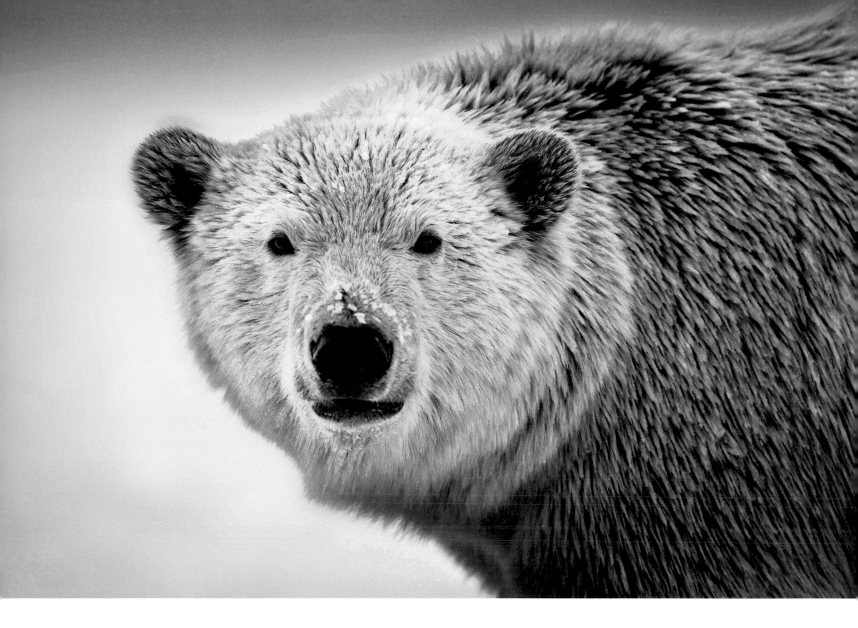

outdoors, who went on to spend most of her 101 years championing the wilds, earning her a Presidential Medal of Freedom and the unofficial title "Grandmother of the Conservation Movement." Olaus arrived in the Great Land in 1920, as a wildlife biologist with the U.S. Bureau of Biological Survey—precursor to the U.S. Fish and Wildlife Service. He went on to become president of The Wilderness Society, director of the Izaak Walton League, and one of the most eminent conservationists in American history.

This green power couple got married in 1924, and for their honeymoon, they headed north of the Arctic Circle to conduct a caribou study. They took a riverboat up the Koyukuk River and then a long dogsled journey in the wilds of the Brooks Range in what is now Gates of the Arctic National Park and Preserve. Some people might consider such a honeymoon grounds for divorce, but the Muries relished it. As Mardy wrote, "Days on the trail taught us that there is always and forever something to rejoice about. It was a fairyland, this highland, this skyland, on a glorious blue-and-gold day. Our seven dogs, the two of us, alone up there, sliding along the top of the world."

A polar bear searching for food along the Arctic Ocean shore of the Arctic National Wildlife Refuge. As its scientific name, *Ursus maritimus*, suggests, polar bears are marine mammals as much as terrestrial ones. Their huge paws serve as powerful paddles, and their outer hairs are water repellent.

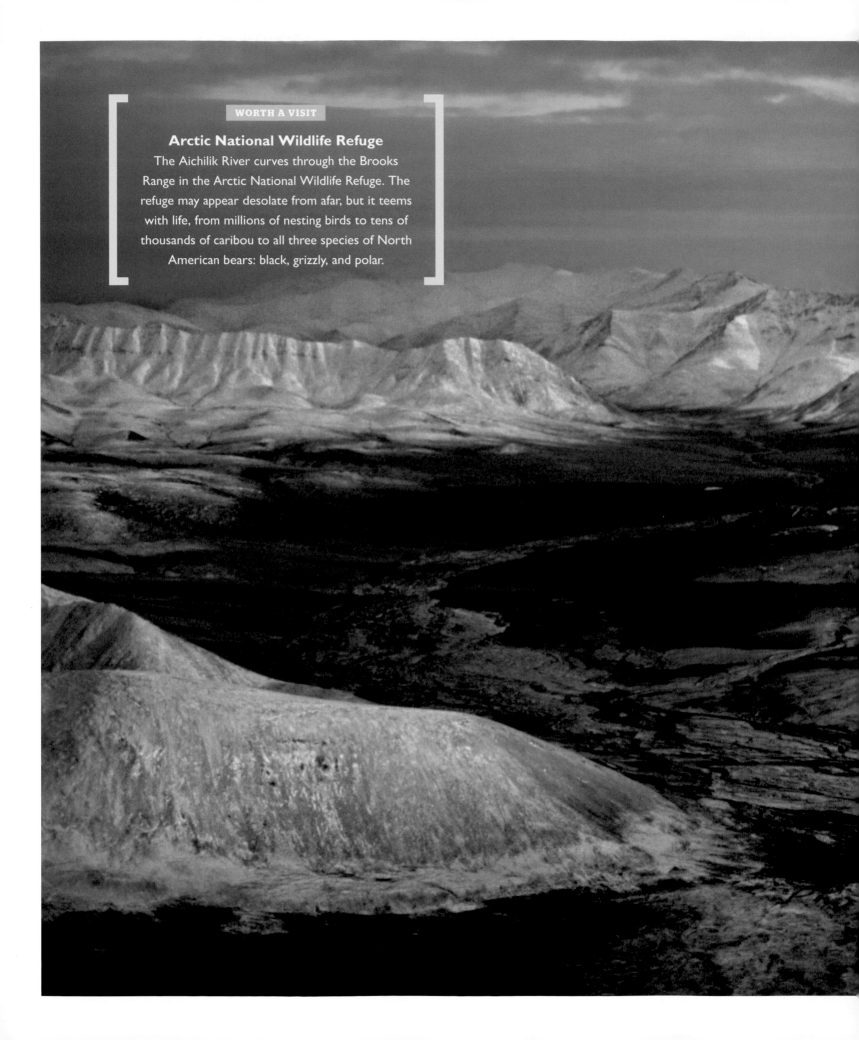

Arctic National Wildlife Refuge

The Aichilik River curves through the Brooks Range in the Arctic National Wildlife Refuge. The refuge may appear desolate from afar, but it teems with life, from millions of nesting birds to tens of thousands of caribou to all three species of North American bears: black, grizzly, and polar.

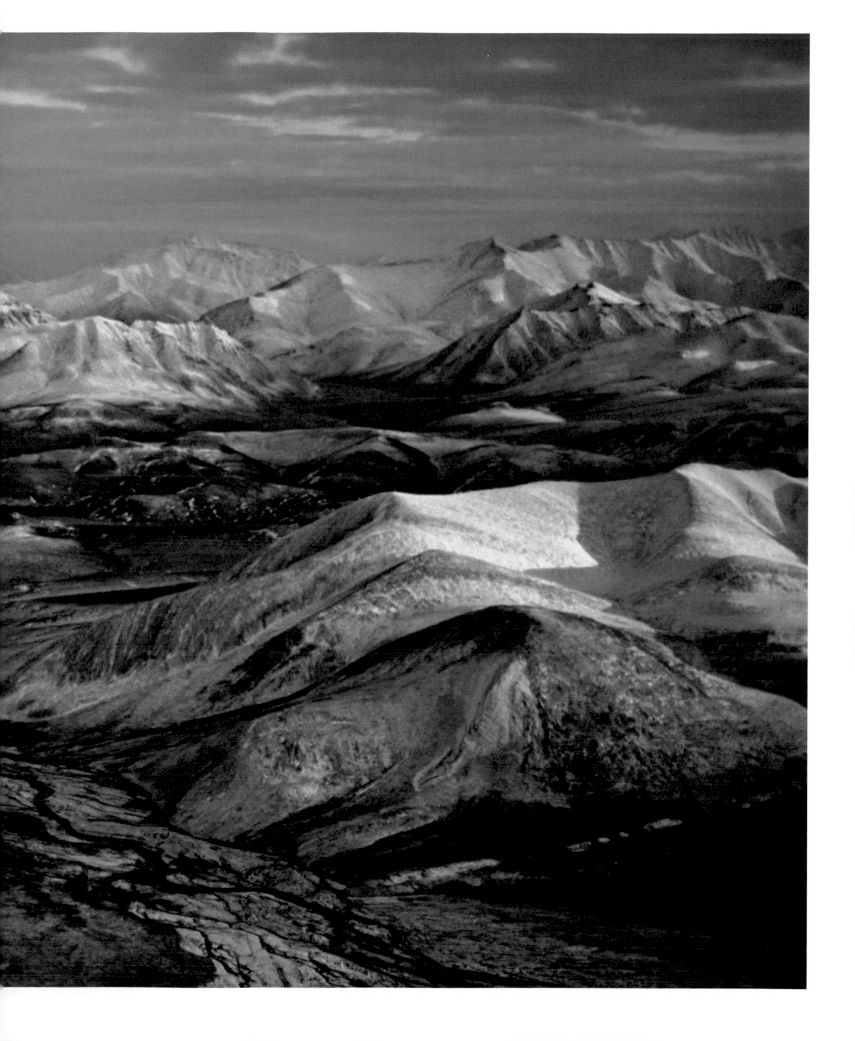

In 1956, the Muries took a three-month journey on the Sheenjek River in what is now the ANWR. They thought the area should remain undeveloped, so they and three companions set out to gather information about the wildlife and natural history of the area as grist for lobbying the federal government for protection. It worked. In 1960, President Dwight Eisenhower declared nearly nine million acres to be the Arctic National Wildlife Range. In 1980, that designation was changed from "range" to "refuge," and ten million additional acres were added.

ANWR is a tough place to get to (think bush planes landing on gravel bars), a tough place to get around in (think trailless hiking and wilderness river running), and a tough place to get along with (think mosquitoes, days of fog, and bears). Ah, but the payoff is as big as the place. The refuge is thought to have the greatest diversity of flora and fauna of any park or refuge in the circumpolar Arctic. Visitors may see wolves, moose, musk oxen, arctic foxes, lynx, and all three species of bear—grizzly, black, and polar. And if travelers catch the migration, they may see the antlered multitudes of the 170,000-strong Porcupine caribou herd moving through the refuge.

Peregrine falcon chicks in their nesting area on a bluff above the tundra on the North Slope. Many raptors nest on the North Slope's riverside cliffs, notably record numbers of peregrines, gyrfalcons, and rough-legged hawks along the Colville River corridor.

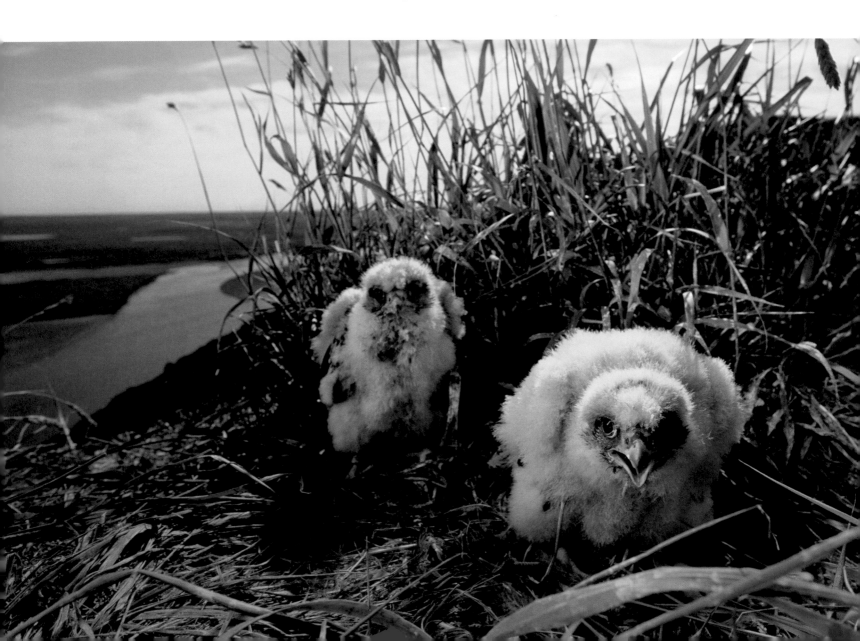

As the Dalton Highway slides farther downhill and emerges from the Brooks Range, it broaches the North Slope, the mostly flat, waterlogged, tundra-covered terrain that stretches east to west across all 600 miles of the far north. At its narrowest point, in the ANWR, the North Slope measures just a couple of dozen miles north to south, and at its widest point, in the middle, it measures maybe 200 miles north to south. Long brushed aside as a wasteland, the North Slope is now known to be doubly rich, but in conflicting ways: rich in oil and gas, and rich in natural and cultural values.

Caribou are some of the most famous wild denizens of the North Slope. Alaska's four largest herds, together numbering more than 600,000 animals, live year-round or seasonally on the North Slope. The caribou play a crucial role in the lives of some Alaska natives, notably the Gwich'in, who are sometimes called "the caribou people." Due to the Arctic melting brought on by climate change, perhaps the most renowned inhabitants of the North Slope are the 1,000 or so polar bears, renowned even though they only live along the coast and spend most of their lives out on the sea ice—or, at least, they did until that ice starting melting excessively.

The bountiful wildlife of the North Slope isn't limited to polar bears, caribou, and other furry, four-legged luminaries. Consider the birds. Think back to all those migrating birds that throng birding hotspots and inspire birding festivals in the more southerly parts of Alaska, like the Copper River Delta, Kachemak Bay, Creamer's Field in Fairbanks, and the Stikine River. Most of those migratory millions are heading for the North Slope, where they nest, raise their young, and molt in the summer. Dunlins come from the coast of China; yellow wagtails from southern Asia and Africa; buff-breasted sandpipers from the Argentine Pampas; red phalaropes from the waters off the coast of Chile; and arctic terns, those nonpareil migrants, all the way from Antarctica.

These birds don't fly thousands of miles for the exercise. They come largely for the food. Though the North Slope summer may only last a couple of months, that midnight

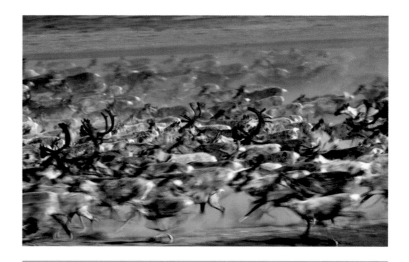

Caribou Herds

1 Central Arctic As of 2011, this herd numbered about 67,000, but caribou populations can fluctuate significantly due to disease, climate change, predation, hunting pressure, and other factors. The Central Arctic herd's territory stretches from the central Brooks Range to the shore of the Arctic Ocean and overlaps with all three of the other far-north herds. However, the Central Arctic herd has its own unique calving area, which is what defines a caribou herd.

2 Porcupine Due to their prominence during the debate about whether to drill for oil and gas in the Arctic National Wildlife Refuge, the 170,000 members of the Porcupine herd are probably the most famous caribou in the United States. Like all large herds, they must keep moving to find sufficient willows, sedges, lichens, and other food; this relentless quest leads the Porcupine herd into northwestern Canada at certain times of year.

3 Teshekpuk The smallest herd in the far north but the fourth largest (as of 2011) in Alaska, the Teshekpuk caribou roam an area east and south of Barrow, down to the Brooks Range. Most of their territory lies within the National Petroleum Reserve in Alaska, which makes their welfare a leading concern in discussions regarding oil and gas development in the reserve.

4 Western Arctic Wildlife biologists who want to survey the Western Arctic herd had better top off the gas tanks of their bush planes, because this herd is Alaska's largest, ranging from perhaps 300,000 to 500,000. As befits a herd of this size, its territory also is vast, extending from the Arctic Ocean around Barrow well over 500 miles south to the northern edge of the Yukon-Kuskokwim Delta.

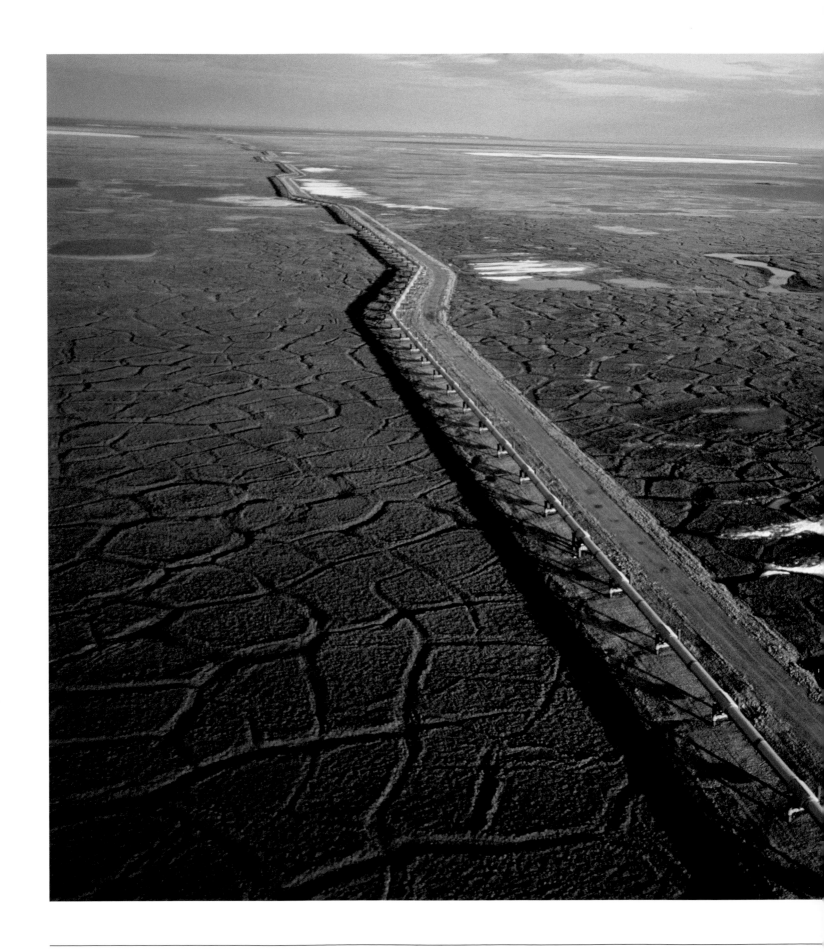

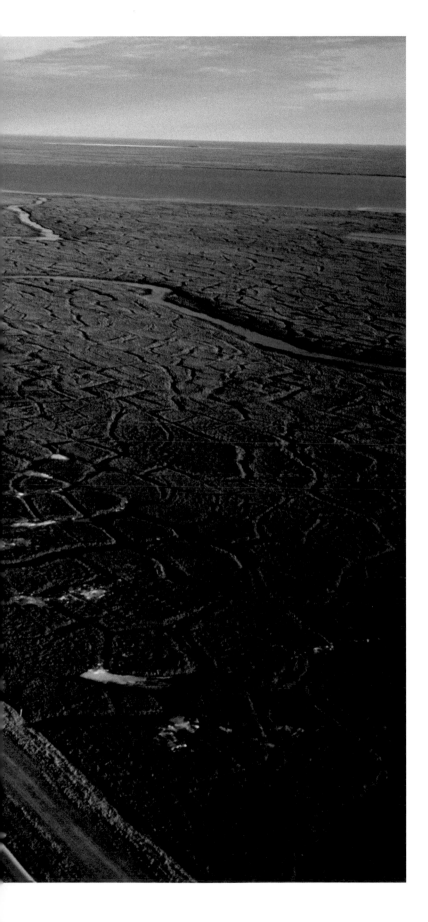

sun raises temperatures into the 50s and 60s, and ignites an explosion of tasty insects and young plant growth. Travelers may not welcome the emergence of billions of mosquitoes, but birds lustily hoover them up both for themselves and for their nestlings.

Travelers who venture into the northern sections of the ANWR or to other remote portions of the North Slope will witness this avian extravaganza, but motorists along the Dalton also can glimpse it—and they enjoy the added bonus of watching from the bug-free interiors of their vehicles. Perhaps a colorful spectacled eider will swim into view on a pond. A traveler might see an arctic tern that's hovering 50 feet above a

> ❝ I have many young men and women in my crew. So I [teach] them how to hunt the whales . . . what I've been taught from my forefathers. We pass it to the younger generation. ❞
>
> **[Ned Arey, Sr., Barrow whaling captain]**

small lake suddenly dive and knife into the water, emerging a moment later brandishing a fish. A careful observer scanning the tundra with binoculars might spot a red phalarope on its nest, hiding under the scrubby vegetation; it's a male, because female phalaropes head back to their wintering grounds as soon as they've laid their eggs, leaving the egg warming and nestling care to the males. That observer also might see one of the predators from which the phalarope is hiding: a gull-like jaeger, slowly cruising above the tundra looking for a nest to raid. Patient visitors can watch an age-old drama unfold, a drama with many characters and a complex plot.

However, there's a plot twist that may significantly affect this drama in a vast expanse of the North Slope known as the National Petroleum Reserve in Alaska (NPR-A). Even larger than the ANWR, its 23 million acres sprawl across most of the

The trans-Alaska pipeline carries oil from the fields in Prudhoe Bay 800 miles south to the ice-free port of Valdez, where the oil is loaded onto huge tankers.

The Death of Will & Wiley

In the summer of 1935, a couple of friends who also happened to be two of the most famous men in the United States decided to fly a small plane around the world. The pilot was Wiley Post, who was the most renowned aviator in the nation with the exception of Charles Lindbergh. Among many accomplishments, he was the first person to fly around the world solo. The passenger was Will Rogers, beloved humorist, newspaper columnist, and movie star. On August 15, they took off from a lagoon near Barrow, but almost immediately, the plane experienced engine trouble and nose-dived into the water, killing both men.

western half of the North Slope. As its name suggests, one purpose of the reserve is to provide energy development, but congressional legislation also places high value on the tremendous ecological value of this still mostly wildland, which biologists consider comparable to the ANWR. In 2013, the Department of the Interior announced a plan for balancing oil and gas development with environmental concerns. The plan would enable development of most of the NPR-A's energy reserves, but it still sparked some opposition from pro-development forces, so just how this plot twist plays out remains to be seen.

Travelers whose wallets and stomachs can handle bush plane travel or long river trips can visit some of the special places that would be protected by Interior's plan, such as the Utukok uplands, in the northern foothills of the Brooks Range. The Western Arctic Caribou Herd, Alaska's largest, calves there each summer. The presence of 300,000 to 500,000 caribou draws a full suite of predators, too, including wolves, grizzlies, and the cleanup crew that scavenges the carcasses, such as wolverines, arctic foxes, and birds. Another feature in the Brooks foothills that would be protected by Interior's plan is the Colville River corridor. It is renowned for the record numbers of gyrfalcons, peregrine falcons, and rough-legged hawks that nest on its bluffs.

Perhaps most notably, Interior's plan would protect millions of acres of Arctic coastal plain that include Teshekpuk Lake and the rich array of tundra and wetlands that surrounds it. The 60,000 or so animals in the straightforwardly named Teshekpuk Lake Caribou Herd are some of the area's vital assets, but most treasured are the birds, especially the hundreds of thousands of waterfowl, and even more especially the geese. About 35,000 greater white-fronted geese, an equal number of Pacific black brant (one-third the world's population), thousands of Canada geese, and thousands of snow geese come here to nest and molt. Teshekpuk Lake and environs are the most important molting sites for geese in the circumpolar north.

Once or twice a year, birds molt, losing old, battered feathers and growing nice new ones. Most species molt gradually and never lose the ability to fly, but waterfowl are synchronous molters that do the changeover all at once, in the space of two to four weeks, which makes them exceptionally vulnerable during their earthbound period. Scientists think waterfowl evolved this risky strategy because they're heavy relative to their wing size, and shedding even a few feathers would turn them into clumsy fliers; perhaps it's better to just get it over with than to flap awkwardly around for much of

the year. Clearly, when geese are grounded it's crucial that they have a safe spot to molt, and Teshekpuk Lake and vicinity provide excellent molting habitat.

If a traveler took off in a floatplane from Teshekpuk Lake and steered north, she'd be above the Arctic Ocean in about ten minutes. Yet, as close as it is to the tundra and wetlands of the coastal plain, the shore and the sea beyond constitute another world, a water world of seafaring people, marine mammals, and saltwater animals and plants.

The unofficial capital of this realm and of Alaska's far north is Barrow—a town of about 4,300, most of whom are Inupiat—and located close to the tip of Point Barrow. Point Barrow is the northernmost spot in the United States, about 350 miles north of the Arctic Circle and a place where the sun doesn't set for most of the summer. First-time visitors might want to start a tour of Barrow by going to the beach and staring at the Arctic Ocean, perhaps dipping a toe in it if the ocean isn't frozen. In the past, it would have been solid ice maybe ten months out of the year, but with climate change, the open-water season is lengthening. As visitors continue wandering around town, they may see whale bones leaning against houses and seal meat drying on racks juxtaposed with SUVs and racquetball courts; Barrow maintains a balance between the modern and the traditional.

The few visitors who leave the relative familiarity of Barrow and travel out to the Inupiat villages scattered along the shore will find a very different balance, one that skews heavily to the traditional. But even in Barrow, many Inupiat participate at some

Barrow's 4,300 citizens, most of them Inupiat, occupy the northernmost town in the United States, huddled on the shore of the Arctic Ocean some 330 miles north of the Arctic Circle. During the summer, the sun doesn't set for more than 80 days in a row.

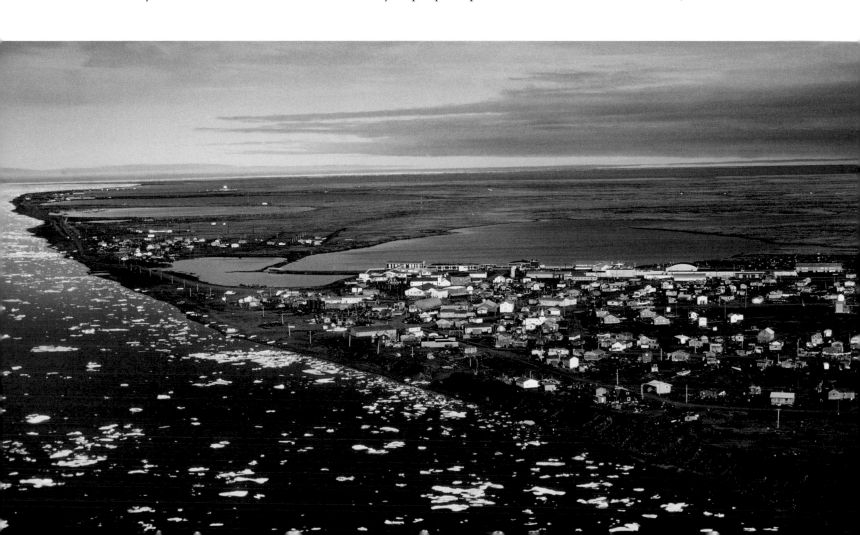

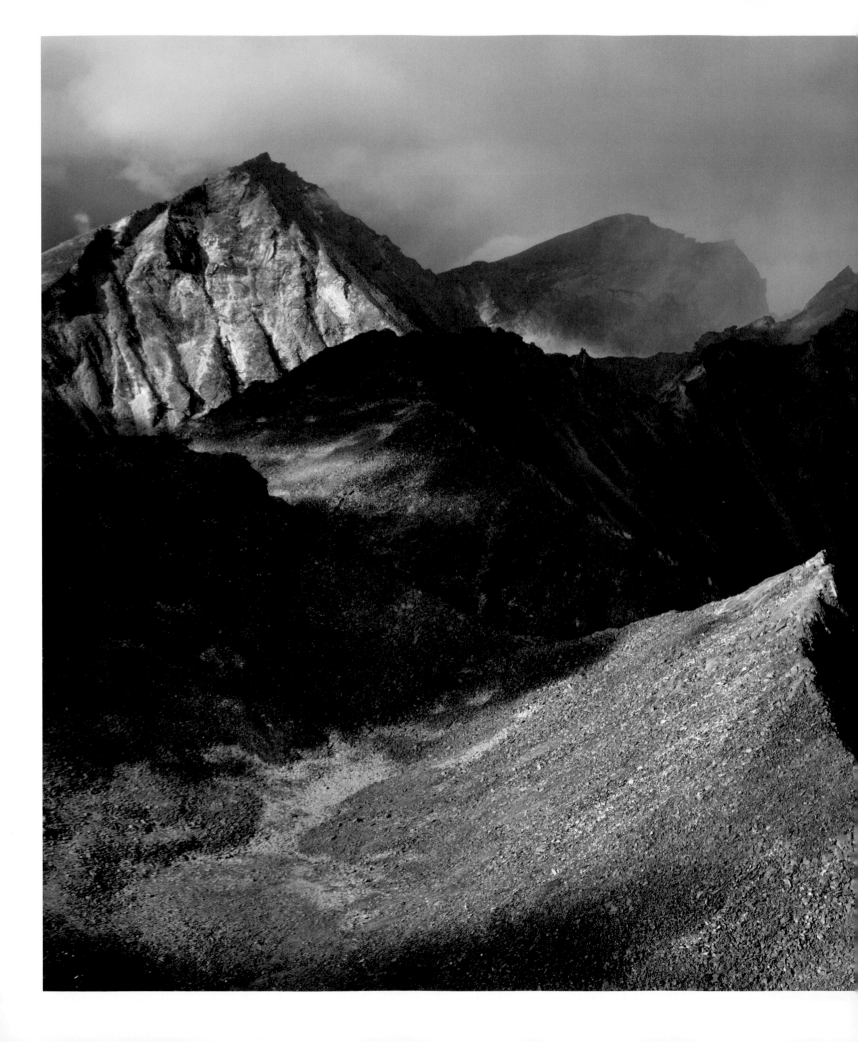

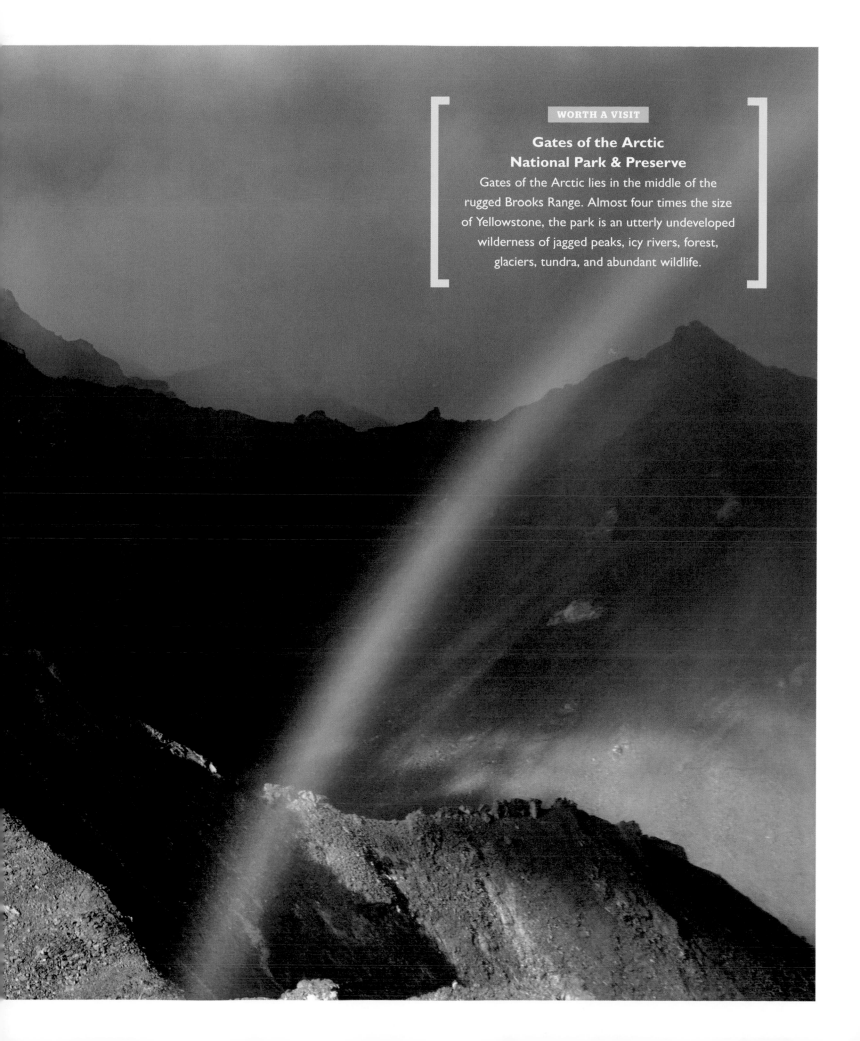

Gates of the Arctic
National Park & Preserve

Gates of the Arctic lies in the middle of the rugged Brooks Range. Almost four times the size of Yellowstone, the park is an utterly undeveloped wilderness of jagged peaks, icy rivers, forest, glaciers, tundra, and abundant wildlife.

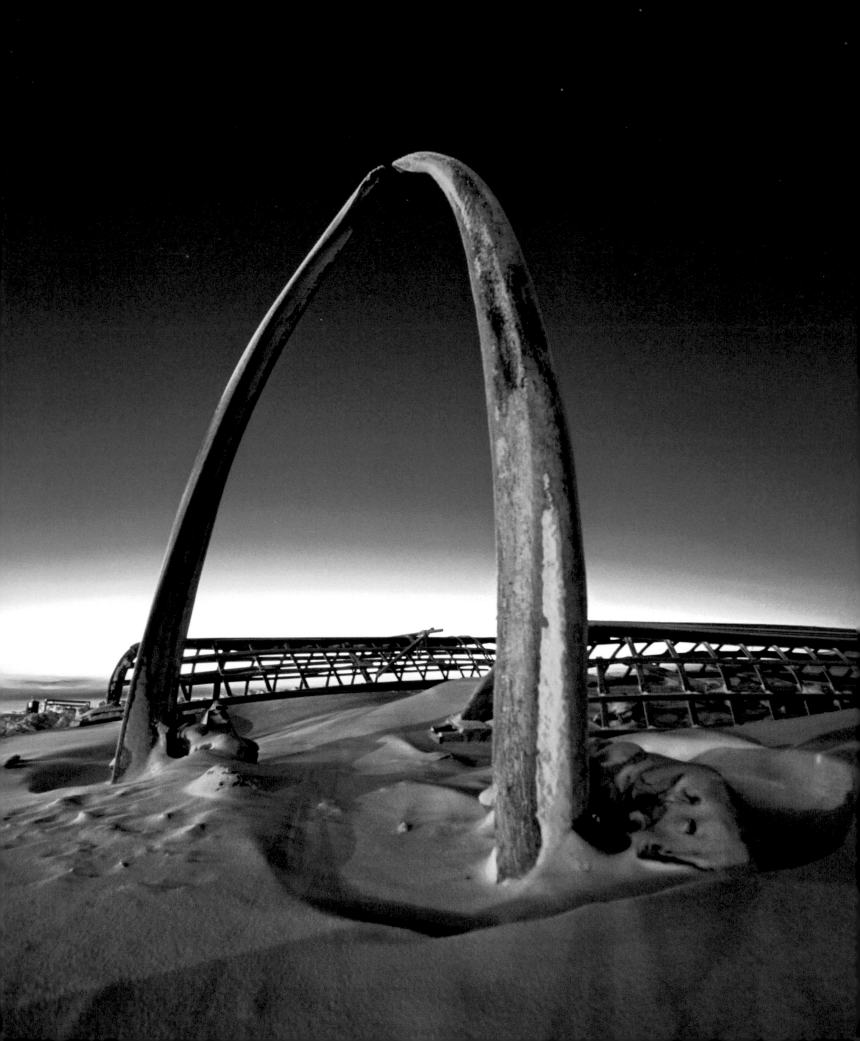

level in the most central Inupiat cultural touchstone: subsistence whale hunting. For thousands of years, the Inupiat have harvested migrating bowhead whales, which pass through channels in the ice during the spring and fall.

This ancient tradition may soon be disrupted, however. There's a growing push for offshore drilling, despite the fact that the harsh conditions in the Arctic Ocean are likely to cause oil spills and the fact that spills would be difficult if not impossible to clean up in this region. Many locals worry that drilling would harm the whales and that increased commercial activity in the Arctic Ocean in general would force the bowheads to migrate farther from shore where they'd be hard to reach. Other locals would welcome the jobs that drilling would bring. Again, the perpetual quest for balance between the modern and the traditional.

These days, the fall hunt is typically a utilitarian affair in which the hunters use powerboats to approach a bowhead and a bulldozer to haul its carcass onto the beach. But even the fall hunt observes some customs. Lots of people gather as a whale is dragged ashore and butchered on the spot, creating a festive, communal atmosphere. Women quickly boil some of the blubber and walk around offering it to people. For days after a successful hunt, whaling boat captains hold open houses and distribute whale meat throughout the community. The food provided by whales sustains many households, especially in the villages.

The spring hunt is often more traditional. As in the fall, the butchering of the whale is a communal event and the products are widely shared, but in spring, the hunt itself is usually prepared for and conducted much as it has been in generations past. A hunter kills a bearded seal, whose skin is used to cover a wooden boat frame, using caribou sinew as thread. The result is an umiak, which the whalers paddle after a bowhead. Instead of a bulldozer, dozens of people use a rope tug-of-war style to pull the dead whale onto the beach, where the butchering ensues.

One hopes that the Inupiat achieve a balance between the modern and the traditional that enables some of the old ways to live on. Likewise, one hopes that the cycle of life in the far north continues for the whales, the caribou, the geese, the polar bears, and all the other animals, right down to the wood frogs and,

Opposite: A whale-bone arch in Barrow underscores the importance of whaling to Inupiat culture. *Right:* Inupiat hunters paddle a traditional umiak in search of bowhead whales.

yes, even the mosquitoes. A century from now, on the day when the sun once again rises above the horizon after months of winter slumber, one hopes that its wan but strengthening light will shine down on a landscape in which the call of the wild still resounds. ■

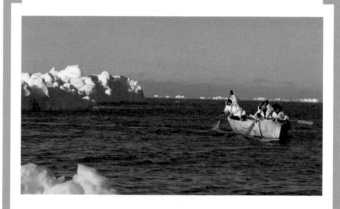

ICONIC CHARACTER

The Inupiat Whaling Captain

Hunting bowhead whales is a matter of immense cultural and practical importance to the Inupiat, thus whaling captains are figures of great respect. In modern times, whaling captains also garner the official stamp of approval from the state in the form of a license; several dozen licensed captains live in Barrow, for example. With help from crew and elders, these captains must understand all sorts of factors that go into successful whale hunts, such as bowhead habits, migration patterns, ocean currents, and shifting sea ice conditions.

Sites and Sights in the Far North

Three factors combine to make **Kotzebue** a no-frills kind of town. One, it doesn't attract throngs of travelers, particularly travelers who are not visiting the region to fish or hunt. Two, the majority of the 3,300 or so residents lead at least a partly subsistence lifestyle, which means someone's front yard is more likely to be a staging area for a walrus hunt than an aesthetic showcase for the neighbors to admire. Three, the town is exposed on the tip of a narrow, three-mile-long spit that juts into the Chukchi Sea, so Kotzebue is frequently pummeled by bruising weather; if the town built a cute little gazebo in the park or set out elaborate winter holiday displays, they'd be shredded. Accordingly, its buildings tend to be plain and practical. A stroll will give visitors a glimpse of this hardworking town. Visitors might start on Shore Avenue; though it's only a gravel road, it serves as the town's main drag. It parallels the beach, which faces Kotzebue Sound and the Chukchi Sea. Visitors may see boats hauled out on the sand for repairs, and long strips of salmon drying outside on racks. During the endless daylight of summer, this beach is a great place to go in the middle of the night to watch the sun hover on the horizon, casting a warm golden glow across the shimmering surface of the sea. *cityofkotzebue.com*

The airy **Northwest Arctic Heritage Center** serves both as a museum covering natural history and Inupiat culture and as National Park Service headquarters for four nearby park service units: Kobuk Valley National Park, Noatak National Preserve, Bering Land Bridge National Preserve, and Cape Krusenstern National Monument. As visitors enter, they are greeted by a floor-to-ceiling painting of a woolly mammoth. In the main hall, visitors can go with the flow, literally—a stream of water that starts in a mountain scene, flows on into the forest and tundra, and then on to the beach. Animals such as Dall sheep, caribou, and beluga whales appear in the appropriate habitats. Check out the umiak (a large, open Inupiaq boat made of animal skins stretched over a wooden frame)

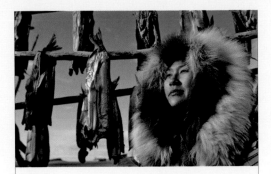

Kotzebue woman drying fish

hanging upside down from the ceiling of the lobby. This symbolizes shelter; during a storm, Inupiat hunters might take refuge beneath an overturned umiak on the sea ice or on shore. Visitors can also go to storytelling stations and listen to recordings of elders and others telling traditional tales, as well as accounts of contemporary local life. *cityofkotzebue.com*

From its headwaters deep in the Brooks Range, the Noatak River flows almost 400 miles west to Kotzebue Sound, about 15 miles across from Kotzebue. But **Noatak National Preserve** is much more than just the river. Its 6.6 million acres encompass nearly the entire watershed, making this such a rare and unspoiled landscape that it was designated an international Biosphere Reserve. Most of the river corridor itself is protected as a Wild and Scenic River, a designation it emphatically lives up to. Most visitors fly in to a remote site and then float down the river; numerous put-in points allow rafters, kayakers, and canoeists to carve those 400 miles into shorter segments. The river begins in forested mountains but soon descends into the broad, gently sloping Noatak Basin, characterized by rolling hills, boreal forest, and tundra. Wildlife abounds throughout the preserve and includes major mammals, such as moose, grizzlies, Dall sheep, and wolves, as well as more than 150 species of birds. Many river runners bring fishing gear so they can reel in some whitefish, arctic char, or grayling for dinner. As it flows on toward the sea, the river passes through the 65-mile-long Grand Canyon of the Noatak and the

seven miles of the steeper Noatak Canyon. *nps.gov/noat*

Travelers go to **Cape Krusenstern National Monument** for various reasons. Some yearn to see musk oxen in the wild. Birders may come to scan the skies for rare species blown in from Asia by a storm. People might wander the monument during the caribou migration in hopes of seeing some of the Western Arctic herd, which numbers in the hundreds of thousands. Plenty of good reasons exist to visit the monument, yet it wasn't established primarily for the people of today. It was created for people from the past, long-gone residents dating as far back as 5,000 years. The monument contains an archaeological district consisting of scores of limestone ridges that run from the shore back into the interior like a series of giant earthen waves. Digs have yielded stone tools, harpoons, pottery, and other artifacts ranging from thousands of years ago to more recent times. Cape Krusenstern is a bit more accessible than most of the northwest coast because it's only about a dozen miles from Kotzebue, and travelers can hire bush planes or boats to take them to this gateway to the past. *nps.gov/cakr*

Fireweed in Gates of the Arctic National Park

The Kobuk River valley, including **Kobuk Valley National Park,** has been home to people for more than 12,000 years. Today's residents still make extensive use of the valley's bounty, hunting bear, caribou, moose, and waterfowl and gathering edible and medicinal plants. Visitors should be respectful of any cabins, camps, or nets they encounter. Most travelers explore the park via the mostly easygoing Kobuk River, watching the banks for grizzlies and golden eagles as they paddle or drift along. The valley is a bit of a land that time forgot; the cold, dry climate resembles that of the late ice ages, enabling the landscape to support plants that grew long ago on the Bering land bridge that connected North America and Asia. Dry but much warmer conditions await summer visitors who hike a mile or two up from the river to the **Great Kobuk Sand Dunes:** 25 square miles of dunes rising a hundred feet into air where temperatures can rise to a surprising 90°F. *nps.gov/kova*

When travelers get to **Point Barrow,** they cannot get any farther north in the United States. Up here, some 350 miles north of the Arctic Circle, there's flat tundra and icy Arctic Ocean as far as the eye can see. Just a few miles south sits the town of **Barrow,** a municipality of about 4,300, most of whom are Inupiat, that functions as the unofficial capital of the far, far north. Visitors who aren't in town on business often start a tour of Barrow by going to the beach and gazing at the Arctic Ocean, perhaps dipping a toe in if it isn't frozen. If there's no blizzard and if the bugs aren't overwhelming, travelers may wish to continue wandering around town, taking in the blend of traditional and modern: whale bones leaning against houses and seal meat drying on racks juxtaposed with people texting on their smartphones and playing basketball in the fine gym at the $80 million high school. At the **Inupiat Heritage Center,** visitors can take in displays on whaling, Inupiat culture, and natural history and watch demonstrations of traditional crafts. *cityofbarrow.org, nps.gov/inup*

Come on, kids! Let's go visit the National Petroleum Reserve! Well, that sounds about as enticing as taking a tour of a dry-cleaning museum, but the **National Petroleum Reserve-Alaska** is not what it sounds like. Roughly the size of Indiana, most of the reserve is a wild landscape that sprawls between the Arctic Ocean and the Brooks Range. Though some of it is being developed for oil and gas and a lot more may be in the future, instead of oil derricks, visitors today will see caribou, geese, wolves, gyrfalcons, grizzlies, peregrine falcons, arctic foxes, wolverines, and all the other denizens of a prime far-north wilderness. This is a tough place to get to and is not set up for visitors in any way, so travelers need to do their homework to figure out how to take a trip to this hidden gem. The city of Barrow would be a good place to start, as the reserve nearly engulfs the town.

Travelers who have overdosed on North Slope tundra and are pining for mountains can scratch their itch in **Gates of the Arctic National Park and Preserve.** Here, they will find sawtooth peaks hitting heights of 5,000, 6,000, and more than 7,000 feet. On the south side of the Brooks Range, respectable conifer forests provide a contrast to the knee-high tundra vegetation that blankets so much of the far north. Nearly four times the size of Yellowstone, Gates of the Arctic is a wilderness, but numerous outfitters will take visitors into the park on hiking and paddling trips. River trips are especially popular because the park offers several designated wild-and-scenic rivers and paddling experiences ranging from frothing white water to placid floats. Travelers usually enter Gates of the Arctic by flying into the gateway communities of Bettles or Anaktuvuk Pass or by driving up the Dalton Highway to Coldfoot and flying into the park from there. Visitors who lack the time or inclination to tackle this challenging park can get a glimpse by going on a flightseeing trip. *nps.gov/gaar*

As one might expect given that it covers more than 19 million acres, the **Arctic National Wildlife Refuge** offers travelers a wide choice of habitats. The highest summits of the

Brooks Range, topping 9,000 feet, rise in the refuge. To the north, the land flattens and turns to lowland tundra before reaching the Arctic Ocean shore. To the south of the Brooks Range, the refuge holds millions of acres of boreal forest streaked with rivers. And, of course, being a wildlife refuge, it brims with wildlife—the greatest diversity of any park or refuge in the circumpolar Arctic. The refuge hits the rare trifecta of black bears, grizzly bears, and polar bears. *fws.gov/alaska/nwr/arctic*

Atigun Pass, Dalton Highway

The **Dalton Highway** has its drawbacks. It's a 414-mile gravel road that gets dicey in spots and is primarily used by trucks serving the oil fields at the northern end of the line in Prudhoe Bay. But the Dalton is the one road that leads from the rest of Alaska to the far north of the state, and it passes through some exquisite wilderness, so many travelers find it worth the trouble. "Trouble" means bringing extra equipment, such as two full-size, mounted spare tires; replacement headlights and belts; coolant, plenty of food and water; blankets and sleeping bags; and extra gas. When one of the big gravel-flinging trucks that service the oil fields approaches, motorists should pull over and pray for the safety of their windshields. And tourists should always drive with their headlights on. Note that many car rental companies don't allow their vehicles to be driven on the Dalton. Travelers who prefer to avoid this much "trouble" can sign on with one of the tour outfits that run vans up and down the Dalton. *fairbanks-alaska.com*

Acknowledgments & About the Author

Acknowledgments

Thanks to the many Alaskans who patiently answered question after question after question. A special thanks to those who helped sort out particularly challenging subjects: Tina Buxbaum, program director of the Alaska Center for Climate Assessment and Policy; Jenny Evans, administrator at the Alaska Eskimo Whaling Commission; Mike Koskey, assistant professor in the Department of Alaska Native Studies and Rural Development, University of Alaska, Fairbanks; and Jeff Rasic, National Park Service archaeologist. And, as always, the biggest thanks of all to Mary, my wife, for her enduring support.

About the Author

Bob Devine has been writing about the environment, natural history, and travel since the 1980s. His books include *Bush Versus the Environment; Alien Invasion: America's Battle with Non-native Animals and Plants; National Geographic Traveler: Alaska; National Geographic Guide to America's Outdoors: Pacific Northwest;* and *National Geographic Guide to America's Outdoors: Western Canada.* He has written articles for many leading publications, including *The Atlantic, Audubon, National Geographic Traveler, Sierra, Nature Conservancy, Travel & Leisure, Wildlife Conservation, Defenders,* and *International Wildlife.* Devine currently lives with his wife in Corvallis, Oregon.

Key Alaska Events

Fur Rendezvous
Anchorage, late February to early March, tel. 907/274-1177, *furrondy.net.* Alaska's biggest winter festival offers three weeks of diversions, from a fur auction to ice bowling.

Iditarod Trail Sled Dog Race
From Anchorage to Nome, the granddaddy of all sled dog races starts the first Saturday in March, tel. 907/376-5155, *iditarod.com.*

Copper River Delta Shorebird Festival
Cordova, early May, tel. 907/424-7260, *cordovachamber.com.* Celebrates the arrival of millions of shorebirds at the Copper River Delta. Workshops and birding trips.

Kodiak Crab Festival
Kodiak, late May, tel. 907/486-4782 or 800/789-4782, *kodiak.org/crabfest.html.* Five-day festival features crab fixed any way you can imagine, plus tennis, fencing, poetry, folk dancing, etc.

Midnight Sun Baseball Game
Fairbanks, June 20/21/22, tel. 907/451-0095, *goldpanners.com/midnight_sun_game.html.* On the summer solstice the Fairbanks Goldpanners play a team from outside, in a tradition that dates to 1906. Played only by natural light, the game goes from about 10:30 p.m. to 1:30 a.m.

Sitka Summer Music Festival
Sitka, early June, tel. 907/747-6774, *sitkamusicfestival.org.* Three-week chamber music series attracts world-class performers.

Mount Marathon Race
Seward, July 4, tel. 907/224-8051, *sewardak.org.* Since about 1915, runners starting at sea level in Seward have raced 1.5 miles up this 3,000-foot mountain and back. This famously rugged race draws tens of thousands of onlookers.

World Eskimo-Indian Olympics
Fairbanks, mid- to late July, tel. 907/452-6646, *weio.org.* Alaska native athletes gather for four days of competition in traditional events that derive from survival skills. These challenges include one man carrying four men and a tug-of-war using one's ears.

Alaska State Fair
Palmer, late August through early September, tel. 907/745-4827, *alaskastatefair.org.* Big-name entertainers, livestock, arts and crafts, and those incomparable giant veggies.

Alaska Bald Eagle Festival
Haines, usually the second weekend in November, tel. 907/766-3094, *baldeagles.org/festival.* Attracts bird experts, artists, and entertainers for several days of lectures, photography workshops, and guided eagle viewing tours.

Further Resources

Books

Bodett, Tom. *As Far as You Can Go Without a Passport: The View from the End of the Road.* Da Capo Press, 1986.

Hoagland, Edward. *Alaska Travels: Far-Flung Tales of Love and Adventure.* Arcade Publishing, 2012.

Hobbie, John, and Huryn, Alex. *Land of Extremes: A Natural History of the Arctic North Slope of Alaska.* University of Alaska Press, 2012.

Huntington, Sidney. *Shadows on the Koyukuk: An Alaskan Native's Life Along the River.* Alaska Northwest Books, 1993.

Jans, Nick. *The Last Light Breaking: Living Among Alaska's Inupiat Eskimos.* Alaska Northwest Books, 2007.

Kantner, Seth. *Shopping for Porcupine: A Life in Arctic Alaska.* Milkweed Editions, 2009.

Keith, Sam, and Proenneke, Richard. *One Man's Wilderness.* Alaska Northwest Books, 2003 (first published 1973).

Krakauer, Jon. *Into the Wild.* Anchor, 1997.

Lende, Heather. *If You Lived Here, I'd Know Your Name: News From Small-town Alaska.* Algonquin Books, 2006.

London, Jack. *Call of the Wild.* Macmillan, 1903.

McPhee, John. *Coming Into the Country.* Farrar, Straus & Giroux, 1977.

The Milepost. Morris Communications Corp., Annual.

Murie, Margaret E. *Two in the Far North.* Alaska Northwest Books, 2003 (first published 1957).

Nelson, Richard K. *Make Prayers to the Raven: A Koyukon View of the Northern Forest.* University of Chicago Press, 1986.

O'Donoghue, Brian Patrick, and Schultz, Jeff. *Iditarod Glory.* Graphic Arts Center, 2006

Sale, Richard. *A Complete Guide to Arctic Wildlife.* Firefly Books, 2012.

Sherwonit, Bill. *To the Top of Denali: Climbing Adventures on North America's Highest Peak.* Alaska Northwest Books, 2000.

Wallis, Velma. *Two Old Women: An Alaska Legend of Betrayal, Courage and Survival.* Harper Perennial, 2004 (first published 1993).

Websites

Alaska Conservation Foundation. **alaskaconservation.org**

Alaska Geographic. **alaskageographic.org**

Alaska Department of Fish and Game. **adfg.alaska.gov**

Alaska Native Heritage Center. **alaskanative.net**

Alaska.org. **alaska.org**

Alaska Public Lands Information Centers. **alaskacenters.gov**

Anchorage Museum. **anchoragemuseum.org**

Bureau of Land Management, Alaska region. **blm.gov/ak**

Travel Alaska. **travelalaska.com**

U.S. Fish and Wildlife Service, Alaska region. **alaska.fws.gov**

U.S. Forest Service, Alaska region. **www.fs.usda.gov/r10**

Apps

The Alaska App. Alaska Channel

Milepost

Map Sources

Alaska Department of Natural Resources, Alaska Mapper: dnr.alaska.gov/MapAK/

Alaska Marine Highway System: dot.state.ak.us/amhs/index.shtml

Alaska State Geospatial Data Clearinghouse: asgdc.state.ak.us

Department of Transportation, Federal Highway Administration, NHPN (National Highway Planning Network) geospatial database: fhwa.dot.gov/planning/processes/tools/nhpn

Google Maps: maps.google.com

National Atlas of the United States: nationalatlas.gov

National Park Service: nps.gov

Natural Resources Canada, GeoBase: geobase.ca/geobase/en/index.html

OpenStreetMap: openstreetmap.org

U.S. Fish and Wildlife Service/USFWS National Cadastral Data: fws.gov/gis/data/cadastraldb

OpenStreetMap: openstreetmap.org

U.S. Fish and Wildlife Service/USFWS National Cadastral Data: fws.gov/gis/data/cadastraldb

Illustrations Credits

Front Jacket: www.alaskaphotographics.com/Patrick J Endres.
Back Jacket: (UPLE), John Hyde/Alaska Stock Images/National Geographic Creative; (UPCTR), Mike Berenson/Colorado Captures/Getty Images; (UPRT), Alaska State Library, Historical Collections, ASL-P306-1040; (LOLE), Mint Images-Frans Lanting/Getty Images; (LOCTR), D.B. Church/National Geographic Creative; (LORT), Nick Jans/Alaska Stock Images/National Geographic Creative.
Front Matter: 2-3, Tom Soucek/Alaska Stock Images/National Geographic Creative; 4, Clark James Mishler/Alaska Stock Images/National Geographic Creative; 6-7, Alaska Stock Images/National Geographic Creative; 8-9, Aurora Open/Getty Images; 10-11, Michael Melford/National Geographic Creative; 12-13, Michael Melford/National Geographic Creative; 14-15, Ian Shive/TandemStock.com; 18, Kenneth Wiedemann/iStockphoto; 18-19, Loren Holmes/Alaska Dispatch/AccentAlaska.com; 20, Paul Tessier/iStockphoto; 21, eye-CatchLight Photography/Shutterstock; 22, Christopher Boswell/Shutterstock; 23, George Burba/iStockphoto.
Chapter 1: 24-5, Alaska Stock Images/National Geographic Creative; 26, George F. Mobley/National Geographic Creative; 27, Mingei International Museum/Art Resource, NY; 28, Ken Canning/iStockphoto; 29, J. Baylor Roberts/National Geographic Creative; 30-31, Thomas Sbampato/Alaska Stock Images/National Geographic Creative; 32, Matthias Breiter/Minden Pictures/National Geographic Creative; 33, Michael S. Quinton/National Geographic Creative; 34, Grosset & Dunlap, 1914; 35, Andy Krakovski/iStockphoto; 36, Daryl Pederson/AlaskaStock/Corbis; 37, Michio Hoshino/Minden Pictures/National Geographic Creative; 38-39, Robert Siciliano/AlaskaStock/Corbis; 40-41, Florian Schulz; 42, DmitryND/iStockphoto; 43, TT/iStockphoto; 44-45, Michael Melford/National Geographic Creative; 46-47, Ira Block/National Geographic Creative; 48, Werner Forman/Corbis; 49, North Wind Picture Archives/Alamy; 50 (UP), Freshwater and Marine Image Bank/University of Washington; 50 (LO), Private Collection; 51, W. Robert Moore/National Geographic Creative; 52-3, DeAgostini/Getty Images; 54, John Hyde/Alaska Stock Images/National Geographic Creative; 55, Alaska State Library, Historical Collections, ASL-P320-57; 57, Courtesy of the Bancroft Library, University of California, Berkeley, Muir-John-POR33; 58, UIG via Getty Images; 59, Didyk/iStockphoto; 60-61, Bettmann/Corbis; 62, AlaskaStock/Corbis; 64, Corbis; 65, Melville B. Grosvenor/National Geographic Creative.
Chapter 2: 66-67, Josh Whalen/TandemStock.com; 69, Seattle Art Museum, Gift of John H. Hauberg, 91.1.124; 70, Lee Prince/Shutterstock; 71, Chrisarchytekt/Dreamstime.com; 72-73, Walleyelj/Dreamstime.com; 74, Rich Reid/National Geographic Creative; 75, mchebby/iStockphoto; 77, Carr Clifton/Minden Pictures/National Geographic Creative; 78-9, Paul Whitfield/Dorling Kindersley/Getty Images; 80 81, W. E. Garrctt/National Geographic Creative; 82, Jim Patterson; 83, Pep Roig/Alamy; 84-5, Michael Melford/National Geographic Creative; 86, Lee Prince/Shutterstock; 87, Joel Sartore/

National Geographic Creative; 88, Joy Prescott/Shutterstock; 89, Melissa Farlow/National Geographic Creative; 90-91, Marc Muench/TandemStock.com; 92, Courtesy of the New Bedford Whaling Museum; 93, North Wind Picture Archives/Alamy; 94, Randall Tate/TandemStock.com; 96-97, Ty Maloney/iStockphoto; 98, Michael Price/iStockphoto; 99, Ernest Manewal/Alaska Stock Images/National Geographic Creative; 100, Carr Clifton/Minden Pictures/National Geographic Creative; 101, Ralph Lee Hopkins/National Geographic Creative; 102-103, Carr Clifton/Minden Pictures/National Geographic Creative; 104-105, Alaska Stock Images/National Geographic Creative; 105, Kevin Morris/Getty Images; 106, Museum of History and Industry/Corbis; 107, Dagny Willis/Getty Images; 109, Don Fink/iStockphoto; 110, Lee Prince/Shutterstock; 111, Deborah Maxemow/iStockphoto.
Chapter 3: 112-13, Karen Kasmauski/National Geographic Creative; 115, Musée de Boulogne-sur-Mer; 116, Tom Evans/Alaska Stock Images/National Geographic Creative; 117, Natalie Fobes/Corbis; 118-19, Heinz Wohner/Getty Images; 120, Charlie Borland/FogStock/Aurora Photos; 121, Bettmann/Corbis; 122, Saturated/iStockphoto; 122-3, Kevin G. Smith/Alaska Stock/Alamy; 124, Calvin W. Hall/Alaska Stock Images/National Geographic Creative; 126, Karine Aigner/National Geographic Creative; 127, Carr Clifton/Minden Pictures/National Geographic Creative; 128-9, Natalie Fobes/Science Faction/Corbis; 130-31, Steve Raymer/National Geographic Creative; 132, Kmreport/Dreamstime.com; 133, Thomas Kline/Alaska Stock/Corbis; 134-5, Mint Images-Frans Lanting/Getty Images; 136, Joel Sartore/National Geographic Creative; 137, Library of Congress, Prints & Photographs Division, HAER, #AK-1-D-2, photo by Jet Lowe; 138, Christian Heeb/age fotostock; 139, Stephen Lackie/Corbis; 140-41, Frans Lanting/Corbis; 142-3, Michael Melford/National Geographic Creative; 144, Romko_chuk/iStockphoto; 145 (UP), Walter Bibikow/age fotostock; 145 (LO), Frank Leung/iStockphoto.
Chapter 4: 146-7, Alaska Stock/Corbis; 149, National Museum of Denmark, Ethnographic Collections; 150, Kyle Waters/Shutterstock; 151, Library of Congress, Prints & Photographs Division, Carpenter Collection #LC-DIG-ppmsc-01799; 152-3, ScottDickerson.com; 154, Daryl Pederson/Alaska Stock Images/National Geographic Creative; 155, Frank Hildebrand/iStockphoto; 156-7, Rich Reid/TandemStock.com; 158, John Elk/Lonely Planet Images/Getty Images; 158-9, Kevin Smith/Design Pics/Corbis; 160-61, Michele Cornelius/Dreamstime.com; 162, Mount McKinley, (oil on canvas), Laurence, Sidney (1865–1939)/Private Collection/Photo © Christie's Images/The Bridgeman Art Library; 163, Chris Arend/Alaska Stock; 165, Wien Collection; Anchorage Museum, B1985.027.2095; 166, Jeff Schultz/Alaska Stock Images/National Geographic Creative; 167, Chris Boswell/Dreamstime.com; 168-9, Ethan Welty/TandemStock.com; 171, Alaska Stock/Corbis; 172-3, Carl R. Battreall/Alaska Stock Images/National Geographic Creative; 174, Christopher Boswell/Shutterstock; 175, Donna Dewhurst/AccentAlaska.com; 176 (UP), Michael DeYoung/

Alaska Stock Images/National Geographic Creative; 176 (LO), FugeSpot/iStockphoto; 177, Alan T. Bassett/Shutterstock.

Chapter 5: 178-9, Chlaus Lotscher/Alaska Stock Images/National Geographic Creative; 181, Marilyn Angel Wynn/NativeStock.com; 182, Alaska Stock Images/National Geographic Creative; 183, brytta/iStockphoto; 184 (UP), otme/iStockphoto; 184 (LO), otme/iStockphoto; 185, AP Photo/Mark Thiessen, File; 186, Mauricio Handler/National Geographic Creative; 187, Nancy Nehring/iStockphoto; 188-9, Sunny K. Awazuhara-Reed; 191, Alaska Stock Images/National Geographic Creative; 192-3, Michael DeYoung/Alaska Stock Images/National Geographic Creative; 194, Steve Kaufman/Corbis; 195, Michele Cornelius/Dreamstime.com; 196, Rich Reid/National Geographic Creative; 198-9, Mark A. Johnson/Corbis; 200, Doug Lindstrand/Alaska Stock Images/National Geographic Creative; 201, Green Blue Red, Oil on Canvas, Alex Duff Combs, 2005. Fine Arts Collection, Pratt Museum, Homer, Alaska. Purchase of this artwork for the Pratt Museum permanent collection was made possible through the generous support of the Rasmuson Foundation. PM 2005.027.0001; 202-203, Scott Dickerson/Alaska Stock Images/National Geographic Creative; 204, Olga Popova/Shutterstock; 205, Klaus Nigge/National Geographic Creative; 206, Alaska Stock Images/National Geographic Creative; 207, John DeLapp/AlaskaStock/Corbis; 208-209, Wayde Carroll; 210, Alaska Stock Images/National Geographic Creative; 211 (UP), Michael DeYoung/Design Pics/Corbis; 211 (LO), Alaska Stock Images/National Geographic Creative.

Chapter 6: 212-13, Ian Shive/TandemStock.com; 215, Marilyn Angel Wynn/NativeStock/Getty Images; 216, Corbis; 217, Art Wolfe/Getty Images; 218, D.B. Church/National Geographic Creative; 219, Gary Schultz/Alaska Stock Images/National Geographic Creative; 220-21, Barrett Hedges/National Geographic Creative; 222, Justin Reznick/iStockphoto; 223, bkp/Shutterstock; 224-5, Barry Tessman/National Geographic Creative; 226-7, University of Alaska Museum of the North; 227, Frank Hildebrand/iStockphoto; 228, Aleut in Festival Dress in Alaska, Mikhail T. Tikhanov, 1818, pubic domain image from Wikipedia; 230-31, Fred Hirschmann/Science Faction/Corbis; 232, Alaska Stock Images/National Geographic Creative; 233, Dan Lamont/Corbis; 234-5, Dan Parrett/Alaska Stock Images/National Geographic Creative; 237, Alaska State Library, Historical Collections, ASL-P306-1040; 238-9, Paul Souders/Corbis; 240, Boonchuay Promjiam/Shutterstock; 241, Roberta Olenick/All Canada Photos/Corbis; 242-3, Jacob Maentz/Corbis; 244, Suzi Eszterhas/Minden Pictures/Getty Images; 245 (LE), Vance Gese/Alaska Stock Images/National Geographic Creative; 245 (RT), wildrev/iStockphoto.

Chapter 7: 246-7, Michael Melford/National Geographic Creative; 249, Mingei International Museum/Art Resource, NY; 250, Flip Nicklin/Minden Pictures/National Geographic Creative; 251, Douglas Demarest/Design Pics/Corbis; 252-3, Michio Hoshino/Minden Pictures/National Geographic Creative; 254, Stephen Krasemann/Getty Images; 255, Lynn Johnson/National Geographic Creative; 256, Corbis; 257, Gerrit Vyn/naturepl.com; 258-9, Clark James Mishler/AlaskaStock.com; 260, Joel Sartore/National Geographic Creative; 261, Riccardo Savi/Getty Images; 262-3, Michael Melford/National Geographic Creative; 264, Kevin Smith/Design Pics/Corbis; 266, Ira Block/National Geographic Creative; 267, Lomen Brothers/NGS Archives; 268-9, Hal Brindley/Shutterstock; 270, Michael Melford/National Geographic Creative; 271, Harry Walker/Alaska Stock Images/National Geographic Creative; 272 (UP), Tom Soucek/Alaska Stock Images/National Geographic Creative; 272 (LO), MCT via Getty Images; 273, www.alaskaphotographics.com/Patrick J Endres.

Chapter 8: 274-5, Gail Johnson/Shutterstock; 277, University of Alaska Museum of the North; 278, Alaska State Library, Historical Collections, ASL-P277-004-089; 279, dawnn/iStockphoto; 280-81, RONSAN4D/iStockphoto; 281, Joel Sartore/National Geographic Creative; 282, dawnn/iStockphoto; 283, Gail Johnson/Shutterstock; 284, Tom Berger/National Geographic Your Shot; 286-7, Thomas Riggs, Jr./NGS Archives; 288-9, Dan Evans/National Geographic Your Shot; 290, Library of Congress, Prints & Photographs Division, Carpenter Collection, #LC-DIG-ppmsc-01564; 291, Nat Farbman/Time & Life Pictures/Getty Images; 292-3, Jeff Schultz/Alaska Stock Images/National Geographic Creative; 294, AlaskaStock/Corbis; 295, AP Photo/Anchorage Daily News, Bill Roth; 296-7, Mike Berenson/Colorado Captures/Getty Images; 298, Alaska Stock Images/National Geographic Creative; 299, Alison Wright/National Geographic Creative; 300-301, Michael DeYoung/AlaskaStock/Corbis; 302, Jochen Schlenker/Getty Images; 303, Jochen Schlenker/Robert Harding Picture Library Ltd./Alamy; 304 (UP), TT/iStockphoto; 304 (LO), ArtBoyMB/iStockphoto; 305, Alison Wright/National Geographic Creative.

Chapter 9: 306-307, Alaska Stock Images/National Geographic Creative; 309, John Elk/Lonely Planet Images/Getty Images; 310, Fred Hirschmann/Science Faction/Corbis; 311, Steven Kazlowski/Alaska Stock Images/National Geographic Creative; 312-13, Steven Kazlowski/Alaska Stock Images/National Geographic Creative; 314, Clark James Mishler/Alaska Stock Images/National Geographic Creative; 315, Nick Jans/Alaska Stock Images/National Geographic Creative; 316, Douglas Demarest/Design Pics/Corbis; 318, Rolf Hicker/All Canada Photos/Corbis; 320-21, Michael Christopher Brown/National Geographic Creative; 322, The Murie Center Archives; 323, Hugh Rose/AccentAlaska.com; 324-5, James P. Blair/National Geographic Creative; 326, Joel Sartore/National Geographic Creative; 327, Michio Hoshino/Minden Pictures/National Geographic Creative; 328-9, Joel Sartore/National Geographic Creative; 330, Alaska Stock Images/National Geographic Creative; 331, Emory Kristof/National Geographic Creative; 332-3, Michael Christopher Brown/National Geographic Creative; 334, Chris Arend/Alaska Stock Images/National Geographic Creative; 335, Alaska Stock Images/National Geographic Creative; 336 (UP), Alaska Stock Images/National Geographic Creative; 336 (LO), R. Vickers/Shutterstock; 337, Wheninusa/iStockphoto; 338, Mary Devine.

Index

Index

Index

Index

Alaska

BOB DEVINE

Published by the National Geographic Society

Gary E. Knell, *President and Chief Executive Officer*

John M. Fahey, *Chairman of the Board*

Declan Moore, *Executive Vice President;
President, Publishing and Travel*

Melina Gerosa Bellows, *Executive Vice President; Publisher
and Chief Creative Officer, Books, Kids, and Family*

Prepared by the Book Division

Hector Sierra, *Senior Vice President and General Manager*

Janet Goldstein, *Senior Vice President
and Editorial Director*

Jonathan Halling, *Creative Director*

Marianne Koszorus, *Design Director*

Lisa Thomas, *Senior Editor*

R. Gary Colbert, *Production Director*

Jennifer A. Thornton, *Director of Managing Editorial*

Susan S. Blair, *Director of Photography*

Meredith C. Wilcox, *Director,
Administration and Rights Clearance*

Staff for This Book

Barbara Payne, *Editor*

Sanaa Akkach, *Art Director*

Matt Propert, *Illustrations Editor*

Jennifer Gibson Frink, *Designer*

Marty Ittner, *Design Consultant*

Carl Mehler, *Director of Maps*

Marshall Kiker, *Associate Managing Editor*

Judith Klein, *Production Editor*

Katie Olsen, *Production Design Assistant*

Production Services

Phillip L. Schlosser, *Senior Vice President*

Chris Brown, *Vice President, NG Book Manufacturing*

Nicole Elliott, *Director of Production*

George Bounelis, *Senior Production Manager*

Darrick McRae, *Imaging Technician*

The National Geographic Society is one of the world's largest nonprofit scientific and educational organizations. Its mission is to inspire people to care about the planet. Founded in 1888, the Society is member supported and offers a community for members to get closer to explorers, connect with other members, and help make a difference. The Society reaches more than 450 million people worldwide each month through *National Geographic* and other magazines; National Geographic Channel; television documentaries; music; radio; films; books; DVDs; maps; exhibitions; live events; school publishing programs; interactive media; and merchandise. National Geographic has funded more than 10,000 scientific research, conservation, and exploration projects and supports an education program promoting geographic literacy. For more information, visit www.nationalgeographic.com.

For more information, please call 1-800-NGS LINE (647-5463) or write to the following address:

National Geographic Society
1145 17th Street N.W.
Washington, D.C. 20036-4688 U.S.A.

For information about special discounts for bulk purchases, please contact National Geographic Books Special Sales: ngspecsales@ngs.org

For rights or permissions inquiries, please contact National Geographic Books Subsidiary Rights: ngbookrights@ngs.org

Library of Congress Cataloging-in-Publication Data
Devine, Bob, 1951-
 Alaska : a visual tour of America's great land / Bob Devine.
 p. cm.
 Includes bibliographical references and index.
 ISBN 978-1-4262-1339-7 (hardcover : alkaline paper) -- ISBN
 978-1-4262-1340-3 (hardcover (deluxe) : alkaline paper)
 1. Alaska--Description and travel. 2. Alaska--Pictorial works.
 I. Title.
 F910.5.D47 2014
 979.8--dc23
 2013046522

Printed in the United States of America

14/RRDW-CML/1

Armchair Travel And More From National Geographic

▲ Quick travel tips and fun lists are incorporated into the rich history of the Enchanted Isles. Language origins, customs, and little-known lore, as well as a complete index round out this ultimate and unique reference.

▲ For travelers seeking the most authentic, immersive experiences imaginable, this gem provides inside information on the best way to discover a foreign culture and its people from regional festivals to little-known local restaurants.

 Expert travel writer and Alaska authority Bob Devine shares his experiences at all the best spots and goes off the beaten path to give a full portrait of this amazing state. Vivid photographs capture the beauty and detailed maps ensure you won't get lost. This essential guide includes a robust Travelwise section with all you need to get to and around Alaska.

 Like us on Facebook.com: Nat Geo Books

Follow us on Twitter.com: @NatGeoBooks

AVAILABLE WHEREVER BOOKS ARE SOLD
nationalgeographic.com/books